W9-BWP-351

SCYTHIAN GOLD

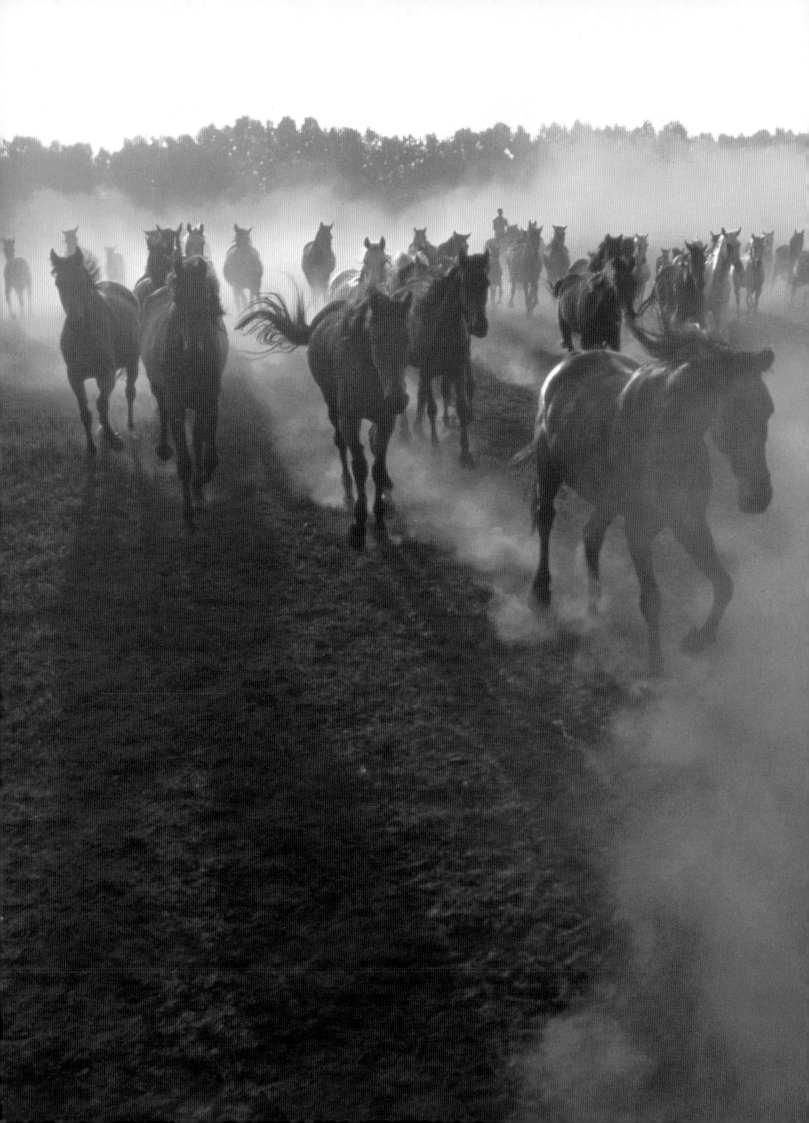

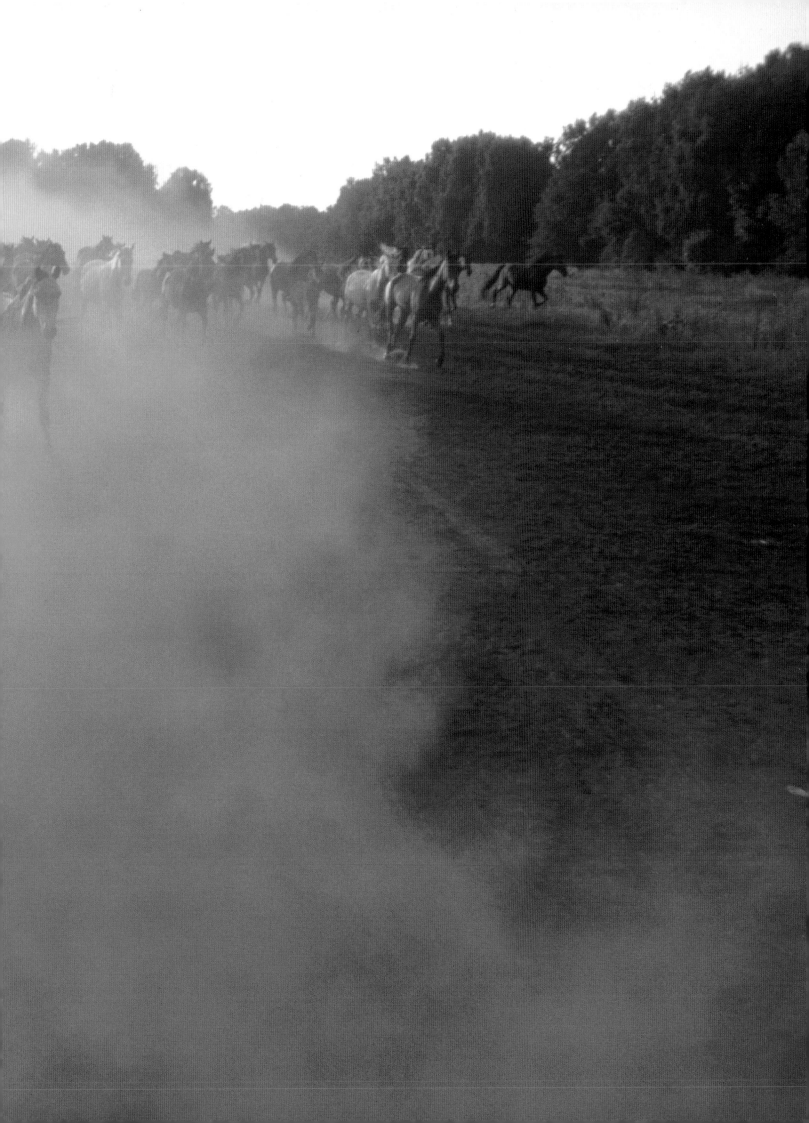

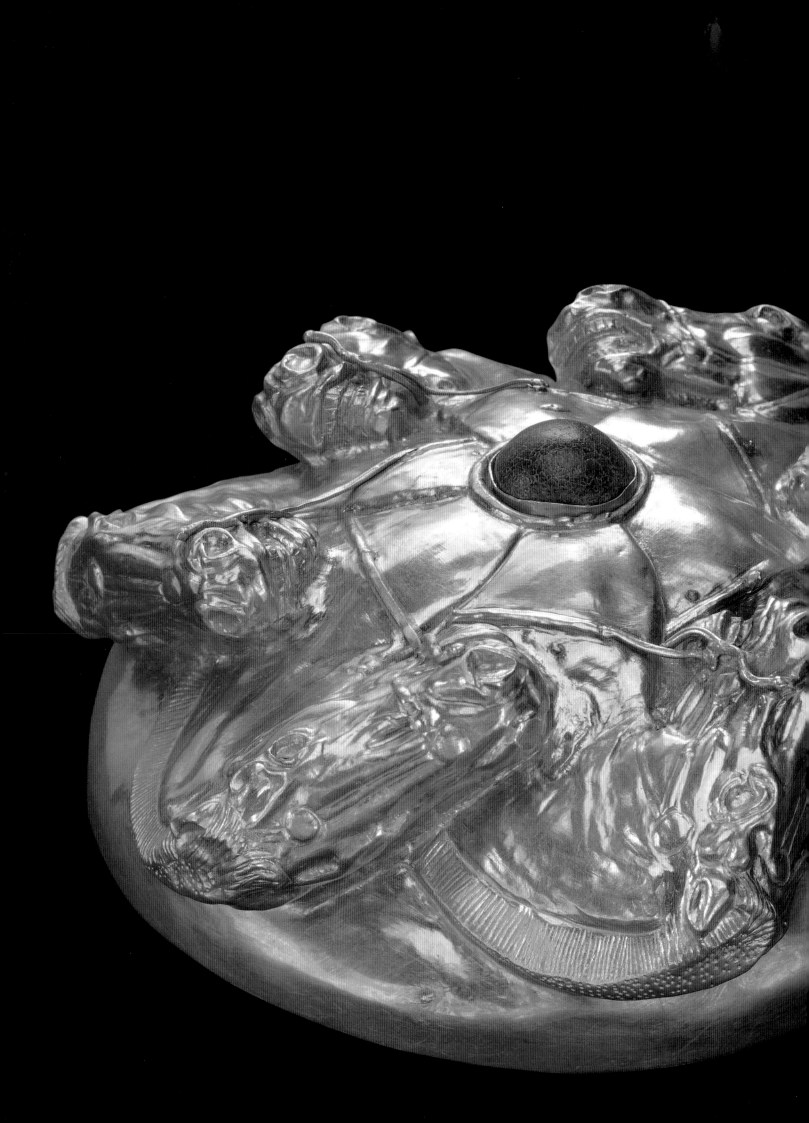

SCYTHIAN GOLD

TREASURES FROM ANCIENT UKRAINE

ELLEN D. REEDER

editor

With essays by
ESTHER JACOBSON, LADA ONYSHKEVYCH, ELLEN REEDER, MICHAEL TREISTER,
P. P. TOLOCHKO AND S.V. POLIN, V. I. MURZIN, TETIANA BOHUSH AND HALYNA BUZIAN,
SVITLANA KORETS'KA AND LIUDMYLA STROKOVA, OLENA PIDVYSOTS'KA

HARRY N. ABRAMS, INC., PUBLISHERS
in association with
The Walters Art Gallery and the San Antonio Museum of Art

THE SAN ANTONIO MUSEUM OF ART
San Antonio, Texas
November 7, 1999–January 30, 2000

THE LOS ANGELES COUNTY MUSEUM OF ART
Los Angeles, California
July 2–September 24, 2000

THE NELSON-ATKINS MUSEUM OF ART
Kansas City, Missouri
May 27–September 11, 2001

THE WALTERS ART GALLERY
Baltimore, Maryland
March 5–May 28, 2000

THE BROOKLYN MUSEUM OF ART
Brooklyn, New York
October 29, 2000–January 21, 2001

THE GRAND PALAIS
Paris, France
September 25–December 31, 2001

Honorary Chair of the Exhibition
THE FIRST LADY HILLARY RODHAM CLINTON

Lenders to the Exhibition:
National Museum of the History of Ukraine
Museum of Historical Treasures of Ukraine
Institute of Archaeology of the National Academy of Sciences of Ukraine
State Historical Archaeological Preserve, Pereiaslav-Khmel'nyts'kyi

This publication is made possible in part through the generosity of Sarah E. Harte

This exhibition is supported by an indemnity from the Federal Council on the Arts and Humanities

Project Manager: Ellen Nidy
Editor: Ellen D. Reeder
Designer: Alex Castro

Library of Congress Cataloging-in-Publication Data

Scythian Gold : treasures from ancient ukraine / Ellen Reeder, editor;
with essays by Esther Jacobson . . . [et al.]
 p. cm.
 Catalog of an exhibition held at San Antonio Museum of Art,
San Antonio, Tex., the Walters Art Gallery, Baltimore, Md., the
Los Angeles County Museum of Art, Los Angeles, Calif., and the
Brooklyn Museum of Art, Brooklyn, N.Y.
 Includes bibliographical references and index.
 ISBN 0–8109–4476–6 (Abrams cloth) 0–8109–2938–4 (Mus. pbk)
 1. Goldwork, Scythian exhibitions. 2. Decoration and ornament—
Animal forms Exhibitions. 3. Goldwork—Ukraine—Kiev Exhibitions.
4. Muzeĭ istorychnykh koshtovnosteĭ Ukraïns 'koï RSR Exhibitions.
5. Instytut arkheolohiï (Natsional 'na akademiia nauk Ukraïny)
Exhibitions. I. Reeder, Ellen D. II. Jacobson, Esther.
III. San Antonio Museum of Art (San Antonio, Tex.) IV. Walters
Art Gallery (Baltimore, Md.) V. Los Angeles County Museum of Art
(Los Angeles, Calif.) VI. Brooklyn Museum of Art (Brooklyn, N.Y.)
NK7106.4.S38S39 1999
739.2'273951'07473—DC21 99–14769

Harry N. Abrams, Inc.
100 Fifth Avenue
New York, N.Y. 10011
www.abramsbooks.com

Front cover: Catalogue 136, *Finial*, 5th c., Gold; Institute of Archaeology of the National Academy
 of Sciences of Ukraine. *Photograph Lynton Gardiner*
Back cover: Catalogue 124, *Helmet with Combat Scenes*, 4th c., Gold; Museum of Historical Treasures
 of Ukraine. *Photograph Bruce White*
Page 1: detail, Catalogue 124, *Helmet with Combat Scenes*. *Photograph Bruce White*.
Page 2–3: Horses running in Ukraine. *Photograph National Geographic*.
Page 4–5: Catalogue 134, *Cup with horses*, Kyiv, Institute of Archaeology. *Photograph Lynton Gardiner*.

Contents

Foreword

My first visit to Kyiv, during the record-setting cold of December 1997, left a lasting impression. A deep blue sky, a huge golden sun hanging low, the brilliant white of the snow, and the reflected golden brilliance of the dome of the Cathedral of Sviata Sofia. But even that vision pales in retrospect, as I compare it to the dazzling impact of the Scythian treasures I encountered then for the first time.

For this reason, for the affection I nourish for the Ukrainians I met on that visit and since, and for the ground-breaking scholarship that Dr. Ellen Reeder, Walters Curator of Ancient Art, brings to bear in this magnificent catalogue—for all of these reasons, I feel a tremendous sense of pride and privilege in helping to bring the artistic treasures of this great ancient civilization to the United States.

I owe a special debt of gratitude to Dr. Gerry Scott, Interim Director of the San Antonio Museum of Art, for he has been with us, both as an able museum director and as a collaborating scholar, every step of the way. And I offer my enduring thanks to Professor P. Tolochko, Director of the Institute of Archaeology of the National Academy of Sciences of Ukraine, as well as to Serhii Chaikovs'kyi, Director, National Museum of the History of Ukraine, without whom this magnificent project could never have been realized.

<div align="center">Dr. Gary Vikan, Director, The Walters Art Gallery, Baltimore</div>

This catalogue, which accompanies the first exhibition of art work from Ukraine in the United States since Ukraine became independent, represents a tremendous accomplishment of scholarship and collaboration. It is the result of more than two years work by the curatorial departments of the San Antonio Art Museum and the Walters Art Gallery, and by our friends and colleagues in Ukraine. It is also the first major exhibition of ancient Scythian art to tour the United States since the 1970s, when *From the Land of the Scythians,* organized by the Metropolitan Museum of Art, was seen in New York and Los Angeles.

The present catalogue and exhibition bring the extraordinary artistic accomplishments of ancient Ukraine to a wider American audience and incorporate the latest advances in scholarship and archaeology. Indeed, many of the objects included have only been excavated within the last two decades. Also significant is the fact that this catalogue presents those archaeological treasures from an art-historical perspective and places the objects within their cultural context, often with new insight. For these accomplishments, I am deeply grateful to my colleague Dr. Ellen Reeder of the Walters Art Gallery, who has tirelessly and with remarkable dedication brought her considerable talent to assembling, editing, and contributing to this splendid catalogue. Her curatorial vision and scholarship have been essential to the project.

I am also especially grateful to Dr. Gary Vikan, Director of the Walters Art Gallery, for joining with the San Antonio Museum of Art to make this important initiative possible. His wisdom, enthusiasm, and administrative acumen have contributed immeasurably. Finally, I am deeply indebted to our many Ukrainian friends and colleagues who have contributed so much to this project, especially to Mr. Serhii Chaikovs'kyi, Director of the National Museum of the History of Ukraine, and to Professor P. Tolochko, Director of the Institute of Archaeology of the National Academy of Sciences of Ukraine, whose leadership and guidance have been invaluable.

<div align="center">Dr. Gerry D. Scott III, Interim Director, San Antonio Museum of Art</div>

THE NATIONAL MUSEUM OF THE HISTORY OF UKRAINE and the State Historical Archaeological Preserve, Pereiaslav-Khmel'nyts'kyi join with the Institute of Archaeology and the Museum of Archaeology of the National Academy of Sciences of Ukraine in organizing this exhibition. This landmark exhibition represents the first time that museums of independent Ukraine are represented in the United States of America.

The National Museum of the History of Ukraine is one of the oldest museums in Ukraine. Over five hundred thousand objects are included in its collection, which spans the full history of Ukraine, from paleolithic times to the modern day. In addition to its archaeological material, the museum is particularly well known for its numismatic collection.

The Scythian gold in the National Museum of the History of Ukraine is a source of great pride to the people of Ukraine. Over the years, international interest in the collection has brought us the pleasure of welcoming to the museum distinguished guests from many foreign nations. It is now our honor to share with the people of the United States these masterpieces of human achievement. We hope that this exhibition will bring to its many American visitors a heightened awareness of independent Ukraine and of the treasures in its museums and buried in its earth.

We appreciate the assistance and support of the government of the United States of America, the San Antonio Museum of Art, and the Walters Art Gallery in making this exhibition possible.

Serhii M. Chaikovs'kyi,
Director, National Museum of the History of Ukraine

IT IS WITH PARTICULAR PRIDE that the Institute of Archaeology participates in this unprecedented exhibition of the finest Scythian objects from Ukraine. We are particularly pleased that the exhibition is presented in the United States, a nation with which Ukraine has had a long tradition of cultural exchange.

The collection of the Institute of Archaeology has its roots in the first part of this century and today numbers hundreds of thousands of objects, dating from earliest times to the late Middle Ages. Every year, the collection is enhanced by hundreds of new objects recovered from archaeological excavations.

Most of the works of art lent to this exhibition from the Institute of Archaeology were excavated within the last ten years. Several objects were discovered as recently as 1998. Of particular note is the material from three kurhans: Babyna Mohyla, Soboleva Mohyla from Dnipropetrovs'ka Oblast' and Bratoliubivs'kyi Kurhan from Khersons'ka Oblast'.

It is hoped that this exhibition will offer visitors an informative window onto Ukraine and its culture. For Americans of Ukrainian descent, we hope that this exhibition will provide a particularly meaningful link with the ancient history of their fatherland.

Professor P. Tolochko,
Director, Institute of Archaeology of the National Academy of Sciences of Ukraine

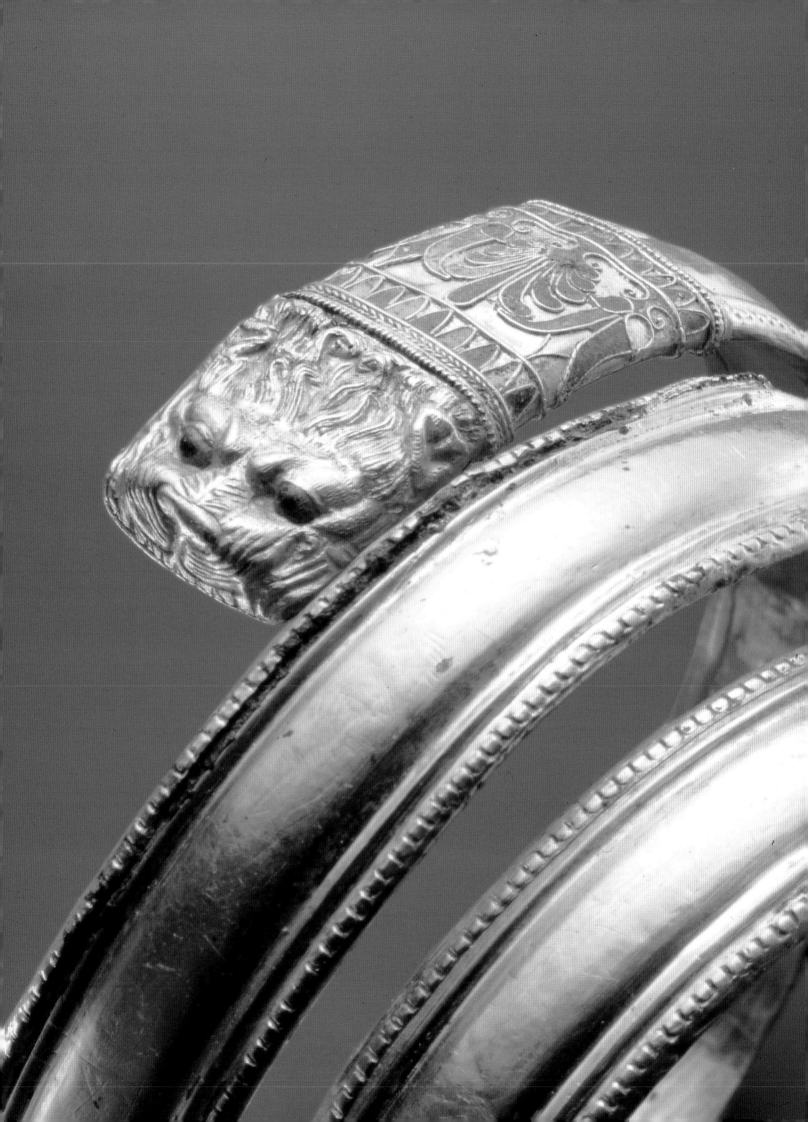

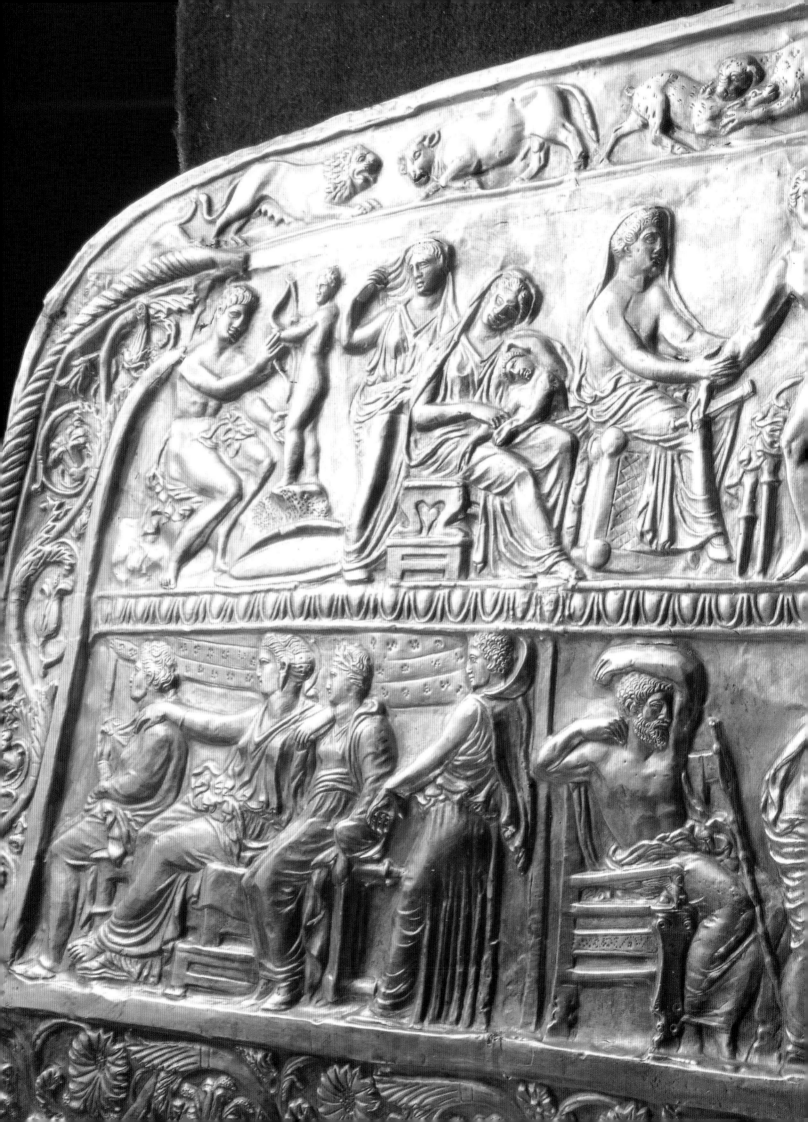

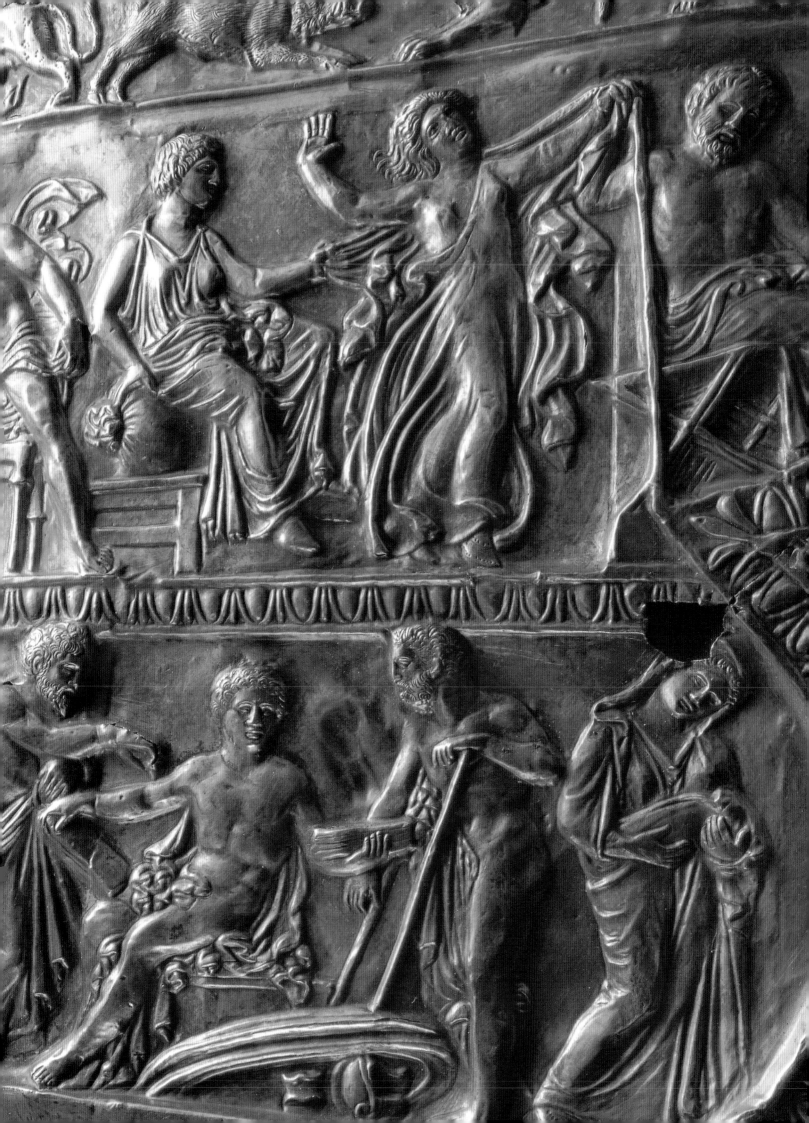

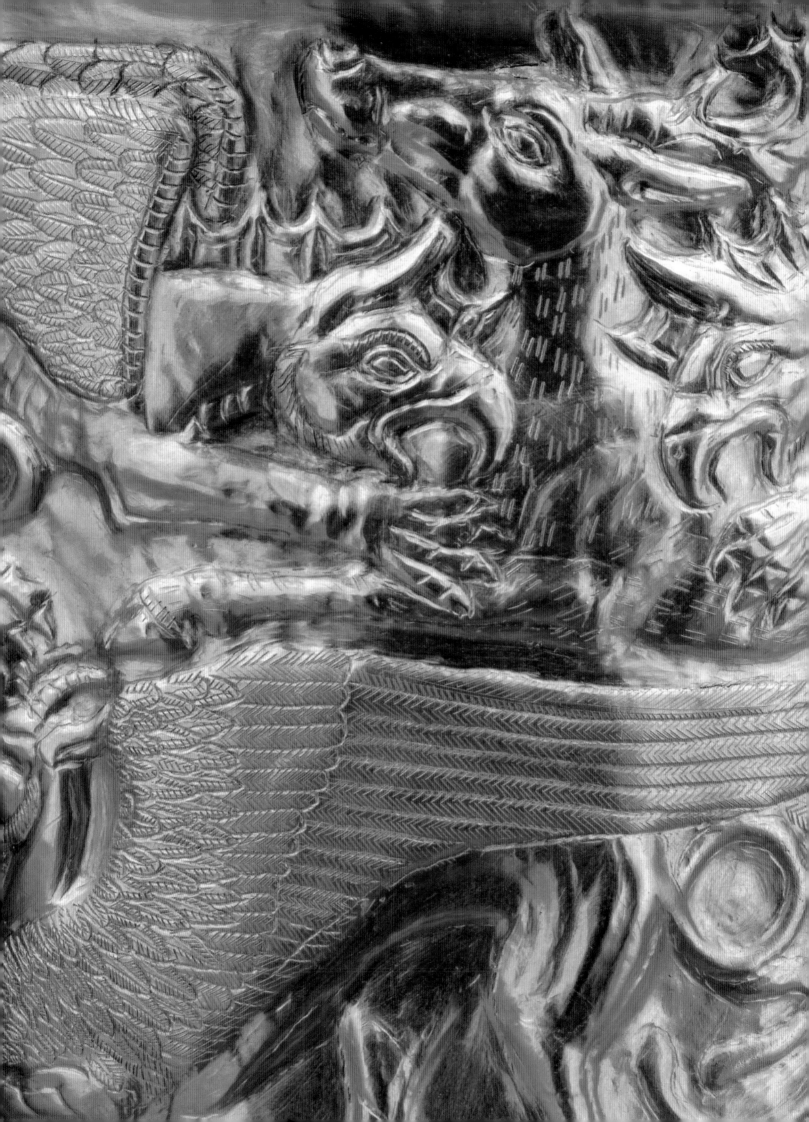

Preface

This assemblage of the finest Scythian objects in Ukrainian museums tells the story of a nomadic people who acquired extraordinary wealth in the fourth century B.C. by providing grain to Greek markets. While rooted in central Asia, Scythian culture and art were enriched through contact with the Greek world and the civilizations of the ancient Near East. Scythian art thus represents a dialogue between the artistic traditions of central Asia and those of western Asia and the Mediterranean world. This avenue of exploration promises to be a fruitful one that will reward future study.

Almost every object presented here was recovered during controlled excavations. The systematic investigation of the burial contexts has provided valuable insight into Scythian culture: that women were buried with armament and weaponry; that human sacrifice formed part of the burial ritual; that the kurhans, or burial mounds, were reopened to accommodate later burials; and that certain objects were so consistently placed at the entrance to the burial chamber that a specific cultic function is highly likely. This kind of information, which could not have been obtained if the burials had been disturbed through looting, leads us back through the objects to the heart of Scythian culture.

This exhibition is the most ambitious exhibition Ukraine has sent abroad since gaining independence in 1991. The exhibition is also the first one that Ukraine as an independent nation has sent to the United States. The international cultural rapport that this exhibition represents both parallels and fosters an ever-deepening understanding of Scythian culture, as the works of art and original publications become available to a wider body of scholars. With the dissolution of these literal and figurative modern borders, so is the realization growing that the ancient frontier between the Scythians and their Greek neighbors was not the fixed line of demarcation that has conventionally been envisioned, but was rather as a membrane through which Greeks and Scythians regularly interacted and drew mutual benefit. Thus, events in modern times shape and guide the progress and the nature of our thinking about the ancient world.

Preceding pages:

Page 10: detail, Vessel with animal combat, Kyiv, Institute of Archaeology, inv. no. KP-V-661 (cat. no. 164).
　　Photograph Lynton Gardiner.
Page 11: detail, Bracelet, Kyiv, Museum of Historical Treasures of Ukraine, inv. no. AZS-2281/1 (cat. no. 97).
　　Photograph Bruce White.
Page 12–13: detail, Gorytos cover, Kyiv, Museum of Historical Treasures of Ukraine, inv. no. AZS-1416 (cat. no. 105).
　　Photograph Bruce White.
Opposite: detail, Finial, Kyiv, Institute of Archaeology, inv. no. Z-4116 (cat. no. 136).
　　Photograph Lynton Gardiner.

CONTRIBUTORS TO THE CATALOGUE

Ellen Reeder, Carla Brenner, Michael Treister, Lada Onyshkevych, Motrja Paluch, Nancy Zinn

INSTITUTE OF ARCHAEOLOGY OF THE NATIONAL ACADEMY OF SCIENCES OF UKRAINE
Serhii Polin
Olena Fialko

NATIONAL MUSEUM OF THE HISTORY OF UKRAINE
Svitlana Korets'ka
Liudmyla Strokova

MUSEUM OF HISTORICAL TREASURES OF UKRAINE
Olena Pidvysots'ka
Liubov Klochko
Iurii Bilan
Tetiana Shamina
Svitlana Berezova

STATE HISTORICAL ART PRESERVE, PEREIASLAV-KHMEL'NYTS'KYI
Halyna Buzian
Tetiana Bohush

Acknowledgments

This project has been characterized from its inception by a remarkable degree of positive interaction and good will with our Ukrainian colleagues. I want to thank Serhii Chaikovs'kyi, Director, National Museum of the History of Ukraine, and Ivan Yavtushenko, Deputy Director, National Museum of the History of Ukraine, for their hospitality and thoughtfulness on many, many occasions. I have also enjoyed collaborating with Denis Kozak, Director, Institute of Archaeology; and Serhii Polin, V. I. Murzin, Natalya Son, and O.I. Fialko, also of the Institute of Archaeology. Svitlana Korets'ka of the National Museum of the History of Ukraine provided insight, humor, and nourishment at much needed moments, and Andrey Timoshenko of the Laboratory of Applied Holography added his enthusiasm and English language skills, especially at the very beginning of the project. At the State Historical Archaeological Preserve of Pereiaslav-Khmel'nyts'kyi, Michael Sicorsky gave unstintingly of his time and interest in support of this endeavor. Pereiaslav-Khmel'nyts'kyi is a remarkable monument to the preservation of Ukrainian heritage, and I am especially honored that that it and Michael Sicorsky are involved in this exhibition. I am also grateful to Valerie Smoliy, Vice-Premier Minister of the Cabinet; Dmytro Ostapenko, Minister of the Art and Culture of Ukraine; Leonid Novokhatko, Deputy Minister of Culture and Art of Ukraine; Peter P. Tolochko, Honorary Director of the Institute of Archaeology, and Petro Rymar of the National Museum of the History of Ukraine, for their support of this project. And, of course, all of us in the United States involved with this exhibition are grateful for the support of President Leonid Danilovich Kuchma.

I want to express particular thanks to Nadia Shatskaya, Project Manager for the exhibition in Kyiv. Her never-ending hard work and competence have played an important part in the success of this effort, and I am enormously appreciative and respectful of her coolness under pressure, her admirable sense of professionalism, and her untiring dedication to achieving the highest standards. I also want to thank Ron Dwight who introduced Nadia to me and who made great efforts to facilitate her participation in the project. The Honorable Steven Pifer, Ambassador of the United States to Ukraine, and The Honorable William Green Miller, former Ambassador of the United States to Ukraine, provided much appreciated assistance. I also want to thank Mary A. Kruger and Gregory Orr of the United States Embassy in Kyiv. Others in Ukraine whose goodwill I want to acknowledge include Victor Bagley, conservator at the Treasures of Ukraine Museum, and Leonid Marchenko, Director, and Galina Nikolaenko, National Preserve of Tauric Chersonesos.

In the United States, I particularly want to thank Gerry Scott, III, Interim Director of the San Antonio Museum of Art, who first brought this project to the attention of the Walters Art Gallery. Gerry's good judgment, perspective, spirit of collaboration, sense of humor, and grace under pressure have been critical to the realization of this project, and I have enjoyed every minute that I have spent working with him. Also critical to this venture have been the support, enthusiasm, and advice of Gary Vikan, Director of the Walters Art Gallery, whose openness to adventure and willingness to accept ambiguity were essential factors in the completion of this project.

I also want to thank the First Lady Hillary Rodham Clinton, Honorary Chair of the Exhibition. Her support and that of Melanne Verveer, Chief of Staff to the First Lady, have been extremely helpful in moving this project forward, and I appreciate both their enthusiasm and the alacrity with

which they acted to assist the realization of this project. I am also grateful to The Honorable Anton Buteiko, Ambassador of Ukraine to the United States; The Honorable Yuri Scherbak, former Ambassador of Ukraine to the United States; and to Natalia M. Zarudna, Counselor; and Vasyl Zorya, Secretary of Culture, of the Embassy of Ukraine in Washington, D.C.

I also want to thank Graham Beal, Director, the Los Angeles County Museum of Art, and Arnold Lehman, Director, the Brooklyn Museum of Art. Their enthusiasm and spirit of cooperation moved this project along quickly in moments when that pace was necessary, and I appreciate their support and goodwill. Nancy Thomas of the Los Angeles County Museum of Art and Richard Fazzini and Jim Romano of the Brooklyn Museum of Art were bastions of curatorial support, and I have come away with ever greater admiration for the many Egyptological colleagues with which I have been collaborating with such pleasure.

Providing the initial spark to this exhibition was Professor Joseph Carter of the University of Texas at Austin. Joe's excavations at the Historic Preserve in Chersonesos have been instrumental in building bridges between American and Ukrainian scholars, and his friendships and introductions laid the foundation for this exhibition. Joe's visions of an archaeological park in Chersonesos and of an exhibition that will explore the Greek cities of the Black Sea coast are important projects that will hopefully come to completion in a few years.

Nancy Zinn, Assistant Curator for the exhibition, was instrumental in navigating the complexities of virtually every aspect of a highly complicated endeavor that offered particular challenges in issues of translation and communication. The exhibition could not have moved forward as it did without Nancy's superb supervision and her willingness to take on roles that ranged from editor to cartographer. I am grateful that, upon Nancy's departure from the project, Betsy Gordon willingly assumed such a daunting mantle and brought to the project her own extensive experience in international exhibitions, as well as her keen judgment and managerial skills. This exhibition could not have moved forward as it did without the unrelenting standard of excellence to which both Nancy and Betsy adhere.

Alex Castro, designer of the exhibition and of the catalogue, has been a guiding force in crystallizing the essence of the exhibition, in enabling the objects to speak at their most eloquent, and in bringing to my input an articulation it did not always have. I have learned a great deal about Scythian art and culture by examining and discussing the objects with Alex, and his willingness to rethink and his patience to endure complexities have been of inestimable value to me. I have especially appreciated Alex's ability to glide from a conceptual analysis of art and culture to a discussion on practical procedure, and I have relied upon his good advice many times in the progress of this project. Kevin Meadowcroft has also been extremely helpful in navigating the complexities of the book and installation design.

I am especially grateful to the catalogue essayists, who were presented with tight and unyielding deadlines. Michael Treister, Esther Jacobson, and Lada Onyshkevych willingly shared their expertise with me, and for that I am extremely appreciative. The Ukrainian essayists, Serhii Polin, V. I. Murzin, P. P. Tolochko, Tetiana Bohush, Halyna Buzian, Svitlana Korets'ka, Liudmyla Strokova, and Olena Pidvysots'ka have generously shared with me their familiarity with both the objects and the sites, and I value the friendships this close contact has nurtured.

The catalogue owes an enormous debt to Carla Brenner, whose contribution went well beyond the role as editor. Carla's ability to identify key concepts and her tolerance for the idiosyncrasies of a writer's style characterize her special talent as an editor, and this book would not read as it does or have been completed on time without her fervent input. Bernard Brenner provided valuable editing assistance at a critical stage, and Nancy Eickel willingly lent to the project her admirable skills as proofreader and editor. Margaret Beers also provided much appreciated proofreading talents.

The superb photography, carried out under challenging conditions and circumstances, is the work of Lynton Gardiner and Bruce White, whose equanimity and consistently high performance under duress have won them their superb reputations in the art world. Ariel Herrmann's exceptional eye was an invaluable addition to the project, both in the photographing of the pieces and in the original selection of the objects. For her remarkable knowledge and judgment, I have infinite respect and admiration. Other photographs were contributed by Perry Conway and Tom Brakefield, who also generously shared with me their deep knowledge of golden eagles and snow leopards. Alan Shoemaker of the Riverbanks Zoological Park and Botanical Garden, Columbia, South Carolina, was a valuable source of information and images relating to the spotted leopard and I thank him for that assistance. Sisse Brimberg and Charles O'Rear of the National Geographic came to our assistance with superb transparencies and slides, as did Gary Tepfer, with his arresting transparencies of the Altai. I also thank Andrej Yu. Alexeev, Curator of the Scythian Collection, the Hermitage, for supplying much appreciated images. Dan Przywara and Tina Grazziano of Geo Systems, Inc; and Emery Miller of WorldSat International Inc. were extremely helpful with the complicated maps.

Key contributors to the catalogue were Lada Onyshkevych and Motrja Paluch, who labored over the challenging Russian and Ukrainian texts and the complex transliterations. Motrja worked ceaselessly with the multitude of problems that the Russian- Ukrainian- and English-language bibliography presented, and both of them spent much time with aspects of the volume's maps. At Abrams, I want to thank Paul Gottlieb, Maggie Chace, and Ellen Nidy, who have taken an intense interest in the volume from its inception and whose on-going encouragement has been much appreciated.

In bringing the installation of the exhibition to completion, I thank Ted Theodore for his wisdom, humor, and expertise in international exhibitions. Rachel Mauldin of the San Antonio Museum of Art and Joan-Elisabeth Reid at the Walters Art Gallery managed the complex registrarial aspects of this endeavor and I thank them for the peace of mind that I had by knowing the exhibition was in their hands. In the execution of the installation design, Jack Eby of the Museum of Fine Arts, Houston, contributed his masterful design and production skills. Pony Allen and Suzanne McGarraugh at the San Antonio Museum were critical to the installation and mounts of the material. David Miller lent his superb talents to the execution of the mounts. For the introductory film, Martha Teichner of CBS "Sunday Morning" and Sharon Jackson of Spicer Productions were invaluable, as always.

At the San Antonio Museum of Art, the enthusiasm and support of Gilbert N. Denman, Jr., Trustee, made possible the initial organization of the project; the assistance of the Ewing Halsell Foundation in San Antonio is especially appreciated. Sarah E. Harte, Trustee and former Board Chair, supplied strong encouragement and backing. Emory A. Hamilton, Board Chair, is also to be thanked. Others within the museum whose valuable role in this project is here acknowledged include Sandra Ferguson, Karen Branson, Chaddie Kruger, Margaret Woodhull, Kathleen Scanlan, and Tracy Baker-White.

Acknowledgments for a book and exhibition are always, by necessity, written months before the project has reached completion. For that reason, I apologize for the omission of the names of individuals who in the coming months will be instrumental to the final stages of this effort. Without the assistance of all of those whom I have named and not named, the exhibition and its catalogue would never have come to realization.

ELLEN D. REEDER
Baltimore, February, 1999

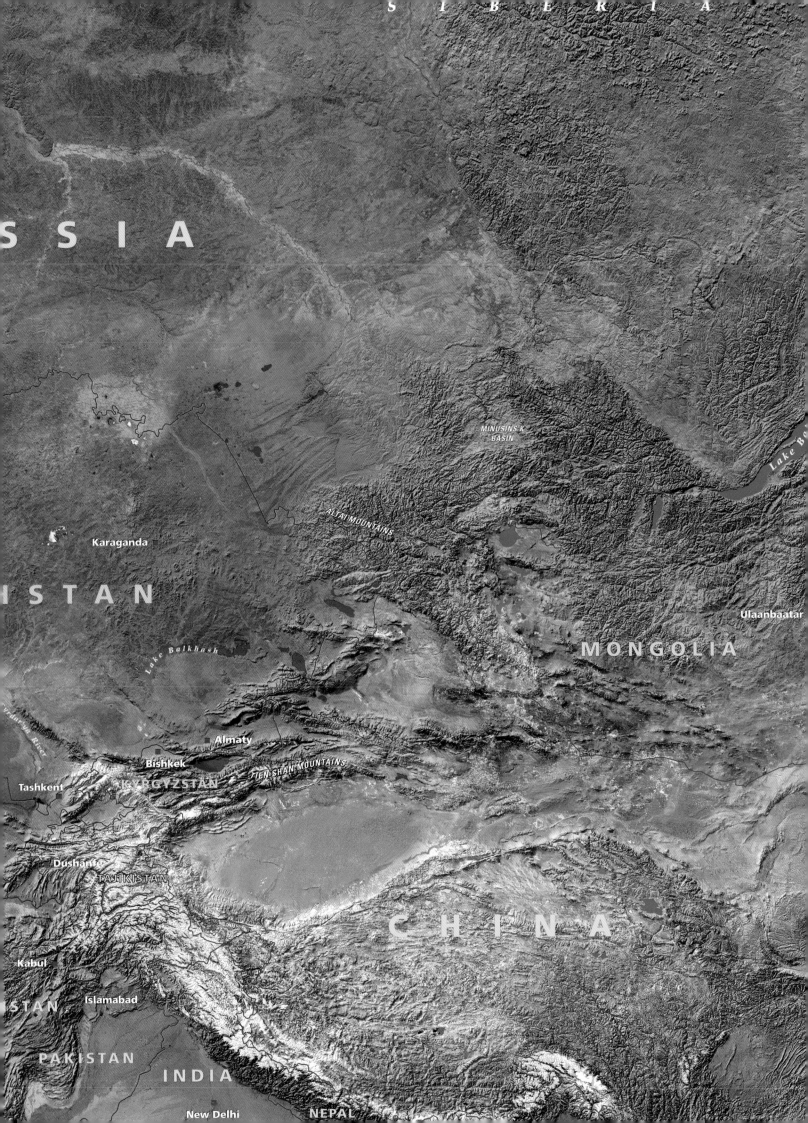

Scythia and the Scythians

Lada Onyshkevych

Much is known today about the ancient Scythians who lived on the northern shores of the Black Sea from the seventh to about the third or second centuries B.C., both from ancient literary sources like the Greek historian Herodotus and from archaeological evidence like the material included in this exhibition. The picture that emerges is of a warlike nomadic people, riding the steppes and controlling regional trade to finance their love of the rich gold ornamentation that is so often found in their burials.

We know that the rough parameters of the land called Scythia in antiquity covered much of modern Ukraine, extending south to the Black Sea and Krym (the Crimea), east to the Tanais (Don) River and Lake Maeotis (the Sea of Azov), and west to the Ister (Dunai or Danube) River. The northern boundary of Scythia and Scythian influence, however, remains unclear. It may have extended as far as modern Kyiv, or only to the borderline between the steppe and forest-steppe zones about two hundred kilometers south of Kyiv (see satellite map). Herodotus (4.101) describes Scythia of the fifth century B.C. as being roughly square in shape, each side equal to a journey of twenty days (4,000 stades, or about 700 km). At times, Scythian territory extended beyond these boundaries, to Caucasia in the southeast and to Dobruja (also called Scythia Minor) in the west.[1] Within this region, the Scythians were concentrated in the steppe, huge extensive flatlands of tall waving grasses and wild flowers that suited the needs of nomadic, pastoral horsemen like the Scythians, as well as of the Cimmerians who preceded them and the Sarmatians who followed. Herodotus (4.28, 31, and 82), as other ancient writers, describes the climate of the steppe region as harsh in the winter, but he speaks of the land as "level and grassy and well-watered" and proceeds to name its many rivers (4.47). To the north of the steppe is an intermediate forest-steppe zone that combines, as the name suggests, characteristics of the steppe plains with the forests located further to the north. The forest-steppe zone is more topographically varied than the flat steppes and, with its many rivers, streams, and lush natural vegetation, has always been very productive agriculturally. South of the steppe zone, along the coastal region of the Black Sea, a number of ancient Greek colonies had been established, starting with Berezan' and Olbia at the mouth of the Dnipro and Buh rivers in the mid-seventh century B.C. They were followed by Pantikapaion, Nymphaion, Phanagoria, and other cities of the Bosphoran kingdom in eastern Krym (Crimea).[2]

Herodotus devoted almost an entire book (book 4) of his *Histories* to the northern Black Sea region, having visited the Greek colony of Olbia himself. He not only describes the Greeks who lived in these cities, but he also speaks extensively of the Scythians and other peoples living there and examines the interconnections between this region and the Near East and Greece. For example, he

Opposite:
fig. 1. View of Ukraine. *Photograph National Geographic*

describes (4.64) the custom of each Scythian drinking "the blood of the first man he kills." He records how they brought the heads of all enemies slain to the Scythian king and used the scalps as "handkerchiefs" to decorate horse bridles or sewed them into "cloaks." The skin of enemies' hands was fashioned into quivers, and their skulls were sometimes gilded and used as cups (4.64–65). Individuals who had killed many enemies had two such cups, according to Herodotus (4.66), and would drink from both at once during special yearly gatherings, while those with no "kills" to their credit were not allowed to drink at these gatherings at all. Herodotus (4.2) also describes fermented mare's milk (*kumys*), a characteristic Scythian drink that was obtained by blowing into a bone tube inserted into the mare's anus in order to force the udder down.

Accounts of other ancient Greek visitors to the northern Black Sea region can be found in the Corpus Hippocraticum, in a section written by a physician of the fifth or fourth centuries B.C. who very much disliked the region and the Scythian people in particular. The Roman writer Ovid, exiled to Tomis in nearby Rumania, wrote of the miserable winters he spent in a land still called Scythia in the first centuries B.C. and A.D., long after the Scythians themselves had disappeared from this area. Dio Chrysostomos, at the end of the first century A.D., also wrote about the area around Olbia. While only these few authors had actually visited the region, many other Greek and later Roman writers wrote about Scythians and the region of Scythia. Aristotle (*Gen. An.* 748a25, *Hist. An.* 576a21), Strabo (vii.4.8), Pliny (*Nat. Hist.* 8.165), Frontinus (II.4.20), and others described the Scythians' extraordinary and ruthless military prowess, their use of hooked and poisoned arrowheads, their clever military strategies, and their skill at breeding and training horses. Still others referred to the known weaknesses of the Scythians, such as their fondness for alcohol and hemp: Athenaeus (*Deipnosophistae* xi.499f), for example, writes around 200 A.D. that Scythians "are in the habit of drinking to great excess," and he cites the third-century B.C. philosopher Hieronymus of Rhodes as saying that "to get drunk is to behave like a Scythian." Herodotus (4.84) and the sixth-century B.C. poet Anacreon (356.6–11) both refer to the Scythian custom of drinking wine neat, not diluted with water as the Greeks considered proper. The Spartans, Herodotus says, "use the phrase 'Scythian fashion' when they want a stronger drink than usual." Hesychius of Alexandria defines hemp as "Scythian incense" in the fifth century A.D., with a reference to Herodotus; the latter (4.74–75) describes Scythian steam baths as involving the vapor of hemp seeds and says that "the Scythians howl in joy for the vapor-bath." Stories about "blood-brotherhood" between Scythians are related, for example, by Lucian (*Toxaris, or Friendship 1*), and these accounts appear to be bolstered by depictions on jewelry (cat. nos. 40 and 42). Herodotus (4.70) describes a ceremony solemnizing a blood oath in which the parties share a drink of wine mixed with a few drops of their blood.

The Scythians were not indigenous to the northern Black Sea region. Archaeological evidence suggests that these nomadic peoples moved into the area from the east sometime around the seventh century B.C.[3] and may have mixed to some degree with the local populations.[4] Herodotus (4.5–13) relates four stories that he had heard regarding Scythian origins, including the Scythians' own version: They descended from Targitaus, whose father was Zeus and whose mother was the daughter of the local Borysthenes (Dnipro) River god a thousand years before Darius' attack on Scythia in 512 B.C.. Targitaus' three sons, Lipoxais, Apoxais, and Coloxais, all had descendants among the peoples of Scythia, but the Royal Scythians, or Scoloti as they called themselves, descended from the youngest son Coloxais, the only one able to take up four golden treasures that had burst into flames when his brothers approached. Herodotus provides a variation of this story as told by the Greek colonists of the region: the divine hero Herakles fathered three sons by a local viper-woman: Agathyrsus, Gelonus, and Scythes. The elder two were unable to draw their father's bow or put on the girdle Herakles had left for them. The youngest son, Scythes, accomplished these tasks and started a line of Scythian kings. In Herodotus' third version, the one he considered most likely, after the

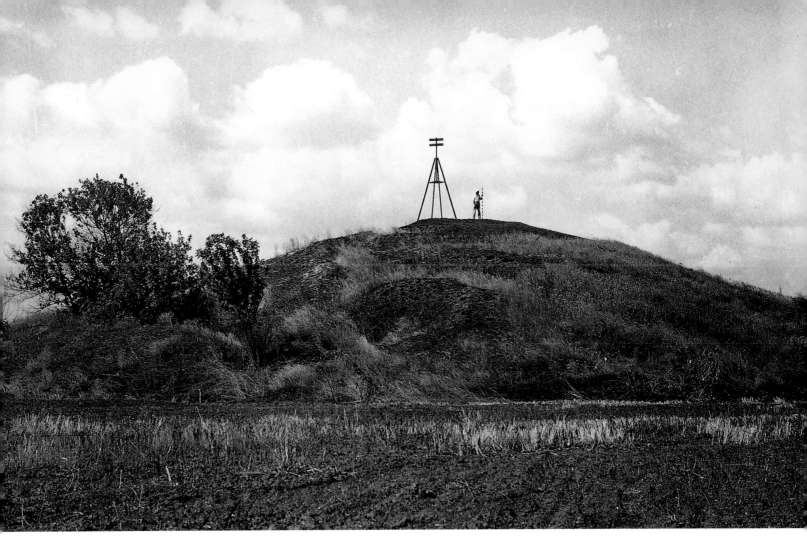

Fig. 2. Kurhan near Novyistarodub, Kirovohrads'ka Oblast'

Scythians had been pushed out of Asia by the Massagetae, they then proceeded to chase the Cimmerians out of the northern Pontic area and occupied it themselves. The final story, which Herodotus cites from a poet named Aristeas (4.13), mentions various tribes who displaced each other domino style: the Arimaspians pushed out the Issedones, who in turn pushed out the Scythians, who then pushed out the Cimmerians and occupied the northern Pontic region. The last two of these versions of Scythian origin coincide most closely with the archaeological evidence and reflect the Scythians' probable Asian origins (see the essay by Jacobson in this volume).

The archaeological record indicates that the Cimmerians, nomadic horsemen like the Scythians, did live in this area in the eighth to the first half of the seventh centuries B.C. This exhibition contains several objects attributed to the Cimmerian culture, including jewelry, horse ornaments, and a sword (cat. nos. 1–4). The Cimmerians indeed do appear to have been expelled from the region by the Scythians around the middle of the seventh century B.C.,[5] as reported by Herodotus (4.11–12), Strabo (II.2, 4, 5, 7.4), and Plutarch (*Marius* II). Then, in the third century B.C., just as the nomadic Scythians had expelled the Cimmerians, the Scythians themselves were displaced by the Sarmatians, also a nomadic, horse-riding people who dominated the region from the second century B.C. to the fourth century A.D.[6] (The Sarmatians are represented in the exhibition by cat. nos. 168–71.)

Archaeology, in fact, provides considerable evidence to complement the literary testimonia. The greatest source of such archaeological material for the Scythian culture is the many massive burial mounds, or *mohyly,* also called *kurhany* (or kurhans), that rise from the flat plains of the steppe region. If they have escaped looting over the millennia, they contain a wealth of both gold and

information. The Scythians, like the people of many other cultures around the world, invested a great deal of time and wealth in the burials of their elite, and so the kurhany in Ukraine have yielded extraordinary objects of gold and other precious materials. From the sixth century B.C. onward, when trade with the Greek colonies was well under way,[7] there is an increase in the quantity and lavishness of grave goods found in these kurhany, reaching a high point in the fifth and fourth centuries B.C. To this period belong thousands of Scythian kurhany in Ukraine.[8] The grandest of these include Tov-sta Mohyla, Babyna Mohyla, and Soboleva Mohyla in the Dnipropetrovs'ka Oblast'; Ohuz Kurhan and Bratoliubivs'kyi Kurhan in the Khersons'ka Oblast'; and Haimanova Mohyla, Berdians'kyi Kurhan, and Melitopol's'kyi Kurhan in the Zaporizhs'ka Oblast' (see map). Many objects from these kurhany are included in this exhibition. Toward the end of the fourth and into the third century B.C., a rapid decline in the wealth and number of Scythian burials is apparent, as the Sarmatian tribes gain control of the steppes but do not fully displace the Scythians from the region.[9]

The tallest of the lavish kurhany can reach twenty-one meters in height, with a diameter as great as one hundred meters at the base. Some scholars, like Mozolevs'kyi, see a correlation between the size of the kurhan and the status of the deceased buried inside (as reflected in the wealth of the grave goods), with the poorest Scythians buried in mohyly only one meter high.[10] Sometimes, the kurhany are arranged in groups numbering into the hundreds, although many have been plowed over during recent centuries of agricultural cultivation of the steppes.[11] Examination of the fill of the mounds themselves has revealed that they were not built up simply from dirt dug up from holes in the area. Instead, they were made up of turf (fig. 1). Only the top-most, grass-growing layers of black earth were used, taken from vast stretches of the steppe surrounding the kurhan and leaving no deep pits. The reason for this is unclear; perhaps it was connected with a hope for good pasturage in the next life.[12]

The kurhany in the steppes of Ukraine have exhibited differing details of construction, but most share the basic structure of a tall mound of black earth, sometimes surrounded by a circular ditch. Animal bones and broken amphoras (terra-cotta wine containers like cat. no. 90) are sometimes found in very large quantities in parts of some of these ditches, as at Tovsta Mohyla, and most likely represent the debris from funeral feasting.[13] The main burials were placed in chambers within the mounds, at depths ranging from two to fourteen meters below ground level. These were accessed by means of shafts cut through the firm earth, often with steep steps cut into the sides to ease descent.[14] The burial chambers were usually large, rounded in shape, and often had side chambers and niches cut into their walls. After the burial was completed, the access shafts were filled in, leaving the burial chamber unfilled but its entrance blocked, sometimes by wooden wheels, possibly from the funeral wagon, as at Tovsta Mohyla.[15] The mohyly were then mounded up and completed. Secondary burial chambers and shafts were cut into the mounds of some kurhany for later burials, or tunnels were cut to reach the original chamber when a new body was added.[16]

Within the burial chamber, the deceased was laid out, usually in a prone position, and the body was clothed as richly as possible. While garments rarely survive, outlines of the deceased's costume can be deduced from the position of little gold plaques and other ornaments that had been sewn on the cloth (see cat. nos. 15 and 17, reconstructions of a woman's costume from Tovsta Mohyla and women's shoes).[17] Scythian women apparently wore long, loose robes, richly ornamented with variously decorated gold plaques (fig. 3). They also wore a variety of different headdresses, some conical in shape, others more like flattened cylinders (cat. nos. 43 and 109).[18] Jewelry, including bracelets, finger rings, earrings, necklaces, and torques, has been found in many unlooted burials of both females and males, and has provided some of the most spectacular examples of Scythian art (e.g., cat. nos. 96, 130, 135, etc.). Scythian men (fig. 4) wore long tunics, slim trousers, and sometimes metal armor (see cat. no. 10, a reconstruction of a man's costume from Hladkivshchyna).[19] Male burials are accompanied by weapons and armor of various types, especially knives and the typical Scythian

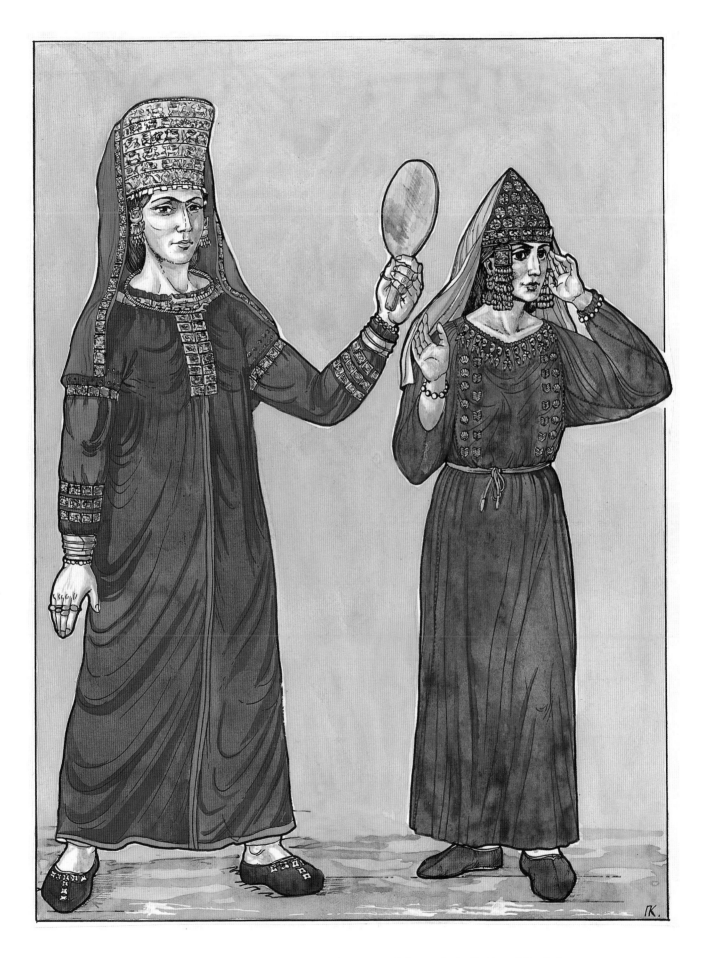

Fig. 3. Dress of Scythian women, based on burials at Tovsta Mohyla. *Drawing by Klochko and Korniienko.*

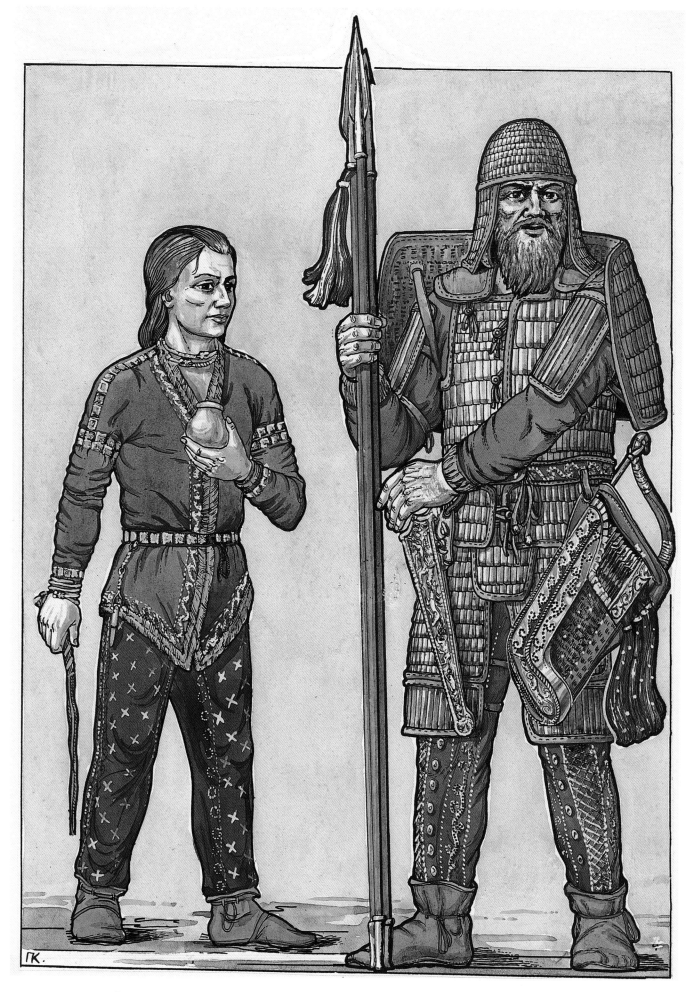

Fig. 4. Garments of Scythian men, based on burials at Pisky Village. Cherkas'ka Oblast'. *Drawing by Korniienko.*

short swords (*akinakes*), sometimes in richly decorated scabbards. Also found are the bow and quiver cases called gorytoi, along with shields, helmets, and whips with decorative handles (e.g., cat. nos. 9, 13, 14, 47, 105, and 124). Female burials sometimes contain these items as well. Surrounding the body of the deceased were also containers for provisions of all sorts, apparently to ensure that needs were met in the next life. These include great bronze vessels for cooking and storage (cat. nos. 82–89), amphoras, cups and bowls, and other vessels (e.g., cat. nos. 90, 162–165).[20] Also found in some earlier Scythian burials are other bronze objects, such as poletops in the form of animal heads, that reveal traces of an earlier, nomadic artistic style whose roots are in Asia (see the essay by Jacobson in this volume and cat. nos. 5–7 and 36–39).

In some cases, the main burial was accompanied by others. Horses, for example, were placed in quite a few burial chambers, often with rich gold, silver, or bronze ornaments (e.g. at Babyna Mohyla, fig. 5). Presumably, these horses belonged to the deceased and either died along with their human master or were killed specifically to accompany him in the burial chamber.[21] Secondary human burials are sometimes found as well, placed alongside or at the feet of the main burial and with humbler grave goods.[22] It was once assumed that these secondary burials were the servants, concubines, or wives of the main burial, killed to accompany the "master" in death. A more recent interpretation, however, focuses on the likelihood that at least some of these were relatives or close associates who died some time after the deceased in the main burial and for whom a second shaft was cut into the mound.[23]

Tovsta Mohyla, a kurhan of the fourth century B.C., seems to provide some evidence to support this second, less sensational reading. The central chamber, unfortunately looted,[24] contained a male burial, weaponry, and armor, and about six hundred ornamental gold discs (e.g. cat. nos. 37 and 122). In the passageway leading to the chamber were grave goods missed by the looters, including bronze vessels, an amphora, and—most notably—the well-known gold pectoral (cat. no. 172). Near this main burial were separate burials of two horses and two "grooms," all ornamented with varying degrees of lavishness.[25] Shortly after the mohyla was built up over the grave, when grass had already begun to grow on the mound surface, a second shaft and a side chamber, left unplundered, were cut into the mound to accommodate the body of a young woman. She was laid to rest richly clothed and bejeweled, with eleven rings and three gold armbands, as well as torques, pendants, and beads (see the reconstruction of her costume, cat. no. 15). Terra-cotta and silver vessels and other grave goods were found as well. Some time later, another shaft was cut to reach her burial chamber, and a child's body was placed there, to her right. One armband, resembling the three found with the woman's body, was placed in the child's hands. Four other bodies, whom the excavators identify as servants because of their poorer grave goods, were also placed in the grave, as were horses with their own ornaments. The timing of these secondary burials in relation to each other, however, is unclear.[26]

From the evidence in the kurhany and information from ancient literary sources, we can begin to construct a picture of the lifestyles of the ancient Scythians. These were clearly a nomadic people for whom the horse was of great importance, as reflected in the many richly decorated horse trappings found in the kurhany (cat. nos. 30–33 and 137–152) and by the occasional depiction of mounted Scythians or harnessed horses in jewelry and other metalwork (cat. nos. 5, 123, and 134). The ancient sources stress this as well (e.g., Strabo vii.4.8; Pliny *Nat. Hist.* 8.165; Frontinus ii.4.20). Herodotus (4.2, 46) regales us with stories about the Scythians drinking mare's milk, living their entire lives on horseback, and selectively breeding horses. Pseudo-Hippocrates (Corpus Hippocraticum *De Aere, aquis, locis* xvii–xxii) writes of their reliance on horses and the supposed negative effects of such a lifestyle. Herding also played a key role, providing a source for meat, milk, and leather. As we know from Herodotus (4.46) and from archaeological evidence, the Scythian tribes followed their vast herds of livestock across the steppes, pulling their belongings along in wagons.[27]

The Scythians raised and traded cattle, horses, sheep, and goats (some of them appear on the pectoral from Tovsta Mohyla). They did not, however, breed pigs at all, as Herodotus specifies (4.63).

Another key part of Scythian life was the bow and arrow, indispensable both for hunting and for warfare. It was the most effective weapon that could be used while on horseback. The gorytos that held the bow and arrows was worn slung around the rider's back (cat. nos. 46 and 105). In addition, mounted Scythians wore short swords, knives, and whips, and they hung shields on their bodies to leave their hands free.[28]

We know less about Scythian women than we do about Scythian men, as women were seldom depicted, and Greek and Roman writers rarely referred to them or to women of any culture. Evidence from kurhany has provided an idea of their costume, as noted above, and has shown that they most likely used weapons just as men did, since weapons and armor were sometimes found in their burials (e.g. in Ordzhonikidze, Kurhan 13, burial 2).[29] These women, however, are distinct from the Amazons of Greek mythology, whom Herodotus (4.110–117) describes as living east of Lake Maeotis (the Sea of Azov), and whom the Scythians themselves called Oiorpata, or man-killers. Herodotus distinguishes between the weapon-wielding, hunting Amazons and the Scythian women who stay at home and do "women's work" (4.114). He also states that the Sauromatae were descended from Scythian men and these Amazon women (4.110–117).

Our main sources of information about Scythian society and religion are, again, the accounts of Greek authors, who may well have misunderstood aspects of this foreign and "barbarian" (i.e., non-Greek speaking) people. Herodotus tells us that there were different classes within this society and

Fig. 5. Excavation of a burial, Babyna Mohyla. 1986. *Photograph Institute of Archaeology, Kyiv*

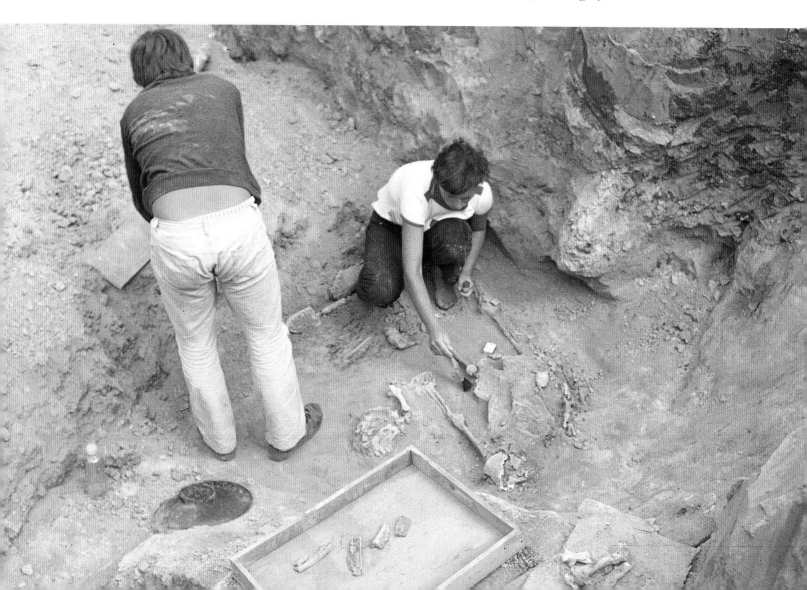

that the Scythians, like other societies of the time, had slaves and servants (4.2–4). The richest kurhan burials very likely represent the elite, those who were wealthy enough to possess multiple, richly decorated gold objects. Average or poor Scythians, according to Lucian (*Toxaris, or Friendship 1*), possessed no such gold; they owned only a pair of oxen and a wagon, and were therefore called *octopi,* referring to the oxen's eight feet. Herodotus also writes that there were different Scythian tribes, with the one more noble than the rest called the Royal Scythians. He places them geographically around the Tanais (Don) River, north of Lake Maeotis (the Sea of Azov) (4.20, 57).

Herodotus (4.59) lists Scythian deities along with their Greek equivalents. Tabiti, or Hestia, goddess of the hearth, was their "chief deity." Next in importance was Papaeus (Father), or Zeus, and his wife Api, or Earth (who may be represented in cat. no. 107). Then follow the secondary deities: Oetosyrus, or Apollo; Argimpasa, or Celestial Aphrodite; and also Herakles and Ares (for whom Herodotus does not supply the Scythian names). In addition, the Royal Scythians, according to Herodotus, worshiped the sea god Thagimasadas, or Poseidon. Scythian iconography from the fifth century B.C. onward also includes such Hellenic deities and heroes as Hera, Herakles, Hermes, and Cybele (cat. nos. 78, 141, and 142). Herodotus also describes in detail the normal method of sacrifice of cattle or horses to these gods (4.60–61). Of all the Scythian deities, however, only the war god Ares was honored with effigies or "temples" (4.62). These, he says, were "immense heap(s) of brushwood," replenished yearly, with an iron sword planted at the top to represent the god. Horses, cattle, and even prisoners of war were sacrificed before these brushwood structures (4.62).

Also through the ancient literary sources we can trace many of the Scythians' military exploits and their resulting reputation of strength, skill, and viciousness. Herodotus (1.104–106 and 4.1) tells us of the twenty-eight years during which the Scythians seized and retained control of Media in the Near East, demanding exorbitant tribute and also seizing or destroying the property of their subject peoples. The Mede Cyaxares finally tricked them by getting them very drunk and slaughtering them. Later, in the sixth century B.C., we hear of the military efforts of the Persian king Darius, first against the Scythians' Asian cousins, the Sakas, who were defeated about 520/19 B.C. The Saka king Skuka is depicted in a Persian stone relief in Bisitun as bringing tribute from his subject peoples to the victorious Darius.[30] While Darius was able to subdue the Sakas, he had no such luck with the Scythians themselves around 512 B.C. Herodotus (4.1.1, 83–92, 97–98, and 118–136) describes the Scythians' "scorched-earth" strategy and their general disregard of Darius' attempts to conquer their lands. When the Scythians finally agreed to meet Darius in battle, they placed so little importance on this encounter that they allowed themselves to be distracted by a hare running past their front line and took off in pursuit, at which point the severely demoralized Darius abandoned his sick and wounded and turned toward home under the cover of night. The Scythians retained their fierce reputation of invincibility into later centuries as well, as, for example, in 331 B.C., when Zopyrion, Alexander the Great's general, made an ill-fated attempt to conquer them and to besiege the Greek city of Olbia. He lost not only his army but also his own life in the process (Justin. xii.1.4; cf. Macrobius *Sat.* i.ii.33). Yet our literary sources tell us of at least two occasions in the fourth and second centuries B.C. when the Scythians were in fact defeated by others: in 339 B.C., Philip II of Macedonia, the father of Alexander the Great, killed the formidable Scythian king Ateas, who was ninety years old at the time; and in 110–107 B.C., Diophantes, a general leading the forces of Mithridates VI of the Pontic kingdom of the northern and southern shores of the Black Sea, defeated the Scythian king Palacus (Diod. xx.22; cf. Strabo vii.3.19 for Ateas). This waning of Scythia's military power allowed the Sarmatians to gain control of the region in the third to second centuries B.C. and to dominate it until the fourth century A.D.

The warlike and nomadic Scythians were probably not farmers themselves, but they most likely retained control of the fertile forest-steppe zones and the agricultural peoples who lived there. The form of this control is unclear, and we do not know if the Scythians extracted tribute from the

agricultural tribes or simply imposed heavy tariffs on the agricultural products that passed through the steppe zone for trade with the Greek colonies on the coast of the Black Sea. In any case, it is reasonably clear that the Scythians amassed the vast wealth necessary to acquire the precious objects found in tombs of their elite through control of such trade and by acting as middlemen. As Murzin points out, the forest-steppe agricultural zone had access to the Greek colonial markets only by means of the rivers (such as Dnipro and Buh) and other trade routes that coursed through the Scythian-controlled steppes. This, in fact, was the strategic advantage that the lower Dnipro region held for the nomadic Scythians and maybe what caused them to remain there.[31] The wealth of the kurhany in this region increases in the late seventh to sixth centuries B.C., when the first Greek trade colonies of Berezan' and Olbia begin to develop. Greek goods such as wine amphoras (e.g., cat. no. 90) testify to the existence of this trade.[32] The grain sold by Scythian middlemen to the Greeks went to the Aegean and to Greece itself to feed the people of Athens (Plutarch *Perikles* xx.1–2).

Coexisting with the Scythians were various agricultural peoples in the forest-steppe zone, as well as other nomadic pastoral peoples. Herodotus (4.17–27 and 103–109) identifies the Callipidae, a "Greco-Scythian tribe" living west of the Dnipro River mouth, and the Alazones to the east. He places to the north of the Alazones the "agricultural Scythian tribes," who grew grain for export. The Neuri are said to live far north along the Buh River. To the east is a region called Hylaea, or the Woodland, where the Borysthenites, another agricultural people, occupied an area extending north as far as an eleven-day boat journey. Beyond this is a desert, according to Herodotus, and then the home of the Androphagi, or man-eaters. The Melanchlaenoi, or Black-Cloaks, are said to live north of the "Royal Scythian" territory above the Sea of Azov. Beyond the Tanais (Don) River are the Sauromatae, Budini, Thyssagetae, and Iyrkae, and then the Argippaoi, relatives of the Scythians; east of them are the Issedones or Arimaspians (one-eyed peoples), whom Herodotus (4.26) describes as having equal rights for men and women, and among whom he places the origins of fantastic tales of gold-guarding griffins. In Krym are the Tauroi, a wild people who, Herodotus says (4.103), practiced human sacrifice.[33]

While Herodotus refers to some of the peoples as "agricultural Scythians," it is not clear if there was an ethnic connection, perhaps through intermarriage, between Scythians and local tribes. Some scholars, such as Murzin,[34] consider the agricultural inhabitants of the steppes to be related to the Scythians, and the forest-steppe dwellers to be proto-Slavs. Others consider that none of the other tribes listed by Herodotus was related to the Irano-lingual Scythians.[35]

Scythian society, like all others, changed over time. Around the late fifth to fourth centuries B.C., some Scythians appear to have become at least partially sedentary, and some fortified Scythian settlements from this period have been found. Kamens'ke Horodyshche (Stone City) was built near the modern town of Kam'ianka-Dniprovs'ka in the Zaporizhs'ka Oblast', apparently to function as a metallurgical center for the manufacture of armor and weaponry, horse trappings, ornaments, and so on. Quantities of metal-working tools were found in this town, as were fragments of broken metalwork, alongside typically Scythian handmade pottery. A few other such towns have also been found in that area, although those were generally unfortified.[36] Scythian Neapolis, located near modern Simferopol' in Krym, was built at the end of the Scythian period in the third century B.C. on the site of a former Taurian settlement. It appears to be a regular settlement, like others in eastern Krym, although very heavily fortified.[37]

Scythian relations and trade with their Greek colonist neighbors on the northern shore of the Black Sea and in Krym were influential on the material aspects of both cultures.[38] Scythian-style weaponry, such as arrowheads (see cat. no. 13), has been found in many Greek burials, and the typically Scythian bow appears in a bronze bow model and on coins and gravestones in Olbia.[39] The Scythians sold to the Greeks of Olbia and the Bosphoran kingdom grain from the forest-steppe

zone, as well as fish, honey, leather, and animal pelts; some scholars argue that slaves were traded as well.[40] The Greeks then passed these goods along to the larger Greek world, to Athens and to other cities (Polybius 4.38, Strabo xi.493). In fact, Athens is known to have relied heavily on Pontic grain exports in the fifth century B.C. Demosthenes tells us that the Bosphoran kingdom alone exported 400,000 *medimnoi* (about 18,432,000 liters) of grain to Athens during the reign of the Bosphoran king Leukon I (389/8–348/7 B.C.) (Demosthenes *vs. Leptines, vs. Phormion, vs. Lakrytes;* also Hdt. 7.147; Plutarch *Perikles* xx.1–2).[41] The famous Athenian leader Perikles may have made a special voyage into the Black Sea in the second half of the fifth century B.C., according to Plutarch (xx.1–2),[42] probably to take care of matters relating to this grain supply. Some northern Black Sea cities even seem to have been included in the Athenian tribute lists for 425 B.C., although it is doubtful that those cities actually paid tribute to Athens.[43] Sometimes Scythians themselves traveled to the Aegean and hired themselves out as mercenaries or policemen. Greeks viewed the Scythians as fierce fighters, easily drunk (Athenaeus xi.499f), and prone to smoking hemp (Hesychius of Alexandria, Hdt. 4.75), as mentioned above. Herodotus (vi.84.3) tells us that the Spartans attributed the madness of one of their leaders, Cleomenes, to his adoption of the Scythian custom of drinking wine undiluted, a habit he picked up from Scythians who had come to Sparta to plan a joint attack on the Persian king Darius. In Greek art, Scythians are always depicted like other "eastern" peoples, such as Persians or Amazons, with slim-fitting trousers and pointed hats.[44] In general, the Greeks viewed Scythians as barbaric and primitive, although they often regarded Scythia itself as a region critical for the Aegean economy.

At this time, Scythians seem to have played a fairly important role in the politics of the Greek Pontic cities. Diodorus (xx.24), a historian of the first century B.C., writes that Scythians living near Pantikapaion, the capital of the Greek Bosphoran kingdom in eastern Krym, played a pivotal role in the fight between King Perisades' heirs around 310 B.C. by supporting Satyrus in a much-admired equestrian battle maneuver. After Satyrus' death, the Scythian king Agarus sheltered Satyrus' son from his murderous uncle Eumelus.[45]

The Scythians were affected in many ways by Hellenizing influences from the Greek cities on the northern Black Sea coast and in Krym. This influence is seen most clearly in goods purchased from the Greeks that appear in Scythian kurhany, including amphoras, bronze cauldrons, and even rings made from Greek coins (cat. nos. 82, 84–90, and 94) and in Scythian-made imitations of Greek items.[46] Of even greater interest is the artistic influence that Greeks exerted on Scythian art (see the essays by Reeder and Jacobson in this volume). While it is likely that the Scythians did make some of their own metallurgical objects, since their culture does include metalwork predating contact with the Greeks (cat. nos. 5–7 and 43), clearly a considerable percentage of the gold jewelry, vessels, weaponry, and other items found in the most splendid of the kurhany was made in workshops in the Greek cities along the northern coast of the Black Sea. The source of the gold used in these pieces is not known; there are no natural gold sources in Scythia or in modern Ukraine. Possibly, it was obtained by trade with the Caucasus region, where gold sources continue to be mined to this day. Other possibilities include Kazakhstan and the Altai Mountains, or Transylvania.[47]

From literary evidence, we know that individual Scythians did at times allow themselves to become more fully Hellenized, even though Scythian society at large frowned on such practice. King Saulius, for example, shot his own brother, the learned Anacharsis, who had traveled all over Greece, because on his return home Anacharsis, fulfilling a vow of thanksgiving for his safe return, performed a ceremony to the Mother of the Gods in the manner of the Cyzicene Greeks (Hdt. 4.76). Herodotus (4.78–80) also tells us of the Scythian king Scylas, who kept a house and a wife within the Greek city of Olbia and periodically left his army encamped outside the city walls (in the *proasteion*) while he lived in the city for months at a time, dressing and behaving like a Greek and even

worshiping the Greek god Dionysos. When other Scythians of his tribe found this out, however, they deposed him, and his brother chased him down to Thrace and beheaded him for performing "alien customs."[48] This negative attitude toward Hellenization (Hdt. 4.76.1) seems to have been pervasive, and if more Scythians besides Scylas lived in Olbia, they are difficult to trace in archaeological evidence from burials in the Olbian necropolis or among the names recorded in stone inscriptions of the Classical period.[49]

In general, the Scythians appear to have coexisted peacefully with their Greek neighbors, trading with them even if they did not wish to become like them. Other peoples in the steppes of Scythia probably lived under Scythian domination, while the Persians and other enemies seem to have feared the fierce mounted warriors. For us today, however, these warriors have left a rich artistic and cultural tradition embodied in the objects of this exhibition.

1. Rolle (1980), 11.
2. Cf. Graham (1982), 160–62; (1983), 99.
3. Cf. Terenozhkin (1952), 3–14; Iessen (1953), 49–110; contra Artamonov (1973), 3–15, and (1950), 37–47; and Iatsenko and Raevskii (1980), 112, who argue for autochthony, and connections with the Zrubne or Timber Grave culture.
4. Murzin (1984), 27.
5. Illins'ka and Terenozhkin (1971), 8–33.
6. Viaz'mitina (1971), 185–271; Kovpanenko (1986b).
7. Cf. Graham (1982), 129.
8. Murzin (1996), 56.
9. Murzin (1996), 60.
10. Mozolevs'kyi (1979), 150, 239.
11. Rolle (1980), 19–20.
12. Rolle (1980), 32–34; cf. Mozolevs'kyi (1979), 17.
13. Mozolevs'kyi (1979), 17–25, 232, 239.
14. Rolle (1980), 21; Mozolevs'kyi (1979), 150.
15. Cf. Mozolevs'kyi (1979), 239, 96–97.
16. Mozolevs'kyi (1979), 99–100, fig. 80; Rolle (1980), 22, 29.
17. Cf. Mozolevs'kyi (1979), fig. 87.
18. Cf. Rolle (1980), 60.
19. Cf. Rolle (1980), 58-60.
20. Mozolevs'kyi (1979), 192–97, fig 80.
21. Mozolevs'kyi (1979), 26–45.
22. Mozolevs'kyi (1979), 97; Rolle (1980), 24, 27.
23. Cf. Jacobson (1993), 9.
24. As apparent from the looters' passageways; cf. Mozolevs'kyi (1979), 49–51.
25. Mozolevs'kyi (1979), 239 and 26–45, 46–93.
26. Mozolevs'kyi (1979), 239, 94–147; cf. Rolle (1980), 29, 32.
27. Cf. Rolle (1980), 114–15.
28. Cf. Rolle (1980), 64–69.
29. Cf. Il'inskaia and Terenozhkin (1983), 176–82.
30. Rolle (1980), 47, fig. 25.
31. Murzin (1996), 52–53; also Bibikov (1957), 262; Onaiko (1966), 50.
32. Murzin (1996), 52.
33. Cf. Stryzhak (1988) for a detailed examination of the etymology of names and the locations of all these tribes.
34. Murzin (1996), 56.
35. Illins'ka and Terenozhkin (1971), 37; Abaev (1965); Sulimirski and Taylor (1991), 552.
36. Illins'ka and Terenozhkin (1971), 72; Grakov (1954).
37. Illins'ka and Terenozhkin (1971), 246–49.
38. Cf. Slavin (1958), 12–14; Bibikov (1957), 260–62; Kaposhina (1958b), 98.
39. Kozub (1973), 270–72, and (1974), 122; Onaiko (1966), 47; Graham (1982), 129.
40. Cf. Finley (1981), ch. 10, esp. pp. 168–69.
41. Cf. Tod (1927), 1–32, esp. 14, 18, and 173 ff.; Adcock (1927), 165–92, 173; Anokhin (1971), 423–35, esp. 424–25; Meiggs (1972), 95.
42. Cf. Stadter (1989), 217, who suggests this is based on Ephorus; cf. Meiggs (1972), 199; Ferrarese (1974), 7–19; Brashinskii (1963), 60.
43. A5, A9, Merritt, Wade-Grey, and McGregor (1939–1953) vol. 1; also in *Inscriptiones Graecae* I3 71.163–170 (IG I3, 1981). Cf. Craterus (Jacoby [1962], 342, frg. 8) for Nymphaion being assessed, or paying, one talent to Athens. Also cf. Meiggs and Lewis (1969), no. 69; Merritt and West (1934). Brashinskii (1955), 148–61, esp. 71–72, argues against any northern Black Sea cities' inclusion in the Athenian tribute lists (cf. Robert and Robert [1958], no. 173, 226–27).
44. Vos-Jongkees (1963).
45. Olbia has even been thought by some scholars to have had a tributary relationship with the Scythians, but no evidence supports this; cf. Graham (1982), 127, and (1983.5), 461–62; contra Vinogradov (1981), 52–73. The relationship was most likely one of mutual trade.
46. Cf. Havryliuk (1984), 8; Kruglikova (1963), 65–79; Brashinskii (1963), 7–8.
47. Rolle (1980), 52–53.
48. Cf. Kozub (1979), 32; Talbot Rice (1958), 53.
49. Kozub (1974), 119–25, contra Slavin (1958), 9, and Boardman (1962/63), 43; cf. Bibikov (1957), 262; Graham (1983), 106, and (1982), 128; Minns (1913), 37–38, 471; Rostovtzeff (1922a), 60.

Scythian Art

Ellen Reeder

It is generally believed that the Scythians first entered what is present-day Ukraine in about the eighth century B.C. They brought with them an artistic tradition of considerable antiquity, one that had probably already been influenced to some degree by the art of the ancient Near East. More intensive artistic influence from the cultures of the ancient Near East would soon follow, and, later, inspiration from the Greek world.

The ancestral homeland that the Scythians had left behind lay in the Altai Mountains, at approximately the juncture of present-day Kazakhstan, Russia, Mongolia, and China (map 1, fig. 1). The Altai Mountains occupy the middle of the Asian continent, midway between the Ural Mountains and the Pacific Ocean. This area, where the forests of Siberia converge with the grasslands of Central Asia, has been one of the great cultural vortices of mankind, and it is from here that the Huns and the Mongols would later emerge. In the Altai, sweeping and undulating arcs of land form concave bowls that rise to crests and distant snowy mountain peaks. Its stunning vistas and curving reaches would not be a terrain easy to forget, and it probably remained as securely locked in the Scythian psyche as, indisputably, were the animals who inhabited it. The people whose descendants would be known as Scythians lived in this region until sometime after 1000 B.C. Originally, they were hunters, and by the late second millennium they were herders of horses, sheep, and cattle.

Archaeological discoveries in the Altai and surrounding area have yielded numerous parallels with material recovered from Scythian burials in Ukraine. Unfortunately, much of the richest Altai evidence, that from the tombs of Pazyryk and the area around Lake Issyk, is fairly late, from the fifth and fourth centuries. By this time, the peoples living in the Altai, like the Scythians in their new homeland north of the Black Sea, had already been influenced by the art and culture of western Asia.[1] Indeed, during the sixth century B.C., the area between the Oxus River (Amudar'ya) and the Jaxartes (Syrdar'ya) in modern Kazakhstan and Uzbekistan constituted the province of Sogdiana within the Achaemenid Empire. For this reason, some of the similarities in the cultures of the Scythians and the peoples of the Altai, such as the use of torques or of gold plaques to decorate clothing, are possibly the result of mutual contact with the ancient Near East.

Aside from these elements that suggest shared reception of later influences, there exist such compelling parallels between the culture of the Scythians and that of the ancient peoples of the Altai Mountain area that a common ancestry is now widely accepted. Poletops (cat. nos. 36-38), which are regularly found in Scythian contexts, are known from burials as early as the eighth century in the Altai area.[2] The knob-handled mirror (cat. no. 22) found in Scythian burials probably originated in China.[3] From Chiliktin in eastern Kazakhstan come plaques of the seventh to sixth centuries depicting recumbent antlered stags that are remarkably similar to those found in Scythian tombs (cat. no.

Opposite:
fig. 1. View of the Altai. *Photograph Gary Tepfer*

43).[4] Other close examples have come from the Minusins'k Basin in Mongolia.[5] It has even been suggested that the large carved stones of Scythian burial mounds (cat. nos. 132 and 133) may have their prototypes in the similar deer-stones of Siberia.[6] The well-known Golden Man from Issyk, dating from the fifth to fourth centuries B.C., was found about thirty miles east of Almaty in southern Kazakhstan.[7] He has been identified as a Saka, one of the Scytho-Siberian groups of Central Asia. His peaked cap is reminiscent of Scythian apparel (cat. nos. 16 and 43), as are the gold plaques that studded his garments.

One of the most persuasive links between the cultures of these widely separated areas is the presence in both artistic traditions of the motifs of the bird, feline, and deer, which find their closest parallels in the golden eagle, spotted leopard, snow leopard, and red deer, all of which still inhabit the Altai. As Esther Jacobson points out, these animals were not denizens of the steppes that the Scythians would come to know in Ukraine, but rather of the forested slopes of the Altai region.[8] Jacobson reasons persuasively that the eagle, leopard, and deer would be less meaningful to a herding people than to a hunting society concerned with prey and competing predator and that, by extension, the motifs must have had a long history in Scythian thought, going back to the hunting phase of the Scythians' forebears.

Sometime in the tenth or ninth century, some kind of pressure, whether environmental or human, resulted in a migration westward of the people whom we will now call the Scythians. For the next three hundred or more years, the Scythians lived a largely ambulatory lifestyle, and even upon entering, or returning to, Ukraine in the sixth century, they remained predominantly nomadic through the fourth century.

The Scythian migration westward took them across Kazakhstan, which stretches to the Caspian Sea and is approximately one-half the size of the continental United States (see satellite map). A vast

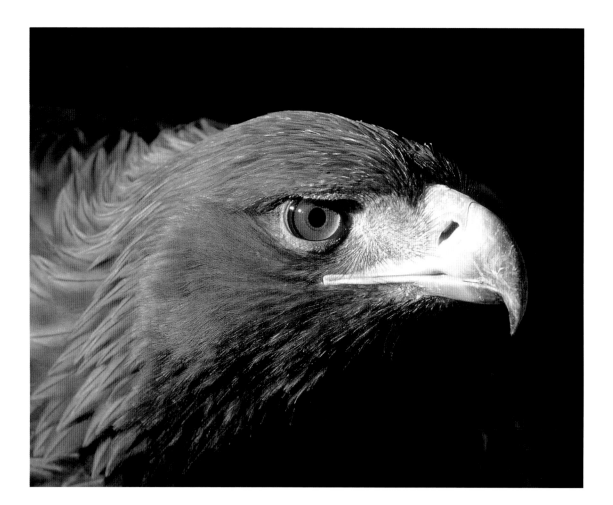

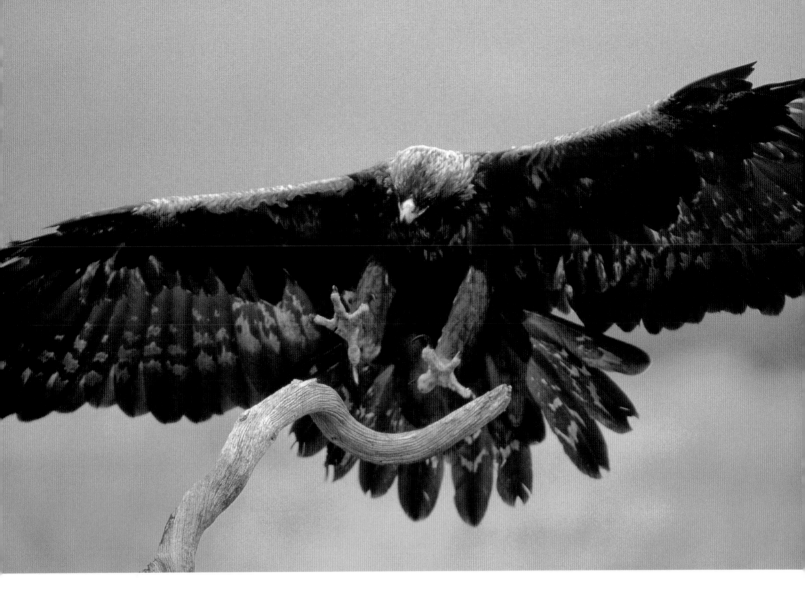

Opposite and above: figs. 2 and 3. Golden eagle. *Photographs Perry Conway*

expanse of largely dry, grassy steppe, it would not have offered hospitable terrain for the Scythians to traverse easily. Indeed, the unsuccessful agricultural Virgin Lands Campaign of 1954–1962 demonstrated how arid and delicate these grasslands are.[9] It is likely that the Scythians traveled instead through the northern foothills of the Tien Shan Mountains, which form the southern frontier of Kazakhstan. The Scythians could then have moved up the river valley of either the Syrdar'ya (Jaxartes) or the Amudar'ya (Oxus) to the Aral Sea. Passing over the Aral Sea, the Scythians would have passed through the land of the Massagetae before skirting the Caspian Sea and entering Ukraine in about the eighth century. Another branch of the Scythians may not have followed the river valleys northward but may have traveled south through present-day Turkmenistan before arriving on the Iranian plateau, perhaps also by the eighth century.[10]

On their journey westward, the Scythians would have continued to encounter the animals that figure so prominently in their art: the eagle, leopard, and deer. In their travels over the steppes north of the Aral Sea and Caspian Sea, and in the humus-rich steppes of Ukraine, they would have become familiar with a different host of animals that they chose to depict rarely, if at all: fox, wolf, jackal, rabbit, badger, tortoise, hedgehog, and small antelope. In the mountainous areas they would have seen bear and ibex, which are also seldom, if ever, represented. We do not even encounter images of the Caspian tiger, which was extant in the Amudar'ya river valley into the 1970s.[11] Instead, the eagle, leopard, and deer remain dominant motifs and even serve as prototypes when additions are made to the

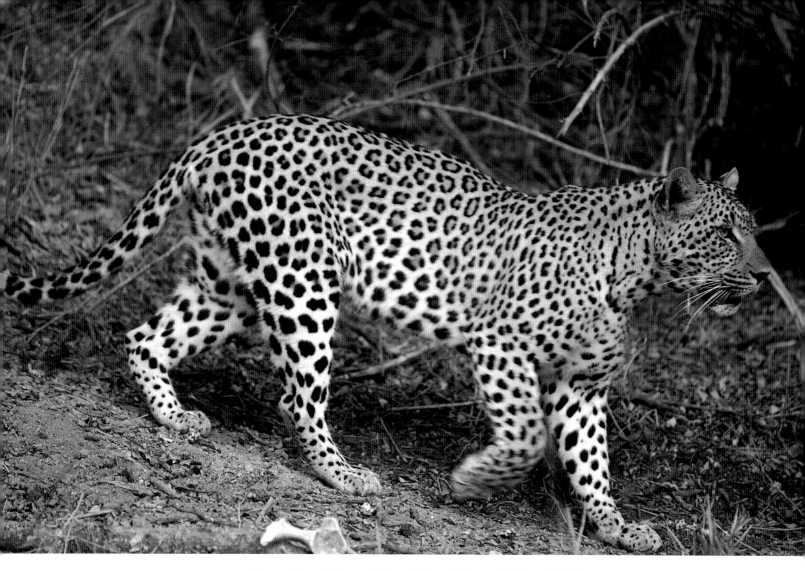

Above and opposite: figs. 4 and 5. Spotted leopard. *Photographs Tom Brakefield*

Scythian vocabulary. Representations of the lion, for example, which the Scythians would have encountered on the Iranian plateau and in Mesopotamia, are based on depictions of the leopard.

With an eight-foot wingspan for the female, a little less for the male, the golden eagle (figs. 2 and 3) is an awesome sight, even larger than the American bald eagle. The expression eagle-eyed is founded on the bird's sharpness of vision, which is six to eight times as great as that of a human.[12] An eagle can spot prey the size of a hare over an area of three square miles, and it can then fly from 150 to 190 miles an hour to overtake it.[13] The bird will use its front claws like a grappling iron, while its back talons pierce the lungs and spinal column of its victim.[14] So lethal are the talons of a golden eagle that they can fracture the leg or skull of a human being and can easily kill a small deer. The hooked, rapier-like bill is also formidable, with the ability both to pierce an eyeball and to dig nimbly for food. The soft upper element of the beak, which is a lighter yellow than the curved lower section, is known as the cere. The golden eagle prefers small prey, including the jackal, squirrel, and fox, but in a harsh winter it also feeds off of carrion, usually larger animals felled by weather conditions. In times when food is extremely scarce, an eagle will also kill lambs.[15] Like a falcon, the golden eagle can be trained to kill and return, and it is known that this skill was practiced in Mongolia in antiquity.[16] Whether the Scythians were familiar with this is unclear but not unlikely.

The habits of the golden eagle offered the Scythians much to respect and much with which to identify. Particularly admirable is the bird's economical use of energy. It spends ninety percent of its time simply perching, waiting for the weak and ill to appear.[17] Because the golden eagle, at twelve pounds, requires considerable energy to set itself in motion, the bird prefers to live and perch near

cliff edges, where it can make use of thermals (rising currents of warm air).[18] Once aloft, an eagle may choose to obtain food, not by hunting (where its kill rate is one-quarter to one-half) but by stealing the fresh kills of smaller birds, such as the falcon.[19] Remarkably solicitous of their young, golden eagles live twenty-five to fifty years and mate for life. When one bird dies, the survivor takes on a younger mate, with which it lives until death.[20]

The eagle's size, power, aggressiveness, domination of the skies, keen vision, disapproving stare, and economical use of energy have secured its status as a revered symbol in many societies, ancient and modern. In Greek religion the golden eagle was associated with the supreme sky god Zeus, and in the Roman world the golden eagle was identified with the imperial power represented by the emperor. It is not surprising that the bird would be deeply meaningful to the Scythians, whose own lifestyle relied upon so many of the same skills in which the eagle excelled.

The spotted leopard (figs. 4 and 5) is a solitary mega-predator that has been called a perfect engine of destruction. The male leopard is fifty percent larger than the female and can weigh up to two hundred pounds. A superb stalker, the spotted leopard is immensely powerful and is capable of bringing down animals twice its size. Because of its extraordinary strength, it can then drag its prey

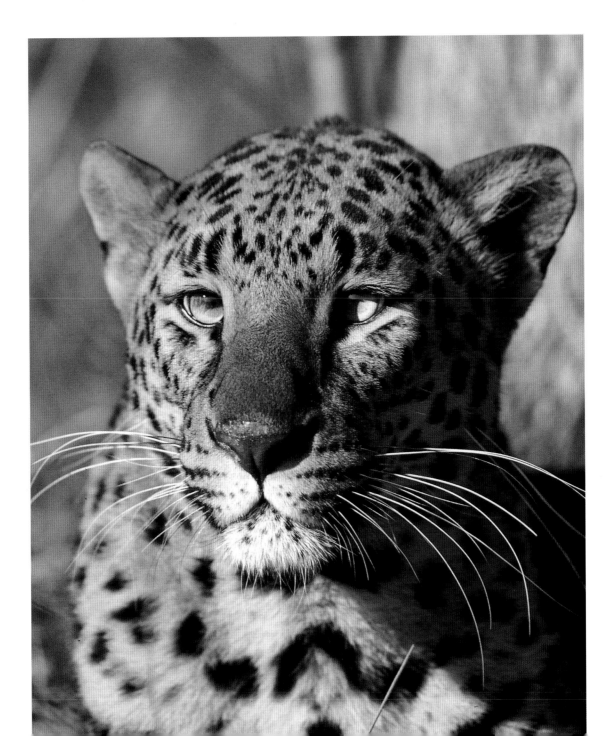

up a tree, protecting its food supply from competition. The leopard kills by biting the throat, twisting the neck, or crushing the vertebrae of its victim. Especially lethal are its curved claws, because the grooved underside collects matter that becomes septic; hence a leopard attack has always been especially feared because the lacerations can cause fatal infections. The spotted leopard lives in all types of forests as well as rugged mountains. Although the animal prefers small-scale prey, the exigencies of food sources or of unremitting winters could have prompted leopard attacks on the sheep, horses, and cattle that were vital to the survival of early herding communities.[21]

With the valleys in the Altai at a high altitude, ancient peoples seeking pasture for their flocks in summer frequently would have moved above the 8,000-foot level. Here, in both the Altai and the Tien Shan Mountains, the spotted leopard gives way to the snow leopard (figs. 6 and 7), an almost legendary animal so rarely seen and of such magnificence that it evokes awe and even reverence in those who have beheld it.[22] Weighing up to 165 pounds, the snow leopard is remarkably agile and prefers to stalk its prey along the crests of cliffs and ridgelines. A snow leopard leap of forty-nine feet has been recorded, and the animal can also jump to the ground, landing on its feet, from a height of sixty feet. The snow leopard's victims are mountain goats and sheep, which it kills by strangling. For human hunters, the killing of a snow leopard has traditionally brought special status. The depiction of a snow leopard hunt on an ancient Mongolian petroglyph suggests the same situation existed in antiquity. Two snow leopards are seen on the peaked headdress of the Golden Man from Issyk.

Below and opposite: figs. 6 and 7. Snow leopard. *Photographs Tom Brakefield*

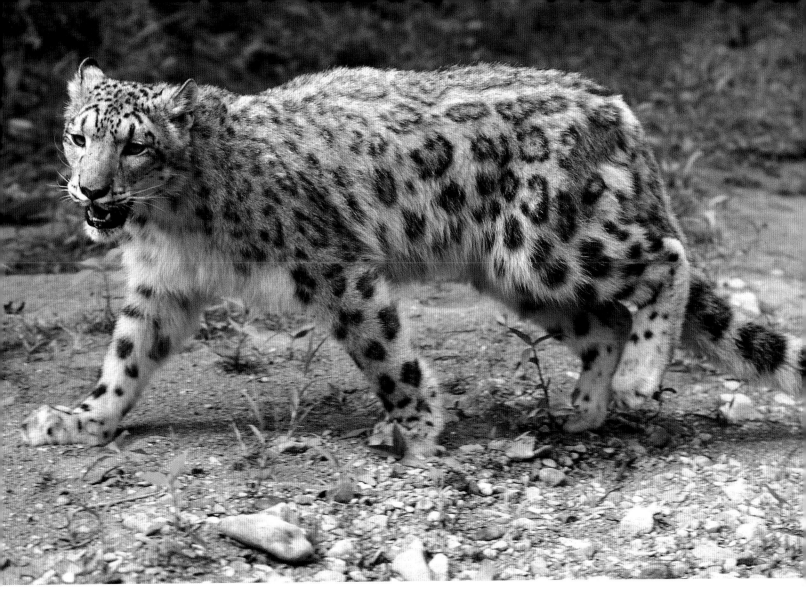

The red deer (figs. 8 and 9) that the Scythians would have encountered was about the size and appearance of the Rocky Mountain elk.[23] With a weight ranging from 225 to 650 pounds, the red deer is a denizen of broadleaf forests and also inhabits high mountain ranges. The male sheds its antlers every year, and with each year's regrowth another branch emerges. The phenomenon renders plausible the argument, discussed below, that the Scythians likened the stag's antlers to a tree of life. The correlation is underscored in the animal's behavior, because stags form a herd apart from females and, thus, a herd of antlered stags would have resembled a moving forest.

The significance to the Scythians of the eagle, leopard, and deer is clearly related to a theme that recurs repeatedly in their art and that was, in fact, the fundamental principle, even definition, of their nomadic and later seminomadic (transhumant) life. From the curving bowls of the Altai terrain to the wheels of the carts they rolled westward, the Scythian world was one of movement. Every day they watched the moving legs of the horses, sheep, leopards, and deer or the soaring flight of eagles, the blowing grasses, and the sway of women's garments. They witnessed daily the movement inherent in the life cycle, as victims perished so that others would survive. Change was intrinsic, the only stable and constant element in their culture. It is not difficult to understand why the Scythians would have been fascinated by the appearance, behavior, habits, and sounds of undomesticated animals that were masters of this way of life. Nor is it surprising that a salient principle of the works of Scythian art least influenced by Near Eastern and Greek traditions is, simply, *movement*, whether that manifests itself as continuity, evolution, rotation, curvature, transformation, or even sound.

Above and opposite: figs. 8 and 9. Red deer, *Cervus elephas. Photographs* National Geographic

Other aspects of the Scythian lifestyle affected both the objects they created and the way they decorated them. The communal nature of their lifestyle is dramatically illustrated by the size of their cauldrons (cat. nos. 27 and 28). The oval shape these often take not only facilitated handling but also seems to reflect a penchant that is elsewhere evident in Scythian art. It is also worth remembering that a mobile lifestyle precluded the kind of large, heavy object that sedentary peoples use for identification and self-image. For people on the move, portable objects have to suffice, and garments and other wearable objects become the primary vehicle of self-presentation. Hence, the Scythian emphasis on heavily adorned clothing is completely logical. One should also keep in mind that adaptability to environmental conditions is essential to the survival of a people living an ambulatory lifestyle. The flexibility necessitated by their lifestyle may have nurtured, or simply be another manifestation of, the openness to foreign influences that is such a hallmark of Scythian art and culture.

The term "animal style" is often applied not only to the quintessential character of Scythian art but also to the art of most of the ancient peoples of Central Asia. These characteristics include: the prominence of the motifs of the stag, feline, and bird; the isolation of the animal; the juxtaposition

of planes; the compartmentalization of body parts; and the transformation of one form or animal body part into another form or animal. The ubiquity of the term's application implies both a uniformity among the art of the ancient central Asian cultures and an absence of stylistic development within them. However, as will be shown here, an evolution in Scythian style is very much distinguishable, and such will surely also prove to be the case for other ancient cultures of this vast expanse. As the current paucity of material, publication, understanding, and accessibility is corrected, the term animal style will probably become as loose a descriptive phrase as the adjective Classical.

Certain additional features characterize those Scythian objects that seem least affected by contact with the ancient Near East and Greece. These traditional elements usually relate to the principle of movement that seems to be so intrinsic to Scythian culture. On a plaque that, with several others, encircled the rim of a bowl (cat. no. 52), the forms of the motif can be read as several bird heads centered on tight circles, which call to mind the volutes in Near Eastern and Greek art. A bird head at the top of the plaque is recognized by the round eye, and the tip of the beak forms a tight roll with a

circle at the center. The cere, the upper part of the beak, is also articulated. A second bird head emerges when the plaque is turned ninety degrees to the viewer's left. Now the circle at the center of the first bird's beak serves as the eye, while the beak, also articulating the cere, winds into another tight coil that has a circle at the center and a palmette emerging from one side. If the plaque is turned a further 180 degrees in the same direction, still another bird head emerges. The beak of this third bird is actually the eye of the first bird, and the eye of the third bird is a smaller circle through which passed the ancient pin for attachment. The composition thus creates a rotating dynamic while it exhibits the Scythian interest in transformation and evolution: one bird head becomes part of another one, and the palmette winds from the curved beak.

Other plaques offer variations on this scheme. On another gold bowl, three bird heads can be identified in each plaque (cat. no. 54); another plaque (cat. no. 53) has a more complex composition but fewer birds. An analogous organization distinguishes the hilt of a gold sword and scabbard (cat. no. 121). Here the curved end of the hilt is occupied by two stylized bird heads positioned back-to-back. When the sword is held with tip vertically upward, each bird head is distinctive for the round eye with circular iris, the articulated cere, and the curving lower beak, rendered in two or three arcs. When the sword is rotated ninety degrees, the cere serves as the eye and forehead of a second bird, and the sections of what was the lower beak of the first bird become the cere and beak of the second bird head. Again, a strong dynamic of rotation and continuity is established.

The Scythian interest in transformation is expressed in a variety of other ways. On plaques from a gold gorytos (cat. no. 46), bird heads emerge from the angle of the boar's shoulder as well as from the tip of the tail. On the plaque decorating a gold scabbard (cat. no. 122), not only is each of the animal's hooves rendered as a bird head, but the stag's antlers also take the form of a series of bird heads. The transformation of antlers to bird heads is seen again on the gold plaque from a drinking horn (cat. no. 116) and on bronze plaques with the head of a moose (cat. no. 49). Esther Jacobson interprets the motif as an expression of a belief in rebirth and regeneration that she relates to an ancient Siberian Tree of Life. In effect, the antlers function as branches of this Tree of Life, and these branches evolve into birds, as the ever-renewing life cycle continues its rotation.[24]

Given the association in the Scythian mind of the bird, and especially the eagle, with transformation and continuity, it is likely that a curious staff ornament (cat. no. 39) figured in Scythian cult. A nude man stands surrounded by tree branches on which perch birds (probably eagles) with outstretched wings. Here, humans are inserted into the cycle of transformation and regeneration that is symbolized by the trees and eagles. The many pendants hanging from the tree branches underscore the theme of movement and change. Their tinkling sound is both delicate and appropriately complex.

The Scythian liking of eagle motifs is pervasive. Representations of the full eagle, as seen on a gold scabbard (cat. no. 50), are far less common than renderings of the bird head alone, which frequently receives a stylized interpretation. On the scabbard for a dagger, an eagle head forms the chape (cat. no. 8). A gold bowl (cat. no. 51) has the oval shape of an eagle egg and bears an eagle head and tail.

Images of transformation can take many different forms. On a gold sword and scabbard (cat. no. 121), a palmette grows from the mane of the boar at the top of the scabbard. On a gold torque (cat. no. 55), a volute winds from the base of the bird's beak back toward the eye. The same treatment appears in the head of a horse that forms the clasp to a gold necklace (cat. no. 135).

The Scythian emphasis upon the dynamic of movement, and especially rotation, is also well illustrated in depictions of the second animal of their triad: the feline. On a horse decoration in the shape of a cross (cat. no. 48), each of the three arms has the form of a disc that seems to rotate around a center disc. Each disc is occupied by a single feline curled over its prey beneath. The same motif

appears in the upper part of the vertical base of the cross where it is contiguous to the central disc. This affection for rotation reappears on an elegant gold cup with horses (cat. no. 134).

The stag, the third animal of the Scythian triad, is usually portrayed in a recumbent pose, often termed *couchant*. The pose signals the imminent collapse of the animal, probably at the hands of a successful hunter, although the frequent emergence of bird heads, or volutes, from the antlers speaks to a regenerated vitality as the life cycle continues. Esther Jacobson convincingly argues that the motif of the stag is ultimately derived from that of the reindeer, which early ancestors of the Scythians would have first hunted, and then domesticated, in northern Siberia.[25] As already noted, the stags on a peaked hat (cat. no. 43) have close parallels in tombs of eastern Kazakhstan, another indication of the motif's great antiquity.

The isolation represented by the stag on the peaked hat recurs both in the handling of stags on a series of gold plaques (cat. no. 44) and in the circular field on the hilt of a gold sword (cat. no. 122). Other animals are isolated as well, including the collapsing boar on a gold scabbard (cat. no. 47), the two leopards on another gold scabbard (cat. no. 121), and various animals on a gold gorytos (cat. no. 46). The predisposition for isolation may help explain the Scythian disinterest in creating a unified composition for a single surface. On the gold scabbards (cat. nos. 121 and 122), both animal combat groups and individual motifs are supplied to fill in the exigencies of space or shape. On a gold gorytos (cat. no. 46), the animals are laid out in rows, without any effort to complement the shape of the object or to present the animals in proportion to one another. Even on the gold gorytos (cat. no. 154) the organizing principle is to use individual elements to obtain an allover composition. This approach is traditionally characteristic of textiles, an art with which the Scythians would have been familiar.

The tendency in Scythian art toward isolation also manifests itself within the rendering of a single animal. On a gold gorytos (cat. no. 46), the parts of the boar's body are so separated by deep grooves that each shoulder, tail, eye, and snout are initially read as separate designs. On a gold scabbard (cat. no. 47), parts of the animal, such as the shoulder, belly, and haunch, are articulated by abruptly angled planes, a technique that has been associated with woodcarving, a tradition with which the Scythians and their ancestors would have been familiar. The tendency to isolate, even compartmentalize, body parts leads to the rendering of individual parts as discrete designs; thus, on a gold plaque of a stag (cat. no. 44), deep channels isolate the eye, mouth, and haunch.

The prototypical renderings of animals in Scythian art become, unsurprisingly, the templates by which other animals are subsequently rendered. Esther Jacobson notes that the posture of the stag motif is adapted to represent the horse (cat. no. 45). The secondary role of the horse in Scythian art is an interesting phenomenon, with most Scythian depictions of the animal exhibiting later Near Eastern or Greek influence. The horse may not have been a primary subject before this because the animal was domesticated and was relied upon for meat, hides, horse hair, and transportation. Not only did the horse lack the exotic appeal of a wild animal, but it was also distressingly vulnerable. In fact, most depictions of the horse show it as prey to felines or griffins (on a gold quiver cover, cat. no. 50) or lions (on a gold finial, cat. no. 136). That the Scythians did admire the horse's speed is evident in an extreme example of the Scythian tendency to compartmentalize. In a bronze cheekpiece in the form of the haunches and hind legs of a horse (cat. no. 56), the artist made the subject of his work not the animal itself but the horse's potential for power and movement. The impression would have been underscored when the cheekpiece was in place, taking on the animal's vigor and rhythmic movement.

Intrinsic to the Scythian emphasis on movement is a predilection for sound. In addition to the tinkling staff ornament (cat. no. 39), the Scythians created other bronze poletops in the shape of cages that contained a loose ball or clapper (cat. nos. 36-38). Headdress pendants (cat. no. 19), including those inspired by smaller Greek prototypes known as leech or boat-shaped earrings (cat. no. 129), are

laden with a host of tinkling pendants. A whip ornamented with gold balls (cat. no. 14) would have had the added attraction of a crackling sound and an eye-catching moving display of wavelike forms.

Just when the Scythians arrived in what is present-day Ukraine and how deeply into the area these early arrivals penetrated are still uncertain. It is increasingly believed that the Cimmerians, whose art is dated to the ninth or eighth century (cat. nos. 1 and 2), were an early group of Scythians.[26] Sometime in the eighth century, a branch of Scythians traveled across the Caucasus Mountains and settled in the area near Lake Urmia, in the intersection of eastern Anatolia and northern Iran. Here, the Scythians proved themselves viable players in the jostling for power that was then taking place all over the Near East. The nearby kingdom of Urartu, at first an amicable neighbor, eventually became an adversary. To the Assyrians, the Scythians evidently posed enough of a concern that the king Esarhaddon (681–668 B.C.) gave his daughter in marriage to a Scythian leader. By the late seventh century, the Scythians had allied themselves with the Medes, but in the early sixth century the Scythians fled over the Caucasus before the advance of Median armies, which also conquered Urartu (590).

Herodotus speaks of the Scythian presence in the Near East as lasting for twenty-eight years, and, although the sojourn was apparently longer, the Scythians were probably indeed a force with which to be reckoned for at least the span Herodotus records. Their presence in the Near East brought with it exposure to artistic traditions of a number of ancient cultures, and the Scythians proved exceptionally responsive to the influences they encountered.

Pinpointing the precise source of Near Eastern influences in Scythian art is not always possible, because many Scythian objects displaying such influence date from the fourth century, and by this time motifs either could have been embedded in Scythian traditions for several centuries or could have entered by way of contemporary Greek or Near Eastern works of art that were themselves derived from earlier Near Eastern prototypes. What does seem true, and logical, is that the kinds of Near Eastern objects that the Scythians borrowed were hearty objects for daily use, like the rhyton shape (cat. no. 116) and motifs for bronze belt plaques (cat. no. 12) that suited the Scythian lifestyle as well as their means in that period. Especially influential seems to have been the art of Urartu and Assyria. It may, perhaps, have been in Urartian art that the Scythians became familiar with the griffin.[27] The motif thrived in Scythian art, appealing to several Scythian predilections: for the eagle, for the feline, and for the concept of transformation inherent in hybrid beings. Usually the lion-griffin is depicted, with lion head and paws, but the eagle-griffin is also encountered on a gold scabbard (cat. no. 122), and here the feet take the form of talons. The elegant curves of a long-necked eagle-griffin on a hatchet (cat. no. 23) call to mind bronze griffin attachments from Urartu.

On a gold gorytos (cat. no. 154) the feathered man clasps the necks of two flanking serpents whose heads, with their bulbous protrusions, call to mind the griffins of Urartian art. Yet, the near-symmetrical composition, the multiple wings, the contrasting textures rendered by various patterns, and even the nape-length hair invite parallels with wall reliefs from the palace of Nimrud of the ninth century, which depict both formal anointing scenes and fantastic bird-footed beings.[28] The Scythian scene also calls to mind Assyrian cylinder seals showing a hero grasping in each hand the tail of a fantastic animal.[29] To whatever extent the Scythians absorbed the meaning of the Assyrian scenes, it is certainly plausible that the Scythians associated the image on the gorytos with pre-existing figures in their own oral traditions. By contrast, it is possible that another of the gorytos strips was completely decorative. Here, a chain of fantastic beings, which are bird-headed and serpent-tailed, have as many as four pairs of wings and find parallels on Assyrian reliefs. Even the openwork technique may have been borrowed from Assyrian metalwork.[30]

Assyrian echoes can also be detected in the openwork plaque that surmounted the head of a horse (cat. no. 123). The very form of the ornament recalls horse-head decorations on Assyrian

reliefs.[31] The hunting scene rendered on the Scythian plaque includes trees and vegetation in the form of palmettes that are reminiscent of the handling of trees in wall reliefs from Nineveh of the time of Ashurbanipal.[32] On the plaque, the rider advances from the viewer's left, and it may well be from the art of Assyria that the Scythians inherited a tendency to depict action from right to left, the reverse of what they would encounter in the Greek world. Whether on the horse decoration (cat. no. 123), the gorytos (cat. no. 154), or the scabbard scenes (cat. no. 121), the viewer is asked to read the action from the right. By contrast, the recumbent stag (cat. nos. 43 and 50), which is a quintessential Scythian image, appears in right profile, as are the recumbent horse (cat. no. 45) and boar (cat. nos. 46 and 47) that are based on the same motif.

The openwork plaque raises the intriguing question of the degree to which representations of narrative and of cult were intrinsic to Scythian artistic traditions or were only subsequently intro-duced as a result of borrowings of naturalistic human forms from other artistic traditions. On the openwork plaque, the narrative content is strong, and the Scythian love of movement is clearly evi-dent. The tree sways and the horse's ears are pricked back as he pulls himself suddenly to a halt. The horseman brings both legs over the saddle as he prepares to jump to the ground, and the stag, the target of two arrows, is so near collapse that tense expectation is a strong part of the presentation. It is quite possible that both the story and its narrative rhythm have much earlier antecedents in Scythian art, because dramatic hunting scenes on eloquent ancient petroglyphs from the Altai testi-fy to a deeply rooted tradition in this area of narrative expression related to the theme of hunting.

Other Assyrian echoes in Scythian art are the striated locks seen on the boar's mane on a gold scabbard (cat. no. 121). The locks wind into tight curls reminiscent of the Assyrian treatment of human hair. Noteworthy also is the braided element that is read as the mane on the gold plaque of a recumbent horse (cat. no. 45). A very similar braided element forms part of the bridle in renderings on Assyrian reliefs, where the object is interpreted as a nape strap.[33] Another motif probably bor-rowed from Assyria is the image of a prisoner with hands bound behind his back, seen on a gold dia-dem (cat. no. 40).[34] The isolated human or animal head also brings to mind the appearance of severed heads on Assyrian reliefs.[35] A human head lies between the paws of a spotted leopard on a gold gorytos (cat. no. 46), and a ram head lies in the field below a lion on a gold ring (cat. no. 99); another is seen in front of the captured prisoner on the gold diadem (cat. no. 40).

The Scythians surely also borrowed from the Near East the manner of representing an animal in profile with face frontal, a motif that appears in works of art ranging from Phoenician ivories to a gold sheet from Ziwiyeh in northern Iran.[36] Whatever its source, the frontal head became a popular, even conventional, part of rendering an animal in profile, and we see it on a gold scabbard (cat. no. 121), gold gorytos (cat. no. 46), and the remarkable gold finial (cat. no. 136).

Still other elements in Scythian art have closer parallels with Achaemenid art of the fifth and fourth centuries. A drinking horn with a finial in the form of a ram head (cat. no. 163) finds parallels in the Achaemenid world,[37] and from the same source came inspiration for clothing plaques in the shape of a griffin (cat. no. 20), as well as bronze plaques for a belt in the form of heads of full-maned lions (cat. no. 12).[38] The symmetrical bird heads that adorn the top of a sword blade (cat. no. 121) call to mind the similar position of animal motifs on Achaemenid swords.[39] Fantastic animal beings that fill the field of Scythian gold appliques (cat. no. 161) can be compared with those on similar Achaemenid gold discs.[40] And the symmetrical lion-griffins on the side of the gold gorytos from Melitopol' (cat. no. 105) may also have been inspired by Achaemenid or possibly earlier Near Eastern forms.

It is likely that there is some truth behind Herodotus' tale that when the Scythians returned over the Caucasus to the Black Sea, they discovered that those Scythian women who had remained behind had married slave men, a situation that precipitated conflict. Indeed, one can well imagine

considerable upheavals during the sixth century before the new arrivals were completely integrated. It is also logical that the first Scythian settlements of note would be to the east of the Black Sea, where, in fact, the richest early burials have been found. During the sixth century, the Scythians moved westward, settled the steppes to the north of the Black Sea, and began the interaction that would lead to domination of the pre-Scythian agricultural communities that inhabited the forest-steppe region to the north.

Soon after their arrival from the Near East, the Scythians would have come into contact with Greek settlements along the north coast of the Black Sea.[41] The island of Berezan' was settled by Miletos in the second half of the seventh century, about the same time that Olbia was established on the nearby mainland.[42] In the late seventh century, Miletos also colonized Pantikapaion on the Kerch peninsula at the eastern end of Krym (Crimea), at the mouth of the Sea of Azov. Nymphaion and Theodosia were established nearby during the sixth century. Initial contact introduced the Scythians to a spirited and decorative version of Archaic Greek art that reflected both the liveliness of Ionian culture and the contact with the Near East that western Anatolia had long experienced.

As the Greek mainland increased its demand for grain in the fifth century, the Scythians began to take over the north-south trade routes. By the fourth century, they completely dominated the agricultural communities, which were now probably somewhat integrated into Scythian culture.[43] With this domination, the Scythians commanded a trading network that brought grain (barley, wheat, and millet) as well as fish, amber, and fur southward to ports along the Black Sea, where these products were exchanged for Greek wine, olive oil, and luxury items. The profit brought the Scythians a prosperity that made possible a multitude of gold objects; much of the gold was probably obtained from the gold-rich rivers of the Urals, Tien Shan, and Altai.[44]

In discussing the ethnicity of the artists who created the many gold objects from Scythian burials, it is important to remember that long before the fifth and fourth centuries the Scythians were sophisticated metallurgists, whose lifestyle had long necessitated a command of the techniques used in manufacturing a wide range of objects, from axles to horse bits to arrowheads. Many centuries before their contact with the Greek world, the Scythians probably also had some experience working with gold. Certainly, the gold objects recovered from eastern Kazakhstan speak to the familiarity with gold that ancient peoples living in this area could claim. The principal technique in working gold in the latter area was matrix-hammering. It is important to note that those Scythian gold objects that are most unrelated to Near Eastern and Greek artistic traditions were made by hammering sheets of gold into a matrix of metal in which the representation had been carved in intaglio.

Many objects that have been found in Scythian tombs were obviously made by Greek craftsmen, and in recent years a consensus is emerging that most of these pieces must have been made in Pantikapaion, the capital of the kingdom of Bosphoros. Pantikapaion is long known to have been a polyglot urban center, and much of the population was apparently the product of mixed marriages. Some Scythians probably lived in the city; others, as we know from the location of burials, lived not far outside. There could have been considerable interaction between craftsmen and Scythian patrons familiar with metalworking techniques.[45]

The affluence of Scythian customers must have been a lure to metal craftsmen living as far away as Athens, Macedonia, and southern Italy. Itinerant by nature, the metalworkers must not have found it difficult to pack up their matrices and molds and travel to the Black Sea to compete for elaborate private commissions. Once set up in the Pontic cities, these metalworkers must have quickly realized that some objects they were used to making, especially rings (cat. nos. 98 and 99), were immediately appealing to the Scythians with no adaptation necessary. In fact, a coin from Pantikapaion (cat. no. 94) was simply given a band and transformed into a ring for a Scythian owner. Other objects required some alteration to please Scythian tastes. A sphinx earring (cat. no. 96) is slightly

larger than one would expect, and on a bracelet with lion-head finials (cat. no. 97), the artist has laid gold over a less expensive bronze form. On a pendant in the form of a woman's head (cat. no. 95), the diadem seems especially high, perhaps in response to tall Scythian headdresses. To meet the Scythian taste for whetstones, an artist prepared an elaborate filigree handle of paired volutes (cat. no. 100), to which the addition of two rows of loops lends the design a resemblance to the bird heads familiar from Scythian tradition. Some silver phalerae for the decoration of a horse's bridle may have been produced without any adaptation except in the choice of subject, because metalworkers quickly learned that Scylla (cat. no. 143) and Cerberus (cat. no. 141) appealed to the Scythian enthusiasm for hybrid forms and the deeds of Herakles. Other horse reliefs received a slight adjustment; on a silver relief depicting the Weary Herakles by Lysippos (cat. no. 145), the artist has draped an extension of the lion skin over Herakles' head so that the mane rises upward with radiating locks, forming an ostentatious headdress that appealed to Scythian notions of self-presentation.

Fig. 10. Modern clay cast made in ancient clay impression. Athenian Agora, T 2361. *Photograph Agora Excavations*

Soon after the beginning of Greek and Scythian collaboration in metal working, perhaps still in the fifth century, people of mixed, and probably even Scythian, ancestry apprenticed in these metalworking shops. Many objects requested in mass by Scythian customers and requiring simple matrix-hammering could have been created by these initially semi-skilled workers. Motifs derived from Greek coinage were easily simplified and applied to gold plaques destined for clothing. A Gorgon's head (cat. no. 73), which was found in Theodosia, calls to mind coins of Athens, Neapolis Datenon, Lesbos, and Melos.[46] The motif of a man in an Archaic running pose (cat. no. 112) could have been borrowed from a coin of Cyzicus.[47] The griffin with its paw elevated (cat. no. 21) could have been inspired from coinage of Abdera,[48] and a coin of Ephesos could be the ultimate prototype for the relief of a bee or insect (cat. no. 104).[49] A head of Athena on coinage from Athens may have inspired a motif in which a lion head emerges from the back of a helmet (cat. no. 111),[50] and a coin from Cyzicus could have been a source for the motif of Herakles in combat with the Nemean Lion (cat. no. 113).[51]

Some of the objects from Scythian tombs testify to collaboration between trained, probably Greek, metalworkers and less-skilled apprentices who were so clearly familiar with Scythian culture that they may well have been Scythian. The combats on a gold helmet (cat. no. 124) are based on mid-fifth-century depictions of Amazons and Greeks in Attic red-figure pottery.[52] The heads of the Scythians are the work of an extremely skilled hand and, indeed, bear a marked resemblance to the bearded head on an ancient clay impression from a metal relief that had been made in Athens at about this time (fig. 10).[53] The rest of the scene, including the detailed rendering of Scythian garments, was executed by less-skilled craftsmen who certainly could have been Scythian. The receptivity of the less-skilled artists to Greek motifs is evident in the plants scattered around the uneven terrain. The vegetal elements are a reminder that the Scythians were traditionally so focused on large-scale animal life that depictions of vegetation and the miniature aspect of nature were introduced only under Greek influence.

The subject of the helmet raises once more the question of Scythian narrative. Amazons were a mythical society of women who inhabited the farthest northeastern reaches of the Greek world and

whose resistance to male-dominated society resulted in bitter engagements with Greek warriors. In the helmet's version of the composition, all the warriors are Scythian males, and thus the scene is, ironically, a realistic adaptation of a prototype depicting a Greek myth inspired from this general region. The exact nature of the adaptation is, however, unclear, because the Scythians did not normally favor representations of themselves in combat. Neither, however, could they claim a peace-loving past, and it is possible that the Scythian owners of the helmet read into the scene tales of combat from their own oral traditions.

Issues of collaboration and narrative are encountered again on a gold gorytos from Melitopol' (cat. no. 105), which has three identical mates from Chortomlyk, Illintsi, and P'iatybratni (Five Brothers) Kurhany. The pieces are testimony to the degree to which Greek forms, but not necessarily their meaning, could be mastered outside the mainstream of Greek culture. Each of these gorytoi was hammered in a combination of matrices, following the technique of matrix-hammering in which the Greeks themselves had long excelled. However, whereas the style of the figures and objects bears a striking resemblance to that of fifth-century Athens, the scene exhibits a remarkable number of departures, not only from the conventional manner of depiction but also from actual usage. On the lower register, a woman is seated on a stool that sits on its side; her companion is seated on a fabric-covered footstool that is placed on top of another one. In the register above, another woman sits on a footstool that rests upon another one, and still another stool, on the upper register, has five legs. On the lower register, a man leans not on one staff but on two. And in the upper register, a seated woman grabs the drapery of a dancing female. This familiar image from Greek art, however, almost never has her flowing garments distributed in this way. Throughout the gorytos, every effort is made to occupy both hands, in contrast to the Classical Athenian style, where one hand is often idle. Moreover, the artist was also careful to cover all male genitalia, a proclivity evident also in the gold diadem (cat. no. 40) and a gold plaque where two Scythians swear a blood oath (cat. no. 42). On the gorytos, the junctures of reliefs made in discrete matrices are not difficult to recognize, and some reliefs overlap the upper border of the topmost scene, while others, inconsistently, do not. The gorytos thus exhibits, in addition to an admirable mastery of the forms of the Classical Greek style, a cultural and iconographical ignorance as well as technical shortcomings. These features argue against Greek workmanship, both in fabricating the matrices and in hammering the gold relief.

The artist or artists who fabricated the matrices may not have determined the order in which the matrices would be combined. That task was probably carried out in consultation with a Scythian owner or by a master craftsman who gave considerable thought to Scythian tastes. It is unlikely that the sequence of matrices is haphazard, because meaningless subject matter was antithetical to Scythian taste and was especially implausible on so large and expensive an object. It is more likely that the matrix sequence is a response to a complex and specifically Scythian oral narrative that is here presented by means of Greek forms. As with the gold helmet (cat. no. 124), the openwork plaque (cat. no. 123), and the winged man on the gold gorytos (cat. no. 154), borrowed forms have apparently been employed to illustrate Scythian myths or sagas.

Fig. 11. Cat. no. 146

The question of borrowed forms conveying Scythian meaning applies also to a gold diadem (cat. no. 40) and a gold plaque (no. 41), on which a seated female with a mirror is attended by a male figure, who, on the diadem, carries a drinking horn. Jacobson convincingly argues that both are scenes of obeisance before a female deity, probably Tabiti, mentioned by Herodotus as the primary Scythian goddess.[54] She points out that with few exceptions, all Siberian religions until the beginning of this century were centered on a female deity.[55] It appears then that Greek and Near Eastern forms have been adopted to provide naturalistic renderings of ideas deeply embedded in Scythian religion and myth. A similar explanation may account for the popularity within Scythian art of a Greek motif that shows a female whose body below the waist takes the form of two opposed crescents or snaky forms. The motif (cat. no. 107) has been linked with the goddess Api, whom Herodotus mentions, but the association is tenuous.[56] What is known is that a female divine force associated with birds and fish existed in the early religion of Ukraine, and Elizabeth Barber observes that the strains of these beliefs are still clearly evident in Slavic traditions of this area.[57] It is possible that the Scythians were introduced to this tradition by the agricultural peoples who predated the Scythians in the forest-steppe region. The Greek motif could then have become easily attached to popular beliefs.

In connection with the apparent prominence of the female both in Scythian religion and in popular belief, it is interesting to note that women in Scythian art appear almost never in a realistic or domestic context. Instead, they are consistently rendered in a form that suggests an otherworldly identity, replete with mythical context. The women on a pair of gold earrings (cat. no. 128) sit on elaborate thrones surmounted by large, winged sphinxes. A woman framed by stag heads that emerge from a landscape of volutes (cat. no. 153) does not have a ready parallel in Greek art, even though both the figure and the volute pattern are individually well attested. A Scythian preference for imaginary females, coupled with the Scythian enthusiasm for transformed shapes, could also explain the choice of a snaky, footed woman (cat. no. 147) and a winged female (cat. no. 146 and fig. 11), as well as the semi-canine Scylla (cat. no. 143). Other hybrid women borrowed from Greek art include sirens (bird-women) who appear on the handle attachments of a Greek bronze hydria (cat. no. 82) and louterion (cat. no. 83) that were discovered hundreds of miles up the Dnipro, obviously intended for Scythian ownership. A related female of hybrid form is seen in the pendants of a gold necklace (cat. no. 101).

The determination to decorate Scythian forms with Greek elements can be tenacious. On several Scythian headdresses (cat. nos. 108–110) Greek volute ornament is juxtaposed, but not really integrated into, traditional Scythian decorative schemes. By contrast, we also encounter an un-willingness to allow traditional Scythian attitudes to be eclipsed by the wealth of available Greek imagery. On the hilt of a sword (cat. no. 122), the Greek god Pan plays his pipes, but in contrast to the symmetrical animals that in Greek depictions would flank him, the god is here shown between two deliberately asymmetrical animals in keeping with Scythian avoidance of static compositions. Other manifestations of a distinct Scythian point of view are evident in the very absence of certain subject matter. Scythian owners obviously did not warm to lascivious Greek scenes of satyrs carrying off maenads, nor to nude women or to nude male genitalia. For all their hardiness and exposure to foreign cultures, the Scythians seem to have had a certain reserve and even prudery.

A number of objects assertively adapt Greek designs to Scythian sensibilities. On a gold openwork plaque (cat. no. 155), the palmettes and volutes are easily recognized as borrowings from the Greek world. But one would not see in Greek art the insistent upward continuation of the acanthus framing the large palmette. The acanthus blends into volutes, palmettes, and half-palmettes while it encloses a smaller palmette flanked by buds and supported by volutes. Similarly non-Greek is the handling of a gold plaque with a woman standing amid a volute and acanthus pattern of Greek origin (cat. no. 153). Here what appear at first glance to be palmettes at her shoulder are actually the

heads of stags. Especially interesting is the treatment of the Greek motifs of the lotus and acanthus in a pair of gold openwork plaques (cat. no. 126). Four lotus flowers are arranged in a circle around a central flower, an emphasis on rotation we have noted already on the cross-shaped horse ornament (cat. no. 48). Partly in response to the exigencies of the technique, which require a continuous connection between the gold parts, the edges of the acanthus leaves beneath each lotus are in contact with each other. The X-shaped open space enclosed by these leaves has been made an insistent part of the design.

On a number of objects, the integration of Greek and Scythian traditions is truly exceptional. On a gold drinking horn (cat. no. 116), a guilloche pattern has been modified through the addition of a row of punched hemispheres along the upper and bottom edge, transforming the circular pattern into a series of bird heads seen on the diagonal. On a beaker distinguished by a series of rosettes (cat. no. 117), the volutes of the original Greek design have evolved into an oblong form that has a bird head at each end. The new design not only underscores two directions of movement but also emphasizes a diagonal axis, as the eye is drawn to the elongated necks and angles of the bird heads. On the handle of a bronze mirror of Greek type (cat. no. 118), the terminal is not in the form of Greek volutes, as one would expect, but of confronted eagle heads, which happily balance the pair

Fig. 12. Horse skulls with ornaments, Babyna Mohyla, 1986. *Photograph Institute of Archaeology, Kyiv*

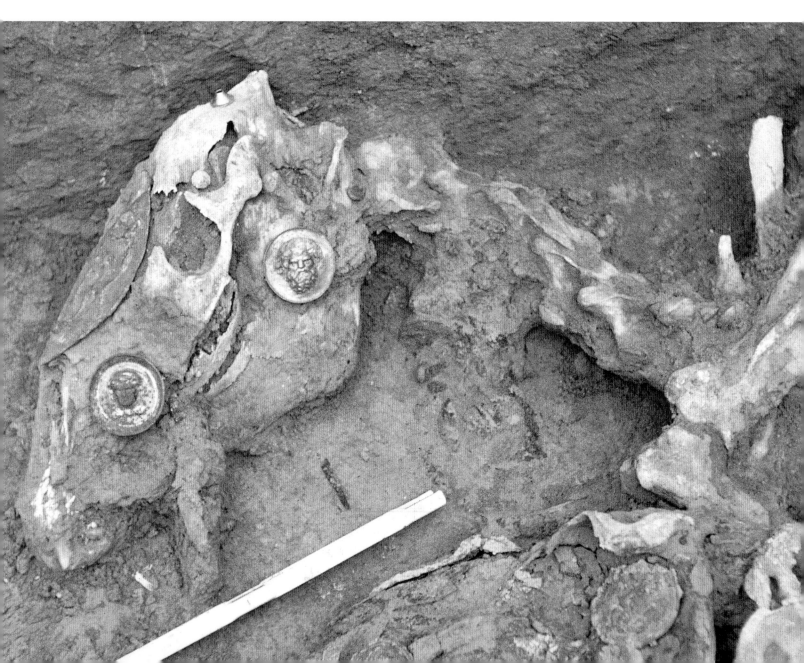

of volutes at the base of the disc. On the handle of another bronze mirror of Greek type (cat. no. 119), a feline worked in the round takes the familiar Scythian crouching pose, its body rendered as a series of planes meeting at angular juxtapositions. Familiar from traditional Scythian representations is the way the paws, petal ears, and tail are isolated by their discrete ornamental treatment, which relates each circular form more to the other shapes than to the animal's body as an organic whole.

An extraordinary gold bowl (cat. no. 134) is an unsurpassable example of a true fusion of Greek and Scythian artistic traditions. The horse heads are descended from those on the Parthenon frieze (442–438),[58] but unmistakably Scythian is their rotation around a central disc made of Baltic amber. Here the Scythian inclination toward rotation creates a whirling, insistent rhythm that is decidedly not Greek.

The horse cup was found together with a necklace of Greek type but with terminals of Scythian form (cat. no. 135). In the same burial was also discovered a cylindrical object, perhaps a finial (cat. no. 136). Here, the skillful combination of matrices creates an allover design, where earthly combats of lions and horses on the lower registers give way to conflicts between horses, lions, and otherwordly griffins in the rows above. In the circular field on the top, where a spotted leopard brings down a stag, two motifs traditionally separated in Scythian art are brought together in a new way. The spotted leopard is depicted on a frontal plane and with a stylized frontal head. The animal's form is derived not from the curving or recumbent prototype of Scythian tradition, but rather from a Near Eastern forebear, much like his cousins on a gold scabbard (cat. no. 121). The stag is not at all in the traditional Scythian recumbent pose but exhibits unmistakable vitality in resistance. The animal elevates its front leg and throws back its head. The artist has endowed the stag with a glorious set of antlers, but nowhere is there even the slightest sign of an emerging bird head.

Another influence beyond the Greek and Near Eastern worlds becomes apparent in Scythian art of the fourth century. On a series of silver plaques from a horse bridle (cat. no. 32), we encounter a different style and subject matter. The style and scale are larger than one is used to seeing in Scythian art, and the subject, a hero in combat with an animal, is also new. The rendering is stylized, and the hero has a large, round, frontal face, with staring eyes, a hairstyle of bangs fringing the face, and boots with turned-up toes. Even the ornament is different; animal heads are indeed arranged in a composition of rotation, but the forms are large expanses and the convex curvature is emphasized rather than an abrupt juxtaposition of flat or slightly curved planes. The closest parallels to this style lie in the art of the Thracians, who inhabited the lands of the lower Danube River and who themselves may have had some early contact by this date with the Celts, who lived farther to the west.[59] It would not be unusual for the Scythians to have had contact with the Thracians, and another set of horse decorations (cat. no. 166), as well as the clover motifs on a pair of shoes (cat. no. 17), may also reflect such influence.

Although the curving form of the great pectoral from Tovsta Mohyla (cat. no. 172) may possibly derive from the Near East,[60] the volute ornament and the exquisite skill with which it is rendered argue that the piece was fabricated by the hands of a craftsman who had been thoroughly imbued with and trained in Greek centers. Greek influence is also unmistakable in the subject and mood of the domestic vignettes. It is rare enough to see Scythians depicted in their own art and almost unique to see them in a domestic moment that is neither combat (on the gold helmet, cat. no. 124) nor ritual, as, for example, on the diadem (cat. no. 40) or a plaque depicting two Scythians sharing a single drinking horn in the taking of a blood oath (cat. no. 42). The focus upon the mundane act of sewing a fleece is almost without parallel in Scythian art. Even the handling of the horse is unique, because it is not the animal's speed that is celebrated on the pectoral, but rather its fertility. Moreover,

the pectoral's observation of natural life, vegetation, and insects has few parallels in Scythian art and none that is not heavily inspired by Greek art.

What may be a distinctly Scythian note in the pectoral's composition is the ordering of the action. The same drive to organization seen on the finial (cat. no. 136) is here also apparent as an outer world of violence encircles the inner arc of domestic, unthreatened scenes. This emphasis on domesticity speaks to Greek influence, not only on the art of the Scythians but also on their lifestyle. As trade with the Greek world encouraged the Scythians to become ever more sedentary in their role as prosperous traders and, eventually, settled agriculturalists, the benign calm emanating from the pectoral scenes testifies to a diminution of Scythian vitality that would have disastrous consequences.

Indeed, in the third century the golden days of the Scythians came to an end. Pressing from the east were the Sarmatians, a people with whom the Scythians probably had had contact through the years, but who only now had become emboldened to push westward. On a gold torque (cat. no. 168), the curved wings of the fantastic beings suggest that they are griffins, but here the animals blend together, without the isolation of animal or animal part, and without the abrupt juxtaposition of planes that distinguished Scythian predecessors. Moreover, on the Sarmatian necklace is a prominence of inlaid stones, reflecting influence from Hellenistic Greek art. Although the Scythians would hold on for many years more after the Sarmatian presence made itself known, Scythian prosperity was soon compromised, and the wondrous stream of gold objects abruptly ceased.

Fig. 13. Gorytos (cat. no. 154) from Soboleva Mohyla in situ, 1990–91. *Photograph Institute of Archaeology, Kyiv*

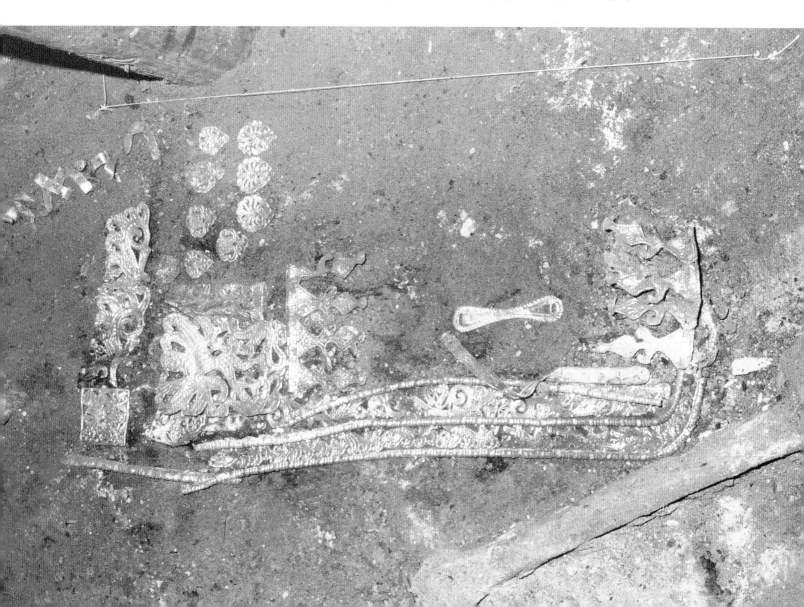

1. Jacobson (1995), 38; Yablonsky, *History* (1995), 193.

2. Jacobson (1995), 247–48.

3. Ibid., 182; Jacobson (1993), 154.

4. Ibid., 24; Schiltz, *Scythes* (1994), 294, no. 219 A, B; New York, *Scythians* (1975), 102, no. 29, pl. 4.

5. London, *Frozen Tombs* (1978) 87, no. 112.

6. Jacobson (1993), 158–62.

7. Ibid., 76, 240; King, Noble, and Humphreys (1996) 195, 381; Schiltz, *Scythes* (1994), 299-302; Mantua, *L'uomo d'oro* (1998), 42, 175–79. See also Jacobson (1995), 143, 163. He could possibly be female; see Davis-Kimball (1997), 40–41.

8. Jacobson (1993), 4, 31, 32.

9. Whittell (1993), 272, 274; King, Noble, and Humphreys (1996), 35, 53, 179.

10. Jacobson (1995), 31, 37.

11. King, Noble, and Humphreys (1996), 41.

12. Carey and Carey (1998), 8; Jones (1996), 30–34; Grambo (1997), 13 and see 47–56.

13. Jones (1996), 34.

14. Ibid., 33; Carey and Carey (1998), 13.

15. Carey and Carey (1998), 66; Campbell and Dennis (1996), 55, 84; Grambo (1997), 55.

16. Campbell and Dennis (1996), 10–11, 80; Whittell (1993), 242; Chang (1998), 1.

17. Jones (1996), 96, 104.

18. Carey and Carey (1998), 54, 58, 68; Grambo (1997), 27, 33, 50.

19. Jones (1996), 39–43.

20. Campbell and Dennis (1996), 76.

21. I thank Alan Shoemaker, International Leopard Studbook Keeper/Collection manager, Riverbanks Zoological Park and Botanical Garden, Columbia, S.C.. See Brakefield (1993), 69–85; Boitani and Bartoli (1983), no. 317.

22. Whittell (1993), 242. I thank Tom Brakefield, Henderson, Tennessee. See Brakefield (1993), 145–53; Boitani and Bartoli (1983), no. 319; Maier (1994), 203, 240.

23. I thank Dr. Ross McPhee, Department of Mammalogy, American Museum of Natural History, New York, and Dr. Alexei Tikhonov, Zoological Institute, Russian Academy of Sciences, St. Petersburg.

24. Jacobson (1993), 47, 61, 97, 179, 230–31, 238, 240.

25. Ibid., 43, 157, 169, 175.

26. Jacobson (1995), 32–33.

27. See Culican (1965), 39–41 and 243, fig. 17 from Ziwiyeh, 7th c.; Godard (1950), 45 and 40, fig. 30; Parrot (1961b), 139, fig. 169; Ghirshman (1964), 105, figs. 105–106, and 314–15, 338–39.

28. Reade (1983), 37, figs. 33 and 38 from Nimrud, ca. 865; Amiet (1977), fig. 609 from the palace of Sargon II at Khorsabad, 721–725. See also Strommenger (1964), pl. 194. Compare also Assyrian ivories: Strommenger (1964), pl. 267; Amiet (1977), pls. 121, 609.

29. Collon (1995), 115, fig. 93, of 1400–1300.

30. Compare a bronze plaque from Nimrud of the 9th c. in Curtis and Reade (1995), 124, no. 84.

31. Curtis and Reade (1995), 63, no. 13, from Nimrud, 730–727, and Reade (1983), 80, fig. 95, and 82, fig. 96, from Sennacherib's palace at Nineveh, ca. 660–650. See also Parrot (1961b), 38, fig. 45; Strommenger (1964), pls. 238, 252; Amiet (1977), pl. 118.

32. Reade (1983), 48, fig. 49 from the palace of Sargon at Khorsabad, ca. 710, and 61, fig. 65, from the palace of Sennacherib at Nineveh, ca. 640–615; Parrot (1961b), 62, fig. 66.

33. Curtis and Reade (1995), 162–63.

34. Reade (1983) 43, fig. 43 from the palace of Tiglath-Pileser at Nimrud, ca. 730.

35. Curtis and Reade (1995), 189, nos. 195–97, for a seal impression from Nineveh of the 7th c.

36. Collon (1995), 159, fig. 128, for a Phoenician ivory from Nimrud of the 8th–7th c.; for the Ziwiyeh plaque, see 178, no. 142, dated 800-700.

37. But see comments in Culican (1965), 248, nos. 55–56, and 249, nos. 57 and 62. See also Amiet (1977), figs. 722–24.

38. Ghirshman (1964), 382, fig. 554, of the 5th and 4th c. Compare the motifs on the felt carpet from Pazyryk of the 4th c.: 362, fig. 470.

39. Briant (1992), 56; Ghirshman (1964), 267, fig. 328.

40. Porada (1963), 169, from Ecbatana of the 4th c.

41. Kouznetsov (1993), 10-15; Kochelenko (1993), 4–9; Kochelenko and Kouznetsov (1993), 34–39; Tolstikov (1993), 40–45.

42. Kryjitskij (1993), 16–25.

43. Melyukova (1995), 27, 33, 34, 36, 51, 54, 55; Jacobson (1995), 39, 41.

44. Jacobson (1995), 31.

45. Petrenko (1995), 69.

46. For Athens, see Kraay (1966), 326, nos. 349-50, pl. 115, dated 530–520. For Neapolis Datenon, see ibid., 334, nos. 433–34, pl. 140, dated 500–480 and 400–350. For Lesbos, see ibid., 368, no. 693, pl. 197, dated 480–400. For Melos, see ibid., 346, no. 533, pl. 163, dated 420–416.

47. Ibid., no. 704, pl. 198, dated ca. 500.

48. Ibid., 333, nos. 426–27, pl. 138, dated 520–490 and 473–449.

49. Ibid., 356–57, nos. 599–600, pl. 179, dated 420–400 and 375–300.

50. Ibid., 323, no. 357, pl. XII, dated 479 and 323, no. 363, pl. 119, dated 440–430.

51. Ibid., 292, no. 129, pl. VII, dated 390–380.

52. Vos-Jongkees (1963); von Bothmer (1957). Compare a dinos in London, attributed to the Group of Polygnotos, 162, no. 12, pl. LXXVII.2, and a cup in Bryn Mawr by the Amymone Painter, 184, no. 71, pl. LXXX.5.

53. Williams (1976), 53, no. 6, pl. 7 (inv. no. T 2361).

54. Jacobson (1993), 4, 163–67, 174, 177, 214, 217.

55. Ibid., 184, 215; Jacobson (1995), 60.

56. Jacobson (1993), 216.

57. Barber (1997), 12–16.

58. Jenkins (1994), 94–102.

59. Cunliffe (1997), 123–24, 168–69, 170; Marazov (1998), 22–29. Compare 128, no. 49 of the 4th c., and 131, no. 51, of the same date.

60. Ghirshman (1964), 105, fig. 137 and see 308–11; Culican (1965), 39 and fig. 20; Godard (1950), 20, fig. 10; Parrot (1961b), 138, fig. 167.

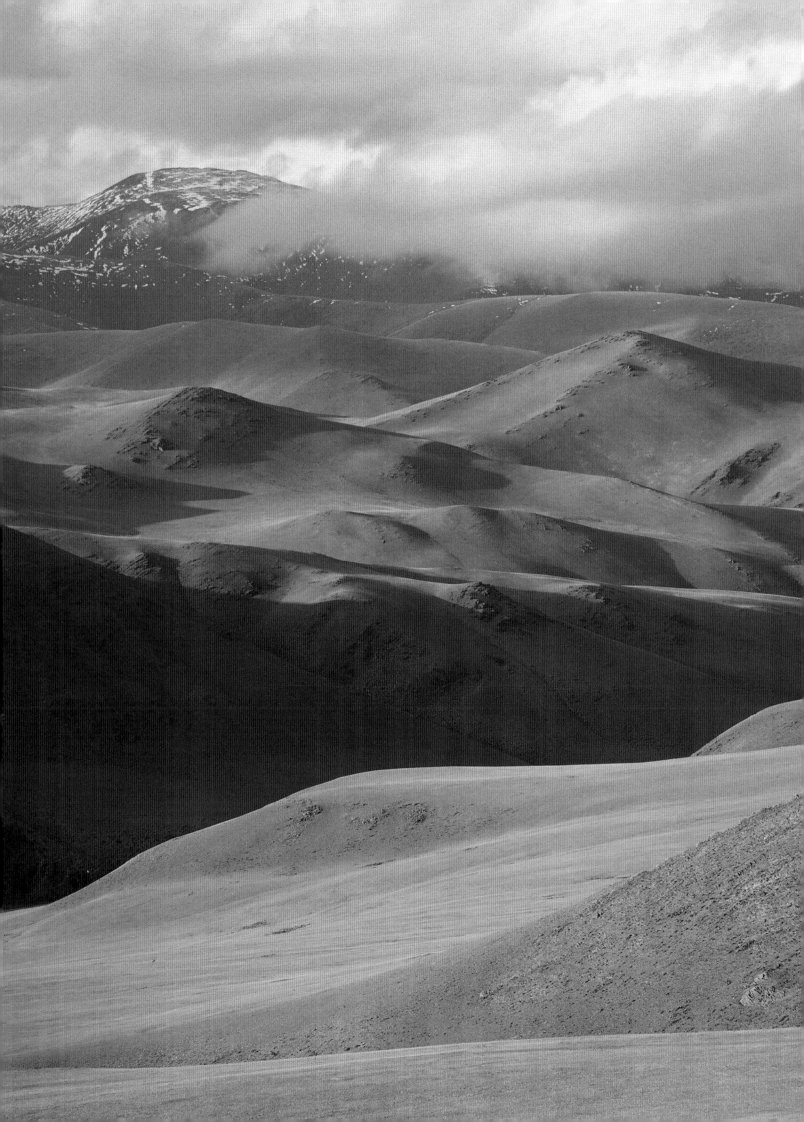

Early Nomadic Sources for Scythian Art

ESTHER JACOBSON

The Scythians were one of a number of related and contemporary semi-nomadic groups scattered across the Eurasian steppe and mountain-steppe zone. The people belonging to these sub-cultures were certainly ethnically and linguistically diverse,[1] but their shared dependence on herding and horse-riding, their common weapon and tool typologies, and striking similarities in burial ritual and structures identify them as members of one large cultural grouping, usually referred to by the convenient though imprecise term *Scytho-Siberian*.[2] In addition to the Scythians, our discussion will focus most importantly on the Sakas (centered in the Tien Shan region of present-day eastern Kazakhstan and western China), the Pazyryks (centered in the northern Altai Mountains and adjoining steppe), and the Tagars of the Minusins'k Basin.[3]

Some scholars have argued that each of these subcultures can be traced directly to one of the expansive Bronze Age cultures of the Eurasian steppe in the latter half of the second millennium B.C. Gimbutas and others,[4] for example, have asserted that the Scythians derived from the Timber Grave, or Zrubne, culture centered in the lower Volga basin. This cultural descent is attractive on several scores, but it obscures a few problems. Very early (eighth-century B.C.) Scythians in the Pontic region used weapon types that were most closely related to bronze and early iron implements of the Siberian Karasuk culture, thus lending weight to the proposition that the Scythian homeland was in northern Central Asia and South Siberia.[5] As we shall see, the earliest Scythian ornamental motifs are most closely related to material from the same area.[6] Tracing the Scythians to the Timber Grave culture does not explain references to them in seventh-century Assyrian documents. Nor does it illuminate Herodotus' complex account of their move into the Black Sea region,[7] or explain the Scytho-Siberian elements detected in metalwork from northern Iran.[8]

The greatest obstacle to tracing Scytho-Siberian descent from Bronze Age cultures of the Eurasian steppe lies elsewhere. Even in its earliest manifestations, which date from the seventh and sixth centuries B.C., Scytho-Siberian art is indicative of a developed, expressive, and supremely confident representational tradition.[9] This is a tradition—and the same is true whether we are speaking of the Scythians, Sakas, Pazyryks, or other groups—united by motifs, by technologies, and by ornamental intention. By contrast, the burials of the steppe Bronze Age cultures are virtually silent in this regard. With only a few exceptions, the expressive traditions associated with these cultures—and known, it should be pointed out, primarily through disrupted burials and settlements—are limited to geometric ornament, an occasional bird motif on pottery or bronzes, and a few small, carved objects.[10] The only Bronze Age culture that appears to have had a significant pictorial tradition expressed in portable objects is the Karasuk of the Minusins'k Basin.[11] There, the filiation between

Opposite:
fig. 1. View of the Altai.
Photograph Gary Tepfer

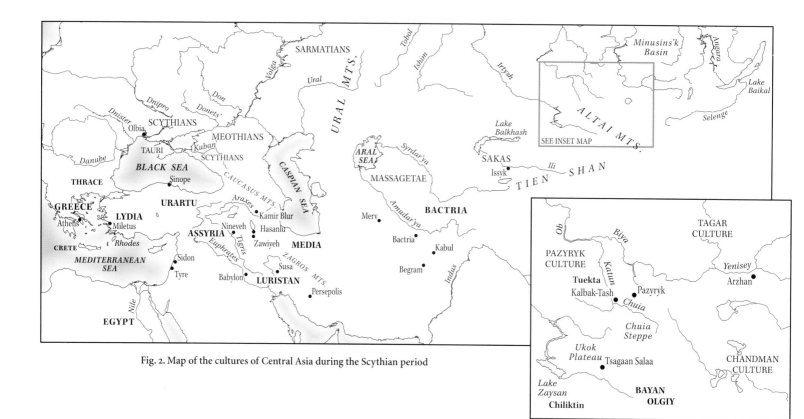

Fig. 2. Map of the cultures of Central Asia during the Scythian period

the Karasuk and its early Iron Age successor, the Tagar culture, is persuasive. But the Karasuk-Tagar representational tradition must also be viewed in light of the monumental stone carvings that were made in the Minusins'k region by the earlier Okunev culture[12] and with reference to the great carved-stone deer images of the Chandman culture in Mongolia.[13] Discussion of Bronze Age representational traditions and the sources of Scytho-Siberian art must, similarly, take into account the rock art on thousands of open-air surfaces in South Siberia, western Mongolia, and eastern Kazakhstan that are unfamiliar to Western scholars.[14] This material testifies to a clear continuity of cultural expression from what has been called the Baikal Neolithic[15] into the first millennium of our own era. Because of the varied nature of the material—representational rock art, and pottery, bronzes, and bone artifacts from burials—synchronization is difficult. Some rock-art images, however, clearly depict weapons attested in Bronze Age burials. In figure 3, for example, a man holds a knife of Karasuk typology, and the snakelike mark above his head is also specifically associated with the Karasuk culture. The rock-carved imagery is an invaluable resource because it is abundant, pictorially expressive, and continuous. It justifies the thesis that the expressive mature art of the Scythians and their nomadic relatives had its source in South Siberia and northern Mongolia and that this tradition was more firmly embedded in rock art than in portable objects.

The art of the early Scythians is overwhelmingly represented by animal imagery. The great gold plaques of deer, crouched felines, and birds from Kelermes and Litoi are a part of the same tradition as the superb feline and ram poletops from Arzhan.[16] Roughly contemporaneous but separated by thousands of miles, these finds and many others from early Scythian burials refer to the animals of a mountainous or forest-steppe region. The treatment of bodies, with smooth planes and sharp, linear definition of musculature, is immediately expressive of a bone- and woodcarving tradition, that is, of a forest-steppe tradition, translated into metalwork. Signs of this archaic Scythian tradition appear in the recumbent stags from Syniavka (cat. no. 43), in the crouching feline on the sixth-century mirror handle from Basivka (cat. no. 119), and in the references to birds of prey on gold plaques that decorated wooden vessels (e.g., cat. nos. 51, 53, 54, and 117). Surviving early Scythian

material, like that from the plundered burials at Arzhan (eighth century B.C.), from Tuekta (sixth century B.C.) in the Altai, and from Chiliktin (seventh century B.C.),[17] is almost completely zoomorphic in its pictorial references. It is unquestionably for this reason that the appellation animal style was applied to the art of the early nomadic peoples of Eurasia.[18] Unfortunately, the term is misleading: the continuous petroglyphic record against which we must begin to consider the more fragmented evidence of burials indicates a strong tradition of human representation associated with the same peoples.

The recumbent deer, the crouched or coiled feline, and the bird or bird head compose what may be called the archaic triad of Scythian imagery.[19] In the early period, these elements are always shown with static monumentality, rendered with a simplicity and directness that lend them a distinctive stability and power. The closest counterparts to these early Scythian images are found among the few remaining objects from early plundered burials, such as the coiled feline from Arzhan,[20] and in rock-art images of stags, birds, and felines dating to the early first millennium B.C. (figs. 4 and 5). Many objects from early burials demonstrate that these separate

Fig. 3. Rock-carved image of a man holding a knife of Karasuk culture typology; above his head is an object of unknown significance, also associated with the Karasuk culture. Late Bronze Age–Early Nomadic period, ca. 1000 B.C. Tsagaan Salaa IV, Altai Mountains, Mongolia. *Photograph Gary Tepfer*

images were intended to be juxtaposed, either actually or conceptually, so that the feline became, in effect, the predator of the recumbent deer and the rival of the bird of prey.[21] We cannot discuss here the complex symbolism of these animals, but we can assert that the early images all refer to living animals and to a struggle in the natural world between the predator animal and the raptor bird for the source of life, the deer. In no instance from early Scythian art is the prey represented as dead.

Fig. 4. Rock-carved image of a recumbent stag. Early Nomadic period, ca. 900 B.C. Tsagaan Salaa IV, Altai Mountains, Mongolia. *Photograph Gary Tepfer*

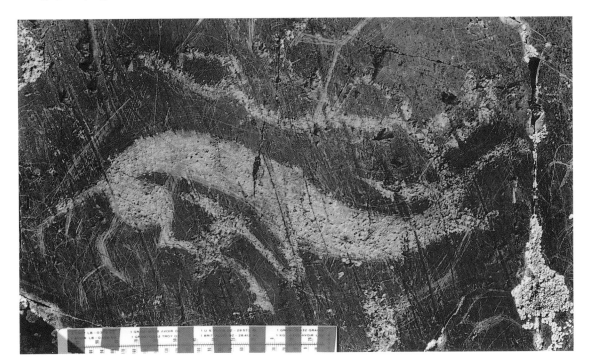

Fig. 5. Rock-carved image of an eagle or vulture. Early Nomadic period, ca. 800 B.C. Tsagaan Salaa IV, Altai Mountains, Mongolia. *Photograph Gary Tepfer*

Almost all the early examples from Scythia, the expressive leather and felt constructions from Pazyryk burials in the Altai Mountains of Central Asia,[22] and contemporary rock art from Central Asia (e.g., fig. 6) vividly express the vitality, majesty, and grace of the prey, whether deer, elk, moose, or a ram. By contrast, in fifth-century Scythian art, representations of the actual attack (e.g., on the scabbard overlay from Illicheve, cat. no. 50) begin to evoke a sense of pathos and the process of death. This degree of realism is not a part of the archaic Scythian tradition. In it, and in the texturing of the animals' ears, eyes, feathers, and scales, we note the intrusion of Hellenized sensibilities and tastes.[23]

The transition from archaic Scythian motifs and style is represented by a group of gorytos plaques from the fifth-century burial at Arkhanhel-s'ka Sloboda (cat. no. 46). The boar motif can be found across the Scytho-Siberian world, and the addition of bird heads at the boar's tail, shoulders, and possibly at the ear has many Siberian and Central Asian antecedents.[24] This type of syncretic handling of zoomorphic elements appears to have been revitalized in fifth-century Scythia by the intrusion of new nomadic elements out of Central Asia.[25] Animals are rendered in terms of smooth planes and sharply defined edges, that is, in a manner more reminiscent of bone- and woodcarving techniques than of goldwork. Nonetheless, these fifth-century plaques presage change: the ornamental texturing of the animals' spines, ears, and head bristles, and the rampant posture of the wolflike animal announce the appearance of a realism that is not Scytho-Siberian. The small leopard plaques in the same group of gorytos ornaments distantly recall the archaic carving tradition, but by depicting the animal gnawing on a human head, the artist has taken the motif out of the nomadic tradition and into one influenced by Persian and Greek conceptions.[26]

The representation of animals in mortal conflict seems to have invaded Scythian art in the fifth and more resolutely in the fourth century B.C., just at the time it also appears in the art of Pazyryk in the Altai and Issyk in Tien Shan. A more decisive change, one that heralds the increasing importance of a Hellenized sensibility, occurs in Scythian art by the early fourth century: the leopardlike feline becomes, decisively, a lion (e.g., the cup from Soboleva Mohyla, cat. no. 164); the bird becomes a winged griffin; and the monumental stag of the archaic triad loses its references to the large elk,[27] becoming merely a deer or a horse (e.g., the scabbard from Illicheve, cat. no. 50, or the Soboleva Mohyla cup, cat. no. 164). This transformation of the ancient triad from a distant mountain-steppe idiom into an elegant Hellenized formulation is beautifully expressed in the great pectoral from Tovsta Mohyla, where lions and griffins savage deer, horses, and boar with consummately graceful naturalism.

Just as the Scythians shared with their Central Asian relatives the traditions of horse-riding and horse sacrifice as a part of the burial ritual, they also shared specific forms of horse regalia, many of which are represented in this exhibition. The sixth-century carved-bone cheekpieces from Budky (cat. no. 29) reduce the horse to a head and hoof. Their *pars pro toto* conception recalls many similar examples from Pazyryk burials.[28] Scythian forehead plaques decorated with hovering birds or felines savaging animals, represented by the fourth-century horse plaques from Ohuz and Soboleva Mohyla (cat. nos. 32 and 166), echo the motifs of feline predation on deer or the struggle of bird

against feline that are impressively represented on harness ornaments from Pazyryk. Indeed, the motif of a feline head superimposed on winglike projections used on a horse frontlet reflects more articulate and older formulations from Tuekta and Pazyryk.[29] But the process of Hellenization was as pervasive in Scythian horse ornaments as elsewhere: once decorated with archaic imagery,[30] bridle trappings were ultimately embossed with the heads of satyrs or Herakles (e.g., those from Babyna Mohyla, cat. nos. 137–140).

Certain object types persisted long after they were presumably brought by the Scythians' ancestors to the Pontic region from a Central Asian homeland. Bronze poletops crowned with animal motifs (cat. nos. 36–38) reflect a tradition that is well documented in South Siberian nomadic burials; they were a part of Scythian burial ritual until the fourth century. The eighth-century ram poletops from Arzhan represent the earliest known examples of a style that developed with considerable power and grace in the region of Tuva and the Minusins'k Basin.[31] Finds from the China borderlands indicate the tradition's continuation there until late in the millennium.[32]

Scythian vessels also reflect ancient nomadic traditions in pottery. Two silver vessels from Soboleva Mohyla (cat. nos. 164 and 165) repeat a shape already established in the sturdy pottery of the early Scythians. It is duplicated as well in contemporary vessels recovered from Issyk, Pazyryk, and other burials.[33] The functional form of the Soboleva silver vessels was, in other words, an established nomadic tradition that reflected the requirements of households periodically on the move in search of new pasture. A similar taste is revealed in the bowl plaques from the fourth-century burial at Berdians'kyi Kurhan(cat. no. 51). The form of the original wooden vessel and its wing-shaped handles can be duplicated in many pieces from Pazyryk burials that have lost or never had the gold appliques that allowed archaeologists to recreate their Scythian counterparts. Unquestionably, these wooden vessels were both lightweight and durable, easily made, carried, and repaired. The gold added luster and ornament to what was basically a simple object.[34] The various cup plaques from Berdians'kyi Kurhan testify to the longevity of this tradition within Scythia, but it is useful to note that only with the translation of the wooden bowl into silver (as in the case of the famous vessel from Solokha with scenes of Scythian youths and mythical lions)[35] did the archaic Scythian taste turn decisively from nomadic traditions.

Even the casual viewer of Scythian art notes the extent to which gold is applied to simple objects, transforming them, one might say, from base materials into gold. This is especially true of clothing. Garment and belt plaques, which appear in Scythian burials from the seventh through the fourth centuries, are well represented in this exhibition and are depicted on objects such as the gold helmet from Zrubne (cat. no. 124). Use of gold clothing plaques persisted throughout the main Scythian period, but their size and solidity tended to diminish, just as their motifs became increasingly Hellenized.[36] The tradition of using gold clothing plaques is similarly well established throughout the Saka and Pazyryk worlds, where gold was said to have been abundant in the mountain rivers.[37] By pounding the gold, the early nomads created a foil that could be used and reused, and by applying it over a carved surface, they were able to give simple wood or sturdy leather ornaments the appearance of solid gold without its weight and cost.

Fig. 6. Composition with rock-carved images of a stag attacked by two wolves or snow leopards (right) and a man with horned headdress, walking to the right. Early Nomadic period, ca. 800 B.C. Tsagaan Salaa I, Altai Mountains, Mongolia. *Photograph Gary Tepfer*

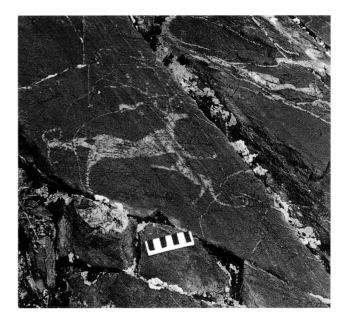

Fig. 7. Rock-carved composition with wild goats and a hunter (upper left). Pazyryk period, mid-1st millennium, B.C. Baga Oigor IV, Altai Mountains, Mongolia. *Photograph Gary Tepfer*

The extensive use of gold-covered ornaments by the Pazyryks is attested by the presence of such ornaments in rich burials, such as those at Tuekta, and in the commoner burials of the Chuia Steppe as well.[38] The most spectacular array of gold clothing ornaments was found with the so-called Golden Man in a fifth-century burial at Issyk.[39] He had been dressed in boots, a belted jacket, and an elaborate hood, all virtually covered with gold plaques. Those on his jacket were ornamented with geometric forms and frontal feline heads similar to the belt plaques from Berestniahy (cat. no. 12). The plaques ornamenting his peaked hat were both representational and geometric. Between the time the Issyk man was buried and when he was found in 1978, the cloth, leather, and wood backing of these plaques had disappeared, leaving only the gold pieces fallen around his body.[40]

The Scythians also continued a Scytho-Siberian custom of using gold plaques to ornament bow-and-arrow cases. The basic case, called a gorytos in Scythia, appears to have been made of sturdy leather around a thin wooden frame and to have been large enough to carry several hundred arrows.[41] In nomadic burials from Siberia, these practical cases have essentially disappeared, leaving behind only the arrowheads. They are clearly represented, however, in petroglyphs in the Altai mountain region dating to the early part of the first millennium B.C. (figs. 7–9). In these images it is clear that the case was large and that it hung from the waist of the hunter so as not to impede his movements.[42] At some point early in their use, the leather cases began to be ornamented with gold plaques. This is attested by gold ornaments from a gorytos that were found in a seventh-century burial at Chiliktin[43] and by a gorytos cover from Ziwiyeh (eighth to seventh century B.C.), which is decorated with deer, wild goats, and feline heads.[44] In both of these early examples, the ornamental motifs recall the recumbent deer on the reliefs from Syniavka (cat. no. 43).

From Scythia all that remains of gorytoi are images of them in use[45] and the gold with which they were adorned. Gradually, the extent of the gold covering increased and the decorative motifs changed, becoming, by the late fourth century, elaborate expressions of Hellenized taste.

With the Hellenized motifs on the gorytos plates from Melitopol' (cat. no. 105) we come to the most complex element in our discussion of Central Asian sources for Scythian artistic traditions. The figures found on other Hellenized works, like the great pectoral from Tovsta Mohyla, the vessels from Solokha and Kul'-Oba, and the great Chortomlyk amphora,[46] detail their Scythian subjects almost lovingly, with an intimacy that would seem impossible for an outsider. Yet it is precisely these figural representations that have encouraged a tenacious conclusion: that the best pieces of fourth-century metalwork had to have been made by Greek artists working for Scythian clients. The attribution of all fine figural representation in Scythian art to Greek workmanship and the attendant arrogation of the best work to Greek artisanship presume two conditions: first, that the Scythians were not capable of learning the techniques for working with precious metals,[47] and second, that they had no figural tradition of their own from which to draw. Put more crudely, "barbarians" were not capable of representing the human figure or of representing an extended narrative.

Let us consider the relevant facts. Except for images of an Iranianizing nature, there are almost no figural representations on early Scythian materials from the seventh to the sixth century, all of it from plundered burials.[48] Yet, accurate or not, Herodotus' account asserts the likelihood that the Scythians had a developed narrative tradition when they arrived in the Pontic region, one that was centered on heroic figures and explained clan origins.[49]

Further east, among the Scythians' steppe cousins, there is a similar dearth of evidence for human representation in burials, virtually all of which were also plundered. There are, however, a few significant exceptions. Recovered from the mid-fourth-century burial of Pazyryk 5[50] was a huge felt hanging decorated with repeated images of a rider approaching a seated, and apparently superior, female.[51] Allowing for the degree of stylization enforced by the medium, these fine images—particularly those of the young man—are impressive and could not have been made outside a greater native context of figural representation. The same may be said of the carved wooden human faces decorating a horse harness from Pazyryk 1.[52] These few examples represent figure types extremely close—one might even say identical—to those in the paired gold plaques from the Siberian Treasure of Peter the Great.[53] Taken together, these objects suggest a narrative tradition centered on a heroic figure. The probability that such an epic tradition existed in northern Central Asia was suggested long ago and has been confirmed by a number of subsequent literary studies.[54]

I have referred to the almost complete silence of Bronze Age burials in northern Central Asia and South Siberia with reference to human representations (or even to representations of any kind), but I have also pointed out that the evidence for a strong and articulate Bronze Age figural tradition on contemporary rock images is clear and undeniable. We can use the style and subject matter from the Pazyryk period as a guide to contemporary Scythian art of the sixth and fifth centuries, when Scythian art lacks human representations except in Iranianizing formulations. We may then compare it to imagery from the preceding Early Nomadic period,[55] the time when the Scythians' ancestors moved out of Central Asia and the time that most closely corresponds to the pronounced shift from the pastoral and hunting dependencies of the Bronze Age to a greater reliance on horse-based herding.

Fig. 8. Rock-carved composition of a hunter releasing his arrow in the direction of a large stag and a wild bull, partially obscured by lichen. Early Nomadic period, ca. 900 B.C. Tsagaan Salaa III, Altai Mountains, Mongolia. *Photograph Gary Tepfer*

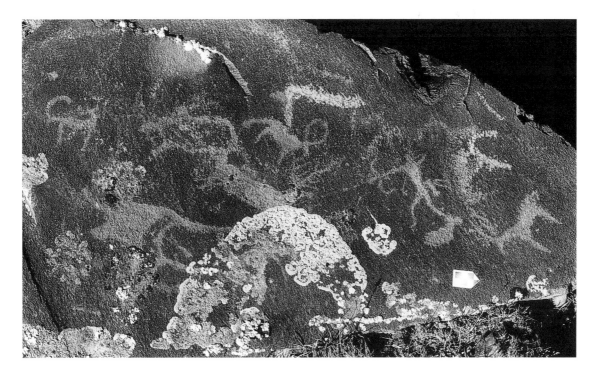

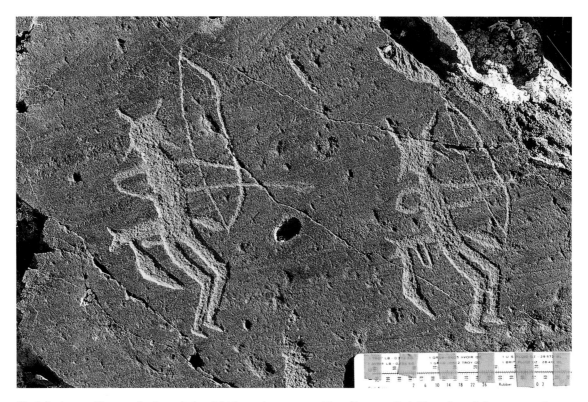

Fig. 9. Rock-carved images of archers, aiming right; from a larger composition of hunters. Early Nomadic period, ca. 900 B.C. Baga Oigor II, Altai Mountains, Mongolia. *Photograph Gary Tepfer*

In petroglyphs of the Pazyryk period, the treatment of human figures is, in fact, often of little interest. Pazyryk artists were simply more concerned with the animal image. For example, in a panel depicting elegant wild goats from a large complex in the Mongolian Altai (fig. 7), the small hunter seems incidental to the animals.[56] In images that can be dated somewhat earlier, that is, to the Early Nomadic period, human figures are considerably more interesting. This emerges in an extended scene from the Mongolian Altai, where we see an elegant deer attacked by two snow leopards (fig. 6). Approaching these animals is the figure of a man wearing a horned headdress. He seems to project into the viewer's space as he walks purposefully in the direction of the deer. A greater emphasis on the human figure, frequently that of a hunter, appears in numerous examples of rock art dated to approximately 1000 B.C. On another large scene from the Mongolian Altai, a hunter strides forward, pulling back his tensed bowstring as he moves (fig. 8). His arms, head, and well-shaped legs all express energy and concentrated attention; his prey, the bull and deer partially hidden by lichen, leap up and flee from his approach. The hunter wears the gorytos indicative of his Early Nomadic identity and carries the compound bow that came to be associated with Central Asian nomads.

On a third large rock surface from a related site in the Mongolian Altai, a number of hunters carry objects that may be gorytoi. In this case, their long bows and horned headdresses are like those of the hunter in figure 5. The beauty of the carving, the expressive postures of the figures, and their eloquent spacing suggest that they reflect a ritual ceremony or events embedded in an oral narrative. Indeed, when we begin to consider the possibility that many rock-art scenes may reflect oral narrative traditions, it becomes easier to understand the frequency with which complex scenes appear in the Early Nomadic period and preceding Bronze Age.[57] Such complexity is exemplified by a panel from Tsagaan Gol (fig. 10). Small hunters wearing distinctive rounded hats and the large pouches associated with the Central Asian Bronze Age energetically confront several wild animals. The primary object of their attention is a great deer in the center, before which, as if in some commanding

role, stands the large figure of a woman. Here, as with so many other compositions from the Altai Mountain region, the combination of elements suggests that we may be observing a pictorial representation of an ancient oral tradition involving a great hunter, an animal with magical powers, and a powerful deity.[58]

I would argue that these several panels and others, published and unpublished, testify to the existence of a narrative tradition in the late second and early first millennia B.C. in northern Central Asia and of a parallel representational tradition with the human figure at its center. By extension, they suggest a different approach for considering the apparently sudden emergence of a figural tradition in Scythian art. When the future Scythians left their ancestral homeland, they had both an epic and a corresponding pictorial tradition, but their pictorial tradition was most developed in and preserved by rock art. When, by the eighth century, they had arrived on the shores of the Black Sea, their heroic narratives were embedded in oral recitation and had essentially lost their representational base. From the Greeks, one surmises, the Scythians relearned the representation of human figures, but now in metal and now with Hellenized forms. This model for considering figural representation in Scythian art—as a radical reworking of anciently developed traditions preserved through oral recitation—may also help us understand the context and meaning of many of the figural representations on Scythian works. Up to now, scholars have tried to fit the Scythian figures of the Tovsta Mohyla pectoral, the Chortomlyk amphora, the Kul'-Oba and Haimanova Mohyla cups, and the Melitopol' and related gorytoi into an account reconstructed through Herodotus, or simply into a Greek mythic tale.[59] As all know who have labored in this endeavor, this attempt has not worked: there is no easy fit. Perhaps this is because we have insisted on simplifying the situation, assuming that "if it looks Greek, it must be Greek." In the case of Scythian art, an object may indeed look Greek, or at least Hellenized, but its underlying narrative reference may be quite different, from a vastly different place and time, and from a very different set of cultural values.

Fig. 10. Rock-carved composition of a hunt: small animals and hunters around a giant elk in the center; a large female figure on the left, in front of the elk. Bronze Age, latter half of the 2nd millennium B.C. Tsagaan Gol, Altai Mountains, Mongolia. *Photograph Gary Tepfer*

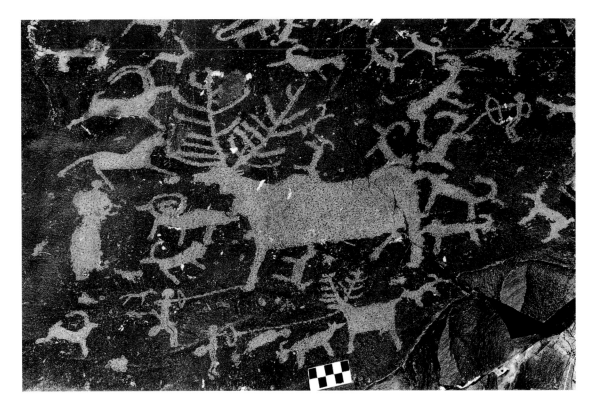

1. It is commonly believed that the Scythians spoke an Iranian language. We do not know the languages spoken by the other groups, nor can we assume that spoken language predicts ethnic identity. Research by Yablonsky and colleagues indicates there was a significant admixture of a Mongolian element in the Saka culture, Davis-Kimball, Bashilov, and Yablonsky (1995, 189–252; and recent DNA testing on materials from Altai excavations establishes the probability of a dominant Mongol strain within the Altai Pazyryk culture (unpublished personal communication; and see the BBC Horizon film *The Ice Maiden* in the series "Ice Mummies").

2. The term is unsatisfactory, since it appears to exclude a number of the most important groups, e.g., the Saka and the Chandman (see below, note 13). Unfortunately one sees it too often. On the other hand, it is considerably more accurate than applying the specific term Scythian to all related subcultures across the Eurasian Steppe. For this reason, Scytho-Siberian will be used here to denote this large grouping of semi-nomadic peoples in the first millennium. The specific names—Scythian, Saka, Pazyryk, etc.—will refer to the related and archaeologically attested groups within the larger designation. The term Early Nomad will refer to the forerunners of the Scytho-Siberians in the region of northern Central Asia (ca. 1000–800), while early nomads will simply refer to the semi-nomadic peoples of the first millennium. About these terms, see Jacobson (1993), xix and elsewhere. In a strict sense, nomad is inappropriate here since at best the Scytho-Siberians were semi-nomadic or transhumant.

3. These cultures, their material evidence, and the complexities attendant on periodizing their chronologies have developed a huge literature. For a recent review of this material, see Davis-Kimball, Bashilov, and Yablonsky (1995); see, in particular, Bokovenko's review of dating systems used in the case of the Pazyryk culture, 257–61.

4. See Gimbutas (1965).

5. Terenozhkin (1975).

6. Tuvan and Altai burials of the 8th to 6th c. and the remains of a plundered burial at Chiliktin (7th c.) in northeastern Kazakhstan. Chernikov (1964).

7. Herodotus 4.1 and 11–13.

8. The Ziwiyeh horde (8th–7th c.). Regarding these and relevant sources, see Jacobson (1995), 31–35.

9. See, e.g., objects from the burials of Kelermes, Litoi, and Kostromskaia.

10. See Bader, Krainov, Kosarev (1987), Chernikov (1960), Gimbutas (1965), inter alia. A major exception to this observation is offered by the burials at Karakol, in the Katun River valley of the Altai Republic, Kubarev (1988). But these burials may be quite early in the Bronze Age and the slabs of stone carrying representations seem to have been cut out of established rock-art complexes; regarding disagreements in its dating, see Molodin (1993).

11. See Kiselev (1951), Chlenova (1972), idem (1976); for an overview of these and related cultures, see Gryaznov (1969) and Jacobson (1995).

12. On the Okunev culture, see Kyzlasov (1986); Vadetskaia, Leont'ev, and Maksimenkov (1980); and materials included in Okunevskii Sbornik (1997), especially the article by V. A. Semenov, 152–60.

13. There is almost no literature in Western sources on the so-called Chandman culture; for a very brief discussion, see Volkov (1995). This culture is poorly known outside Mongolia, in part because of the poor condition of related burials, in part because of the history of archaeology in northern Mongolia. Associated surface monuments, such as large altars (khereksur) and the monumental carved stones known as deer stones, suggest that northern Mongolia may be a major source of the artistic traditions called Scytho-Siberian. See also Volkov (1981).

14. This material was extensively documented by A. P. Okladnikov and colleagues over a period of several decades. The volumes they published from the 1950s to the early 1980s represent a valiant effort to record great petroglyphic complexes before many were submerged by the rising waters of hydroelectric projects. Unfortunately, this priceless documentation was poorly recorded in the methodologies of that time, and much has now been lost. In recent years a collaborative project undertaken by J. A. Sher of Kemerova University and H.-P. Francfort seeks to publish a series of studies of as yet unpublished Central Asian complexes. This project will certainly encourage more modern methodologies and renewed efforts toward preservation. For references to major Central Asian petroglyphic sites studied through the 1970s, see Sher (1980); for documentation of South Siberian complexes through the early 1990s, see Jacobson (1993); and see the three volumes published to date in the project, *Répertoire des Petroglyphes d'Asie centrale*: Sher (1994), Francfort and Sher (1995); and Kubarev and Jacobson (1996). Regarding the outstanding complex of Tamgaly, which also represents fairly continuous activity from the early Bronze Age, or earlier, through to the Saka period, see Maksimova, Ermolaeva, and Mar'iashev (1985); and Francfort et al. (1995).

15. Okladnikov (1959).

16. Gryaznov (1980), figs. 15, 25.

17. Here and throughout, for discussions of individual objects and for references to illustrative and descriptive sources, see Jacobson (1995).

18. See Bunker, Chatwin, and Farkas (1970); and see Jettmar (1967).

19. The most famous examples include, for the stag, the shield plaque from Kostroms'kyi; for the crouched feline, the shield plaque from Kelermes; and for the bird, the belt plaques from the Litoi, or Melgunov, mound.

20. Gryaznov (1980); Basilov (1989), pl. 20.

21. As on, e.g., the gorytos cover and scabbard wing from Kelermes; see Jacobson (1995), ch. 5, VII.1, VIII.A.1, 2.

22. Rudenko (1960) and idem (1970).

23. The motif, however, of a stag with bird-headed antler tines is found throughout the Scytho-Siberian world; see Jacobson (1984) and Francfort (1995).

24. See Jacobson (1984).

25. Alekseev (1991) has argued that this intrusion, documented in newly vitalized Altaic elements in fifth-century Scythian art, may have been the result of Persian campaigns in Central Asia.

26. In art of the Pazyryk culture, animal heads of prey appear in association with, or in the jaws of, the heads of the predators, but the only Scytho-Siberian culture in which animal (or human) parts are routinely represented in a scene of savagery is that of the Xiongnu, the latest and most eastern of all the related groupings. Compare, e.g., So and Bunker (1995), no. 52 and fig. 52.1 with fig. 52.2.

27. That is, of the genus and species *Cervus elaphus sibiricus*.

28. For example, a cheekpiece from Pazyryk 3, where the struggle between the feline and bird is reduced to a feline head on one end and to that of the bird on the other. See Rudenko (1970), pl. 104/A; and Brussels, *L'or* (1991), pl. 122.

29. E.g., Rudenko (1960), pls. XCIV, XCV.

30. See Jacobson (1995), 261–74, passim.

31. Gryaznov (1980); Zavitukhina (1983); and Martynov (1979).

32. See, e.g., Tian and Guo (1986), pls. XI, XIII, XIV. The lack of such objects from Pazyryk and Saka burials may reflect more on the plundered state of virtually all such burials than on the lack of cultural interest in their use.

33. See, e.g., Il'inskaia (1975), Rudenko (1970), Kubarev (1987), idem (1991); also Polos'mak (1994), Akishev (1978).

34. On this vessel type in Scythia and its gradual elaboration, see Jacobson (1995), 192–200. An excellent example of a one-horn vessel of nomadic manufacture was recovered from the frozen burial of a wealthy young woman on the Ukok plateau; see Polos'mak (1994).

35. See Jacobson (1995), ch. 5, VI.C.1; and Mantsevich (1987), no. 61.

36. For a discussion of this transformation, see Jacobson (1995), ch. 5, sec. IV.

37. See Jacobson (1995), 12–13. The Altai wealth in gold was a significant source of Tsarist Russia's interest in absorbing that region into the imperium.

38. Rudenko (1960), Kubarev (1987), and idem (1992). Gold-foil covered wooden ornaments are found even in the simplest of burials, as I have observed with children's burials in the Chuia Steppe.

39. Akishev (1978); and see reconstruction in Basilov (1989), 26.

40. To judge from the fragmentary finds at other Central Asian sites, the elaborate ornamentation of the Golden Man at Issyk was not unique; see Jacobson (1985). A similar indication of the interconnection between rich fabric or fur and gold ornamentation is impressively indicated in fragments of clothing from the plundered aristocratic burials at Pazyryk.

41. See Chernenko (1981); Jacobson (1995), 222–24.

42. None of the petroglyphs we have documented to date represent hunters carrying the gorytos so they ride horses. This omission would suggest that these images, and the gorytos itself, began to be used late in the second or early in the first millennium, before horse-riding became common.

43. Chernikov (1965).

44. Ghirshman (1964), pl. 143.

45. See, e.g., the Kul'-Oba cup with Scythians resting, and the Tovsta Mohyla pectoral, where a gorytos hangs from a tree above the central men. See Jacobson (1995), ch. 5, II.A.1, and VI.D.1.

46. For discussion and references, see ibid., VI.C.1, VI.D.1, VI. E. 1.

47. For a response to this argument, see ibid., 4–13.

48. See, e.g., the scabbard and axe overlays from Kelermes and Litoi; ibid., VIII.A.1,2, VIII.A.3.

49. Herodotus 4.2–10. The Scythian epic tradition has been traced down to that of modern-day Ossetians by a number of scholars. See, in particular, the studies by V. I. Abaev (1949) and idem (1962).

50. On the relative dating of the great Saian-Altai burials, see Marsadolov (1988).

51. Rudenko (1970), pls. 147, 154.

52. Gryaznov (1950), fig. 14, pl. XVIII; Rudenko (1970), pls. 91, 92.

53. Rudenko (1962), pl. VII; Brussels, L'or (1991), no. 85. Although these plaques are unprovenanced, their similarities to the Pazyryk 5 felt hanging and to an number of other objects from Scytho-Siberian art add weight to their authenticity; see Jacobson (1993), 77–87.

54. The existence of epic was suggested by M. Gryaznov (1961); see Jacobson (1990a). For literary studies, see, e.g., Meletinskii (1963); Pukhov (1962). On the basis of semantic usage and structural elements, several scholars have argued that the Central Asian heroic epic, which emerged by the middle of the first millennium, was centered on the figure of a hero-hunter, who was often dependent on the material support of a female figure, such as a sister, mother, or lover. The epic tradition referred to here was one of the great resources of myth and history for the Central Asian Turkic and Mongol periods. Much of that tradition was lost during the Socialist period in the former USSR. For information on the Central Asian epic tradition, in English, see Shoolbraid (1975).

55. I use the term Early Nomad to refer to the forerunner of the Scytho-Siberians in the region of northern Central Asia. See note 2 above.

56. The examples here are all drawn from newly documented petroglyphic sites in the Mongolian Altai. Work in that area has been conducted by the author in conjunction with Mongolian and Russian colleagues (D. Tseveendorj, V. D. Kubarev) as a part of the Joint Mongolian-American-Russian Project, "Altay." Most of the material presented here will be published as part of the project's study of a large site, Tsagaan Salaa/Baga Oigor.

57. The possibility of an epic narrative base for many of the compositions we are documenting in the Mongolian Altai would also help to explain why we find what appear to be repetitions of the same, or similar, stories.

58. See Jacobson (1997).

59. See discussion and references in Jacobson (1995), 225–30. The probability of the ancient emergence of a significant tradition of oral recitation is increased when we consider the existence of large amphitheater-like ritual spaces that have been identified in the Altai Mountains in connection with Bronze Age, Early Nomadic, and Pazyryk period rock-carved images; see Jacobson and Kubarev (1994).

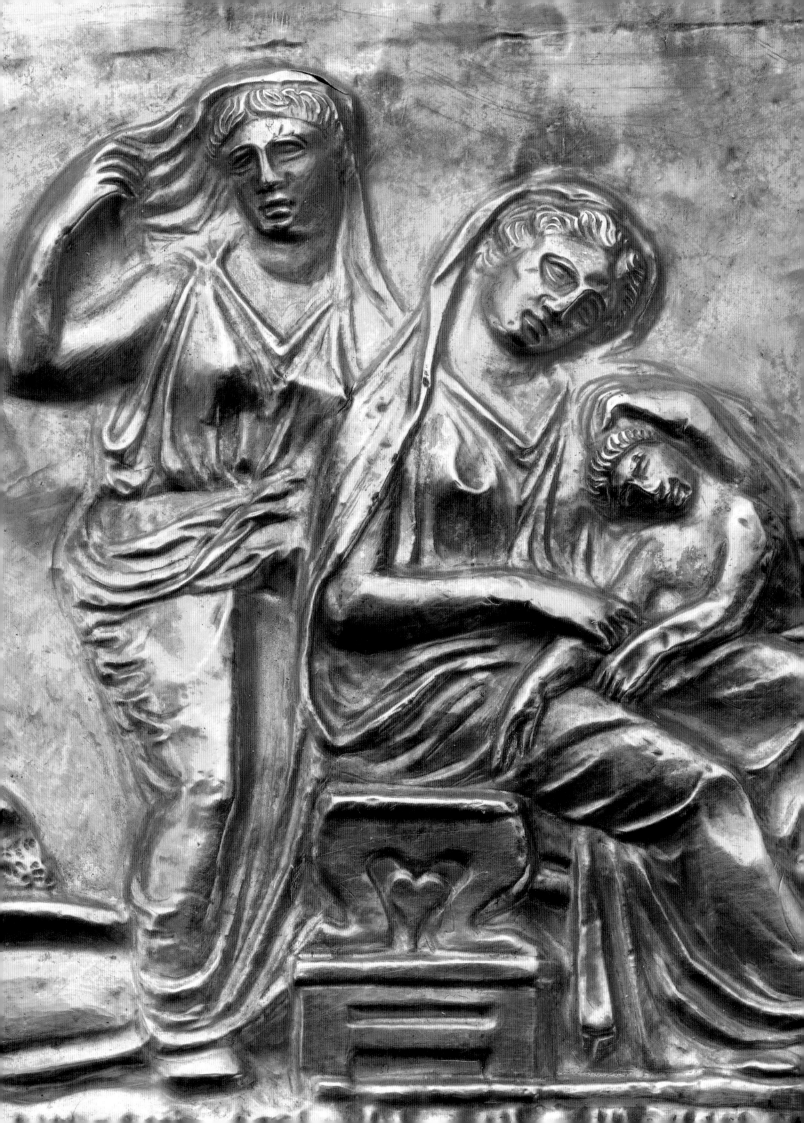

The Workshop of the Gorytos and Scabbard Overlays

MICHAEL TREISTER

A mong the gold objects found in Scythian kurhany, two types have particularly attracted the attention of scholars and the general public ever since the first example was found in Chortomlyk more than 130 years ago. These are figural overlays made for gorytoi and scabbards.

Four identical gold gorytos overlays have been found in the kurhany of Chortomlyk[1] (figs. 5, 6, and 7), Illintsi,[2] Melitopol' (cat. no. 105),[3] and Kurhan 8 from the P'iatybratni (Five Brothers) Kurhany.[4] Two more overlays, with battle scenes, were found in Karagodeuashkh in the Kuban basin[5] and in what is known as Philip's Tomb in Vergina.[6]

The traditional view was that all of the reliefs of the so-called Chortomlyk series were hammered in one bronze matrix.[7] This was challenged in 1984 by Z. H. Szymanska, who proposed that a number of different matrices were used in combination.[8] It has also been suggested that the matrix scenes were recarved at some point, which would account for differences between the overlays. Onaiko suggested that the overlay from Melitopol' was the earliest of the Chortomlyk series, followed by the one from Illintsi. According to Onaiko, the next overlay was the one from Chortomlyk, which has less distinct images. The last in the series is the P'iatybratni (Five Brothers) piece, which includes evidence of considerable recarving of the matrix. The last two pieces are also distinguished by a number of variable elements, including details of furniture and attributes.[9]

In 1889, C. Robert suggested that the two figural friezes illustrate the discovery of Achilles on Skyros,[10] an interpretation that was generally accepted until recently, when K. Stähler proposed that they rather represent an episode from an Iranian epic.[11] H.-H. Nieswandt gave support to that hypothesis when he pointed out the irregularity of the imagery and its use, casting doubt on the generally accepted supposition that the gorytoi were the work of a Greek artist associated with Attic tradition.[12]

Ample evidence exists for the use of multiple matrices. The overlapping or partial interruption of the egg-and-dart band that divides the two figural scenes would have been impossible if the relief was hammered in a single matrix. Moreover, the group of women on the (viewer's) left side of the lower frieze are all gazing inexplicably into the distance.[13] These women are separated from the figures behind them by a vertical band (fig. 5), comparable to the borders framing the frieze at the bottom and left side. Anomalies like these can be explained only if we first accept that the friezes were hammered into a matrix composed of several separate pieces. Another vertical displacement of planes, indicating a juncture of matrices, is seen in the lower frieze, dividing the seated youth and the bearded man who stands before him (fig. 2 and 3).

Opposite:
Fig. 1. Detail of gorytos, cat. no. 105

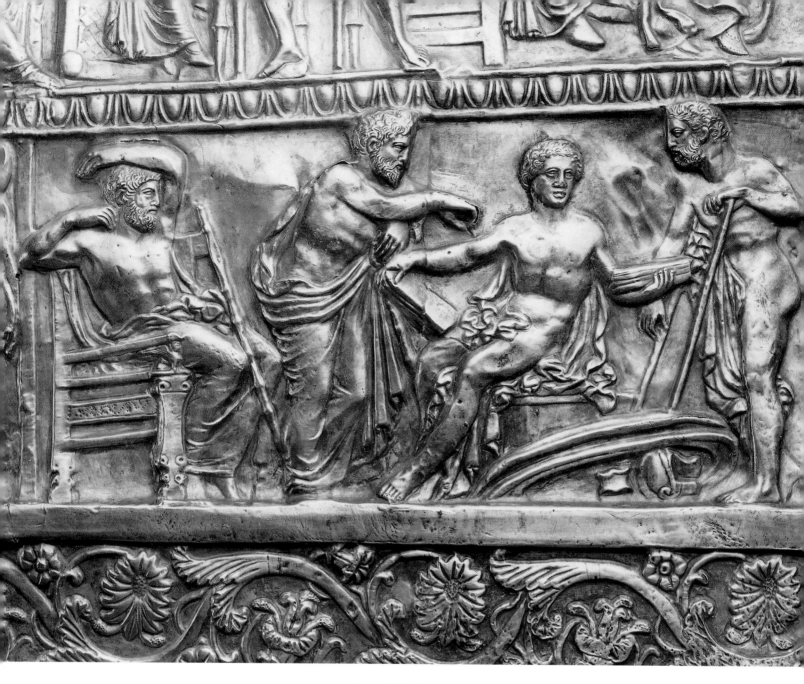

Fig. 2: Detail of cat. no. 105

Evidence for matrix joins can also be noted in the upper frieze. It is apparent that on the Meli-topol' gorytos both the seated man on the far right and the youth reclining in front of him (fig. 4) were hammered before the scene to their left. We can clearly see a vertical offset of planes below the raised right arm of the seated man; this is the edge of the matrix. His right arm is partially obscured by the drapery of the dancing female behind him, who belonged to another matrix. The fact that this area is to be identified as a seam between matrices is especially clear on the Chortomlyk gorytos, where the folds of drapery to the right of the dancing woman are executed in so rough a manner as to suggest that this area had been damaged during the hammering process and restored free-hand by an unskilled craftsman.

On the basis of this evidence it is possible to suggest that the lower friezes were composed of at least three matrices: one with the four female figures, one with the figures of a seated and standing man, and the last with the remaining four figures. In the upper frieze we identified at least two matri-ces by the offset dividing the two men at the far right from the other figures. So long are the left and central portions of the upper friezes that they are unlikely to have been made over a single matrix,

but no juncture of planes clearly marks the division. A single rectangular matrix was used for the projecting flap decorated with griffins savaging a feline.

I was able to study the gorytos from Melitopol' in Kyiv in August 1998 and to establish the following sequence. In the lower register, the ovolos cut off the crown of the head of the woman who stands with her back to the seated man; the ovolos were, therefore, hammered after the seated women. Because the elbow of the seated man directly behind this woman overlaps the flat vertical rib that divides the women from the other figures (fig. 2), that man and the figures with him on the same matrix were worked after the four women. Supporting this sequence is the fact that the heads of the two standing men to the far right (fig. 3) partially overlap the ovolo border above them and so must have been hammered after it. The scene farthest to the right was probably the last to be produced.

The ovolo border along the right edge of the gorytos (fig. 4) was hammered after the figural friezes, the acanthus scroll, and the lotus and palmette designs. It partly overlaps the shield in the upper frieze and the drapery of the female in the lower frieze. This was perhaps the final step in production, since the ovolos on the right partly overlap those framing the rectangular projection. It is

Fig. 3: Detail of cat. no. 105

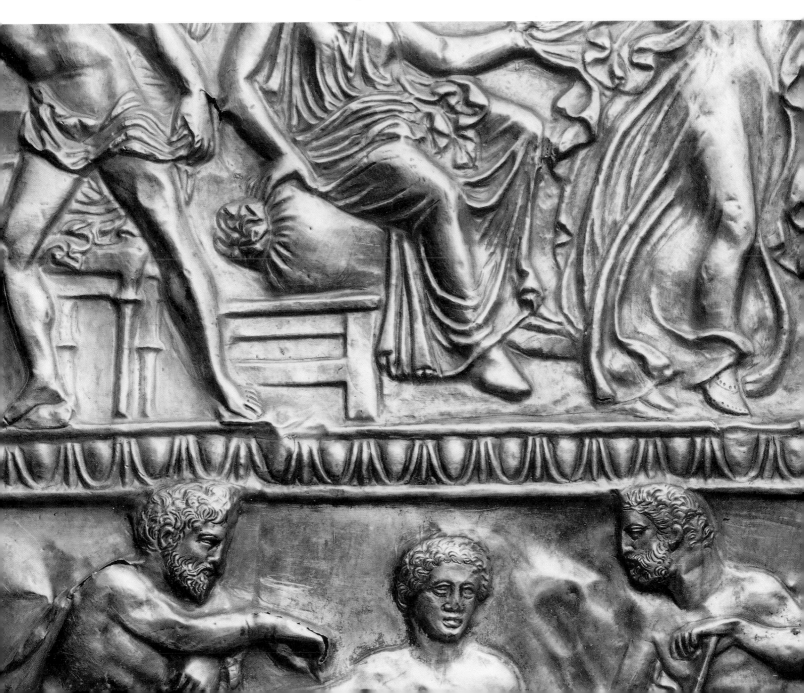

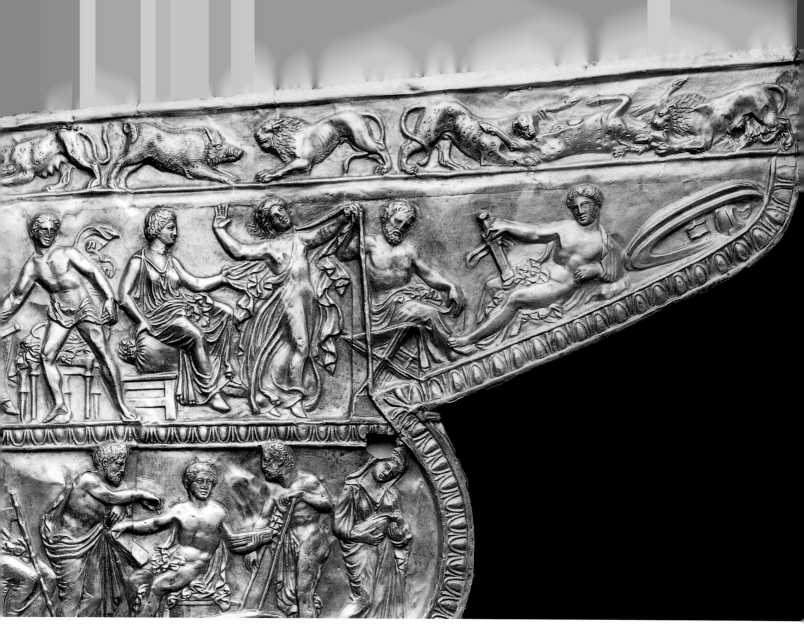

Fig. 4: Detail of cat. no. 105

apparent that the central part of the projection, with the two griffins, was executed after the frame had been already stamped, because the feathers of one of the griffins interrupt the Lesbian kymation.

The uppermost frieze, decorated with animals in combat, is of special interest. The left side shows sign of repair. The final figure on the left was smoothed over after being hammered, although its contours and a vertical offset of planes denoting a matrix edge can still be clearly seen to the left of it. To the right of the smoothed figure is a hare, and to the right of that is a feline, of which only the curved tail is preserved. In this area, the gold sheet was broken and repaired with two rivets. Here a dog was stamped, moving in pursuit of the hare, but in the opposite direction from the earlier feline. Either this was a repair made by another craftsman or an improvisation by the original artist. The latter suggestion is bolstered by comparison with the gorytoi from Chortomlyk and the P'iatybratni (Five Brothers) Kurhany, on which the dogs are partly preserved without any evidence of an earlier feline. This scenario is also reasonable if the Melitopol' gorytos is the earliest in the series.

It has been already remarked that the Vergina and Karagodeuashkh gorytoi are close to those of the Chortomlyk series.[14] The scene on the Vergina and Karagodeuashkh overlays has usually been identified as some episode from the Trojan cycle,[15] or as the attack on the sanctuary of Cabiri in Thebes by the Epigoni (Pausanius 9.25.7).[16] Recently Stähler concluded that, like the Chortomlyk

series, the scenes represent an Iranian or Scythian legend or myth.[17] A similar technique of using separate matrices was also employed for decorating these gorytoi. On the better-preserved piece from Vergina one can easily see vertical offset lines in the upper and lower friezes. The area at the upper right (corresponding to the two men on the Chortomlyk gorytos series) was not large enough to accommodate a separate scene and was consequently filled with a rather senseless composition of standing figures, shields, helmets, and bucrania. The lower projection on the Karagodeuashkh-type overlays is decorated with a standing figure wearing a corslet and crested helmet and holding a round shield.

The gorytos and scabbard workshop

The technical similarities between the Chortomlyk and the Karagodeuashkh gorytoi, as well as the close similarity between the ornamental patterns of ovolo and Lesbian kymation, argue for a common workshop. Other objects can be identified with this workshop. A small applique, now in a private collection in the United States, is decorated with a female wearing a flowing garment and raising her right hand toward her hair.[18] She grasps a small cult statue in the field behind her. The plaque is almost identical with the scene in the upper right on the overlays of the Karagodeuashkh type, although on the overlay from Vergina the figure does not hold the cult statue. Another piece that can be connected with this workshop is a gold lion plaque from Vovkivtsi (cat. no. 106), which closely resembles the lion in the animal frieze on the Chortomlyk-type gorytoi (compare the one from Melitopol', cat. no. 105).

Other objects to be associated with this, or a closely related workshop, are:

1. Three scabbard casings found in Chortomlyk,[19] in the Chaian Kurhan in Krym and now in the Metropolitan Museum,[20] and Kurhan 8 from the P'iatybratni (Five Brothers) complex[21] have identical scenes of Greeks battling non-Greeks. Technical features indicate the use of two matrices for the Chortomlyk scabbard, with details added after hammering.

2. These scabbards are, in turn, comparable in shape, composition, and technical execution with another group, represented by the finds from Velyka Bilozerka (cat. no. 121), Tovsta Mohyla (cat. no. 122), and Kul'-Oba. The griffins and lions on the scabbard from Tovsta Mohyla have stylistic links with the Chortomlyk series. By contrast, the exaggerated ribs, use of double lines for the legs, curling lion manes, and frontal leopard heads of the Kul'-Oba and Velyka Bilozerka (cat. no. 121) scabbards are reminiscent of earlier scabbards from the second half of the fifth and the fourth centuries,[22] and of a round-bottomed silver vessel from Kul'-Oba.[23]

3. Animal imagery on the Chortomlyk gorytos overlays is comparable with that on a number of other works, including another round-bottomed vessel[24] and a pair of armbands from Kul'-Oba,[25] the silver amphora from Chortomlyk,[26] a gold diadem from the Tr'okhbratni (Three Brothers) Kurhany near Kerch,[27] a lamellar bracelet from Chaian Kurhan,[28] and the gold lion plaque from a kurhan near Vovkivtsi (cat. no. 106).

4. The elaborate floral scrolls decorating a gold diadem from Diiv Kurhan[29] and the silver Karagodeuashkh rhyton[30] are comparable with the framing bands of the Chortomlyk-type gorytos overlays.[31]

5. The treatment of drapery of the dancing female figure on the overlays of the Chortomlyk type is comparable with that on the gold plaque with nymphs from Kul'-Oba[32] and a gold pedimental diadem in Istanbul.[33]

6. Flying ducks on vessels from Kul'-Oba[34] and Chmyreva Mohyla,[35] and on the silver rhyton from Karagodeuashkh noted above are comparable to those decorating the Karagodeuashkh and Vergina gorytoi.

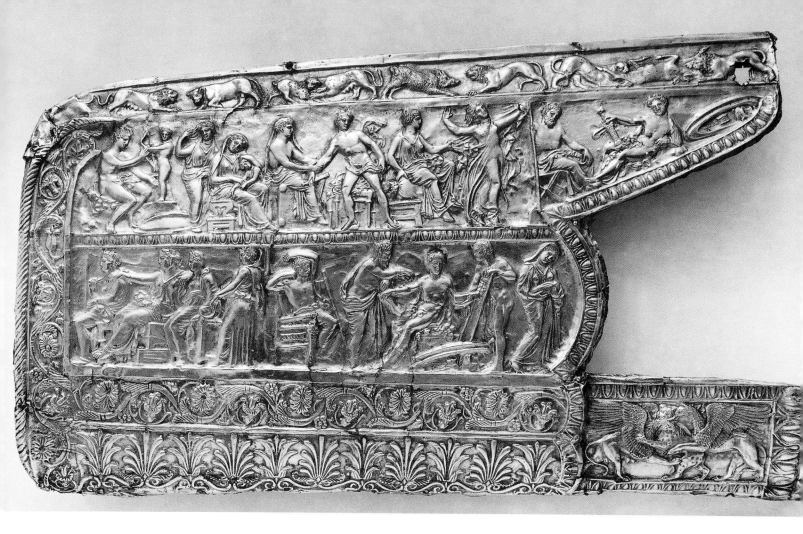

Fig. 5: Gorytos from Chortomlyk. *Photograph State Hermitage Museum, St. Petersburg.*

Toolmarks and technical parallels

Toolmarks can sometimes be a decisive factor in attributing works of art,[36] and they provide additional evidence that objects were manufactured in the same workshops. On the gorytos from Melitopol' (cat. no. 105), the bodies of the leopards are decorated with groups of chiseled dots forming a kind of irregular rosette. The bodies of stags, on the other hand, are decorated with short parallel lines. That the same regular patterns appear on the Tovsta Mohyla scabbard (cat. no. 122) and the well-known pectoral from Tovsta Mohyla (cat. no. 172), as well as on the scabbard from Velyka Bilozerka (cat. no. 121) is hardly by chance. Moreover, we find the same stylistic detail on the abovementioned silver-gilt vessel and bracelet from Kul'-Oba, on sword scabbards that depict Greeks battling non-Greeks, on a silver gorytos overlay from Solokha,[37] and on a gold ring from Kurhan 6 of the Semybratni (Seven Brothers) complex (where parallel lines decorate both the stag and leopard).[38] It is significant also that on the Chortomlyk gorytos the same patterns are used but reversed. There the stags have chiseled dots and the leopards short parallel lines.

The shields and furniture on the gorytoi of the Chortomlyk and Karagodeuashkh series are decorated with scrolls, sometimes a running-wave pattern composed of tiny chiseled dots. The same decoration is characteristic of the Chortomlyk scabbard overlays and is also seen in the triangular plaque from Karagodeuashkh.[39]

The gorytoi under discussion followed typologically and perhaps also technically the earlier example from Solokha. Like the Chortomlyk gorytoi, the uppermost band on the gorytos from Solokha is occupied with an animal frieze, but its center section has one register, not two. The

Solokha overlay is surely a predecessor in the development of the two later series, but, given differences in toolmarks, it must have been manufactured in another workshop.

The use of matrices to decorate different types of objects and the use of several separate matrices to create large narrative compositions were unprecedented innovations of a fourth-century North Pontic workshop. We have no early parallels for such a complicated production method, even though matrices were the most common tool for producing relief metalwork in the early Hellenistic period.[40] Indeed, matrix-hammered votive plaques of comparatively large dimensions have been found in fourth-century contexts in various parts of the Greek world, including Thrace, Eretria, and the Athenian Kerameikos.[41] It is also possible that a group of Hellenistic pedimental diadems from Asia Minor was made in a process that involved the use of multiple matrices.[42]

Stylistic connections

Many scholars have described parallels between the motifs and style of the metalwork found in the Scythian burials and metalwork from other parts of the ancient world.

Of particular note are lion-head finials, which were hammered in matrices or embossed with stamps and which appear on bracelets from Kul'-Oba and Chaian (noted above), on the spiral lamellar bracelets from the Tr'okhbratni (Three Brothers) Kurhany (cat. no. 97) and Theodosia,[43] and on a gold necklace from the Pavlovs'kyi Kurhan.[44] Similar lions are seen also on a plaque from Kul'-Oba,[45] a gold ring from the Kekuvats'kyi Kurhan,[46] and the rein appliques from Babyna Mohyla (cat.

Fig. 6: Detail of Gorytos from Chortomlyk. *Photograph State Hermitage Museum, St. Petersburg.*

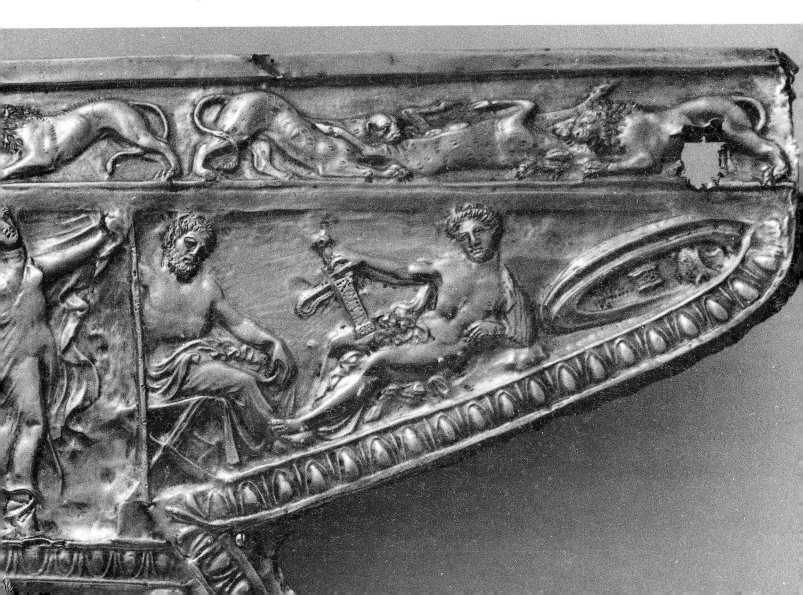

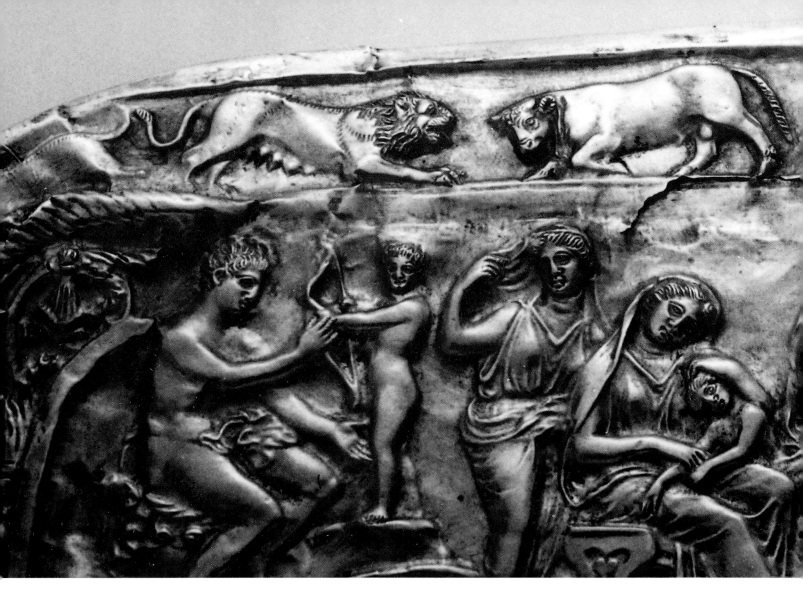

Fig. 7: Detail of Gorytos from Chortomlyk. *Photograph State Hermitage Museum, St. Petersburg.*

no. 151). Some of these, to my mind, should be assigned to the same gorytos and scabbard workshop. We find comparable treatment of lion protomes already in sixth- and fifth-century works from Greece[47] and south Italy,[48] but closer parallels are with later works from Macedonia, including small silver-gilt plaques from the first half of the fourth century at Katerini,[49] a late-fifth-century gold plaque from Stavropoulis,[50] and fourth-century fibulas from Derveni, Sedes, and Thessalonika.[51] Also from Stavropoulis come gold plaques with naturalistic profile lions[52] comparable to those that appear in the upper zone on the gorytos overlays of the Chortomlyk type.

The Lesbian kymation decorating the gorytos overlays of both the Chortomlyk and Karagodeuashkh series are of characteristic shape, distinguished by the three-petal pattern between the leaves. Similar, though not identical, features appear on a bowl from Haimanova Mohyla[53] and the wooden sarcophagus from a kurhan in the vicinity of Anapa.[54] The three-petal motif is characteristic for architectural and toreutic ornament in Italy,[55] but it is also well represented on metalwork from Macedonia, primarily from the third quarter of the fourth century.[56] It is found as well on bronze and silver vessels of the fourth and third centuries from Asia Minor.[57]

The combination of Lesbian kymation and guilloche bands, such as those that frame the gorytos overlays of the Karagodeuashkh series, is found on the silver vessels from Macedonia mentioned above (Derveni, Vergina, and Nikesiani), as well as on a cup supposedly from Acarnania in the Metropolitan Museum.[58] The same combination is also seen on the Alexander sarcophagus in Istanbul.[59]

Conclusions

There has been much discussion about where the gold objects in the Scythian burials were produced, with most scholars pointing to the Bosphoran (Pantikapaion) area. With the discovery of the gorytos in Vergina, M. Andronicos proposed that production took place both in Pantikapaion and in northern Greece and Macedonia.[60] Pfrommer also considered that there were production centers both in the Bosphoros and Macedonia, employing local and Italian craftsmen.[61] More recently, it has been suggested that all the gorytos overlays were manufactured in Bosphoran workshops, and that the example in Vergina is to be understood as a trophy taken during Philip's campaign against the Scythians in 339.[62]

The traditionally broad dissemination of metalworking techniques and motifs, coupled with the high mobility of ancient metalworkers, makes it very difficult to determine the origin of the craftsmen. It is undeniable, however, that most stylistic parallels, especially the decorative framing motifs on the gorytoi, point to Macedonia.[63] It is my belief that in the fourth century invitations were extended from the Scythian court of Spartokides to craftsmen from Macedonia and elsewhere. The difficulties imposed by the Peloponnesian War prompted the emigration of metalworkers from Attica.[64] These artists could have brought matrices with them, among them a number of rather old pieces, and other matrices could have been made locally to satisfy the taste of local clients. The workshop of the gorytos and scabbard overlays operated most probably in Pantikapaion from about 360 to 340. It was one of about a dozen workshops in the capital of the Bosphoran kingdom between the early fourth and the early third centuries, when Pantikapaion was one of the leading centers of goldwork in the ancient world.[65]

Several factors suggest that these Bosphoran workshops employed craftsmen of diverse origins, including Bosphoran Greeks and Scythians: the lack of stylistic consistency; the changes made to Classical prototypes and the inclusion of elements unusual in Greek, and especially Attic, art; and, finally, the possibility that the overlays illustrate episodes from Scytho-Iranian myths or epics. Working together with itinerant Greek, south Italian, or Macedonian craftsmen, Scythian artists could have learned manufacturing techniques rather quickly. Much more difficult was overcoming their limited knowledge of the rich repertoire of Greek art. As for the possibility of Scythian artisans trained in Greece, this seems highly improbable, at least for the period when the so-called Greco-Scythian style was being developed. Whether the products of these late-fifth- and early-fourth-century Borphoran workshops were specifically intended from the beginning for Scythian customers remains an open question.[66]

The author wishes to thank the Fonds zur Förderung wissenschaftlicher Forschung (Vienna) for the Lisa-Meitner Fellowship, which allowed to him to conduct the research for his monograph, Hammering Techniques in Greek and Roman Jewelry and Toreutics, *at the Institute of Classical Archaeology, University of Vienna. He also thanks his host, Professor Jürgen Borchhardt.*

1. Artamonov (1969b), pls. 181–82; Gajdukevic (1971), 133, fig. 21; Rätzel (1978), 174–75, fig. 7; Chernenko (1981), 76–77, fig. 53; 81, fig. 59; Pfrommer (1982), 152–53, fig. 29; Galanina and Grach (1986), figs. 224–25; Alexeev, Murzin, and Rolle (1991), 223–30, no. 189; Jacobson (1995), 225–26, VII.3, fig. 102.

2. Onaiko (1970), 116, no. 781, pl. 21; Gajdukevic (1971), 136; Rätzel (1978), 174; Chernenko (1981), 78, fig. 54.

3. The photo in Schiltz, *Scythes* (1994), 142–43, fig. 106, is not the overlay from Melitopol', as it is labeled, but the one from Chortomlyk.

4. Gajdukevic (1971), 136–37; Gamber (1978), 305, fig. 320; Rätzel (1978), 174–76; Chernenko (1981), 80, fig. 56; Shcheglov and Katz (1991), 110, figs. 22–24; Zurich, *Schatzkammern* (1993), no. 62.

5. Schefold (1938), 23, fig. 15; Rätzel (1978), 176–77, fig. 9; Schiltz (1979a), 305–307, fig. 1; Chernenko (1981), 67–74, figs. 48–51; Pfrommer (1983), 240, note 25; Jacobson (1995), 228–30, VII. 4; Stähler (1997b), 88.

6. Thessalonika, *Treasures* (1978), no. 89, pl. 22; Schiltz (1979a), 307–308, fig. 2; Schiltz, *Scythes* (1994), 144, fig. 107; Washington, *Alexander* (1980), no. 160, pl. 28; Chernenko (1981), 67–74, figs. 45–47; Pfrommer (1983), 240, note 25; Andronicos (1984), 180–86, figs. 146–49; Charbonneaux, Martin, and Villard (1988), 495, fig. 490; Boardman (1994), 204–205, fig. 6.25; Hanover, *Makedonen* (1995), no. 259; Hammond (1994), 182, pl. 11a; Daumas (1997), 206–207, fig. 7; Stähler (1997b), 85 ff., figs. 34–35, 37.

7 . Onaiko (1974); Chernenko (1981), 76, 87, 89.

8. Szymanska (1984), 107.

9. Onaiko (1974), 79–81.

10. Robert, AA (1889), 151–53.

11. Stähler and Nieswandt (1991/92), 103–108.

12. Ibid., 102–03.

13. Most recently this was noted by Jacobson (1995), 227–28.

14. Ibid., 229.

15. Andronicos (1984), 181; Schiltz, *Scythes* (1994), 302.

16. Daumas (1997), 206–207; cf. Andronicos (1984), 181, who suggested that this theme finds no convincing support.

17 . Stähler (1997b), 89 ff.

18. This information courtesy of Derek Content. Taisei Gallery (1992), no. 166; Boardman (1994), 339, note 51.

19. Artamonov (1969b), pls. 183, 185; Boardman (1994), 204–205, fig. 6.26; Jacobson (1995), 244–46, VIII.D.1; Michel (1995), 91, fig. 52; Stähler (1997a), 61ff.

20. Richter (1931), 44–48; von Bothmer (1984), no. 91; Shcheglov and Katz (1991), 98–99, fig. 1, 101–103, no. 1; Williams and Ogden (1994), no. 112; Jacobson (1995), 244–46, VIII.D.2; Stähler (1997a), 61ff.

21. Shilov (1961), figs. 11–13; Gaidukevic (1971), 139; Chernenko (1981), 20, fig. 11; Shcheglov and Katz (1991), 97, 100, fig. 3, 102; Zurich, *Schatzkammern* (1993), no. 61a; Jacobson (1995), 245; Stähler (1997a), 61ff.

22. From Solokha: Rostowcew (1931), 371; Mantsevich (1969), 96 ff., figs. 2–4, 10; (1980b), 95, fig. 14; (1987), no. 49; Artamonov (1969b), pl. 145; Il'inskaya and Terenozhkin (1983), fig. on p. 125; Galanina and Grach (1986), figs. 155–56; Jacobson (1995), 239–40, VIII. C.1, fig. 107; Michel (1995), 266, fig. 50; (1997), 29; Stähler (1997a), 78–79, fig. 32. 2). From Elizavetovsk Kurhan 16 (Ushakov): Minns (1913), 270, fig. 186; Ebert (1929), pl. 33A, a; Rostowcew (1931), 362, 470–71; Mantsevich (1969), 99, fig. 2, 3; 105; Grach (1984), 105, 107, fig. 16; Galanina and Grach (1986), fig. 219; Jacobson (1995), 242–43, VIII. C. 4, fig. 108; Vlasova (1996), 10–3; Stähler (1997a), 78.

23. Mantsevich (1962), 111, fig. 8; Artamonov (1969b), pls. 241, 243–44; Grach (1984), 106, pl. III, figs. 10–15; Galanina and Grach (1986), figs. 190–92; Schiltz, *Scythes* (1994), 164–65, fig. 121; Jacobson (1995), 207, VI.D.5. Jacobson also notes a similarity between the style of the above-mentioned vessel from Kul'-Oba and the scabbard from Ushakov Kurhan, supposing, however, that "similarities between this and the other spherical vessels, however, suggest that such a varied treatment is the result of deliberate stylization, perhaps from within the same workshop." I would rather share the view of Grach (1984), 105, who suggested that the scabbard overlays from Kul'-Oba, Solokha, and Ushakov Kurhany, as well as one of the vessels from Kul'-Oba, were probably manufactured in the same toreutic center somewhere in the northern Caucasus.

24. Artamonov (1969b), pls. 242, 245–46; Galanina and Grach (1986), figs. 193–95; Boardman (1994), 202, fig. 6.22; Schiltz, *Scythes* (1994), 160, fig. 118; Jacobson (1995), 207, VI.D.4, figs. 88–89.

25. Artamonov (1969b), pls. 237–38; Petrenko (1978), 57; Galanina and Grach (1986), fig. 179; Williams and Ogden (1994), no. 86; Grach (1994), 137–38, figs. 2–3; Jacobson (1995), 136, II.E.5.

26. Artamonov (1969b), pls. 162–76; *The Dawn of Art* (1974), no. 48; Sokolov (1974), 66–67, nos. 53–54; Galanina and Grach (1986), fig. 266; Alekseev, Murzin, and Rolle (1991), no. 91; figs. on pp. 178–79; Boardman (1994), 205–206, figs. 6.28a–b; Schiltz, Scythes (1994), 195, fig. 144; Jacobson (1995), 209–13, VI.E.1, figs. 90–91.

27. Sokolov (1974), no. 24; Shtitel'man (1977), no. 161; Galanina and Grach (1986), fig. 223; cf. Pfrommer (1990), 268–69, note 2348, FK 126: burial date: early 3rd c. B.C.; Jacobson (1995), 150, III.A.5.

28. Hoffmann and Davidson (1965), no. 82; Shcheglov and Katz (1991), 106, 108–11, no. 4, figs. 16–21.

29. Artamonov (1969b), 58, fig. 121; Galanina and Grach (1986), fig. 135; Jacobson (1995), 154–55, III.B.2. A very similar design is seen on the cut out band of the Scythian kalathos from the kurhan near Vil'na Ukraina (Vienna, *Gold* [1993], no. 33). It is even maintained that both decorations were made in the same matrix (Gebauer [1997], 157, note 48).

30. Artamonov (1969b), 81–82, fig. 157, Gajdukevic (1971), 148, fig. 33; Pfrommer (1982), 151, 153; Hamburg, *Gold* (1993), no. 67; Jacobson (1995), 220, VI.G.5.

31. Pfrommer (1982), 153–55; cf. Jacobson (1995), 155.

32. Il'inskaia and Terenozhkin (1983), fig. on p. 213, second row, right; Kopeikina (1986), 40–41, no. 5: late 5th c. B.C., Ionic school; 149, fig. 5; Boardman (1994), 215, fig. 6.41a; Williams and Ogden (1994), no. 90: ca. 350 B.C.; Jacobson (1995), 176, IV.E.16; Kruglov (1997), 125, fig. 19.

33. Basak (1962), 27–29, pls. 1–2.

34. Artamonov (1969b), pls. 239–40; Il'inskaia and Terenozhkin (1983), fig. on p. 216; Grach (1984), 102–103, figs. 2a–d; Galanina and Grach (1986), figs. 188–89; Schiltz, *Scythes* (1994), 161, fig. 119; Jacobson (1995), 206, VI.D.3.

35. Onaiko (1970), pl. XXX, no. 437; Il'inskaia and Terenozhkin (1983), fig. on p. 147; Jacobson (1995), 206.

36. See, e.g., Meyers (1981), 49–54; Kull (1997), 699.

37. Blavatskii (1954), 16, fig. 5; Lullies (1962), pl. 38, 1; Manstevich (1962), 107–21, figs. 1–5, 10–15; (1987), no. 53; Artamonov (1969b), pls. 160–61; Onaiko (1970), 23–24; Gajdukevic (1971), 144–45, fig. 30; Il'inskaia (1973), 58–59, fig. 11; Chernenko (1981), 76, fig. 52; Il'inskaia and Terenozhkin (1983), fig. on p. 129; Jacobson (1995), 225, VII.2; Stähler (1997b), 86.

38. Mantsevich (1962), 111, fig. 7; Artamonov (1969b), pl. 132; Boardman (1970), 297, pl. 694; Nikulina (1994), fig. 170.

39. Zazoff, Höcker, and Schneider (1985) 625, fig. 26; Galanina and Grach (1986), fig. 232; Venice, *Tesori* (1987), no. 103; Schiltz, *Scythes* (1994), 189, fig. 138; 383, fig. 304; Jacobson (1995), 157–58, III.B.4, fig. 33; Jünger (1997), 51, 53, fig. 22; Fuhrmeister (1997), 161.

40. See, e.g., two late-4th–early-3rd-c. matrices from the mid-2nd-c. treasure in Osanica in Hercegovina, in the ancient Illyrian city Daors (modern Osanici near Stolac, north of Dubrovnik), now in Sarajevo: Maric (1979a), 211–42, pls. I–XIV; (1979b), 38–51, pls. III–XVII; an early Ptolemaic bronze matrix with numerous designs, mixing Achaemenid and Egyptian motifs; from the George Ortiz collection: Treister (1996b), 172–76, figs. 1–6.

41. In the sanctuary of Demeter in Thracian Mesemvria: Reber (1983), 77–83, pl. 21 1–2; Naumann (1983), 346, no. 444a; Simon (1997), no. 77. In Eretria: Knigge (1980), 264–65, fig. 13. In the Kerameikos: Schöne-Denkinger (1993), 165–69, no. 6, pls. 34, 1, 35.

42. It has been maintained that the diadem from Madytos in the Metropolitan Museum showing Dionysos and Ariadne "was made by pressing a single piece of sheet gold into a design carved in intaglio in a die, most probably of copper alloy. One large die was used to produce the whole design in one process, rather than one or more smaller dies being used sequentially" (Williams and Ogden [1994], 108, no. 620). However, my comparison (forthcoming) with its closest parallel—the diadem found in Tagara, north of Abydos, now in the Victoria and Albert Museum (Greifenhagen [1967], 34–36, figs. 11, 12)—suggests the subsequent use of separate dies.

43. Deppert-Lippitz (1985), 189, fig. 137.

44. Artamonov (1969b), pl. 277; Williams and Ogden (1994), no. 106: 330–300 B.C.

45. Galanina and Grach, (1986), fig. 181; Shcheglov and Katz (1991), 103, 105, figs. 7–8; Zurich, *Schatzkammern* (1993), no. 36; Grach (1994), 141–42, fig. 7.

46. Artamonov (1969b), pl. 141; Williams and Ogden (1994), no. 104: ca. 350 B.C.

47. Gauer (1991), 124–25, 286, pl. 110, 3: E 226.

48. Langlotz (1963), 87, pl. 128 below; Boucher (1970), nos. 19–20; Maass (1985), 105–106, fig. 73; Tarditi (1996), 41, no. 58; 138–40, figs. 19, 21; Di Bello (1997), 369-70, fig. 5.

49. Thessalonika, *Treasures* (1978), no. 22.

50. Hanover, *Makedonen* (1995), no. 248.

51. Amandry (1963), 204-209, figs. 110a-b; 112.

52. Hanover, *Makedonen* (1995), nos. 247, 249.

53. Sokolov (1974), no. 34; Shtitel'man (1977), no. 157; Galanina and Grach (1986), figs. 166-70; Schleswig, *Gold* (1991), no. 96; Boardman (1994), 201-202, fig. 6.23a-b; Schiltz, *Scythes* (1994), 176-77, figs. 128-29; Jacobson (1995), 200-202, VI.C.2; Gebauer (1997), 153-54, fig. 52; Fuhrmeister (1997), 164-66, figs. 60-66.

54. Vaulina and Wasowicz (1974), 87 ff., no. 12, figs. 38-40, pl. LXVIII; LXXVII, b; LXXVIII, b; LXXIX, b; LXXX, b; LXXXI, b; LXXXII, b.

55. Pfrommer (1982), 129, fig. 28; 141, note 85; Milan, *Tesori* (1995), 128, 173-74, no. 91; Bolla (1993), 72 ff., pls. XL-I, figs. 2-3; Castoldi (1995), 25-26, no. 22, pl. XVIII, figs. 39-40.

56. See, e.g., silver kalyx cups from Derveni: Pfrommer (1982), 120, fig. 6; 141; Sedes: Thessalonika, *Treasures* (1978), no. 317; Nikesiani: Thessalonika, *Treasures* (1978), no. 401; Washington, *Alexander* (1980), no. 120; Hanover, *Makedonen* (1995), no. 304; Vergina: Washington, *Alexander* (1980), no. 164; "Pappa" Kurhan at Sevasti: Hanover, *Makedonen* (1995), no. 281; from Stavroupoli: Barr-Sharrar (1982), 132, fig. 17, and on comparable silver bowl from the Fleischmann collection: Malibu, *Fleischmann* (1994), no. 31a, as well as on the foot of a bronze krater from grave B at Derveni: Makaronas (1963), pls. 230-31; Thessalonika, *Treasures* (1978), no. 184; Washington, *Alexander* (1980), no. 127; Barr-Sharrar (1982), 133, fig. 19a; Charbonneaux, Martin, and Villard (1988), 225, fig. 236. A comparable pattern also decorates the gold straps of the iron cuirass from "Philip's Tomb" in Vergina: Andronicos (1984), 1383-89, figs. 95-96; 140, 142; Musti (1992), 185, no. 147.4; 271; Hammond (1994), pl. 4; Archibald (1998), 199, note 23.

57. See, e.g., pattern on the foot of the 4th-c. bronze hydria bought in Smyrna: Comstock and Vermeule (1971), no. 427, now in Boston, and on the foot of the bronze cauldron from Samsun, now in Berlin, dated to the mid-4th century: Züchner (1938), 20, fig. 15; 25; Bolla (1993), 74-75, pl. XLIV, fig. 7a., as well as on a 3rd-c. silver pyxis reported to be from Asia Minor, now in Boston: Toledo, *Silver* (1977), no. 21. We see exactly the same pattern also on the frieze along the rim of the Berlin maenad krater: Züchner (1938), 8-9, fig. 7; pls. 1-2, which was dated to the first decades of the 4th c. B.C.

58. Von Bothmer (1984), no. 78; Pfrommer (1987), 235, KaB M 13, pl. 43, e.

59. Von Graeve (1970), 40, pls. 8-9.

60. Andronicos (1984), 181-86.

61. Pfrommer (1982), 166. He explains the gorytos in Vergina as a present given by Spartokides to the Macedonian court. See also Stähler (1997b), 88, that the gorytos from Vergina may have been a diplomatic gift. The gift exchange seems to be confirmed by the find in Karagodeuashkh of the so-called Achaemenid bowl of the Macedonian type; see: Völker-Janssen (1993), 202-203, note 120.

62. Bouzek and Ondrejova (1987), 91-92; Shcheglov and Katz (1991), 116; Boardman (1994), 205; Hanover, *Makedonen* (1995), no. 259. See on the Scytho-Macedonian conflict: Shelov (1971), 54-63; Hammond (1994), 135-37; on the find of a bronze coin of Philip II in the Scythian settlement of the forest-steppe zone: Gavrysh (1995), 135-37.

63. The celebrated pectoral from Tovsta Mohyla, whose imagery is so similar to the items made by our workshop although cast in round, points if not to Thraco-Macedonian artists, then at least is the proof of inspiration from there. The shape of the pectoral is also well represented in finds from Thrace and Macedonia. I agree with Z. H. Archibald (1985), 181, that the pectoral from Tovsta Mohyla "should be seen as imitating in à jour the more substantial Thraco-Macedonian collars."

64. See, e.g., Macdonald (1981), 159-68. About the work of Attic craftsmen in the 4th-c. Bosphoros: Treister (1987), 8-12; (1988), 155-56; (1996a) 239.

65. According to Williams and Ogden (1994), 126-27, there were relatively few major goldsmiths or workshops in the Bosphoran region in the 4th c.; however, analysis of objects made by the author (Treister, forthcoming) suggests that there were more workshops. See on the attribution of individual workshops and craftsmen: Grach (1984); Rudolph (1986); idem (1993); Williams and Ogden (1994), 126-27; Williams (1998), 100-103.

66. Of interest in this regard are the inscriptions on the Solokha phiale (see Jacobson [1995], 213-14, VI.F.1, figs. 92, 93). The first of these was almost completely destroyed but is read as: *Hermon [has donated this bowl to] Antistenos [in memory of the] Eleuteria.* A second inscription was nearly obliterated (Mantsevich [1950], 227-32, figs. 110, 111, and [1987], 80, 82). This allows us to suggest that there were at least three owners of the vessel, that the first owners were not Scythians, and that the first two inscriptions were intentionally destroyed by the third owner, who remained anonymous (Mantsevich [1950], 232). Festivals of Eleutheria were celebrated in different places; however, its existence in the Bosphoros is not attested. The names mentioned in the inscription need a special prosopographic study. They do not appear in the 1998 reprint of L. H. Jeffery's *The Local Scripts of Archaic Greece* (1990). I can cite one Antistenos, a Spartiate, mentioned by Thucydides (8.39.1), and another, an Athenian philosopher and pupil of Socrates (Guarducci [1974], 421.).

Burial Mounds of the Scythian Aristocracy in the Northern Black Sea Area

P. P. Tolochko and S. V. Polin

Scholars have learned much over the years about the civilization of the Scythians in the Black Sea region, but they have met with great difficulty in finding a definitive answer to one question in particular: where was Gerrhus, the site of what the Greek historian Herodotus said was the royal Scythian necropolis?

Herodotus is reported to have visited the northern shores of the Black Sea in the mid-fifth century B.C., and he left a brilliant record of the Scythians' history, daily life, and customs. In that account, however, are several inconsistent notes on the precise location of Gerrhus. Herodotus had, at best, a nebulous conception of Scythia's general geography, and the task of turning his descriptions into a reliable map has been the greatest stumbling block in locating the royal necropolis.

According to Herodotus, the Scythians buried their kings in the land of the Gerrhi along the Borysthenes (the modern Dnipro River), whose course was known to his contemporaries. Gerrhus, the most remote of Scythian territories, was said to lie at the point to which the river was navigable, a voyage of forty days from the sea. There, the Gerrhus River diverged from the Borysthenes, forming a natural divide between the territories of the nomadic and Royal Scythians.

Herodotus tells us about the funeral rites that attended the death of a Scythian king. When a king died, a large square tomb was dug and the king was embalmed. Before burial, however, the body was placed on a wagon and, accompanied by a large retinue, was taken on a final farewell circuit of all tribes under Scythian rule. Each tribe, once it had been visited, joined the forty-day procession that ended when it returned to the land of the Gerrhi. There the body of the dead king was laid in the grave on a straw mattress, with spears fixed in the ground on either side of the corpse. Above it, beams were stretched across and covered by reed thatching. Next, one of the late king's concubines was killed and interred along with his cup-bearer, cook, groom, lackey, messenger, some of his horses, "firstlings of all his other possessions," and gold cups. Then a vast mound was raised above the grave. When a year had gone by, another fifty of the king's attendants and fifty horses were killed and mounted on posts around the tomb. These "riders" were left in their circle as perpetual sentinels (Hdt. 4.71-72).

In the past, scholars guided by Herodotus reached varying conclusions concerning the location of Gerrhus. One study (by A. Guerrin and F. Ukkert) placed the necropolis in the vicinity of what is now Mogiliov, Belarus. Other research pointed to places north of Chernihiv (A. Hansen) or near

Opposite:
fig. 1. Aerial view of a Scythian wall, 20 ft. high, south of Kyiv. *Photograph Charles O'Rear*

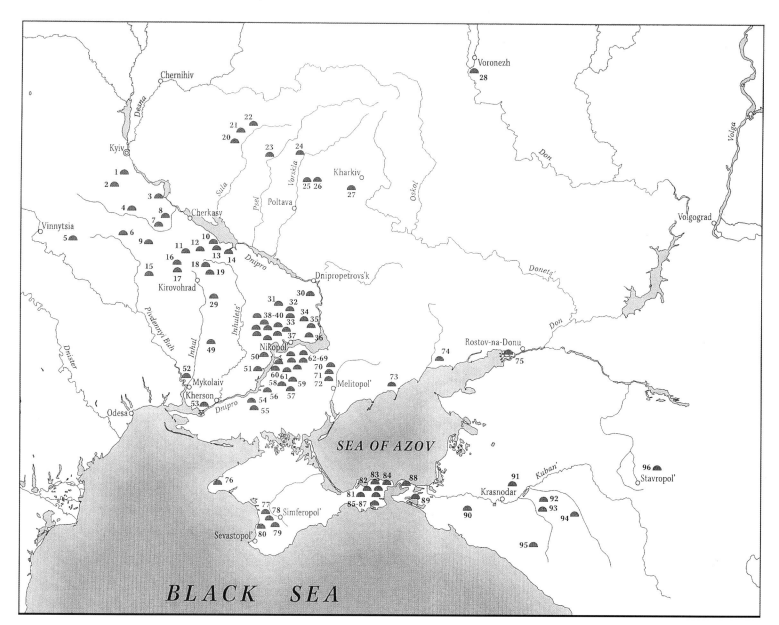

Fig. 2. Burial Mounds of the Scythian Aristocracy, 700–400 B.C.

FOREST-STEPPE OF THE RIGHT BANK

1. Hlevakha
2. Perep'iatykha
3. Bobrytsia, Kurhan 35
4. Syniavka, Kurhan 100
5. Illintsi, 1901-1902 Kurhan
6. Velykyi Ryzhanivs'kyi Kurhan
7. Stebliv
8. Sakhnivka
9. Novoselytsia
10. Huliai-Pole, Kurhan 38
11. Matusiv, Rep'iakhuvata Mohyla
12. Velyka Iablunivka
13. Zhabotyn, Kurhan 524
14. Hrushivka
15. Kurhan halfway between Romeikove and
 Petrakove
16. Zhurivka
17. Martonosha
18. Mel'hunivs'kyi Kurhan
19. Mederovo

FOREST-STEPPE OF THE LEFT BANK

20. Aksiutyntsi, Starsha Mohyla et al.
21. Mali Budky
22. Vovkivtsi, kurhan at Shumeiko stead et al.
23. Brovarky
24. Skorobor

25. Vitova Mohyla
26. Opishlianka
27. Pesochyns'kyi Mohyl'nyk
28. Voronezhs'ki Kurhany

STEPPE OF THE RIGHT BANK

29. Inhulo-Kam'ianka, Taranova Mohyla
30. Bashmachka
31. Oleksandropol'
32. Krasnokuts'kyi Kurhan
33. Kam'iana Mohyla
34. Slonivs'ka Blyznytsia
35. Tomakivs'ka Blyznytsia
36. Heremesivs'ka Blyznytsia
37. Chortomlyk
38. Kurhan Baba
39. Rozkopana Mohyla
40. Babyna Mohyla
41. Zhovtokam'ianka
42. Kam'ians'ka Blyznytsia
43. Vodiana Mohyla
44. Soboleva Mohyla
45. Strashna Mohyla
46. Tovsta Mohyla (Ordzhonikidze)
47. Khomyna Mohyla
48. Denysova Mohyla
49. Pisky
50. Zolota Balka (Riadovi Mohyly)

51. Dudchany
52. Mykolaiv (Novyi Vodopii)
53. Kherson (Rozhnivs'kyi Kurhan).

STEPPE OF THE LEFT BANK

54. Krasnoperekops'ki Kurhany (Vil'na
 Ukraina, Arkhanhels'ka Sloboda)
55. Mordvinivs'ki Kurhany
56. Bratoliubivs'kyi kurhan
57. Diiv Kurhan
58. Ohuz
59. Kozel
60. Mala Lepetykha
61. Vyshneva Mohyla
62. Verkhnii Rohachyk
63. Solokha
64. Lemeshev Kurhan
65. Haimanova Mohyla
66. Kazenna Mohyla
67. Velyka Tsymbalka
68. Orel
69. Chmyreva Mohyla
70. Tashchenak
71. Shul'hivka (Novo-Mykolaivka)
72. Melitopol's'kyi Kurhan
73. Berdians'kyi Kurhan
74. Dvohorba Mohyla
75. P'iatybratni Kurhany (Five Brothers
 Kurhans)

KRYM

76. Ak Mechet'
77. Zolotyi Kurhan (Golden Kurhan)
78. Talaivs'kyi Kurhan
79. Dart-Oba
80. Kurhan Kulakovs'koho
81. Kurhan Kekuvats'koho
82. Kul'-Oba
83. Patinioti
84. Baksy (Hlazivka)
85. Ak-Burun
86. Nimfeis'ki Kurhany (Nymphaion Kurhan)
87. Tr'okhbratni Kurhany (Three Brothers
 Kurhan)

TAMAN' PENINSULA, THE KUBAN' VALLEY

88. Velyka Blyznytsia
89. Semybratni Kurhany (Seven Brothers
 Kurhans)
90. Karagodeuashkh
91. Voronezhs'ka Stanytsia (settlement)
92. Ul'ski Kurgani
93. Kelermes'kyi Mohyl'nyk
94. Kostroms'ka Stanytsia
95. Kurdzhyps
96. Krasnoznam'ians'ki Kurhany

now Mogiliov, Belarus. Other research pointed to places north of Chernihiv (A. Hansen) or near Kyiv (K. Abicht, H. Stein).

When the lands north of the Black Sea became part of the Russian Empire following the Russian-Turkish wars of the late eighteenth century, a series of geographic and, to a lesser extent, archaeological explorations was undertaken. Clusters of mounds, impressive in height and number, were discovered within one hundred kilometers of the Dnipro cataracts, and initially it was expected that this area would prove to be Gerrhus. However, years of research and excavation have shown that these mounds date to the fourth century B.C., leaving the fifth-century B.C. necropolis described by Herodotus still undiscovered. Nonetheless, the notion that Gerrhus was associated with this region has persisted (M. I. Artamonov, B. M. Grakov, A. I. Meliukova, I. V. Iatsenko, B. A. Rybakov, and others). B. M. Mozolevs'kyi found encouraging corroborating evidence when he discovered material dating to the fifth century B.C., although those finds also come largely from the end of the century, again after Herodotus.

Another view concerning the location of Gerrhus emerged in the late 1800s, when huge tumuli were discovered midway along the Sula River. Those mounds are currently thought to date to the seventh and sixth centuries B.C., and they do exhibit some similarities to Herodotus' accounts, prompting some scholars (F. H. Mishchenko, D. Ia. Samokvasova, and V. A. Illins'ka) to locate an early Gerrhus in the Sula valley. Another challenging interpretation recently has been offered by V. P. Bilozor. Based on analogies in the myths of different Indo-European peoples who shared a concept of hero-ancestors dwelling in an otherworldly abode, Bilozor suggested that Gerrhus had never actually existed. In this view, the consistent failure of scholars to locate Gerrhus is due to the fact that they had confused a description of some legendary land with information about the funeral of one particular chieftain.

Comprehensive archaeological investigations carried out in the Pontic steppes over the past three decades lead to another, more plausible explanation for the location of Gerrhus. We now know that there was little Scythian presence there in the seventh and sixth centuries B.C., and that the political and military center from which the Scythians directed their long raids in the Near East was in the northern Caucasus. In the latter area, tumuli of this period, including those at Kelermes and others, exhaustively demonstrate the funerary practices described by Herodotus. This area may, indeed, be the Gerrhus of which Herodotus speaks.

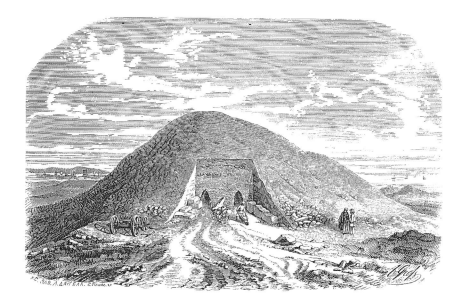

Fig. 3. Kurhan excavations on Iuz-Oba ridge near Kerch. *Drawing F. Gross*

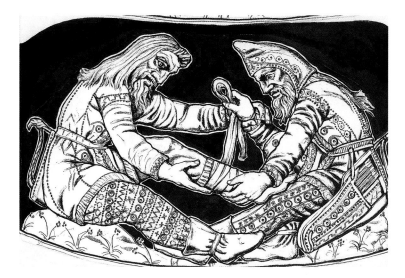

Fig. 4. Kurhan Kul'-Oba. Scene of Scythian life on vessel from Kul'-Oba, *St. Petersburg, State Hermitage Museum, inv. no.* КО 11

Archaeological study of Scythian mounds on the northern shores of the Black Sea has now continued for more than two hundred years. In 1763, a kurhan near Ielysavethrad (now Kirovohrad) was explored under the supervision of A. P. Melgunov, governor general of Novorossiya (New Russia), and has since been known as Mel'hunivs'kyi Kurhan. The mound contained a rich inventory, including a splendid gold scabbard, a gold diadem, seventeen eagle-decorated gold belt plaques, and items clearly obtained during Near Eastern campaigns. The finds generated so much interest in St. Petersburg that Empress Catherine II ordered them handed over to academician G. F. Miller to ascertain the peoples to "whom said artifacts may be attributable." Miller, after diligent scrutiny, pointed to the Scythians. Thus began fieldwork in Scythian archaeology. From Catherine's period also date some vague references to excavations of kurhany in the lower reaches of the Dnipro by obscure military commanders during the Turkish-Russian wars or by contractors of Imperial Prince Potemkin.

Archaeological investigation was next influenced by events near Kerch, at the site of the ancient city of Pantikapaion, which had been the capital of the Bosphoran kingdom. As new construction in the town and harbor progressed, nearby mounds yielded ancient Greek burials. In 1820, a Scythian grave was unearthed in one of the mounds, later called Kurhan Patinioti. It contained a solid torque, numerous dress ornaments, a bronze cauldron, arrowheads, and Greek amphoras. Unfortunately, all of this material has since been lost or stolen.

Another landmark in the study of Scythian antiquities was the excavation in 1830 of Kurhan Kul'-Oba near Kerch. There, under a mound ten meters high, an above-ground tomb was discovered containing the burial of a high-born warrior (perhaps a Scythian ruler), his wife, and an attendant. The tomb also yielded a great number of gold objects, including dress plaques, bracelets, a scabbard decorated with mythical animals, a large shield plate in the form of a stag, a diadem, and torque. By far the most remarkable find in this tomb was an electrum vessel depicting scenes of daily life.

Soon afterward excavations commenced in the Scythian steppes, where Gerrhus was still expected to be found. From 1852 to 1856, one of the largest mounds in Pontic Scythia, the twenty-meter-high Oleksandropol's'ky Kurhan, was examined. Years of excavation unearthed complex underground structures where three persons of distinction had been buried in succession, together with their servants. The *pièce de résistance* was the discovery of horse burials: one in a separate grave and another fifteen in an underground passage. Almost every one of the animals had been ornamented with incomparable gold, silver, or bronze trappings. The funeral chamber also included fragments of iron wheel bindings and exquisite bronze finials that had decorated funeral wagons.

As excavation of Scythian burial sites expanded and attracted ever-greater interest, the Imperial Archaeological Commission was established in 1859 to foster a systematic and orderly study of these antiquities. One of its initial steps was to order the resumption, in a renewed quest for Gerrhus, of studies into the tumuli on the right (west) bank of the Dnipro, near Nikopol', and on the left (east) bank in what is now the Khersons'ka Oblast' of Ukraine. There, from 1859 through 1868, a number of Scythian kurhany were excavated under the guidance of I. E. Zabelin (Heremesivs'ka Blyznytsia,

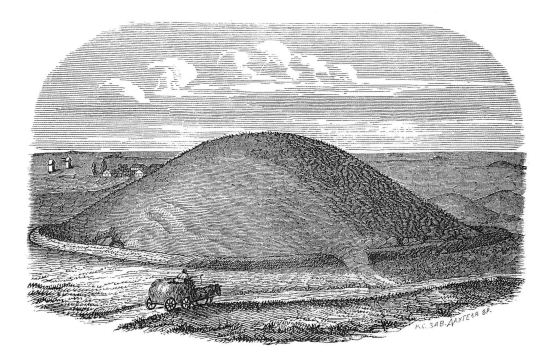

Fig. 5. A view of Oleksandropol's'kyi Kurhan

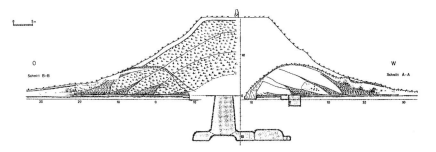

Fig. 6. A reconstruction of a kurhan section *(by V. Hertz and G. Tomm)*

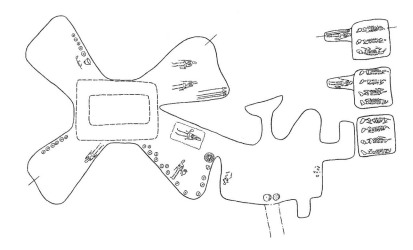

Fig. 7. Kurhan Chortomlyk, general plan of burials

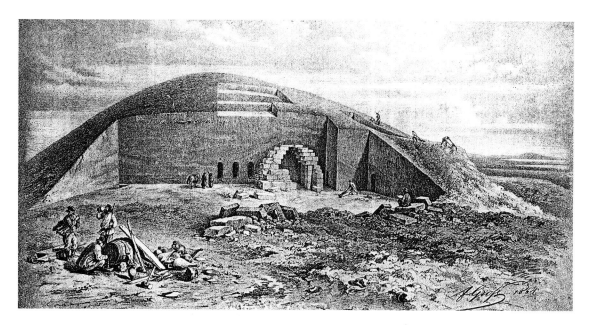

Fig. 8. Excavations of the Kurhan Velyka Blyznytsia on the Taman', 1864. *Drawing F. Gross*

Krasnokuts'kyi Kurhan, Hostra Tomakivs'ka Mohyla, Kam'iana Mohyla, Tomakivs'ka and Slonivs'-ka Blyznytsia, Kozel, Velyka Tsymbalka, and others). These tombs provided insight into Scythian funeral rites and supplied the basis for understanding many aspects of their material and spiritual culture. The highlight of Zabelin's exploration in this region was his excavation of the twenty-meter Kurhan Chortomlyk , where burials of eleven horses and two grooms were found and a magnificent underground structure uncovered. A square pit twelve meters deep branched into four spacious funeral chambers, containing the rich graves of a man and woman, and their attendants. Although disturbed by robbers in ancient times, the barrow yielded a treasure of goods that had been placed in the tomb to accompany the dead on their last journey, including a gold scabbard, figural gold sheaths for a gorytos (bow-and-arrow case), and hundreds of other ornaments and implements. Finally came a stunning silver-gilt amphora decorated on the lower portion with a scrolling floral design and with griffins attacking a stag and, on the shoulder, a frieze illustrating Scythians taming a horse and training it for the saddle.

After these spectacular discoveries, the Archaeological Commission stepped up efforts in the Taman' Peninsula, excavating the Kurhan Velyka Blyznytsia, which was thought to have served as a shrine to priestesses of Demeter. In the Kuban' region, the outstanding Semybratni (Seven Brothers) and Karagodeuashkh kurhany were excavated and a few exceptional finds recovered, including a silver gorytos similar to the one from Chortomlyk. Between 1870 and 1890, intense research followed in the Crimean Peninsula (warrior burials in the necropolis of Hellenic Nymphaion, Kurhan Kulakovs'koho, Ak-Burun, and Ak-Mechet'). In this period also came the exploration of Zolotyi and Talaivs'kyi Kurhany and Dart-Oba near Simferopol'. These explorations began the dazzling professional career of N. I. Veselovs'kyi.

During the 1890s, Veselovs'kyi went on to explore burials along the banks of the lower Dnipro, at the Shul'kivs'kyi and Diiv Kurhany, and began work at the twenty-meter mound at Ohuz, one of Scythia's largest. From 1891 to 1894, incomplete excavation of the central part revealed a stonework crypt with a terraced span of Bosphoran type—something unique for Scythian burials—but the tomb had been plundered in ancient times and, sadly, study of Ohuz was suspended. Its history continued with illegal predatory excavations and police reprisals. Following a major looting, efforts to revive scientific exploration at Ohuz succeeded in 1902, when V. N. Rot, a member of the Archaeological Commission, managed to conduct a limited excavation. Much later, in 1972, a major effort to

explore the mound was made by O. M. Lieskov. In fieldwork carried out at Ohuz from 1979 to 1981, Iu. V. Boltryk unearthed more lavish burials and gathered important information about many features of Scythian funerary rituals.

Although the Archaeological Commission focused on excavations of the rich kurhany in the south, the forest steppes of Ukraine also attracted some attention, especially from local amateur antiquarians. In the 1870s, professional archaeologists began studying the promising cluster of kurhany near the village of Oksiutyntsi on the Sula River. T. V. Kybalchych, B. V. Antonovych, S. A. Mazaraki, D. Ia. Samokvasova, N. E. Brandenburg, and others took part in excavations that continued there for nearly forty years. Other burials were studied near Velyki Budky, Mali Budky, and Vovkivtsi. According to V. A. Illins'ka's data, some five hundred kurhany were excavated in those years in the vicinity of the Sula River, some of them up to twenty meters high. Most burials at these sites were of males in distinctive timber graves that contained weapons. The Sula River sites, unlike those in other areas, did not yield any remains of sacrificed horses, but archaeologists did find many bridle ornaments.

Study of the kurhany in the forest steppes along the right bank of the Dnipro had begun a little earlier, in 1845, when the Kurhan Perep'iatykha not far from Kyiv was first explored. Count O. O. Bobryns'kyi conducted excavations for thirty-five years, studying more than five hundred mounds around the town of Smila, including the Zhurivka burials and many others. The finds from these explorations were thoroughly recorded in a comprehensive set of publications.

As the nineteenth century drew to a close, intense excavation continued in the Kuban' area. In 1898, in mound 1 near Ul'ska Stanitsia, N. I. Veselovs'kyi discovered the remains of more than four hundred sacrificed horses. Twenty groups of eighteen horses were discovered close to tethering posts around the base of the mound. Another fifty horses had been buried inside the mound on a flat site laid out for that purpose. This kurhan is associated with the period of Scythian raids into Asia Minor and is indicative of the power held by the nomadic leaders. In 1903 and 1904, research at the seventh-century mound of Kelermes uncovered more graves of Scythian chiefs and produced objects of eastern types, including a battle axe with a golden grip bearing images of fantastic creatures, rhytons, a mirror, a sword with a gold-plated sheath, a panther plaque, and many other unique items. Finds like these represent only a fraction of what lay in the grave sites before they were looted.

Field studies of kurhany near Voronezhs'ka and Kostroms'ka Stanytsi resulted in the discovery of peculiar timber graves with the remains of dozens of buried horses. The singular Kostroms'kyi gold stag shield plaque was also found there. From 1912 to 1917 excavations of the Elyzavetyns'kyi kurhany

Fig. 9. Kurhan Ohuz, reconstruction of key elements *(by Iu. V. Boltryk and M.I. Ievlev)*

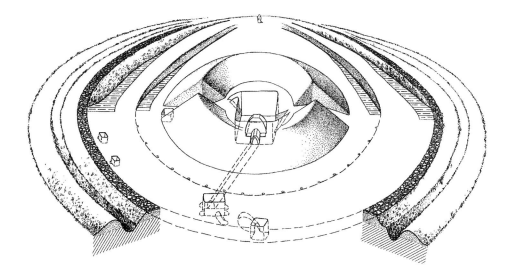

of the fifth and fourth centuries were crowned by the discovery of vast vaults containing the remains of up to two hundred horses. This finding proved that the tradition of burying horses with their owners had continued over many centuries. The most significant finds from these sites were a Panathenaic amphora, a bronze breastplate with a representation of Medusa, remarkable sets of bronze bridle trappings, and fragments of horse carts.

During the same years in the early twentieth century, Veselovs'kyi was also involved in the territories of the lower Dnipro. Excavations of Chmyreva Mohyla, begun by F. Braun in 1898, were resumed in 1909 and the next year produced a burial cache of ten silver vessels with gilded relief and an interment of ten horses with exquisite silver bridle work. Burial mounds near Mala Lepetykha and Verkhnii Rohachyk were explored from 1911 to 1915, and from 1912 to 1923 Veselovs'kyi excavated at Solokha. That discovery, the last of the four largest Scythian mounds, at eighteen meters high, included two noble burials surrounded by graves of servants and horses. The central burial chamber had been looted in ancient times, but the side chamber remained intact. There, archaeologists found the remains of a Scythian king and hundreds of objects made of precious metal, including gold-decorated weaponry. The chamber also held a silver libation bowl with a scene of mounted Scythians hunting lions and an unsurpassed masterpiece of ancient Greek art—a gold comb with sculpted figures of three Scythians in battle, one mounted on his horse. The exceptional realism of this piece is evidenced in the minutely reproduced details of the warriors' clothing and weapons and of the horse's bridle.

In 1914, just before the outbreak of World War I, N. E. Makarenko and V. V. Sakhanev, inspired by academician M. I. Rostovtsev, began excavations at Mordvinivs'kyi Kurhan east of Kakhivka. These were carried out with the most advanced techniques of the time: soil was removed in layers down to ground level with a careful examination of excavated surfaces at each stage recorded in field notes and documented in photographs. Excavators found a considerably plundered central burial chamber similar to the type at Chortomlyk, with four catacombs off the entrance and a side burial of an adolescent attended by his servant and provided with a gold headdress, garment decorations, a necklace, armbands, and a rhyton. The war soon began, however; excavations were discontinued and records were lost. Studies of this kurhan were not completed until 1970 by Lieskov.

Veselovs'kyi's and N. Makarenko's expeditions to southern Ukraine and the upper Kuban' marked the end of the initial period of Scythian studies. Exploration of major kurhany in all areas north of the Black Sea did not resume for more than fifty years. The official position of the Soviet era was that the old Imperial Archaeological Commission had aimed its research only at providing new

Fig. 10. Kurhan Perep'iatykha and its environs near Kyiv

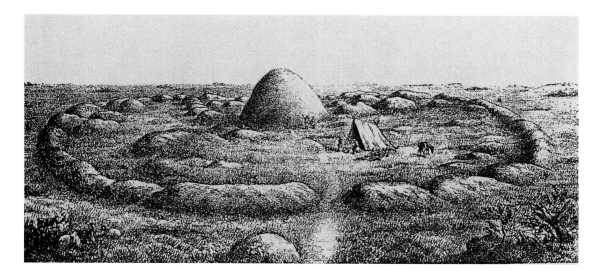

exhibits for the Hermitage royal collections. There is some truth in this, since pre-Soviet excavations looked only at large kurhany and in a cursory way, digging just one blind trench to find burials as quickly as possible. Work was abandoned if looting had left no treasure or if the mound was of such an early date that gold finds were unlikely. Scholars knew virtually nothing about the smaller Scythian kurhany, because no field studies of these had ever been carried out. To redress this situation, archaeologists throughout the Soviet period concentrated their efforts on exploring burials of low-ranking Scythians and the sites of Scythian settlements. Another reason for the retreat from exploration of major sites was their difficulty and expense in a period of limited resources. It should also be admitted that archaeology had begun to suffer from a lack of expertise.

There was one exception to the general Soviet-era reluctance to explore major Scythian sites. This was the excavation of the Royal Scythian mound in Melitopol', which began after a chance discovery in 1954. Workers digging a cellar under a local teacher's house, next to a largely destroyed burial mound, unearthed a chamber containing numerous gold plaques. At the site of the former mound, O. I. Terenozhkin and E. F. Pokrovs'ka uncovered two plundered Scythian burials of the fourth century, remains of interred horses, and quite a number of extraordinary items, including garment plaques, tools, weapons, bridles, pottery, fragments of horse carts, and much more. The most magnificent article was a gorytos sheath (cat. no. 105) worked in gold and identical to those from Chortomlyk and Illintsi.

The arrival of the 1960s in Ukraine brought new concerns for archaeologists, with construction of extensive irrigation systems in the Dnipro, Inhul, Inhulets', Pivdennyi Buh, and Danube river basins, and similar projects in Russia, in the lower flows of the Don and Kuban' rivers. These projects, accompanied by the construction of many large industrial facilities, were carried out over a period of more than thirty years and meant the likely destruction of a huge number of important sites. One positive outcome of these construction projects has been a new method of excavation using heavy machinery, a system that allows experts to examine fairly quickly the whole of any mound. It should also be noted that in the mid-1960s the Institute of Archaeology of the Academy of Sciences initiated a series of carefully planned field studies and expeditions in the steppe regions. These have produced hundreds of new sites, including some rich kurhany.

In recent years, the excavations of Haimanova Mohyla, Tovsta Mohyla, and Berdians'kyi Kurhan have produced spectacular results. Archaeologists have also re-examined sites that had been initially investigated before 1917, undertaking new research at Mordvinivs'kyi Kurhan 1, Ohuz, and Chortomlyk. Also worthy of mention are the efforts at the second Mordvinivs'kyi and Bratoliubivs'kyi Kurhany, mounds near the villages of Arkhanhels'ka Sloboda, Vil'na Ukraina, Vodoslavka, Zolota Balka, Dudchany, L'vove, and Volchans'ke in Khersons'ka Oblast'; Vyshneva Mohyla, Kazenna Mohyla, and mounds near Velyka Bilozerka, Velyka Znam'ianka, Hunivka, and Tashchenak villages in Zaporizhs'ka Oblast'; and the burial mound near Zhovtokam'ians'ka as well as the Vodiana, Babyna, Strashna, Khomyna, Denysova, and Soboleva Mohyla in the Dnipropetrovs'ka Oblast'. This short list is limited to only the most significant monuments examined in the last thirty years; a complete list would occupy a far greater space. Studies of the sites listed were pursued by O. M. Lieskov, V. I. Bidzilia, B. M. Mozolevs'kyi, M. M. Cherednychenko, A. I. Kubyshev, Iu. V. Boltryk, G. L. Ievdokimov, and others. This exhibition includes many finds uncovered as the result of their work.

Unfortunately, we are on the eve of another forced recess in the study of major Scythian kurhany. This may well be a fairly long hiatus, because the economic adversities affecting Ukraine today have inflicted a heavy toll on archeological research. The scope of archeological excavation in the south has shrunk abruptly. And plans for excavating the many major kurhany remaining in the steppes exist only as wishful thinking.

A Short Note on Scythians in the History of Ukraine

V. I. Murzin

The steppe constitutes nearly forty percent of the territory of Ukraine. It was in this vast region that the Cimmerians, beginning in about the tenth century B.C., and followed some three hundred years later by the Scythians, forged a distinct western version of nomadic culture.

In the middle of the seventh century B.C, an important new factor was introduced into the economy of the region when the first Greek colonies, most of them associated with the Ionian migration, were established on the northern shores of the Black Sea. Significantly, excavations of settlements and kurhany from the central territory of the northern Black Sea, the right bank of the Dnipro, and the central Vorskla regions yield Greek goods in levels dated to the end of the seventh and beginning of the sixth century B.C. Most of these initial imports are expensive decorated pottery, but their nature and distribution soon expanded. There are particularly plentiful finds of Greek amphoras, for example, in sixth-century strata in the forest-steppe regions.

The evidence suggests that, from at least the sixth century, close trade contacts existed between the Greek colonists (initially those from Olbia and Berezan') and the forest-steppe settlements. This situation presented an obvious and attractive opportunity: to the north of the steppe corridor were well-developed agricultural lands, to the south were the wealthy Greek poleis. Trade between them was susceptible to control by nomadic peoples—and the Scythians were quick to realize it. It is this opportunity that allows us to understand the Scythians' reorientation following the end of the Near Eastern campaigns in the middle of the sixth century B.C, when the main group of them moved from the plains of the northern Caucasus and journeyed west into the steppes north of the Black Sea.

Archaeological evidence continues to grow for this major shift, as other essays and the material in this exhibition attest. The process culminated in the creation of Greater Scythia, a state that united under its aegis nomads of different backgrounds, different ways of life, and different cultural affiliations, together with more settled peoples from the steppe and forest-steppe regions. According to Herodotus, Scythian territory formed a square, a twenty-day journey east to west from the Danube to the Don, and the same distance from the Black Sea littoral north. It was the rise of this large and affluent Scythian state that attracted the attention of historians and ethnographers like Herodotus. He devoted a significant part of the *Histories* to the war between the Scythians and the Persians at the end of the sixth century B.C. His account of the tribute given by the Scythians to Persian king Darius testifies to their power and self-confidence. In place of the usual earth and water, which symbolized the subjugation of a territory, the Scythians sent the king a bird, a mouse, a frog, and five arrows. Their message was clear: if the Persians did not hide themselves with the same skill as these

animals, they would suffer defeat from the Scythian arrows (Hdt. 4.126-32). And so it happened. Darius was forced to flee with the remnants of his once-mighty force, and Scythian arms earned a reputation for being unbeatable.

The apex of Scythian power came during the fourth century. It was then that the grandest of the kurhany—Chortomlyk, Ohuz, Oleksandropol's'kyi, Kozel, and others—were constructed in the area of the lower Dnipro. Perhaps under one of these mounds will eventually be discovered the tomb of King Atei, whose name is associated with the Scythians' attempt to acquire control over the western regions of the Black Sea and its wealthy Greek cites. The expansion was stalled by the increasing power of Macedonia, and in 339 B.C, Atei, then well over ninety, was decisively defeated by Philip. This military disaster did not signal a complete end to Scythian influence, because they managed a few years later to repel the forces of Zopyrion. Moreover, rich kurhany continued to be built down to 300 B.C (fig. 1).

After this, at the turn of the fourth and third centuries, the kurhany suddenly disappear. The Scythian demise is believed by scholars today to have been brought about by several factors, including worsening climatic conditions that made the steppe drier and less productive, the continuous trampling of the grasses from intensive grazing of cattle, and dwindling economic resources in the forest-steppe region due to over-utilization. The Scythians did not disappear entirely; their tribes continued to live in the region until they were overtaken by the next wave of nomads, the Sarmatians.

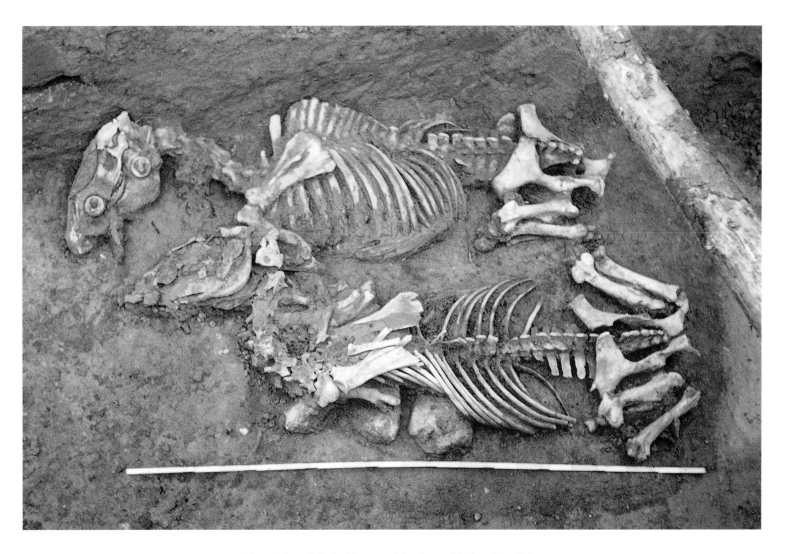

Fig. 1. Babyna Moyla. *Photograph Institute of Archaeology, Kyiv*

Scythian Culture
of the Central Dnipro Area

Tetiana Bohush and Halyna Buzian

The forest-steppe zone of Ukraine was inhabited by a number of settled, agricultural, and cattle-breeding peoples, who shared common forms of land management and organization, religious beliefs, construction techniques, settlement structures, and fortification systems. This paper will focus on material from the central Dnipro, or Kyiv-Cherkasy, region.

Most finds in the central Dnipro area have been concentrated on the right (west) bank in the basins of the Tiasmyn, Ros', and Irpen' rivers, and on the left (east) bank in the valleys of the Trubizh and Supii rivers, near the town of Pereiaslav-Khmel'nyts'kyi. The Scythian period began here about the middle of the seventh century B.C., and Scythian artifacts of this date are routinely discovered in burials of the local population. Archaeological investigation has shown that the majority of the settled population was of a different origin and ethnicity than the nomadic Scythians who spoke an Iranian language. Most modern scholars consider the settled population to have been proto-Slavs. Already by the second half of the seventh century B.C, the culture had been strongly affected by the contact with Scythian nomads.

Following the establishment of Greek city-states on the northern coast of the Black Sea, an active trade developed, but until the end of the sixth century B.C, the import of Greek goods was directed primarily toward the agricultural tribes in the central Dnipro area. Later, Greek goods began to appear in the steppe regions controlled by nomadic Scythian chieftains. A former peat bog near the village of Pishchane, along the Supii River, yielded a number of bronze vessels, apparently of Greek manufacture (e.g. cat. nos. 84–89). The first one to be discovered as the peat was being cut is a large basin from about 500 B.C., now in the Pereiaslav-Khmel'nyts'kyi State Historical Archaeological Preserve (cat. no. 83). Another Greek import is the helmet (cat. no. 93) that was a chance find discovered in 1899 near the river Karan, a tributary of the Dnipro, not far from Pereiaslav-Khmel'nyts'kyi.

In the early fourth century B.C, major changes took place in the lives of people in the agricultural settlements. The nomadic Scythians evidently required the support of an agricultural economy and therefore expanded from the south and east in the direction of the forest-steppe zone. Faced with imminent threat, the local population mobilized to construct a number of fortified settlements at this time, including those at Pastyrs'ke, Trakhtemyrivs'ke, and other sites represented in this exhibition. Most of these settlements were small, from thirty to fifty acres, but Motronins'ke in the Tias-

myn River valley occupied some five hundred acres, and Trakhtemyrivs'ke on the right bank, thirteen hundred acres.

The settlements were fortified by a defensive system of trenches and earthen walls reinforced with wood. Studies in 1967 showed that the Trakhtemyriv settlement had been encircled by an earthen wall three to four meters high and surrounded by a deep moat. Its external fortification line extended 6.5 kilometers and included wooden structures that had been filled and puttied with clay. In the center of the settlement, the acropolis (called the Mali Valky, or "little walls"), was ringed by another series of walls. They enclosed a settlement area of some 350 to 400 square meters, where the entire population lived. The rest of the settlement area was given over to outbuildings and barns for livestock. In Mali Valky, thirty-five dwellings have been excavated. Some were built above ground, while others were half-dug into the earth. They had walls of wattle puttied with clay, stone hearths, and pits, most of which were for storing grain. A clay altar decorated with spiral reliefs was discovered in one of the dwellings, and similar altars, apparently associated with fertility cults, were later found in settlements at Pastyrs'ke, Motronins'ke, and Velyke Kanivs'ke. Excavations at Trakhtemyriv have also uncovered remains of a bronze foundry, as well as bronze and iron axes, arrowheads and spear tips, and elements of horse harnesses. Archaeologists also found vessels of local manufacture and high-quality pottery imported from the Greek city-states along the Black Sea, including a wide variety of amphoras that had been used as containers for grain and wine. From Trakhtemyriv also came one particularly large grain vessel of Villanovan type, with a highly burnished black surface that had been manufactured locally about 700 B.C(cat. no. 26).

A large part of the population of the central Dnipro region lived in villages far from these fortified settlements, on the banks of small rivers and by the steppe valleys. Several such villages have been found on the left (east) bank of the Dnipro, near Pereiaslav-Khmel'nyts'kyi, in the hills along the remnants of the Karan River and the old bed of the Dnipro. Zarubs'kyi Ford, which is the next to last fording place inside the forest-steppe region, was traditionally the most convenient crossing point from the west (right) bank of the Dnipro to Pereiaslav-Khmel'nyts'kyi on the east (left) bank. The first ford was just opposite the estuary of the Trubizh River, by the former village of Monastyrok (Monastyrs'ka Shoal). There the Dnipro was 320 meters wide but only one meter deep. The second ford was located close to Trakhtemyriv (Trakhtemyriv Shoal), where the river was 250 meters wide and just over one meter deep. It is clear, therefore, that the Dnipro did not separate the population of the left and right banks; rather it brought them together into a single cultural and ethnic community.

These settlements continued the burial practices of older funerary traditions. Certain characteristics date back as far as the Chornolis'ka (Black Forest) culture of 1000 to 800 B.C. These include interment both in barrows and cemetery areas, the construction of living quarters inside burial complexes, and a mixture of cremation and inhumation burials. Most burials were located on high plateaus, where several dozen, or even several hundred, individual mounds might be arranged in several groups. The dead were buried in simple pits faced with wood. Most mounds were raised as earth embankments, but sometimes stones were also used. Their size also varied; the Kurhan-Perep'iatykha, for example, is as high as eleven meters. Cremation remained the dominant burial tradition during the entire Scythian period. From the sixth century B.C, small fires would be set inside or on top of the grave, which often contained coals, ashes, and red ocher.

In the fourth century, steppe-type burial vaults appear in the regions bordering steppe lands. Their presence can be explained by the increased penetration of nomadic Scythians into the forest-steppe region. In the area around Pereiaslav-Khmel'nyts'kyi on the east bank of the Dnipro, the settled agricultural population of the central Dnipro came into contact with these steppe nomads. Archaeologists studying the kurhany southeast of Kyiv, between Boryspil' and Pereiaslav-

Khmel'nyts'kyi, have discovered two types of fifth- to fourth-century burials: simple wooden tombs and vaults. The wooden tombs consistently contained coal, along with other materials characteristic of the cremation burials that had been common among the pre-Slavic peoples since the Bronze Age. It is clear, however, that the agricultural population had adopted many aspects of nomadic culture, because the grave goods found in these burials are typically Scythian and include weapons and knives.

The vault tombs, by contrast, are similar to steppe burials. Usually the deceased was accompanied by a horse, a bronze pot, all manner of weapons (arrowheads, javelins, spears, and swords), and sometimes gold ornaments. This was the type of tomb occupied by common Scythian warriors, who might own only a single ox-driven cart. Among these poor burials, a number of richer ones do stand out; one even included a servant. All of this supports the assumption that in the late fifth and early fourth centuries B.C, the nomads began occupying the central Dnipro region, moving up to the latitude of Kyiv on the east bank, seizing the pasture lands from the local populations, and burying their dead in vault tombs.

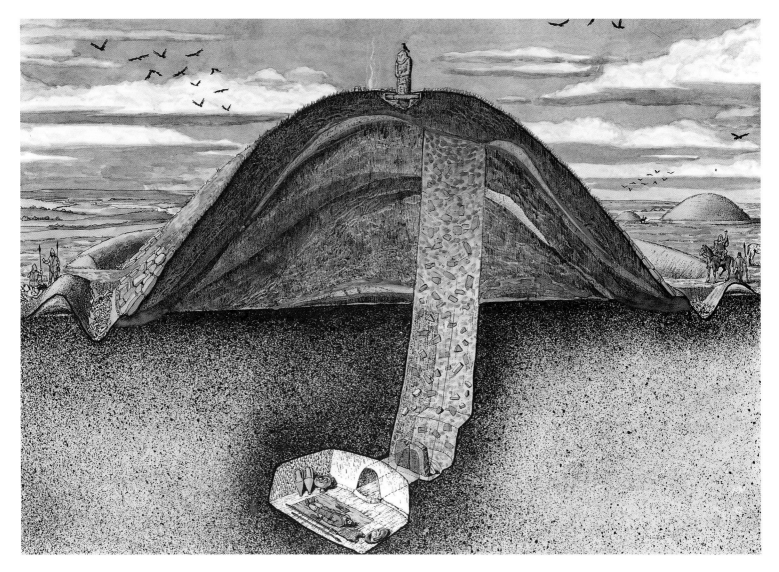

Fig. 1. Kurhan with Scythian warrior's grave, Pervomaievka village. *Drawing by Korniienko.*

The National Museum of the History of Ukraine: The Iron Age Collection

Svitlana Korets'ka and Liudmyla Strokova

The National Museum of the History of Ukraine, founded almost one hundred years ago in Kyiv, is a treasury of the nation's heritage and culture. The museum's collections, built over the years as the institution itself evolved, preserve the history and art of all the various peoples who have lived in what is now Ukraine, from the Stone Age to the present. Its archaeological collections are among the largest and most important in the territories of the former Soviet Union, ranking behind those of only Moscow and St. Petersburg.

A significant part of the collection is devoted to the rich and unique culture of the Scythians. In the Scythian period, three distinct societies lived and interacted in the region north of the Black Sea: nomads in the steppes, settled agricultural and cattle-breeding peoples in the forest-steppe region, and Greek colonists in city-states founded in the seventh to fifth centuries B.C.

Turning first to the east of the Dnipro River, we find that tombs of the so-called Sula River group date largely from the seventh and sixth centuries B.C. These graves of wealthy nomadic warriors and herdsmen contained horse trappings and weapons decorated in the so-called animal style. From the same date come poletops with openwork bronze shells and interior clappers (cat. nos. 36 and 38). Later finials, from around 500 to 400 B.C, typically have suspended bells. Precisely how the finials were used remains uncertain. They were mounted on poles, up to two meters in length, that might have formed a part of wagons, funeral carts, or tents. Archaeologists have been unable to determine any more specific function because the finials have been discovered in so many different contexts. Some emerged from human burials, others from burials of horses; still others were found along with the remains of wagons. Remarkably, they always occur in pairs, in sets of two, four, or six. Most have been recovered from the Kuban' basin, and a very few along the Dnister or Buh rivers. Not a single example has come to light from the west bank of the Dnipro.

Also from the lands east of the Dnipro come a number of early animal-style horse ornaments. A bronze frontlet from Romens'kyi Raion (cat. no. 48) is made in the shape of a cross and decorated with felines and other beasts with coiled bodies. Carved bone cheekpieces represent the horse with an abbreviated but powerful manner, reducing its image to a head and hoof (cat. no. 29). These pieces were meant to show the animal simultaneously in repose and at a gallop. Equally appealing are the plaques (cat. nos. 12 and 49) that were attached to a sword belt. All of these designs may have had symbolic value.

Still other objects found in this area east of the Dnipro include short swords, *akinakes* (cat. no. 9), dating between 600 and 500 B.C. These are recovered from both rich and modest burials, and were a standard part of military gear. Swords were also understood to represent the god Ares, and the Greek historian Herodotus describes their use in the god's rites. Arrowheads (cat. no. 13) were equally a part of every warrior's equipment. Quivers have been found that contained as many as two hundred arrowheads, and, in some cases, the bronze points are believed to have been used as money.

In contrast with the east bank of the Dnipro, the population in the forest-steppe regions on the west bank engaged in an active trade for Greek goods. Scythian burial sites there often produce bronze and ceramic wares that must have been brought by Greek traders. From this west-bank region, for example, came a group of bronze vessels for water and wine (e.g., cat. nos. 84–89), all produced in the fifth century B.C by Greek craftsmen, who also made the bronze helmets (cat. nos. 91 and 92).

A number of mirrors of a type represented in the exhibition by cat. nos. 118 and 119 are usually attributed to Greek metalworkers from the city of Olbia, although examples have also been found near the Dnipro and Buh. Olbia is the source of the largest single group of artifacts held by the National Museum of the History of Ukraine. Included among these objects are many examples of pottery (cat. nos. 67, 70–72, and 76, among others).

A final group of artifacts in the National Museum of the History of Ukraine comes from later burial sites of the Scythian steppe, including Krym. This is the region that, according to Herodotus, was inhabited by the most powerful and numerous Scythian tribes, who regarded other Scythians as their slaves. The burial kurhany of the so-called Royal Scythians, dating mainly to the fourth century B.C., are larger and more complex than those of earlier dates. The Melitopol's'kyi Kurhan, for example, which dates to about 400, was reinforced with seagrass. Although this tomb, which contained the graves of a man, a woman, and a female servant, had been pillaged in ancient times, archaeologists in 1954 still managed to find many gold objects, including a gorytos sheath (cat. no. 105) and plaques (including cat. no. 18) that had decorated the woman's headdress, clothing, and footwear. The burial also included glass-paste beads with "eyes" (cat. no. 59), which may have had an apotropaic function, amphoras, and a large bronze cauldron (cat. no. 28).

Goods from rich tombs like the Melitopol's'kyi Kurhan bear witness to a unique fusion of two styles: the Scythian animal style, so expressive of the ties between people and the world around them, and the vegetal ornament and more naturalistic representation of Classical Greek art.

The history of the National Museum of the History of Ukraine goes back to 1897 when Borys Khanenko, a leading archaeologist, patron of the arts, and public figure, became chairman of a newly organized History and Arts Society in Kyiv. By 1899, when an international archaeological congress was scheduled, the society had arranged an exhibition in what it hoped would become a new museum. That exhibition, built largely around Khanenko's private collection of antiquities, led to the creation of a Municipal History Museum. On December 30, 1904, the municipal museum was reorganized as the National Museum of the History of Ukraine.

The museum's collections grew in the new century as excavations in Ukraine proceeded. By the 1930s, finds began flowing from a new series of regular excavations carried out by the Institute of Archaeology of the Academy of Sciences of Ukraine. In that period the museum expanded its collections with material from excavations in Olbia and other ancient cities, including Pantikapaion and Chersonesos (now Sevastopol, also in Krym). Recent excavations have produced an increasingly clear picture of Scythian culture in Ukraine, and in 1969 the museum opened a new branch, the Museum of Historical Treasures of Ukraine, to house its gold and silver archaeological finds.

Scythian Gold in the Museum of Historical Treasures

Olena Pidvysots'ka

The Museum of Historical Treasures of Ukraine opened in 1969 as a branch of the National Museum of the History of Ukraine. The museum's mission is to document the nation's history through objects made of precious metals. Among its rich holdings, the collection of Scythian gold objects is easily the most resplendent.

The first discovery of a gold object of the Scythian period was a chance find by herdsmen in the Poltavs'ka Oblast' in 1746. The piece quickly became part of the Hermitage Gold Collection in St. Petersburg. The first kurhan to be explored was Lyta Mohyla, near the present city of Kirovohrad. In 1763, on the orders of A. P. Melgunov, then governor general of Novorossiya, the mound was excavated. The governor presented the gold objects that were recovered to Catherine II, and later, as "Melgunov's treasures," the items were exhibited in the St. Petersburg *Kunstkammer*, the museum of rarities and curiosities founded by Peter I in 1714. The excavations of Lyta Mohyla may be deemed the beginning of Scythian archaeology. Since then, over the last 250 years, archaeologists have explored hundreds—perhaps more than a thousand—of these history-rich mounds.

The earliest Scythian objects date to the seventh century B.C. and exemplify the Scythian animal style. Animals are represented in distinctive stylized postures, coiled and curled to fit within predetermined frames. Scholars today believe that the animal style first emerged in bone carving, woodwork, and embroidery and textile appliques before it was transferred to bronze, silver, and gold.

Eventually the contributions of Near Eastern and Greek art resulted in the emergence of a distinctly new animal style. Its much richer imagery features motifs of the lion, griffin, sphinx, and boar. Another novelty is its depiction of animal combat, scenes that are full of movement, tension, and the confrontation of life and death—a sharp contrast with quiet and succinct representations on earlier work. Another tendency was the gradual incorporation of animal images within a general ornamental scheme, especially geometric or vegetal patterns.

The needs and tastes of the Scythian elite prompted Greek goldsmiths to develop realistic depictions of nomads and Scythian mythical traditions. We find, for example, images of Scythians at war, as on the gold helmet from Perederieva Mohyla (cat. no. 124) and images of Scythians at peace and performing ceremonial rites (cat. no. 40). At the same time, Scythian clients also admired goods with Greek subjects, especially when they coincided with their own tastes—as, for example, on the gorytos from Melitopol's'kyi Kurhan (cat. no. 105) and the plaques bearing images of a Gorgon, Athena, or maenads (cat. nos. 73, 111, and 114).

The objects in this exhibition illustrate the entire range of Scythian gold, encompassing very different types of objects and different techniques of manufacture. What they share are their overwhelming originality and high degree of artistic skill.

Following page: Kurhan Ohuz. *Photograph Institute of Archaeology, Kyiv.*

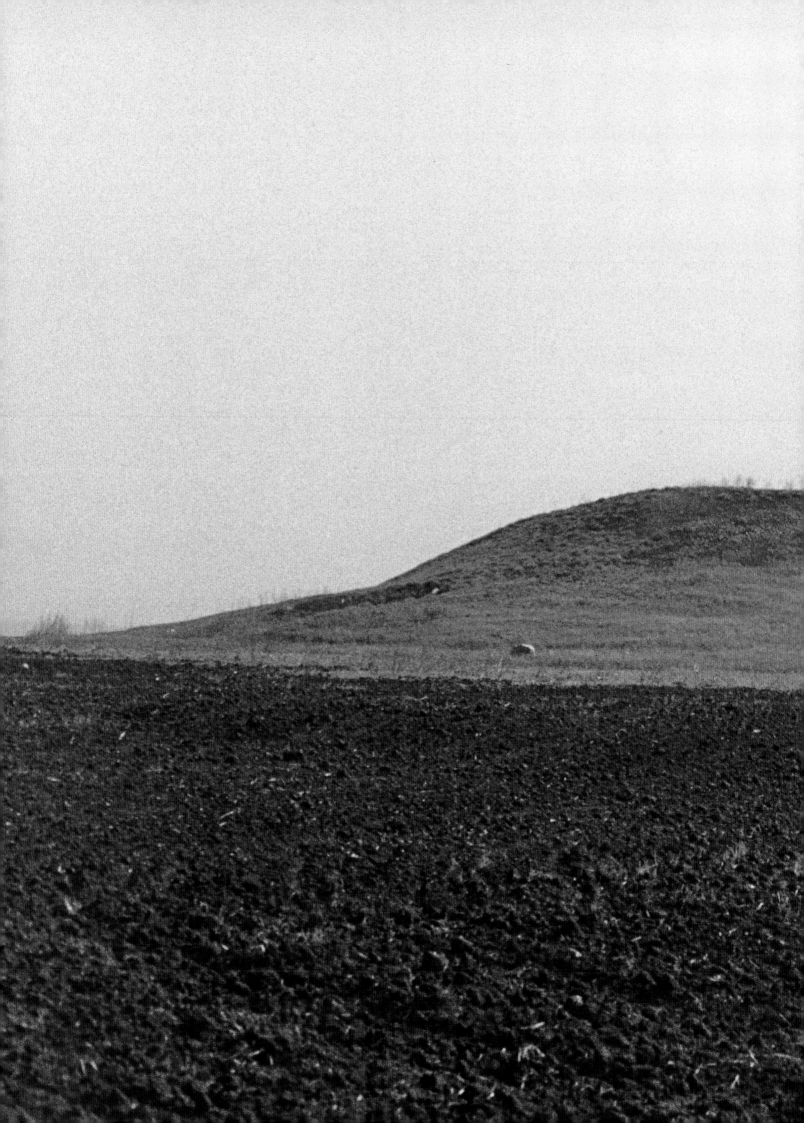

CATALOGUE

MHTU: Museum of Historical Treasures of Ukraine
NMHU: National Museum of the History of Ukraine
AI: Institute of Archaeology
SHAP: State Historical Archaeological Preserve

1

1. PIN

9th–8th c.
Gold, faience, glass inlay
MHTU inv. no. AZS-3774
Cimmerian
From Kurhan 1, burial 3, near village of Vil'shany, Horodyshchens'kyi Raion,
Cherkas'ka Oblast'. Excavated by H. T. Kovpanenko, 1984.
L: 7.8 cm; W: 1.5 cm max; wt: 17.33 g.

Publications: Kovpanenko (1986a), 248; Schleswig, *Gold* (1991), 302, no. 81;Tokyo, *Scythian Gold* (1992), 37, no. 5;
Edinburgh, *Warriors* (1993), 21, no. 8; Toulouse, *L'or* (1993), 46, no 8; Vienna, *Gold* (1993), 78–79, no. 5;
Milan, *Tesori* (1995), 35, 185, no. 8; Luxembourg, *TrésORS* (1997), 61, no. 1. Vicenza, *Oro* (1997), 42, no. 1;

The tapered shaft is surmounted by wrappings of gold wire. Between the shaft and the head of the pin is a
decorative element consisting of spiral wire frames around four inlays of faience and tiny blue glass beads.
The head is an incomplete cylinder, decorated with parallel rows of soldered wire.

The original purpose of this object, which is the only known example of its type, remains unclear. It may
have been a clasp or a pendant worn at the neck, or a scepter finial made in imitation of a *klevets*, a pointed
hammer-like weapon common in central and eastern Europe from the end of the neolithic period. The style
of the decoration is typically Cimmerian, distinguished by a preference for faience inlays, spirals, meander
patterns, single and concentric circles, and wire wrapping.

The pin was found in a Bronze Age mound that contained nine burials of different dates, including one of
a high-born Cimmerian from the ninth to eighth century. The warrior's social standing is suggested by the
richness of the grave goods: arms (more than ninety arrows, two spears, and a sword), five bridle sets, vari-
ous vessels, and gold ornaments.

2. DISC

8th c.
Gold, silver, faience
MHTU, inv. no. AZS-2676
Cimmerian
From Vysoka Mohyla, burial 2, near village of Balky, Vasylivs'kyi Raion,
Zaporizhs'ka Oblast'. Excavated by V. I. Bidzilia, 1971.
D: 3.6 cm; wt: 20 g.

Publications: Bidzilia and Iakovenko (1974), 150, fig. 4.1; Terenozhkin (1976) 29-30, 166, 174, fig. 5.1 ;Schleswig, *Gold* (1991), 301, no. 78; 21-22, no. 9; Edinburgh, *Warriors* (1993), Toulouse, *L'or* (1993), 47, no. 9; Vienna, *Gold* (1993), 80-81, no. 6; Milan, *Tesori* (1995), 36, 186, no. 9; Luxembourg, *TrésORS* (1997), 61, no. 2; Vicenza, *Oro* (1997), 44, no. 3.

Hatched gold wire imitating granulation divides the disc into two concentric bands around a central inlay of pinkish white faience. The outer band consists of flat wire ringlets, the inner one of four raised pellets. On the reverse is a silver loop.

This disc is one of the earliest examples of the polychromed style to have been found in the forest-steppe area around the Dnipro. The Cimmerians probably first learned about faience during their campaigns in Anatolia in the first half of the eighth century.[1] Archaeologists trace the motif of concentric circles as far back as the third millennium. The design was common in the Near East and in the Trypillia, Catacomb, and Zrubne (Timber Grave) cultures of eastern Europe, where it decorated cult objects, bridles, and weaponry.

The disc was found in the tomb of a Cimmerian warrior in the Vysoka Mohyla, or "High Mound." The man had been placed on a grass cushion inside a wooden crib. Beside him were a large clay container, a bit of pyrite for striking fire, and a sword and scabbard with gold ornaments. This disc may have decorated the scabbard strap. A similar plaque was found in another Cimmerian burial in the Cherkas'ka Oblast'.

1. See the essay by Onyshkevych in this volume.

2

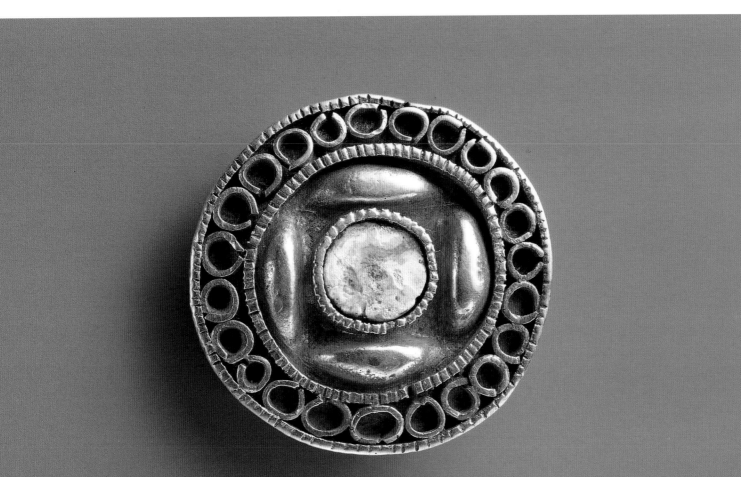

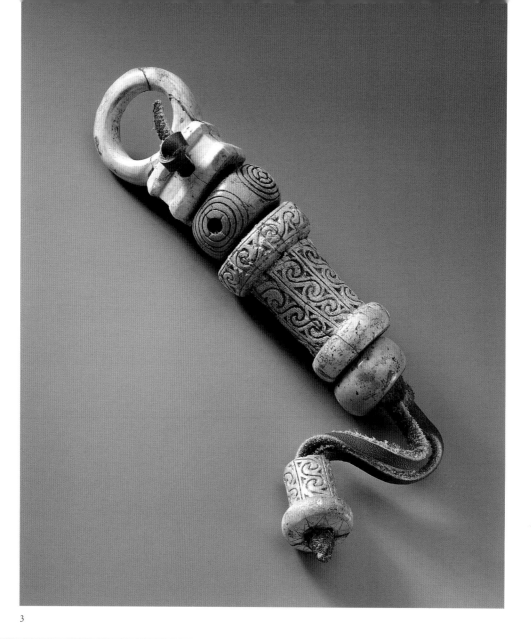

3

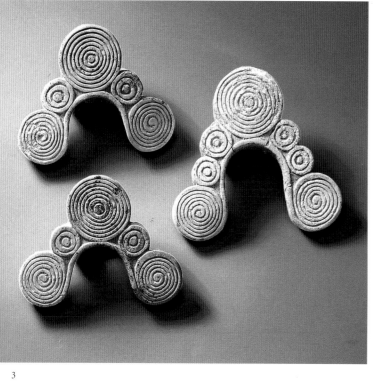

3

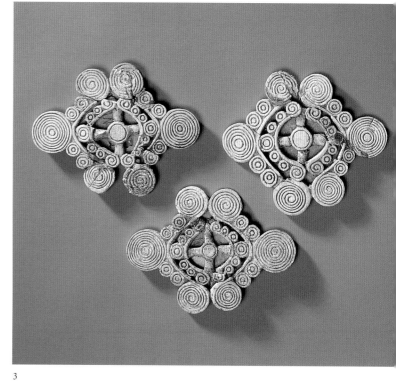

3

3

3. BRIDLE AND WHIP ORNAMENTS

9th–8th c.
Bone, with traces of red pigment
AI, inv. no. AM 657 (a, b, c), AM 656 (d, e, f), AM 658 (whip handle) and separate decorative disc
Cimmerian
From kurhan near village of Zil'ne, Simferopol's'kyi Raion, Krym. Excavated by A. O. Shchepyns'kyi, 1959.
Plaques (a, b, c, AM 657): 8.9 x 7.1 x 2 cm; 9 x 6.2 x 2 cm; 9 x 6.8 x 2 cm. Plaques (d, e, f, AM 656): 5.6 x 5.7 x 2 cm; 5.6 x 5.7 x
2 cm; 5.2 x 4.5 x 2 cm. Whip handle (5 pieces, strung on modern thong, AM 658): overall L: 12 cm; D: (max) 2.5 cm.
Decorative disc (AI 113): D: 3.2 cm; wt: 500 g.

Publications: Shchepinskii (1962), 57–65; Leskov (1974), 24, fig. 35; Milan, *Tesori* (1995), 27;
Rimini, *Mille* (1995), 54–55, nos. 5a, 5b; Katowice, *Koczownicy* (1996), 165, 225, no. 5; Dubovskaia (1997), 62, figs. 1, 3.

The set of burnished bone horse trappings and whip handle includes twelve pieces. There are three lunate plaques (a–c), on which alternate three large and two small discs. The two outermost discs are incised as a volute enclosing the center three discs, which are incised with concentric circles. The plaques have horizontal loops on the back. Three additional plaques (d–f) employ two of the same lunate shapes (with seven discs each) arranged back-to-back to enclose, first, a ring of similar, smaller volutes and circles, and then, a cross-shaped element with a central disc. These have no loops but must have been attached through open spaces on the design. The scored patterns on all of these plaques are accentuated with red ocher. A single disc, with an openwork Maltese cross and bearing a solar symbol in the center, has a bracket on the reverse (h).

The remaining pieces were parts of a whip handle now strung on a modern thong. These include rings, one decorated with incised spokes and concentric ovals (pierced with a bore in one dimension), a collared socket and cylinder incised with an all over running wave pattern, and a coupling with an iron fragment. The incised patterns on the whip handle were filled with black pigment.

The identification of the lunate plaques as bridle decorations is based on the presence of the whip handle and the discovery of a horse bit nearby.

The pattern of concentric circles dominates the decoration of the trappings, and concentric ovals are found on one of the whip handle elements. They appear to reflect a distinct preference of the Cimmerians (see also cat. nos. 1 and 2), a taste that is somewhat different from the Scythian love of volutes.

4. SWORD

9th–8th c.
Iron, bronze
AI, inv. no. z/777/115/1,2
Cimmerian
From Subotivs'ke Horodyshche, near village of Subotiv, Chyhyryns'kyi Raion, Cherkas'ka Oblast'.
Excavated by V. A. Illins'ka and O. I. Terenozhkin, 1971.
Sword: L: 107 cm; W: (hilt): 9.5 cm; L: (all other than blade) 13.5 cm; W: (handle) 6.2 cm.
Scabbard tip: L: 10.2 cm; W: 3.4 cm; wt: 2200 g.

Publications: Terenozhkin (1976), 82–83, fig. 50; Shramko, Fomin, and Solntsev (1977), 63–64;
Katowice, *Koczownicy* (1996), 163, 225, no. 1.13.

The iron sword is double edged and tapers to a point. The bronze haft is decorated with cast coils that imitate wire wrapping. It has a rounded pommel and a simple horizontal crossguard. The cast-bronze chape is rounded at the bottom and has two horizontal flanges, each decorated with hatched lines.

This sword is the oldest long sword made of iron to have been found in eastern Europe. The chape, which protected the point of the sword, is all that remains of a wood and leather scabbard.

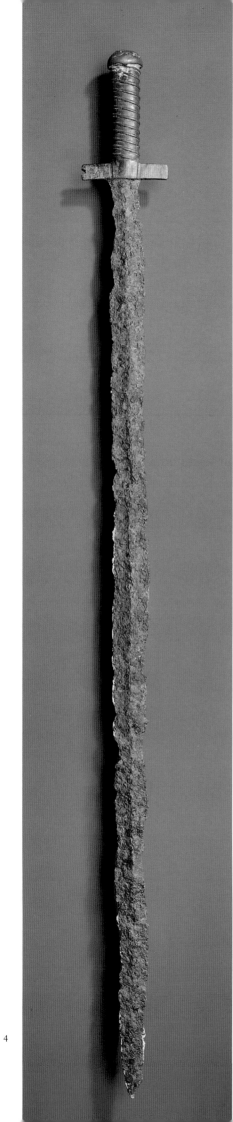

4

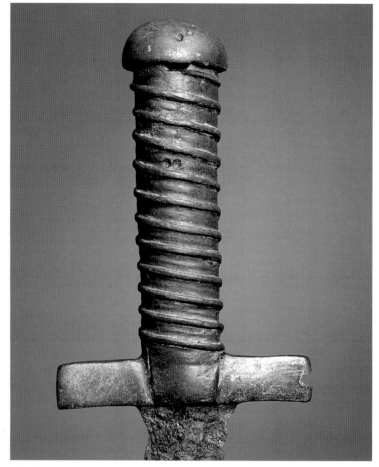

4 detail

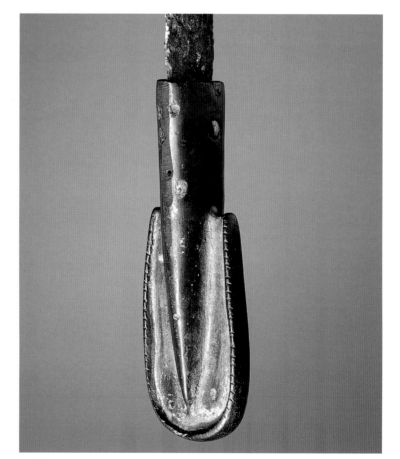

4 detail

5. FIGURAL GROUP

7th–6th c.
Bronze
NMHU, inv. no. B 2699
From the Caucasus. Purchased by NMHU in 1912.
H: (max) 9 cm; L: (max) 17 cm; W: (max) 6 cm; wt: 500 g.

Publications: Tokyo, *Scythian Gold* (1992), 39, no. 9; Toulouse, *L'or* (1993), 50, no. 11; Vienna, *Gold* (1993), 83, no. 8.

The finial's horizontal plate is formed of six large spirals, with two smaller spirals behind them. These extend into long, tapering tails with scored decoration. On top, standing on four of the large spirals, are two primitive figures of riders on horseback. The men's features are barely suggested. Their stallions, with two columnar legs apiece, wear nose- and browbands on elongated heads. Projecting laterally from each side of the plate were three schematic ram heads with wide horns (one now missing). Three of these are still hung with conical bells.

The horses and riders have the tubular bodies and pinched features of crude figures made of clay. They convey no sense of muscle or physical structure, and in this they are quite different from other Scythian representations, which are marked by articulated bodies and distinct juxtaposition of planar surfaces. Objects like this one have been found in Iran and the northern Caucasus. The finial would have been set on a pole, perhaps carried by a rider or attached to a cart, allowing its bells to jingle with the movement. The forms may have been inspired by similar clay figures of riders and chariots that have been found in Mesopotamia and that are believed, like this finial, to have had a cultic purpose.

5

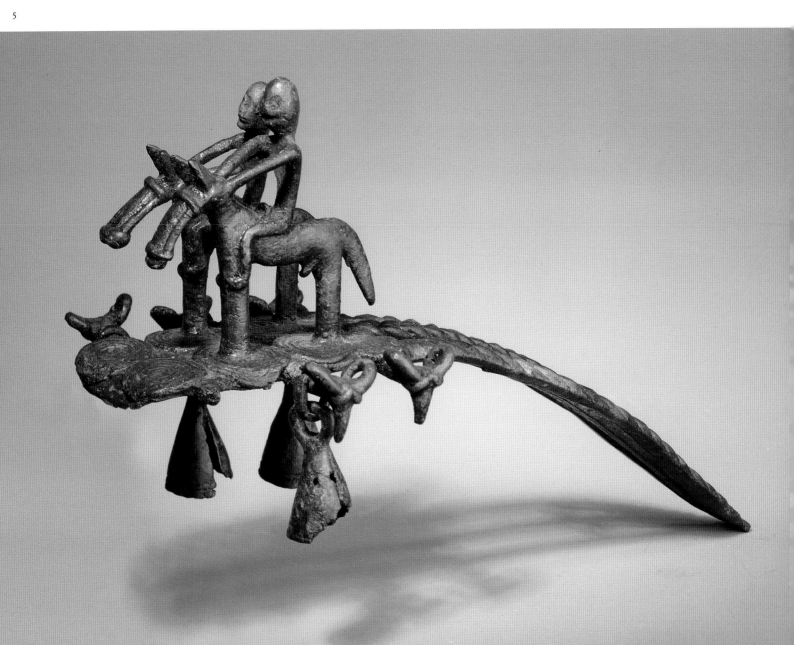

6

6. FIGURAL SCEPTER

7th–6th c.
Bronze
NMHU , inv. no. B 2336
From Siberia. Collection of B. I. and V. N. Khanenko. Year of find unknown.
H: 32 cm; W: 8 cm; wt: 1000 g.

Publications: Tokyo, *Scythian Gold* (1992), 41, no. 14; Toulouse, *L'or* (1993), 50, no. 10; Vienna, *Gold* (1993), 82, no. 7.

The hatchet-shaped scepter and all its details were cast as a single piece in an open mold. The reverse is smooth, flaring at the base, and has a knob in the center of the top. The piece is flat on the front and back, and tapers downward. On the front, a human face is schematically rendered, with round eyes, an oval mouth, and vertical ridges for hair. The horizontal brows are continuous with a straight vertical nose. A raised diagonal element across the hair on the right may represent a snake. On each side a short three-fingered arm emerges above five horizontal ribs. The projection on the lower right appears to be a schematic representation of an ascending animal, its tail and nose connecting with the shaft.

Hatchet-bladed scepters set on the tops of poles were used widely for cultic purposes in Siberia and the Altai. This object, however, shows no sign of attachment, and so it must have been held in the hand. There is some indication of wear at the top.

7. OPENWORK BELT BUCKLE

7th–5th c.
Bronze
NMHU inv. no. B 2698
From Aul Tseia, North Ossetia, Caucasus. Excavation date unknown.
H: 9.5 cm; W: 9.5 cm; wt: 500 g.

Publications: Tokyo, *Scythian Gold* (1992), 40, no. 11; Edinburgh, *Warriors* (1993), 22, no. 12;
Toulouse, *L'or* (1993), 51, no. 12; Vienna, *Gold* (1993), 84–85, no. 9.

Inside the square openwork plaque, a deer or stag stands in right profile, its head turned back in a tight sinuous curve. Its exaggeratedly thin body swells into rounded forms at the haunches and neck. It has a prominent raised eye indented at the pupil, long ears, and a long tongue, the tip of which curls into a volute. Its antlers branch out to meet the frame, which is crosshatched to resemble braided wire. Beneath the animal's body a smaller animal rears up in left profile, its weight on its hind legs, its left front leg extended. The tail curls forward and the tip winds into a spiral. Between the larger animal and the frame is a double reversing volute. There is a boss at each corner of the frame. On the reverse, where the bosses and stag's body are concave, remain fragments of two loops that attached the buckle to a belt.

Belt buckles of this type have been found in South Ossetia, Georgia, and the northern Caucasus. Most archaeologists believe that the type can be traced to Caucasian models from the late Bronze Age and early Iron Age.

In contrast to the forms traditional in Scythian art, those here are smooth, rounded, and unarticulated, except for the rendering of the knees and hocks as right angles. No attempt has been made to represent the antlers as bird heads. The presence of the smaller animal, in a nursing position, indicates that the antlers have devolved into purely stylized ornament, and that this image should be understood as an image of a mother and her young.

7

8. DAGGER WITH SCABBARD ORNAMENT

Late 7th c.–550
Bronze, iron
AI, inv. no. z/857/80 (dagger), z/857/81 (chape)
From Rep'iakhuvata Mohyla, near village of Matusiv, Shpolians'kyi Raion, Cherkas'ka Oblast'.
Excavated by O. I. Terenozhkin, V. A. Illins'ka, B. M. Mozolevs'kyi, 1974.
Overall: L: 33 cm; W: 5.4 cm (max). Chape: L: 7 cm; W: 2.7 cm; wt: 900 g.

Publications: Il'inskaia, Mozolevskii, and Terenozhkin (1980), 41–42, fig. 12; Kossack (1987), 71–76; Polin (1987), 26–27; Rimini, *Mille* (1995), 61, no. 13; Katowice, *Koczownicy* (1996), 169, 226, no. 12.

The iron dagger is heavily corroded; on the underside corrosion has fused the dagger blade and a separate knife. The dagger has a heart-shaped crossguard, ribbed haft, and flat horizontal pommel. Traces of the wooden scabbard were found on the blade.

The rounded end of the cast-bronze chape takes the form of a stylized eagle head, with a protruding spherical eye. The bird's curving beak encloses an oval opening, through which the scabbard was tied to the leg. The opposite end of the chape has a ribbed edge and two holes for attachment to the wooden scabbard. An early example of Scythian art, the chape exhibits a feature familiar on works of later date: a stylized eagle head that forms a terminal, whether for a blade guard, as here, the hilt of a sword (cat. no. 121), or a mirror finial (cat. no. 118).

These pieces were found together with two horse bits, cat. no. 31.

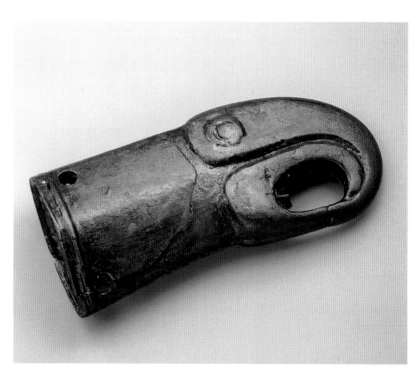

8 detail

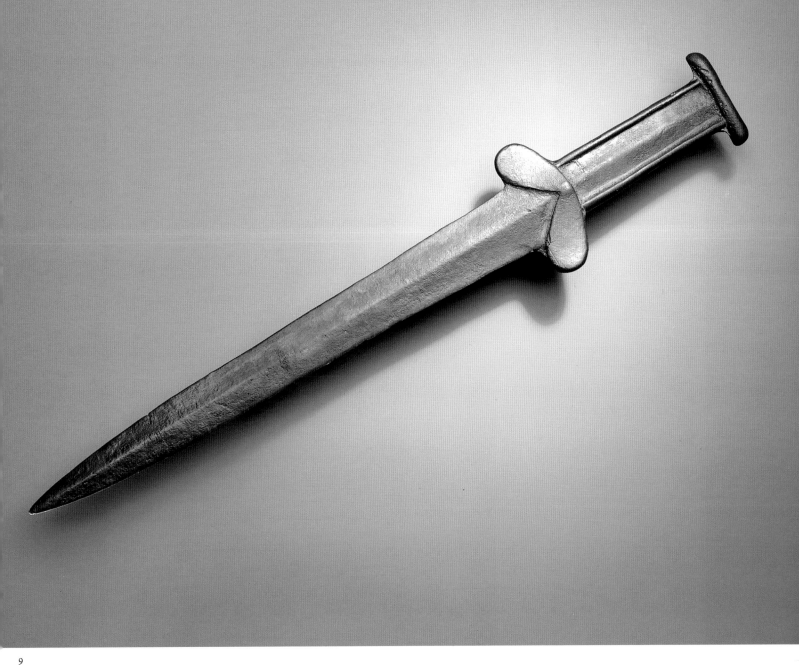

9

9. DAGGER

6th c.
Bronze
NMHU, inv. no. B 1029
From kurhan near village of Kam'ianka, Cherkas'ka Oblast'.
Excavated at the beginning of the 20th century.
L: 39 cm; wt: 700 g.

Publications: Bobrinskii (1901), 146, pl. xv(5); Il'inskaia (1975), 98, fig. 6;
Turku, *Skyyttien* (1990), 48, no. 30; Tokyo, *Scythian Gold* (1992), 49, no. 30.

The short, cast sword has two ribs along the sides of the hilt, a flat rectangular pommel, and a heart-shaped crossguard. The blade has a central rib.

A short sword, called an *akinak*, was a key part of the Scythian warrior's equipment in life and death. Examples are found in male burials of both rich and poor, and sometimes in female burials as well. The short iron swords also played a role in the worship of the war god Ares. According to Herodotus (4.60–62), a sword was planted at the top of immense brush heaps that served as altars to the god.

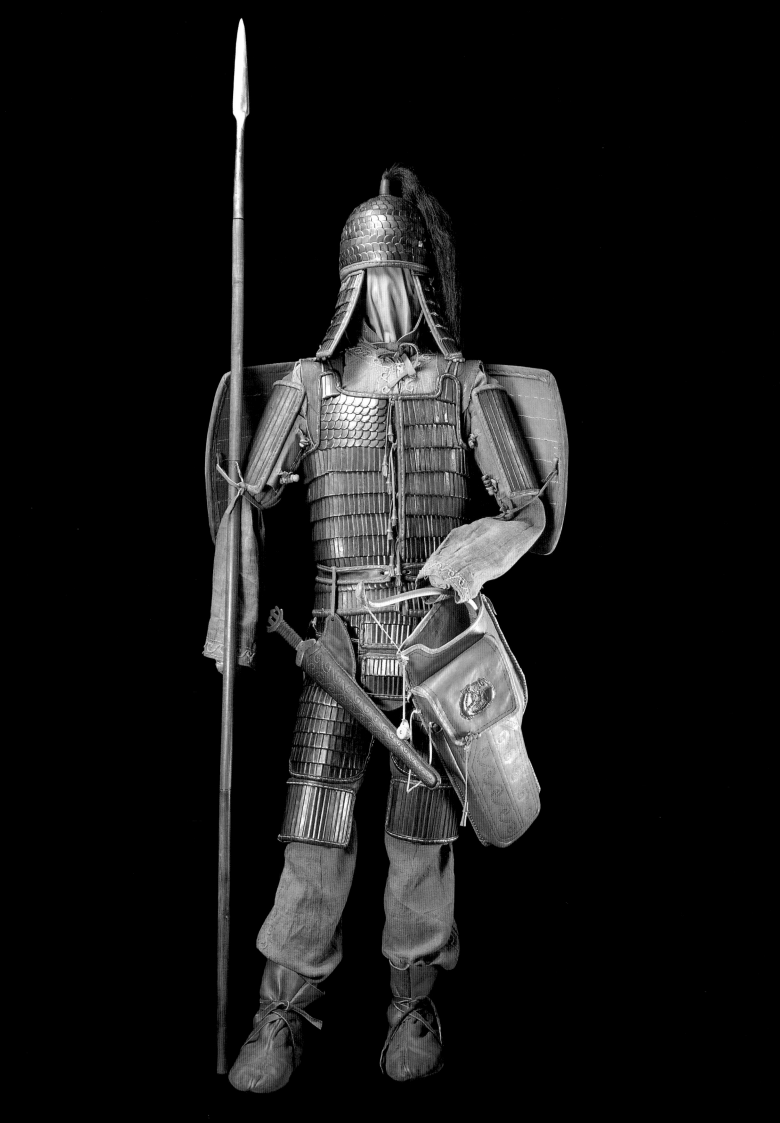

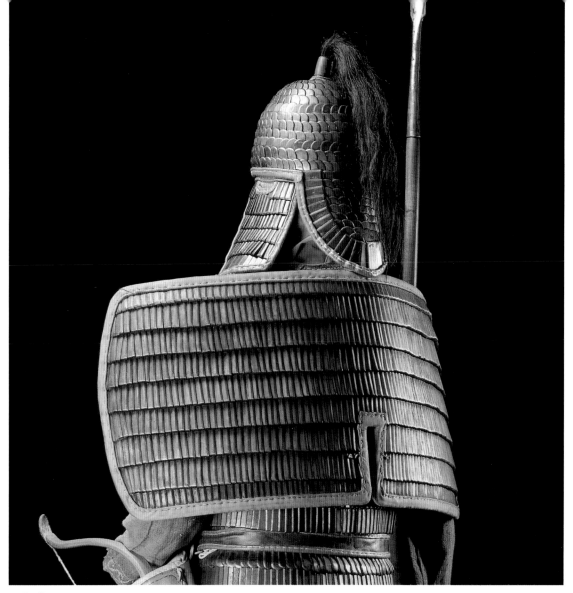

10 detail

Opposite: 10

10. COSTUME (MODERN) OF A SCYTHIAN WARRIOR OF THE 5TH–4TH C.

Leather, iron, wood, bronze, horsehair, fabric
MHTU, inv. no. TV-2605
Reconstruction by O. I. Minzhulin, based on excavated material from
Kurhan 2, near Hladkivshchyna, Zolotonos'kyi Raion, Cherkas'ka Oblast'. Excavated by V. P. Hryhoriev, 1982.
Helmet: H: 39 cm. Shield: H: 94 cm; W: 39 cm. Mailshirt: H: 112 cm; W: 49 cm.
Breeches: H: 70 cm; W: 54 cm. Sword: L: 51 cm. Cover: L: 51 cm; W: 29 cm. Bow: L: 72.5 cm.

Publications: Minzhulin (1988), 116–26, figs. 1–4;
Tokyo, *Scythian Gold* (1992), 103, no. 122.

This reconstruction reproduces the costume of a Scythian warrior based on finds from a tomb of the fifth to fourth century. The figure wears a linen undergarment. His armor, consisting of helmet, shirt, leg coverings, and shield, is made of leather covered with iron plates. His weapons include an iron sword, and a bow and bronze-tipped arrows in a gorytos. (The gorytos itself was not uncovered in the tomb and is based on other evidence.) The entire panoply, including garments and footwear, weighs 22.7 kg. The ensemble would have taken a team of twelve to fifteen craftsmen approximately four months to make.

Plated helmets with cheek and neck flaps gained currency in Scythia in the fifth to fourth century. Two such helmets have been recovered intact, one at Nova Rozanivka (Mykolaivs'ka Oblast'), the other at Oleksandrivka (Dnipropetrovs'ka Oblast'). Plated body armor was also common. More than four hundred examples, dating between the sixth and fourth centuries, have been found in the area north of the Black Sea and in the northern Caucasus. A late-seventh-century tomb in Kostroms'kyi Kurhan yielded an iron-plated shield of the type that can also be seen in cat. no. 124.

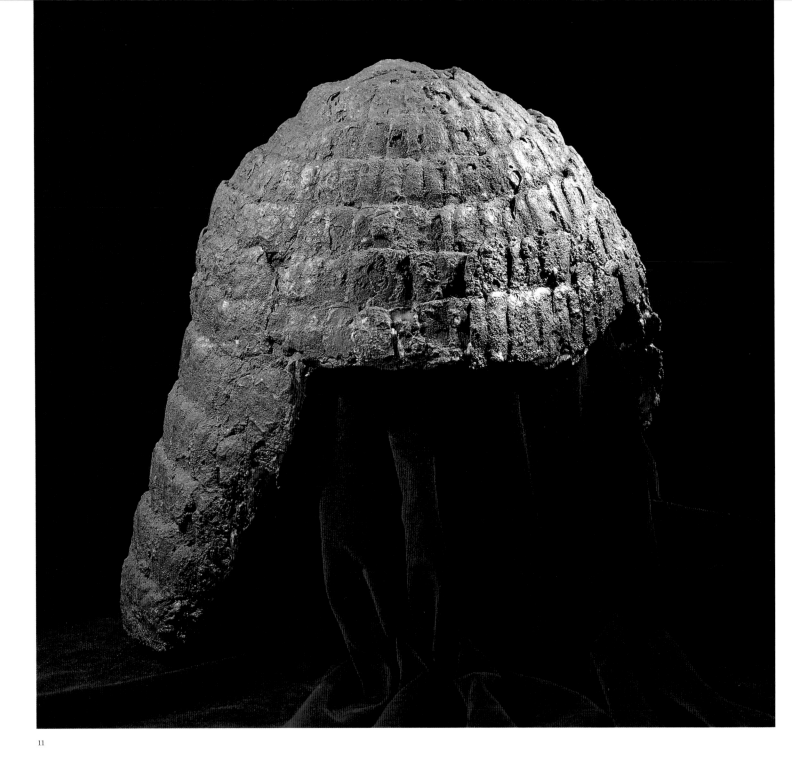

11

11. HELMET

5th c.
Iron
SHAP, Pereiaslav-Khmel'nyts'kyi, inv. no. A-969
From Kurhan 2, burial 1, near village of Novofedorivka, Khersons'ka Oblast'. Excavated by O. V. Symonenko, 1981.
H: 75.3 cm; W: 65 cm; D: 42 cm; wt: 3000 g.

Publications: Katowice, *Koczownicy* (1996), 171, 227, no. 17.

The iron-scale helmet has cheekpieces of trapezoidal shape.

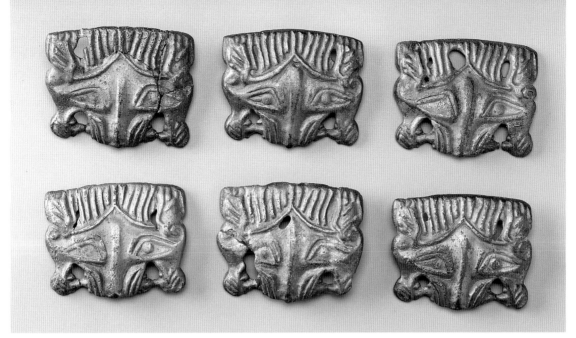

12

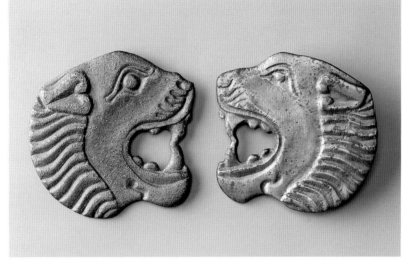

12

12. BELT PLAQUES

5th c.
Bronze
NMHU, inv. no .B 738/1–3, 5, 8, 10; B 739/1–2
From Kurhan 4, Berestniahy, Kanivs'kyi Raion, Cherkas'ka Oblast'. Excavated by Ie. O. Znos'ko-Borovs'kyi, 1897.
Frontal Lion Masks (B 738/1-3, 5, 8, 10): H: 4.7 cm; W: 5.9 cm. Profile Lion Heads (B 739/1-2): H 6.9 cm; W: 7.7 cm; total wt: 400 g.

Publications: Khanenko and Khanenko (1900), pl. vi; Bobrinskii (1901), 94–97; Petrenko (1967),
pl. 37–17; Chernenko (1968), 66–67, fig. 36; Tokyo, *Scythian Gold* (1992), 52, no. 37.

The cast plaques are of two designs. The large plaques are mirror images of each other: profile lion heads with open jaws exposing the animal's teeth and fangs. Upper and lower fangs meet, creating an openwork effect. Details of the lion's faces and ears are indicated, and their manes are rendered by grooves. The smaller plaques are frontal masks of lion heads with highly stylized features. On the reverse are loops for attachment. These plaques were attached to a leather baldric, the belt that was worn over the shoulder to carry a scabbard. The leather strap must have passed through the openings in the lions' mouths and have been fastened in front. Gold plaques with stylized frontal heads of a tiger decorated the borders of the garment worn by the Golden Man from Issyk, from eastern Kazakhstan, of the fifth to fourth century.[1]

The plaques were found together with cat. no. 53.

1. Schiltz, *Scythes* (1994), 299–302; Mantua, *L'uomo d'oro* (1998), 179. See the essay by Reeder in this volume.

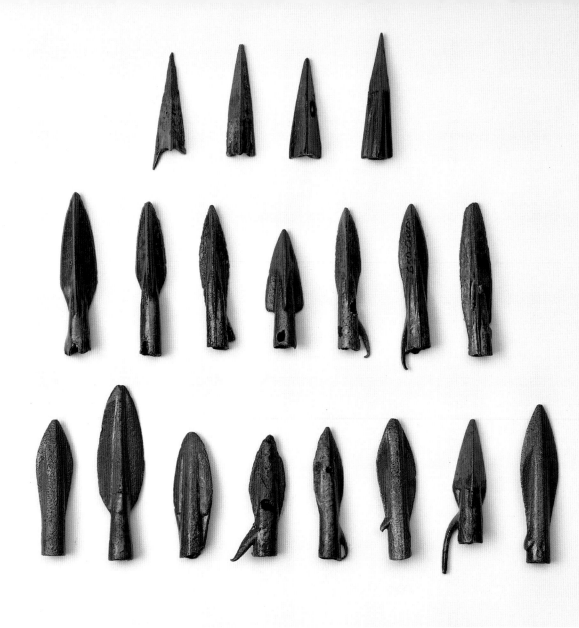

13. ARROWHEADS

6th–4th c.
Bronze
NMHU, inv. no. B 50–272; B 28-4239
From Rivne, Cherkas'ka Oblast'. O. O. Bobryns'kyi collection.
Arrowheads (B 50-272, 10 pieces): L: 1.5–5.0 cm.
Arrowheads (B 28-4239, 10 pieces): L: 1.5–5.0 cm; total wt: 200 g.

Publications: Bobrinskii (1894), pl. iv; Petrenko (1967), 44–48, pl. 34; Tokyo, *Scythian Gold* (1992), 49, no. 32; Rimini, *Mille* (1995), 61, no. 15.

The cast arrowheads represent many common types, including socketed, bi- and trilobate, and barbed examples.

The differing forms of these arrowheads represent not only different designs that were in use over a three-hundred-year span, but also the requirements of different targets. If the prey was a bird, for example, the archer aimed for the eye and so used a small tip. Barbs made removal difficult, and holes increased an arrow's flight. It is estimated that a pierced trilobate arrow shot from a compound bow would attain speeds up to 50 meters per second, about what can be achieved by a modern crossbow.[1] The arrow shafts were made of soft wood with feathered tips, and Scythian men carried them in the same case (gorytos) as their bows. Gorytoi have been found that included as many as 211 arrowheads.

1. Taylor (1994), 381.

14. DECORATIONS FOR A WHIP

4th c.
Gold
MHTU, inv. no. AZS-2489; AZS-2491/1–18
From Tovsta Mohyla, near Ordzhonikidze, Dnipropetrovs'ka Oblast'. Excavated by B. M. Mozolevs'kyi, 1971.
Plaque (AZS-2489): L: 30.0 cm; wt: 25.37 g.
Bead (AZS-2491/1): H: 1.7 cm; D: 1.6 cm; wt: 1.61 g. Bead (AZS-2491/2): H: 1.7 cm; D: 1.6 cm; wt: 1.36 g.
Bead (AZS-2491/3): H: 1.7 cm; D: 1.6 cm; wt: 1.48 g. Bead (AZS-2491/4): H: 1.7 cm; D: 1.6 cm; wt: 1.53 g.
Bead (AZS-2491/5): H: 1.7 cm; D: 1.6 cm; wt: 1.28 g. Bead (AZS-2491/6): H: 1.7 cm; D: 1.6 cm; wt: 1.28 g.
Bead (AZS-2491/7): H: 1.7 cm; D: 1.6 cm; wt: 2.48 g. Bead (AZS-2491/8): H: 1.7 cm; D: 1.6 cm; wt: 1.42 g.
Bead (AZS-2491/9): H: 1.7 cm; D: 1.6 cm; wt: 1.41 g. Bead (AZS-2491/10): H: 1.7 cm; D: 1.6 cm; wt: 1.65 g.
Bead (AZS-2491/11): H: 1.7 cm; D: 1.6 cm; wt: 1.12 g. Bead (AZS-2491/12): H: 1.7 cm; D: 1.6 cm; wt: 1.44 g.
Bead (AZS-2491/13): H: 1.7 cm; D: 1.6 cm; wt: 1.49 g. Bead (AZS-2491/14): H: 1.7 cm; D: 1.6 cm; wt: 1.58 g.
Bead (AZS-2491/15): H: 1.7 cm; D: 1.6 cm; wt: 1.49 g. Bead (AZS-2491/16): H: 1.7 cm; D: 1.6 cm; wt: 1.35 g.
Bead (AZS-2491/17): H: : 1.7 cm; D: 1.6 cm; wt: 1.36 g. Bead (AZS-2491/18): H: 1.7 cm; D: 1.6 cm; wt: 1.28 g.

Publications: Mozolevs'kyi (1979), 69; Tokyo, *Scythian Gold* (1992), 60, no. 47.

The whip is reconstructed on a wooden handle. Wrapped in eleven spirals around it is a ribbon-like gold strip (now in four fragments) bordered by rows of punched dots. Holes on each of the two rounded ends of the strip were for attachment to the shaft. From the handle extends a chain of eighteen biconical beads. These are formed of sheet gold and soldered at the seam. Thin wires are soldered at each end.

Whips were important tools in a culture so dependent on the horse. They are often found in burials, including those of wealthy Scythian women, and are also depicted on stone steles. This example is unique in having a beaded chain, which would have embellished the whip not only with gold decoration but also with sound. Other whips are represented in the exhibition by the similar gold winding strips from Soboleva Mohyla (cat. no. 156) and by the Cimmerian bone handle (cat. no. 3). Gold strips were also used to decorate the handles of axes.

A similar whip accompanied the Golden Man from Issyk, discovered in eastern Kazakhstan.[1]

1. Schiltz, *Scythes* (1994), 299–302; Mantua, *L'uomo d'oro* (1998), 179.

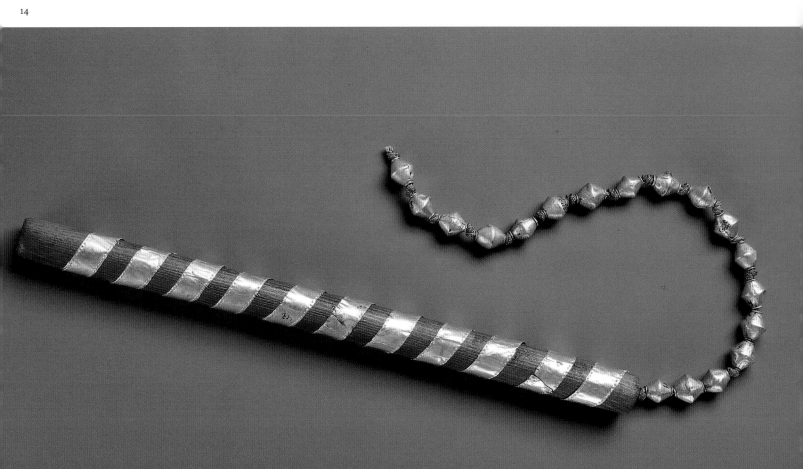

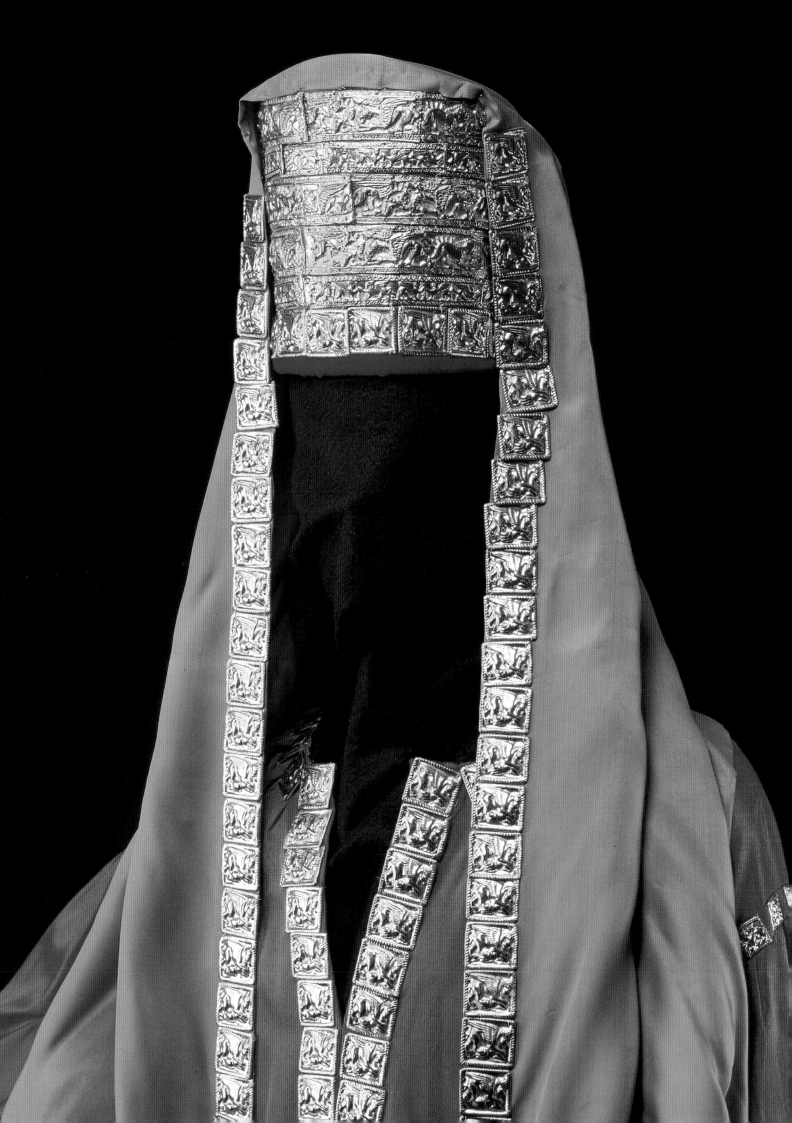

15. COSTUME (MODERN) OF A SCYTHIAN WOMAN OF THE 4TH C.

Textile, leather, copper
MHTU, inv. no. NDF-251, 252, 259, 392, 394, 395
Reconstructed by B. M. Mozolevs'kyi, L. S. Klochko, based on excavated materials from Tovsta Mohyla, burial 2,
near Ordzhonikidze, Dnipropetrovs'ka Oblast'. Excavated by B. M. Mozolevs'kyi, 1971.
Lifesize.

Publications: Mozolevs'kyi (1979), 198–209; Klochko (1992), 21, fig. 3.

The costume includes a headdress, garment, and shoes. The headdress comprises a cap supported on willow twigs and a separate shoulder drape. The cap is decorated with five horizontal relief bands, depicting 1) griffins in combat, 2) heraldic winged sphinxes, 3) griffins in combat, 4) winged griffins and other mythological creatures, and 5) heraldic sphinxes. Square plaques decorating the bottom of the cap and the edges of the head drape bear images of a griffin in right profile. The dress (made of satin in the reconstruction) is decorated at the neckline with square plaques that depict a griffin attacking a doe. Those on the sleeves depict a lion-griffin, a lion attacking a doe, a sphinx, and a woman mounted on a bird. Each shoe is reconstructed of a single piece of leather with a center seam that is ornamented with gold cross-shaped appliques. The costume is based on and employs many of the finds from the rich grave of a Scythian woman, who had been buried with servants to attend her in the afterlife. The position of the gold appliques around the body enabled archaeologists to reconstruct the woman's dress.

16. WOMAN'S HEADDRESS

ca. 350
Gold, cloth
AI, inv. no. Z-1204, 1210, 1214, 1215, 1218, 1222–1224, 1226, 1227, 1237, 1242, 1243,
1245, 1253, 1255–1259, 1261, 1265, 1268, 1274, 1279, 1280, 1283, 1289–1419, 1421–1503
From Tetianyna Mohyla, near Ordzhonikidze, Dnipropetrovs'ka Oblast'. Excavated by V. I. Murzin, R. Rolle, 1986.
Plaques (9): 1.7–1.8 x 1.7–1.8 cm. Plaques (10): 2.3–2.5 x 2.4–2.5 cm. Plaques (30): 2.6–2.7 x 2.6–2.7 cm.
Plaques (51): 2.3 x 2.3 cm. Plaques (15): 1.7–1.8 x 1.7–1.8 cm. Plaques (15): 1.7–1.8 x 1.5–1.55 cm.
Plaques (30): 1.6–1.7 x 1.2–1.3 cm. Plaques (38): 1 x 1 cm. Plaques (39): 1.8 x 1.8 cm. Total wt: 150.65 g.

Unpublished.

The woman's headdress, reconstructed with modern fabric, consists of a conical cap and separate drape. Decorating it are 243 gold plaques that were found in one kurhan. They include flat plaques with large nine-petal rosettes, convex plaques with fourteen-petal rosettes, plaques decorated with lotuses or palmettes, plaques depicting Gorgon heads in high relief, plaques with a bearded head, and, finally, plaques with five bosses arranged as a quatrefoil around a central hub.

The design of many of these plaques can be paralleled in other ornaments used as headdress or garment appliques, or as other ornaments. In particular, the plaques with bosses reappear on the shoes from the same burial (cat. no. 17). They also recall similar groups of three hemispheres on the appliques found in Mohyla Ternivka and employed in the reconstruction of the headdress, cat. no. 43.

The headdress was found together with cat. nos. 17 and 108.

Opposite: 15 detail

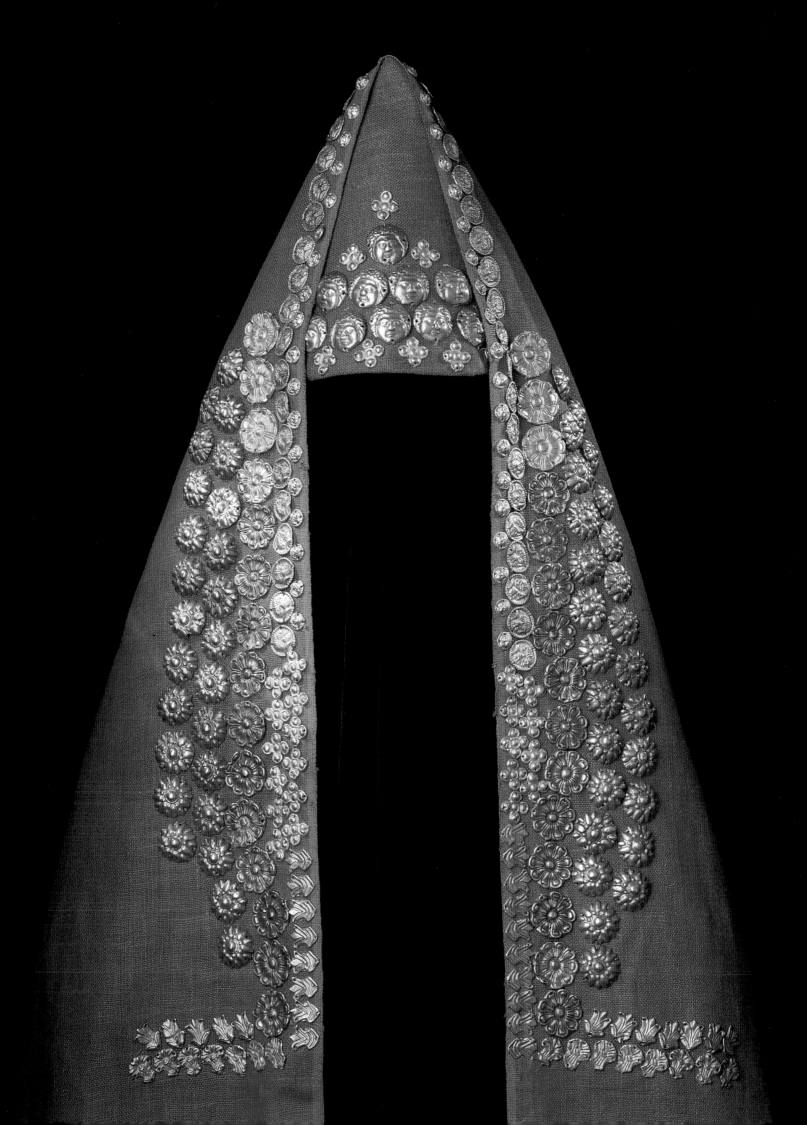

17. PAIR OF SHOES

ca. 350
Gold, woolen cloth
AI inv. no. Z-1181, 1183, 1188, 1192, 1194–1196, 1198–1200, 1202, 1203, 1205–1209, 1212
From Tetianyna Mohyla, near Ordzhonikidze, Dnipropetrovs'ka Oblast'.
Excavated by V. I. Murzin, R. Rolle, 1986. Reconstructed by O. I. Fialko.
H: 1.7–1.8 cm each; W: 1.7–1.8 cm each; D: 0.2 cm each; wt: 9.68 g (for 22 items).

Publications: Prilipko and Boltrik (1991), 18–33; Murzin, Polin, and Rolle (1993), 85–101.

The shoes are decorated along the single, front seam and around the ankle opening with gold plaques of four hemispherical bosses arranged like petals around another central boss (compare cat. no. 43). They were found in the same kurhan that yielded the plaques of the headdress, cat. no. 16. Gold plaques attached to shoes have been recovered from several steppe burials of the fourth century, including those from Melitopol's'kyi Kurhan and Tovsta Mohyla. But it was the discovery of an undecorated but more completely preserved pair of shoes in the grave of a girl from Vyshneva Mohyla that provided the information on which this reconstruction is based.

These shoes were found together with cat. nos. 16 and 108.

17

Opposite: 16

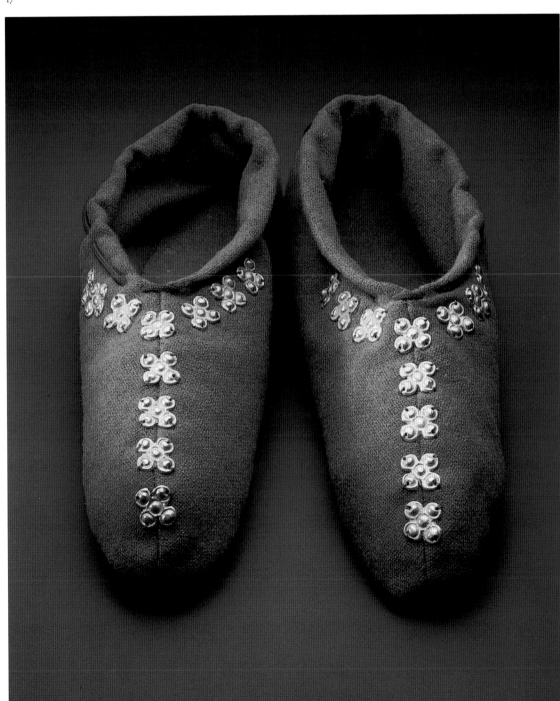

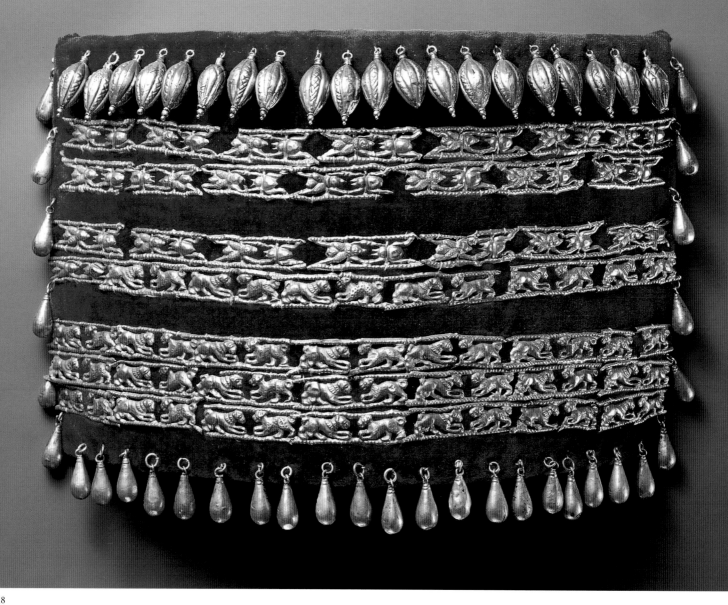

18. PLAQUES FOR CLOTHING

4th c.
Gold
MHTU, inv. no. AZS-1371/1–13; AZS-1402; AZS-1335/1–14; AZS-1372/15–28;
AZS-1339/1–20; AZS-1346/21–32; AZS-1329/14–20; AZS-1393; AZS-1338/1–20
From Melitopol's'kyi Kurhan, burial 1, Melitopol', Zaporizhs'ka Oblast'. Excavated by O. I. Terenozhkin, 1954.
Plaques (13) with image of spider and bee (AZS-1371/1–13): 3.5–4.3 x 1.1–1.5 cm; wt: 10.22 g.
Plaques (7) with image of spider and bee (AZS-1329/14–20): 3.5–4.3 x 1.1–1.5 cm; wt: 5.63 g.
Plaque with image of spider and bee (AZS-1393): 3.5–4.3 x 1.1–1.5 cm; wt: 0.64 g.
Plaque with image of spider and bee (AZS-1402): 3.5–4.3 x 1.1–1.5 cm; wt: 0.72 g.
Plaques (14) with image of lion and leopard (AZS-1335/1–14): 4.0–4.8 x 1.2–1.8 cm; wt: 13.56 g.
Plaques (14) with image of lion and leopard (AZS-1372/15–28): 4.0–4.8 x 1.2–1.8 cm; wt: 14.24 g.
Pendants (20) (AZS-1339/1–20): H: 3.1 cm; wt: 30.93 g. Pendants (20) (AZS-1338/1–20): H: 1.8 cm; wt: 17.51 g.

Publications: Hanina (1974), figs. 25, 27; New York, *Scythians* (1975), 127, no. 178, pl. 30;
Terenozhkin and Mozolevskii (1988), 93, 97, figs. 98.4, 7, 11, 14, 103; Tokyo, *Scythian Gold* (1992), 96, no. 104 b–c;
Milan, *Tesori* (1995), 96, 202, no. 51; Luxembourg, *TrésORS* (1997), 96, no. 49.

This assemblage of ornaments includes amphora-shaped pendants with alternating smooth and hatched ribs, plain teardrop-shaped pendants, and seven openwork bands. These bands are composed of relief plaques that represent confronted insects (spiders and bees) and felines (lions and spotted leopards). Each plaque is framed by beaded borders above and below.

The plaques and pendants surely decorated clothing; their current arrangement is not based on archaeological evidence.

19. HEADDRESS PENDANTS WITH GRIFFIN ATTACK

4th c.
Gold
MHTU, inv. no. DM-6435–6436
From Kurhan 4, near village of Novosilky, Monastyrshchens'kyi Raion, Cherkas'ka Oblast'.
Excavated by A. Bydlovs'kyi, 1901.
Pendant (DM-6435): H: 16.5 cm; Plate: H: 5.5 cm; W: 4.3 cm; wt: 31 g.
Pendant (DM-6436): H: 16.7 cm; Plate: H: 5.5 cm; W: 4.3 cm; wt: 37.6 g.

Publications: Bydlowski (1904), 53; Hanina (1974), fig. 8; Klochko (1986), 16, fig. 3; Tokyo, *Scythian Gold* (1992), 89, no. 98; Vienna, *Gold* (1993), 152–53, no. 35; Schiltz, *Scythes* (1994), 378, fig. 296; Milan, *Tesori* (1995), 91, 193, no. 43; Luxembourg, *TrésORS* (1997), 99, no. 54; Vicenza, *Oro* (1997), 87, no. 43.

These pendants were attached by clips, still extant on the back, to a woman's headdress. The square plaques with bow-shaped tops and beaded borders are decorated with a griffin in left profile, which plants a leg on the bare chest of a man who collapses on his right elbow while he holds a sword in his right hand. His right knee is drawn up. In the bow-shaped crown are two plants, each with a central bud, perhaps lotuses. Triangular pendants are linked in five vertical rows, the top of each connected to the base of the one above by loops of wire. The pendants are also attached horizontally. Two oval pendants hang freely like tassels from the base of each triangle. The outside triangular pendants have additional ovals attached at the sides. The lowest row of pendants consists of ovals only. The oval pendants have vertical flutes and a central branch motif; the triangular pendants bear two horizontal rows of beading.

The outsize scale of the ornaments speaks to the importance of self-presentation in a nomadic culture. The rustle that the pendants make is further evidence of the Scythian appreciation of sound (see also cat. nos. 36-39).

19

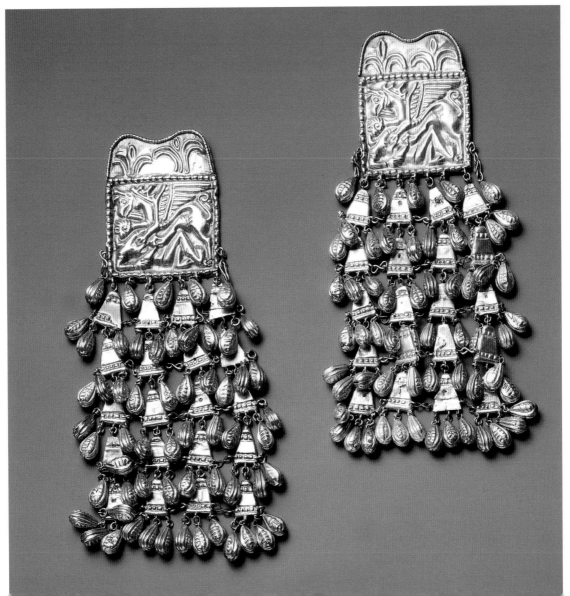

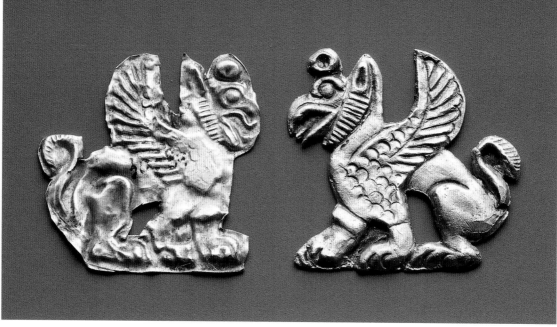

20

20. TWO PLAQUES IN THE FORM OF GRIFFINS

Late 7th c.
Gold, gilt silver
MHTU, inv. no. AZS-1640, AZS-984/8
From Kurhan Perep'iatykha, near village of Mar'ianivka, Vasyl'kivs'kyi Raion, Kyivs'ka Oblast'.
Excavated by M. D. Ivanisheva, 1845.
Plaque (AZS-1640; gilt silver): H: 2.7 cm; W: 3 cm; wt: 1.3 g. Plaque (AZS-984/8; gold): H: 2.7 cm; W: 2.8 cm; wt: 0.93 g.

Publications: Hanina (1974), fig. 3; Skoryi (1990), 38–43, pl. 7.2.5; Toulouse, *L'or* (1993), 74, nos. 46, 47; Luxembourg, *TrésORS* (1997), 89, no. 38.

The plaques, originally attached to clothing, take the form of eagle-headed griffins seated in left profile. Each has upturned wings, a curled tail, short beak, and a protrusion on the top of the head in the form of a sphere or volute. On the griffins' necks, a series of ridges forms a short ruff or mane.

Ultimately the knob on the head seems to have originated in the Near East.[1] The upright pose and short beak find parallels among Achaemenid (Persian) objects, although these features, as well as the upturned wings, could have been known to the Scythians through both Greek and Near Eastern prototypes. A comparable griffin plaque was found in Kurhan Perep'iatykha.[2]

1. See the essay by Reeder in this volume.
2. Skoryi (1996), pl. 5.

21 detail

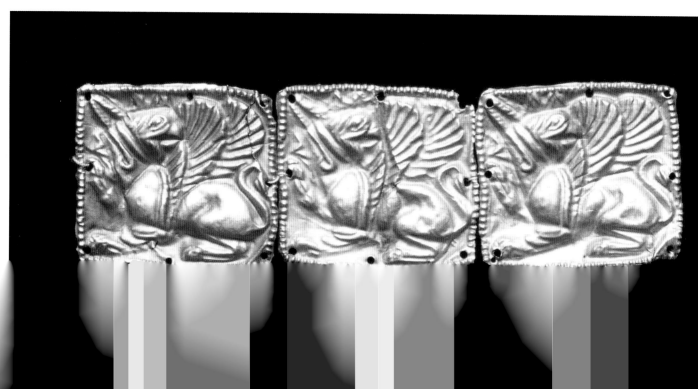

21. GROUP OF PLAQUES WITH GRIFFINS

4th c.
Gold
MHTU, inv. no. AZS-3077/65–87
From Berdians'kyi Kurhan, central burial chamber, near village of Novovasylivka, Berdians'kyi Raion, Zaporizhs'ka Oblast'.
Excavated by M. M. Cherednychenko, 1978.
H: 3.8 cm; L: 4.3 cm; wt: 78.66 g.

Publications: Cherednychenko and Murzin (1996), 69–78.

These square relief plaques, intended for clothing, are framed with delicate beaded borders. Inside, in left profile, is a relief depicting a crouching eagle-headed griffin, its right front paw raised, its head turned back toward its two flared wings and curled tail. Small holes around the perimeter were for attachment. The present configuration is modern.

Borrowed from the ancient Near East, the griffin was a popular motif in Scythian art. Its pose here, with head turned back, may have been inspired by Near Eastern sources, but it also closely echoes the traditional Scythian manner of representing the stag (see cat. no. 44).

These plaques were found together with cat. no. 131.

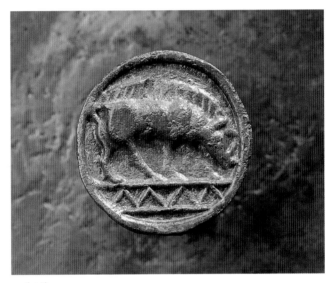

22 detail

22. MIRROR

ca. 550
Bronze
NMHU, inv. no. B 760
From Kurhan 35, near village of Bobrytsia, Kanivs'kyi Raion, Cherkas'ka Oblast'. Excavated by Ie. O. Znos'ko-Borovs'kyi, 1897.
D: (disc) 14 cm; H: (handle) 3 cm; D: (plaque) 2.7 cm; wt: 700 g.

Publications: Khanenko and Khanenko (1900), pl. lviii, b; Bobrinskii (1901), 112–14, pl. xix, fig. 62; Kaposhina (1958a), 182, fig. 22.

The cast-bronze mirror has a plain disc and a vertical, fluted handle on the reverse. The end of the handle widens into a medallion decorated in relief with an image of a grazing boar in right profile. The animal stands on a groundline indicated by two horizontal ridges enclosing a zigzag pattern.

Most early Scythian mirrors are of this type, with a central vertical handle. On a similar example, dated from the seventh to sixth century and found in Kelermes, the handle is decorated with a feline.[1] It is believed that the type originated in China.[2]

The mirror was found together with two plaques in the form of horses, cat. no. 45.

1. Schiltz, *Scythes* (1994), 114, pl. 85.
2. Jacobson (1995), 182; Jacobson (1993), 154.

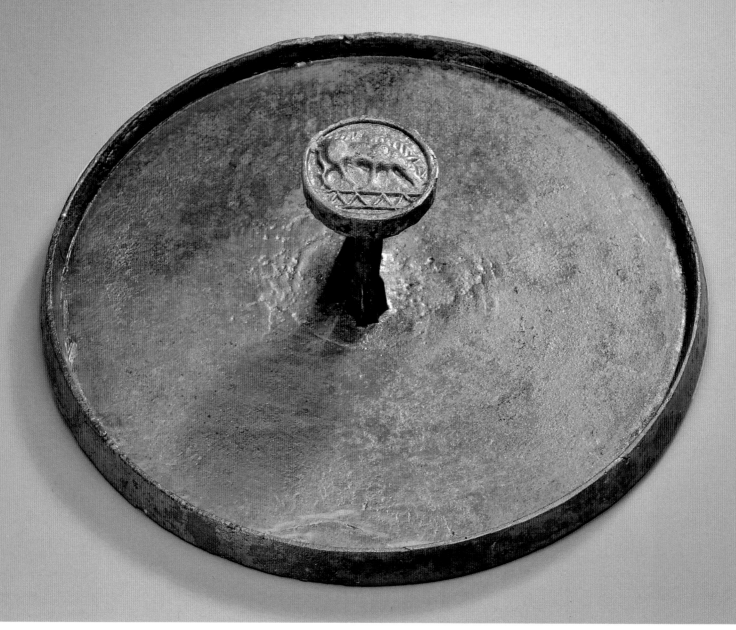

23. HATCHET

5th c.
Bronze
MHTU inv. no. AZS-3301
From Kurhan 18, burial 2, in village of L'vove, Beryslavs'kyi Raion, Khersons'ka Oblast'. Excavated by A. I. Kubyshev, 1977.
L: 12.4 cm; W: 7.3 cm; wt: 700 g.

Publications: Kubyshev, Nikolova, and Polin (1982), 140–41, 147, fig. 10; Turku, *Skyyttien* (1990), 11, 56, no. 11;
Schleswig, *Gold* (1991), 303, no. 87; Tokyo, *Scythian Gold* (1992), 52, no. 36; Schiltz, *Scythes* (1994), 393, fig. 319.

Opposite: 23

The cast hatchet has a curved blade, which shows wear. The sides of the blade curve into one or two arcs. The end opposite the blade takes the shape of an eagle-griffin, with ears pricked and beak open. The arched neck is accentuated by a scalloped crest along the nape and by bands of cast and engraved ornament down the neck. The eyes are electrum.

This hatchet was recovered from a male burial in a fourth-century mound that included five tombs and yielded many objects of the fifth and fourth centuries.

When the hatchet was in use, the animals would have seemed to be in motion. Similar axe heads with engraved animal images were found in the necropolis of Koban.[1]

1. Vienna, *Skythen* (1988), 35, no. 6, and 36, no. 7.

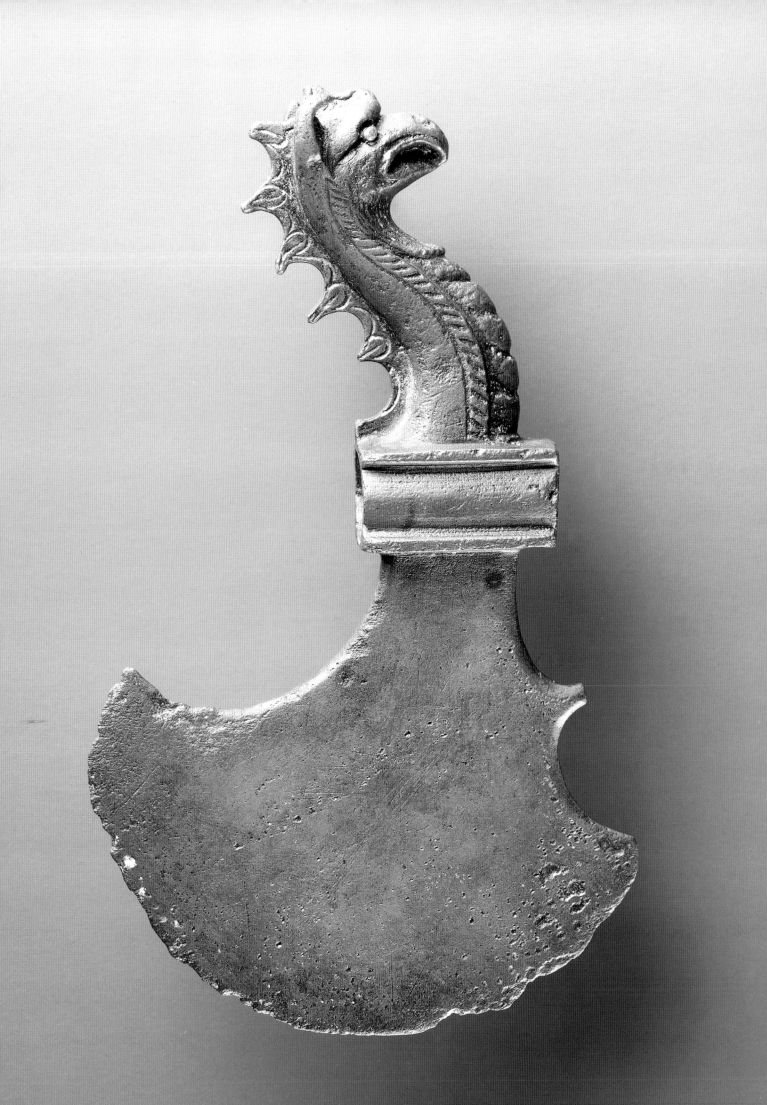

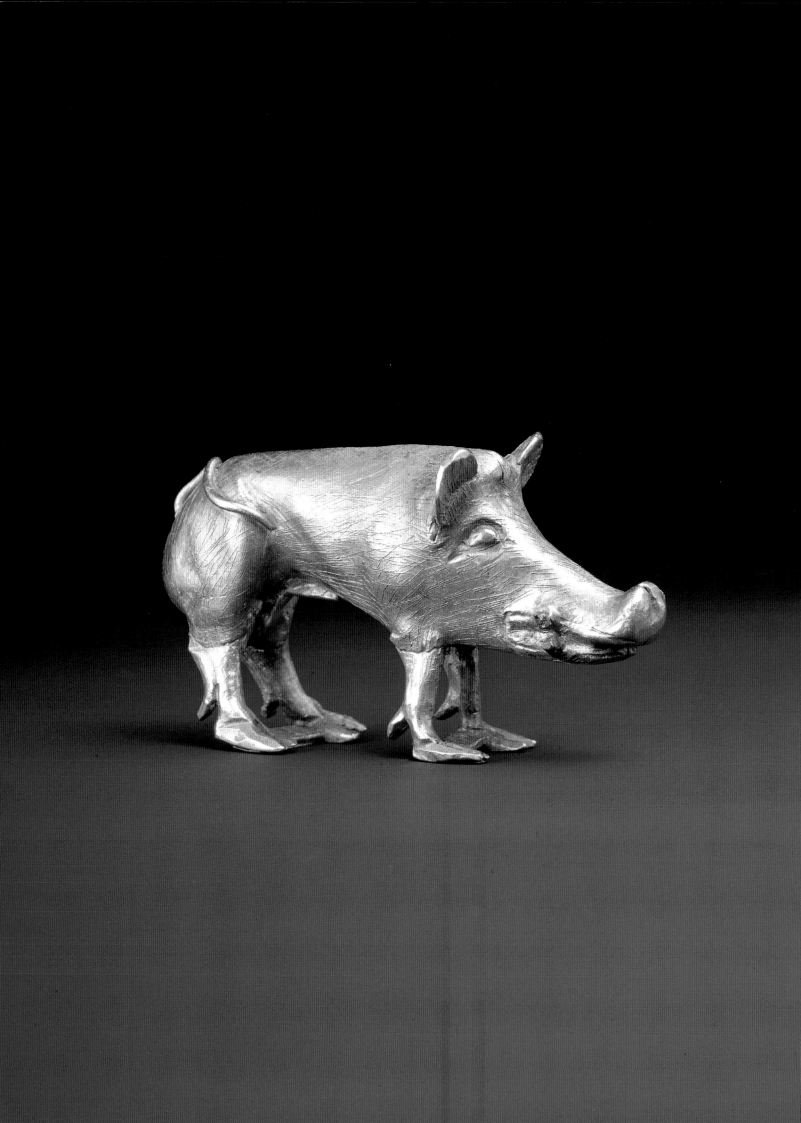

24. BOAR

4th c.
Gold, silver
MHTU, inv. no. AZS-2451
From Khomyna Mohyla (Kurhan 13), burial 1, near village of Nahirne, Nikopol's'kyi Raion, Dnipropetrovs'ka Oblast'.
Excavated by B. M. Mozolevs'kyi, 1970.
H: 2.8 cm; L: 5 cm; wt: 20.58 g.

Publications: Mozolevskii (1972), 224, fig. 32.13; Turku, *Skyyttien* (1990), 15, 48, no. 16; Schleswig, *Gold* (1991), 307, no. 97; Edinburgh, *Warriors* (1993), 29, no. 32; Toulouse, *L'or* (1993), 67, no. 31; Vienna, *Gold* (1993), 136–37, no. 28; Schiltz, *Scythes* (1994), 218, fig. 160; Milan, *Tesori* (1995), 71, 188, no. 22; Luxembourg, *TrésORS* (1997), 75, no. 19; Vicenza, *Oro* (1997), 54, no. 11.

The hollow body of the boar is formed of two soldered halves; its legs and tail were made separately. The animal has small protuberant eyes, a cleft nose, and silver fangs. Its muscles are well delineated, with the tail looped onto the haunch. Engraved lines on the body indicate its bristly coat.

This was probably the handle of a wooden cup, fastened via the soldered plates under the boar's elongated feet. It may be that the deeply scored bristles made the piece easier to grasp. The boar is forcefully rendered, and the flat feet, necessitated by the object's use, add to the animal's charm. The artist had a keen eye for both anatomy and individual character.

This handle was found in the plundered tomb of a man who must have held high rank, because his burial mound, 3.2 meters high, included the remains of sacrificed horses in richly ornamented bridles.

25. CYLINDRICAL VESSEL

6th c.
Clay
NMHU, inv. no. B 47–8
From Kurhan 378, village of Kostiantynivka, Cherkas'ka Oblast'. Excavated by O. O. Bobryns'kyi.
L: 20 cm; D: 10.5 cm; wt: 900 g.

Publications: Bobrinskii (1901), 112–14, pl. xix, fig. 62; Il'inskaia (1975), 143, pl. xvi, 12.

The cylindrical U-shaped vessel flares slightly at each end. One end is open and decorated with a row of relief dots around the rim; the other end is closed by a flat top incised with an X-shaped pattern. Along the curved body are six deeply scored crosshatched bands. The incised patterns are filled with a white substance.

This vessel is of an unusual early type that seems to have disappeared after the middle of the sixth century. It is thought that it was used for heating, perhaps for heating some substance with water. The vessel was found in a modest burial, which included a partial human skull, the bones of a horse or ox, the iron tip of a spear, a small ladle, and fragments of clay pottery.

26. STORAGE VESSEL

6th c.
Clay

Opposite: 24

SHAP, Pereiaslav-Khmel'nyts'kyi, inv. no. PXDIKZ-T3–1977
From village of Trakhtemyriv, Cherkas'ka Oblast'. Excavated by H. T. Kovpanenko, 1965–1966.
H: 77 cm; D: at edge 39 cm; D: at bottom 18 cm; D: 61 cm; wt: 15,000 g.

Publications: Kovpanenko (1967), 103–106; Kovpanenko, Bessonova, and Skoryi (1989), 52.

The vessel, with a burnished black surface, has a sharply angled wide rim and a steeply flaring conical body that narrows to a small flat base. On the exterior were four applied vertical ornaments, one now missing. Clay vessels of this type were used for the winter storage of grain and flour.

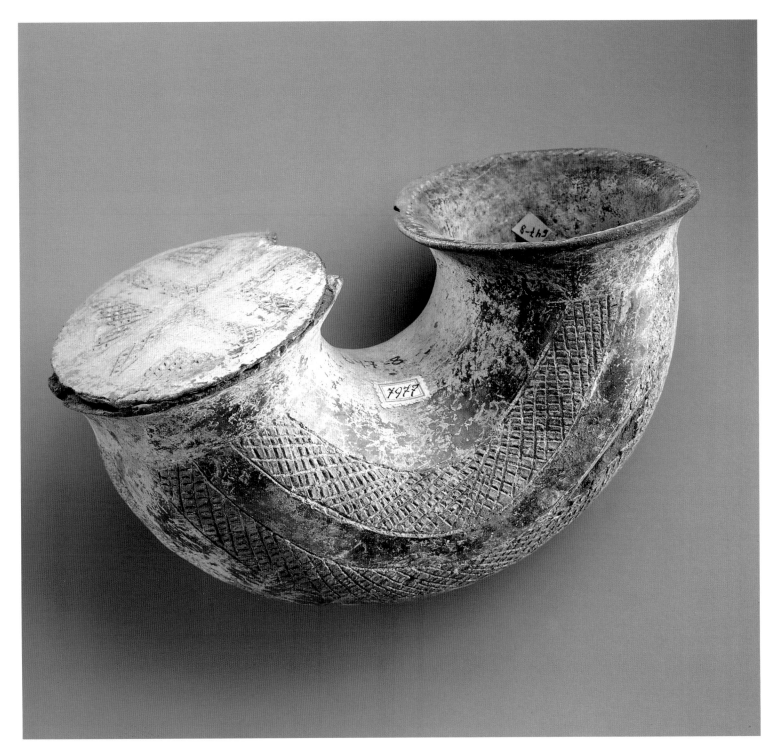

25

Opposite: 26

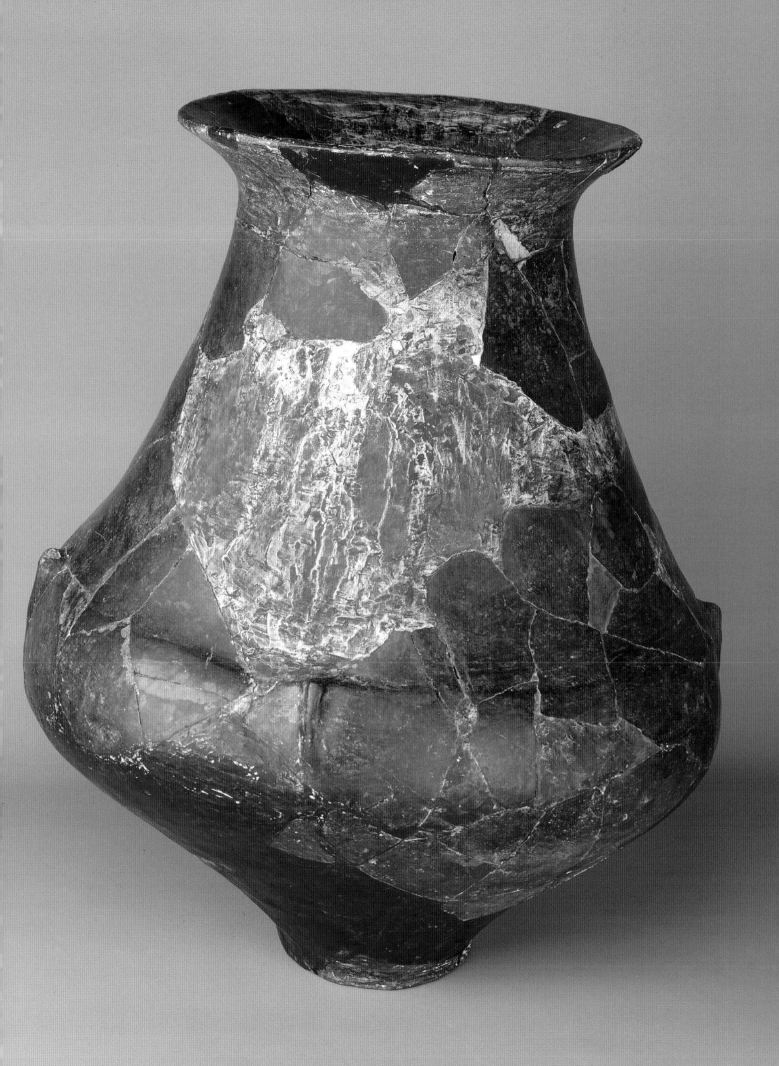

27. CAULDRON

5th c.
Bronze
SHAP, Pereiaslav- Khmel'nyts'kyi, inv. no. PXDIKZ-T3-566
From Kurhan 2, burial 1, village of Chervonyi Peredil, Khersons'ka Oblast'. Excavated by O. V. Symonenko, 1974.
H: 36 cm; D: 28 cm; wt: 17,000 g.

Publications: Polin (1984), 112–13.

The wide ovoid basin of the bronze vessel rests on a crudely fashioned high conical flaring foot. The handle loops are formed with volute-like ornaments beneath.

Similar cauldrons have been found in burials of the forest-steppe zone. The vessel has the shape of a tureen, its shape and size conforming well to the hands.

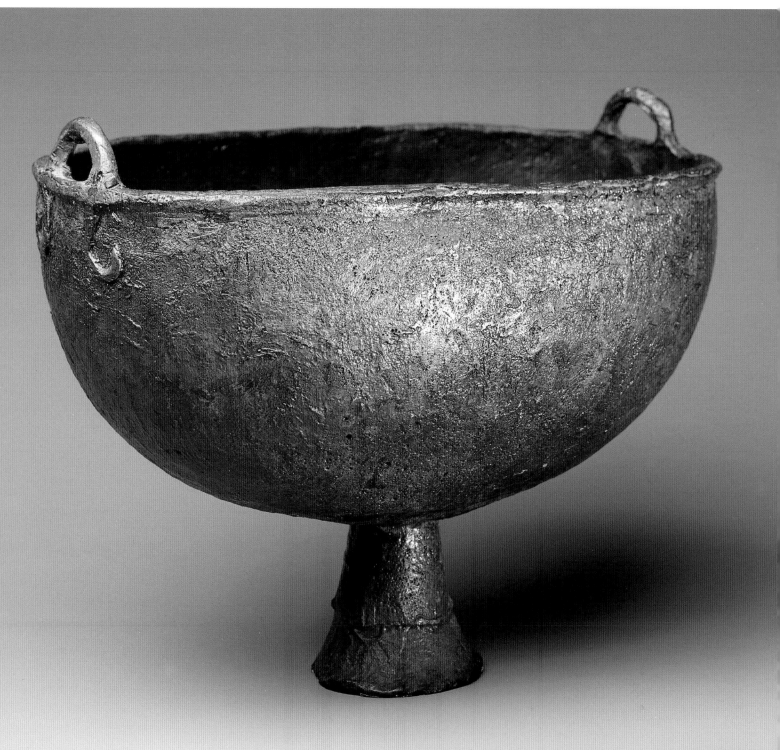

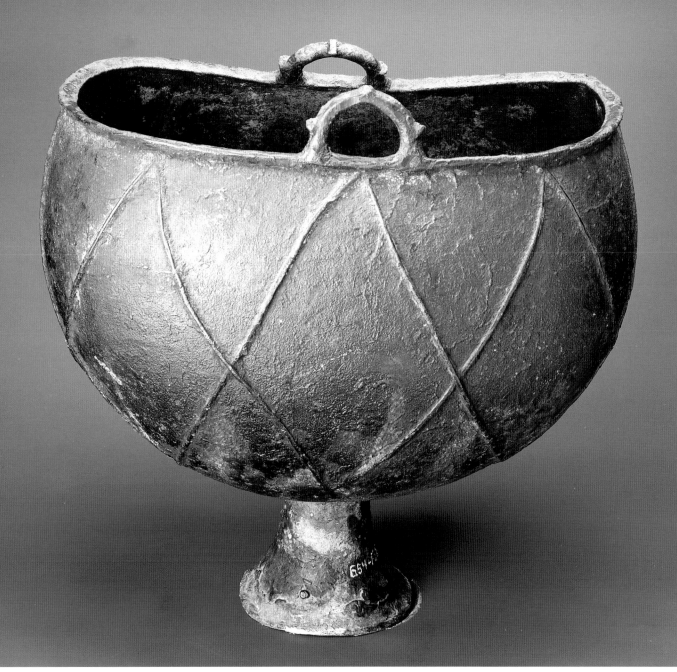

28. CAULDRON

4th c.
Bronze
NMHU, inv. no. B 54-138
From Melitopol's'kyi Kurhan, Melitopol', Zaporizhs'ka Oblast'. Excavated by O. I. Terenozhkin, 1954.
Largest dimension 58.5 cm; shortest dimension 41 cm; H: 58 cm; D: (base) 18.5 cm; H: (base) 13 cm; wt: 25,000 g.

Publications: Pokrovskaia (1955), 191, fig. i–3; Terenozhkin (1955); Terenozhkin and Mozolevskii (1988), 76, fig. i–17.

The ovoid cauldron rests on a narrow flaring conical base. On the outside a lattice of relief lines reproduces the look of a rope sling. The handles (now missing) were suspended from two large loops, with stops, attached to the narrow out-turned lip.

The cauldron was recovered from tomb 1 of the so-called Royal (Tsars'kyi) Kurhan, in the vicinity of a female servant's grave. Inside the vessel were the bones of a ram, apparently remnants of a funerary meal. Next to it were fragments of the bone haft of a knife.

Datable to the early sixth to fourth centuries, cauldrons of this type have been found in several rich burials, mostly in the steppe region of Ukraine. They are fairly uncommon in the forest-steppe region on the left bank of the Dnipro.

29. TWO CHEEKPIECES

6th c.
Bone
NMHU, inv. no. B 33–52; B 41–237
From Romens'kyi Raion, Sums'ka Oblast' (village of Budky for B 33–52). Excavated by S. A. Mazaraki, 1887–1898.
Cheekpiece (B 41–237): L: 22.1 cm; W: 1.5–2.0 cm; wt: 70 g. Cheekpiece (B 33–52): L: 18.5 cm; W: 1.5–2.0 cm; wt: 85 g.

Publications: Khanenko and Khanenko (1900), 8, pl. l-531; Bobrinskii (1901), vol. 3, pl. vii;
Il'inskaia (1968), 41; Tokyo, *Scythian Gold* (1992), 24, 25.

The cheekpieces have a gentle curve and three holes pierced in the center. One end is decorated with a stylized horse head, the eye formed by concentric circles; the muzzle, mouth, and nostrils are also indicated. The horses' flat ears are represented as grooved triangles, decorated, on one of the cheekpieces, with concentric circles. The opposite end of each piece takes the form of a hoof. One cheekpiece is scored along the inside of the curve, perhaps to imitate the animal's heavy coat.

These cheekpieces belong to a group of early Scythian objects that have been found in kurhany along the Sula River in eastern Ukraine.[1] Cheekpieces like these seem to have been widespread in the northern Caucasus, the Krasnodar territory in Russia, and in the forest-steppe region along the left bank of the Dnipro. When in use they would have rested more or less horizontally, so that as the horse galloped forward, they too would seem to move, sharing the rhythm of the animal's gait.

1. For another example from the Sumy region, see Vienna, *Skythen* (1988), 65, no. 31; New York, *Scythians* (1975), 105, no. 43.

30. HORSE BIT

6th–5th c.
Bronze
NMHU, inv. no. B 1281
From Liubny, Poltavs'ka Oblast'.
From the Temnyts'kyi Collection. Year of find unknown.
Overall L: 24.5 cm; L: (from ring to ring) 20 cm; L: (horizontal piece) 10.5 cm; H: (cheekpiece, top to bottom) 16 cm; wt: 700 g.

Publications: Titenko (1954); Tokyo, *Scythian Gold* (1992), 47, no. 26.

Each side of the roweled snaffle bit was cast as a single unit with an arched cheekpiece that terminates in hooves.

The roweling shows evidence of wear; as on modern bits, it provided greater control over the animal. Much less severe examples are seen in cat. no. 31. The large rings on this bit were for the reins, the smaller ones perhaps to attach the bridle cheekstrap.

31. TWO HORSE BITS

Late 7th c.–550
Bronze
AI, inv. no. Z/857/18, Z/857/59
From Rep'iakhuvata Mohyla, near village of Matusiv, Shpolians'kyi Raion, Cherkas'ka Oblast'.
Excavated by O. I. Terenozhkin, V. A. Illins'ka, B. M. Mozolevs'kyi, 1974.
Bit (Z/857/18): L: 17 cm; Ear 2.17 cm. Bit (Z/857/59): L: 17 cm; total wt: 700 g.

Publications: Il'inskaia, Mozolevskii, and Terenozhkin (1980), 36, figs. 4, 17; Kossack (1987), 71–76; Polin (1987), 26–27; Rimini, *Mille* (1995), 65, no. 28; Katowice, *Koczownicy* (1996), 168, 226, no. 11.

These two snaffle bits are cast in bronze. One is smooth, the other studded. Both have round interlocking center rings and stirrup-shaped loops on both ends. On one bit casting spurs are still visible.

Compare these relatively light, slender bits with the larger and more severe example, cat. no. 30. The bits were found together with the dagger and scabbard ornament, cat. no. 8.

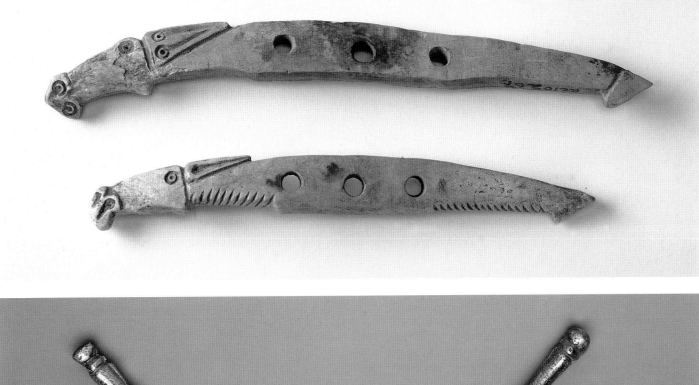

29

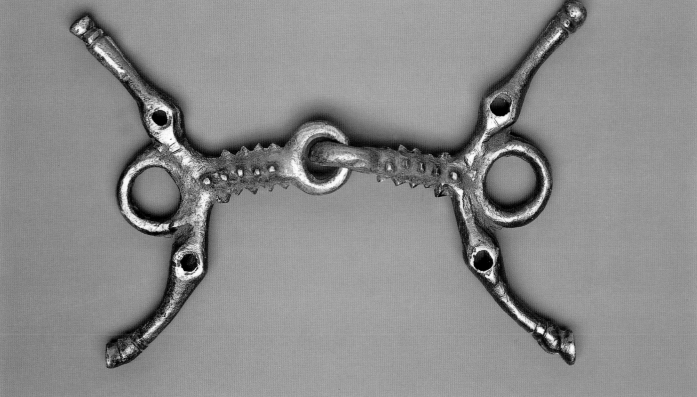

30

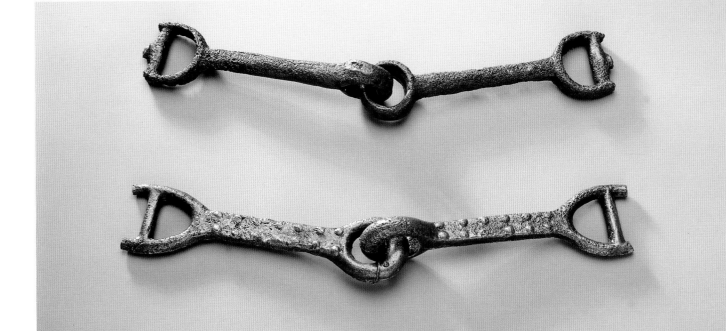

31

32. BRIDLE ORNAMENTS

4th c.
Silver
MHTU, inv. no. AZS-3754/1–12
From Kurhan Ohuz (Pivnichna Mohyla), near Nyzhni Sirohozy, Khersons'ka Oblast'. Excavated by Iu. V. Boltryk, 1980.
Ring (AZS-3754/10): D: 6 cm; wt: 10.6 g. Cheek plaque (AZS-3754/4): H: 7.55 cm; W: 8.2 cm; wt: 43.3 g.
Cheek plaque (AZS-3754/5): H: 7.9 cm; W: 8.2 cm; wt: 41.5 g. Decoration for horse's head (AZS-3754/1): H: 6.7 cm; W: 4.55 cm; wt: 27.8 g.
Cheek plaque (AZS-3754/3): H: 13.3 cm; W: 6 cm; wt: 70.6 g. Cheek plaque (AZS-3754/2): H: 13 cm; W: 5.75 cm; wt: 64.5 g.
Cheek plaque (AZS-3754/6): H: 7.2 cm; W: 7.7 cm; wt: 35.8 g. Cheek plaque (AZS-3754/7): H: 8.1 cm; W: 7.9 cm; wt: 43 g.
Round plaque (AZS-3754/9): D: 5.85 cm; wt: 23.1 g. Round plaque (AZS-3754/8): D: 5.85 cm; wt: 22.9 g.
Decoration in form of cone (AZS-3754/12): H: 7 cm; wt: 6.2 g. Decoration in form of cone (AZS-3754/11): H: 7 cm; wt: 6.6 g.

Publications: Meliukova (1976), 112, 116, 126, figs. 3.4–9, 4.7, 5.4–5. 11.10–11; Boltrik (1981), 233–34; Boltryk and Fialko (1991), 178–80, no. 102; Vienna, *Gold* (1993), 122–23, no. 23; Milan, *Tesori* (1995), 59, 187, no. 13.

These silver horse trappings include 1) a shaped noseband with chased ornament and a lion-head protome, 2) two cheekstrap plaques decorated with a scene of combat between a lion and a winged deity, 3) four square plates, 4) two discs, and 5) two conical studs and a ring.

The lion protome, known from other examples, is distinguished by a ruff in large locks, outward curving snout, and large eye.

The two cheekpieces are mirror images of each other. On each a male figure stands frontally on columnar legs, grasping a lion on one side while holding a dagger in the opposite hand. His face is round, with large round eyes, an accentuated brow that continues to the outer corner of the eye, and a roll of hair over the forehead. Feathered wings flare out behind him on either side. His shoulders and arms are rendered as a curving ovolo band, which mirrors the crescent-shaped projections of the feathered wing. The lion has a large prominent eye and a tail ending in a volute, balanced by a scroll on the opposite side. The bottom and inside edges of the plaques are scalloped and decorated with scrolls.

The square plates are organized around a central boss with a swirling pattern, flanked by back-to-back crescents that wind into a griffin (or bird?) suggested by a large eye ringed by a raised ridge, a scroll that turns back to suggest the beak, and an ear or horn. A raised bud between the elements balances the eyes and swelling necks.

The important role played by the horse in Scythian life was reflected in funeral practices. In tens, perhaps hundreds, of tombs across the Eurasian steppe, horses have been found buried with gold, silver, or bronze bridle sets. Horses were also sacrificed. Excavation of this Kurhan Ohuz revealed the skeletons of fourteen horses buried with their masters for the last journey to the afterworld. It is likely that the griffin heads and other imagery were thought to offer protection for both horse and rider.

A bronze set almost identical to this one comes from the Krasnokuts'kyi Kurhan (Kharkivs'ka Oblast').[1] The style, like that of three silver bridle sets uncovered from the tomb of a Scythian woman, finds its closest parallels in the art of the Thracians, who lived to the west of the Scythians. The square plaques of this set can be compared with a fourth-century gold plaque from Cucuteni-Baiceni (Romania). There the heads of felines fill the frame, eliminating the need for additional ornament.[2] The design of the square griffin plaques is not unlike that of cat. no. 149, and the bridle set, cat. no. 166, is also comparable.

The ornaments were found together with cat. nos. 101, 111, and 126.

1. Artamonov (1969b), 66, 280, no. 127.

2. Schiltz, *Scythes* (1994), 71, no. 45.

Opposite: 32

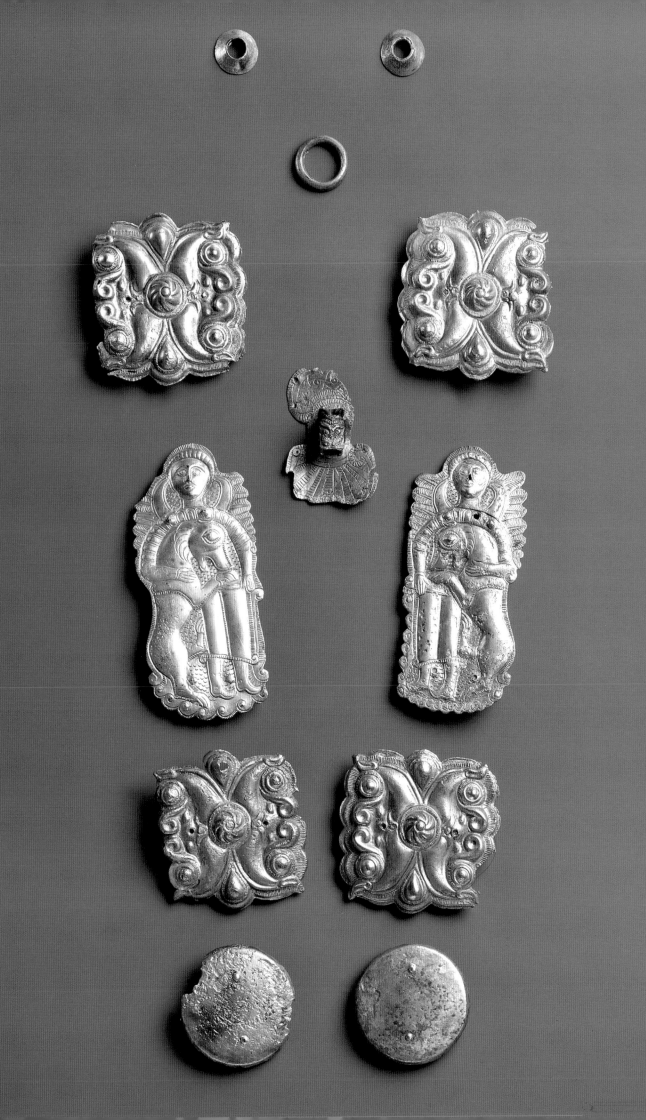

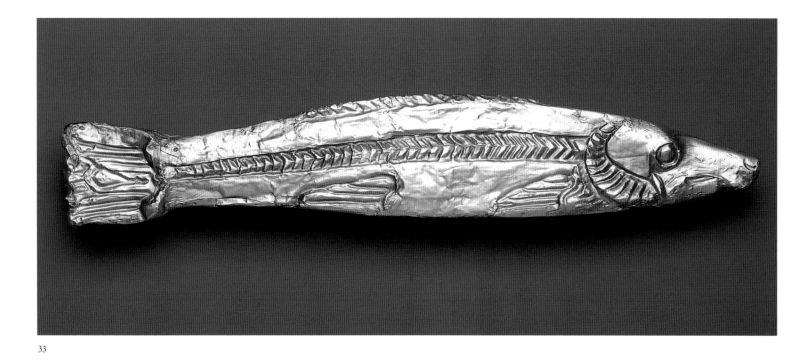

33

33. FRONTLET IN THE FORM OF A FISH

4th c.
Gold
AI, inv. no. Z-15
From Taranova Mohyla, near village of Inhulo-Kam'ianka, Novhorodkivs'kyi Raion, Kirovohrads'ka Oblast'.
Excavated by V. F. Ieliseiev, 1989.
L: 34.3 cm; W: 5.8 cm max; wt: 34.67 g.

Publications: Schleswig, *Gold* (1991), 320, no. 122; Milan, *Tesori* (1995), 58, 186, no. 12; Rimini, *Mille* (1995), 80, no. 50.

The applique takes the form of a fish, probably a sturgeon, with its eye, fins, gills, and tail slightly stylized. The relief was fitted closely over a wooden backing, with the edges passing around the side of the wood plate and pinned through small holes. A fragment of the wooden backing was also found.

This was a horse frontlet, which was worn vertically between the eyes with the fish head up. Similar horse decorations, also in the form of a fish, come from Solokha and from Vovkivtsi, in the Romens'kyi region.[1]

1. Solokha: Artamonov (1969b), 286, pl. 146. Vovkivtsi: Schleswig, *Gold* (1991), 306, no. 94.

34. BOW TIP

6th–5th c.
Bone
NMHU inv. no. B 2277
From village of Mali Budky, Sums'ka Oblast'. Excavated by I. A. Linnychenko.
L: 12.6 cm; W: 2.1 cm; wt: 100 g.

Publications: Iakovenko (1969), 202, fig. 1.2; Kyiv, *Археологія* (1971), vol. 2, 140, fig. 36 (3.2).

The wide end of the tusk has been carved to represent the head of a wolf in left profile. The animal has a flat ear pressed against its neck and a large hemispherical eye rimmed by a raised ring. Its nose curves up in a volute, with a smaller volute below. Its mouth is open, revealing large fangs.

Objects of this type are thought to have been used as the tip of a bow or to decorate a sword scabbard. They might also have been part of a bridle. They were probably acquired in trade because their shape and

carving style are characteristic of Sauromatian, more than Scythian, work. Close parallels to this piece and cat. no. 35 are found among fifth-century Sauromatian carved boar tusks from the lower Volga region.[1] Also comparable are sixth-century examples from the Don area and southern Ural steppes.[2] A bronze bridle ornament with a similar representation was found in eastern Kazakhstan.[3]

1. Dvornichenko (1995), 108–109, fig. 11.
2. Ibid., 115, fig. 28.
3. Mantua, *L'uomo d'oro* (1998), 157, nos. 211–13.

35. BOW TIP

6th–5th c.
Bone
NMHU, inv. no. B 2278
From village of Mali Budky, Sums'ka Oblast'. Excavated by I. A. Linnychenko.
L: 7.8 cm; W: 2.4 cm; wt: 100 g.

Publications: Iakovenko (1969), 202, fig. 1.2; Kyiv, *Археологія* (1971), vol. 2, 140, fig. 36 (3.2).

The top of the tusk is incised with a band of interlocking geometric forms. Below this are three frontal animal heads, with upright ears and eyes rendered by a circle and dot. The scored manes(?) are represented as if seen from above. The end of the tusk takes the form of a lion head, with petal-shaped ears, also seen from above.

See the entry for cat. no. 34.

34, 35

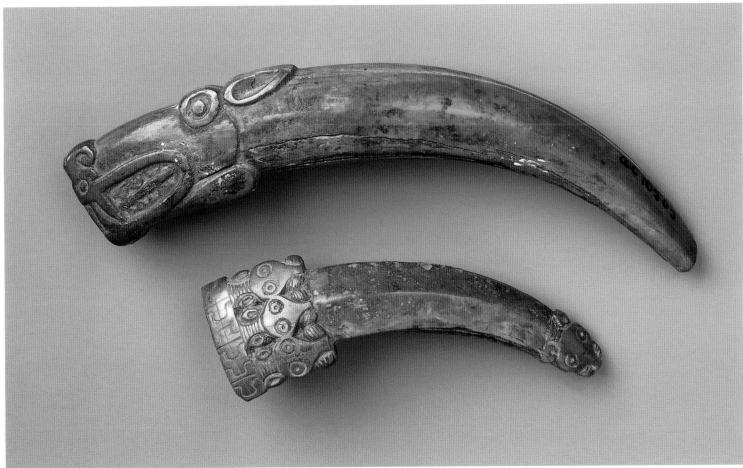

36. POLETOP

6th c.
Bronze
NMHU, inv. no. B 41–425
From Romens'kyi Raion, Sums'ka Oblast'. Excavated by D. Ia. Samokvasova after 1886.
L: 23.5 cm; W: 6 cm; wt: 1100 g.

Publications: Bobrinskii (1901), pl. 17, fig. 3; Shleev (1950); Illins'ka (1963), 37, fig. 3.3; Tokyo, *Scythian Gold* (1992), 48, nos. 28, 29;
Edinburgh, *Warriors* (1993), 23, nos. 17, 18; Toulouse, *L'or* (1993), 54, nos. 15, 16; Vienna, *Gold* (1993), 88–89, no. 12.

The finial's tapering conical shaft is ornamented at the bottom with four grooved curves. At the top of the shaft an open ring between two square moldings supports an egg-shaped bell, with a ball clapper inside. The bell is pierced with two tiers of teardrop-shaped cutouts, with five cutouts in each row. The bell is surmounted by a long-eared stag, its rear legs brought under its body, tail extended.

Jingling finials like this one and its mate (cat. no. 38) constitute an important class of Scythian objects. These examples are close in shape and workmanship to a group of finials found in the northern Caucasus, where their manufacture was probably centered. Most of the finials discovered in Ukraine have come from the left (east) bank of the Dnipro; those found close to the Sula River valley (the Posullia area) are dated to the fifth and fourth centuries. Finials of later date are also found in the steppe lands along the Dnipro's right (west) bank, though not in the nearby forest-steppe region.

Finials of this type (see cat. no. 37) must have been mounted on poles, which have not survived. Some finials have been found with the remains of carts near the entrances of women's tombs, and it is thought that both carts and finials belonged to movable shrines.

37. POLETOP

4th c.
Bronze
MHTU, inv. no. AZS-2554/3
From Tovsta Mohyla, burial 1, near Ordzhonikidze, Dnipropetrovs'ka Oblast'.
Excavated by B. M. Mozolevs'kyi, 1971.
H: 17 cm; W: 7.5 cm; wt: 300 g.

Publications: Mozolevs'kyi (1979), 119–20, figs. 102.1–3; Turku, *Skyyttien* (1990), 13, 56, no. 13;
Tokyo, *Scythian Gold* (1992), 57, no. 42; Schleswig, *Gold* (1991), 323, no. 140b.

The cast finial has an egg-shaped body formed of openwork palmettes with two side rings. At the top a horizontal base supports a recumbent stag. Its elaborate antlers curl into volutes along the whole length of its back. The two volutes in front curl backward, while the remaining six curl forward. The animal's shoulder and tail are also represented as volutes, and there is another volute-like element under the chin.

Several of the richer Scythian kurhany have yielded similar objects, which must have been mounted on poles (see cat. nos. 36 and 38). Typically they are found along with the remains of carts that had been used to block the entrances of female tombs. Some researchers believe these carts were small, mobile shrines.

This poletop was found together with cat. no. 122.

Opposite: 36

38. POLETOP

6th c.
Bronze
NMHU, inv. no. B 41–426
From Romens'kyi Raion, Sums'ka Oblast'. Excavated by D. Ia. Samokvasova after 1886.
L: 24.3 cm; W: 6 cm; wt: 1100 g.

Publications: Bobrinskii (1901), pl. 17, fig. 3; Shleev (1950); Illins'ka (1963), 37, fig. 3.3; Vienna, *Gold* (1993), 88–89, no. 13.

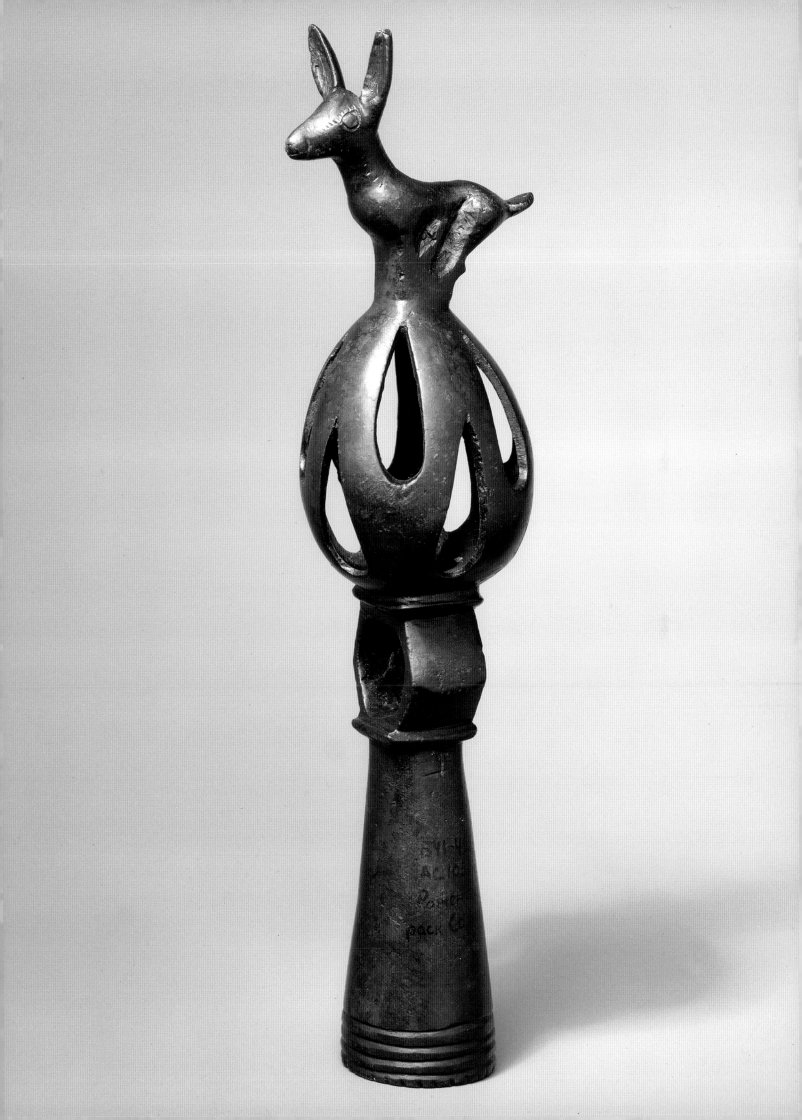

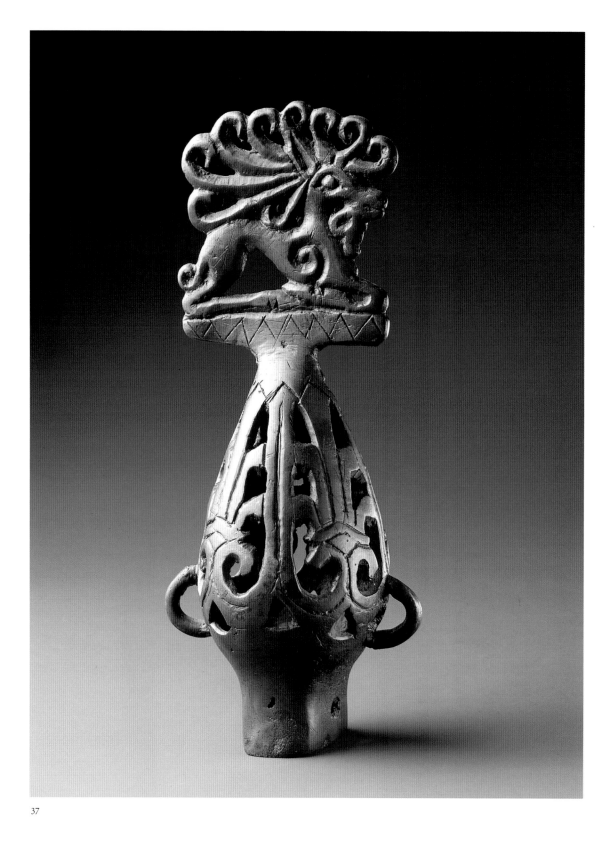

The finial's swelling conical shaft is ornamented at the bottom by four grooved bands. At the top of the shaft an open ring between two square moldings supports an egg-shaped bell, with a ball clapper inside. The bell is pierced with an upper row of triangular cutouts and a lower row of teardrop-shaped ones. It is surmounted by a long-eared stag, its rear legs brought under its body, with its tail extended.

See the entry cat. no. 37.

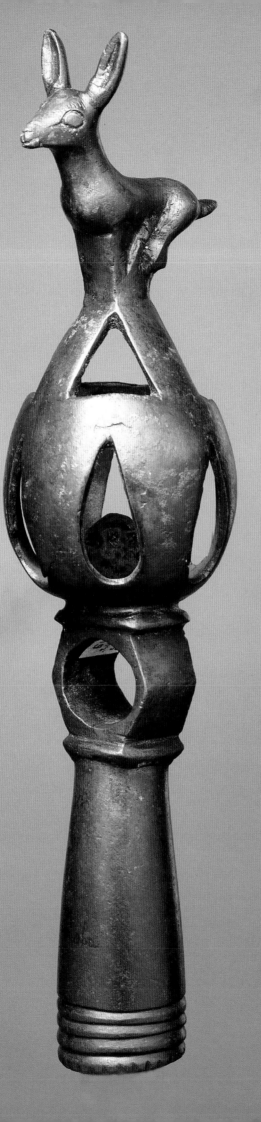

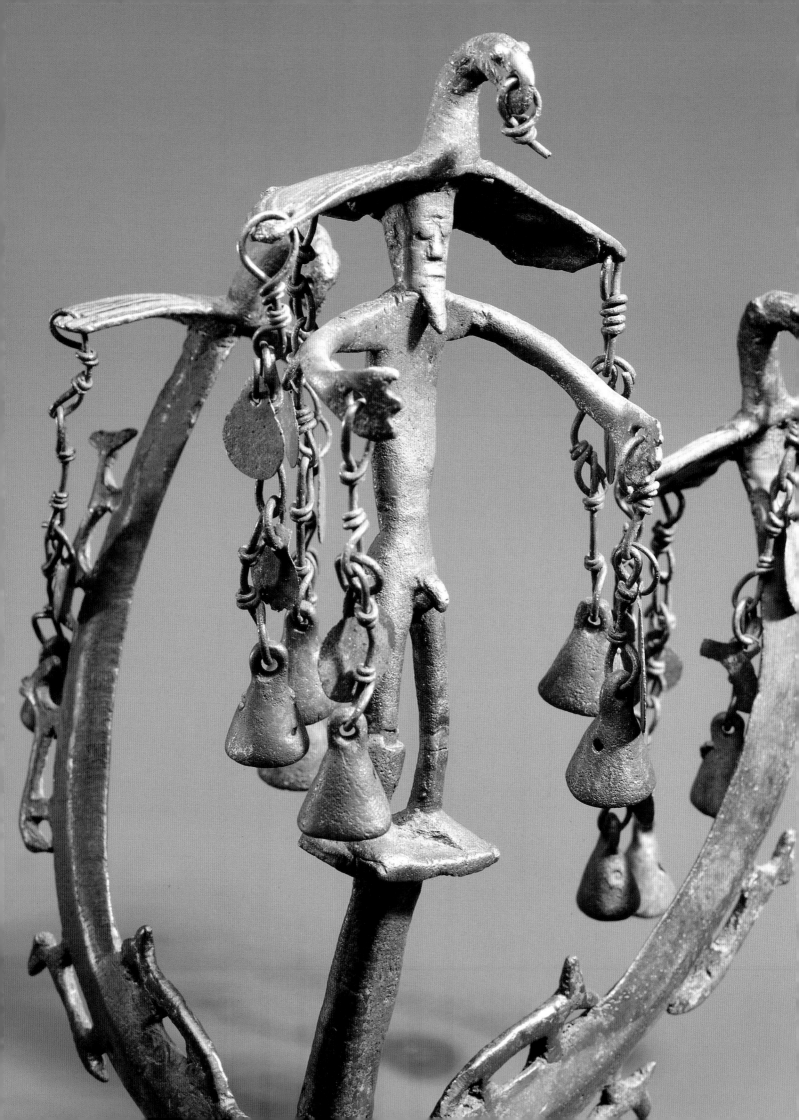

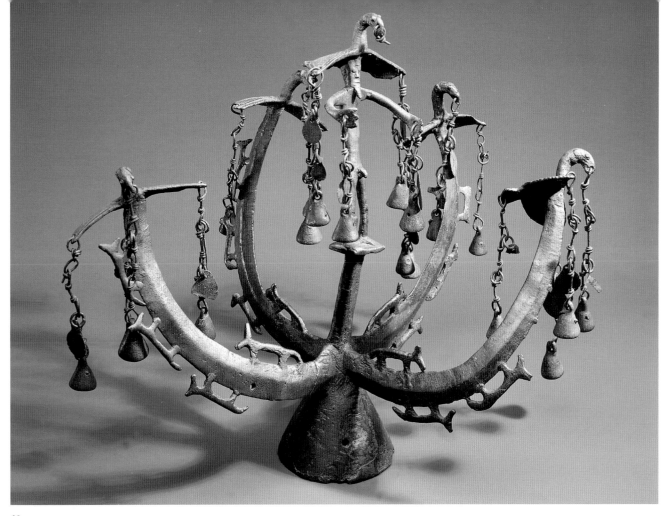

39

39. STAFF ORNAMENT WITH MALE FIGURE

4th c.
Bronze
NMHU, inv. no. B 2380
Chance find at Lysa Hora, Dnipropetrovs'ka Oblast'. Found at the end of the 19th century.
H: 36 cm; W: 45 cm (max); H: of man alone 19 cm (with base and headdress); 14.8 cm (feet to hat brim); wt: 2200 g.

Publications: Khanenko and Khanenko (1901), 21, 14; Illins'ka (1963), 43, fig. 6; Grakov (1971), 82–84; Rybakov (1981), 554–55;
Bessonova (1983), 41–43, fig. 2; Turku, *Skyyttien* (1990), 13, 48, no. 12; Schleswig, *Gold* (1991), 319, no. 121;
Tokyo, *Scythian Gold* (1992), 55, no. 40; Zurich, *Schatzkammern* (1993), 67, no. 23; Schiltz, *Scythes* (1994), 79, fig. 59.

Two arcs create the effect of four branches encircling a shorter vertical element, which supports a platform on which a bearded nude male figure stands, phallus erect, arms outstretched. An eagle with wings outspread stands on top of his head, and similar eagles are perched on the top of each branch. They have prominent eyeballs, curved beaks, and protrusions behind the head; their wings are grooved to indicate feathers. All the eagles and the man face in the same direction. On the branches, as if climbing up them, are long-backed animals (foxes?). From the eagle's beaks, tails, and wing tips are suspended chains with disc- and crescent-shaped pendants and small conical bells, several of whose clappers survive. The base is formed of a hollow cone, pierced with four openings.

The male figure is repaired across both lower legs; one branch is repaired at the base.

Opposite: 39 detail

Fragments of a few similar finials have been found in the Ukrainian steppes, but nowhere else. Probably they can all be traced back to a single manufacturing center. An example from Oleksandropol'[1] is formed of two arcs and a vertical element creating three branches, each surmounted by an eagle with wings folded. On that finial, too, bells hang on chains suspended from the beaks of the outer eagles. The finials were originally mounted on wooden poles, and the sound they made as the poles were moved must have been a significant element of their function and appeal.

The figure of the nude male here is unique. He may be intended to represent a deity (Papaeus-Zeus or perhaps Oetosyrus-Apollo?).[2]

1. Vienna, *Skythen* (1988), 145, no. 81; Schiltz, *Scythes* (1994), 81, no. 60.

2. See the essay by Onyshkevych in this volume.

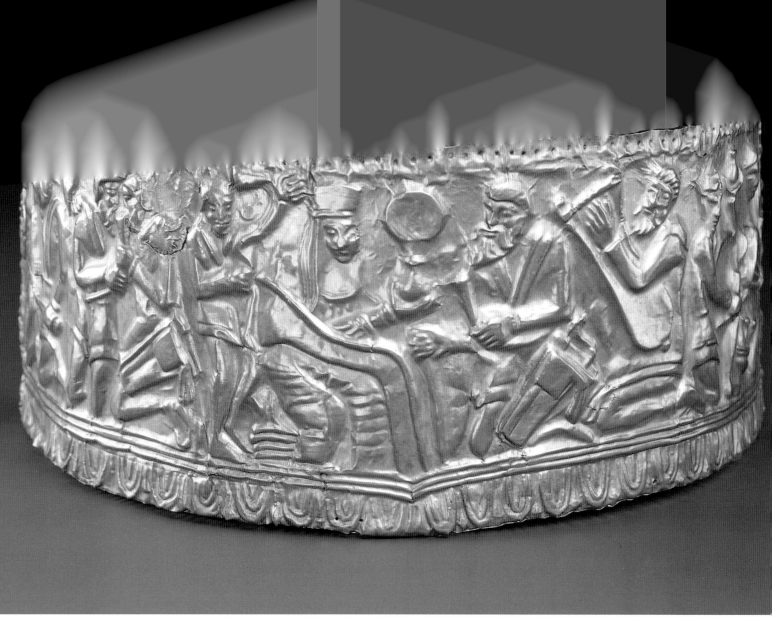

40. DIADEM WITH CULT SCENES

ca. 350–300
Gold
MHTU, inv. no. DM-1639
From Kurhan 2, near village of Sakhnivka, Korsun'-Shevchenkivs'kyi Raion, Cherkas'ka Oblast'. Excavated by V. Ie. Heze, 1901.
L: 36.5 cm max; H: 9.8 cm; wt: 64.58 g.

Publications: Kyiv, *летопись* (1901), 213–15; Hanina (1974), figs. 6, 7; Bessonova (1983), 99–107; Schleswig, *Gold* (1991), 308, no. 99;
Tokyo, *Scythian Gold* (1992), 88, no. 94; Edinburgh, *Warriors* (1993), 31–32, no. 38; Toulouse, *L'or* (1993), 70–71, no. 37;
Vienna, *Gold* (1993), 148–51, no. 34; Schiltz, *Scythes* (1994), 188, fig. 135; Milan, *Tesori* (1995), 73, 189, no. 26;
Luxembourg, *TrésORS* (1997), 99, no. 53; Rusiaieva (1997b), 46–56; Vicenza, *Oro* (1997), 86, no. 42.

Ten figures are represented on the relief band. All kneel except for the seated woman in the center and her standing attendant. The woman, in right profile and wearing a high headdress and shoulder drape, holds a mirror in her left hand and a vessel in her right. Before her, a bearded man in left profile holds a drinking horn in his left hand and a rod in his right. He wears a gorytos at his hip. He is followed by another bearded man who plays a lyre-like instrument and by two beardless men, whose faces are frontal. One of these men holds a vessel aloft with his left hand and with his right hand clasps a drinking horn, into which the second figure pours from a large fluted amphora. Between them is a large-mouth vessel containing three smaller vessels, as well as what appears to be a large dipper. Behind the seated woman, a standing man holds a drinking horn in his raised right hand. Behind him two bearded men, one with a gorytos, drink from a single horn. They are followed by a man who restrains a captive with his right hand while pointing with his left. The prisoner's left arm is behind him; a ram's head is in front of his chest. Except for the prisoner, who is bare-

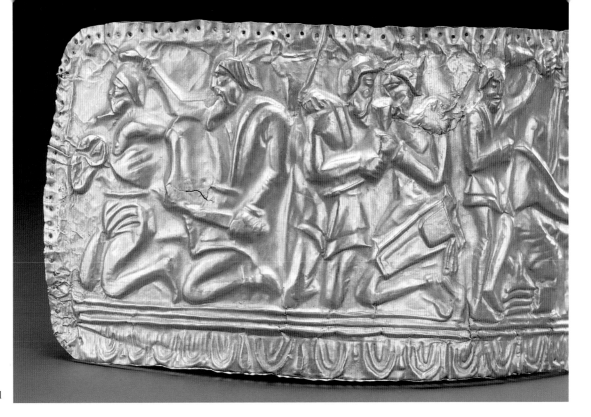

chested and wears very short pants, all of the male figures wear belted, sleeved garments that extend to mid-thigh and have clearly defined bands at the hem. The groundline consists of three raised horizontal ridges that form a V beneath the seated woman; below the ridges is an ovolo border. The top and sides of the diadem are punched with small holes for attachment; one loop also survives.

Apart from the captive at the viewer's far left, this relief's depictions of dress, hairstyle, and appointments (including gorytoi) are all typically Scythian in character. However, the manner of rendering the figures is undoubtedly the result of Greek influences.

The seated woman is obviously an important figure with a mythic or cultic identity. Jacobson suggests she is a goddess, and the primary deity of the Scythian religion, her ancestry rooted in the culture of the Scythians' forebears.[1]

Unique among the objects in this exhibition is the relief's depiction of a victor and his captive. Perhaps the scene is intended, like the famous pectoral from Tovsta Mohyla, to present all facets of Scythian life: comradeship of warriors, domination of others, the sustenance of drink, and acknowledgment of a divine presence.

1. Jacobson (1993), 4, 163–67, 174, 177, 214, 217.

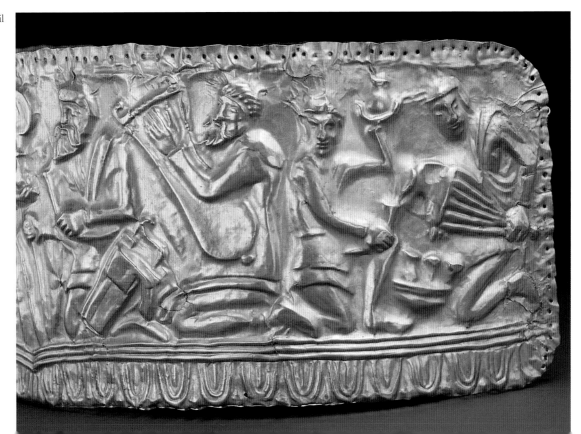

41

41. PLAQUE WITH SEATED GODDESS AND A SCYTHIAN

ca. 350
Gold
MHTU, inv. no. AZS-2696/1
From Kurhan Nosaky (Kurhan 4), burial 1, near Balky, Vasylivs'kyi Raion, Zaporizhs'ka Oblast'. Excavated by V. I. Bidzilia, 1970.
H 3.5 cm; W: 3.7 cm; wt: 3.97 g.

Publications: Bidzilia and Boltrik (1977), 91–92, fig. 11.13; Tokyo, *Scythian Gold* (1992), 97, no. 112;
Toulouse, *L'or* (1993), 76, nos. 55, 56; Vienna, *Gold* (1993), 170–71, no. 46.

The plaque is decorated with the right-profile figure of a seated woman who holds a mirror in her left hand. She wears an ankle-length belted garment and a diadem beneath a head covering, the ends of which pass under a long-sleeved robe that frames the shoulders. Before her stands a beardless, weaponless youth, who sips from a drinking horn held in his right hand and seems to grasp a round object with his left hand. He wears trousers, decorated with an incised X-pattern beneath a jacket that extends to mid-thigh. The figures are framed by a raised edge, a clumsy ovolo, and a narrow beaded border. Holes are pierced in each corner for attachment.

This plaque was found in the grave of a wealthy Scythian woman and was perhaps intended to decorate clothing. The scene may be related to that on the gold diadem (cat. no. 40), where a seated woman also holds a mirror. Jacobson suggests that the women are deities and that the act of drinking from a rhyton is an expression of obeisance.[1]

Similar gold plaques have been discovered in Scythian burials in Chortomlyk, Kul'-Oba, Verkhnyi Rohachyk, and in the first Mordvinivs'kyi, Melitopol's'kyi, and Ohuz kurhany.[2]

1. Jacobson (1993), 4, 163–67, 174, 177, 214, 217.

2. Chortomlyk: Artamonov (1969b), 59, 280, fig. 114; Vienna, *Skythen* (1988), 101, no. 53. Kul'-Oba: Artamonov (1969b), 287, pl. 235. Ohuz: Boltryk and Fialko (1991), pl. 8.

42

42. PLAQUE WITH DRINKING SCENE

Early 4th c.
Gold
MHTU, inv. no. AZS-3076/3
From Berdians'kyi Kurhan, near village of Novovasylivka, Berdians'kyi Raion, Zaporizhs'ka Oblast'.
Excavated by M. M. Cherednychenko, 1977–1978.
H: 2.8 cm; W: 2.7 cm; wt: 1.7 g.

Publications: Tokyo, *Scythian Gold* (1992), 98, no. 113; Toulouse, *L'or* (1993), 76, no. 54; Vienna, *Gold* (1993), 68–69, no. 45;
Milan, *Tesori* (1995), 95, 194, no. 49; Cherednychenko and Murzin (1996), 69–78; Vicenza, *Oro* (1997), 79, no. 35.

The applique bears a depiction of two Scythians squatting with their knees out and feet together, as they
share a drink from a single drinking horn. One figure holds the vessel in his right hand, draping his left arm
around his comrade's back. The figures have shoulder-length hair, and the hems of their garments fall
between their legs. The plaque is framed by a beaded border. A hole is punched in each corner.

This scene depicts the ritual, described by Herodotus (4.70), with which Scythians sealed a solemn oath.
Both parties mixed a bit of their blood with wine and drank it from a common cup, after first dipping into it
a sword, some arrows, a battle-axe, and a spear, and then saying a number of prayers.[1] Similar depictions are
found on gold plaques from Kul'-Oba and Solokha,[2] and appear as parts of larger compositions, such as the
diadem, cat. no. 40.

1. See the essay by Onyshkevych in this volume.
2. Kul'-Oba: Schiltz, *Scythes* (1994), 180–81, no. 130 (4th c.); Vienna, *Skythen* (1988), 121, no. 61. Solokha: Vienna, *Skythen* (1988), no. 47;
Artamonov (1969b), 44, 278, no. 81.

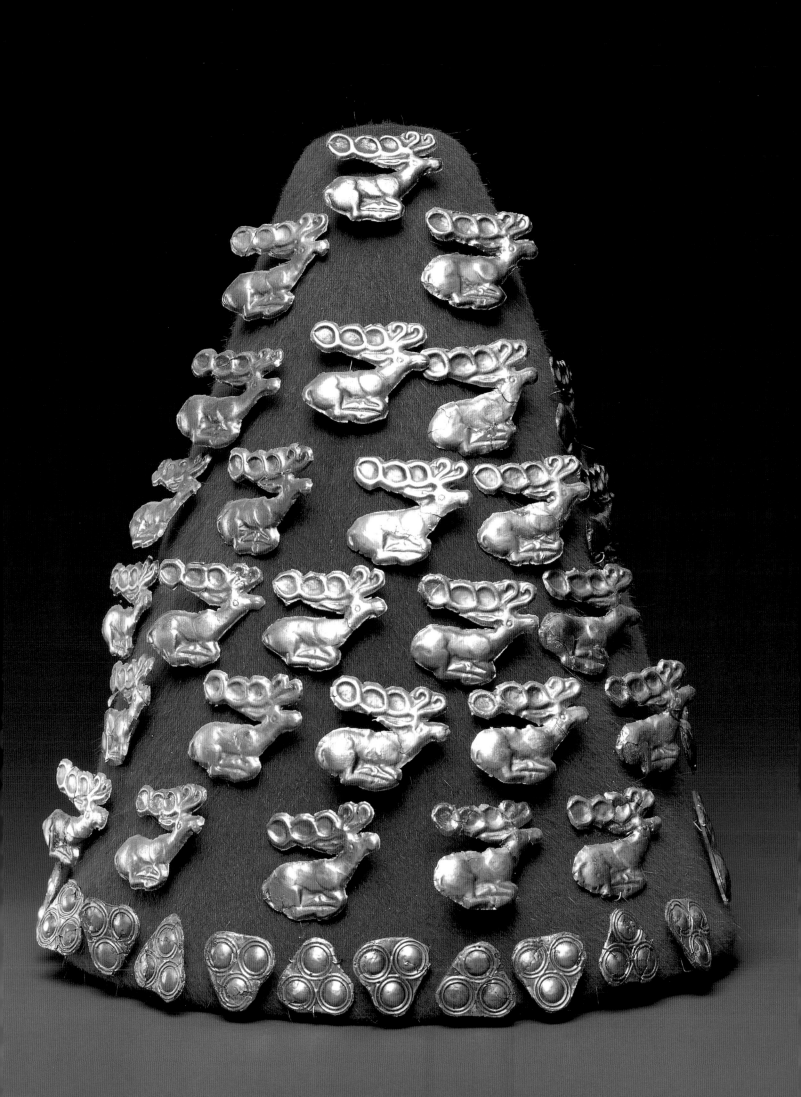

43. HEADDRESS WITH STAG PLAQUES
(MODERN REPLICA WITH TWO ORIGINAL PLAQUES)

Late 7th–early 6th c.
Gold, fabric
MHTU, inv. no. NDF-238–239 (reconstruction), DM-6307/2–3 (2 original gold plaques)
Based on material from Mohyla Ternivka (Kurhan 100), near village of Syniavka, Kanivs'kyi Raion, Cherkas'ka Oblast'.
Excavated by Ie. O. Znos'ko-Borovs'kyi, 1898. Reconstructed by L. S. Klochko.
Original plaque (DM-6307/2): H: 3.3 cm; L: 4 cm; wt: 2.25 g. Original plaque (DM-6307/3): H: 3.4 cm; L: 4 cm; wt: 1.88 g.
Fabric reconstruction (NDF-238): H: 27 cm; W: 24 cm; D: 13 cm. Reconstructed plaques (41)(NDF-239): 4 x 3.3 cm each.

Publications: Bobrinskii (1901), vol. III, 140, pl. xviii.2, figs. 73, 74; Hanina (1974), fig. 1; Il'inskaia (1975), 152; Kovpanenko, Bessonova, and Skoryi (1989), 73, figs. 16, 17; Tokyo, *Scythian Gold* (1992), 43, no. 17; Edinburgh, *Warriors* (1993), 22, no. 13; Toulouse, *L'or* (1993), 72, no. 38; Milan, *Tesori* (1995), 92, 193, no. 44; Luxembourg, *TrésORS* (1997), 90, no. 39; Vicenza, *Oro* (1997), 76, no. 32.

The conical headdress has two types of gold appliques.[1] Around the bottom, triangular plates with three bosses alternate with their points up and down. The remaining plaques, attached in rows over the surface of the cap, take the form of a crouching stag, its neck extended. Its exaggerated antlers curl into two loops over the animal's head, and then branch over its back in three spirals. These modern plaques are based on thirty originals found in Mohyla Ternivka (Kurhan 100), two of which are exhibited here.

The headdress was found in the grave of a richly attired female who had been interred with three servants. Her burial also contained gold earrings or headdress ornaments and three necklaces of gold, rock crystal, agate, amber, and glass. The four-meter height of the woman's burial mound may be an indication of her special status.

Along with the feline and the eagle, the stag was one of the most meaningful and frequently used motifs in Scythian art. Jacobson links the deer or stag with, ultimately, a Siberian mother goddess, as well as with the reindeer, which the ancestors of the Scythians probably hunted.[2] The peaked form of the cap finds parallels both in other Scythian burials and among finds from the Altai area.[3]

1. For a reconstructed headdress using ancient plaques, see cat. no. 16.

2. Jacobson (1993), 47, 61, 97, 179, 230–31, 238, 240. See also the essay by Jacobson in this volume.

3. Compare the peaked cap depicted on a diadem from Karagodeuashkh in the Kuban: Artamonov (1969b), pl. 319; Vienna, *Skythen* (1988), 130, no. 67.

43 detail

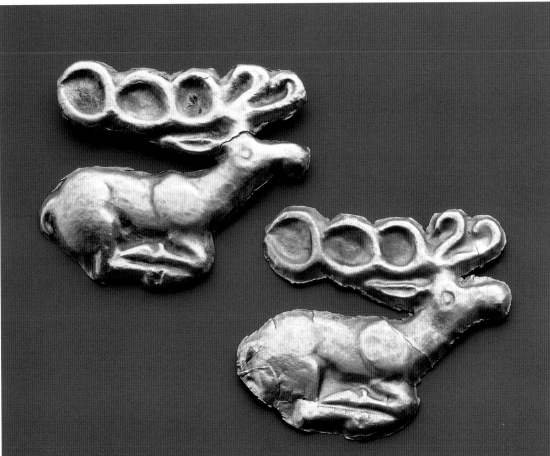

Opposite: 43

44. PLAQUES WITH STAGS

5th c.
Gold
MHTU, inv. no. AZS-2958/1, 2, 3
From Ispanova Mohyla (Kurhan 4), near village of Nahirne, Nikopol's'kyi Raion, Dnipropetrovs'ka Oblast'.
Excavated by B. M. Mozolevs'kyi, 1975.
Plaque (AZS-2958/1): H: 3 cm; L: 3.3 cm; wt: 3.4 g. Plaque (AZS-2958/2): H: 3 cm; L: 4 cm; wt: 3.92 g.
Plaque (AZS-2958/3): H: 2.9 cm; L: 3.3 cm; wt: 3.46 g.

Publications: Mozolevskii (1980), 148, fig. 83.12; Riabova (1984), 31–44;
Tokyo, *Scythian Gold* (1992), 72, no. 66; Luxembourg, *TrésORS* (1997), 74, no. 18.

Each rectangular applique is bent back at the top, retaining on three sides the gold pins that were used to attach it to a wooden cup. Each plaque bears, in high relief, a recumbent stag, whose head is turned down and back over its body. The stag has a prominent eye inside a depressed eye socket, a spherical knob on the top of its head, and highly stylized antlers that take the form of volutes curving around a hemisphere.

The appliques were originally fitted over the rim of a wooden cup. Characteristically Scythian are the isolation of the animal, its recumbent pose with head reversed, the stylized antlers, the abrupt juxtaposition of planes, the isolation of body parts that results in an abstraction of form, and the emphasis on such curvilinear elements as volutes and hemispheres.

45. TWO PLAQUES IN THE FORM OF A HORSE

Late 7th–early 6th c.
Gold
MHTU, inv. no. AZS-988/8–9
From Kurhan 35, near village of Bobrytsia, Kanivs'kyi Raion, Cherkas'ka Oblast'.
Excavated by Ie. O. Znos'ko-Borovs'kyi, 1897.
Plaque (AZS-988/8): H: 2.7 cm; L: 4 cm; wt: 1.4 g. Plaque (AZS-988/9): H: 2.7 cm; L: 4 cm; wt: 1.96 g.

Publications: Bobrinskii (1901), vol. 3, 113, pl. xviii, figs. 7, 8; Il'inskaia (1975), 152; Kovpanenko, Bessonova, and Skoryi (1989),
71–72, figs. 16, 17; Tokyo, *Scythian Gold* (1992), 44, no. 18; Edinburgh, *Warriors* (1993), 22, no. 14;
Milan, *Tesori* (1995), 92, 193, no. 45; Vicenza, *Oro* (1997), 77, no. 33.

The relief appliques take the form of a recumbent horse in right profile, with its head reversed over its back. Each horse has a large round eye beneath a horizontal band that resembles the browband of a bridle. The mane is indicated by a braided arc that echoes the curve of the haunches.

These appliques were part of a set of eighteen such plaques that decorated a ceremonial headdress; the headdress also carried plaques decorated with concentric circles. Since no loops or attachment holes exist, the plaques were probably glued to the cloth support. The horses' recumbent position is typically Scythian, and the pose is probably ultimately based on that of the stag.

Horses played a vital role in the Scythian economy and, as one of the more visible signs of an individual's wealth, were often sacrificed in Scythian burial rites. Horses also figure in what Herodotus (4.8) said was the Greek version of the Scythian foundation myth. To secure the return of his mares, Herakles impregnated a snake-footed goddess, fathering the first Scythian king.

The plaques were found together with the bronze mirror, cat. no. 22.

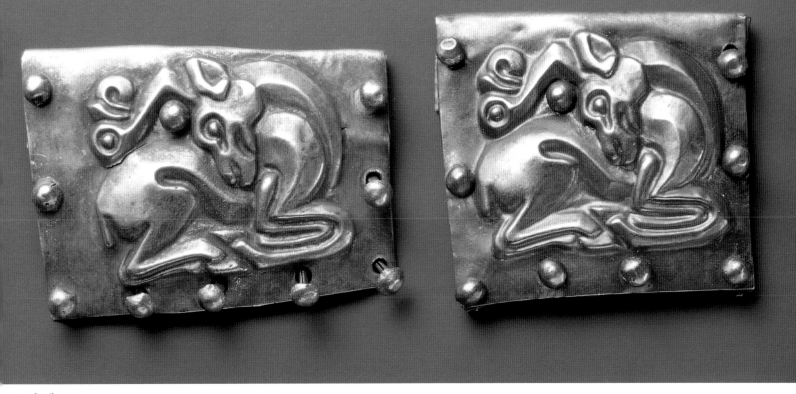

44 detail

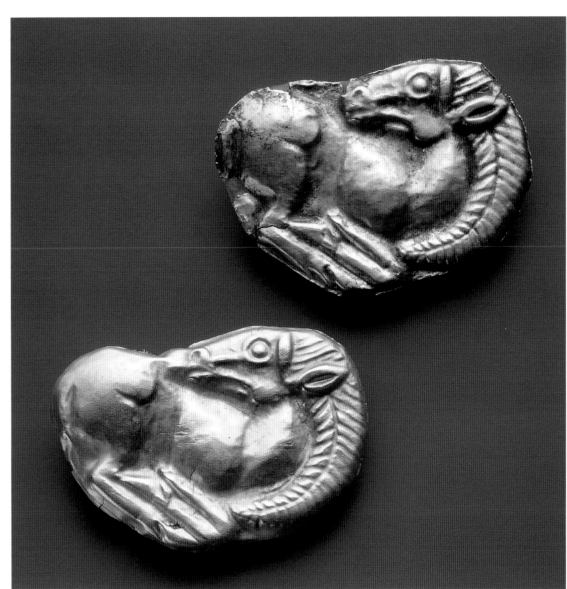

45

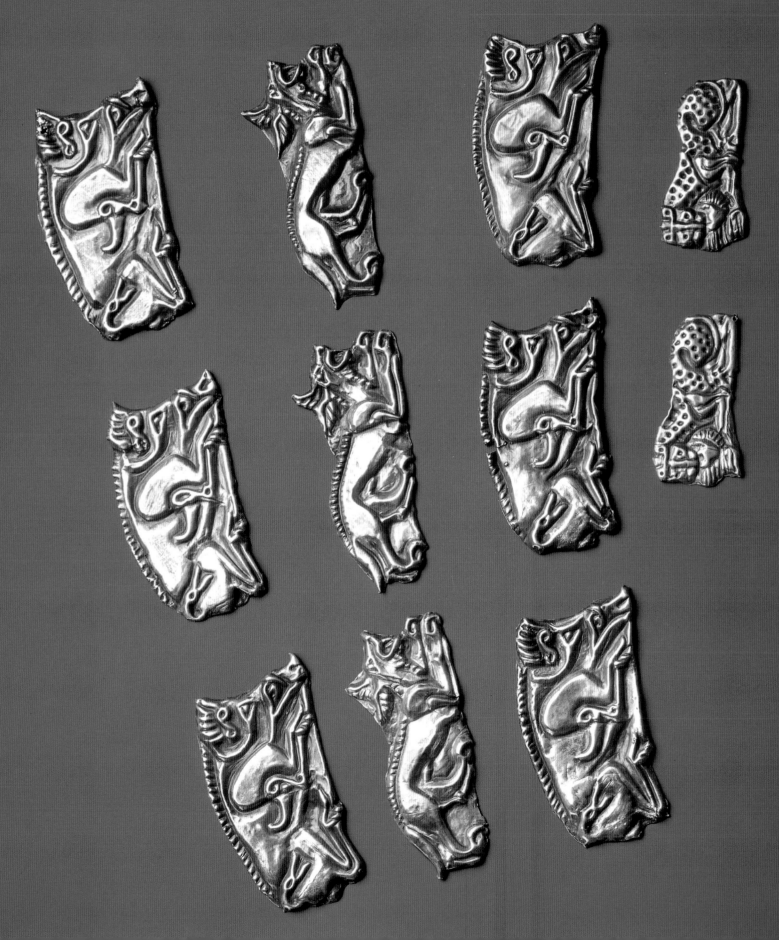

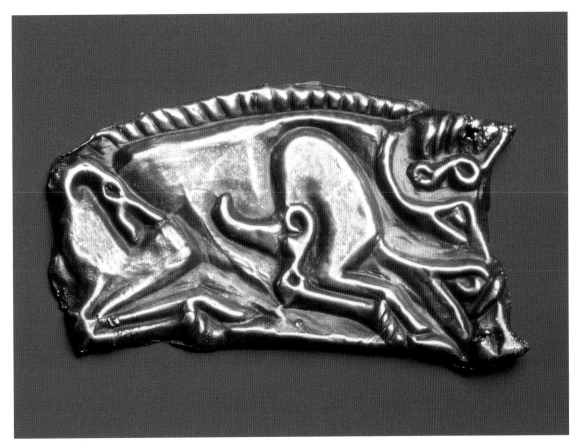

46 detail

46. GORYTOS PLAQUES IN FORM OF BOARS, DOGS, LEOPARDS, AND STAG

5th c.
Gold
MHTU, inv. no. AZS-2325/1–6, AZS-2327/1–3, AZS-2326/1–2, AZS-2328
From Kurhan 5, burial 1, near village of Arkhanhel'ska Sloboda, Kakhivs'kyi Raion, Khersons'ka Oblast'.
Excavated by O. M. Lieskov, 1969.
Plaques of boars (6) (AZS-2325/1–6): L: 8.5 cm; W: 4.5 cm; wt: 70.7 g. Plaques of dogs (3) (AZS-2327/1–3): L: 9.6 cm; W: 4.2 cm; wt: 27 g.
Plaques of leopards (2)(AZS-2326/1–2): L: 6.3 cm; W: 3.3 cm; wt: 9.8 g. Plaque of a stag (AZS-2328): L: 4 cm; W: 3.1 cm; wt: 3.1 g.

Publications: Leskov (1974), 72, fig. 102; Lieskov (1974), 73–76, pls. 55–58; Chernenko (1981), 55–56, fig. 36;
Schleswig, *Gold* (1991), 305, no.91.; Tokyo, *Scythian Gold* (1992), 51, no. 35; Toulouse, *L'or* (1993), 62, no. 23;
Vienna, *Gold* (1993), 103–105, no. 19; Schiltz, *Scythes* (1994), 376, fig. 292

Opposite: 46

These matrix-hammered plaques were originally attached to a gorytos (bow case and quiver). Six represent a crouching boar in right profile. On two plaques a spotted leopard in left profile devours a human head. Three plaques represent a dog or wolf in right profile, and two a stag in right profile. The tails of the boars curl upward to terminate in bird heads, and bird heads emerge behind the boars' shoulders.

Gorytoi were carried by every Scythian warrior and were normally made of wood and leather; hence, few remains of them have been recovered. Representations in metalwork (see, for example, cat. no. 40) indicate that they were worn at the waist, hung from a belt slung over the shoulder. Ordinary Scythians were buried with a single, typically unornamented case, but the graves of wealthier individuals have contained as many as sixteen gorytoi, some decorated, as here, with gold reliefs.

These plaques were excavated from the tumulus of a distinguished warrior who had been buried with three quiver sets, containing 166, 165, and 150 arrowheads, respectively. The position of the relief plaques in the tomb made possible this reconstruction of their placement on the gorytos.

The motif of the lion biting a human head is not common in Scythian art. The frontal head on these profile animals is borrowed from the art of the Near East or Greece. The stylization of the forms and the isolation of the body parts are frequently seen on Scythian works of art.

These plaques were found together with cat. no. 112.

47

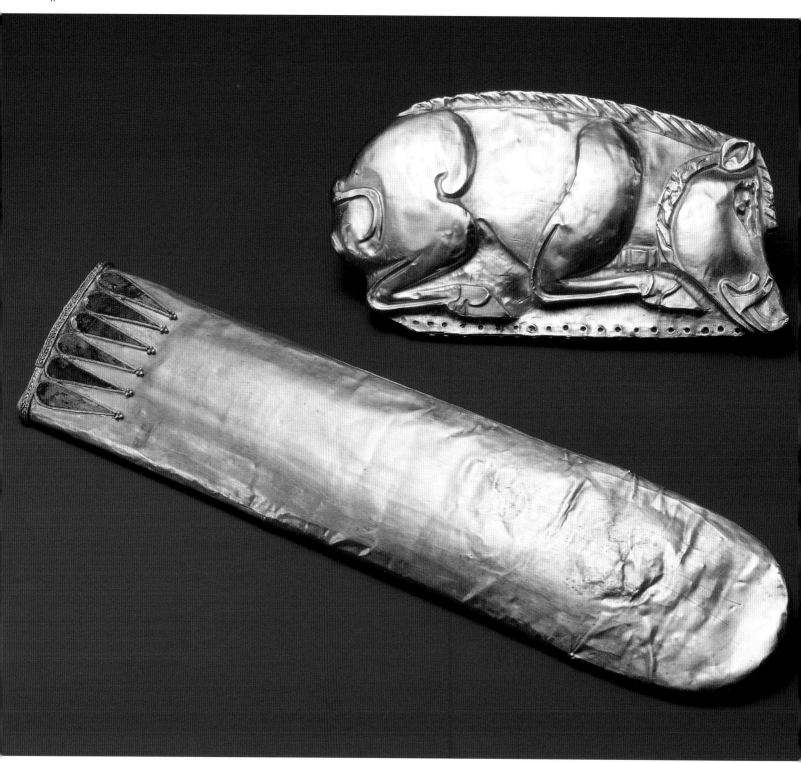

47. SWORD SCABBARD WITH A BOAR

6th–5th c.
Gold, enamel
MHTU, inv. no. AZS-3349–3350
From Kurhan 6, burial 1, near Oleksandrivka, Novomoskovs'kyi Raion, Dnipropetrovs'ka Oblast'. Excavated by I. F. Kovaleva, 1977.
Scabbard: L: 30.5 cm; W: 7 cm; wt: 86.37 g. Sidepiece with boar: L: 18 cm; W: 9.3 cm; wt: 34.12 g.

Publications: Kovaleva and Mukhopad (1982), 97–101, figs. 5.1–3; Turku, *Skyyttien* (1990), 18, 56, no. 31; Schleswig, *Gold* (1991), 304, no. 88; Edinburgh, *Warriors* (1993), 23, 26, no. 20; Toulouse, *L'or* (1993), 58, no. 19; Vienna, *Gold* (1993), 92–93, no. 15; Jacobson (1995), 236, no. VIII.B.1, figs. 105, 106; Milan, *Tesori* (1995), no. 16; Luxembourg, *TrésORS* (1997), 64, no. 4; Vicenza, *Oro* (1997), 45, no. 4.

The two plaques were originally attached to a wooden scabbard. The long, slightly convex plate was wrapped around the edges of the sheath and attached with small nails through holes on the back. It is decorated at the top with a filigree band, from which extend six leaf-shaped cloisons with blue enamel, each with three granulations at the point. The smaller plate covered the side flap. It is embossed with, and takes the outline of, a crouching boar. A scored band represents the animal's back bristle; its neck is encircled by a raised ruff. There is no groundline. The holes below the hooves were used for attachment.

Scabbards of similar shape and decoration have been found in other Scythian tumuli, for example, Hostra Tomakivs'ka Mohyla in Dnipropetrovs'ka Oblast', a mound near the village of Vitashkove in Bulgaria, and the Zolotyi (Golden) Kurhan near Simferopol'.[1] The present example was discovered in the tomb of a Scythian chieftain, along with an iron sword of a type that first appeared in Scythia in the early sixth century and became common in Greek settlements north of the Black Sea, the Caucasus, and Thrace in the sixth and fifth centuries. The style of the scabbard overlays, and particularly of the boar on this example, appears to be early Scythian and represents a transference of woodcarving techniques to metal working.

1. Artamonov (1969b), 18, 274, no. 3.

48. HORSE FRONTLET

5th c.
Bronze
NMHU, inv. no. B 32–99
From kurhan near village of Vovkivtsi, Romens'kyi Raion, Sums'ka Oblast'. Excavated by Ie. O. Znos'ko-Borovs'kyi, 1898.
H: 8.4 cm; W: 7 cm; wt: 150 g.

Publications: Khanenko and Khanenko (1900), pl. xv, no. 316; Tokyo, *Scythian Gold* (1992), 47, no. 27.

The plaque is cast in the shape of a cross with roundels at the top, forming the arms, and in the center. In the center roundel, an animal curls into a circle, with the head seen upside down at the lower left. The same scenes appear in each of three flanking roundels: a four-legged animal whose back is in contact with the center roundel, attacks a crouching four-legged animal. On the top roundel, both attacker and victim are in right profile; in the others both are in left profile. The vertical shaft is decorated, from the bottom, with an upside-down four-legged animal beneath another one. Above is an animal in right profile turned ninety degrees so that the vertical border serves as its groundline, as it appears to advance down to the base of the cross.

This plaque, perhaps once with a gold overlay, decorated the frontlet of a horse harness. It was recovered from a tomb that contained an entire set of trappings, including roundels, bronze cheekpieces, and iron bits. On a very similar example of gold and bronze, each disc forming one of the arms of the cross contains a crouching feline.[1] On another similar example from Olbia, dated in the sixth century, the arms of the cross take the form of bird heads, which appear to rotate around the central roundel.[2] On an example from Matraszek (Hungary), dated to the first century B.C., the cross arms are in the form of horse protomes.[3]

1. Turku, *Skyttien* (1990), 23, no. 39; Schleswig, *Gold* (1991), 306, no. 93.

2. Artamonov (1969b), 23, 2756, no. 34; Vienna, *Skythen* (1988), 71, no. 36; Schiltz, *Scythes* (1994), 120, no. 90; Jacobson (1995), 121. See the essay by Reeder in this volume.

3. Schiltz, *Scythes* (1994), 71, no. 47.

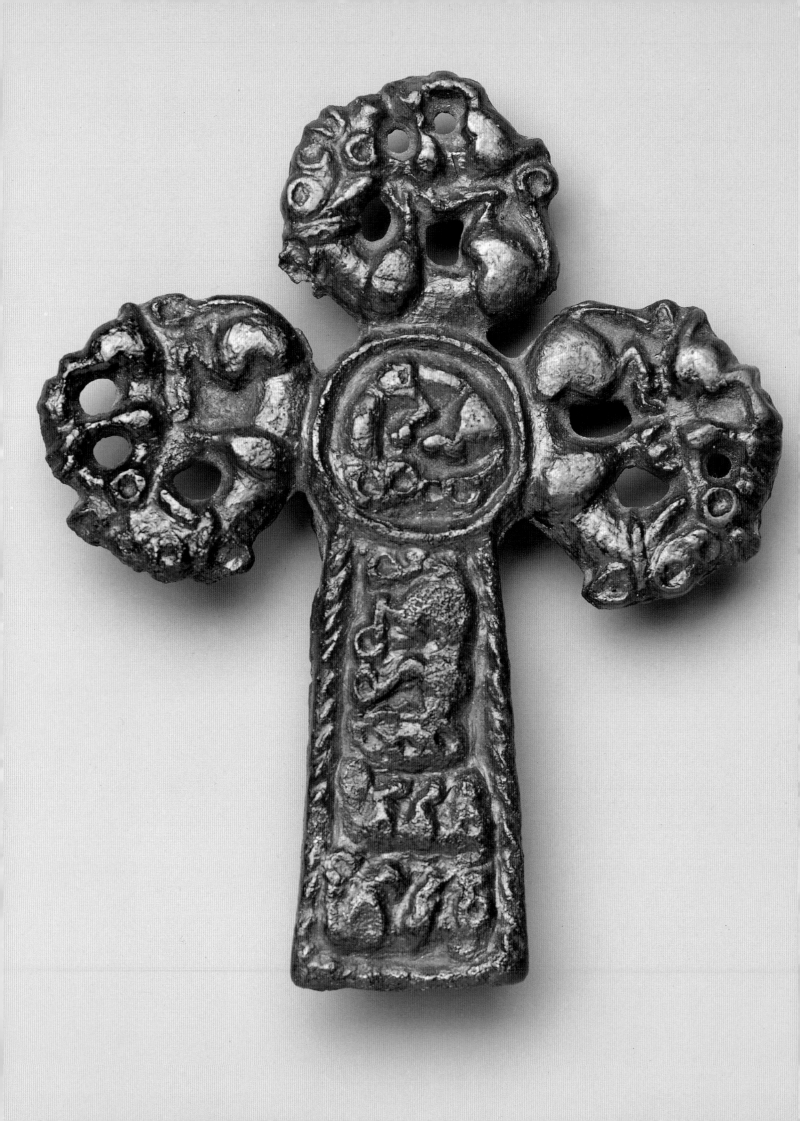

49. BELT PLAQUES IN THE SHAPE OF MOOSE HEADS

5th c.
Bronze
NMHU, inv. no. B 1299
From Kurhan 459, near village of Turia, Kirovohrads'ka Oblast'. Excavated by O. O. Bobryns'kyi, 1905.
H: 5.5 cm; L: 6.5 cm; wt: 400 g.

Publications: Bobrinskii (1901); Petrenko (1967), no. 19, pl. 31.

The cast plaques are in the form of stylized moose heads. The scrolling antlers, which are treated as upside-down bird heads with long beaks, originate from a simplified palmette. The eyes of the bird heads and the moose are made of hemispheres. The moose's nostrils are indicated by two linked volutes. Another volute extending in an S-curve forms the mouth. The highly stylized ear lies against the head, above the mane. On the reverse is a rectangular loop for attachment.

There is some disagreement about what type of object these plaques decorated. The loops on the back are designed so that a leather strap would pass through them vertically. This suggests they might have been attached to a scabbard strap worn across the shoulder. A similar belt was worn by the Golden Man from Issyk,[1] and similar reliefs have been found in a Saka tomb in modern Kazakhstan.[2] The plaques might also have been horse trappings. A similar bridle applique with a moose head was found in Zhurivka.[3] Another close parallel comes from the Nymphaion Kurhany.[4] A similar handling of the antlers is seen on cat. no. 50.

1. See Schiltz, *Scythes* (1994), 299–302; Mantua, *L'uomo d'oro* (1998), 179.
2. Yablonsky (1995), 203, 206, fig. 13.
3. Artamonov (1969b), 284, no. 83, pl. 83. Compare also a similar example, Schiltz, *Scythes* (1994), 31, no. 12.
4. Schiltz, *Scythes* (1994) 31, no. 12.

49

Opposite: 48

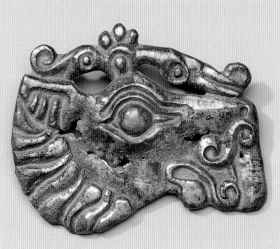

50. QUIVER COVER WITH ATTACK SCENE

5th c.
Gold
MHTU inv. no. AZS-2288/1–2
From Kurhan 1, burial 6, near Illicheve, Lenins'kyi Raion, Krym. Excavated by O. M. Lieskov, 1964.
Relief plaque (AZS-2288/1): L: 10 cm; W: 11 cm; wt: 55 g. Scabbard (AZS-2288/2): L: 23 cm; W: 11 cm; wt: 135.45 g.

Publications: Leskov (1968), 158–65; Leskov (1972), 50–52, fig. 13; Hanina (1974), figs. 60, 61; Leskov (1974), 25, 59, figs. 39, 79.

The two plates were attached to a quiver. The upper applique is decorated with a recumbent stag, in right profile, under attack from a lion, an eagle, and a snake. The long-eared stag has fallen, its legs tucked beneath it. Its antlers branch into stylized bird heads with curling beaks, and its hooves and tail also take the form of bird heads. An ovolo runs down its throat from a volute that defines the jaw. A lion with corrugated mane

Opposite: 50

50 detail

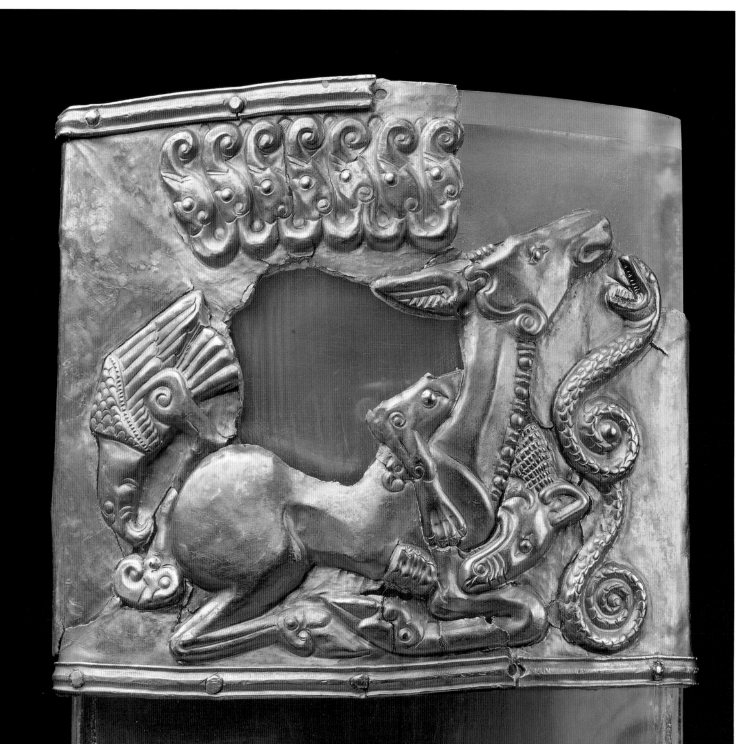

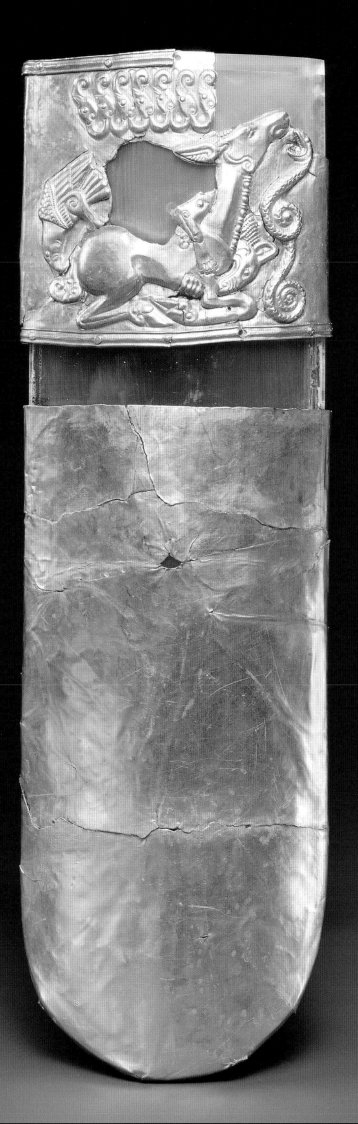

grasps the stag, biting its shoulder. The contour of the lion's jaw is rendered as a bird head. In front of the stag a scaly snake rises up, baring its fangs, its body coiled into two volutes. An eagle perched on the stag's back pecks at the stag's hindquarters. A ribbed border frames the scene above and below, and small studs remain from attachment pins.

The lower portion of the scabbard was clad with a plain rectangular plate with a rounded bottom.

These reliefs were recovered along with a *hryvnia* (torque) and an unidentified object in the form of a truncated cone with an opening on its flat top. The objects had been placed on top of the tomb rather than inside it as was customary—an anomaly researchers have yet to understand.

The transformation of antlers into bird heads is interpreted by Jacobson as an expression of a belief in rebirth and regeneration related to an ancient Siberian Tree of Life and a female divinity.[1] The motif is also found on cat. no. 49, on a gold scabbard from Turia,[2] and on a late-fifth-century wood and leather stag head from Pazyryk.[3]

The recumbent stag and the transformation of antlers and other body parts into bird heads are traditional Scythian elements. Influence from the Greek and Near Eastern worlds is seen, not only in the conflict of feline and stag, but also in the introduction of other animals and the resemblance of the stag's head to the head of a horse.[4]

1. Jacobson (1993), 47, 61, 97, 179, 230–31, 238, 240.

2. Artamonov (1969b), 289, no. 2, pls. 323–24.

3. Vienna, *Skythen* (1988), 203, no. 120.

4. See the essay by Reeder in this volume.

51. BOWL IN THE FORM OF AN EAGLE

4th c.
Gold
MHTU, inv. no. AZS-3068/1–5
From Berdians'kyi Kurhan, near Novovasylivka, Berdians'kyi Raion, Zaporizhs'ka Oblast'. Excavated by M. M. Cherednychenko, 1978.
Plaque (AZS-3068/1): H: 3 cm; L: 6.3 cm; wt: 4.7 g. Plaque (AZS-3068/2): H: 3.6 cm; L: 10.3 cm; wt: 8.4 g.
Plaque (AZS-3068/3): H: 3.2 cm; L: 16.2 cm; wt: 13 g. Plaque (AZS-3068/4): H: 1.3–1.9 cm; L: 4.8 cm; wt: 4 g.
Plaque (AZS 3068/5): H: 2.8 cm; L: 3.55 cm; wt: 3.8 g.

Publications: Cherednychenko and Murzin (1996), 73, fig. 8; Luxembourg, *TrésORS* (1997), 74, no. 16.

The original bowl was egg-shaped and made of wood. A broad gold strip, whose upper edge slipped over the rim, passed entirely around the vessel and was riveted in place above and below. Hammered in relief is a row of crouching eagle-headed griffins in right profile. An eagle head in the round projects from one narrow end of the bowl, and a flaring bird's tail emerges from the other.

Herodotus (4.10) reported that Scythian men wore cups suspended from their belts in honor of their legendary ancestor Herakles (see also cat. nos. 40–42). The cups were normally attached by means of a slit in the rim or handle. This cup lacks such slits, which are present on two other cups with which it was found. The tomb's male occupant possessed in this cup a piece that exhibits quintessential features of the Scythian style: the prominence of the eagle, even to the shape of the vessel that was probably fashioned to resemble an eagle egg; the isolation of repeated crouching animals; and the animation of the subject, which, like the griffin hatchet (cat. no. 23), would have appeared in motion when the object was in use.[1]

Opposite: 51

1. See the essay by Reeder in this volume.

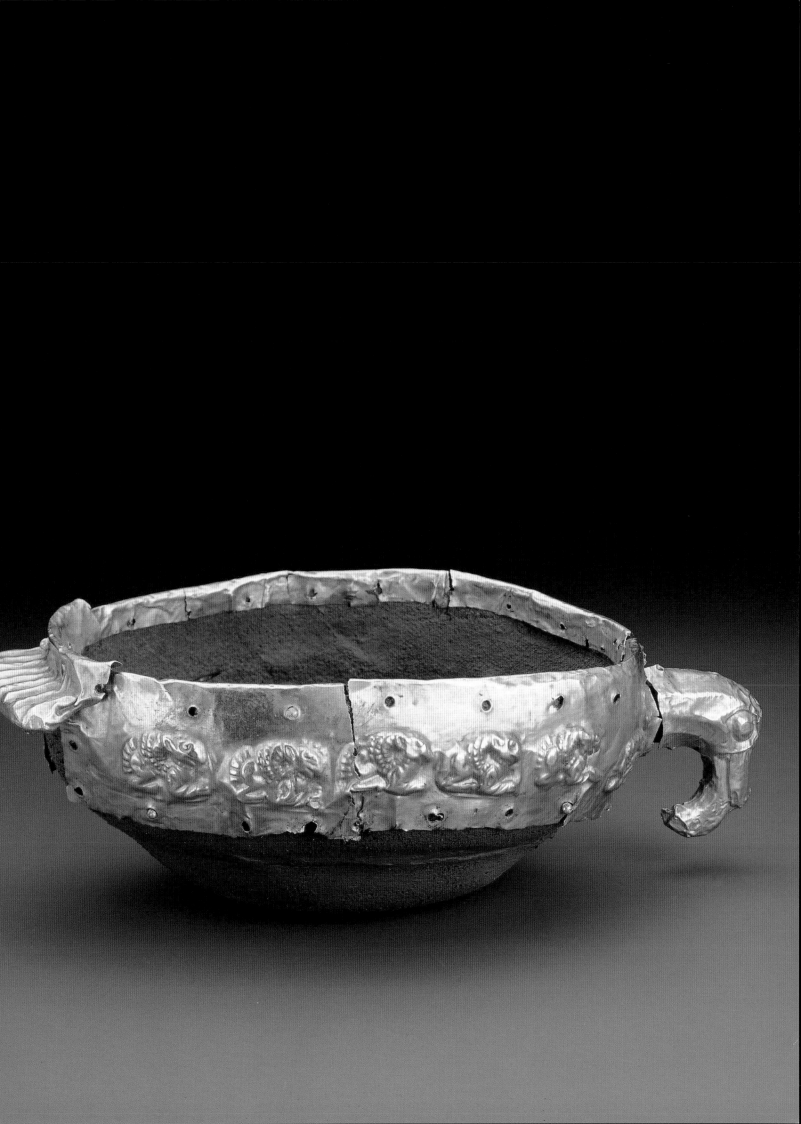

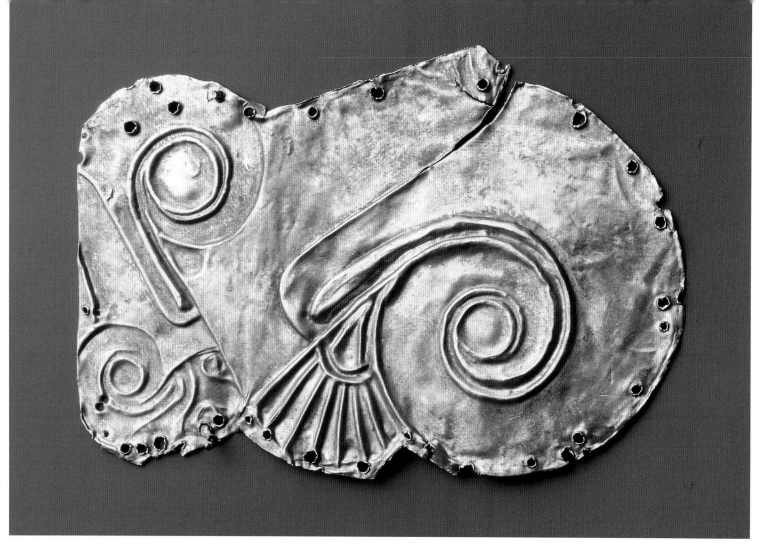

52

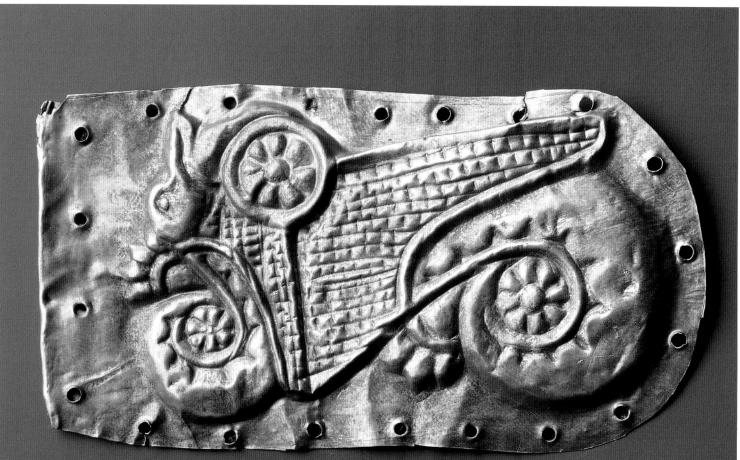

53

52. PLAQUE WITH BIRD HEADS

5th c.
Gold
MHTU, inv. no. DM-6305
findspot unknown.
H: 9.2 cm; W: 6.1 cm max; wt: 17.6 g.

Publications: Tokyo, *Scythian Gold* (1992), 67, no. 56.

The applique's three volutes wind into circles that form part of stylized interlocking images of eagle or griffin heads. The smallest circle forms the eye of one bird head. Extending out from it is the cere (the upper part of an eagle's beak), from which winds a volute that serves as both the curving beak of the first bird and the eye of a second bird. The second bird is best seen by rotating the plaque ninety degrees counter-clockwise. Below its cere, the curving beak winds into the third volute, from which a palmette emerges.

The smallest circle, or volute, functions also as the curving beak of a third bird head, whose eye is partially obscured by an ancient rivet hole on the (viewer's) left side of the plaque.[1]

This plaque decorated a cup or bowl similar to cat. no. 54.

1. See the essay by Reeder in this volume.

53. PLAQUE WITH BIRD HEADS

5th c.
Gold
MHTU, inv. no. DM-6253
From Kurhan 4, Berestniahy, Kanivs'kyi Raion, Cherkas'ka Oblast'. Excavated by Ie. O. Znos'ko-Borovs'kyi, 1897.
L: 11 cm; W: 5.8 cm; wt: 22.2 g.

Publications: Khanenko and Khanenko (1899), pl. lx.x; Bobrinskii (1901), 96, pl. xviii.11; Petrenko (1967), 44, 47, pl. 16.5; Riabova (1984), fig. 2.6; Tokyo, *Scythian Gold* (1992), 67, no. 55.

The plaque is decorated in relief with volutes, rosettes, and hatched patterns that create highly stylized images of bird heads. The first bird head is near the (viewer's) right edge of the plaque: the rosette at the plaque's edge serves as the center of the curving beak; the bird's head, eye, and cere are above it. This large rosette also serves as the eye to a second bird head, best seen if the plaque is rotated counter-clockwise ninety degrees. The bird's beak is articulated into the cere, rendered as horizontal bands interrupted by regularly spaced vertical grooves, and the curving tip, rendered as a volute.[1]

This plaque was attached to a wooden cup or bowl similar to cat. no. 54. Small holes around the periphery were for attachment.

The plaque was found together with cat. no. 12.

1. See the essay by Reeder in this volume.

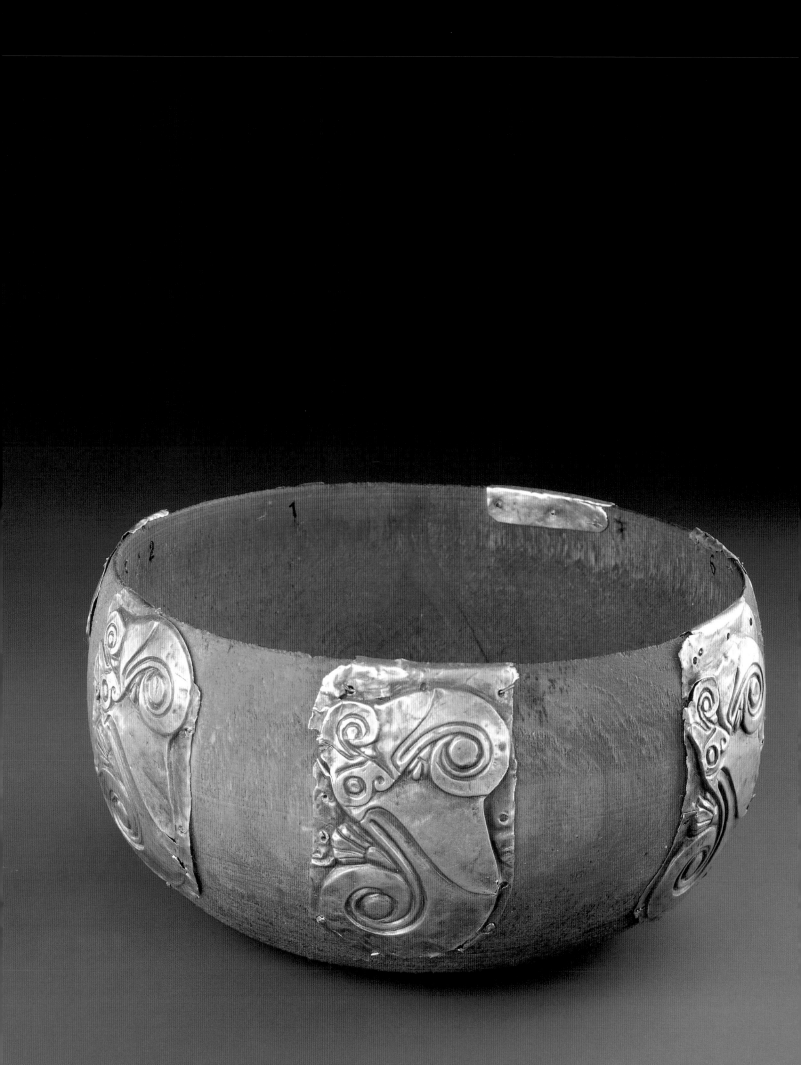

54. BOWL WITH PLAQUES OF BIRD HEADS

5th c.

Gold; wood reconstruction

MHTU, inv. no. AZS-2809/1–7

From Zavads'ka Mohyla, Kurhan 1, near Ordzhonikidze, Dnipropetrovs'ka Oblast'. Excavated by B. M. Mozolevs'kyi, 1973.
Reconstructed cup: H: 9.5 cm; D: 18 cm. Plaque (AZS-2809/1): H: 7.4 cm; W: 4.8 cm; wt: 13.77 g. Plaque (AZS-2809/2): H: 7.8 cm; W: 4.8 cm; wt: 13.84 g. Plaque (AZS-2809/3): H: 7.5 cm; W: 4.8 cm; wt: 13.87 g. Plaque (AZS-2809/4): H: 7.85 cm; W: 4.8 cm; wt: 17.01 g. Plaque (AZS-2809/5): H: 8.05 cm; W: 4.8 cm; wt: 17.62 g. Plaque (AZS-2809/6): H: 8 cm; W: 4 cm; wt: 13.57 g. Plaque (AZS-2809/7): 8 x 4.9 cm; wt: 16.09 g.

Publications: Mozolevskii (1980), 108, figs. 45, 47; Schleswig, *Gold* (1991), 308, no. 98a; Tokyo, *Scythian Gold* (1992), 69, no. 60; Jacobson (1995), 194, no. VI.B.2; Luxembourg, *TrésORS* (1997), 73, no. 14.

On each of these relief plaques, which were originally affixed to a wooden bowl (here restored), are three interlocking eagle heads. The first bird head, in right profile at the top of the plaque, is recognized from the large round eye, the cere (the upper part of the beak), and the volute that forms the curving beak. This last volute serves as the eye of a second bird head, whose beak is formed by the large volute at the bottom of the plaque. This second bird is best seen by rotating the plaque ninety degrees counter-clockwise. The circle, or volute, serving as the eye of the first bird also functions as the curving beak of a third bird head, whose eye is rendered by a circular groove.

With their interlocking forms, the bird-head motifs would have been intelligible no matter how the cup was tilted. A related plaque, also from the fifth century, comes from Maikop, but it can only be read as a single bird head.[1]

Wooden cups with gold appliques, which are found in the tombs of wealthy Scythians, may have had significance beyond serving the needs of the deceased in the afterlife. Herodotus (4.5) reports that a gold cup figured in Scythian legends about the accession to the throne of Colaxais, founder of the royal dynasty. A cup also played a role in Greek accounts of the first Scythian king, Scythes, a son of Herakles. He was shown to be the rightful king ahead of his older brothers because he could, among other achievements, wear his father's belt, to which a cup was attached. Herodotus (4.10) goes on to say that it was for this reason that Scythian men wore cups on their belts.

Opposite: 54

1. Schiltz, *Scythes* (1994), 372, no. 282.

55. TORQUE WITH BIRD-HEAD TERMINAL

4th c.
Gold
MHTU, inv. no. DM-1694
From Kurhan 1, near village of Vovkivtsi, Romens'kyi Raion, Sums'ka Oblast'. Excavated by S. A. Mazaraki, 1897–1898.
D: (front to back) 16.5 cm; D: (side to side) 17 cm; H: 4.1 cm; wt: 227.3 g.

Publications: Khanenko and Khanenko (1899), 6, pl. xxv, 424; Petrenko (1978), 45, pl. xxxiii.5;
Tokyo, *Scythian Gold* (1992), 83, no. 84; Schiltz, *Scythes* (1994), 385, fig. 307.

The torque is formed of a round rod terminating in griffin-head finials that are worked both on the inner and outer surfaces. The heads have a long hooked beak, large round eyes, prominent ears, and a projecting ridge along the top. The jaws and ears are outlined by raised ridges that form S-curves.

This heavy *hryvnia*, or torque, was discovered in a male burial and testifies to the owner's affluence. In the fourth century, when this gold example was made, Scythian torques were fashioned of various materials and in different forms, and were worn by men, women, and children.

This torque was found together with cat. nos. 106 and 115.

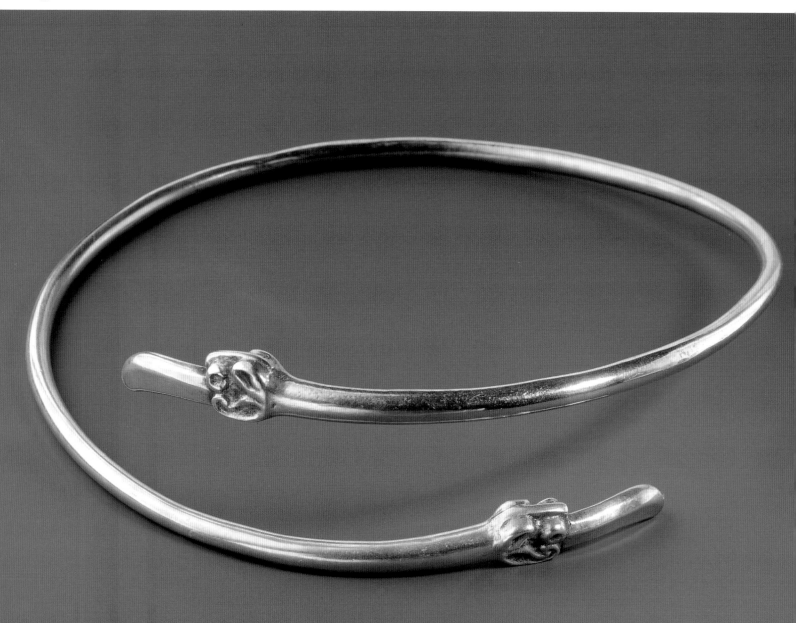

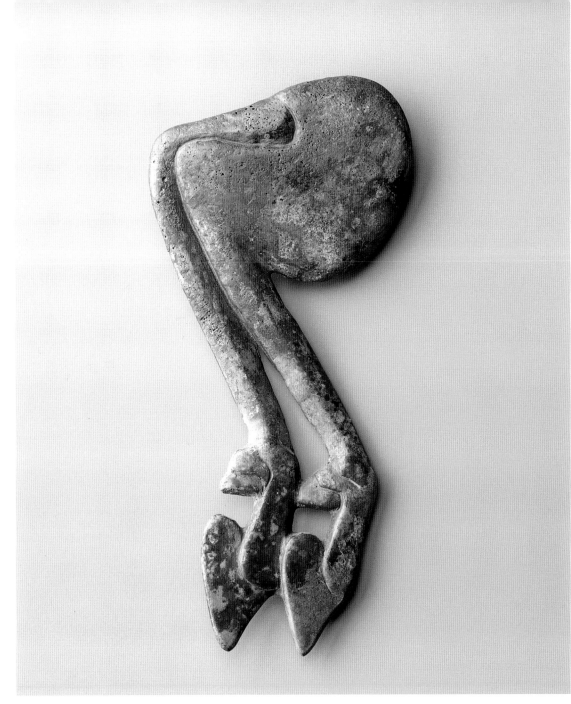

56

56. PLAQUE WITH STAG LEGS

4th–3rd c.
Bronze
NMHU, inv. no. B 698
From Halushchyne Urochyshche, near village of Pastirs'ke, Cherkas'ka Oblast'. Excavated by V. V. Khvoika, 1898.
L: 13.5 cm; W: 6.3 cm; wt: 100 g.

Publications: Khanenko and Khanenko (1900), 27, no. 320; Petrenko (1967), 40, pl. 30.

The cast-bronze plaque is formed as the rear legs and hindquarters of a stag suspended in air, mid-stride. The hooves end in points below exaggerated fetlocks. Short hatched grooves indicate the hair of the legs. The rounded contours of the surface convey a sense of the coiled energy of the animal's haunch, which the artist has rendered unobscured by a tail.

The plaque was found together with the helmet, cat. no. 91.

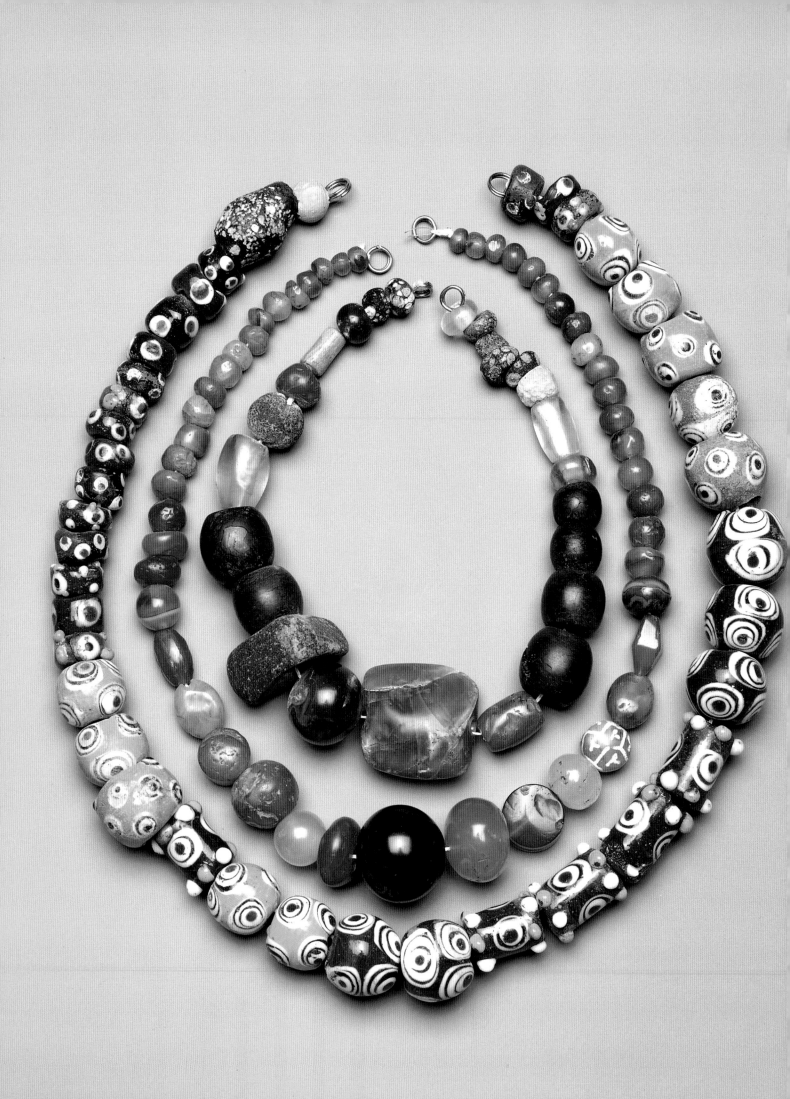

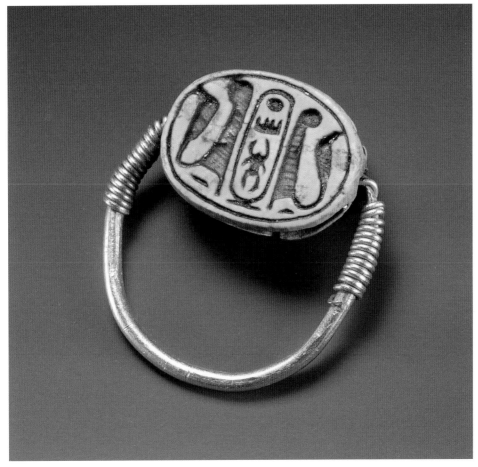

60

60

Opposite: 57, 58, 59

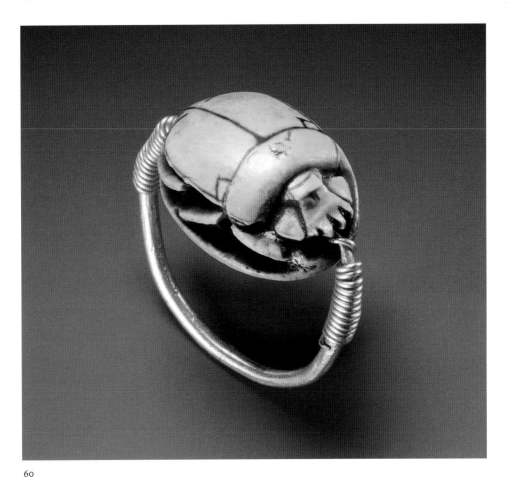

57. STRING OF BEADS

6th–4th c.
Semi-precious stones
NMHU, inv. no. B 1882
From Kanivs'kyi Raion, Cherkas'ka Oblast'. Excavated by Ie. O. Znos'ko-Borovs'kyi, 1897.
Gift to NMHU from the O. O. Bobryns'kyi Collection in 1923.
L: 43.5 cm (modern restringing); wt: 200 g.

Publications: Bobrinskii (1901); Onaiko (1966), 66, 280; Tokyo, *Scythian Gold* (1992), 80, no. 79.

The beads are carved from onyx, chalcedony, and carnelian. Most are spherical or globular; one is biconical and one is amygdaloid. One of the spherical carnelian beads is decorated with a honeycomb pattern.
See the entry for cat. no. 58.

58. STRING OF BEADS

6th–4th c.
Semi-precious stones
NMHU, inv. no. B 1597
From Kurhan 447, near village of Zhurivka, Cherkas'ka Oblast'. Excavated by O. O. Bobryns'kyi, 1904.
L: 30.5 cm (modern restringing); wt: 200 g.

Publications: Bobrinskii (1905), 93–97; Illins'ka (1963), 37; Illins'ka (1966) 58–92; Onaiko (1966), 66, 280;
Tokyo, *Scythian Gold* (1992), 80, no. 80.

The beads are carved from various materials, including onyx, agate, carnelian, bone, amber, sard, sardonyx, and glass paste. Their shapes include spheres, cylinders, discs, and barrels.
Most of the beads strung as cat. no. 58 are carved from carnelian, which can vary in color from a pale pinkish buff to deep purple. The necklace also includes beads of Baltic amber. The beads in cat. no. 57 include many of onyx, which were probably imported from Syria or Ethiopia. Other materials in these necklaces may have come from the Caucasus, Krym (Crimea), and even India, where the unusual honeycomb bead probably originated. Beads are common in Scythian burials, found in the graves of rich individuals and servants alike. Not only were they strung as necklaces, but they were also used to decorate headdresses and garments.

59. STRING OF BEADS

4th c.
Glass paste
NMHU, inv. no. B 54–102
From Melitopol's'kyi Kurhan, burial 1, Melitopol', Zaporizhs'ka Oblast'. Excavated by O. I. Terenozhkin, 1954.
L: 52.5 cm; wt: 200 g.

Publications: Terenozhkin and Mozolevskii (1988), 104–13, figs. 116–20; Tokyo, *Scythian Gold* (1992), 81, no. 81;
Edinburgh, *Warriors* (1993), 32, no. 42; Vienna, *Gold* (1993), 158–59, no. 39.

The necklace is strung with thirty-nine blue and yellow glass-paste beads of various shapes. Most are long or short cylinders, or near-balls decorated with concentric "eyes." Yellow and white knobs project from the long dark blue cylindrical beads; two light blue shorter cylinders have yellow knobs. One pear-shaped bead (speckled black and white) and one spherical bead (yellow and white) are also included.
This modern restringing includes only a small number of the beads that were discovered together in a tomb in the Melitopol's'kyi Kurhan. The beads were stored inside a box that lay to the right of the female occupant, near her head. A bird pendant of Phoenician glass was also inside the box, and elsewhere in the tomb was a pendant made from a shark's tooth.
Beads decorated with "eyes," as are many of the ones here, were thought to afford protection against evil. That belief was probably held by Scythian women in whose tombs beads of this type are often found. Such beads were common from the sixth through the fourth centuries, but they began to disappear in the third.

60. SCARAB RING

7th c.
Gold and glazed jasper
MHTU, inv. no. AZS-1545
Chance find, west necropolis of Scythian Neapolis, Simferopol', Krym.
Bezel: L: 1.8 cm; W: 1.3 cm. Band: D: 2.3 cm; wt: 5.16 g.

Publications: Edinburgh, *Warriors* (1993), 42–43, no. 71; Toulouse, *L'or* (1993), 93, no. 83; Vienna, *Gold* (1993), 228–29, no. 66.

The bezel is a jasper scarab carved on the reverse with a cartouche of Pharaoh Thutmose III (sixteenth century). The scarab is attached via a round wire that passes through a horizontal bore and coils around the hoop on each side of the stone.

Scarabs are found in many parts of the ancient world. Those with royal names, such as this one, probably served as amulets, protecting wearers by invoking the name and power of the pharaoh. It is possible that Thutmose's name in particular was associated with the sun god Amon. Scarabs bearing the pharaoh's cartouche were made and worn long after Thutmose's lifetime, as this ring from a thousand years later attests. Similar rings have also been found in Neapolis.

61. KRATER FRAGMENT FROM BEREZAN'

ca. 575–550
Clay
AI, inv. no. AM 1021/6156
Greek
From Berezan' Island, Ochakivs'kyi Raion, Mykolaivs'ka Oblast'.
D: (inner) 29 cm; D: (max) 46 cm; H: (max) 28 cm; W: (handle) 13.5 cm; H: (handle) 8 cm; wt: 1000 g.

Publications: Walter-Karydi (1973), 82, no. 976 a–b, pl. 119; Korpusova (1987), 50;
Zurich, *Schatzkammern* (1993), 154–55, no. 75.

61

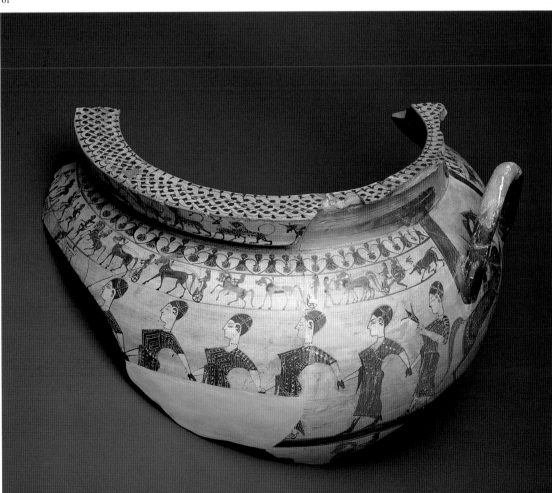

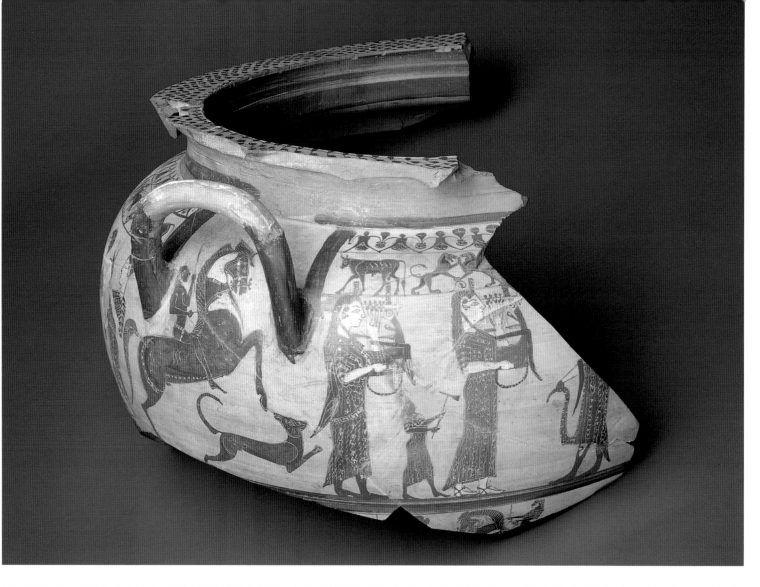

61

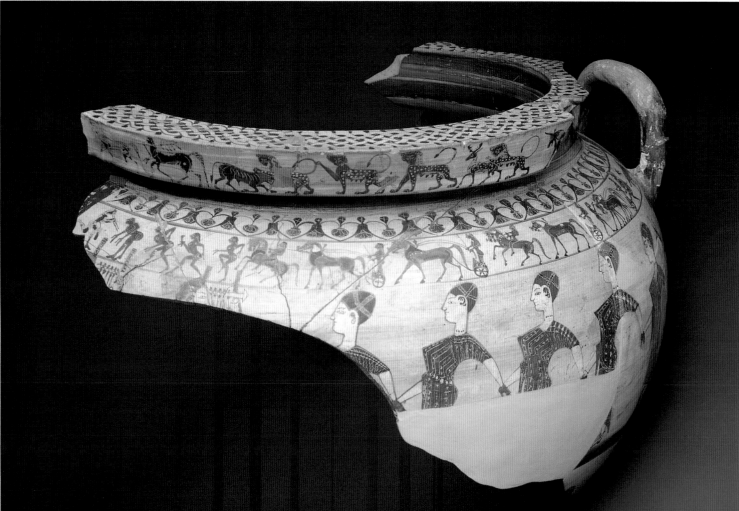

61

The fragmentary black-figure dinos krater has added white and purple paint. On the broad flat rim is an interlace pattern. On the shoulder, encircling the vessel, is a garland of lotus buds above a procession that includes a piper, four dancing figures followed by horsemen, a chariot, a running warrior with a shield, bulls, and rampant lions. On one side of the vase, the main frieze depicts six women moving in left profile toward a kithara player. One of the women holds a lotus. Only part of the other frieze remains, showing two women who play kitharas, flanking a smaller female figure who holds an axe. Under the handle is a male rider on a rearing horse accompanied by a hound below.

Archaic Greek vases, such as this one, illustrate the wealth of vegetal ornament, figural representation, myth, and cult with which Scythians came into contact as they developed trading ties with their Greek neighbors along the Black Sea coast.

62. LYDION FROM OLBIA

6th c.
Clay
NMHU, inv. no. B 7–161
Greek
From Olbia, Burial 30, trench i, near Parutyne, Ochakivs'kyi Raion, Mykolaivs'ka Oblast'.
Excavated by L. M. Slavin, 1940. Given to NMHU by the Institute of Archaeology of the Academy of Sciences of Ukraine.
H: 9 cm; W: 7 cm (max); wt: 300 g.

Publications: Knipovich (1941).

The vase has a high conical base, steeply angled body, and a wide flaring neck with a broad flat rim. It is red-glazed and burnished, except on the foot.

The shape of this vase, which was perhaps made in Greece, is not common in the northern Pontic region. It was found in the same tomb as was a cup from Chios (cat. no. 63).

62

63. BLACK-FIGURE VASE FROM OLBIA

6th c.

Clay

NMHU inv. no. B 7–159

Greek

From Olbia, Burial 30, trench ch, near Parutyne, Ochakivs'kyi Raion, Mykolaivs'ka Oblast'.

Excavated by L. M. Slavin, 1940.

H: 11.3 cm; D: (mouth) 11 cm; D: (foot) 5.5 cm; wt: 300 g.

Publications: Knipovich (1941), fig. 46; Skudnova (1957), 148; Walter-Karydi (1973), 67, 139, no. 759, pl. 95; Moskva, *Археология* (1984), pl. cxli, 4; Lemos (1991), 330, no. 1582, pl. 202; Zurich, *Schatzkammern* (1993), 152–53, no. 74.

The conical cup rests on a high conical base. The interior of the cup, the base, and the exterior of the two horizontal handles are glazed black. The interior of the handles and the exterior of the cup are reserved. The cup is decorated with dancers, perhaps komasts, who move right, their right arms extended, and their heads turned back in left profile. Details of the figures' short costume and headdress are incised. The reserved field is decorated with incised spirals inside black circles. Four horizontal black lines surrounding a panel of hatched and vertical lines mark the transition to the base. Inside, a band of red and white lotus buds and lotus flowers encircles the rim.

Cups of this type, identical in design and size, have been found in the Greek city of Olbia and on the island of Berezan'. This example was found in a tomb that also contained an aryballos and a bronze mirror with a boar-head handle.

63

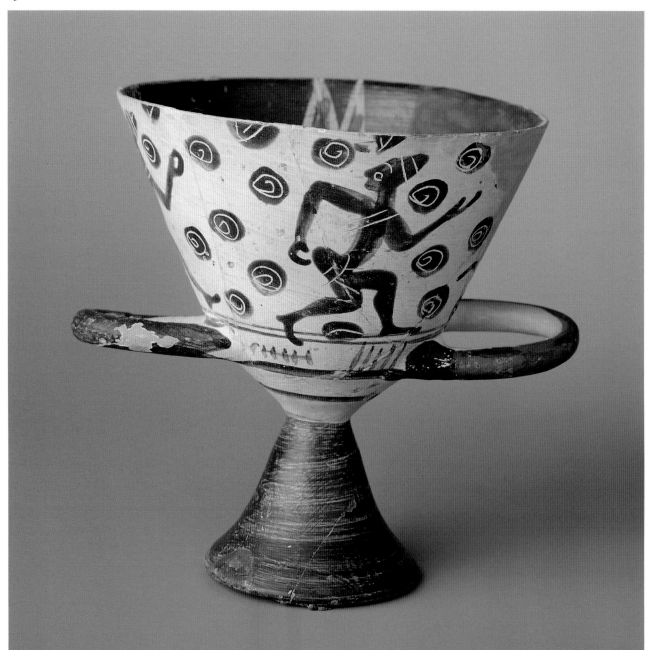

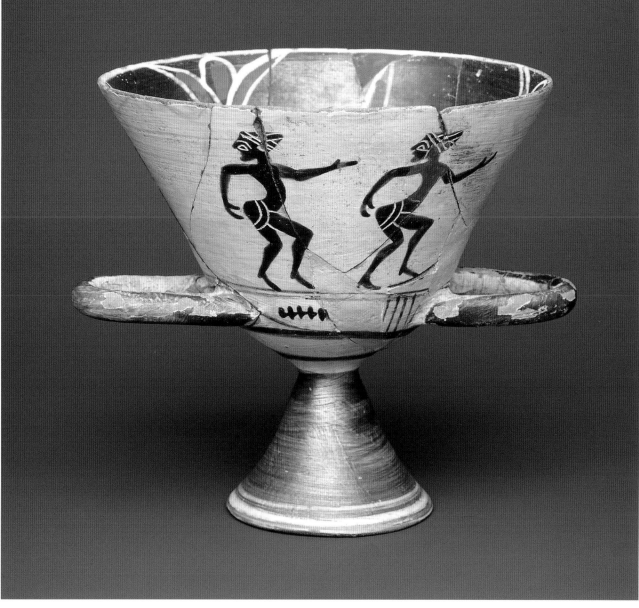

64

64. BLACK-FIGURE VASE FROM BEREZAN'

ca. 575–550
Clay
AI inv. no. AM 983/6155
Greek
From Berezan' Island, Ochakivs'kyi Raion, Mykolaivs'ka Oblast'. Found by V. V. Lapin in the 1950s.
H: 10.8 cm; D: 11 cm; D: base 5.2 cm; wt: 300 g.

Publications: Skudnova (1957), 135, figs. 7.4–5; Lemos (1991), nos. 1561, 1562, pl. 200; Zurich, *Schatzkammern* (1993), 150–51, no. 73.

The conical cup rests on a high conical base. The interior of the cup, the base, and the exterior of the two horizontal handles are glazed black. The cup's exterior is covered with a white slip and decorated on one side with dancers, perhaps komasts. They move right, their right arms extended, their heads turned back in left profile. Details of the figures' short costume and headdress are incised. Below, four horizontal black lines, with a panel of hatched and vertical bands, mark the transition to the base. The interior of the cup is decorated with lotus blossoms and palmettes in red and white.

 See the entry for cat. no. 63.

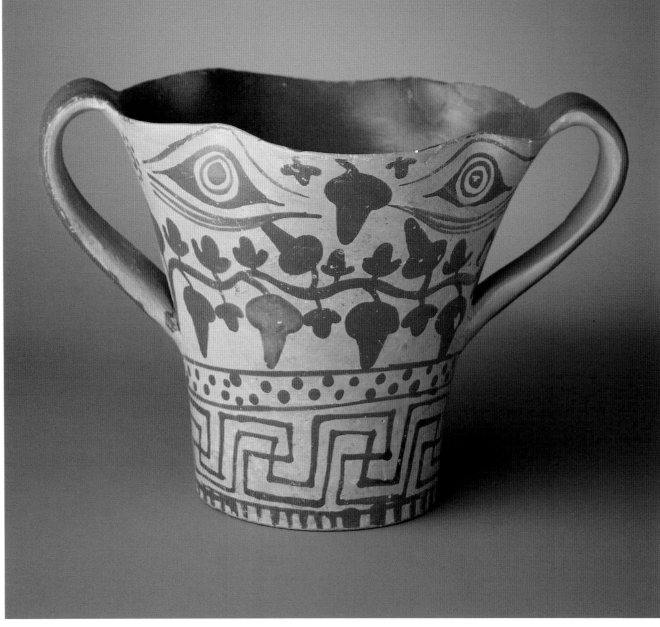

65

65. TWO-HANDLED VASE FROM OLBIA

6th c.
Clay
NMHU, inv. no. B 4–249
Greek
From Olbia, near Parutyne, Ochakivs'kyi Raion, Mykolaivs'ka Oblast'. Excavated by L. M. Slavin, 1937.
Given to NMHU by the Institute of Archaeology of the Academy of Sciences of Ukraine in 1956.
H: 11 cm; D: (across handles) 16 cm; D: (mouth) 14 cm; wt: 500 g.

Publications: Knipovich (1940); Shtitel'man (1977), no. i.12.

The flaring cylindrical cup tapers toward the foot and has a scalloped lip and vertical handles. On the exterior, the reserved clay is decorated in red with a band of grape leaves and large eyes below the four scalloped projections of the lip. Below this is a band of alternating red dots, followed by a red meander and a row of vertical bands. On the underside is an eight-rayed star in red, with a short ray between each tip. The interior of the cup is glazed with red.

The cup was made in Istria, and is a rare find in the north Pontic region. It was discovered in a burial that also included a footed amphora.

66. TWO-HANDLED VASE FROM OLBIA

6th c.
Clay
NMHU, inv. no. B 1–73
Greek
From Olbia, near Parutyne, Ochakivs'kyi Raion, Mykolaivs'ka Oblast'. Excavated by B. V. Farmakovs'kyi, 1882.
From the collection of I. K. Suruchan.
H: 10 cm; W: (overall) 11.4 cm; D: (mouth) 7.8 cm; wt: 150 g.

Unpublished.

In profile the tall cup has a rounded base and flaring neck. Two vertical handles descend from the plain lip. The exterior is covered with a white slip. One horizontal band of black paint runs at the level of the handles. The interior is decorated with a black band below the lip, followed by a band of white slip. The rest of the interior is reserved.

Thought to be an import from Naukratis, this cup was found in a tomb in Olbia. This type of vessel is rarely found in the area north of the Black Sea.

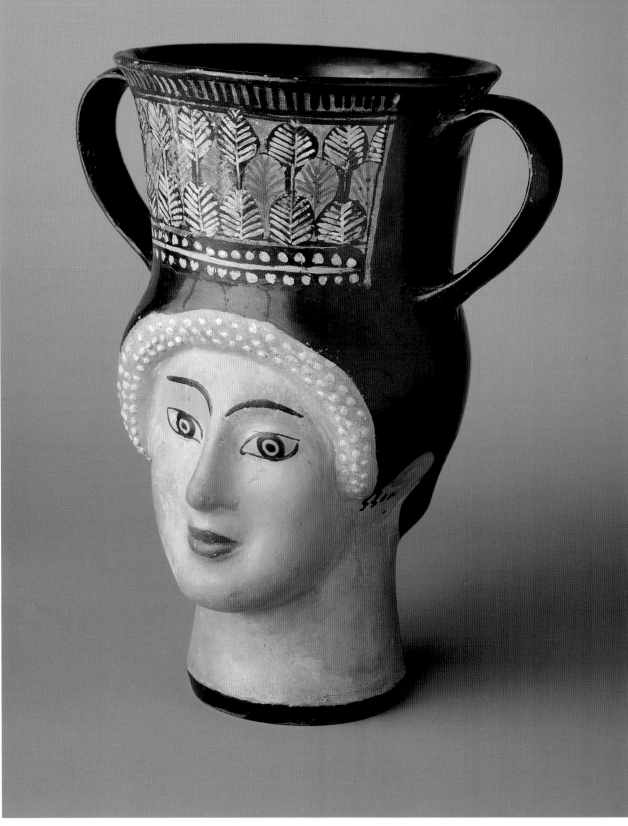

67. HEAD VASE FROM OLBIA

5th c.
Clay
NMHU, inv. no. 5373
Greek
From Olbia, near Parutyne, Ochakivs'kyi Raion, Mykolaivs'ka Oblast'. Date of find unknown.
H: 16.5 cm; D: 10.5 cm; wt: 800 g.

Publications: Turku, *Skyyttien* (1990), 47, 51, no. 145; Tokyo, *Scythian Gold* (1992), 127, no. 147.

A kalathos-like neck extends from the body of a vase that is made in the form of a female head. Between the vertical handles, on front and back, a reserved band is decorated with alternating leaf patterns in red and added white. It is bordered above by a row of alternating red and black vertical lines and below by schematic ivy leaves in added white. The black glaze on the neck of the vase descends to create a sakkos-like headcovering that frames the reserved clay of the woman's hair, face, and neck. Her hair is rendered by three rows of plastically rendered curls accented by white paint (only some of which survives). Her eyebrows are indicated in black paint, as are her large almond-shaped eyes. The pursed mouth is accented in red. Her neck swells outward to the base of the vase, which is painted with a black border.

Head vases like this one in the form of kantharoi were produced in Athens during the Archaic and early Classical periods. Later, they would more typically be shaped as an oinochoe. This example from Olbia is clear evidence of trade with Athens.

68. PENDANT FROM PANTIKAPAION

5th c.
Gold, carnelian
MHTU inv. no. DM-6093
Greek
From Kerch (Pantikapaion), Krym. Collection of B. I. Khanenko. Year of find unknown.
L: 2.2 cm. Bezel: H: 1.1 cm; W: 1.5 cm; wt: 3.23 g.

Publications: Khanenko and Khanenko (1907), 18, pl. viii; Tokyo, *Scythian Gold* (1992), 128, no. 150;
Edinburgh, *Warriors* (1993), 42, no. 72; Toulouse, *L'or* (1993), 93, no. 84; Vienna, *Gold* (1993), 230–31, no. 67.

A carnelian scarab in a dog-tooth setting ornamented with granulation swivels inside a hoop-shaped support. On the reverse is an intaglio of a nude man kneeling in left profile, his torso nearly frontal. He holds a spear and shield. A ladder-like border frames the scene.

The intaglio is probably an Archaic Greek or Etruscan seal stone.

68

68

69

69 detail

69. KYLIX WITH INSCRIPTION FROM OLBIA

5th c.
Clay
NMHU, inv. no. B 1–110
Greek
From Olbia, near Parutyne, Ochakivs'kyi Raion, Mykolaivs'ka Oblast'. Excavated by B. V. Farmakovs'kyi, 1911.
From the collection of I. K. Suruchan.
H: 7.5 cm; L: 25 cm; D: (bowl) 18 cm; D: (base) 7.5 cm; wt: 600 g.

Unpublished.

The stemless carinated kylix is mended from several fragments. It has a round rim and plain ring foot. Much of the black glaze, used on the exterior and interior, has worn off. A graffito in Greek characters inside the bowl is restored as: *Maironos and further Thokros*.

The names inscribed in the bowl of this drinking cup were probably those of two subsequent owners.

70. KYLIX WITH INSCRIPTION FROM OLBIA

5th c.
Clay
NMHU, inv. no. B 5–1482
Greek
From Olbia, near Parutyne, Ochakivs'kyi Raion, Mykolaivs'ka Oblast'. Excavated by L. M. Slavin, 1938.
L: 15 cm; D: 10 cm; H: 4.7 cm; wt: 150 g.

Unpublished.

The low kylix is repaired and one handle is restored. On the underside of the foot a Greek inscription has been scratched through the glaze: *Aphrodite's kylix*.

The kylix is probably of Attic manufacture and was most likely imported to Olbia where the dedicatory inscription to the goddess Aphrodite was added.

70

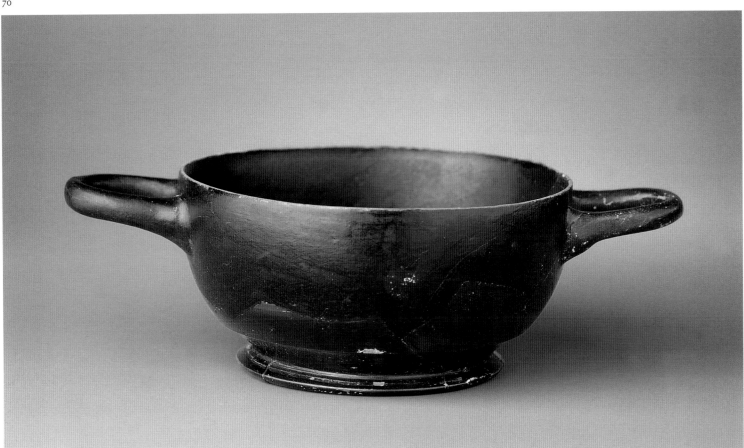

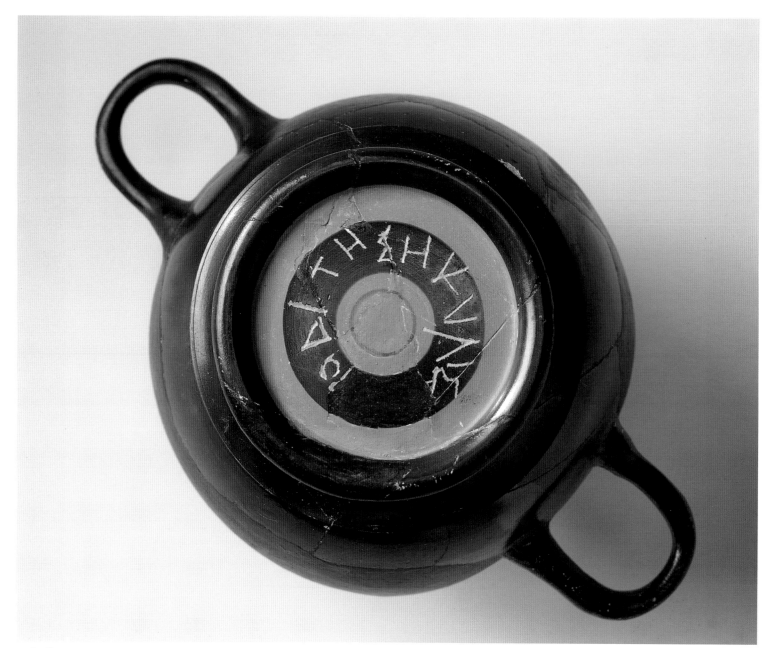

70 detail

71. FRAGMENTARY VESSEL FROM OLBIA

4th c.
Clay
NMHU, inv. no. B 4–756
Greek
From Olbia, near Parutyne, Ochakivs'kyi Raion, Mykolaivs'ka Oblast'. Excavated by L. M. Slavin, 1937.
H: 8 cm; L: 12.8 cm; wt: 200 g.

Unpublished.

The black-glazed rim fragment is an example of Attic pottery known as West Slope ware. It bears an inscription in Greek characters: *Athenodoros*. Athenodoros probably dedicated the vessel in a local sanctuary in Olbia. The remains of other lettering can be seen beneath the inscription.

71

72. FRAGMENTARY INSCRIBED KYLIX FROM OLBIA

5th–4th c.
Clay
NMHU, inv. no. B 3–1674
Greek
From Olbia, near Parutyne, Mykolaivs'ka Oblast'. Excavated by L. M. Slavin, 1936.
Given to NMHU by the Institute of Archaeology of the Academy of Sciences of Ukraine.
H: 7 cm; L: 14.2 cm; wt: 200 g.

Unpublished.

The kylix fragment is decorated with narrow reserved bands flanking a black-glazed band with an incised pattern of scrolling ivy leaves and dots in added white. A graffito in Greek characters on the exterior is restored (by V. P. Iailenko) as: *So-and-so, son of so-and-so, from Mytilene [dedicated this to...].*

The inscription is evidence of the dedicator's pride in literacy, and strength of devotion. His home in Mytilene, on the island of Lesbos, also speaks to Olbia's role as a crossroads of international trade.

72

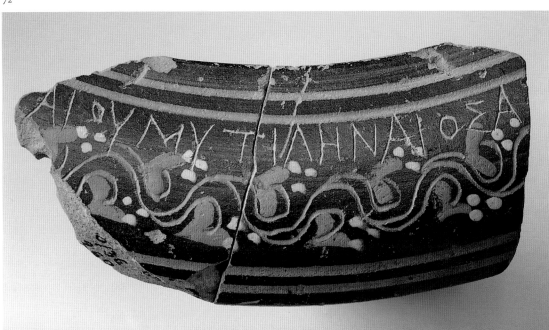

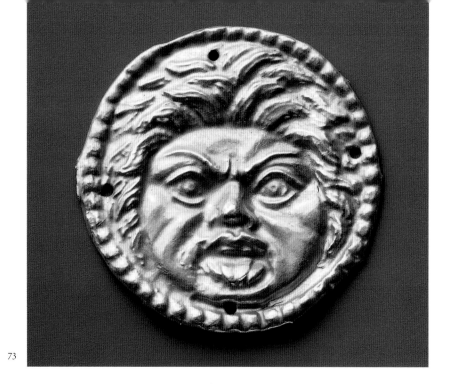

73

73. PLAQUE WITH GORGON MASK

4th–3rd c.
Gold
MHTU, inv. no. AZS-1557
Greek
From Theodosia, Krym. Excavation date unknown.
L: 3.9 cm; W: 3.8 cm; wt: 2.24 g.

Publications: Tokyo, *Scythian Gold* (1992), 99, no. 116; Rusiaeva (1995b), 16–18.

The round applique is decorated with the frontal face of a Gorgon with tongue extended. She has large, slightly bulging eyes, and her hair is rendered as short tufts. Around the perimeter are a beaded border and small holes for attachment.

Medusa and her two Gorgon sisters were winged creatures with snaky hair, whose glance turned onlookers into stone. Representations of Gorgons were introduced to the northern Pontic region during the Archaic period by Greek colonists and would have become especially familiar to the Scythians through coins, from which this image is likely to have been inspired.[1]

Gorgons decorated Scythian military equipment, clothing, and other items, but their most common use was on plaques attached to clothing. Examples have been found in Tovsta Mohyla, Melitopol's'kyi Kurhan, Kurhan Ohuz, and other kurhany. Like the Greeks, the Scythians probably believed the Gorgon's image was effective in warding off evil.

1. Kraay (1966), 346, no. 533k, pl. 163, a stater from Melos of 420–416; 368, no. 693, pl. 197, a billon stater from Lesbos, 480–400; 334, no. 433, pl. 140, a stater from Neapolis Datenon of 500–480.

74. RING WITH HERMES FROM PANTIKAPAION

5th c.
Gold
MHTU, inv. no. AZS-1692
Greek
Chance find in territory of Kerch (Pantikapaion), Krym.
D: 1.9 cm. Bezel: H: 2 cm; W: 1.9 cm; wt: 2.11 g.

Publications: Turku, *Skyyttien* (1990), 51, no. 133; Tokyo, *Scythian Gold* (1992), 187, no. 149; Edinburgh,
Warriors (1993), 43, no. 73; Toulouse, *L'or* (1993), 94, no. 85; Vienna, *Gold* (1993), 231, no. 68.

The narrow, leaf-shaped bezel is engraved with an image of Hermes, nude and in left profile, tying his sandal. His spiky wings rise into the point of the bezel. In the narrow field in front of him is a caduceus. The hoop is round in section and swells slightly toward the bezel, giving the ring a stirrup profile.

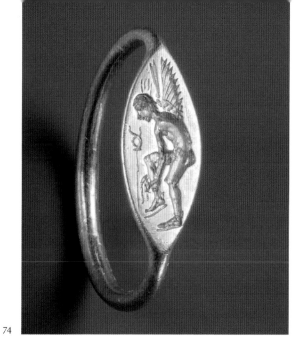

74

The Greek god Hermes was herald of the gods, chaperone of the souls of the dead on their way to the Underworld, protector of travelers, and patron of merchants and traders—so a fitting device for a seal ring.

Rings of similar type are found across the north Pontic area.[1] This shape continued to be popular well into the mid-fifth century B.C.

1. Vickers (1979), 38, pls. vi b–c.

75. HEAD BEAD PENDANT FROM OLBIA

3rd c.
Glass
NMHU, inv. no. B 3–146
Greek
From Olbia, near Parutyne, Ochakivs'kyi Raion, Mykolaivs'ka Oblast'. Excavated by L. M. Slavin, 1936.
Given to NMHU by the Institute of Archaeology of the Academy of Sciences of Ukraine.
H: 4 cm; wt: 30 g.

Publications: Shtitel'man (1977), 79; Turku, *Skyyttien* (1990), 46, 59, no. 146; Tokyo, *Scythian Gold* (1992), 131, no. 155.

The pendant is made of colored glass. It represents a male face with a long head and ears in yellow. He has large, prominent features, including exaggerated white eyes with blue pupils, and a heavy blue beard surrounding his open mouth. At the top of his head, a twisted rope of blue and white glass suggests a turban-like headcovering.

Similar pendants from Syria have been found in other Greek cities of the Black Sea region.

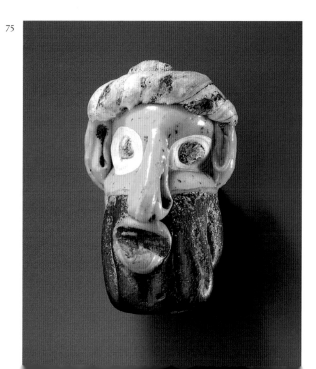

75

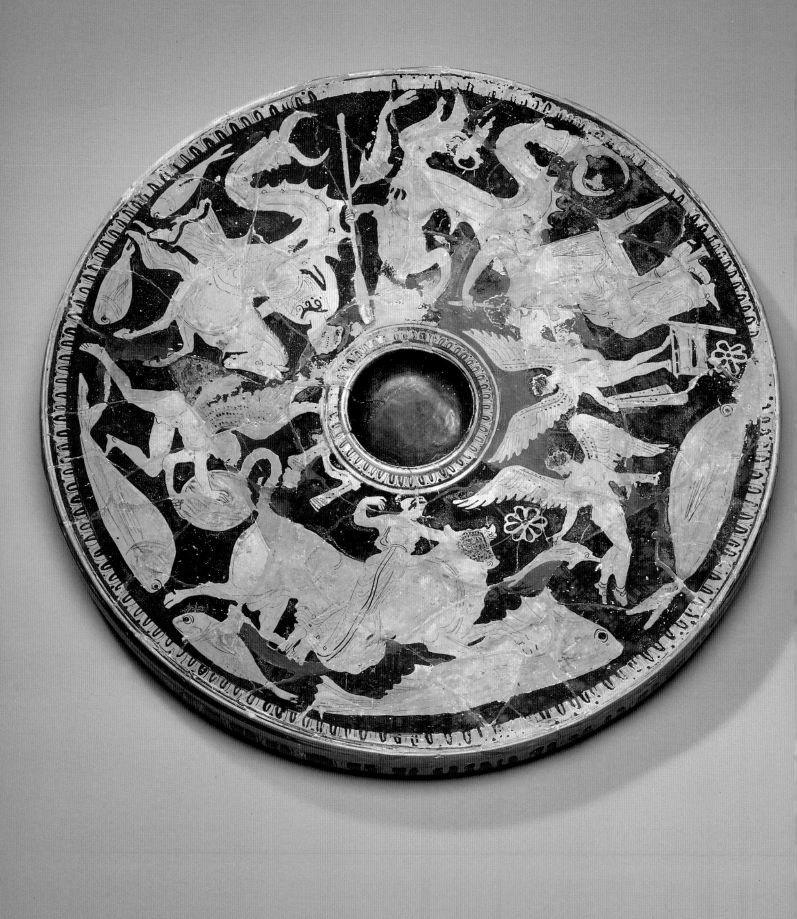

76. ATTIC RED-FIGURE VASE FROM PANTIKAPAION

4th c.
Clay
NMHU, inv. no. B 27–1576
Greek
From Kerch (Pantikapaion), Krym. Given to NMHU from Kerch in 1949.
H: 3.5 cm; D: 37 cm; wt: 1500 g

Publications: Shtitel'man (1977), no. i.48.

The red-figure fish plate has a round depression in the center ringed by an ovolo border. Around this is a figural band that includes Europa mounted on the bull, erotes, a satyr, and a nereid riding a hippocampus, which has a horse forepart, fish hindpart, and a foot in the form of a claw. A second aquatic being has the same hindquarters and claw attached to the body of a bearded male holding an oar. Around the rim are various marine animals above an ovolo border. The down-turned rim is also decorated with ovolos.

An example of the so-called Kerch style, this plate was one of a number of clay vessels exported from Athens to the Black Sea coast during the fourth century. Although the vase was found in Pantikapaion (Kerch), its decoration of hybrid beings would also have appealed to Scythian customers.

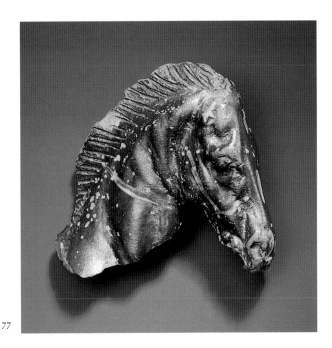

77

77. BLACK-GLAZE HORSE HEAD FROM OLBIA

3rd c.
Clay
NMHU, inv. no. B 1-74
Greek
From Olbia, near Parutyne, Ochakivs'kyi Raion, Mykolaivs'ka Oblast'. Excavated by I. O. Makarenko, 1926.
L: (overall) 8 cm; L: (nose to back) 8 cm; wt: 100 g.

Opposite: 76

Unpublished.

The molded terra-cotta horse head is from a vessel. The treatment of the animal's powerful head and neck is naturalistic and detailed. The black-glazed surface has an almost metallic lustre, and the bridle was highlighted with white slip.

During the fourth century, Greek potters used a metallic glaze in imitation of silver prototypes. In this case the artist was inspired by the same kind of high-relief gold or silver horse heads that also inspired the gold vessel with horse heads (cat. no. 134). The imported vessel to which this clay horse was belonged could not have been inexpensive, but it paled in expense beside the gold bowl, which was just one of several gold objects owned by a single affluent Scythian (see cat. nos. 135 and 136).

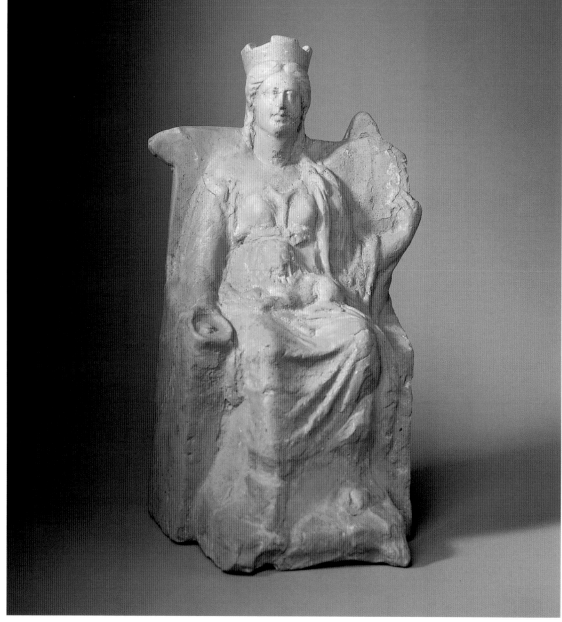

78

78. FIGURINE OF SEATED CYBELE FROM OLBIA

3rd c.
Clay
NMHU, inv. no.B 3–1339
Greek
From Olbia, near Parutyne, Ochakivs'kyi Raion, Mykolaivs'ka Oblast'.
Excavated by L. M. Slavin, 1936. Given to NMHU by Institute of Archaeology of the Academy of Sciences of Ukraine.
H: 24 cm; W: (base) 12 cm; D: 12 cm; wt: 600 g.

Publications: Khudiak (1940), 85–86, fig. 62; Rusiaeva (1979), 101–14.

The molded terra-cotta figurine represents Cybele seated frontally on a high-backed throne. The goddess holds a phiale in her right hand and a tambourine in her left. A small lion sits, facing front, on her lap. Her face is full, with heavy jaw and rounded chin. Her hair, parted in the center, falls in long curls along her neck. She wears a turreted headdress, a chiton belted high under the breasts, and a himation that wraps around her body and left arm and falls in folds across her outstretched left leg.

In the area north of the Black Sea, Cybele, the Great Mother of the Gods, was regarded both as a patron of animal husbandry and the protector of cities. This figurine was found in a cistern in a temenos in Olbia. Of the fragments of more than two thousand terra-cotta votives recovered from the cistern, about seventy represented Cybele, a quantity that would suggest the existence of a temple to the goddess within the city. Both the style and its micaceous clay indicate that this figurine was produced in Asia Minor and exported to Olbia.

79. FIGURE OF A GODDESS FROM PANTIKAPAION

2nd–3rd c. A.D.
Clay
NMHU, inv. no. B 11–81
Greek or Roman
From Kerch (Pantikapaion), Krym. Collection of B. I. Khanenko. Date of find unknown.
H: 19.5 cm; W: (max) 12 cm; wt: 450 g.

Publications: Tokyo, *Scythian Gold* (1992), 136, no. 167.

A terra-cotta figure, playing the double flutes, wears a headdress with four semi-circular extensions surrounding a central, flat-topped element. The figure wears a flaring, belted garment that covers the feet and has wide sleeves that frame a smaller female figure, which is adhered to the front. She seems to wear a diadem and head drape, and a belted garment with an overfold. Her short arms are outstretched and her feet dangle. The piece was once covered in a white slip, with some losses.

Similar terra-cotta figurines have been found in both religious and domestic contexts. Their production seems to have been limited to areas of Krym (Crimea) and the Taman' peninsula that were under the influence of Sarmatian tribes in the first centuries A.D.

79

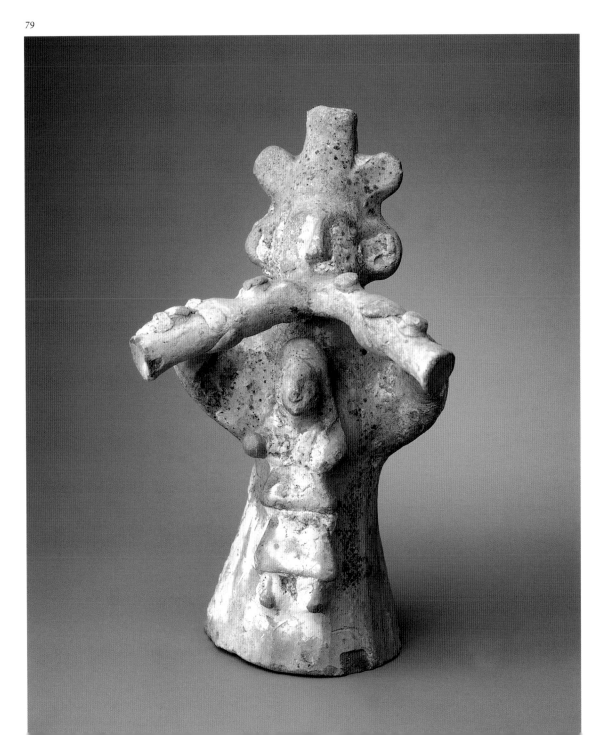

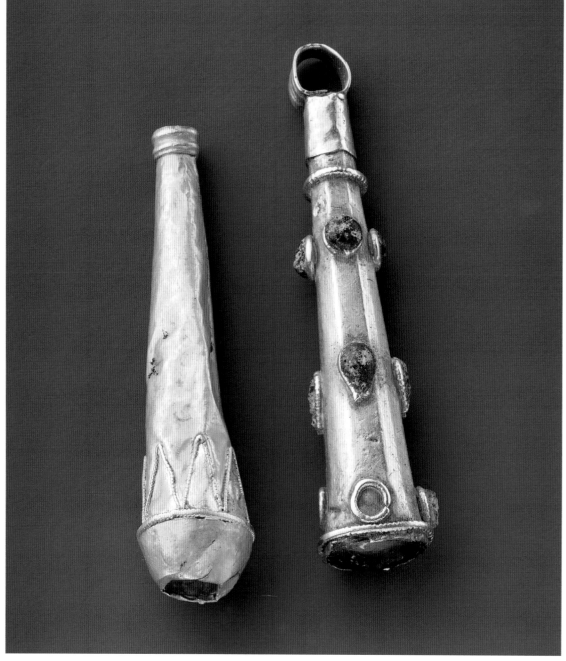

80, 81

80. HERAKLES CLUB PENDANT

1st–3rd c. A.D.
Gold, glass paste
MHTU, inv. no. AZS-1511
From a child's burial, Scythian Neapolis, Simferopol', Krym. Excavated by A. N. Karasiov, 1950.
L: 4.62 cm; D: 0.5–1.05 cm; wt: 4.77 g.

Publications: Shul'ts (1957), 76, fig. 9; Dashevskaia (1991), 38, pl. 69.7; Tokyo, *Scythian Gold* (1992), 137, no. 172.

The hollow pendant is formed from a plate segmented into eight planes and rolled into a faceted tubular shape. The narrow end is capped by a separately worked solid collar to which a plated suspension ring is soldered. The shaft is decorated by two beaded wires at top and bottom and by six circular and three teardrop settings, all but one of which retain glass paste inlays. On the bottom is an oval inlay of green glass paste.

Because of their shape and the studs that resemble the stumps of detached branches, objects of this type have traditionally been called "Herakles club" pendants. The type was widespread from the middle of the second century A.D. Finds comparable to this example, which was perhaps made for an earring, are known in Romania and Hungary.[1]

1. From Reußmarkt (Miercurea Sibiului) in Romania, now in Vienna (Noll [1984], pl. 65, 1); from Jajs (Hungary), now in Pecz (ibid., 448 g, pl. 66, 15); and from Isaccea Neviodunum in Romania (ibid., 448 k, pl. 66, 18).

81. GOLD PENDANT IN FORM OF A HERAKLES CLUB

1st–3rd c. A.D.
Gold, glass paste
MHTU, inv. no. AZS-1902
Sarmatian(?)
From Krym.
H: 4.1 cm; wt: 1.4 g.

Unpublished.

The pendant is formed of a gold sheet rolled into a cone. Filigree wires help disguise the joins of separate pieces at top and bottom. Probably the hemispherical tip originally held a setting for an inlay, now missing. On the shaft, beaded-wire filigree forms six rays, two of which retain turquoise glass paste inlays.

The Herakles club pendant was not uncommon in the first centuries A.D. (see cat. no. 80) and speaks to the Greek mythical hero's popularity in the lands around the Black Sea. His exploits are depicted on a number of Scythian objects (see cat. nos. 113, 141, and 142). This pendant, which is known only to have come from Krym, finds parallels in examples recovered in and around the ancient Greek coastal city of Tauric Chersonesos.

82. HYDRIA WITH SIREN

5th c.
Bronze
NMHU, inv. no. B 41–433
Greek
Chance find near village of Pishchane, Zolotonos'kyi Raion, Cherkas'ka Oblast'.
Given to NMHU by O. D. Hanina in 1961.
H: 44 cm; D: 32 cm; wt: 8500 g.

Publications: Hanina (1970), 84–85, figs. 42, 44; Hanina (1974), fig. 20; New York, *Scythians* (1975), 125, no. 167; Schleswig, *Gold* (1991), 311, no. 103a; Tokyo, *Scythian Gold* (1992), 121, no. 136; Vienna, *Gold* (1993), 222–24, no. 64.

The hammered bronze hydria rests on a cast base decorated with long tongues and a row of beading. The narrow neck of the vessel turns out to form a lip of ovolos with beading along the rim. The faceted handles were cast and soldered to the body. The two horizontal handles are encircled by a tongue pattern, as is the vertical handle where it meets the neck. On the shoulder the vertical handle terminates in an ornamental plate with a siren protome. The siren's long wings are outspread and curl outward, and the feathers are elaborately patterned. Simpler feathers are suggested by scored lines on the body. The siren is superimposed on an elaborate ornamental plate of palmettes and scrolling volutes that are centered with silver hemispheres.

The hydria must have been produced in a Greek workshop, but the choice of the siren motif surely also reflects a responsiveness to the Scythian love of hybrid creatures.[1] A related type of female being is seen on pendants on a necklace from Kurhan Ohuz (cat. no. 101). The swirling volutes, with their silver "eyes," also respond to Scythian tastes.

The hydria was recovered along with fifteen other vessels during operations to extract peat near the village of Pishchane, several hundred miles up the Dnipro (cat. nos. 83–89).

1. See the essay by Reeder in this volume.

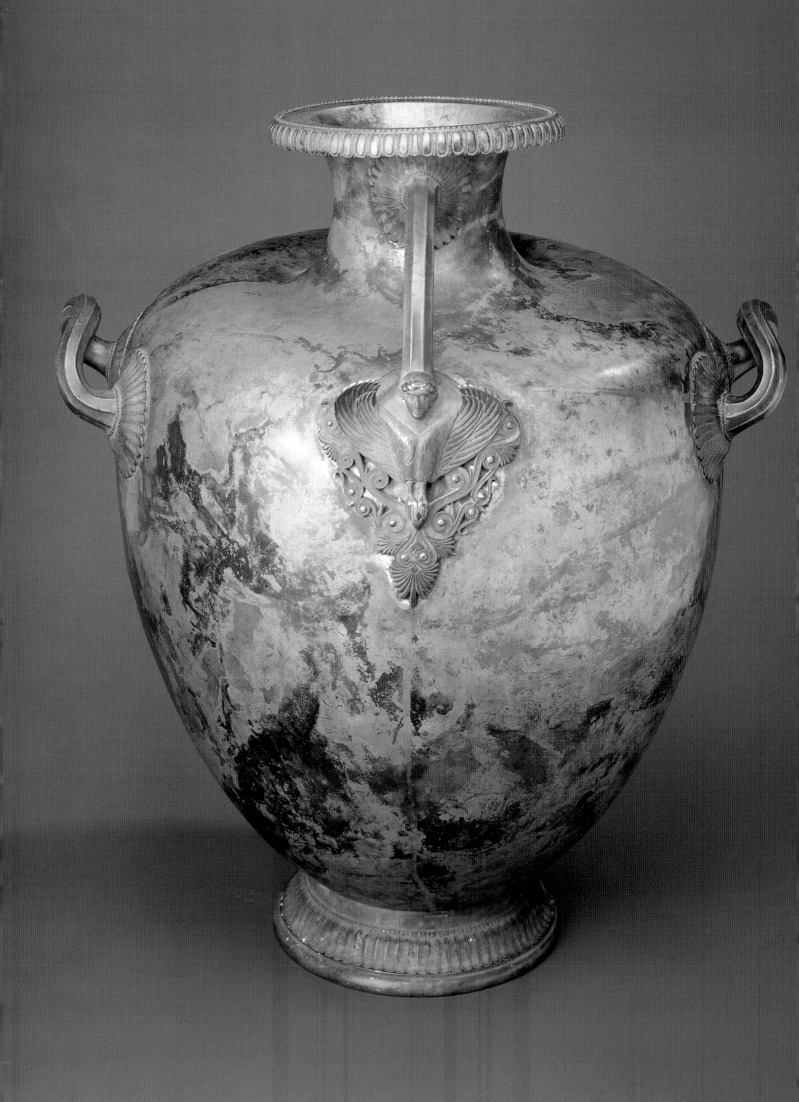

83. LOUTERION WITH SIREN

5th c.
Bronze
SHAP, Pereiaslav-Khmel'nyts'kyi, inv. no. T3–4182
Greek
Chance find near village of Pishchane, Zolotonos'kyi Raion, Cherkas'ka Oblast', 1960.
H: 29 cm; D: 68 cm; wt: 7000 g.

Publications: Ganina (1964), 195–98; Hanina (1970), 91.

Opposite: 82

The hammered bronze basin rests on a ring base with three low, lion-paw feet (one now lost and replaced). Around the exterior, under the rim, are two bands in low relief. Two cast D-shaped handles, each with two knobbed stops, are hinged to plates on each side of the vessel. These handle attachments bear in high relief the protome of a siren, whose wings curl up and outward. Each protome terminates in a single leg, which is supported by an inverted palmette and volutes that wind on each side into other volutes connected by a hatched strap and palmette leaves.

Both the siren and the volute plate recall the more elaborate handle attachment on cat. no. 82. Like that hydria, this basin was among the bronze vessels, probably of Greek manufacture, that were found during peat extraction operations in Pishchane (see also cat. nos. 82 and 84–89). The siren also recalls necklace pendants from Kurhan Ohuz, which represent a winged snake-bodied female (cat. no. 101).

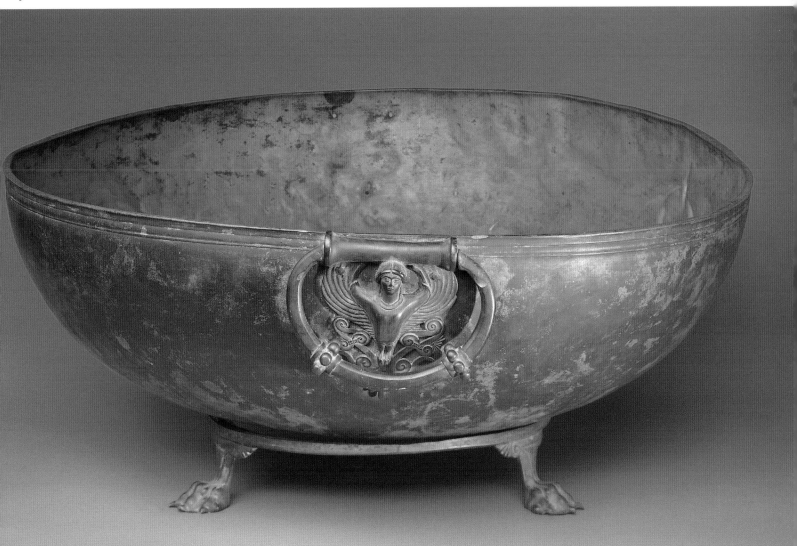

84. LOUTERION WITH GRIFFINS

5th c.
Bronze
NMHU, inv. no. B 41–439
Greek
Chance find near village of Pishchane, Zolotonos'kyi Raion, Cherkas'ka Oblast', 1961.
H: 12.5 cm; D: 44.5 cm; wt: 8000 g.

Publications: Hanina (1970), 91; Hanina (1974), fig. 20; New York, *Scythians* (1975), 126, no. 168; Schleswig, *Gold* (1991), 313, no. 86; Tokyo, *Scythian Gold* (1992), 121, no. 137.

The body of the basin is oval, with an out-turned rim. The foot is a separately cast, soldered ring. The exterior is decorated with two rectangular appliques that are positioned opposite each other around the circumference. Each depicts an eagle-headed griffin in left profile attacking a stag in left profile. The stag has fallen onto its front legs, and its head is turned to its right. The griffin's wings are outspread, its scales represented by chased semi-circles. The scene is framed by a gnarled tree trunk on the viewer's left and a stippled groundline.

Vessels of this type were probably produced in Greece, and the choice of the griffin motif suggests that the Greek suppliers were aware of the griffin's popularity with Scythian buyers. The relief has stylistic and compositional parallels with examples found in Bythinia, Rhodes, and elsewhere. The gnarled tree, in particular, recalls similar motifs on box appliques and mirrors.[1]

1. Schwarzmaier (1997), 328, no. 230, pl. 1, 1; Byvanck-Quarles van Ufford (1966), 43–44, fig. 11; also Schwarzmaier (1997), nos. 7, 32, 72, 75, 133, and 188.

84

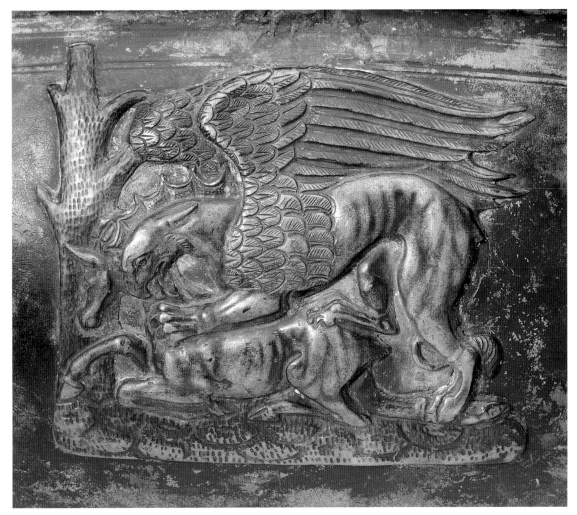

84 detail

85. SITULA

5th c.
Bronze
NMHU, inv. no. B 41–437
Greek
Chance find near village of Pishchane, Zolotonos'kyi Raion, Cherkas'ka' Oblast', 1961.
H: 23 cm; D: 15.5 cm; wt: 3500 g.

Publications: Hanina (1970), 90, figs. 19–22; Hanina (1974), fig. 20; New York, *Scythians* (1975), 127, no. 179;
Schleswig, *Gold* (1991), 312, no. 103f; Tokyo, *Scythian Gold* (1992), 119, no. 135; Vienna, *Gold* (1993), 224, no. 65.

The swelling body of the hammered bronze vessel curves in to the narrow base, where there was an additional ring-like support, now missing. The wide mouth has a flat horizontal lip. A double rectangular bail bends through two loops on relief plaques attached to each side of the vessel; the bail terminates in ribbed and knobbed finials. One of the relief attachments is in the form of a lion head, whose open mouth and extended lower jaw create a pouring spout. The animal's face is in high relief and is framed by its mane, which is treated almost as a two-tiered rosette. On the top of the lion's head, two petals of a vertical palmette curl to form the rings for the bail. The attachment on the opposite side of the vessel depicts the frontal face of Athena. Three locks of hair extend from her Corinthian helmet into loops. She has large, rather blunt features. Venus rings are scored into her neck, and she wears a necklace. The crest of her helmet divides to form the rings for the bail.

The situla, a bucket-like vessel, is widely believed to have had an Etruscan origin, but is found in many places in the north Pontic region, Thrace, and Macedonia, where local imitations might have been made.[1]

1. Archibald (1998), 278.

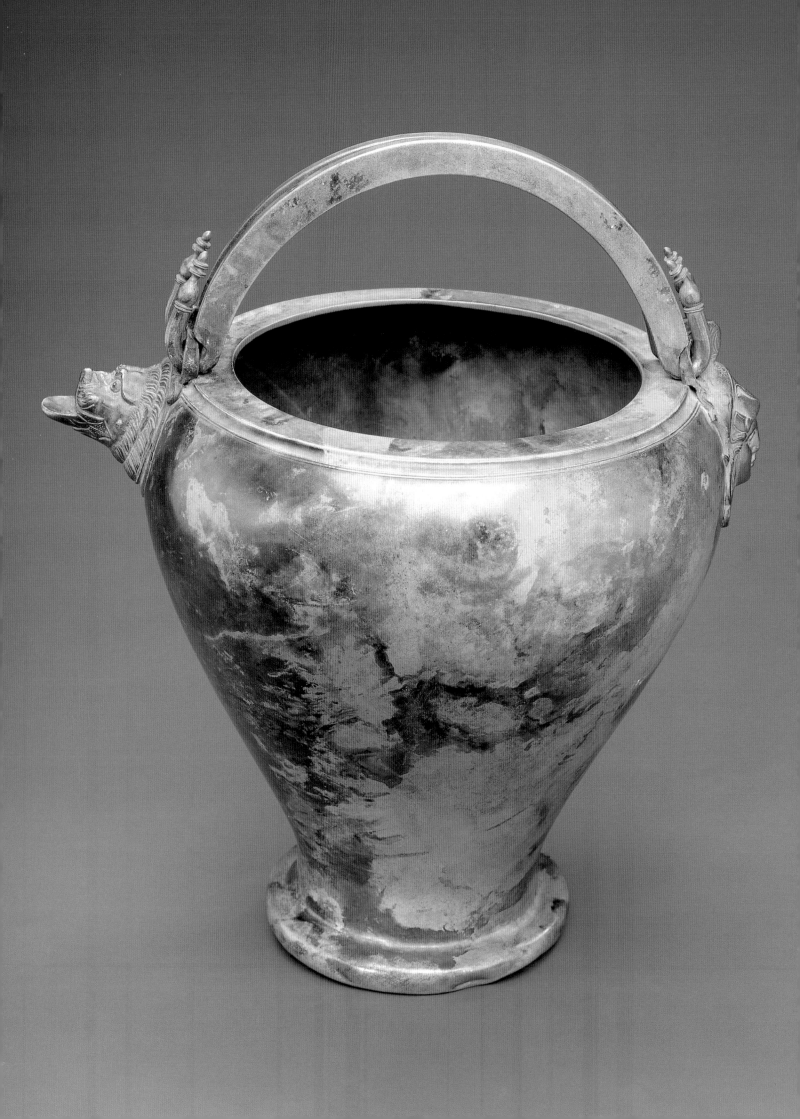

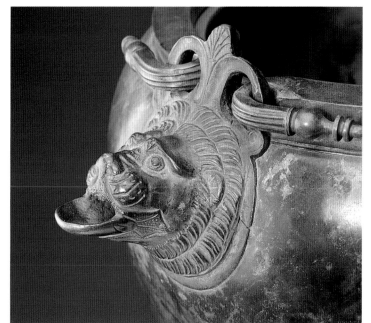

85 detail

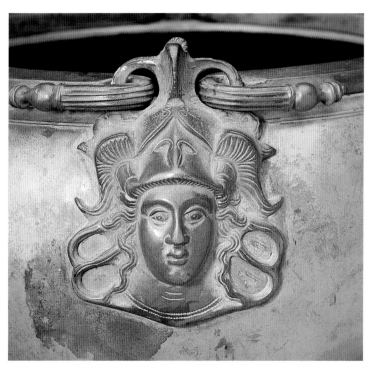

85 detail

86. HYDRIA WITH LION HANDLE

5th c.
Bronze
NMHU, inv. no. B 41–429
Greek
Chance find near village of Pishchane, Zolotonos'kyi Raion, Cherkas'ka Oblast', 1961.
H: 51 cm; D: 37.5 cm; wt: 9000 g.

Publications: Hanina (1970), 82, fig. 5; Tokyo, *Scythian Gold* (1992), 122, no. 138.

Opposite: 85

The hammered amphora has a thick rounded lip above a narrow collar with two ridges. The reeded oval handles are separately cast and attached by rivets at the neck. They terminate on the shoulder with lion-head reliefs. The animals' large eyes are deeply set under a prominent brow, their muzzles stylized with parallel

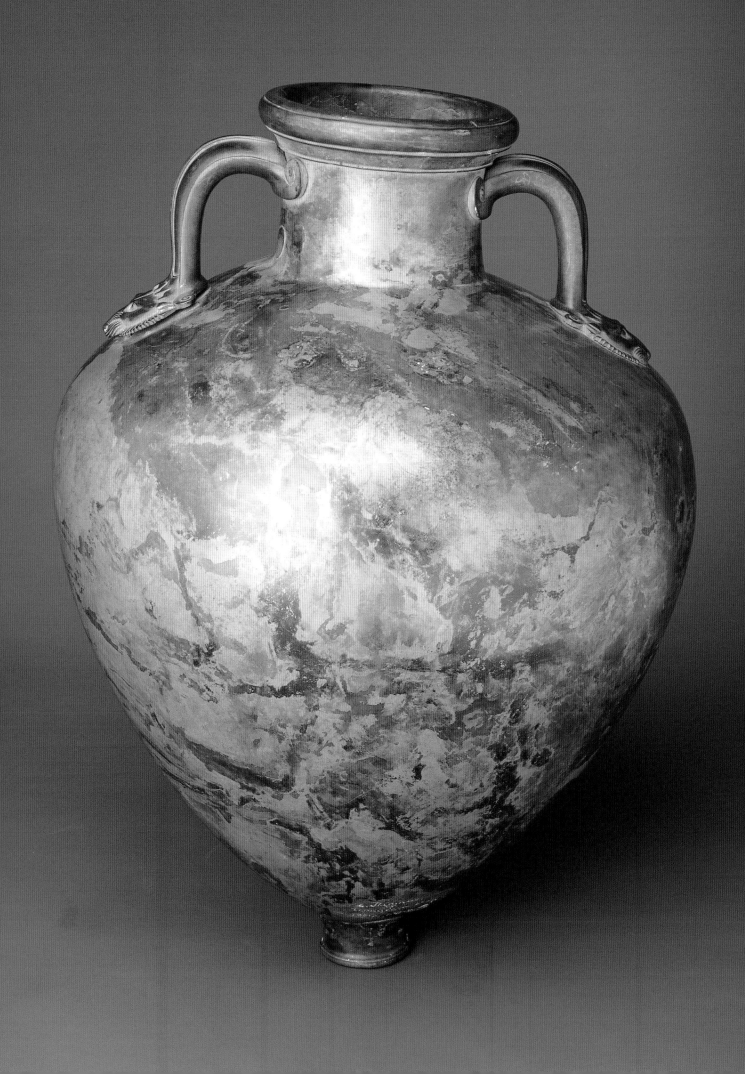

ridges. The lions' faces are fringed with flame-like manes. Extensions of the handles curl into volutes above their ears.

This amphora is probably of Greek workmanship. It was recovered along with fifteen other vessels from a kurhan discovered during operations to extract peat near the village of Pishchane (cat. nos. 82–85, 87–89). Because the site lies several hundred miles up the Dnipro, the vessels testify to extensive trading ties with the Greek world. The stylized lion heads find many parallels among Scythian plaques, including the rein appliques from Babyna Mohyla (cat. no. 151) and belt plaques from Cherkas'ka Oblast' (cat. no. 12).

Opposite: 86

87. HANDLED PAIL

5th c.
Bronze
NMHU, inv. no. B 41–438
Greek
Chance find near village of Pishchane, Zolotonos'kyi Raion, Cherkas'ka Oblast', 1961.
H: 23 cm; W: 21.5 cm; wt: 2500 g.

Publications: Hanina (1970), 89; Schleswig, *Gold* (1991), 312, no. 103g.

The flaring bell-shaped vessel has a wide mouth, decorated with an engraved ovolo at the rim, and a plain flat base. A single swinging handle, square in section, remains. It is supported on each side by a plaque decorated with an inverted palmette below and a smaller palmette above, whose petals branch to form two suspension loops.

This situla appears to be of Greek manufacture. It was among the finds from Pishchane, where a number of other bronze vessels were recovered (cat. nos. 82–86, 88, 89).

Opposite: 88

87

88. HANDLED AMPHORA

5th c.
Bronze
NMHU, inv. no. B 41–428
Greek
Chance find near village of Pishchane, Zolotonos'kyi Raion, Cherkas'ka Oblast'.
H: 32 cm; W: 21 cm; wt: 6000 g.

Publications: Hanina (1970), 83, fig. 39.

The neck-handled amphora is made of hammered bronze; the rounded lower portion appears to have been fabricated separately, probably as a repair in antiquity. The neck has a flaring cup-shaped lip. Double-reeded vertical handles extend to simple volutes at the neck and are attached below with inverted palmettes. At the top of each handle, a ring supports one end of a swinging bail. Another ring at the top of the bail was for a rope or chain.

This vessel is likely to be of Greek manufacture. It was among the finds from Pishchane, where a number of other bronze vessels were recovered (cat. nos. 82–87, 89).

The vase must have been damaged and cut down in antiquity, when its now-missing foot appears to have been replaced with this rounded base. A similar amphora with foot and bail was found in Derveni, in Macedonia.[1] On that example, a chain attached to a lid passed through the ring at the top of the bail.

1. Washington, *Alexander* (1980), 169, no. 134; also 157, no. 109.

89. AMPHORA

5th c.
Bronze
NMHU, inv. no. B 41–430
Greek
Chance find near village of Pishchane, Zolotonos'kyi Raion, Cherkas'ka Oblast', 1961.
H: 51 cm; W: 37.5 cm; wt: 9000 g.

Publications: Hanina (1970), 39–40, 83.

The slender neck-handled amphora is made of hammered bronze with cast and soldered elements. The metal of the neck is folded over to form a plain rim.

This was a chance find near the village of Pishchane, where a number of other bronze vessels were recovered during operations to extract peat (cat. nos. 82–88). It is unclear whether the vessels were privately owned or, more likely, the inventory of a Greek or Scythian trader.

This vessel's egg-like shape can be compared with clay amphoras from Thasos, which were in use during the late sixth and early fifth centuries and which are frequently found in the Black Sea region and lower reaches of the Dnipro.

90. TWO AMPHORAS

ca. 450–400
Clay
AI, inv. no. 5/x/8, 5/x/11
Greek
From Kurhan 13, near village of Velyka Znam'ianka, Kam'ianko-Dniprovs'kyi Raion, Zaporizhs'ka Oblast'.
Excavated by V. V. Otroshchenko and Iu. Ia. Rossamakin, 1984.
Amphora (5/x/8): H: 69 cm; D: (shoulder) 29 cm; wt: 15,000 g. Amphora (5/x/11): H: 75 cm; D: (shoulder) 29.5 cm; wt: 15,000 g.

Publications: Otroshchenko and Rossamakin (1985), 240–46; Katowice, *Koczownicy* (1996), 170, 227, no. 16.

Two neck-handled amphoras have painted red bands under the rim and wide neck collars. The smaller vessel has a red band that extends vertically from the rim down the side of the vessel. The larger amphora has a similar red band extending from the lower join of one of the handles.

Opposite: 89

Vessels like these with collared necks are typical of transport amphoras from Chios in use during the first half of the fifth century. These Greek wine containers are often found in Scythian archaeological contexts, many in and around kurhany. They testify to the active trade between the Scythians and Greeks in this region, as well as to the Scythian fondness for wine. The sixth-century Greek poet Anacreon (356.6–11) uses the phrase "as drunk a Scythian." Broken amphoras are also found in ditches around tombs, evidently the remains of funeral feasting.

90

90

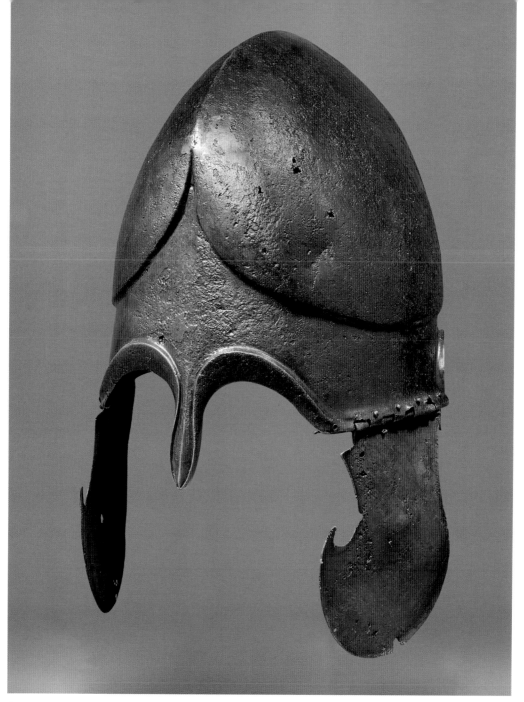

91

91. HELMET

4th c.
Bronze
NMHU, inv. no. B 1201
Greek
From Halushchyne Urochyshche, near village of Pastirs'ke, Cherkas'ka Oblast'.
Excavated by V. V. Khvoika, 1898. Given to NMHU in 1941.
H 32.5 cm; W: (ear to ear) 19 cm; Depth (front to back): 25.5 cm; wt: 2000 g.

Publications: Khanenko and Khanenko (1899), 10–11, pl. ix, 218; Takhtai (1964);
Petrenko (1967), 37; Chernenko (1968), 18, fig. 4, 83–86, fig. 46.

The helmet is of Attic type. The cheekpieces are hook-shaped and are hinged with four pins. The edge is thickened around the eye openings and nose guard.

The helmet was found, along with plated body armor, a sword belt, and bronze plaque (cat. no. 56), in the Cherkasy region, an area where both Scythian graves and those of the settled agricultural population are found. The discovery here of a helmet made in Athens, and of considerable value even there, testifies both to the value of goods that passed along the trade routes dominated by the Scythians and to the affluence the Scythians enjoyed as a result of this commerce.

92

92. HELMET

5th c.
Bronze
SHAP, Pereiaslav-Khmel'nyts'kyi, inv. no. T3-1241
Greek
Chance find near village of Stovpiahy, Kyivs'ka Oblast', 1986.
H: 43 cm; L: 46 cm; W: 17 cm; wt: 1000 g.

Publications: Katowice, *Koczownicy* (1996), 171, 227, no. 18.

The bronze helmet is of the open-faced Attic type. Of the hinged cheekpieces that would have been present on each side, only the holes used to attach them survive. The helmet is of Greek workmanship.

93. VESSEL

4th c.
Glass
SHAP, Pereiaslav-Khmel'nyts'kyi, inv. no. PXDIKZ-2056
From kurhan in Pereiaslav-Khmel'nyts'kyi, Kyivs'ka Oblast'.
Excavated by V. K. Honcharov and E. V. Makhno, 1956.
H: 12.0 cm; wt: 600 g.

Publications: Honcharova and Makhno (1957), 127–44; Milan, *I Goti* (1994), 80, no. 1.18.

The egg-shaped, round-bottomed glass bowl is heavily encrusted and is broken around the entire circumference of the rim. Around the exterior is a row of concave depressions. A row of round impressions decorates the exterior.

93

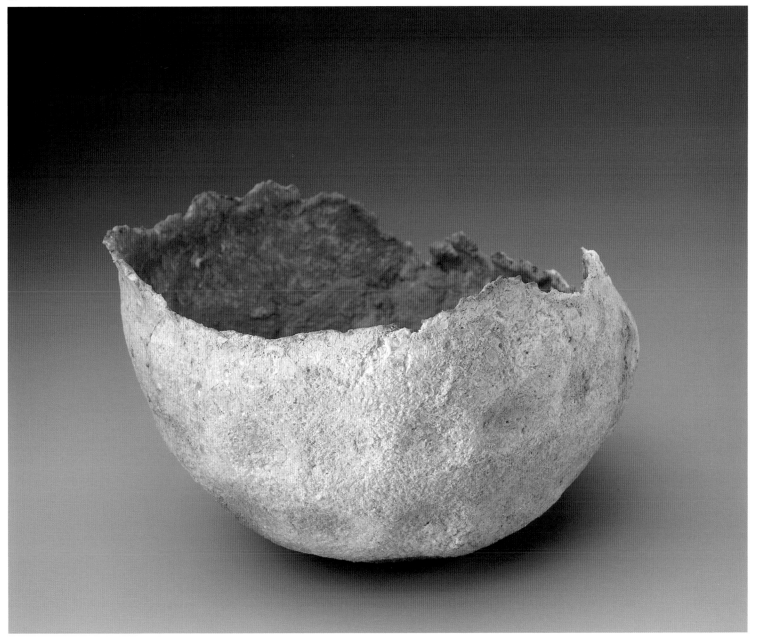

94. RING MADE FROM COIN OF PANTIKAPAION

ca. 350–300
Gold
AI, inv. no. 153
From Velykyi Ryzhanivs'kyi Kurhan, near village of Ryzhanivka, Zvenyhorods'kyi Raion, Cherkas'ka Oblast'. Excavated by S. A. Skoryi
and Ia. Khokhorovs'kyi, 1995–1997.
D: 1.7– 1.8 cm; wt: 11.44 g.

Publications: Anokhin (1986), 140–41, nos. 109, 115, 116; Chochorowski and Skoryi (1997b), 71–92;
Chochorowski and Skoryi (1997c), 12–13.

The bezel is formed of a gold coin attached off-center to an adjustable gold hoop. The coin is a stater from Pantikapaion, minted between 330 and 315, with the head of a satyr in left profile. He has a beard, pointed ear and horn, and a wreath of ivy leaves. On the reverse is a winged griffin in left profile, with raised right front paw and a spear in its mouth. Above it are the Greek letters *PAN*, below it a shaft of wheat.

 The placement of the hoop, on axis with the satyr's head, enabled the head to be seen easily by both the wearer and a viewer. The ring is clear evidence of the Scythians' receptivity to motifs on Greek coinage, which provided inspiration for a number of gold plaques that were attached to Scythian clothing.[1]

1. See the essay by Reeder in this volume.

94

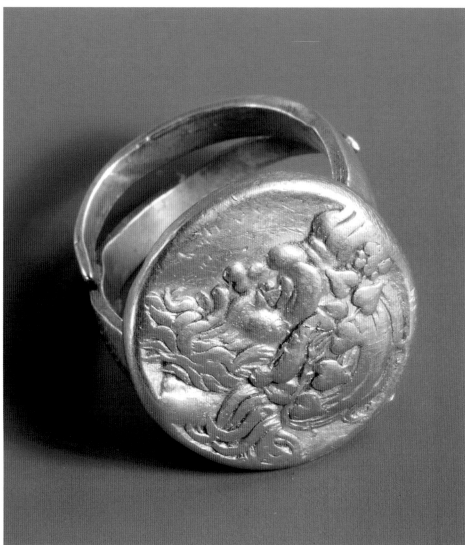

Opposite: 94

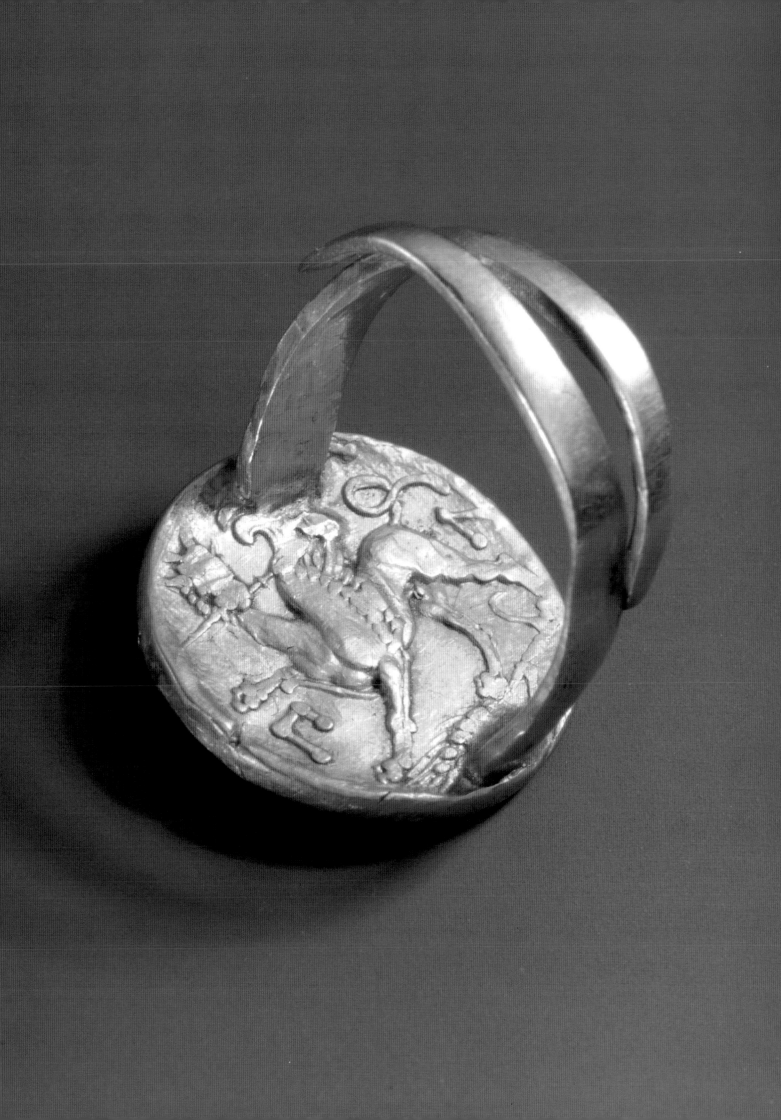

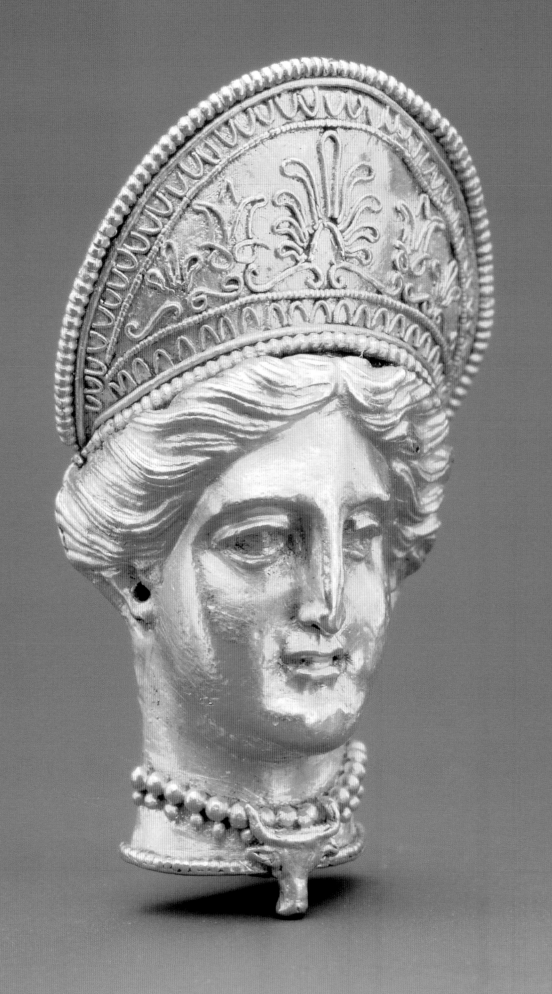

95. PENDANT IN THE FORM OF A FEMALE HEAD

4th c.
Gold
MHTU, inv. no. AZS-2748
From Kurhan 2, burial 3, near village of Velyka Bilozerka, Kam'ianko-Dniprovs'kyi Raion, Zaporizhs'ka Oblast'.
Excavated by V. I. Bidzilia, 1972.
H: 3.2 cm; W: 1.85 cm; wt: 6.13 g.

Publications: Hanina (1974), fig.50, no. 85; 57; Turku, *Skyyttien* (1990), 30, Edinburgh, *Warriors* (1993), 32, no. 43; Toulouse, *L'or* (1993), 74, no. 44; Vienna, *Gold* (1993), 159–61, no. 40; Rusiaeva (1994), 104–109, fig. 1; Milan, *Tesori* (1995), 80, 191, no. 36; Edwards (1996), 66; Katowice, *Koczownicy* (1996), 192, 230, no. 41; Vicenza, *Oro* (1997), 62–63, no. 18.

The pendant, which is hollow and flat on the reverse with a clip for attachment, was made of two separate pieces, the head and the stephane. The woman's wavy hair is parted in the center. Her tall stephane, framed by a beaded wire, is ornamented with a delicate filigree pattern of palmettes, lotus flowers, and scrolls, with an ovolo border. She wears a necklace consisting of a double row of granules and a central bull's head pendant. Small holes in the earlobes suggest the presence of now-lost earrings. On the back are two soldered coils for suspension.

The elaborate detail of this pendant, which was intended to be worn on a necklace, is evidence of a high degree of technical sophistication. The woman's face is modeled on Classical Greek types, with large, almond-shaped eyes, straight nose, heavy, rounded chin, and plump, slightly parted lips.

An identical necklace and pendant are seen on a pair of earrings from Pantikapaion, where the female heads wear a slightly different headdress but have identical rows of beading around the lower edge.[1]

1. Williams and Ogden (1994), 163, no. 103.

Opposite: 95

95

96. SPHINX EARRING

4th c.
Gold, enamel inlays
MHTU, inv. no. AZS-2282/1
From Tr'okhbratni (Three-Brothers) Kurhany, Kurhan 1 (Starshyi), near Ohon'ky, Lenins'kyi Raion, Krym.
Excavated by D. S. Kyrylin, 1965.
H: 4.7 cm; wt: 9.27 g.

Publications: Hanina (1974), fig. 64; Sokolov (1974), 45, no. 26; Kirilin (1978), 183, fig. 5; Petrenko (1978), 32, pls. 50.5, 5a;
Piotrovsky, Galanina, and Grach (1987), 159, figs. 247, 248; Turku, *Skyyttien* (1990), 30, 50, no. 84; Tokyo, *Scythian Gold* (1992), 77, no. 74;
Edinburgh, *Warriors* (1993), 34–35, no. 57; Toulouse, *L'or* (1993), 80, no. 63; Vienna, *Gold* (1993), 182–85, no. 52; Jacobson (1995), 95, I.D.1,
figs. 2, 3; Milan, *Tesori* (1995), 87, 191, no. 37; Vicenza, *Oro* (1997), 67, no. 23.

This pendant earring consists of a winged sphinx perched on a pedestal that is decorated with tongues of beaded wire filled with blue or green enamel. The tongues are framed above and below by a smooth molding inside a row of beading. The sphinx has a prominent rounded chest and flared wings that curve inward. She wears a beaded necklace, disc-type earrings filled with blue enamel, and a diadem decorated with a row of beading beneath filigree ornamentation of palmettes and vine leaves. Her wavy tail curves up and then back. A broad hoop is soldered to the back of the sphinx's head and ornamented on the front with a double rosette, three of whose inner petals are filled with blue enamel.

The earring was found in the burial of a Scythian woman. A similar sphinx earring, exhibiting the same elegant design and finely wrought detail, was found in Kurhan Ohuz .[1]
The earring was found together with cat. nos. 97 and 98.

1. Boltryk and Fialko (1991), pl. 15.

97. BRACELET

ca. 350–300
Gold, bronze, enamel, paste
MHTU, inv. no. AZS-2281/1
From Tr'okhbratni (Three-Brothers) Kurhany, Kurhan 1 (Starshyi), near Ohon'ky, Lenins'kyi Raion, Krym.
Excavated by D. S. Kyrylin, 1965.
H: 7.5 cm; D: 8 cm; wt: 129.85 g.

Publications: Hanina (1974), fig. 65; Kirilin (1978), 184, fig. 2.6; Petrenko (1978), p. 57, pl. 47.13; Tokyo, *Scythian Gold* (1992),
87, no. 93 and cover; Edinburgh, *Warriors* (1993), 35, no. 58; Toulouse, *L'or* (1993), 80, no. 64; Vienna, *Gold* (1993), 186–89, no. 53;
Milan, *Tesori* (1995), 85, 191, no. 35; Luxembourg, *TrésORS* (1997), 89, no. 37; Vicenza, *Oro* (1997), 75, no. 31.

The spiral bracelet is formed of bronze with thin overlays of gold; a third band of gold was laid along the edges and crimped to resemble beading. Within the crimped borders is a raised molding that frames each side of a slightly rounded center band. Each finial consists of two separate plaques. Attached behind a single smooth gold sheet, the inner plaque is decorated with a filigree palmette and flanking lotus flowers framed by filigree bands and ovolos. The ovolos, palmette, and lotus petals are filled with blue and green enamel. The outer collar is formed by a matrix-hammered lion head. Its eyes are emphasized with enamel insets, and its pelt, mane, and whiskers are intricately detailed.

Armbands were popular among the Scythians, worn by men, women, and children alike (although they are found in the graves of women four times more often than in the graves of men and twice as often as in graves of children). Pairs of bracelets were worn both singly, one on each arm, and together on either the right or left side. Most armbands were made of bronze, and more rarely of iron or silver. Gold or gilded examples like this one and its mate are found only in the richest burials.

Opposite: 96

Treister attributes these bracelets to the workshop that produced a gold torque found at Kul'-Oba.[1] The torque, which has terminals that end in the form of mounted Scythians, bears identical filigree and enameled palmette ornaments.[2] Nearly identical ornament is also seen on a gold and bronze finial in the form of a lion head, again from Kul'-Oba.[3] Still another parallel from Kul'-Oba is a pair of bracelets with nearly identical lion masks along its edges.[4]

Similar lion-head terminals are found on the silver rein attachments, cat. no. 151.

This bracelet was found together with cat. nos. 96 and 98.

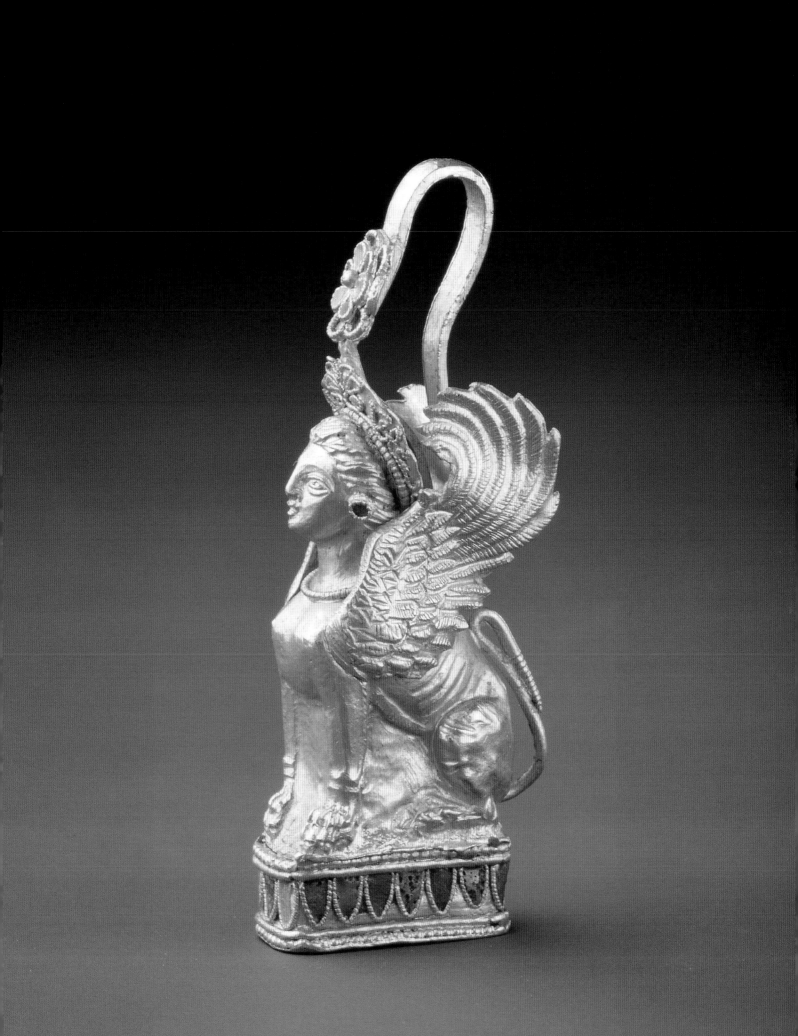

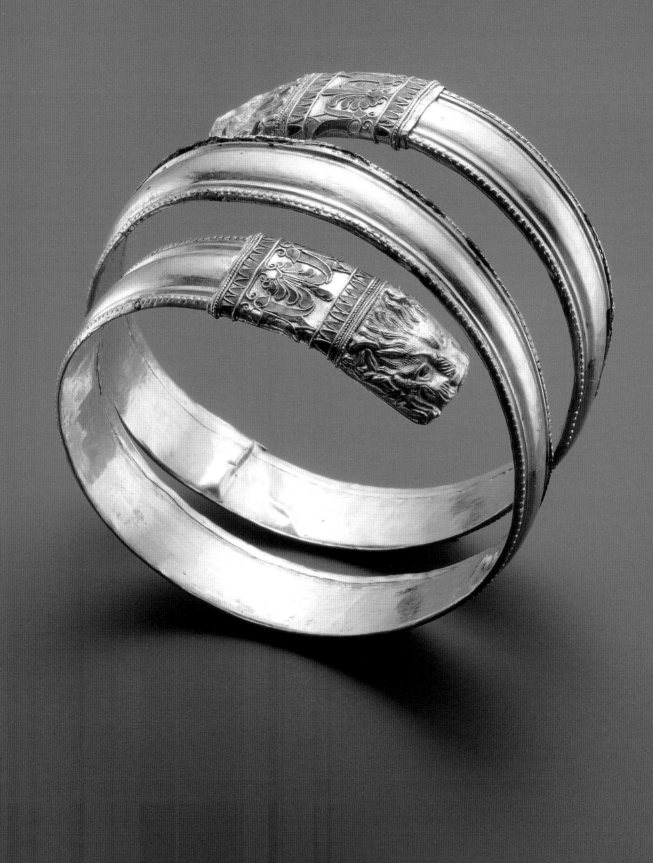

1. See the essay by Treister in this volume.
2. Williams and Ogden (1994), 137, no. 81, and 126–27.
3. Artamonov (1969b), 2
4. Ibid., 287, pls. 236–38.

98. SCARABOID RING

4th c.
Gold
MHTU, inv. no. AZS–2272
From Tr'okhbratni (Three-Brothers) Kurhany, Kurhan 1 (Starshyi), near Ohon'ky, Lenins'kyi Raion, Krym.
Excavated by D. S. Kyrylin, 1965.
Bezel: L: 1.9 cm; W: 1.4 cm. Band: L: 2.7 cm; W: 1.5 cm; wt: 10.36 g.

Publications: Sokolov (1974), 44, no. 23; Kirilin (1978), 185, fig. 7; Schleswig, *Gold* (1991), 316, no. 111; Toulouse, *L'or* (1993), 82, no. 70; Vienna, *Gold* (1993), 186–87, no. 58; Milan, *Tesori* (1995), 90, 192, no. 41; Vicenza, *Oro* (1997), 73, no. 29.

The obverse of the ring's swiveling bezel is a relief scarab with stippled surface. On the reverse, a dog-tooth setting surrounds a relief image of a woman in billowing garments. The bezel is framed by braided and beaded wire. The hoop is formed of braided wires with a beaded wire in the channel.

Scarab rings enjoyed particular popularity from the middle to the second half of the fourth century, with most finds, beyond these from Scythian burials, concentrated in South Italy.[1] An example allegedly found in Sardis suggests that they were also known in Asia Minor.[2] A similar scarab ring from Velyka Blyznytsia bears a representation on the reverse of Eros adjusting Aphrodite's sandal.[3]

This ring was found together with cat. nos. 96 and 97.

1. For South Italy: see, e.g., Williams (1988), 89–90, pls. 39, 1–3; Pianu (1990), 52, no. 33.5, pls. xxi, 1–2; Williams and Ogden (1994), no. 140. See also Segall (1966), 19, pl. 37, 1.

2. Now in Pforzheim; Segall (1966), 19, pl. 9.

98

98

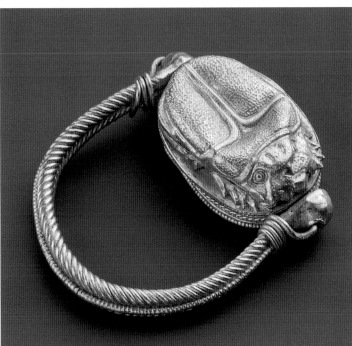

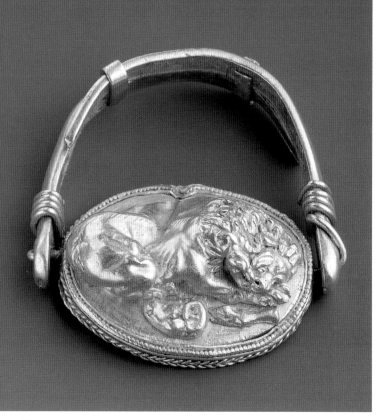

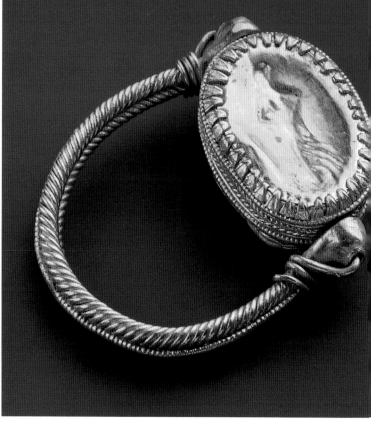

99. FINGER RING WITH GRIFFIN AND HORSE

4th c.
Gold
MHTU, inv. no.AZS-2956
From Denysova Mohyla (Kurhan 6), near Ordzhonikidze, Dnipropetrovs'ka Oblast'.
Excavated by B. M. Mozolevs'kyi, 1972.
Bezel: L: 2.6 cm; W: 2 cm. Band: L: 3.3 cm; W: 2.4 cm; wt: 10.36 g.

Publications: Mozolevskii (1980), 134, 136, figs. 69–70; Turku, *Skyyttien* (1990), 31, 50, no. 92; Schleswig, *Gold* (1991), 316, no. 114;
Tokyo, *Scythian Gold* (1992) 86, no. 91; Edinburgh, *Warriors* (1993), 36, no. 62; Toulouse, *L'or* (1993), 82, no. 69;
Vienna, *Gold* (1993), 194–95, no. 57; Milan, *Tesori* (1995), 90, 192–93, no. 42.

This massive ring has a swiveling oval bezel, framed by braided and beaded wire, and an adjustable band. On the obverse, the bezel is decorated with the figure of a reclining lion in high relief, its head turned to rest on its outstretched paw. In the field below are the dismembered leg and inverted head of a ram. The reverse, which is slightly concave, bears an intaglio scene of a griffin attacking a horse in left profile. The eagle-headed griffin is winged and horned, and its hind legs end in talons.

This ring was found in the grave of a Scythian couple. Unfortunately, the tomb had been plundered in ancient times, and so it is impossible to determine whether the ring was worn by the man or the woman. A similar ring, with a lion sculpted in the round, was found in Velyka Blyznytsia.[1]

1. Artamonov (1969b), 74, 281, fig. 142; Williams and Ogden (1994), 193, no. 125.

100. WHETSTONE HANDLE ORNAMENT

4th c.
Gold
MHTU, inv. no. AZS-3079
From Berdians'kyi Kurhan, near village of Novovasylivka, Berdians'kyi Raion, Zaporizhs'ka Oblast'.
Excavated by M. M. Cherednychenko, 1977–1978.
L: 5.7 cm; D: 1.2–1.9 cm; wt: 13.1 g.

Publications: Tokyo, *Scythian Gold* (1992), 60, no. 46; Cherednychenko and Murzin (1996), 73, fig. 10.

The top of the tapered cylindrical cap is decorated with a filigreed rosette. On the shaft, separated by bands of braided and plain wire, are three registers of opposed pairs of reversing volute spirals. These are formed of plain-wire filigree, and each has a central granule. Small wire "petals" extend between the open pairs of volutes; some petals are vertical, others angled. The shaft is pierced with two holes.

The gold cap was a setting for a whetstone; the holes in the shaft allowed it to be attached to a belt. A whetstone was a conventional part of military equipment; the fact that some were provided with gold caps underscores their importance.

Another richly decorated cap was found in Kul'-Oba,[1] and other examples have come from Taleiev Kurhan near Simferopol' and from Kurhan Mala Blyznytsia in the Kuban.[2] The same volute pattern decorating this cap also appears on cat. no. 135.

1. Artamonov (1969b), 287, pl. 212; Williams and Ogden (1994), 142, no. 84.

2. Piotrovsky (1975), nos. 175–77.

100

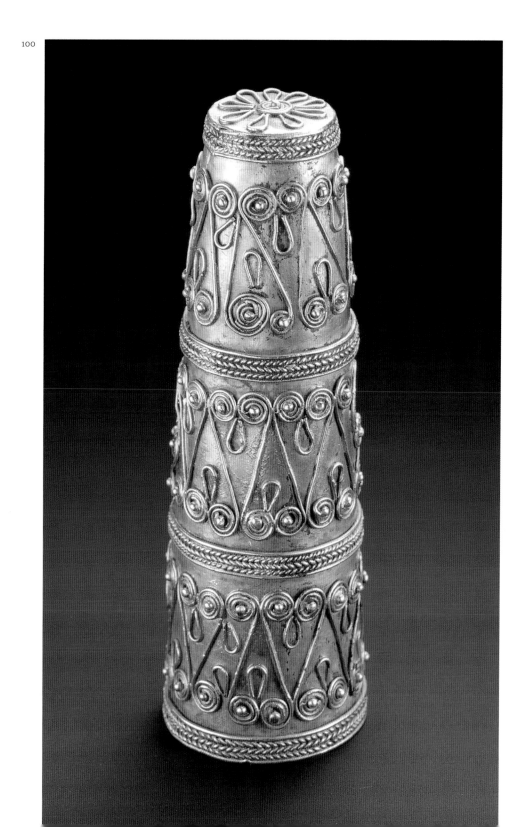

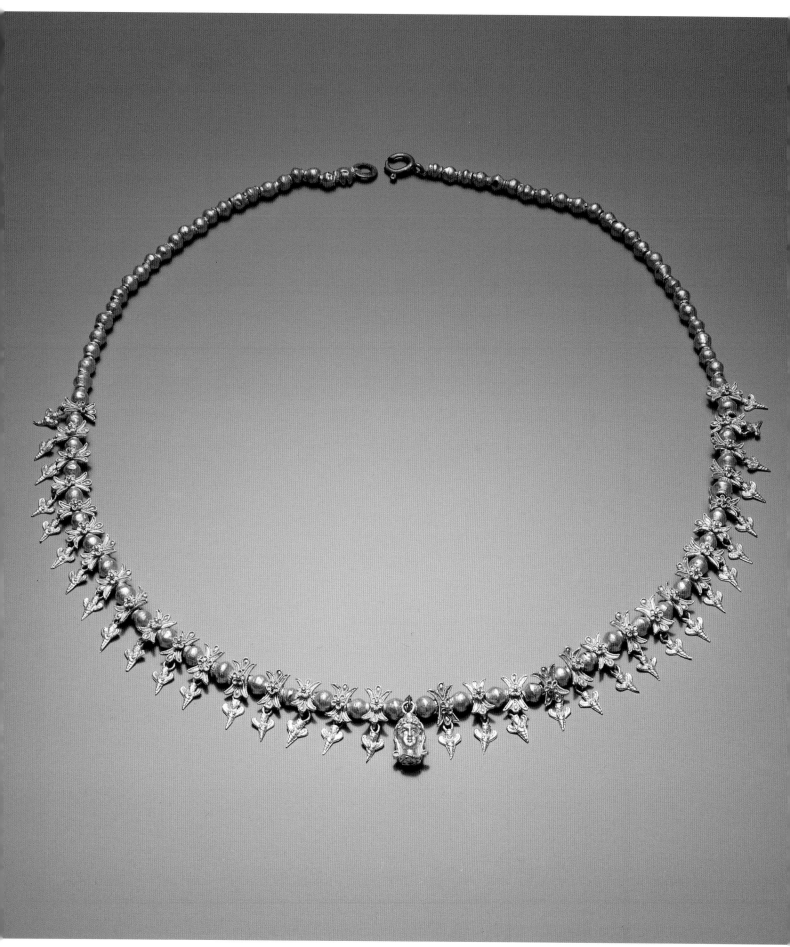

101

101. NECKLACE WITH FEMALE PENDANTS

ca. 325
Gold
AI, inv. no. z-891 to z-1009 (119 items)
From Kurhan Ohuz, near Nyzhni Sirohozy, Khersons'ka Oblast'. Excavated by Iu. V. Boltryk, 1980–1981.
L: (overall) 42.5 cm; total wt: 20.4 g.

Publications: Bidzilia, Boltrik, Otroshchenko, and Iakovenko (1973), 259–62; Boltrik and Fialko (1996), 107–29, pl. 12.1;
Boltrik and Fialko (1997), 75–76.

The necklace consists of biconical beads, formed of sheet gold, alternating for most of the circumference with a floral ornament comprising two back-to-back crescents enclosing a bud above and below, with a five-petal blossom superimposed at the midpoint. Suspended from each floral ornament is a hollow pendant formed of two soldered halves. These take the form of winged females, which resemble sirens but have bodies terminating in spiraling snake coils. Their wings curl upward. A larger, similarly made, central pendant is in the form of a female head. She wears a Phrygian cap and a necklace made of beaded wire.

101 detail

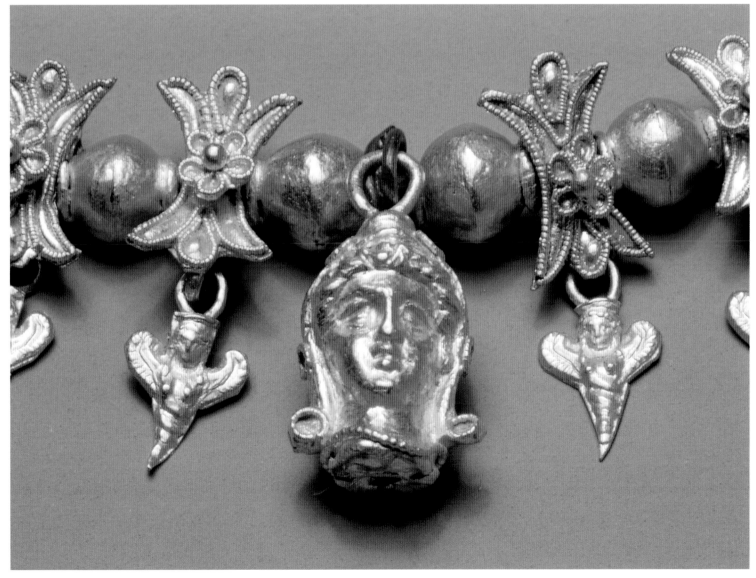

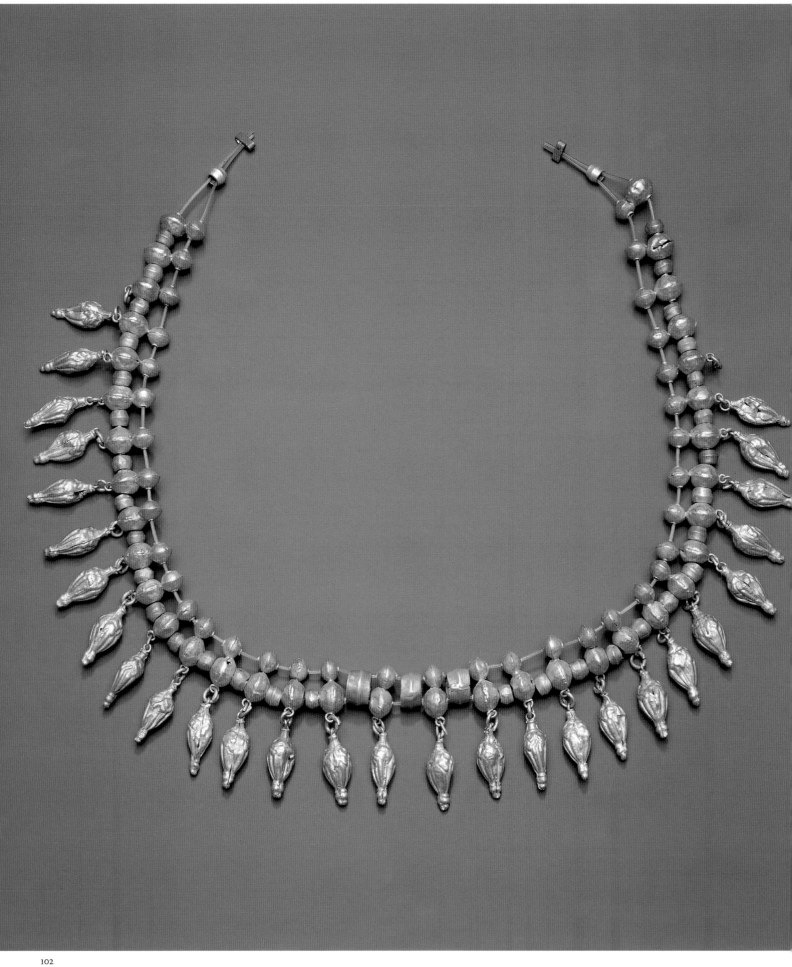

SCYTHIAN GOLD

The small pendants appear to associate the familiar Greek image of a siren with the snake-bodied goddess, who, Herodotus tells us, was considered to be the mother of all Scythians (4.7–10). A similar motif decorates a harness ornament from Babyna Mohyla (cat. no. 147). Sirens are seen on the handle plates of Greek vessels destined for Scythian customers (cat. nos. 82 and 83).

Also interesting is the form of the floral elements between the beads. It is nearly identical to that of the silver plaque, cat. no. 149, and can also be compared with the silver bridle applique, cat. no. 32.

The large pendant representing a woman in a Phrygian cap recalls the bridle ornaments, cat. no. 148. In the Greek world, Phrygian caps were associated with the east, and so with Amazons, who were thought to dwell in the northeastern corner of the known world. It has often been suggested that the Greeks may have associated the mythical Amazons with Scythian women, who were reported to ride and fight, and whose burials sometimes include weapons.

A similar necklace with amphora-shaped pendants was found in Karagodeuashkh.[1] Compare also the spacer elements in a more elaborate necklace, said to be from Taranto.[2]

This necklace was found together with cat. nos. 32, 111, and 126.

1. Artamonov (1969b), 289, pl. 319.

2. Williams and Ogden (1994), 204–5, no. 135.

102. NECKLACE WITH AMPHORA PENDANTS

ca. 350–300
Gold
AI, inv. no. KP-722/4–73
From Kurhan 13, near Ordzhonikidze, Dnipropetrovs'ka Oblast'. Excavated by S. V. Polin and A. V. Nikolova, 1998.
L: 44 cm; wt: 120 g.

Unpublished.

In its modern restringing the necklace consists of two conjoined necklaces: the end of each strand passes through two collars to a single (missing) clasp. The inner necklace is composed of round gold beads, each of which is attached to a larger sphere beneath. In the lower necklace, each sphere is separated by a cylindrical bead. The three central cylinders are replaced by three collars through which both strands pass. From the spheres of the lower necklace are suspended twenty-eight amphora-shaped pendants.

Amphoras were popular motifs in Greek jewelry of the fifth and fourth centuries, although the form of the double beads is unusual.

This necklace was found together with cat. no. 103.

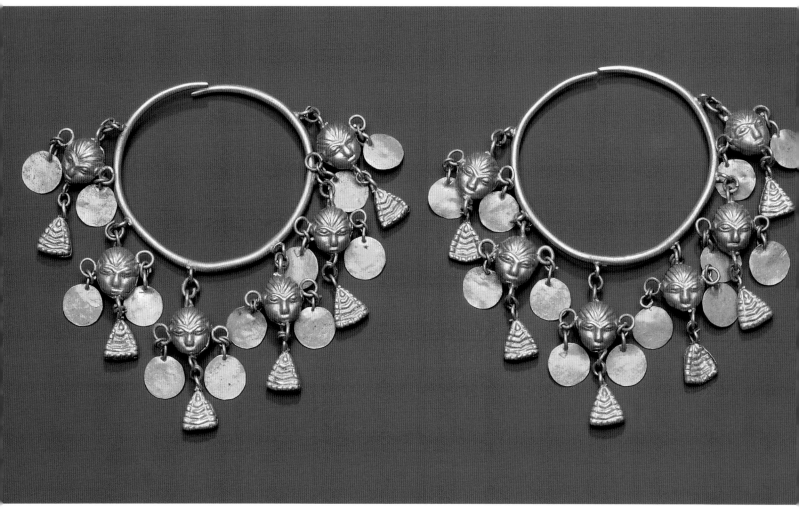

103

103. HEADDRESS PENDANTS

ca. 350–300
Gold
AI, inv. no. KP-722/2–3
From Kurhan 13, near Ordzhonikidze, Dnipropetrovs'ka Oblast'. Excavated by S. V. Polin and A. V. Nikolova, 1998.
Pendants: H: 3.9 cm; W: 4 cm, and H: 3.6 cm; W: 4.2 cm respectively; wt: 17 g.

Unpublished.

The two ornaments are formed of wire hoops, each with six pendants. Each pendant is composed of four separate elements: a human head formed of two soldered halves; a plain flat disc on each side of the head; and a single triangular, horizontally grooved pendant suspended below each head. The heads, discs, and triangular pendants are hung from three rings.

The pendants decorated a woman's headdress. They exemplify the Scythian fondness for display and movement; the pendants, especially the flat discs, would have sparkled in the sunlight.

These pendants were found together with cat. no. 102.

104. PLAQUE WITH BEE

4th c.
Gold
MHTU, inv. no. AZS-2380/1
From Haimanova Mohyla, burial 2, near village of Balky, Vasylivs'kyi Raion, Zaporizhs'ka Oblast'.
Excavated by V. I. Bidzilia, 1969.
L: 2 cm; W: 1 cm; wt: 0.57 g.

Publications: Bidzilia (1971), 47–48.

The rectangular applique is decorated with a relief representation of a bee inside a beaded border. At each corner is a hole for attachment.

The motif and naturalistic handling are inspired from the Greek world, where the bee was closely identified with Artemis. It is possible that the inspiration for this plaque was a coin from Ephesos, where the goddess was worshiped from early times.[1] Bees are not common in Scythian art, but they do appear among the appliques on the gold headdress from Melitopol's'kyi Kurhan 1 (cat. no. 18).

This plaque was discovered in a woman's grave and belongs with a group of appliques that decorated her clothing and bear vegetal, zoomorphic, and human motifs.

1. Kraay (1966), 356–57, pl. 179, nos. 599–600.

104

Following pages: 105

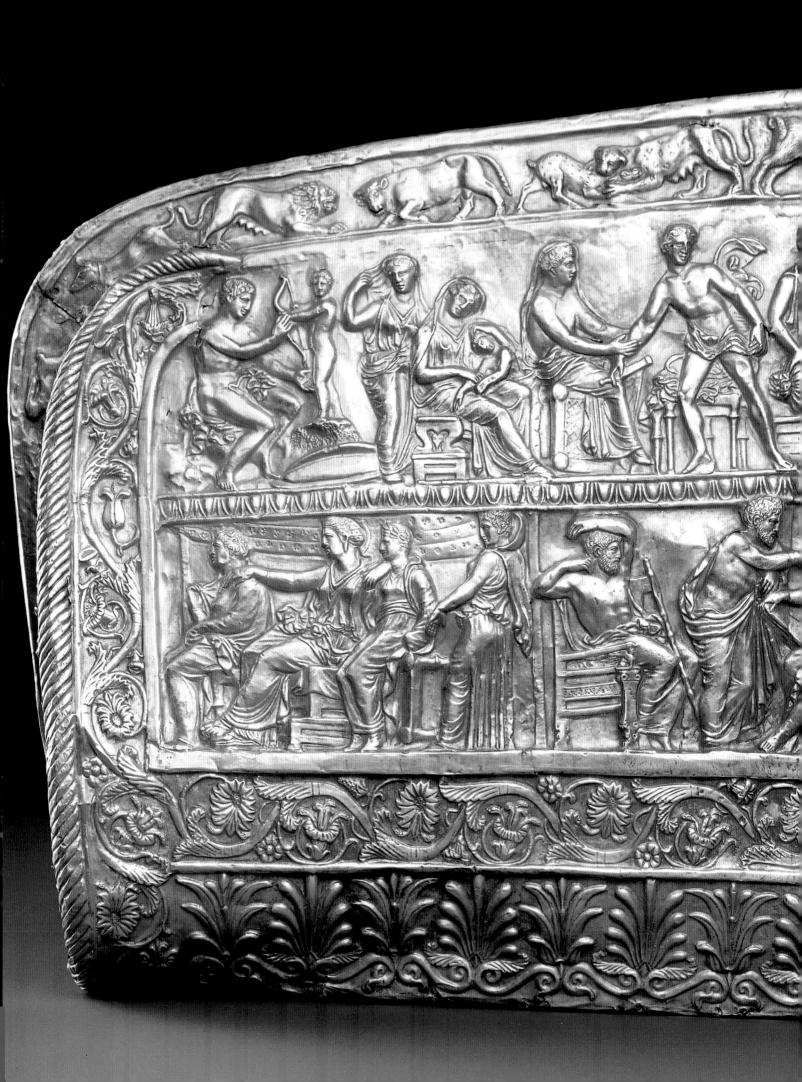

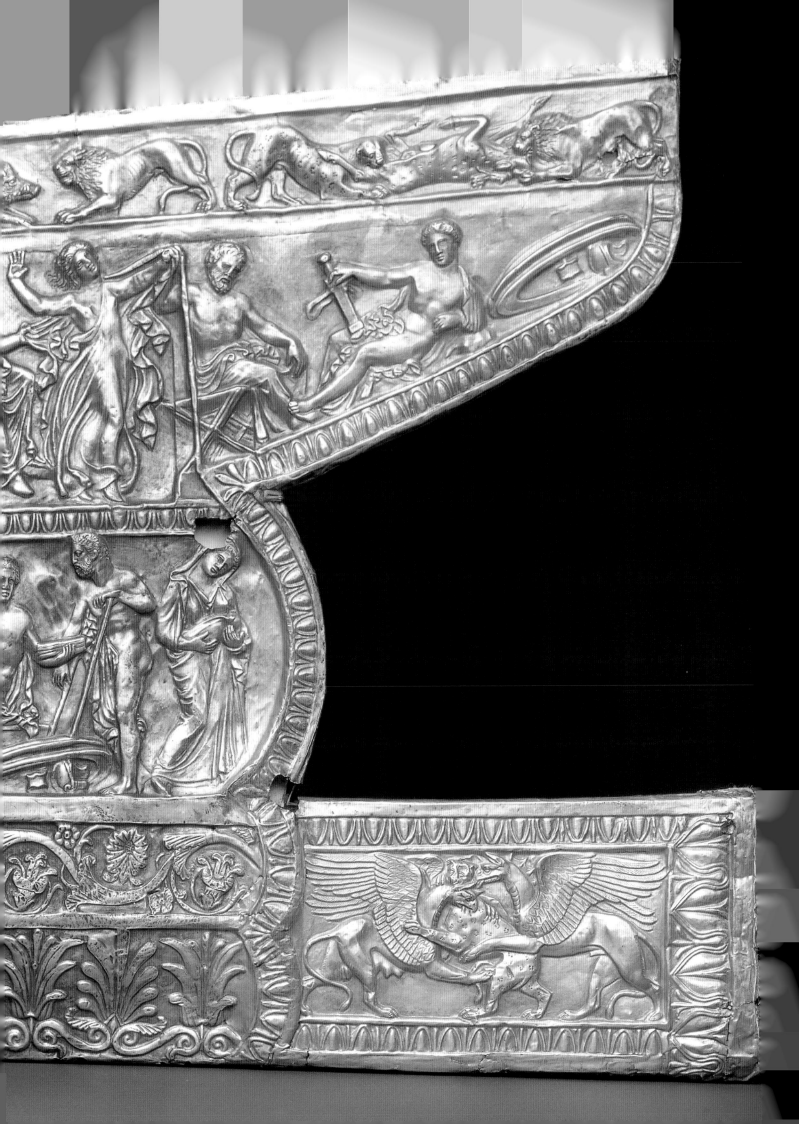

105. GORYTOS COVER

4th c.
Gold
MHTU, inv. no. AZS-1416
From Melitopol's'kyi Kurhan, burial 2, Melitopol', Zaporizhs'ka Oblast'. Excavated by O. I. Terenozhkin, 1954.
L: 47 cm; W: 23–27.5 cm; wt: 206.4 g.

Publications: Hanina (1974), figs. 28–31; Sokolov (1974), 51, no. 35; New York, *Scythians* (1975), 128, no. 186; Chernenko (1981), 76–92, figs. 57–58; Il'inskaia and Terenozhkin (1983), 148, photo on color insert; Piotrovsky, Galanina, and Grach (1987), 149, figs. 224, 225; Terenozhkin and Mozolevskii (1988), 121–28, figs. 141–48; Turku, *Skyyttien* (1990), 21, 48, no. 34; Schleswig, *Gold* (1991), 305, no. 92; Tokyo, *Scythian Gold* (1992), 54, no. 39; Edinburgh, *Warriors* (1993), 26–27, no. 25; Toulouse, *L'or* (1993), 60–61, no. 22; Vienna, *Gold* (1993), 106–17, no. 20; Zurich, *Schatzkammern* (1993), 118–19, no. 62; Schiltz, *Scythes* (1994), 142, figs. 106–107; Jacobson (1995), V.II.3, fig. 102; Milan, *Tesori* (1995), 61, 187, no. 14; Katowice, *Koczownicy* (1996), 88–89, no. 37; Luxembourg, *TrésORS* (1997), 67, no. 8; Vicenza, *Oro* (1997), 48–49, no. 6 and cover.

The matrix-hammered gold plaque was attached to a wood and leather gorytos. Although the bow-and-quiver case would have been worn vertically, its decoration is oriented horizontally. A rectangular extension bears a scene of two eagle-headed griffins, one male, one female, attacking a spotted leopard. This extension is framed with ovolos above and below and by a frieze of heart and dart on the end. Where the extension meets the body of the gorytos is another arcing band of ovolos, part of an ovolo border that extends along the entire right side of the gorytos. The bottom of the case is decorated with a lotus and palmette frieze below an acanthus scroll with rosettes. The acanthus scroll continues up the left side of the gorytos.

Two figural friezes are separated by an ovolo band. The description of them begins at the extreme right of the lower frieze. Here a woman stands in three-quarter right profile, her head draped and lowered; she cradles a child(?) in her hands. Behind her is a nude man in left profile leaning on two staffs. He looks toward a seated nude youth in three-quarter left profile, who turns back, extending his left arm, with elbow bent, to support an object on his forearm. The seated youth's right arm supports another object on his right thigh. In the field before them is a helmet and shield. A draped bearded man stands in front of the nude youth in a bent posture; this man's right arm is extended with the elbow bent. Behind them is a seated man in three-quarter right profile, whose left arm is raised above his head and whose right arm is draped on the back of his chair; a staff leans against the chair back. Behind him stands a woman in left profile, with her left arm extended. In front of her, and completing the lower frieze, are three women seated in left three-quarter profile. The center woman, seated on a draped chest(?) that rests on a stool, reaches out to the woman in front of her and drapes her left arm over the shoulder of the woman behind, who perches on an up-ended stool. Behind these women is drapery supported by tent poles. Above the three women, on the extreme left of the upper frieze, a nude man is seated on a rock, his outstretched arms holding a bow that is also grasped by a small boy standing on a rocky step and looking out toward the viewer; a shield lies in the foreground. Behind the boy is a woman standing in three-quarter right profile, her right hand pulling at her veil. In front of her a woman in three-quarter right profile sits on two stools, her head inclined to the right and down, almost touching the head of a child who holds onto her left thigh. In front of them is a figure seated in right profile on a stool that is tipped over. The upper torso is bare, but the curly locks are those of a woman. Drapery covers the head and frames the shoulders. The figure reaches out to grasp the right arm of a nude, mostly frontal, youth, who leans forward, legs spread, sword and scabbard in his right hand. Behind him drapery rests on a stool. Next is a woman seated in right profile on a cushion(?) resting on a stool. She stretches her left arm to grab the billowing drapery of a dancing woman with upraised arms moving to the right. The scene now continues into the gorytos' triangular extension. A man is seated in three-quarter right profile, his right hand holding a staff. He faces a reclining nude man who supports himself on his left elbow and steadies an upright sword between his legs with his right hand. Behind him, completing the figured frieze are a shield and helmet. All of the female figures are fully draped and the nude men have drapery covering their genitals.

The uppermost relief is decorated with a scene of animal combat, decreasing in size as it curves around the gorytos on the left, where it eventually meets a rope braid. From the viewer's right: a lion and spotted leopard attack an upended stag; a lion and boar confront each other; a spotted female leopard brings down a deer; a bull and lioness approach each other; and a hound pursues a hare down the side. On the side of the gorytos two heraldic winged, horned lion-griffins stand on their hind legs, which rest on an acanthus plant that supports a central vertical ridge. The forepaws rest on a stem that winds from the base of a palmette that is on its side. The animals' horns take the form of an acanthus scroll, and above their heads is a flower surmounted by palmette petals, from which the stem of a flower emerges.

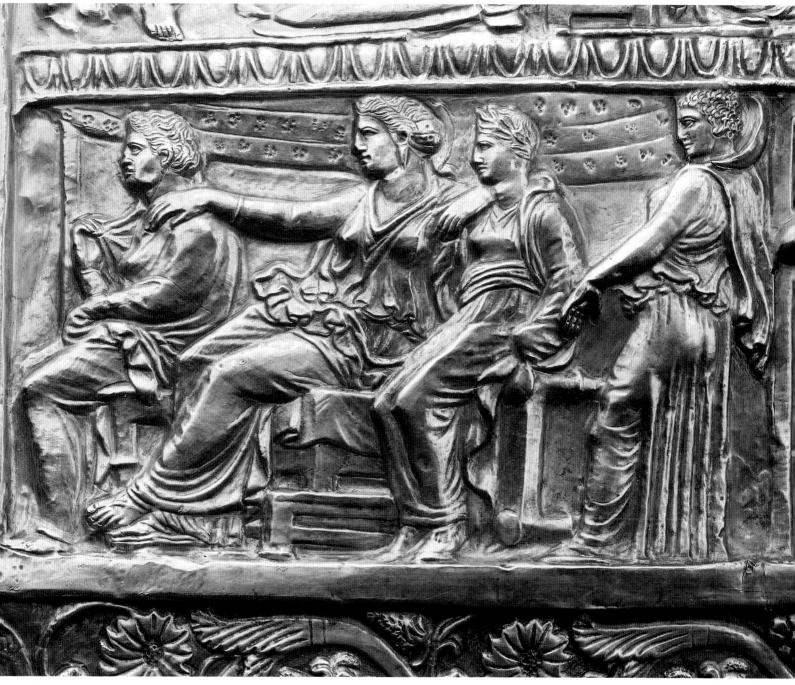

105 detail

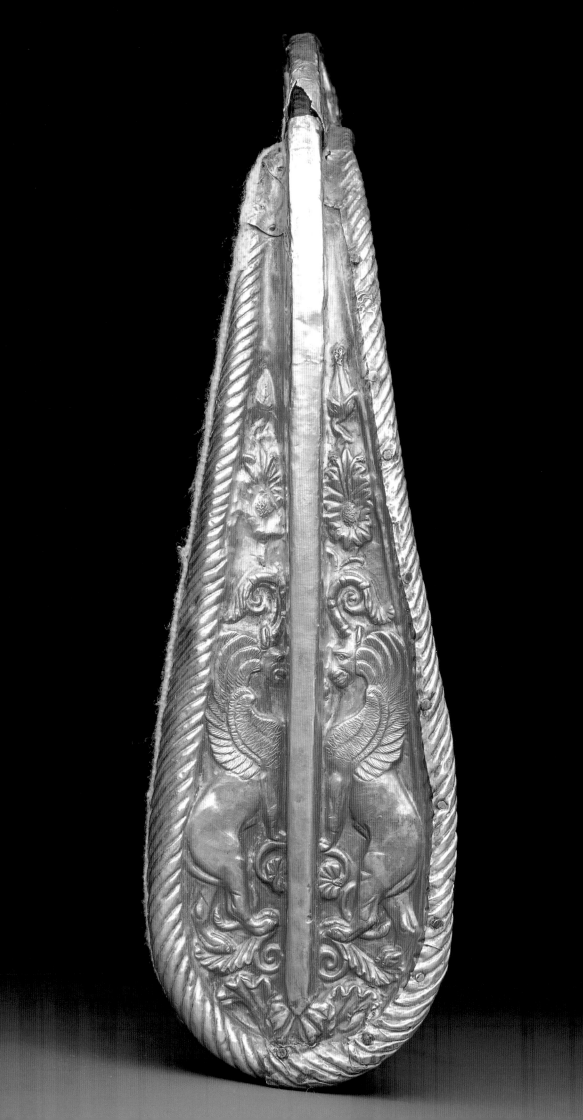

105 details

105

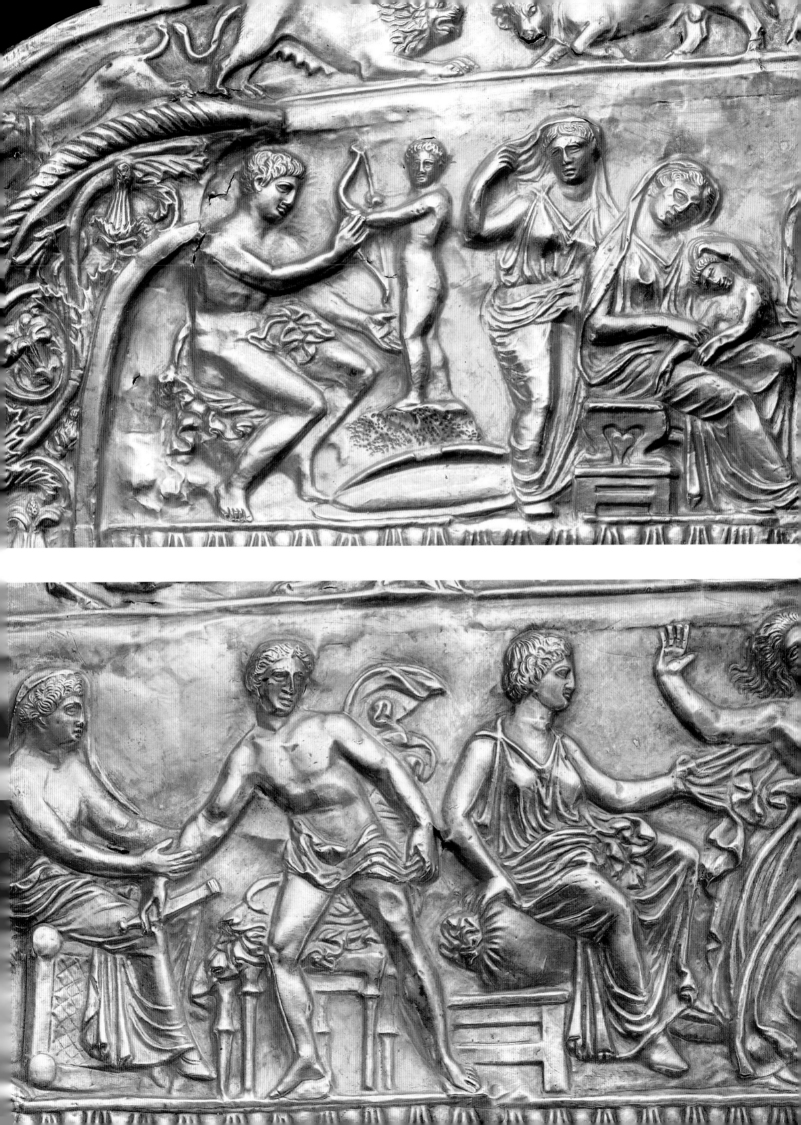

This gorytos is one of several known with nearly identical decoration (see the essay by Treister in this volume). The figural scene has long been identified as illustrating Achilles on Skyros among the daughters of Lycomedes, but in recent years most scholars have rejected this identification. It had been assumed, too, that the gorytos, like other examples of fine goldwork from Scythia, had been produced by Greek artists. This assumption, too, is now being questioned, as the essays by Treister, Jacobson, and Reeder in this volume all attest. Treister has also studied the manufacture of the gorytoi, concluding that the figured scenes were hammered with separate matrices.

106. PLAQUE IN THE SHAPE OF A LION

ca. 350–300
Gold
MHTU Inv. no. DM-1703
From Kurhan 1, near village of Vovkivtsi, Romens'kyi Raion, Sums'ka Oblast'. Excavated by S. A. Mazaraki, 1897.
H: 2 cm; L: 5 cm; wt: 0.96 g.

Publications: Khanenko and Khanenko (1899), 7, 31, pl. xxiv, 410; Il'inskaia (1968), 48, 96–97, pl. xxxvii.19;
Hanina (1974), fig. 15; Tokyo, *Scythian Gold* (1992), 93, no. 103.

The hammered plaque is in the form of a lion in left profile, its rear legs stretched behind and its tail curling between them. Its features and mane are clearly defined. Holes are pierced around the perimeter.

The lion, ready to spring, is depicted with realistic detail and vigorous strength. It corresponds almost exactly to a counterpart in the upper register of the gorytos from Melitopol' (cat. no. 105).[1] Perhaps this plaque was also attached to a gorytos.

The plaque was found together with cat. nos. 55 and 115.

1. See the essay in this volume by Treister, who suggests that they were hammered in the same matrix.

106

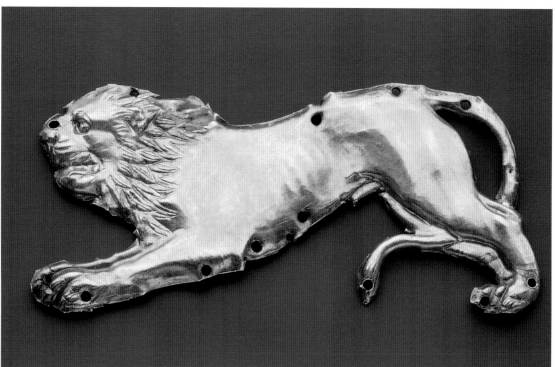

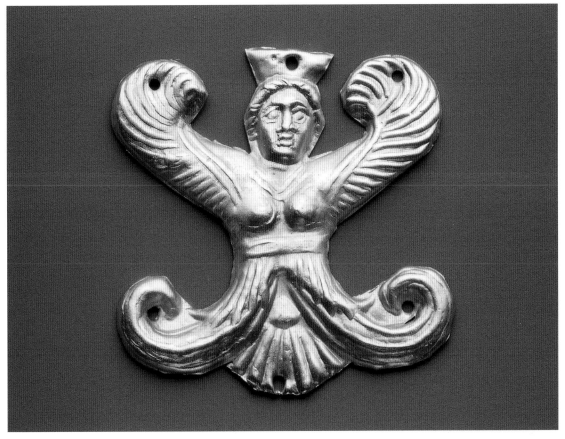

107

107. PLAQUE IN THE FORM OF A WINGED FEMALE

4th c.
Gold
MHTU, inv. no. AZS-1556
Findspot unknown.
L: 3 cm; W: 3 cm; wt: 1.86 g.

Publications: Hanina (1974), fig. 59; Tokyo, *Scythian Gold* (1992), 99, no. 114; Rusiaeva (1997a), 102–5; Vicenza, *Oro* (1997), 85, no. 41.

The relief plaque takes the form of a winged female figure whose lower body is formed by two volutes. Her frontal oval face has large features. The feathers of her upraised wings, which take the place of arms, curl inward. She wears a polos and a chiton belted under the breasts, its folds dividing below her waist into two opposing scrolls, between which is a palmette. Six holes, some with rivets still in place, were punched in the extremities.

The *Rankenfrau*, a female figure whose lower body assumes the shape of an acanthus petal, is of eastern origin. It was a common motif in Etruscan and Greek art,[1] decorating gold objects, mosaics, and vases. Some scholars have linked the motif with the snake-footed goddess described by Herodotus (4.9–10) as the mother of all Scythians. Herodotus tells us that she bore the children of Herakles, one of whom became the first Scythian king.

A number of similar plaques are known, including examples from Velyka Blyznytsia[2] and Oleksandropol'.[3] On a gold plaque from Kul'-Oba, the lower body terminates in serpent and griffin heads, and other griffin heads grow from her back.[4] A simplified version is seen on earrings from a fourth-century tumulus near Mar'ianivka.[5]

1. Cristofani and Martelli (1983), 284, nos. 113–14; Greifenhagen (1970), pl. 67, 5. See also the essay by Reeder in this volume.
2. Artamonov (1969b), 289, no. 308, pl. 308.
3. Vienna, *Skythen* (1988), 147, no. 83.
4. Artamonov (1969b), 287, no. 230, pl. 230.
5. Vienna, *Gold* (1993), 176, no. 49.

108. HAT

ca. 350–325
Gold
AI, inv. no.z-1669, z-1670–1680 (11 pieces), z-1681–1713 (33 pieces), z-1714–1744 (31 pieces)
From Tetianyna Mohyla, near village of Chkalove, Nikopol's'kyi Raion, Dnipropetrovs'ka Oblast'.
Excavated by V. I. Murzin, R. Rolle, 1986. Reconstructed by L. S. Klochko.
Band (z-1669): H: 2.5 cm; D: 35 cm; wt: 15.8 g. Delicate plate (11 pieces)(z-1670–1680): Four plaques at edge:
H: 1.4–2.4 cm, L: 12.3 cm; H: 1.2–2.6 cm, L: 13.5 cm; H: 1.6–2.7 cm, L: 14 cm; H: 1.6–2.4 cm, L: 11 cm; wt: 13.7 g (gold 750).
Seven plaques at top: H: 1.8 cm, L: 3.1 cm; H: 1.4–2.2 cm, L: 5.5 cm; H: 1.7–2.3 cm, L: 12.9 cm; H: 2.4–2.8 cm, L: 9.8 cm;
H: 2.1–2.8 cm, L: 10.3 cm; H: 1.4–2.5 cm, L: 15.5 cm; H: 1.6–2.4 cm, L: 5.2 cm; wt: 13.7 g.
Plaques (33) with image of male head (z-1681–1713): D: 1.2 –1.3 cm; wt: 13.74 g.
Plaques (31) with image of animal mask (z-1714–1744): D: 0.9 cm; wt: 4.84 g.

Publications: Klochko, Murzin, and Rolle (1991), 58–62; Schleswig, *Gold* (1991), 320, no. 124a; Murzin, Polin, and Rolle (1993), 85–101.

The hat is reconstructed, with modern fabric, using seventy-six gold ornaments from Tetianyna Mohyla. The band along the lower edge is embossed with a row of schematic, alternating rosettes and palmettes above a row of half-ovolos. Pairs of small holes evenly spaced around the left border were used for attachment. Above this are two bands of acanthus scrolls, assembled from several separate openwork plaques. Additional ornaments on the hat include small hemispherical plaques representing a lion's muzzle. Other discs bear the image of a man's face, and a further group of plaques are formed as human faces in high relief.

It is thought that the hat to which these ornaments belonged was worn by a woman. The band closest to the face compares closely with the diadem that forms part of a woman's headdress, cat. no. 109.

This hat was found together with cat. nos. 16 and 17.

Opposite: 109 detail

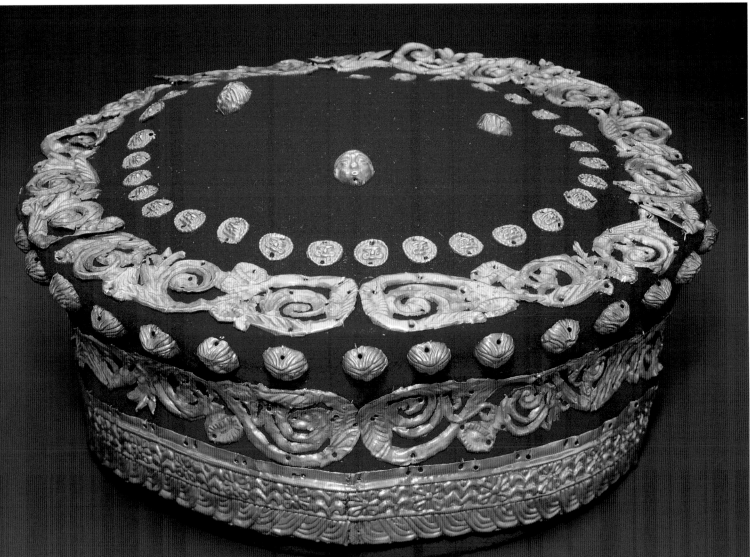

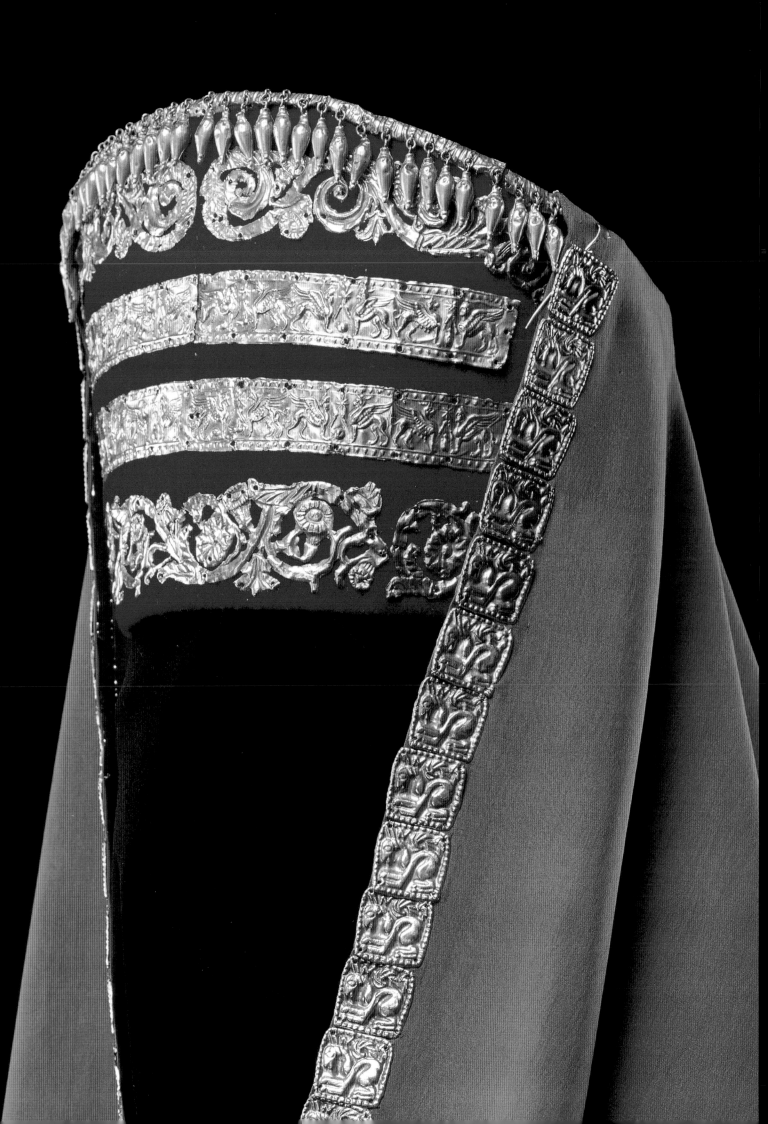

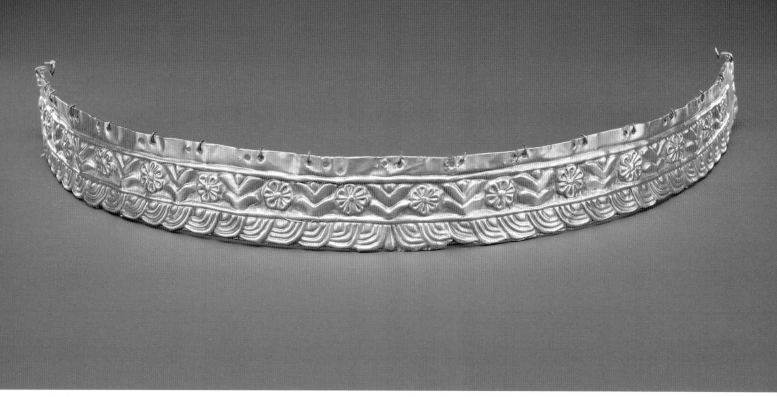

109 detail

109. HEADDRESS

4th c.
Gold
MHTU inv. no. AZS-2410/1–16, 2416/1–54
From Kurhan 22, burial 2, near village of Vil'na Ukraina (formerly Chervonyi Perekop), Kakhivs'kyi Raion, Khersons'ka Oblast'.
Excavated by O. M. Lieskov, 1970. Reconstructed by L. S. Klochko.
Plaque with 25 pendants (AZS-2410/1): 25 x 1.6 cm; wt: 19.2 g. Plaque with 1 pendant (AZS-2410/2): 10 x 1.5 cm; wt: 2.6 g.
Plaque with 14 pendants (AZS-2410/3): 16.5 x 1.5 cm; wt: 11.6 g.
Plaque with 15 pendants (AZS-2410/4): 11 x 1.5 cm; wt: 11.7 g. Diadem (AZS-2410/5): 32 x 2.4 cm; wt: 20 g.
Plaque (consisting of 4 pieces) with griffins and sphinxes (AZS-2410/6–9): 11 x 2.2 cm; wt: 16.1 g.
Plaques (2) with vegetal ornament (AZS-2410/10–11): 23–24.1 x 2.7–2.8 cm; wt: 13.92 g.
Plaques (3) with vegetal ornament (AZS-2410/12–14): 15 x 3.5–3.6 cm; wt: 21.08 g.
Pin (AZS-2410/15): L: 4.7 cm; wt: 0.63 g. Pin (AZS-2410/16): L: 4.2 cm; wt: 0.73 g.
Plaques (54) with horses (AZS-2416/1–54): 2.2 x 2.3 cm; wt: 39.39 g.

Publications: Hanina (1974), fig. 36; Leskov (1974), 83, figs. 126, 128; Lieskov (1974), 89–94; Klochko (1979), 16–28, no. 31;
Tokyo, *Scythian Gold* (1992), 90, no. 96; Edinburgh, *Warriors* (1993), 30–31, no. 37; Toulouse, *L'or* (1993), 69, no. 36;
Vienna, *Gold* (1993), 146–47, no. 33; Milan, *Tesori* (1995), 74–75, 189, no. 27.

The headdress consisted of a tall cylindrical cap supported by a framework of willow twigs and a shoulder drape attached by gold pins. Pigment traces permitted this reconstruction in red and purple. Both cap and drape were ornamented with gold appliques. Individual plaques on the drape are decorated with a stylized horse crouching inside a beaded square frame. A narrow fillet crimped over the top of the cap supports leaf-shaped pendants. In the center of the cap, two bands carry heraldic pairs of facing eagle-headed griffins and human-headed winged beings. Between them a star, which varies in appearance, is seen above alternating locusts, turtles, and other animals. Above and below the bands are openwork vegetal scrolls. Attached to the base of the cap was a diadem decorated with alternating rosettes and stylized plants over a border of schematic ovolos.

This elaborate headdress, with its ornamentation of plant and animal imagery, would have provided its female wearer with a halo of gold that had both aesthetic and symbolic significance.

The diadem finds a close parallel in cat. no. 33.

The headdress was found together with cat. nos. 120 and 125.

110. DIADEM

4th c.
Gold
MHTU, inv. no. AZS-2421
From Kurhan 2, burial 2, near village of Vil'na Ukraina (formerly Chervonyi Perekop), Kakhivs'kyi Raion, Khersons'ka Oblast'.
Excavated by O. M. Lieskov, 1969.
H: 5 cm; L: 26.4 cm; D: (from front) 7 cm; wt: 23.3 g.

Publications: Leskov (1974), 66, fig. 88; Lieskov (1974), 78–83; Klochko (1982b), 37–53.

The diadem is decorated in relief with a central palmette emerging from a symmetrical pair of volutes and tendrils. Smaller palmettes, blossoms, and ivy leaves fill the field. The frieze is framed by a round molding above and below, and with a row of ovolos along the bottom.

This diadem may have been worn alone or in combination with a more elaborate headdress (see cat. no. 109). It is likely that the diadem was accompanied by a drape that extended to the shoulders. Fragments of gold appliques (rectangular plaques decorated with griffins and smooth hemispherical plaques) were discovered in the same tomb, near the body of its female occupant. Both the relatively modest grave goods also included mirrors and Greek pottery, but the low height of the burial mound (1.5 m) suggests that the woman was not from a family of great wealth or prestige.

The vegetal design is inspired from the Greek world and finds numerous parallels in gold jewelry associated with metalworking centers in South Italy, Macedonia, and Greek cities of the Black Sea coast. The low relief of the matrix-hammered piece and the absence of filigree or granulated detail are also in keeping with the owner's apparently moderate means.

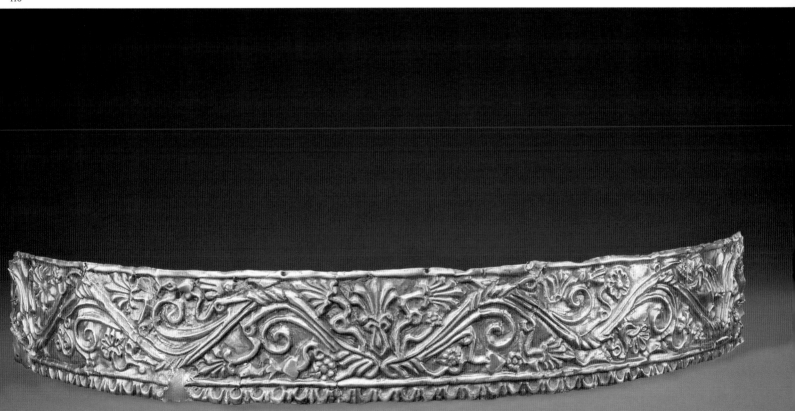

111

111. PLAQUE WITH HUMAN FACE AND LION MASK

4th c.
Gold
MHTU, inv. no. DM-6264
From Kurhan Ohuz (Pivnichna Mohyla), near Nyzhni Sirohozy, Khersons'ka Oblast'. Excavated by B. I. Khanenko.
L: 2.9 cm; W: 2.5 cm; wt: 1.36 g.

Publications: Khanenko and Khanenko (1907), 482, pl. vi; Hanina (1974), fig. 33.

The applique is decorated in relief with a human head in left profile that appears to be combined with the head of a lion in three-quarter view behind it. The face, which has small regular features and deeply set eyes, is framed by parallel locks that curl near the ear and descend down the neck. A ribbed ridge indicating the crest of a helmet runs along the top of the head. On the reverse are three wire loops for attachment to a garment; the plaque also has one hole for this purpose.

It is difficult today to read this image, or even to say whether the face is male or female. The low-crested helmet and long locks of hair have suggested to some that the human image is that of Athena and was inspired from coinage.[1] Others see a male warrior. Another source of inspiration might have been coins from Lesbos, where two back-to-back heads appear on the obverse of a tetradrachm of 375 B.C.[2]

A preference for interlocking forms and for combined motifs that merge with or diverge from each other is typical of Scythian art. Plaques similar to this one have been found in Chortomlyk,[3] Nymphaion,[4] and elsewhere.

This plaque was found together with cat. nos. 32, 101, and 126.

1. Kraay (1966), 326, pls. 118–19, for coins from Athens.
2. Ibid., 368, pl. 197, no. 697.
3. Artamonov (1969b), 55, 279, fig. 106.
4. Ibid., 285, no. 94, pl. 94; Williams and Ogden (1994), 134, no. 78. Here what may be interpreted as the helmet's cheekpiece is transformed into a bird beak.

112. PLAQUES WITH RUNNING FIGURE

5th c.
Gold
MHTU, inv. no. AZS-2333/1, 4–8, 10–11, 13–15, 17, 20, 22–23, 25–27, 32, 35, 38–51, 56, 59–62, 64;
AZS-2333/2, 3, 9, 12, 16, 18–19, 21, 24, 28–31, 33–34, 36–37, 52–55, 57–58, 63, 65
From Kurhan 5, burial 1, near village of Arkhanhels'ka Sloboda, Kakhivs'kyi Raion, Khersons'ka Oblast'.
Excavated by O. M. Lieskov, 1969.
Plaques (AZS-2333/1, 4–8, 10–11, 13–15, 17, 20, 22–23, 25–27, 32, 35, 38–51, 56, 59–62, 64): 2.5 x 2 cm; wt: 34.95 g.
Plaques (AZS-2333/2, 3, 9, 12, 16, 18–19, 21, 24, 28–31, 33–34, 36–37, 52–55, 57–58, 63, 65): 2.5 x 2 cm; wt: 23.85 g.

Publications: Lieskov (1974), 56, 72.

The oval relief plaques are decorated with a nude youth in left profile. He is depicted on bent left knee in the conventional Archaic pose for a running figure, and he appears to hold some object in each hand. His hair is depicted as large ribbed locks drawn back from the face. The appliques are pierced and fitted with attachment loops.

The plaques' shape and decoration suggest inspiration from Archaic Greek coinage,[1] or possibly gems.[2] It has been suggested that a coin depicting the young Herakles wrestling with snakes served as a prototype for this image. However, the motif of the youthful Herakles is later than the date suggested here by the use of the Archaic running pose.

These plaques were found in the impressive burial mound (2.5 m high) of a Scythian warrior. Included also were a gold torque, belt, and a hatchet decorated with gold appliques.

These plaques were found together with cat. no. 46.

1. Kraay (1966), 369, nos. 704, 706, pl. 198, two staters from Cyzicus of 500 B.C.
2. Boardman (1972), 181, pl. 3000, a carnelian scarab in London; 187, pl. 416, a jasper scarab in Cambridge.

112

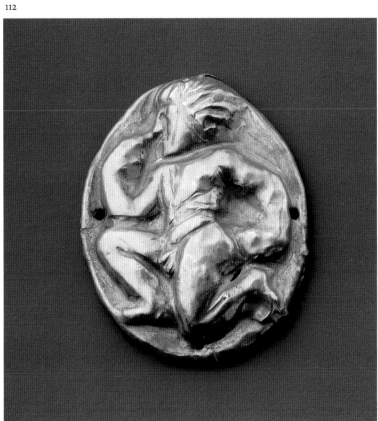

113. PLAQUE WITH HERAKLES AND THE NEMEAN LION

4th c.
Gold
MHTU, inv. no. AZS-2937/1
From Tovsta Zhovtokam'ians'ka Mohyla, burial 1, near village of Taraso-Hryhorivka, Apostolivs'kyi Raion, Dnipropetrovs'ka Oblast'.
Excavated by B. M. Mozolevs'kyi, 1975.
D: 2.2 cm; wt: 0.8 g.

Publications: Mozolevskii (1982), 211, fig. 37.2.

The plaques are decorated in relief. A nude male with short hair is in right profile, resting on his bent right knee and pressing his face into the mane of a lion he grasps in a stranglehold. The lion, in left profile, rests its left paw on the man's outstretched left thigh; the lion's left rear leg sits on or behind the man's left foot. The appliques are pierced for attachment.

These plaques, which depict Herakles with the Nemean Lion, were discovered, along with other burial goods, in a plundered mound 9.2 meters tall. It contained the graves of a man and a woman, their servants, and horses. A plaque similar to the ones seen here was found in Chortomlyk.[1]

Herakles was a well-liked figure in the Greek cities of the Black Sea coast, and his popularity extended into the Scythian world, where, according to Herodotus (4.10), the hero was regarded as a legendary ancestor. Representations of Herakles are not uncommon in Scythian art. He battles the Nemean Lion in cat. no. 142, and another of his labors, the taming of Cerberus, is depicted on cat. no. 141. The hero remained well known in the region into the first centuries A.D., as is attested by cat. nos. 80 and 81.

1. Artamonov (1969b), 53, 279, fig. 103.

113

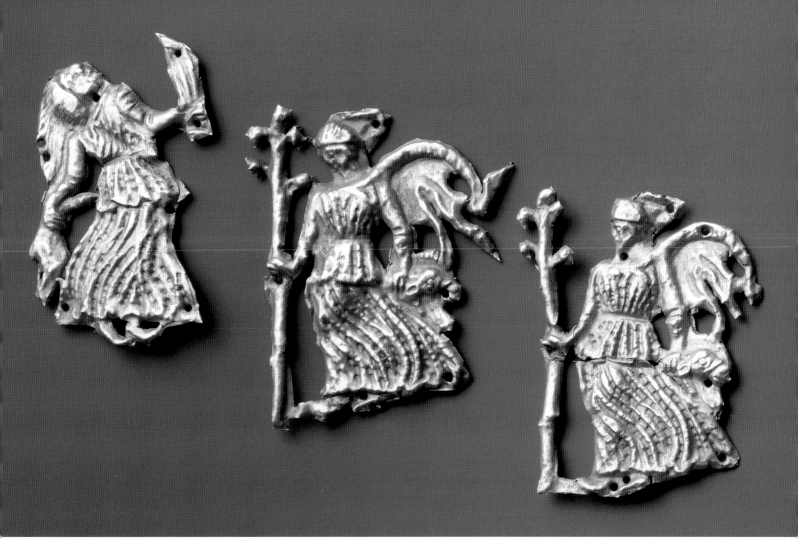

114. THREE PLAQUES WITH MAENADS

4th c.
Gold
MHTU inv. no. AZS-2649/1–2; AZS-2650
From Haimanova Mohyla, southern entry tomb 4, near Balky, Vasylivs'kyi Raion, Zaporizhs'ka Oblast'.
Excavated by V. I. Bidzilia, 1969.
Plaque (AZS-2649/1): H: 4.7 cm; W: 3.8 cm; wt: 1.96 g. Plaque (AZS-2649/2): H: 4.9 cm; W: 4.2 cm; wt: 2.6 g.
Plaque (AZS-2650): H: 4.6 cm; W: 2.8 cm; wt: 2.07 g.

Publications: Bidzilia (1971), 44–56; Hanina (1974), fig. 55; Leskov (1974), 91, fig. 137; Riabova (1979), 49, fig. 1;
Bessonova (1983), 74–76, fig. 6; Piotrovsky, Galanina, and Grach (1987), 106, fig. 135; Milan, *Tesori* (1995), 94, 193–94, no. 47;
Rimini, *Mille* (1995), 74, no. 40; Rusiaieva (1995a), 28–29, fig. 1.5.

These three relief appliques take the form of dancing maenads, who wear long garments with belted over-folds. One stands with her head in left profile supporting an upright thyrsos in her right hand and holding a goat head in the left. Her animal skin billows around her. On each of the other two plaques, a maenad sways with head tilted back in right profile; she holds a severed animal leg in the lowered left hand and another object (possibly a broad knife?) in the right.

Maenads were women who took part in the ecstatic rites of the Greek god Dionysos. Images of maenads similar to these figures are commonly encountered in Greek art of the fifth century. A number of plaques quite comparable to these were found in the Diiv Kurhan,[1] and an almost identical example came from Kurhan 6, near the village of Vodoslavka, Novotroits'kyi Raion, Khersons'ka Oblast'.[2]

1. Artamonov (1969b), 63, 285, no. 121.
2. Milan, *Tesori* (1995), no. 40; Kubyshev (1984), 301–302.

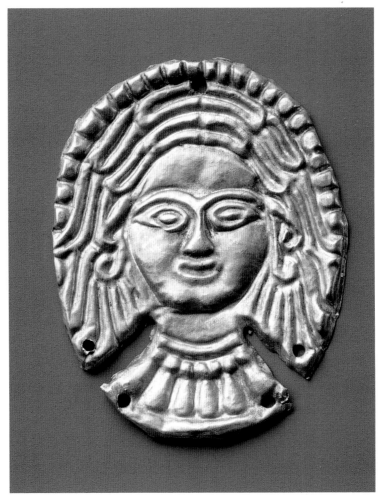

115

115. PLAQUE WITH FRONTAL FEMALE HEAD

ca. 350–300
Gold
MHTU, inv. no. DM-1706/6
From Kurhan 1, near village of Vovkivtsi, Romens'kyi Raion, Sums'ka Oblast'. Excavated by S. A. Mazaraki, 1897–1898.
H: 4.3 cm; W: 3.5 cm; wt: 1.76 g.

Publications: Khanenko and Khanenko (1899), 7, 31, pl. xxv.420; Il'inskaia (1968), 48, 143, pls. xxxvii.1, 2; Hanina (1974), fig. 13;
Tokyo, *Scythian Gold* (1992), 96, nos. 109, 110; Toulouse, *L'or* (1993), 75, no. 53; Vienna, *Gold* (1993), 165–67, no. 44;
Milan, *Tesori* (1995), 94, 194, no. 48; Luxembourg, *TrésORS* (1997), 93, nos. 45–46.

The applique bears the frontal head of a woman, who has a round face and plump chin, almond-shaped eyes, and brows that continue across the bridge of the nose. Her hair is formed by tubular locks that wrap over her head. She wears a beaded diadem, hoop earrings, and a torque above another necklace of beads and large oval pendants.

This is one of twenty such appliques found in a male grave and probably was used to decorate clothing. No parallels to this plaque and its mate are known.

This plaque was found together with cat. nos. 55 and 106.

116. DRINKING HORN

5th c.
Gold, organic material
MHTU, inv. no. AZS-3587
From Kurhan 13, near village of Velyka Znam'ianka, Kam'ianko-Dniprovs'kyi Raion, Zaporizhs'ka Oblast'.
Excavated by V. V. Otroshchenko, 1984. Reconstructed by Iu. Ia. Rossamakin and V. O. Bahlyi.
L: 44.5 cm; D: (mouth) 13.5 cm; wt: 220.61 g.

Publications: Bessonova (1983), 104–5; Otroshchenko and Rossamakin (1985), 243, 245; Turku, *Skyyttien* (1990), 15, 48, no. 15;
Schleswig, *Gold* (1991), 318, no. 120c; Tokyo, *Scythian Gold* (1992), 66, no. 54; Edinburgh, *Warriors* (1993), 28–29, no. 29; Toulouse, *L'or*
(1993), 66, no. 28; Vienna, *Gold* (1993), 130–31, no. 25; Milan, *Tesori* (1995), 68, 188, no. 18; Vicenza, *Oro* (1997), 52, no. 9.

Gold appliques, relief bands, and a lion-head finial were applied to a silver-plated wooden drinking horn
(here reconstructed). Around the rim are nine plaques decorated with the image of a deer whose antlers
extend into stylized griffin heads. A larger plaque on back bears the image of a boar in left profile; the plaque
beneath depicts the right-profile head of a stag, whose antlers take the form of bird heads. An inverted bird
head extends over the stag's head and another touches the animal's back; the other antlers fan outward with
curving tips. At the midpoint of the vessel's body, and between bands of braided filigree, are two bands of
guilloche enclosed above and below by a row of punched hemispheres. Both guilloche bands suggest stylized
bird heads. Three braided filigree bands and a beaded wire precede the lion-head finial. This drinking horn
was part of the impressive funeral inventory discovered in a double (male-female) burial from the fifth cen-
tury. The tomb also contained weapons, vessels containing food and drink, and more than nine thousand
gold decorations. Three side compartments in the walls of the tomb were filled with various vessels, includ-
ing this one.

The gold plaque with bird-headed antlers finds a close parallel on a gold plaque from a kurhan in the
neighborhood of Bukht Ak-Mechet'.[1]

1. Vienna, *Skythen* (1988), 78, no. 40.

116 detail

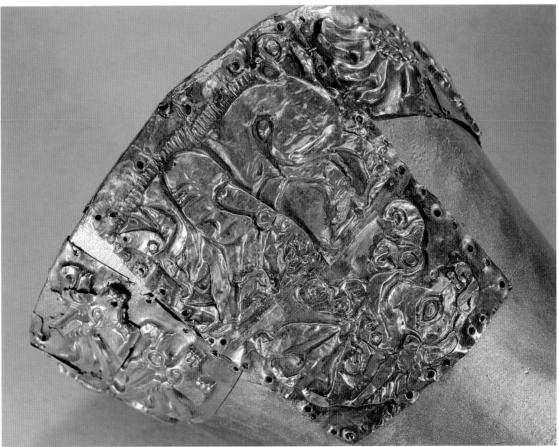

Following pages:
116, 117

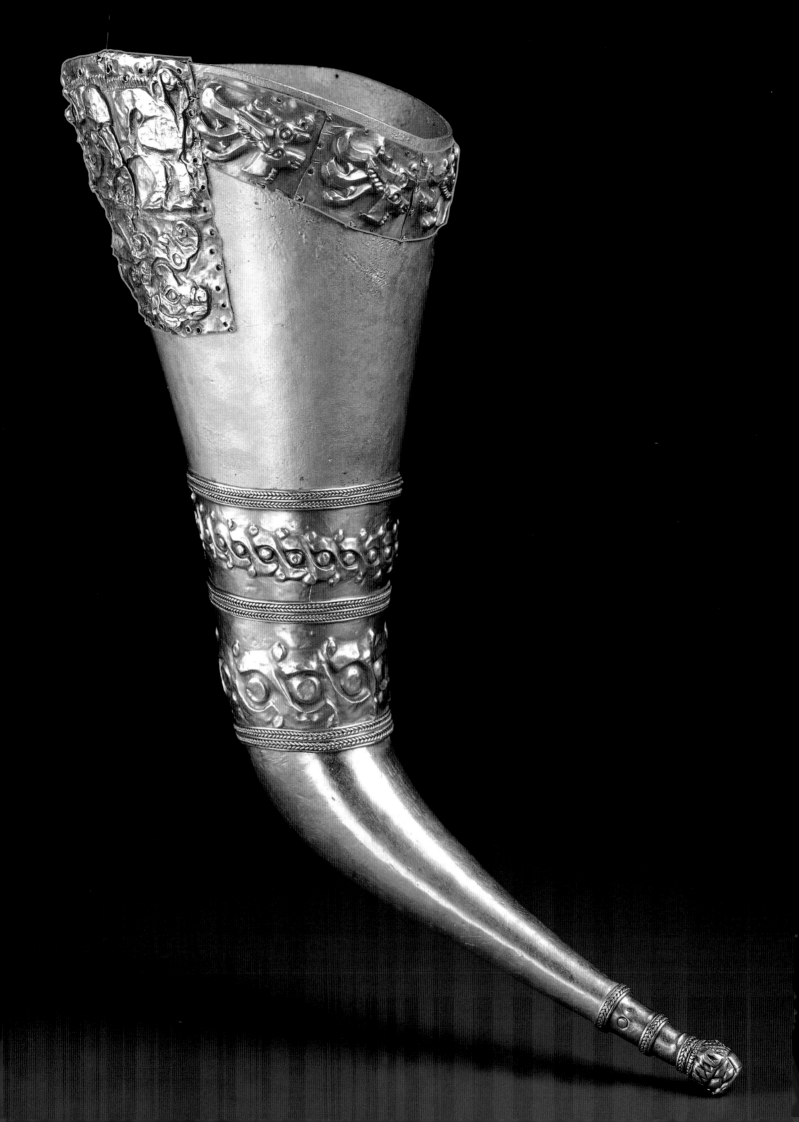

117. BEAKER WITH ROSETTES AND BIRDS

5th c.
Gold, wood
MHTU, inv. no. DM-6453/1, 6453/2; NDF-406
From Kurhan 9, near village of Osytniazhka, Novyi-Myrhorods'kyi Raion, Kirovohrads'ka Oblast'.
Excavated by V. V. Khvoika, 1900.
Beaker: H: 15.5 cm; D: 18.4 cm at top (new restoration). Plaque (NDF-406): H: 13 cm; W: 4.1 cm.
Plaque (AZS/6453/1): H: 13.1 cm; W: 4.1 cm; wt: 64.22 g. Plaque (AZS/6453/2): H: 13.3 cm; W: 4.1 cm; wt: 14.25 g.

Publications: Khvoika (1905), 9; Fialko (1993), 46–53, figs. 1–2, 3.2.

The appliques decorated a wooden beaker (here reconstructed). Some of the small gold pins for attachment still remain. The relief pattern is derived from a volute ornament familiar from the Greek world. Here, the volutes are filled with eight-petal rosettes, and the scroll is transformed into opposed bird or griffin heads, followed by trefoil palmettes. The rendering of each bird head is such that the circular frame enclosing the rosette can be viewed as the bird's curving beak, which winds beyond and beneath the upper part of the beak, known as the cere. The large, round bird eye echoes both the volute/beak and the round elements of the rosettes within the volutes.

These plaques offer rare evidence of a kind of wooden vessel that researchers believe was widely used in the second half of the fifth century for ceremonial purposes. A cup of similar form, decorated with antlered stags, was found in the Zaporizhs'ka Oblast'.[1]

1. Vicenza, *Oro* (1997), 53, no. 10; Luxembourg, *TrésORS* (1997), 72, no. 13.

118. MIRROR WITH EAGLE-HEADED FINIAL

ca. 550–500
Bronze
NMHU, inv. no. B 1132
From village of Basivka, Kurhan 6, Sums'ka Oblast'. Excavated by S. A. Mazaraki, 1897–1898.
D: (disc) 19 cm; L: (large piece) 23 cm; L: (terminal) 6.3 cm; W: (terminal) 8 cm; wt: 900 g.

Publications: Khanenko and Khanenko (1900), 351, pl. xliv; Farmakovskii (1914), 7, pl. xiii; Onaiko (1966), pls. xix.2, xv.35.

A convex double volute with palmette makes the transition between the disc-shaped mirror and the now-lost flat iron handle. Also surviving is the handle finial, which is formed of opposing eagle heads arranged to mirror the volutes above it. The heads have prominent ringed eyes and deeply grooved, sharply curving beaks. Small pins remain that were used to attach the mirror and finial to the handle.

This mirror was found in a grave in mound 6 in the village of Basivka (Romens'kyi Raion), which also included small bronzes and pottery.

The piece is notable for its pairing of traditional Scythian and imported Greek motifs. The convex Ionic volutes on the mirror are consciously echoed by the curving bird heads of the finial.

Opposite: 118

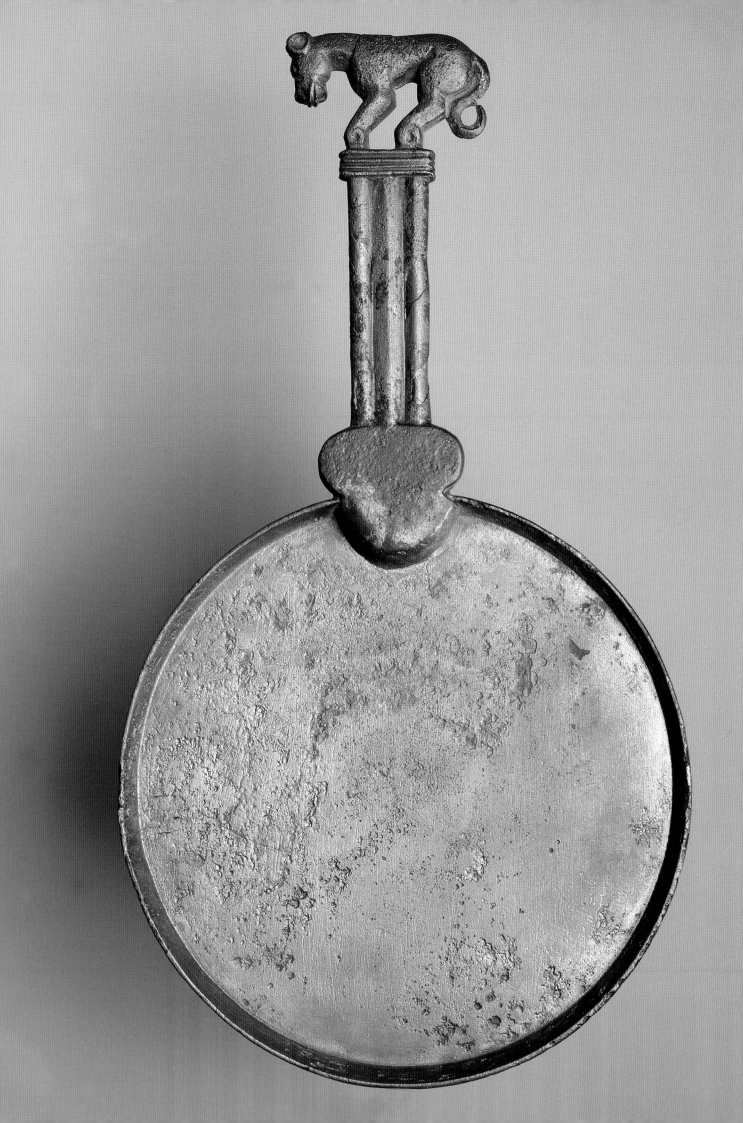

119. MIRROR WITH FELINE

6th c.
Bronze
NMHU, inv. no.B 1128
Chance find in Romens'kyi Raion, Sums'ka Oblast', at end of the 19th century. Exact place and date of discovery unknown.
L: (overall) 33 cm; D: disc (overall) 18.5 cm; H: (animal) 4.5 cm; L: (animal) 7 cm; wt: 1300 g.

Publications: Bobrinskii (1901), 69, fig. 17; Skudnova (1962), 5; Il'inskaia (1968), 152–53, fig. 39.2; Turku, *Skyyttien* (1990), 25, 49, no. 45; Schleswig, *Gold* (1991), 303, no. 86; Tokyo, *Scythian Gold* (1992), 92, no. 99; Toulouse, *L'or* (1993), 69, no. 34; Vienna, *Gold* (1993), 142–43, no. 31; Schiltz, *Scythes* (1994), 361, fig. 268.

The disc of the mirror has an upturned rim on the undecorated back. A reeded handle attaches to the disc by means of a smooth trefoil extension. At the other end of the handle, a lion stands on a platform that has three horizontal grooves. The legs are bent, as the animal seems to crouch or nears collapse. The head is lowered, so that the line of the back and head is horizontal. The animal has small, petal-shaped ears and an indented eye. Its tail curls in a volute, mirroring the annular paws.

There is considerable debate about where such mirrors were produced. One center must have been around Olbia, since of the eighty examples known, sixteen were found in Olbia and four on the nearby island of Berezan'. Other mirrors were probably made in the northern Caucasus and Carpathian regions.

The inspiration for the mirror is Greek, and the reeded handle of this example is certainly modeled on the fluted handles of Greek prototypes. Distinctly Scythian, however, is the handling of the feline, which is noteworthy for the abrupt juxtaposition of planes and the likening of tail, paws, and ears to volute forms.[1] The angular silhouette is especially elegant.

An almost identical example was found near Stavropol' in the northern Caucasus.[2] Also comparable is the pair of felines on a series of gold plaques from Ul'sk in the Kuban.[3]

1. See the essay by Reeder in this volume.

2. Vienna, *Skythen* (1988), 70, no. 35; New York, *Scythians* (1975), no. 45.

3. Vienna, *Skythen* (1988), 63, no. 28.

Opposite: 119

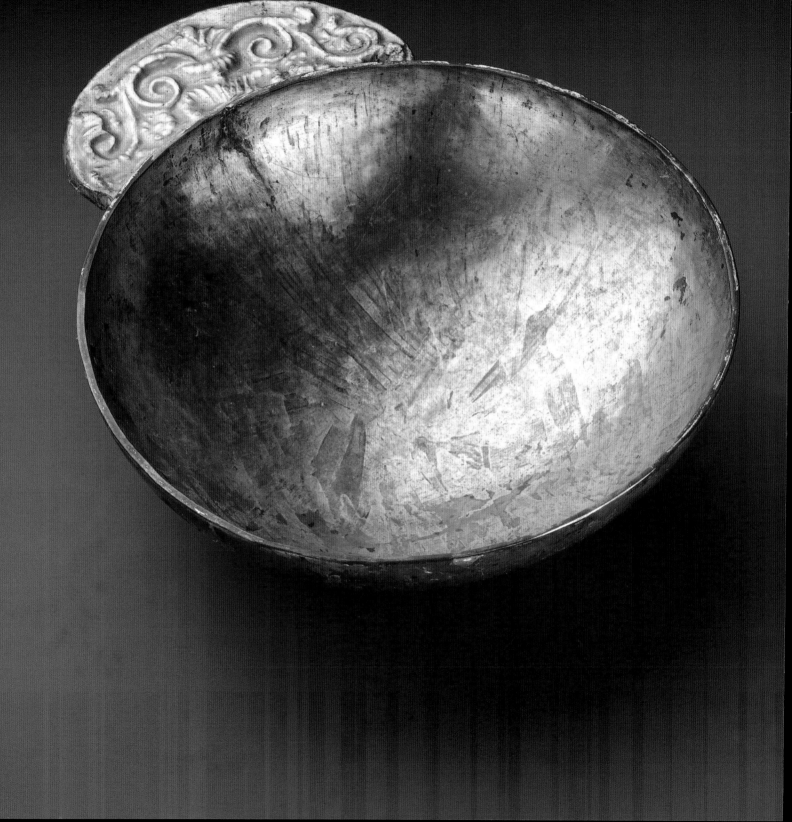

120. BOWL

4th c.
Silver, gilded handle
MHTU inv. no. AZS-2415
From Kurhan 22, burial 2, near village of Vil'na Ukraina (formerly Chervonyi Perekop), Kakhivs'kyi Raion, Khersons'ka Oblast'.
Excavated by O. M. Lieskov, 1970.
Handle: L: 6.6 cm; W: 2.7 cm. Overall: H: 3.6 cm; L: 14 cm; wt: 100.8 g.

Publications: Leskov (1974), 80, fig. 122; Lieskov (1974), 94, fig. 69; Tokyo, *Scythian Gold* (1992), 68, no. 58.

The low hemispherical vessel is made of silver. Its flat, crescent-shaped handle is gilded and decorated with a relief pattern of acanthus leaves and a central palmette. The outer volute on the viewer's left wraps around an eye-like hemisphere.

Cups were such a prominent feature of Scythian culture that, according to Herodotus (4.10), every Scythian male wore one attached to his belt. The bowl seen here came from a woman's grave; it could have held cosmetics, such as rouge or face powder, which Scythian women are known to have used. The owner of the bowl was buried in a garment and headdress decorated with elaborate gold ornaments.

The bowl was found together with cat. nos. 109 and 125.

121. SWORD AND SCABBARD WITH BOAR HEAD

ca. 330–300
Gold, iron
MHTU, inv. no. AZS-3261–3262
From Kurhan 30, near village of Velyka Bilozerka, Kam'ianko-Dniprovs'kyi Raion, Zaporizhs'ka Oblast'.
Excavated by V. V. Otroshchenko, 1979.
Scabbard: L: 55 cm; W: (max) 16.5 cm; wt: 112.9 g. Sword: L: 65.5 cm; wt: 323.8 g.

Publications: Otroshchenko (1984), 121–26; Schleswig, *Gold* (1991), 304, no. 89; Tokyo, *Scythian Gold* (1992), 53, no. 38; Edinburgh, *Warriors* (1993), 26, 28, no. 23, and cover; Toulouse, *L'or* (1993), 63, no. 24; Vienna, *Gold* (1993), 100–102, no. 18; Schiltz, *Scythes* (1994), 399, fig. 329; Jacobson (1995), VIII.C.2, fig. 109; Milan, *Tesori* (1995), 63, 187, no. 15; Luxembourg, *TrésORS* (1997), 64, no. 5; Vicenza, *Oro* (1997), 46, no. 5.

On the scabbard relief, a spotted stag in left profile is under attack by a right-profile griffin and a left-profile lion. The griffin has the feet of a lion. Behind are two crouching spotted leopards, also in left profile. On the crossbar appear two facing profile bird heads separated by a palmette. Along the back of the relief some of the small pins used for attachment to the now-lost wooden scabbard remain. The flap, which was used to tie the scabbard to a belt, takes the form of a boar's head. It, too, has small holes for attachment. On the boar's snout, an inscription reads *IPORI*. The hilt is decorated with the elongated body of a spotted stag lying in left profile. The pommel extends on each side into two semi-abstract bird heads set back-to-back. The guard at the base of the hilt is decorated, on the obverse, with two facing deer, and on the reverse with a deer and a feline. The double-edged sword is extant in fragments.

A similar primary scene, with comparable inscription and bird heads on the crossbar, is found on a scabbard from Kul'-Oba.[1] There the flap bears a hippocampus.

1. Artamonov (1969b), 287, no. 287, pls. 208–209; Schiltz, *Scythes* (1994), 321, fig. 331. See the essay by Treister in this volume.

Opposite: 120

Following pages:
121, 122

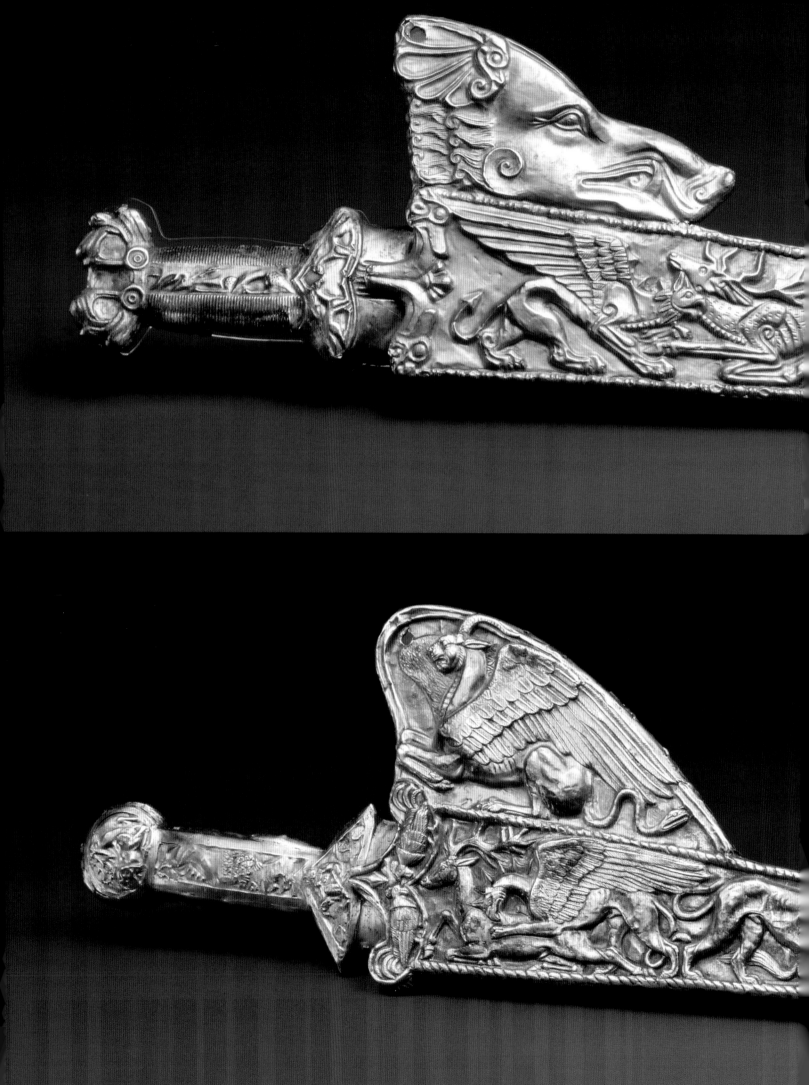

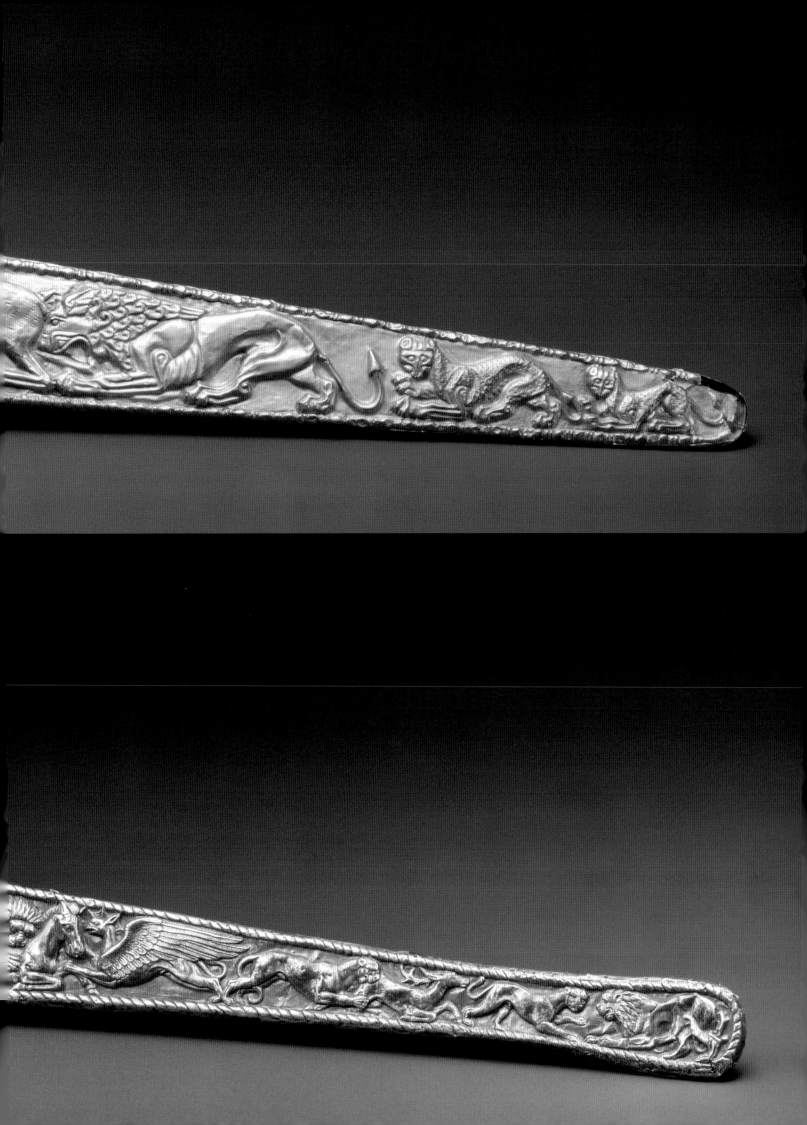

122. SWORD AND SCABBARD WITH GRIFFIN

4th c.
Gold, iron
MHTU, inv. no. AZS-2491–2493
From Tovsta Mohyla, burial 1, near Ordzhonikidze, Dnipropetrovs'ka Oblast'.
Excavated by B. M. Mozolevs'kyi, 1971.
Scabbard: L: 54.2 cm; wt: 62.49 g. Sword: L: 62 cm; wt: 593.7 g.

Publications: Hanina (1974), figs. 47, 48; Chernenko (1975b), 157–65, figs. 5–8; New York, *Scythians* (1975), 126, no. 170, pl. 30; Mozolevs'kyi (1979), 69–73, figs.52–56; Piotrovsky, Galanina, and Grach (1987), 113–15, figs. 150–54; Edinburgh, *Warriors* (1993), 26–27, no. 22; Vienna, *Gold* (1993), 96–99, no. 17; Toulouse, *L'or* (1993), 59, no. 21; Schiltz, *Scythes* (1994), 339, fig. 330; Jacobson (1995), 243, VIII.C.5, fig. 110; Katowice, *Koczownicy* (1996), 187, 279, no. 35; Luxembourg, *TrésORS* (1997), 66, no. 6.

Two plates decorate the scabbard. The relief over the blade features multiple scenes of animal combat: proceeding from the crossguard, two cocks are posed beak-to-beak; a griffin attacks a stag; a lion and a griffin attack a horse; a spotted leopard attacks a stag; and a spotted leopard and lion confront each other. On the flap, a horned lion-griffin, whose legs end in talons, crouches with a flared wing, as if ready to spring. Its undulating tail ends in a serpent head. The hole at the edge of the flap was used to secure it to a belt.

The sword hilt is decorated with similar subject matter. The round pommel bears a crouching stag in right profile, its head bent back to fit within the circular frame. On the vertical band below, a lioness brings down a he-goat. In the triangular area above the blade, the Greek god Pan is flanked by two recumbent goats, one in right profile with its head facing forward, the other in left profile with its head turned back. Fragments of wood and leather from the original scabbard were found on the iron blade.

Because it was a primary weapon of the Scythians, a sword was placed in all warrior graves. Those belonging to the high born were often clad, as here, with gold or silver reliefs. This sword and scabbard were found in Tovsta Mohyla in the same cache that contained the famous pectoral (cat. no. 172).

The scabbard's scene of animal combat finds parallels on examples from Kurhan 8 of the P'iatybratni complex and from a kurhan near Chaian (now in New York).[1] The griffin on the flap has a related counterpart on the scabbard from Chortomlyk,[2] where the primary scene is of helmeted men fighting. Without a known parallel is this scabbard's representation of Pan, god of the flocks, woods, and pasture.

This sword and scabbard were found together with cat. no. 37.

1. Williams and Ogden (1994), 175–76. See also the essay by Treister in this volume.
2. Artamonov (1969b), 286, pl. 185; Vienna, *Skythen* (1988), 104, no. 55. The Tovsta Mohyla scabbard was probably a product of the same workshop that produced the scabbards of the Chortomlyk series (see the essay by Treister in this volume). The similarity of the griffins was noted by Jacobson (1995), 233–44.

123. OPENWORK PLAQUE WITH HUNT SCENE

4th c.
Gold
MHTU inv. no. AZS-2926
From Kurhan 11, burial 4, near village of Hunivka, Kam'ianko-Dniprovs'kyi Raion, Zaporizhs'ka Oblast'.
Excavated by Iu. V. Boltryk, 1976.
H: 20.5 cm; W: 30 cm; wt: 46.79 g.

Publications: Boltryk, Otroshchenko, and Savovskii (1977), 268–70; Bessonova (1983), 117–18, fig. 34; Vienna, *Gold* (1993), 118–19, no. 21; Schiltz, *Scythes* (1994), 125, fig. 95; Luxembourg, *TrésORS* (1997), 71, no. 11; Vicenza, *Oro* (1997), 50, no. 7.

Opposite: 123

In the center of the openwork plaque, the antler-like branches of a tree enclose three reddish inlays. On the left, an archer on horseback, his legs slung forward, is poised to dismount. With one outstretched arm he holds a bow while reaching with his other hand to the gorytos at his hip. The horse's legs are raised mid-stride; its ears are forward, and its reins fly free. On the other side of the tree is the archer's quarry: a stag with exaggerated antlers. Arrows already project from its shoulder and neck. Nearly all surfaces are covered

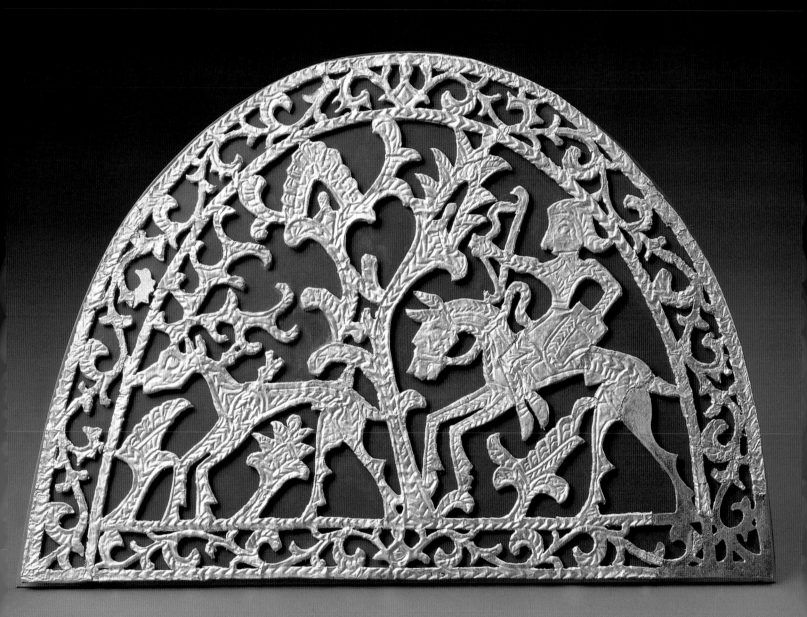

with overall patterns: in the archer's costume and long hair and in the horse's mane and tail are chevrons or braids, while the foliage is indicated with combinations of straight and curving lines. From the groundline arise various plants. The scene is framed by a border of scrolling vines.

This piece comes from the tomb of a noble warrior who was buried along with a groom and two horses. One of the horses had been crowned with this openwork plaque.

The design was strongly influenced by the need to ensure that each element of the composition was attached to the border. Thus, the stag's antlers connect with the arrows that have wounded it, and the horse's legs are in contact with the tree. The result is a pleasing design that balances solid and open space. Originally the plaque would have been seen against a blue leather background. The technique recalls the woodcarving and felt appliques that were found in contemporary burials in the Altai mountains.[1] The scrolling border, however, seems to have been inspired by Greek art.

1. See the essay by Reeder in this volume.

124. HELMET WITH COMBAT SCENES

4th c.
Gold
MHTU, inv. no. AZS-3765
From Perederiieva Mohyla (Kurhan 2), near village of Zrubne, Shakhtars'kyi Raion, Donets'ka Oblast'.
Excavated by A. O. Moruzhenko, 1988.
H: 18.2 cm; D: 16.5 cm; wt: 607.59 g.

Publications: Moruzhenko (1992), 61–64; Zurich, *Schatzkammern* (1993), 124–25, no. 63; Schiltz, *Scythes* (1994), 370, fig. 277; 335, fig. 243; Milan, *Tesori* (1995), 65–67, 187–88, no. 17; Luxembourg, *TrésORS* (1997), 78, no. 21; Vicenza, *Oro* (1997), 58, no. 13.

The bell-shaped helmet is decorated with relief figures of Scythian warriors in a landscape suggested by engraved plants emerging from the stippled, uneven groundline. There are two groups of three combatants; in the center of each group is a fallen warrior whose companion (they are both beardless and youthful) pursues an aggressor who is bearded and older. In the first group, the kneeling youth unsheathes his sword as he turns his head back toward his companion. This figure holds a rectangular shield and points a spear at the older figure opposite him. The older man wears a coil looped around his chest and grabs the shield with his left hand while using the right hand to point a sword at the kneeling figure. In the second group, the standing, beardless warrior grasps the left hand of his fallen companion, while with his right hand he directs a spear at the older warrior, whose left hand grabs the man's hair and whose right points a sword toward both foes. All of the figures have shoulder-length hair and scabbards with tasseled tips, and wear closely fitting trousers tucked into ankle-high boots. Each combatant wears a jacket that extends to mid-thigh. The execution of the figures is uneven, with the faces of the bearded Scythians being more skillfully worked.

The top of the helmet is decorated with a double rosette surrounded by a rope pattern. Around the base of the helmet is a narrow floral band familiar from Greek metalwork;[1] it is interrupted by four short panels with vertical lines.

The helmet was made from a rather thick gold sheet (ca. 2–3 mm). The contours of the figures were hammered from the inside; all details were then engraved from the front. The helmet was repaired in antiquity, using a small plaque attached by rivets.

An openwork helmet of similar shape was found at Ak-Burun near Kerch.[2]

1. See the essay by Reeder in this volume.
2. New York, *Scythians* (1975), 107, no. 61, pl. 9.

Opposite and following pages: 124

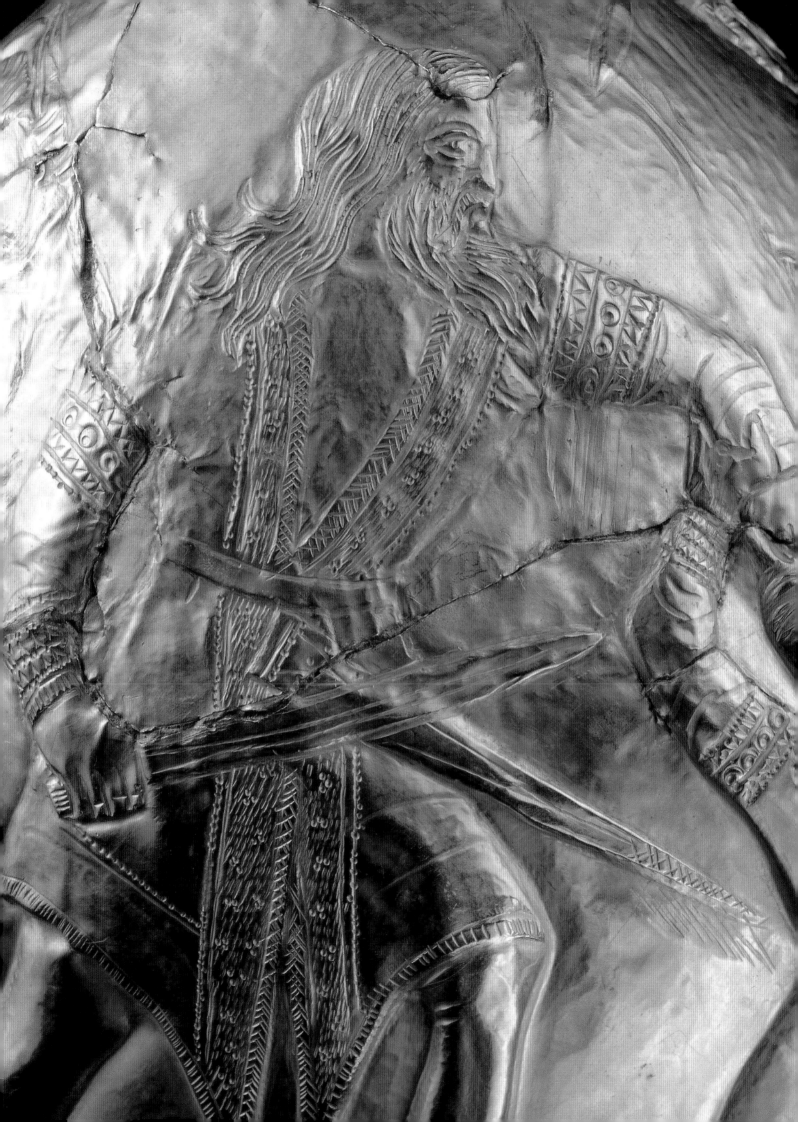

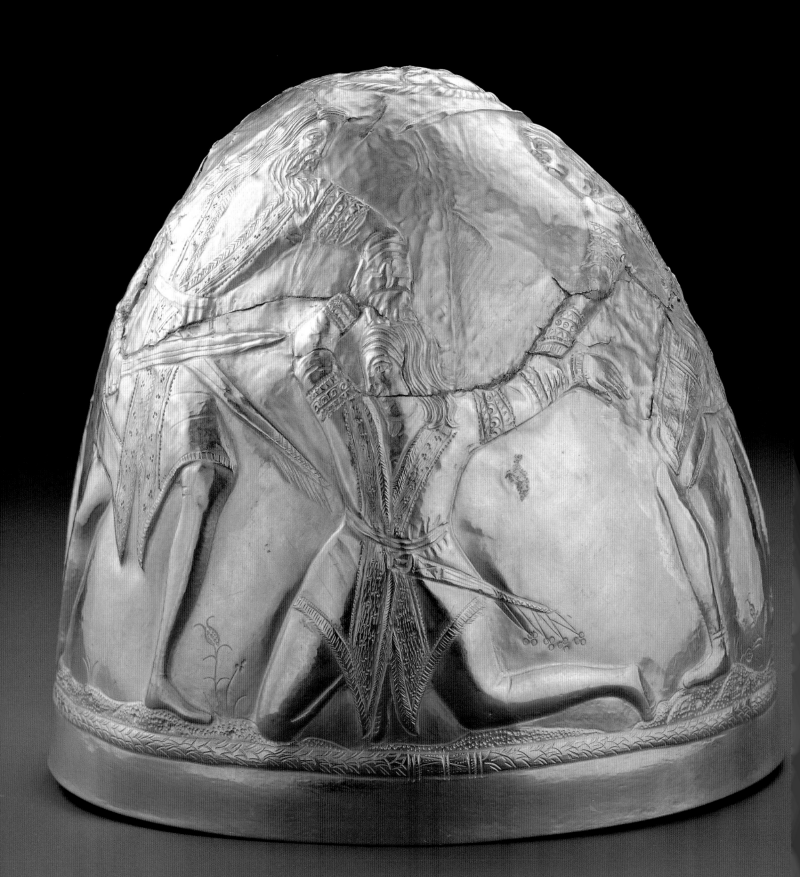

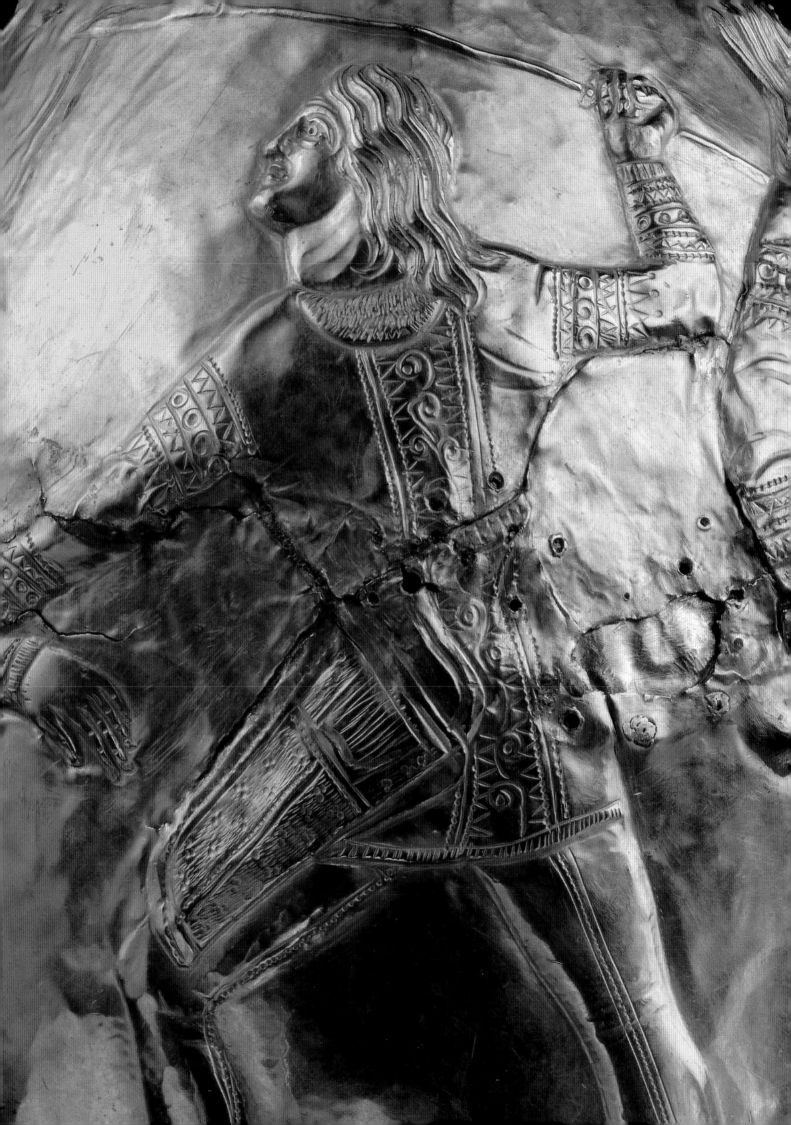

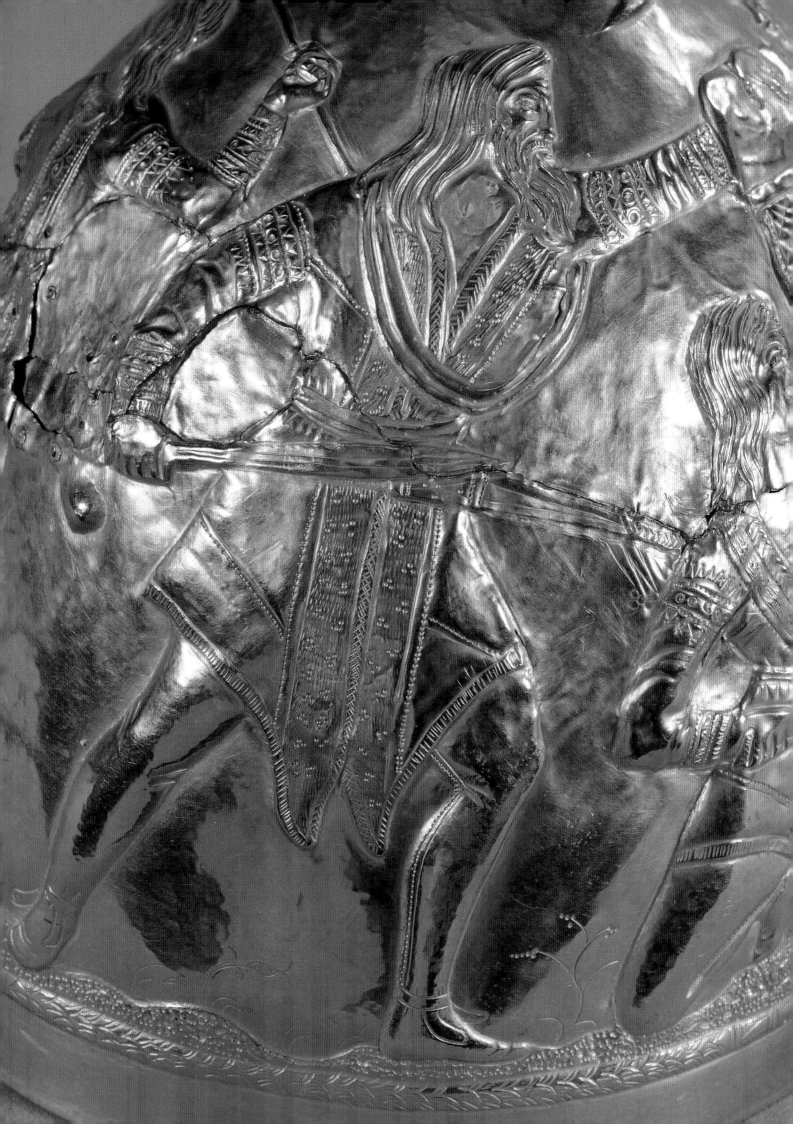

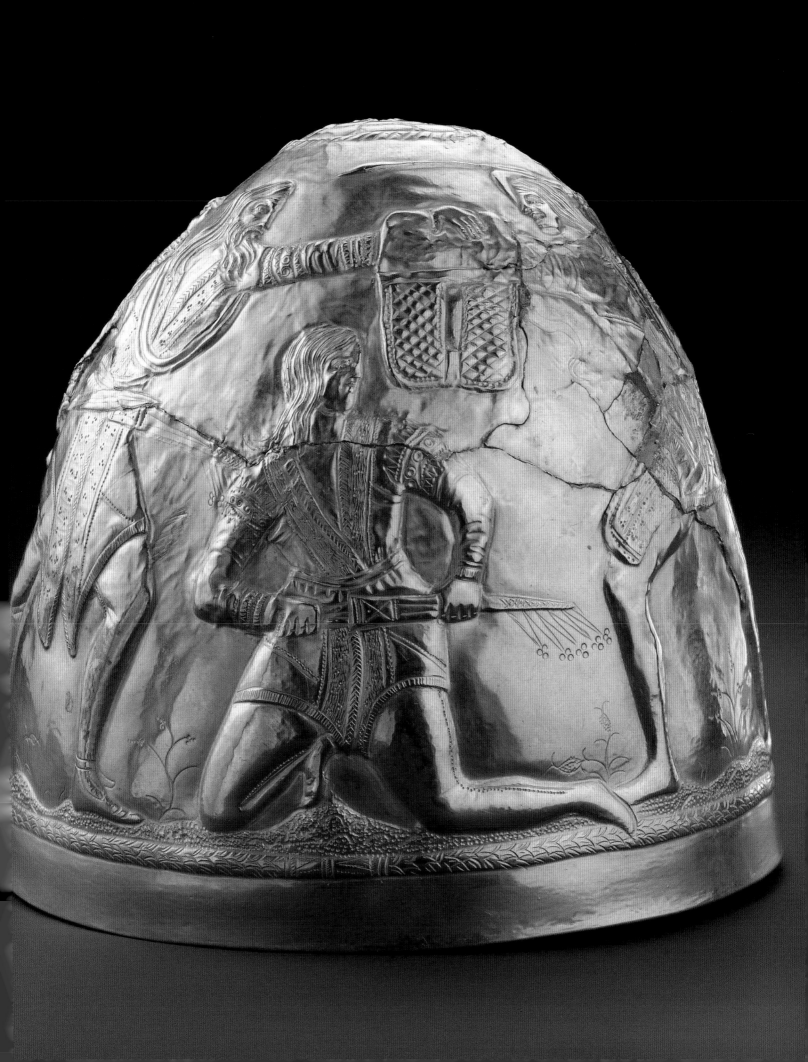

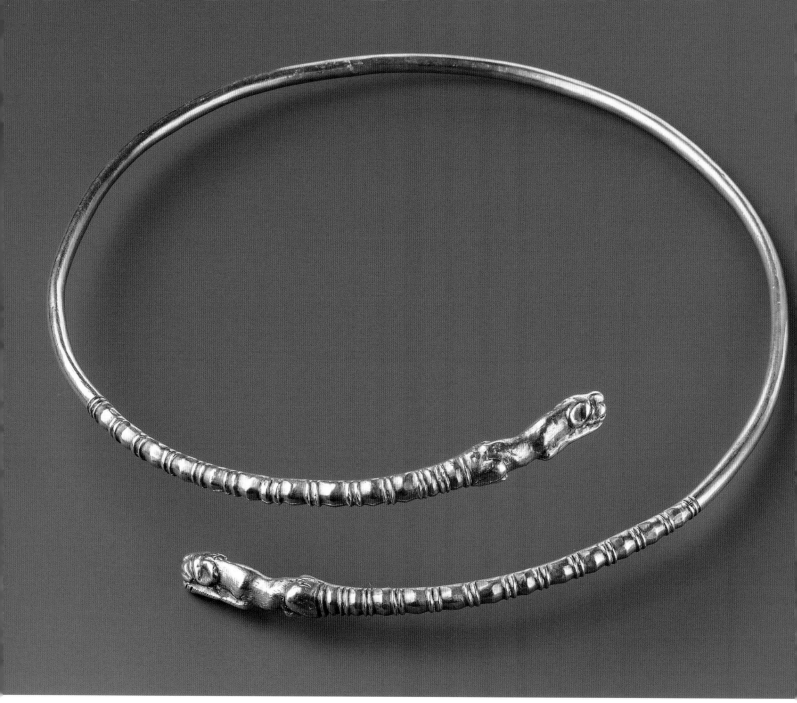

125

125. TORQUE WITH LION FINIALS

4th c.
Gold
AI, inv. no. AZS-2411
From Kurhan 22, burial 2, near village of Vil'na Ukraina (formerly Chervonyi Perekop), Kakhivs'kyi Raion, Khersons'ka Oblast'.
Excavated by O. M. Lieskov, 1970.
D: 17.5 cm; wt: 166.8 g.

Publications: Lieskov (1974), 94, fig. 72; Petrenko (1978), 45, pl. 33, fig. 2.

The torque is formed of plain round wire with finials of reclining lionesses, whose heads rest on their paws. A bead-and-reel ornament extends over approximately one-third of the circumference.

The lion finials are rendered in a realistic manner that reflects the integration of local and Greek styles. More typically Scythian is the torque's use of the bead-and-reel ornament, of Greek origin, to suggest the animal's tail.

This torque was found together with cat. nos. 109 and 120.

126. TWO GOLD PLAQUES WITH LOTUS ORNAMENT

ca. 325
Gold
AI, inv. no. z-463, z-464
From Kurhan Ohuz, near Nyzhni Sirohozy, Khersons'ka Oblast'. Excavated by Iu. V. Boltryk, 1980–1981.
Disc (Z-463): H: 5.5 cm; W: 5.5 cm. Disc (Z-464): H: 5.3 cm; W: 5.6 cm; total wt: 7.31 g.

Publications: Boltrik and Fialko (1996), 107–29, pl. 12.1; Boltrik and Fialko (1997), 5–7.

Each openwork plaque has a central rosette from which extend four pairs of spreading acanthus leaves. From each pair springs a lotus flower that encloses a cup-like rosette. Due to the requirements of the openwork technique, each acanthus leaf and winding lotus tip is in contact with another, which happens to be its mirror reversal. The result is a skillfully balanced design of closed and open forms.

Similar plaques were found in the Kurhan Ohuz .[1]

These plaques were found together with cat. nos. 32, 101, and 111.

2. Boltryk and Fialko (1991), 107–27, pl.12.1.

126

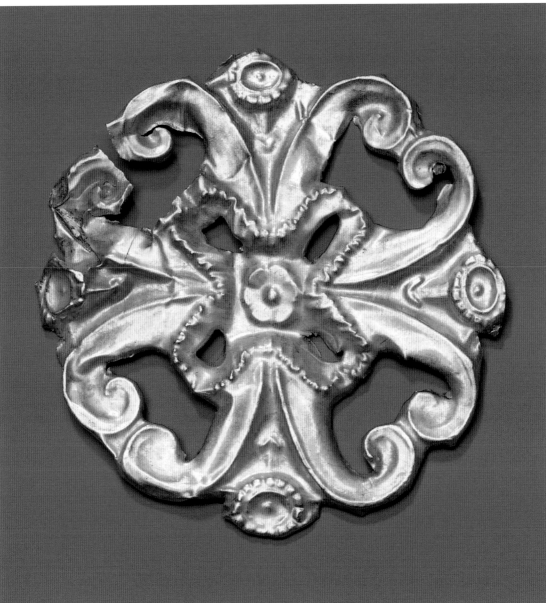

127. PLAQUES FOR A GARMENT

ca. 350–300
Gold
MHTU, inv. no. AZS-2660/1–123, 2655/1–8, 2377/1–6, 2668/1–28, 2670/1–2
From Haimanova Mohyla, near village of Balky, Vasylivs'kyi Raion, Zaporizhs'ka Oblast'. Excavated by V. I. Bidzilia, 1969–1970.
Rolled plaques (123)(AZS-2660/1–123): L: 1.9–3.1 cm; wt: 85.57 g. Pendants (8) AZS-2655/1–8): H: 3.2 cm; wt: 14.98 g.
Pendants (6) (AZS-2377/1–6): H: 1.9 cm; D: 0.8–1.5 cm; wt: 8.81 g. Pendants (28) (AZS-2668/1–28): D: 0.8–1 cm; wt: 10.06 g.
Pendant (AZS-2670/1): H: 2.6 cm; D: 1.6 cm; wt: 0.81 g. Pendant (AZS-2670/2): H: 2.6 cm; D: 1.6 cm; wt: 0.95 g.

Publications: Bidzilia (1971), 48.

Hollow bead-and-reel wire segments are arranged in a net pattern. On the top of each intersection is a rosette with a gold bead in the center. Along the outside edges, ribbed amphora-shaped pendants are suspended via double rosettes (some now missing). The lower edge is reconstructed with a zigzag border. This reconstruction of fragments recovered from a plundered grave is based on comparable latticed chest decorations from Diiv, Mordvinivs'kyi, Mastivnyns'kyi, Oleksandropols'kyi, and Chortomlyk's'kyi kurhany.

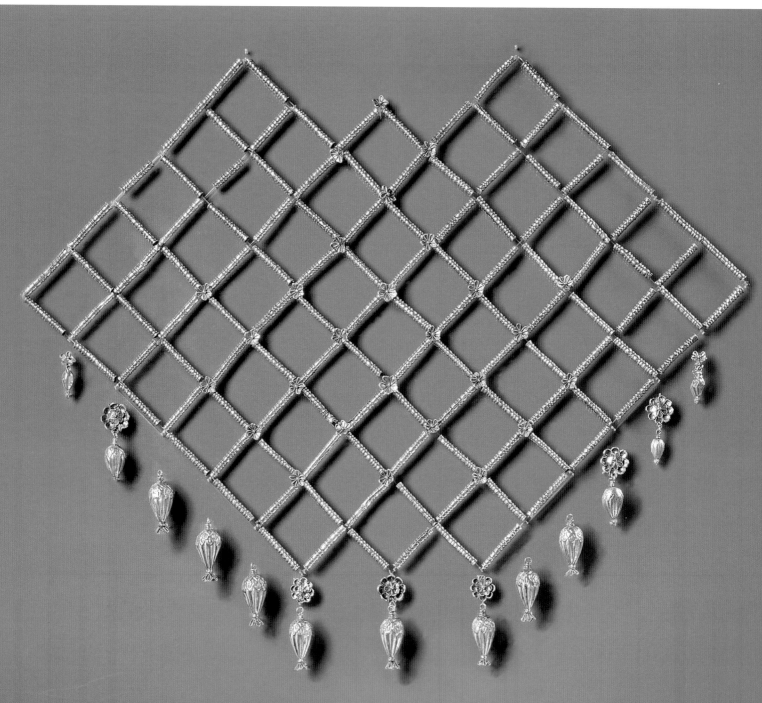

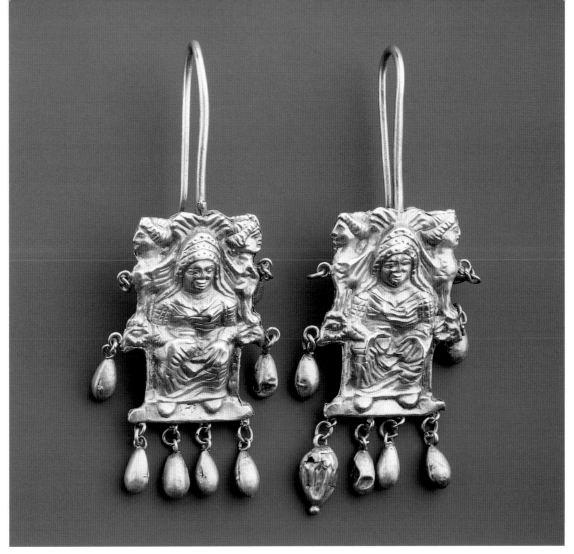

128

128. PAIR OF EARRINGS WITH A SEATED GODDESS

4th c.
Gold
MHTU, inv. no. AZS-3661/1–2
From Kurhan 10, burial 3, near Velyka Znam'ianka, Kam'ianko-Dniprovs'kyi Raion, Zaporizhs'ka Oblast'.
Excavated by Iu. Ia. Rossamakin, 1982.
Earring (AZS-3661/1): H: 8.2 cm; wt: 7.08 g. Earring (AZS-3661/2): H: 8 cm; wt: 7.08 g.

Publications: Zagreb (1989), no. 64; Turku, *Skyyttien* (1990), 27, 50, no. 76; Schleswig, *Gold* (1991), 315, no. 108;
Tokyo, *Scythian Gold* (1992), 76, no. 72; Edinburgh, *Warriors* (1993), 34, no. 56; Toulouse, *L'or* (1993), 78, no. 62;
Vienna, *Gold* (1993), 180–81, no. 51; Berezova (1994), 6–9.

Each earring pendant is composed of two hammered and joined reliefs. A woman wearing an ankle-length garment with sleeves decorated with rows of squares is seated on a throne with her left hand on her knee and her right holding a wide-mouth vessel. She wears a headdress consisting of several horizontal bands with punched ornament; the drapery attached to her headdress frames her shoulders. Her face is round, with large eyes. A pair of winged sphinxes sits back-to-back on the ram-head armrests of her throne. From loops at the sphinxes' chests, the noses of the ram heads, and along the base of the earring hang tiny hollow teardrop and seed-shaped pendants.

The elaborately decorated throne suggests the woman is likely to be a divine being.[1]

These earrings belonged to a Scythian woman between twenty-five and thirty-five years old. She had been buried together with a youthful servant whose hands had been bound. Among the other grave goods were a gold-plated silver torque, a bracelet of beads, a quiver, and a leather pouch containing bits of bark, leaves of grass, the bud of an unidentified plant, two beetles, a centipede, and a cherry stone.

1. See the essay by Reeder in this volume.

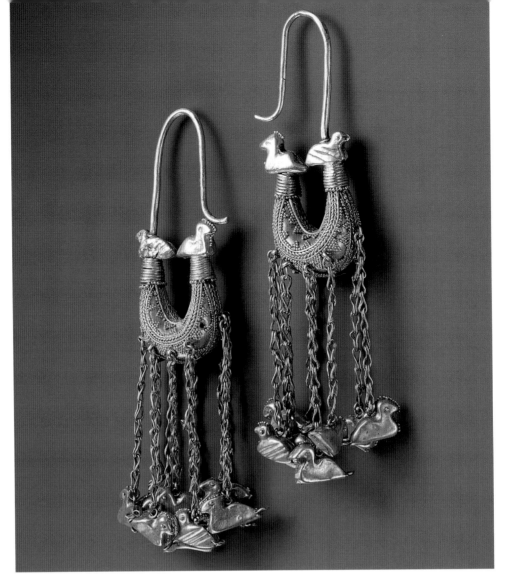

129

129. BOAT EARRINGS WITH PENDANTS

4th c.
Gold
MHTU, inv. no. AZS-3641/1–2
From Kurhan 8, burial 2, near village of Volchans'ke, Akymivs'kyi Raion, Zaporizhs'ka Oblast'. Excavated by A. I. Kubyshev, 1980.
Earring (AZS-3641/1): H: 11.5 cm; wt: 27.1 g. Earring (AZS-3641/2): H: 11.4 cm; wt: 26.04 g.

Publications: Turku, *Skyyttien* (1990), 28, 57, no. 78; Schleswig, *Gold* (1991), 315, no. 109; Tokyo, *Scythian Gold* (1992), 76, no. 73; Edinburgh, *Warriors* (1993), 20, 33, no. 53, fig. 6; Toulouse, *L'or* (1993), 78, no. 59; Vienna, *Gold* (1993), 74–75, no. 48; Luxembourg, *TrésORS* (1997), 86, no. 32; Polin and Kubyshev (1997), 19, figs. 9.3, 4; Vicenza, *Oro* (1997), 66, no. 22.

The earring pendants are hollow boats decorated with braided filigree and granulated triangles. On the horns of the boats, a row of granules and spiral-wrapped wire precedes duck-shaped finials and long hoops. From loops soldered on the body of the boats dangle eight or ten loop-in-loop chains with duck-shaped pendants. These, like the finials, are formed of two stamped halves, with granules along the seam and forming the eye.

Boat-shaped earrings begin appearing in Scythian graves from the fifth century, after ties had been established with the Greek colonies along the Black Sea. The type was especially popular in the fourth century, and a number of distinct variations are known. A pair similar to this one was found in Novosilky, Kurhan 4, in Cherkas'ka Oblast'.[1]

Compared to their Greek prototypes these earrings are larger and heavier, and the pendants are of exaggerated length and number. When worn the earrings would have responded to the Scythian predilection for movement and sound. This pair was found in the burial of a Scythian woman, along with a splendid gold necklace and a headdress richly decorated with gold plaques.

1. Piotrovsky, Galanina, and Grach (1987), nos. 247 and 248. See also Vicenza, *Oro* (1997), no. 20.

130. PAIR OF HOOP EARRINGS

4th c.
Gold
MHTU, inv. no. AZS-3736/1–2
From Kazenna Mohyla, burial 3, near village of Topoline (Shmal'ky), Vasylivs'kyi Raion, Zaporizhs'ka Oblast'.
Excavated by V. I. Bidzilia, 1973.
Earring (AZS-3736/1): H: 4.7 cm; W: 2.8 cm; wt: 7.6 g. Earring (AZS-3736/2): H: 5.15 cm; W: 2.5; wt: 7.62 g.

Publications: Klochko (1982a), 124, fig. 6; Berezova and Klochko (1995), 37–52.

The earring pendants are formed as narrow elongated boats, one end of which extends to become the long hoop. The boats are smooth and flat, with seven clusters of four slightly flattened granules along the outside. Boat earrings enjoyed enormous popularity in Classical Greece and during the fourth century were much in favor among Scythians. The thin, elongated shape and the use of the continuously tapering horn to form the hoop lend this pair particular elegance. These earrings were found in the burial of a woman who was about fifty years old. She also wore an elaborate headdress with gold appliques, rings with round bezels, and a necklace of gilded ceramic beads with a gold crescent-shaped pendant.

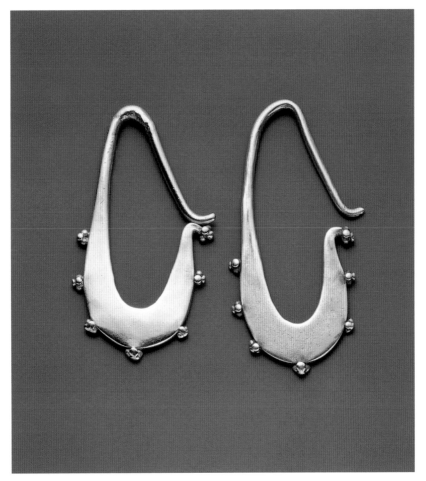

130

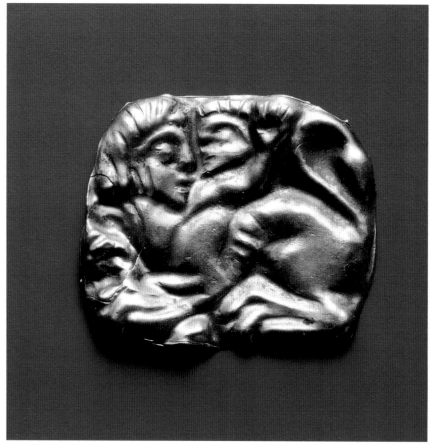

131

131. PLAQUE WITH SPHINX AND MAN

4th c.
Gold
MHTU, inv. no. AZS-3078/100
From Berdians'kyi Kurhan, central burial chamber, near village of Novovasylivka, Berdians'kyi Raion, Zaporizhs'ka Oblast'.
Excavated by M. M. Cherednychenko, 1978.
H: 2.4 cm; L: 2.8 cm; wt: 1.49 g.

Publications: Cherednychenko and Murzin (1996), 69–78.

The oblong relief applique is decorated with the compressed image of a human-headed sphinx fighting a human. The sphinx crouches in left profile, its tail curled high. The head is turned back in right profile to face a smaller human head in the space above its back. The human figure, one arm raised by its head, appears to be struggling to escape after having been trapped. The applique has seven holes for attachment to a garment.

The style of the plaque reflects the Scythian predisposition for hybrid beings and intertwined forms. Another distinctive characteristic is the articulation of the bodies into such discrete components that the entire composition not only is difficult to read but even approaches an abstracted design of stylized forms.

This plaque was found together with cat. no. 21.

Opposite: 132

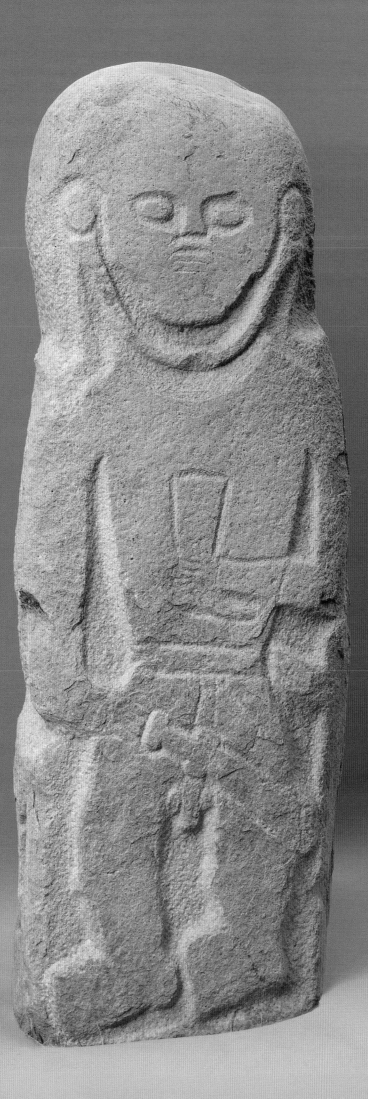

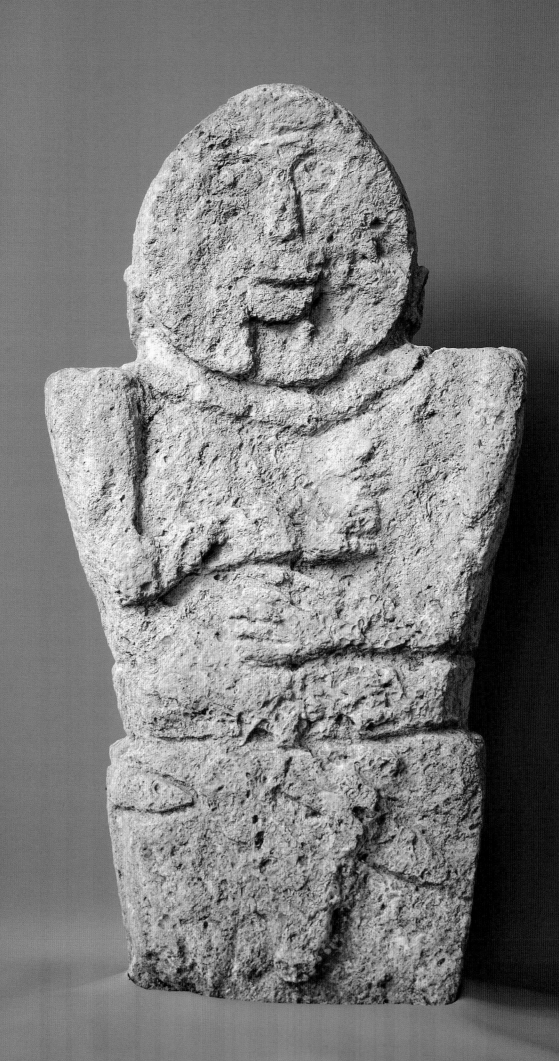

132. STELE

5th c.
Granite
SHAP, Pereiaslav-Khmel'nyts'kyi, inv. no. T3-1484
From village of Plavni, Reniis'kyi Raion, Odes'ka Oblast'. Excavated by Iu. O. Shylov, 1986.
H: 180 cm; W: 52 cm; Depth 40 cm; wt: 400 kg.

Publications: Reni, *Тезисы* (1989); Ol'khovskii and Èvdokimov (1994), 33, fig. 20.

The tapering granite stele is carved in shallow relief with the standing figure of a man. It is broken at the level of the knees. The treatment is cursory and schematic. He has oval eyes that are continuous with a rectangular nose and has a short mouth above incisions on his chin. His chin and neck are rendered as a long arc extending from the ears. Inside this arc a torque is represented by a tubular molding. His left arm is folded across his chest, and the left hand holds an upright drinking horn. His right arm is lowered, reaching to a incised short sword (*akinak*) that crosses his left thigh and genitals. At his waist is an incised belt that supports the scabbard. A gorytos and bow are represented on his left side. The reverse of the stele is undecorated.

A similar tradition of stone sculptures is known from Central Asia.[1] In her essay in this volume, Jacobson discusses the carved stone images of Central Asia, which remain largely unknown to Western scholars. She suggests that they reflect a representational tradition shared by the Scythians' ancestors and one that is rooted in oral epic.

1. See Mantua, *L'uomo d'oro* (1998), 85. See also Jacobson (1993), 158–62, and the essay by Jacobson in this volume.

133. STELE

5th–4th c.
Limestone
SHAP, Pereiaslav-Khmel'nyts'kyi, inv. no. T3-1485
From village of Kozhum'iaky, Verkhnii-Rohachys'kyi Raion, Khersons'ka Oblast'. Excavated by G. Èvdokimov.
H: 145 cm; W: 65 cm; Depth 23 cm; wt: 200 kg.

Publications: Èvdokimov (1994); Ol'khovskii and Èvdokimov (1994), 33, fig. 20.

The shelly limestone is carved with the standing figure of a man. It is broken above the knees and the surface damaged. The figure has a large round head, flat shoulders, and a triangular torso tapering to the waist. His features are schematically rendered in relief; he has a horizontal mouth, oval eyes, and a rectangular nose. Around his neck is a torque. His genitals, belt, *akinake* (short sword), and other details are incised. His arms are folded over his chest. He holds an upright drinking horn in the damaged right hand. On his left side a gorytos and bow are represented. On his right side is a long-handled axe with a decorative finial. The back of the stele is incised to represent the figure's buttocks and legs, and two belts, which cross over his shoulders.

See the entry for cat. no. 132.

Opposite: 133

BRATOLIUBIVS'KYI KURHAN

The Bratoliubivs'kyi Kurhan is located near the village of Ol'hino-Bratoliubivka in Khersons'ka Oblast'. It lies at the southern edge of a chain of kurhany that stretches for ten to fifteen kilometers along the river Konky, a tributary of the Dnipro. The kurhan was explored in the summer of 1990 by the Institute of Archaeology of the National Academy of Sciences of Ukraine, under the direction of A. I. Kubyshev. It is dated to the fourth century.

The kurhan had a diameter of 63 to 65 meters and a height of 7 meters. Large stone blocks were used to form the foundations, and clumps of sod constituted the earthen layers, in combination with small and large pieces of limestone. Pieces of turf were used to cover the top of the kurhan to prevent erosion. A circular ditch around the kurhan measured 1.3–1.5 meters in width and 0.8–1 meter in depth.

The kurhan contained six burials. The central tomb, 7 meters below ground level, had been looted. However, near the head of the deceased, in an oval pit measuring 0.35 by 0.4 meters, and 0.35 meters deep, four gold objects were discovered. In addition to cat. nos. 134–136, the finds included a gold and silver rhyton.

The other burials are thought to belong to attendants. Most of these were looted, but a horse's skeleton, with bridle still in place, was discovered near the skeleton of an adolescent boy. Also undisturbed was the burial of two horses, their gold and bronze bridle ornaments still in place.

Opposite: 134

134

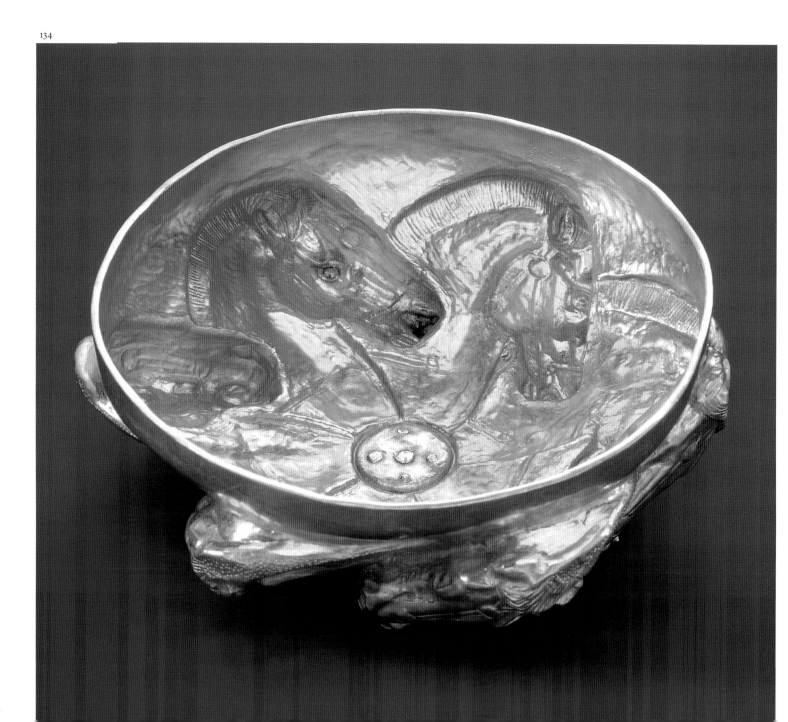

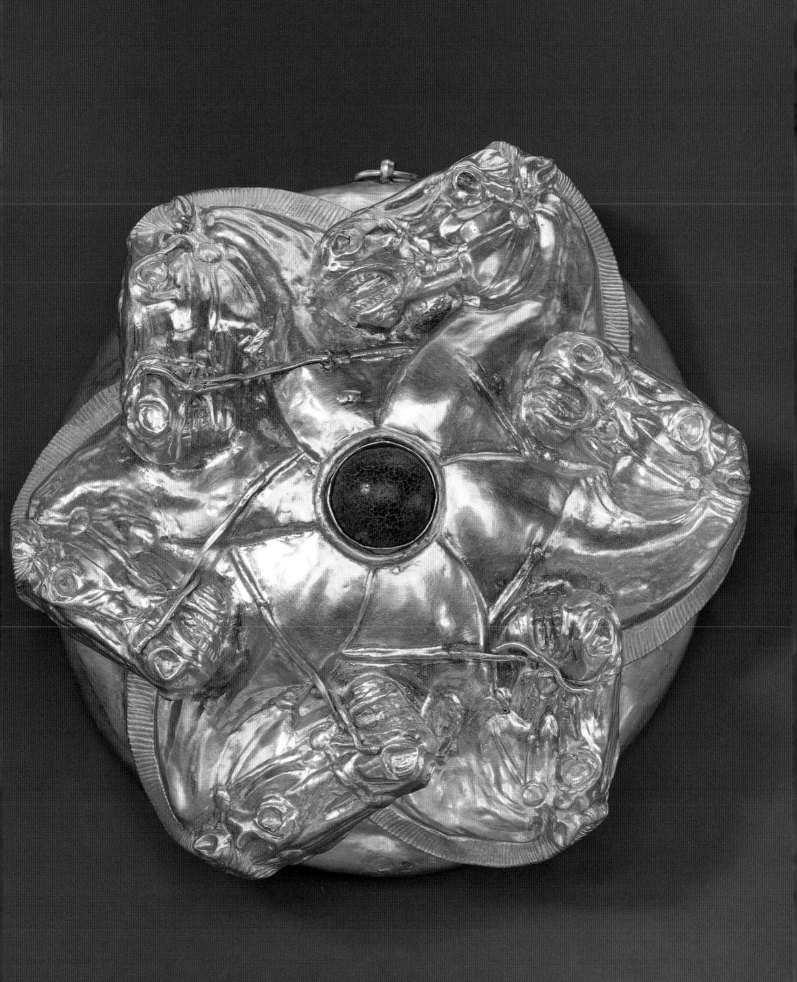

134. CUP WITH HORSES

5th c.
Gold, amber, glass
AI, inv. no. z-4117
From Bratoliubivs'kyi Kurhan, near village of Ol'hyno, Hornostaivs'kyi Raion, Khersons'ka Oblast'.
Excavated by A. I. Kubyshev and M. V. Koval'ov, 1990.
D: 13.5 cm; H: (max) 5.2 cm; wt: 233 g.

Publications: Schleswig, *Gold* (1991), 75–77, 318, 370–72, no. 120e; Tokyo, *Scythian Gold* (1992), 64, no. 51; Zurich, *Schatzkammern* (1993), 96–97, no. 45; Kubyshev and Koval'ov (1994), 141–44; Schiltz, *Scythes* (1994), 68, figs. 41–42; Milan, *Tesori* (1995), 96, 194, no. 52; Rimini, *Mille* (1995), 68, no. 33; Katowice, *Koczownicy* (1996), 177, 228, no. 26.2.

The outside of the phiale is decorated with six horse heads in left profile and in high relief. They move in rotation around a circular domed insert of amber, riveted on the inside. The animals have short cropped manes, flared nostrils, and open mouths revealing upper and lower teeth. Decorative discs (phalerae) are seen at the juncture of the browband and throatlatch, at the juncture of the noseband and cheekpiece, and between the eyes on the strip that extends from browband to noseband. The horses' eyes were accentuated with blue glass insets, only one of which survives. The leather straps and metal parts of their bridles, including the reins, are indicated in relief. Separately soldered strips, some of which have broken away, form each cheekpiece and the adjacent section of rein. On the rim is a ring for attaching the vessel to a belt.

The lines of the horses' necks and reins form a pinwheel design that reinforces the whirling dynamic of the heads. This preference for rotation is characteristically Scythian and is also seen on the horse frontlet (cat. no. 48). The bowl was made by hammering a single sheet of gold into what Treister concludes was a single matrix employed six times. The size and plasticity of the phiale are such that the vessel fits superbly into the palm of the hand.

The bowl was found together with cat. nos. 135 and 136.

135. NECKLACE WITH HORSE-HEAD TERMINALS

5th c.
Gold
AI, inv. no. z-4122
From Bratoliubivs'kyi Kurhan, near village of Ol'hyno, Hornostaivs'kyi Raion, Khersons'ka Oblast'.
Excavated by A. I. Kubyshev and M. V. Koval'ov, 1990.
L: (extended) 52.6 cm; D: (handle) 18.5 cm; L: (top to bottom) 20 cm; W: (strap) 1.4 cm; wt: 191 g.

Publications: Schleswig, *Gold* (1991), 75–77, 318–19, no. 120f; Tokyo, *Scythian Gold* (1992), 65, no. 52; Kubyshev and Koval'ov (1994), 141–44; Milan, *Tesori* (1995), 97, 194–95, no. 53; Rimini, *Mille* (1995), 68, no. 35; Katowice, *Koczownicy* (1996), no. 26.3.

The strap necklace is formed of loop-in-loop chains attached to a filigreed collar that has horse-head finials. Attached to the strap are five six-petal rosettes (one missing), which support pendants, most of which show evidence of heavy use. There are ancient soldered repairs and added wires to fasten the pendants. The collar is bordered top and bottom by bands of braided and plain wire. Between these bands two rows of filigreed tongues enclose opposed pairs of reversing volute spirals, each with a central granule. Small wire loops extend between the open pairs of volutes. The separate horse heads are flat and stylized. From each corner of the mouth three volutes extend over the eye, under the jaw, and under the chin.

Opposite: 135

Strap necklaces are found in Greece from the seventh century, but the schematic horse-head finials on this example have a Scythian rather than Greek inspiration. It is likely that these separate pieces were even produced by different artists. The collars are decorated with a volute design very close to that on the whetstone, cat. no. 100.

The necklace was found together with cat. nos. 134 and 136.

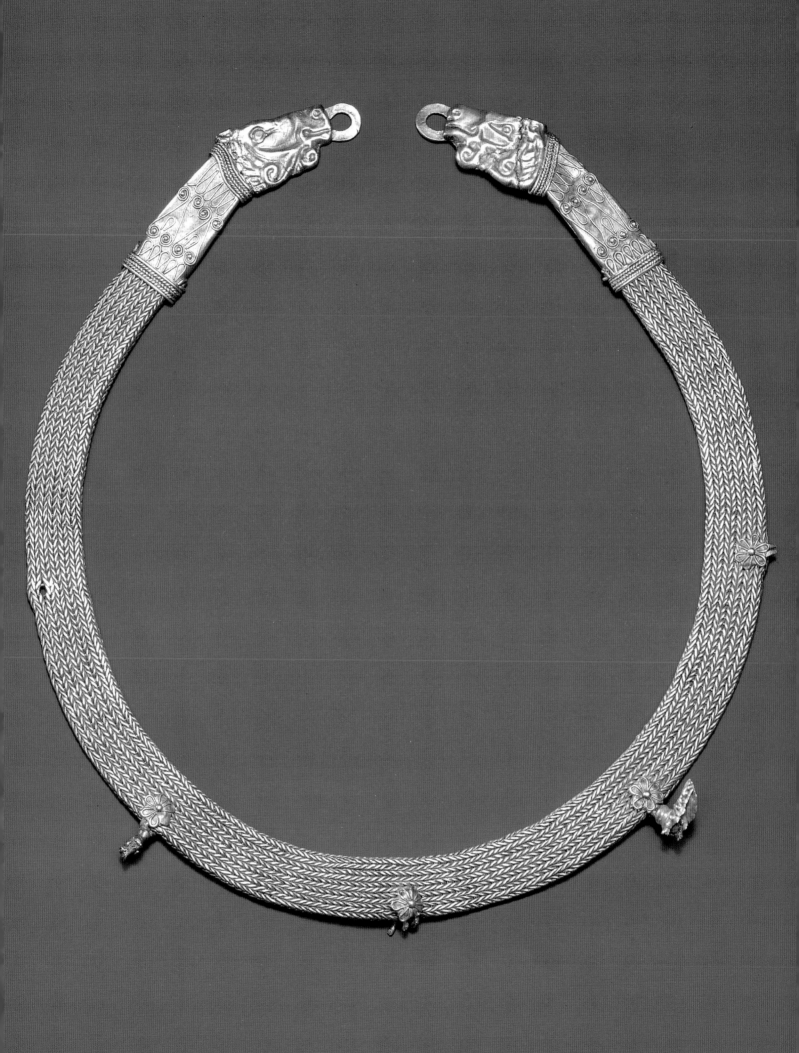

136. FINIAL

5th c.
Gold
AI, inv. no. Z-4116
From Bratoliubivs'kyi Kurhan, near village of Ol'hyno, Hornostaivs'kyi Raion, Khersons'ka Oblast'.
Excavated by A. I. Kubyshev and M. V. Koval'ov, 1990.
H: 17.8 cm; D: (top) 13 cm; D: (base) 18.5 cm; wt: 652.6 g.

Publications: Andrukh (1988), 165–66; Schleswig, *Gold* (1991), 75–77, 318, 366–69, no. 120d; Tokyo, *Scythian Gold* (1992), 62–63, no. 50; Kubyshev and Koval'ov (1994), 141–44; Schiltz, *Scythes* (1994), 150–55, 365, fig. 273; Milan, *Tesori* (1995), 99, 195, no. 54; Rimini, *Mille* (1995), 68, no. 34; Katowice, *Koczownicy* (1996), 176–77, 228, no. 26.1.

The object is shaped as a flaring cone with a flat top, and has rivets through the top attaching a gold plate with a ring inside. There is relief decoration on the sides and top, a plain band at the base, and rope braid around the upper edge. On the top, a spotted leopard attacks a fallen stag, both seen in right profile. The stag raises its left front leg and has naturalistic antlers; the right rear leg of the leopard is unsupported.

On the sides, the relief is worked in four horizontal bands, with the animals in the middle two registers less densely spaced. In the top register are three identical groups, each depicting a pair of eagle-headed and taloned griffins attacking a fallen stag. In the next row, a lion-headed griffin and a lion bring down a stag; a lion and leopard attack an upside-down deer; and a single lion attacks an upside-down animal. Whereas there is almost no contact between the animals of the first and second tier, the animals in the second frieze stand squarely on the backs of those in the row below. Here in the third band, four pairs of lions attack a horse. For a groundline these animals use the backs of the animals in the lowest frieze, which are arranged in four groups. In each combat a pair of lions attack a bull. All of the lions have frontal faces, arching backs, and back feet planted on their prey. There is a repair near the rim.

This is the largest and most richly decorated example of a type of gold object found in Scythian burials from the sixth to the fourth century. Their use remains unclear. The contexts in which these objects have been found imply only an association with warrior burials and do not further illuminate their function. It has been suggested that the ring on the inside may have held a horse-hair streamer.

The progression of animal victims, from cattle to horses to stags at the top, may have been intended to mirror the ordering of the environment from a settled domestic existence to life in the wild, and from predators in nature to those in the mythic world. The decoration reflects a marked stylistic preference for symmetry. Not only are animals confronted as they devour a single prey, but animals are also addorsed, curved haunch to curved haunch. The different textures of wings, hide, and manes are carefully distinguished. Even the pointed wings of the eagle-headed griffins are treated differently from those of the lion-headed griffins.

The dense, interlocking composition of these reliefs resembles the bands of lions attacking horses and deer on a phiale from Solokha.[1] The distinctive treatment of the hide of the stag on the top, with pairs of short lines, and of the leopards' spots, sometimes dotted, sometimes as a broken circle, is paralleled on a horse frontlet that was also found in the Bratoliubivs'kyi Kurhan.[2] It may be that all three of these objects were made in the same workshop sometime in the late fifth or early fourth century.

The finial was found together with cat. nos. 134 and 135.

1. Artamonov (1969b), 286, pls. 157–59; Jacobson (1995), 214.

2. Schiltz, *Scythes* (1994), 124–25, fig. 93.

Opposite and following pages: 136

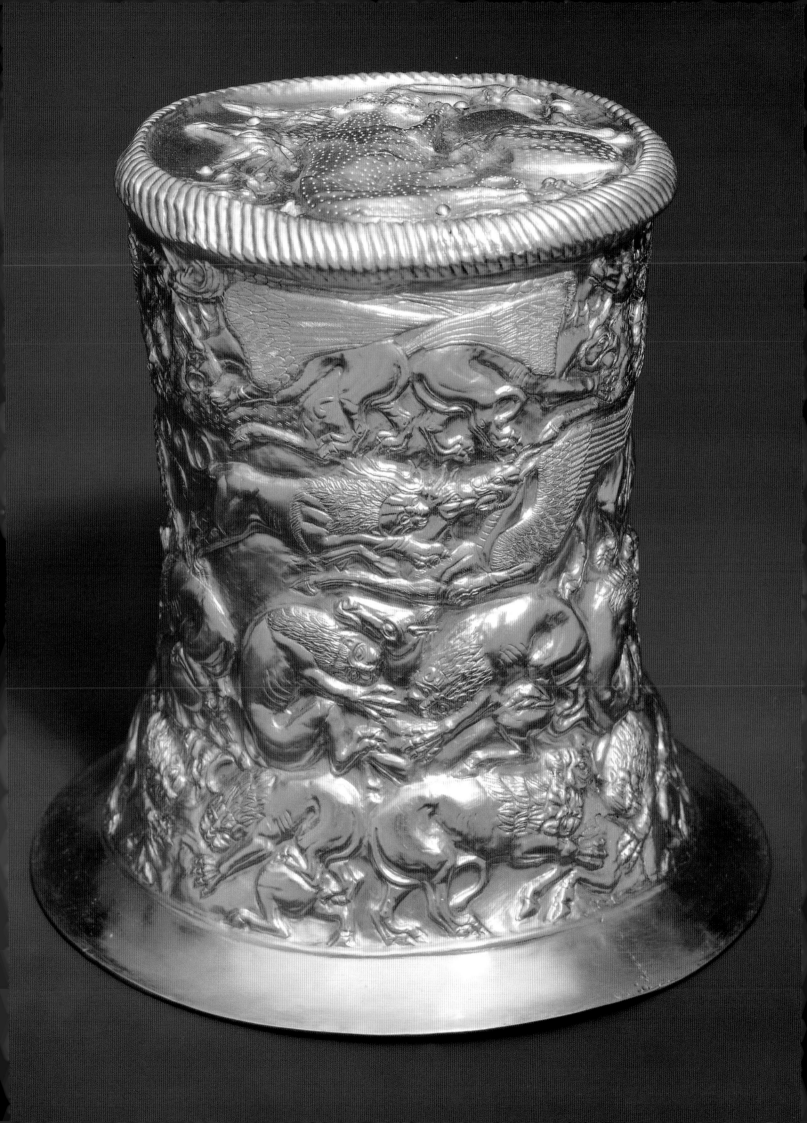

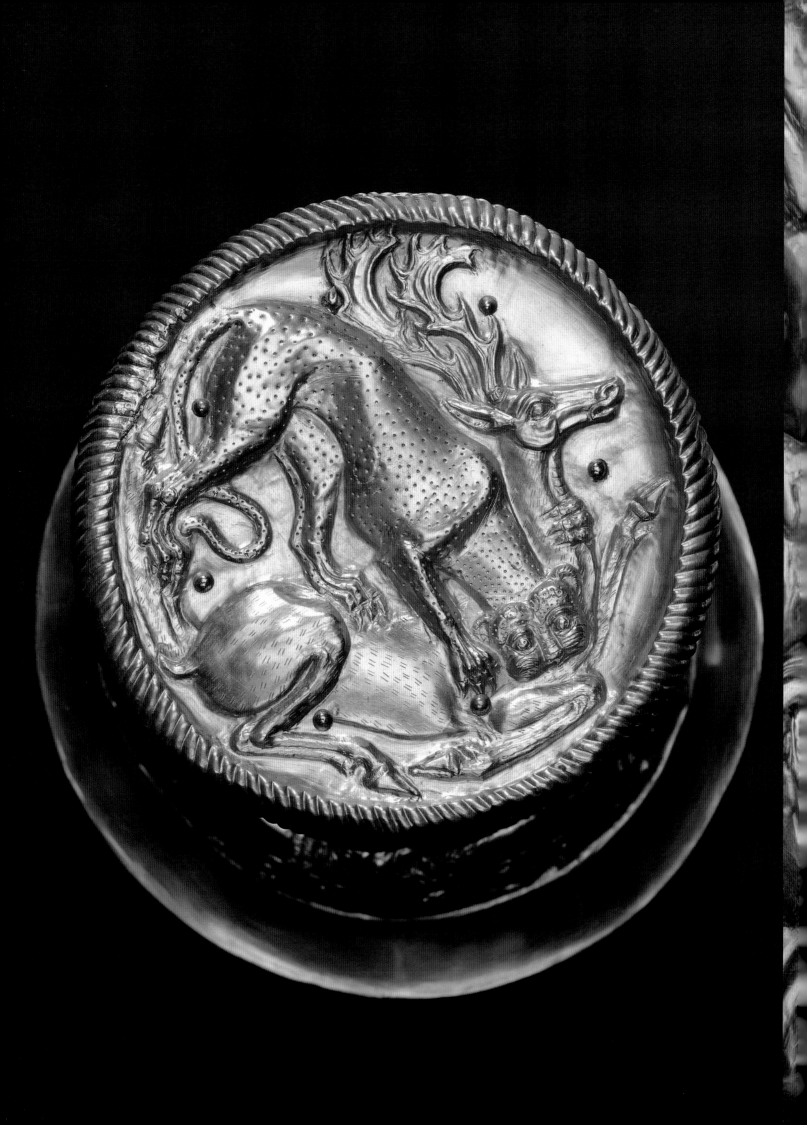

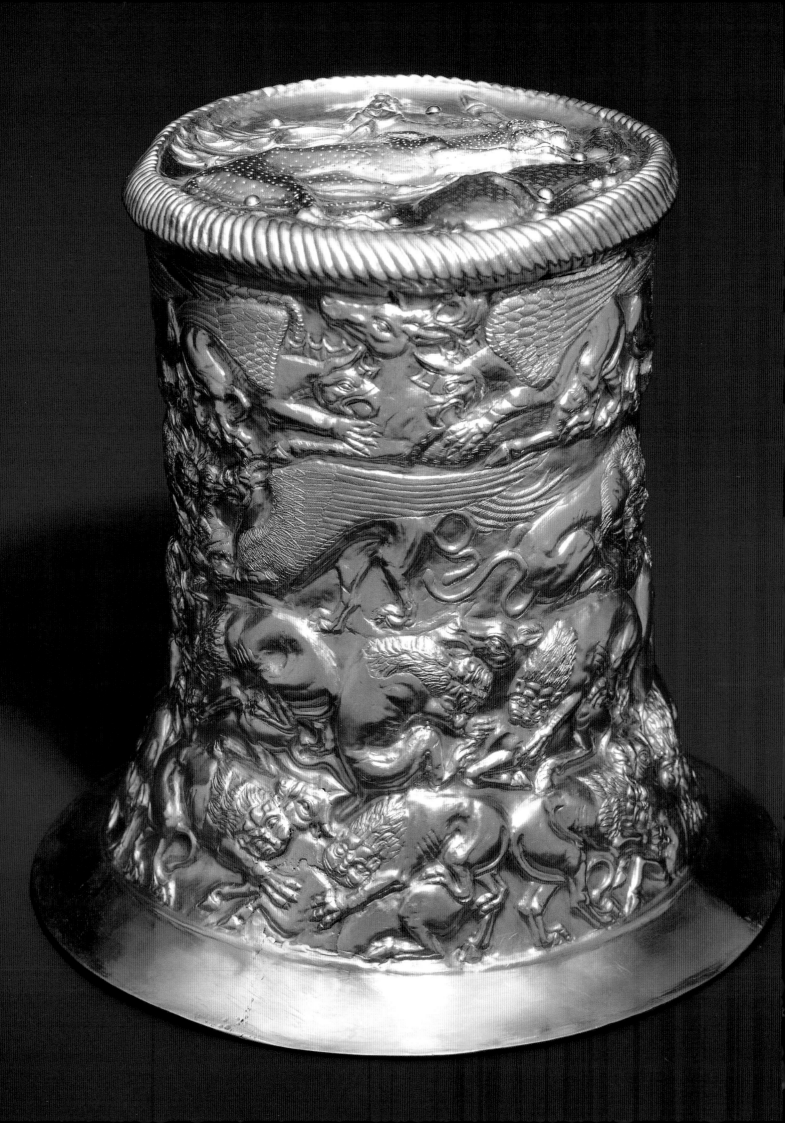

136

Opposite: 136

BABYNA MOHYLA

The kurhan Babyna Mohyla is located near the village of Taraso-Hryhorivka, Apostolivs'kyi Raion, Dnipropetrovs'ka Oblast'. At the time of its excavation, the kurhan's diameter was 60 meters, and its height was 8.15 meters, although it is estimated that in antiquity, the kurhan was probably 10 meters high. The kurhan takes its name from the Scythian anthropomorphic stele that stood on top of the kurhan until the nineteenth century A.D. During the eleventh and twelfth centuries A.D., the top of the kurhan was a holy place of the Polovetsi.

The kurhan was constructed during the fourth century in three phases, each associated with a burial and separated by short intervals of time. Each phase of the kurhan's construction is distinguished by a circular stone foundation, 1.3 to 1.8 meters high, and 1 meter wide, upon which the earthen embankment was laid. The earliest burial, in the middle of the kurhan, was that of a woman, accompanied by a servant. Recovered with her were bronze finials and plaques, believed to have belonged to objects used in the funerary ritual. The second burial was distinguished by a long *dromos* (corridor) that was entered from the north. In one chamber were discovered a man and woman, accompanied by servants and two horses. In an adjacent chamber was the body of a woman. The latest burial in the kurhan was that of a male. With each burial, a solid stone foundation was laid over the existing surface and overlaid with earth and a turf cover.

Finds from the kurhan include gold headdress ornaments and silver plaques for the decoration of bridles, as well as more mundane objects, such as fragments of Greek amphoras, handmade pottery, and a set of weapons.

The kurhan was encircled by a ditch approximately 72 meters in diameter. The western and eastern sections of the ditch have passages that gave access, presumably for funerary-related activities, to the area directly beside the kurhan. In the ditch were discovered remains of a funerary feast: fragments of Attic black-glazed pottery, a stone grinder, a fragment of a stone dish, a set of bronze ornaments for a wagon, horse bridles and harnesses, sherds of more than ninety Greek amphoras, river pebbles, and animal bones (horse, bull, sheep, dog, deer, and wild boar). Also discovered were the remains of a human shoulder blade and hand, which the excavators associate with human sacrifice.

The kurhan was looted twice. The first looting took place not long after the last burial, into which the robbers made their entrance hole. Their knowledge of this burial suggests that they were familiar with the plan of the grave and may even have participated in the funeral ceremony. The second looting took place in the last century through a vertical shaft from the top of the kurhan. Even after these robberies, the graves yielded Greek amphoras, handmade ceramics, weapons, gold dress ornaments, and silver bridle plaques.

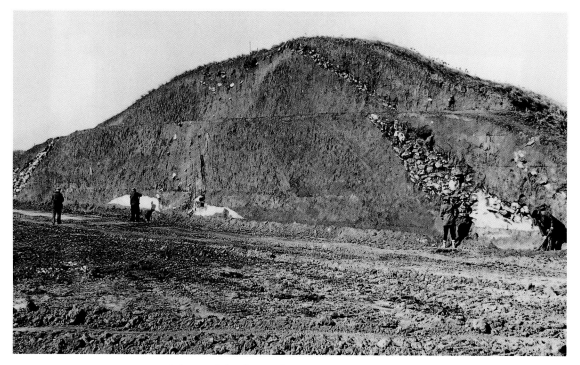

Babyna Mohyla. *Photograph Institute of Archaeology, Kyiv*

137. ROUNDEL (PHALERA) WITH HERAKLES

ca. 350–300
Silver, gilding
AI, inv. no. 138 KP-IV-281
From Babyna Mohyla, near village of Taraso-Hryhorivka, Apostolivs'kyi Raion, Dnipropetrovs'ka Oblast'.
Excavated by B. M. Mozolevs'kyi and S. V. Polin, 1986.
D: 7.2 cm; W: 6.33 cm; wt: 30.6 g.

Publications: Mozolevskii and Polin (1987), 8–9; Turku, *Skyyttien* (1990), 16, 56, no. 22; Rimini, *Mille* (1995), 76, no. 42a.

This roundel from a bridle is decorated with the head of a satyr in relief. The thick hair and beard, some of whose locks curl into volutes, are gilded. Small, cross-scored horns rise from the sides of the head. The face is deeply furrowed, with a prominent brow, blunt features, a snub nose, and full curling mustache. The eyebrows are scored, with the iris engraved and pupils indented. On the reverse are plated silver loops for attachment to leather bridle straps.

Silver or silver-plated bronze bridle ornaments with the frontal heads of gods or other mythological beings have been found in several Scythian kurhany of the second half of the fourth century, including Chmyreva Mohyla, Babyna Mohyla, and Kurhan Ohuz.[1]

This roundel and its mate (cat. no. 138) are closely related to two other plaques with beardless satyrs (cat. nos. 139 and 140). The addition of the beard here and of the knotted animal skins on cat. nos. 139 and 140 were probably intended to change the identification of the head to Herakles, who is given a similar treatment (albeit with a lion scalp) in Attic metalwork of this period.[2] Despite the allusion to Herakles, the curved horns on all four roundels tell us that the original identity of the figures was as satyrs.

1. Chmyreva Mohyla: Jentel (1976), 361, pl. LVIII, fig. 190; Pfrommer (1983), 259, fig. 24. Babyna Mohyla: Schleswig, *Gold* (1991), no. 139; Katowice, *Koczownicy* (1996), no. 271. Kurhan Ohuz: Boltryk and Fialko (1991), 122, pl. 8.

2. Williams (1976), 52, no. 5, pl. 6.

138. ROUNDEL (PHALERA) WITH HERAKLES

ca. 350–300
Silver, gilding
AI, inv. no. KP-IV-385
From Babyna Mohyla, near village of Taraso-Hryhorivka, Apostolivs'kyi Raion, Dnipropetrovs'ka Oblast'.
Excavated by B. M. Mozolevs'kyi and S. V. Polin, 1986.
D: 7.2 cm; wt: 34.68 g.

Publications: Mozolevskii and Polin (1987), 8–9; Katowice, *Koczownicy* (1996), 179, 228, no. 27.1.

The bridle attachment, decorated with the head of a satyr in relief, is badly damaged and has suffered significant losses around the lower edge. The satyr's thick hair and beard retain some gilding.

This roundel is a mate to cat. no. 137 and was hammered in the same matrix. See the discussion in that entry.

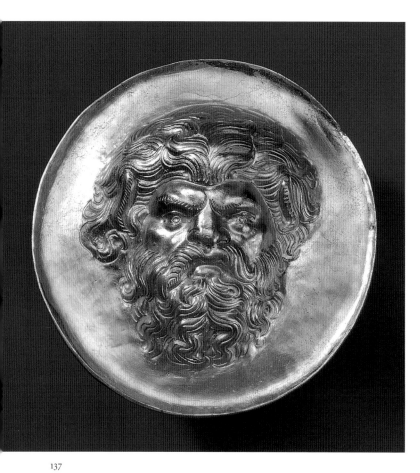

137

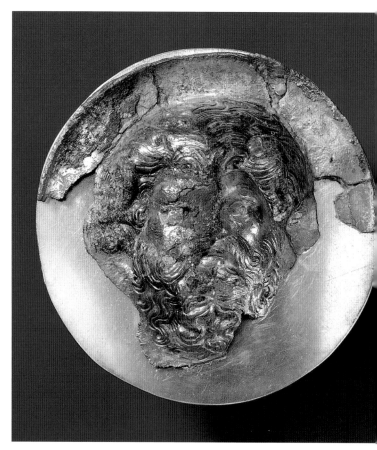

138

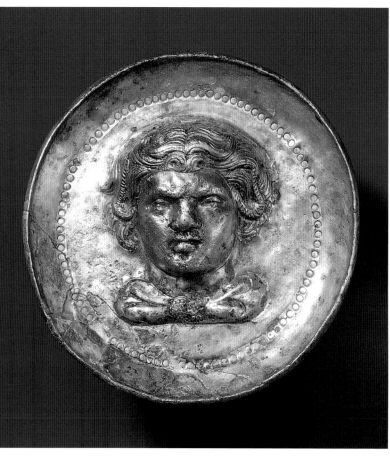

139

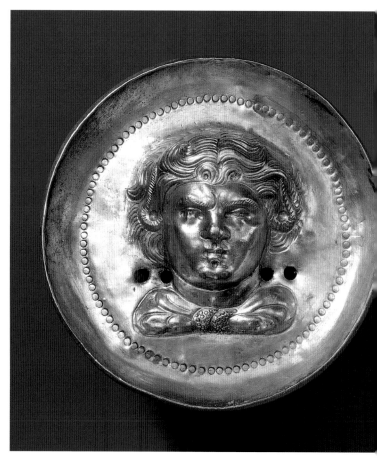

140

SCYTHIAN GOLD

284

139. ROUNDEL (PHALERA) WITH MALE HEAD

ca. 350–300
Silver
AI,inv. no. KP-IV-384
From Babyna Mohyla, near village of Taraso-Hryhorivka, Apostolivs'kyi Raion, Dnipropetrovs'ka Oblast'.
Excavated by B. M. Mozolevs'kyi and S. V. Polin, 1986.
D: 7.5 cm; total wt. with cat. no. 140: 64.4 g.

Publications: Mozolevskii and Polin (1987), 8–9; Rimini, *Mille* (1995), 76, no. 42a.

See the entry for cat. no. 140.

140. ROUNDEL (PHALERA) WITH MALE HEAD

ca. 350–300
Silver, gilding
AI, inv. no. KP-IV-384
From Babyna Mohyla, near village of Taraso-Hryhorivka, Apostolivs'kyi Raion, Dnipropetrovs'ka Oblast'.
Excavated by B. M. Mozolevs'kyi and S. V. Polin, 1986.
D: 7.5 cm; total wt. with cat. no. 139: 64.4 g

Publications: Mozolevskii and Polin (1987), 8–9; Rimini, *Mille* (1995), 76, no. 42a.

This bridle attachment is decorated with the head of a satyr. Large pointed ears and horns emerge from the side of the head and extend into the luxuriant, center-parted hair, which is gilded. The beardless face has a furrowed forehead, hatched eyebrows, eyes whose iris and pupils are indicated, and a snub nose. Around his neck are the knotted paws of an animal skin, also gilded. The relief is framed by a border of gilded dots. Fastening rings on the reverse are now lost, and as on cat. no. 149 have been replaced with two crude holes. This roundel and its mate (cat. no. 139) are clearly related to the two roundels depicting bearded satyrs (cat. nos. 137 and 138), and it is likely that the matrices for all of them were developed in the same workshop from the same prototype. Although the beard and knotted animal skin are associated with Herakles and may have been intended to identify the heads with that hero, the curving horns on all four roundels are unmistakably those of a satyr.

Silver or silver-plated bronze bridle ornaments with the frontal heads of gods have been found in several Scythian kurhany of the second half of the fourth century, including Chmyreva Mohyla, Babyna Mohyla, and Kurhan Ohuz .[1]

1. Chmyreva Mohyla: Jentel (1976), 361, pl. LVIII, fig. 190; Pfrommer (1983), 259, fig. 24. Babyna Mohyla: Schleswig, *Gold* (1991), no. 139; Katowice, *Koczownicy* (1996), no. 271. Kurhan Ohuz: Boltryk and Fialko (1991), 122, pl. 8.

141. ROUNDEL (PHALERA) WITH HERAKLES AND CERBERUS

ca. 350–300
Silver
AI, inv. no. KP-IV-386
From Babyna Mohyla, near village of Taraso-Hryhorivka, Apostolivs'kyi Raion, Dnipropetrovs'ka Oblast'.
Excavated by B. M. Mozolevs'kyi and S. V. Polin, 1986.
D: 8.3 cm; wt: 39.9 g.

Publications: Mozolevskii and Polin (1987), 8–9; Katowice, *Koczownicy* (1996), 179–80, 228, no. 27.5.

The silver bridle attachment depicts, in relief, Herakles and Cerberus, the gatekeeper of Hades in Greek mythology. Cerberus is in left profile. Only two of its three heads are visible. Its right hind leg is raised and pressed against the right lower leg of Herakles; the lion's left foreleg presses against the outside of the same leg. The tail loops between the legs. The animal's heads, fur, and muscled haunches are well rendered. Herakles, nude, leans forward, his weight distributed over both bent legs, but of his left leg only the upper part of the thigh and heel are visible. His torso is turned in three-quarter profile, with his left elbow pressed against the animal's back. The ribs and musculature of his torso are clearly indicated. His right hand holds the end of a leash, which passes in front of his body and is grasped also by his left hand. His head is in right profile, with a large eye and curly hair. The figures stand on a rocky groundline. Behind Herakles are the Nemean lion's skin, with the head and paws clearly indicated, and the hero's upright club, which is rendered with knobs and grooves. The scene is framed by a raised band inside a guilloche and a row of beading. This is one of a set of bridle attachments that also includes cat. nos. 142–144 and displays the same skillful treatment of anatomy and sensitivity to the shape of the frame.

142. ROUNDEL (PHALERA) WITH HERAKLES AND THE NEMEAN LION

ca. 350–300
Silver
AI, inv. no. KP-IV-282
From Babyna Mohyla, near village of Taraso-Hryhorivka, Apostolivs'kyi Raion, Dnipropetrovs'ka Oblast'.
Excavated by B. M. Mozolevs'kyi and S. V. Polin, 1986.
D: 8.4 cm; wt: 37.8 g.

Publications: Mozolevskii and Polin (1987), 8–9; Katowice, *Koczownicy* (1996), 179–80, 228, no. 27.6.

The silver harness attachment is damaged by oxidation and has sustained significant losses. It depicts Herakles with the Nemean lion in relief. The lion is in right profile, with the right hind leg advanced and the paw pressing against Herakles' extended lower right leg. The lion's tail loops between its legs, with the end forming a counter-curve behind the left hock. The tendons in the left hind leg are well rendered, as is the fur along the back contour of the right leg. Herakles is in left profile, resting on his right knee, with his left leg extended and partially bent. His torso is in very high relief. His head, also in left profile, is pressed closely against the lion's mane, and his arms hold the lion's head in a firm grip. Only the hero's left arm and clasped hands are visible. The lion's head is in right profile and, as Herakles' torso bends around it, the head is pressed against the hero's lower torso and hip. The lion's mouth is open, its tongue extended. Herakles' club lies almost horizontally on the rocky ground beneath the figures, behind his left foot. The club is rendered with knobs and grooves. Around it are lightly incised rocks. The scene is framed by a raised band inside a guilloche and a row of beading. On the separate back plate there are three loops for attachment.

 This bridle attachment, one of a set that also includes cat. nos. 141, 143, and 144, is clearly the work of a superior artist. The composition, which perhaps ultimately was inspired from South Italian coinage, nicely fills the frame and echoes its circular shape. The anatomy of the figures is well developed and their poses are convincingly rendered. A more schematized version of the motif is seen on cat. no. 113 and on gold plaques from Chortomlyk and Kul'-Oba.[1]

1. Chortomlyk: Galanina and Grach (1986), fig. 261. Kul'-Oba: Artamonov (1969b), 287, no. 218, pl. 218.

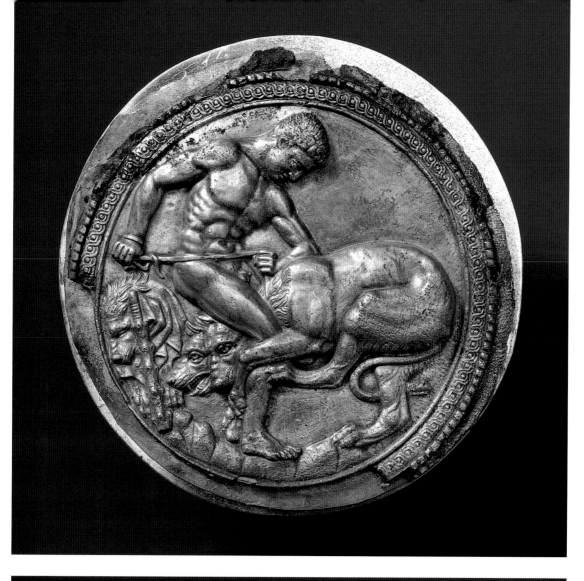

141

142

143. ROUNDEL (PHALERA) WITH SCYLLA

ca. 350–300
Silver
AI, inv. no. KP-IV-283 B/2
From Babyna Mohyla, near village of Taraso-Hryhorivka, Apostolivs'kyi Raion, Dnipropetrovs'ka Oblast'.
Excavated by B. M. Mozolevs'kyi and S. V. Polin, 1986.
D: 8.6 cm; wt: 55.8 g.

Publications: Bilimovich (1962), 133–42; Mozolevskii and Polin (1987), 8–9.

The silver bridle attachment depicts Scylla in relief. The sea monster is composed of a female form with four dog foreparts in place of legs, two on each side. Two of the dogs have fish in their mouths. The dog foreparts end in two snaky bodies, which curve around in a circle before terminating in fish tails. A row of fins edges the snaky coils. Beneath the joined torsos of the dogs are five teats (or fins?), and below this the lower hem of Scylla's garment is rendered in three broadly scalloped folds. The groundline is formed of round stones. Scylla's torso is frontal, and she wears a garment that consists of straps passing between her breasts, where they are fastened by a ring. The garment is belted with a slight overfold forming the same scalloped contour as the lower hem. The garment extends to what would be mid-thigh; her navel is visible and the lower hem billows upward in omega-shaped folds. With both hands she holds aloft an oar, which passes behind her head. Her head is turned in three-quarter left profile and inclined downward. Her hair is brushed back from her face and rises above the back of her head. Over her head is a dolphin in left profile.

The scene is framed by a raised band inside a guilloche and row of beading. The relief is soldered to a flat backing, which has four soldered loops.

This bridle attachment is one of a set that also includes cat. nos. 141, 142, and 144. This piece is a mate to cat. no. 144 and was hammered in the same matrix. Scylla was one of the obstacles Odysseus faced on his journey home, and the motif was an especially popular one on fourth-century metalwork from Magna Graecia, where the mythological creature was traditionally located.

144. ROUNDEL (PHALERA) WITH SCYLLA

ca. 350–300
Silver
AI, inv. no. KP-IV-283 B/1
From Babyna Mohyla, near village of Taraso-Hryhorivka, Apostolivs'kyi Raion, Dnipropetrovs'ka Oblast'.
Excavated by B. M. Mozolevs'kyi and S. V. Polin, 1986.
D: 8.7 cm; wt: 30.4 g.

Publications: Bilimovich (1962), 133–42; Mozolevskii and Polin (1987), 8–9; Katowice, *Koczownicy* (1996), 179, 228, no. 27.4.

The embossed silver harness attachment, depicting the sea monster Scylla, is badly damaged. It belongs to the same set as cat. nos. 141 and 142 and was hammered in the same matrix as cat. no. 143.

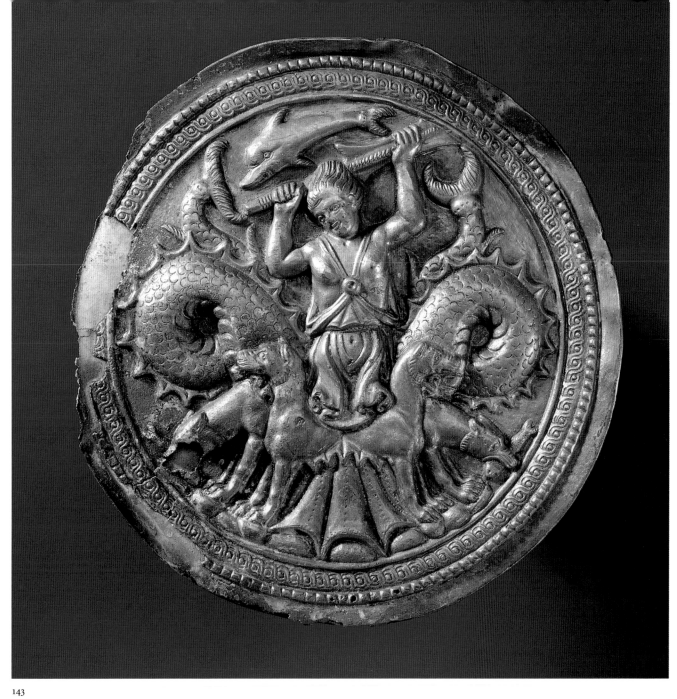

143

144

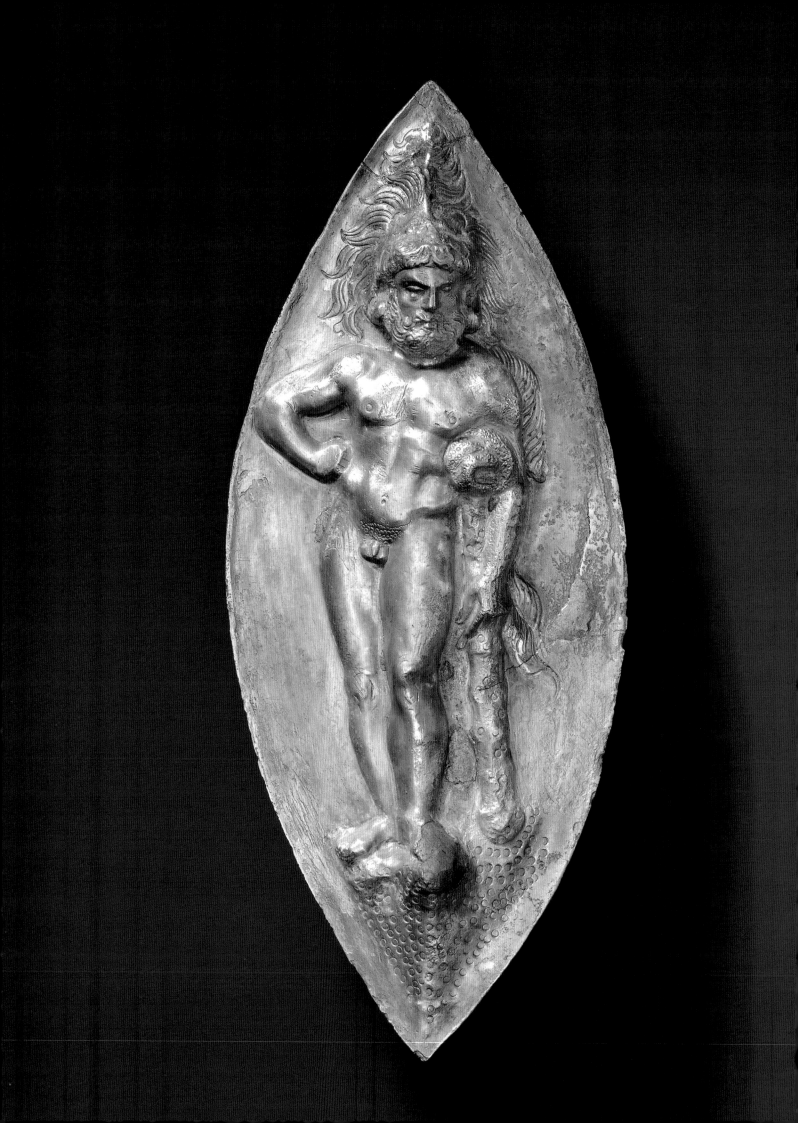

145. PROMETOPIDION WITH THE WEARY HERAKLES

ca. 350–300
Silver
AI, inv. no. KP-IV-283A
From Babyna Mohyla, near village of Taraso-Hryhorivka, Apostolivs'kyi Raion, Dnipropetrovs'ka Oblast'.
Excavated by B. M. Mozolevs'kyi and S. V. Polin, 1986.
H: 20 cm; W: 8.8 cm; wt: 93.9 g.

Publications: Mozolevskii and Polin (1987), 8–9.

The frontlet, of oval shape with pointed tips, was attached to the bridle above the horse's nostrils and beneath the eyes. Represented in high relief is Herakles, who stands, leaning slightly on his club, with his weight on his right leg, the left leg relaxed and slightly advanced. His torso is turned slightly to his right; the back of his right hand rests on his hip; his left hand rests on his club; and he gazes down and slightly to his left. The lion scalp sits closely on Herakles' head, with the jaws framing his face and short beard. The tufts of the mane rise above his head and frame his left shoulder. More of the lion skin rests on the top of the gnarled club under his left arm; the skin's surface is stippled and the ends of the skin blow out to the side.

Many details are gilded. The nipples were made with a circular punch and gilded, and details of his pubic hair were also punched and gilded. Other gilded elements include the beard, the lion skin, the dotted decoration of the club, and the stippled ground. Rings on the reverse, which once attached the plaque to the horse's bridle, are now missing.

The lack of detail on the back of the plaque indicates that it was cast after a wax model rather than hammered in a matrix. The figure, and especially the head, is in fairly high relief. At least two sizes of punches were used to add details from the front, and, interestingly, they are of identical dimensions to punches used to decorate the harness ornaments found in the same burial (cat. nos. 139 and 140).

Oval frontlets like this one are rather rare, but similar examples have been found in Oleksandropol' and Boskaia Blyznytsia.[1] Many elements in the piece exhibit a familiarity with Greek style of the fourth century and with Greek iconography, since the figure is based on the Weary Herakles by Lysippos. At the same time, some features, such as the handling of the lion's mane, are curiously flamboyant, and still other details are clumsy, such as the radiating rows of stippling on the rocky ground and the awkward indentation of the groundline to accommodate the hero's club.

1. Boskaia Blyznytsia: Treister (1996c), 109–110; Schwarzmaier (1997), 21, note 113. Oleksandropol': Pfrommer (1990), 271; Treister (1996c), 110.

146. PROMETOPIDION WITH NUDE YOUTH

ca. 350–300
Silver
AI, inv. no. KP-IV-284
From Babyna Mohyla, near village of Taraso-Hryhorivka, Apostolivs'kyi Raion, Dnipropetrovs'ka Oblast'.
Excavated by B. M. Mozolevs'kyi and S. V. Polin, 1986.
Plaque with youth: H: 11 cm; W: 3.7 cm; wt: 30.5 g. Plaque with female: H: 16.6 cm; W: 7 cm.

Publications: Mozolevskii and Polin (1987), 8–9; Katowice, *Koczownicy* (1996), 179, 228, no. 27.3.

Opposite: 145

The edges of the matrix-hammered front plate are folded over a plain silver backing plate. This horse frontlet is an elongated hexagon with the wide middle section extending laterally to points. A nude winged youth moves to his left, with his right leg advanced, and his head looking back and up in left profile. His torso is in three-quarter profile, and his weight is on the balls of his feet, which are supported by floral scrolls. In his lowered right hand he holds a laurel wreath; his lowered left hands appears to hold leafy stalks. At the bottom is rocky, uneven terrain. Long pointed wings extend well above his head, their ends turning inward. On the back of the frontlet two horizontal loops remain, with fragments of a third. A hole is also punched in the lower center.

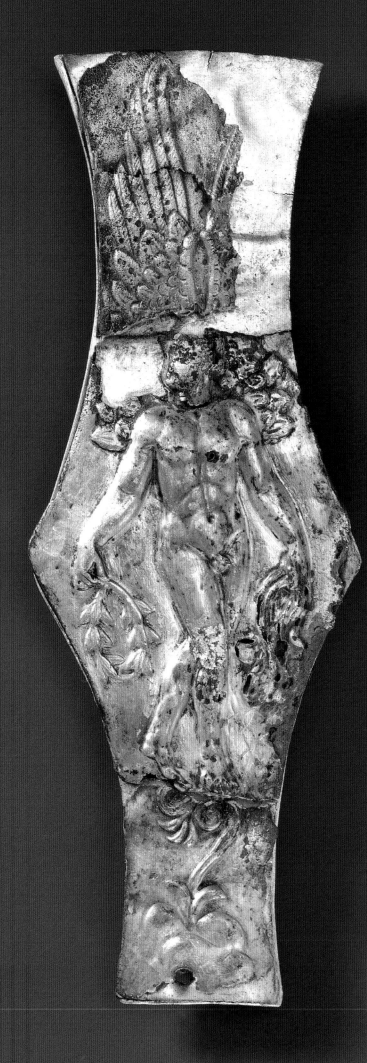

This relief was the upper element of a two-part prometopidion. The other relief (Reeder essay, fig. 11) has an oval field, framed by a row of beading inside a band of garlands, with a pendant suspended from each juncture. A winged frontal female stands with left leg relaxed. She wears a V-necked belted peplos, with overfold, that extends to mid-thigh. Her left hand steadies a staff with a crosspiece at the top. Her lower right hand holds a wreath. Her head is turned slightly to her left, her hair drawn back from her face.

The hexagonal shape of the first relief is paralleled by the well-known mid-fourth-century gold frontlet decorated with the Scythian snake-bodied goddess (see also cat. no. 147) from Tsymbalka and the gilt-silver replica hammered in the same matrix, which was found in Tovsta Mohyla.[1] A prometopidion of similar form but later date is now in the J. Paul Getty Museum.[2]

The omega-shaped ends of the winged female's overfold exhibit a familiarity with Attic art of the late fifth century.

1. Tsymbalka: Schleswig, *Gold* (1991), 152, fig. 1; Tovsta Mohyla: Mozolevs'kyi (1979), 39, fig. 23.
2. Pfrommer (1994), 13–15, 153, no. 26.

147

Opposite: 146

147. BRIDLE ORNAMENT WITH SNAKE-BODIED FEMALE

ca. 350–300
Silver
AI, inv. no. KP-IV-286
From Babyna Mohyla, near village of Taraso-Hryhorivka, Apostolivs'kyi Raion, Dnipropetrovs'ka Oblast'.
Excavated by B. M. Mozolevs'kyi and S. V. Polin, 1986.
L: 7.4 cm; W: 4.7 cm; wt: 20.6 g.

Publications: Mozolevskii and Polin (1987), 8–9; Katowice, *Koczownicy* (1996), 179, 228, no. 27.2.

The cheekpiece is formed of a now-fragmentary embossed silver plate that was originally crimped around the edges of a smooth back plate. A gray material filled the spaces between the two plates. The front, which is badly damaged by oxidation, is decorated in relief with a female figure moving to her left in three-quarter view, her right arm extended back and down. Her hair, parted down the center, is drawn back from her frontal face and knotted above the forehead. She wears a V-necked garment, seemingly belted, with a fold brought forward over the right upper arm. Beneath her torso, her body winds into a snake tail. A plated ring is soldered to the reverse of the back plate for attaching a leather strap.

Herodotus (4.7–10) recounts one legend of the origins of the Scythian people as descendants of Herakles and a snake-bodied goddess. Similar plaques with snake-bodied females have been found in fourth-century mounds in the Kuban basin, at Labins'kaia,[1] Ivanovs'kaia,[2] and from Kul'-Oba.[3] The similarities between the Ivanovs'kaia and Kul'-Oba plaques are so striking as to suggest that they were made in the same Bosphoran workshop in the first half of the fourth century.[4]

1. *CRPétersb* (1909–1910), 214, fig. 245.

2. Mannheim, *Gold* (1989), 117–19, nos. 117–19; Tokyo, *Scythian Gold* (1992), nos. 41–46.

3. Jacobson (1995), 174, IV.E.6, fig. 58; Bonn (1997a), no. 77.

4. Following Kopejkina (1986), 55.

148. TWO HEADS IN PHRYGIAN CAPS

ca. 350–300
Gilt silver
AI, inv. no. KP-IV-262/1,2
From Babyna Mohyla, near village of Taraso-Hryhorivka, Apostolivs'kyi Raion, Dnipropetrovs'ka Oblast'.
Excavated by B. M. Mozolevs'kyi and S. V. Polin, 1986.
H: 3.2 cm; W: 2.8 cm; wt: 5 g.

Publications: Mozolevskii and Polin (1987), 8–9.

The two rectangular bridle ornaments were hammered in the same matrix and bear the head of a woman in relief. She turns in three-quarter right profile, and has large eyes, with the irises and pupils indicated. Long, simply rendered locks of hair emerge from below a Phrygian cap. The peak of the cap extends beyond the frame, which is bordered at top and on the sides by a bead-and-reel ornament. The hair and cap, and probably the face, were gilded. Four holes are pierced in each plaque for attachment.

The punched holes contrast with the labor-intensive loops attached to the backs of other, more carefully worked horse ornaments (cat. nos. 150–152).

It is tempting to identify these women in Phrygian caps as Amazons, the mythical female warriors whom the Greeks located in a vague expanse east of the Black Sea. Depictions of Amazons in Phrygian caps appear frequently on fourth-century Attic vases that were exported to the Greek cities on the Black Sea coast, and it would seem that the subject appealed to Scythian customers; indeed, Amazon imagery inspired the gold helmet with Scythian combatants (cat. no. 124). It is also true that Scythian women rode horses and probably also carried weapons. Swords and other military paraphernalia are not uncommon in female burials.

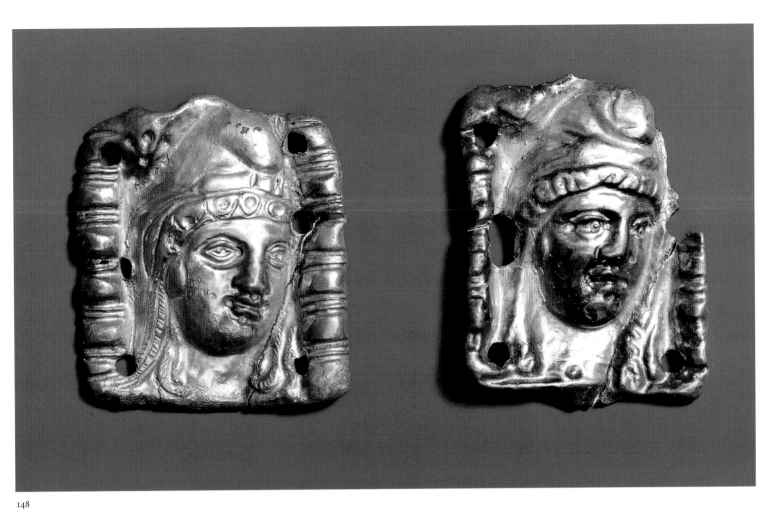

148

149

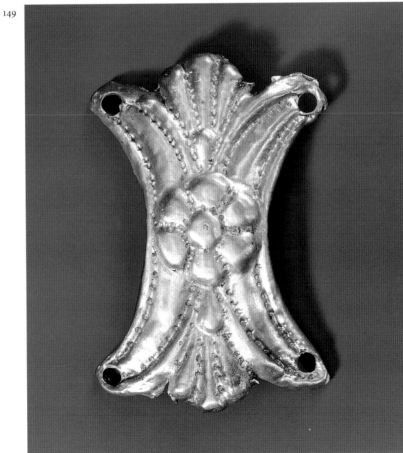

149. ORNAMENT WITH ROSETTE

ca. 350–300
Gilt silver
AI, inv. no. KP-IV-259
From Babyna Mohyla, near village of Taraso-Hryhorivka, Apostolivs'kyi Raion, Dnipropetrovs'ka Oblast'.
Excavated by B. M. Mozolevs'kyi and S. V. Polin, 1986.
Max. H: 3.3 cm; W: 4.7 cm; wt: 3.9 g.

Publications: Mozolevskii and Polin (1987), 8–9.

The plaque was hammered in a matrix, with indented dots worked subsequently from the front. The design is formed of two back-to-back crescents with a superimposed six-petal rosette in the center. Between the diverging horns of the crescents are two three-lobed palmettes with a central bud. The rosette and palmettes are gilded. Four holes are pierced, one at the end of each crescent.

For a similar composition, compare the square plaque on the harness ornaments, cat. no. 32. The same basic shape is also found, on a smaller scale, as a spacer in necklaces.[1]

1. For example, on a necklace from Pantikapaion, Williams and Ogden (1994), 152–55, no. 94.

150. PLAQUES FOR REIN, WITH MAN'S HEAD

ca. 350–300
Silver
AI, inv. no. KP-IV-387
From Babyna Mohyla, near village of Taraso-Hryhorivka, Apostolivs'kyi Raion, Dnipropetrovs'ka Oblast'.
Excavated by B. M. Mozolevs'kyi and S. V. Polin, 1986.
L: 20.4 cm; W: 2.5 cm; wt: 32.07 g.

Publications: Mozolevskii and Polin (1987), 8–9.

The seven rectangular silver plaques were hammered in the same matrix. The frontal face and neck of Herakles are framed on left and right by a bead-and-reel border. The hero has a deeply furrowed brow and indented pupils; he wears a lion skin. The animal's head appears like a helmet on the hero's head, its teeth and ears clearly visible. The paws are knotted around Herakles' neck. On the reverse are four banded loops, soldered at the corners.

These plaques, along with cat. nos. 151 and 152, were used to decorate reins.

151. PLAQUES FOR REIN, WITH LION HEAD

ca. 350–300
Silver
AI, inv. no. KP-IV-383
From Babyna Mohyla, near village of Taraso-Hryhorivka, Apostolivs'kyi Raion, Dnipropetrovs'ka Oblast'.
Excavated by B. M. Mozolevs'kyi and S. V. Polin, 1986.
L: 15.2 cm; W: 1.7 cm; wt: 14.79 g.

Opposite: 150, 151, 152

Publications: Mozolevskii and Polin (1987), 8–9; Rimini, *Mille* (1995), 76, no. 42b.

The ten rectangular silver plaques were hammered in the same matrix. A lion mask is framed on each side by a beaded border. The animal has small petal-shaped ears, indented pupils, and whiskers rendered in low relief. The mane is arranged in three horizontal rows of schematic tufts. Traces of gilding remain. On the reverse of each plaque are two narrow loops.

These plaques, along with cat. nos. 150 and 152, were used to decorate reins. Probably the narrow loops here were stitched directly to the backing.

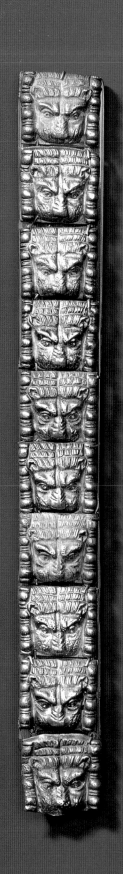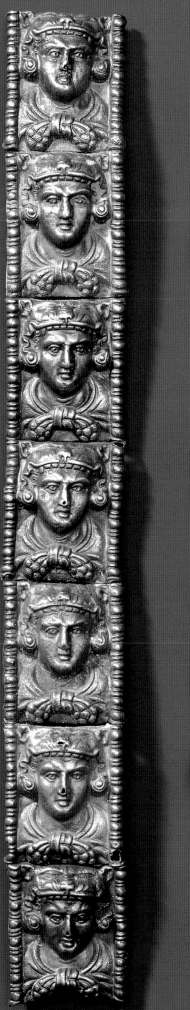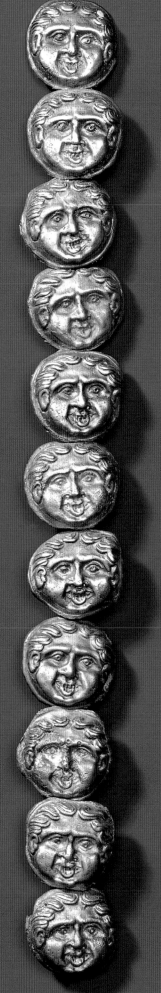

Slightly larger but comparable plaques, also in silver and with similar loops, were found in Macedonia,[1] whence inspiration for these reliefs may have come. Similar lion masks are also found on the bracelet from Kurhan 1 of the Tr'okhbratni Kurhany (cat. no. 97).

1. Thessalonika, *Treasures* (1978), 35–36, no. 22, pl. 5.

152. PLAQUES FOR REIN, WITH GORGON HEAD

ca. 350–300
Silver
AI, inv. no. KP-IV-388
From Babyna Mohyla, near village of Taraso-Hryhorivka, Apostolivs'kyi Raion, Dnipropetrovs'ka Oblast'.
Excavated by B. M. Mozolevs'kyi and S. V. Polin, 1986.
L: 20 cm; W: 2 cm; wt: 21.18 g.

Publications: Mozolevskii and Polin (1987), 8–9; Rimini, *Mille* (1995), 76, no. 42c.

The eleven round silver plaques were hammered in the same matrix. They follow the contour of a Gorgon head. Her teeth are visible around her protruding tongue. Three well-defined clumps of hair appear on either side of the center part. Her pupils are indented, and the eyebrows are rendered as wavy ridges. On the reverse of each disc is a pair of loops.

These plaques, along with cat. nos. 150 and 151, were used to decorate reins. The massing of the discs in this set calls to mind a group of coins, and this must reflect their ultimate inspiration.

153. OPENWORK PLAQUE WITH FEMALE

ca. 350–300
Gold
AI, inv. no. Z-1745
From Babyna Mohyla, near village of Taraso-Hryhorivka, Apostolivs'kyi Raion, Dnipropetrovs'ka Oblast'.
Excavated by B. M. Mozolevs'kyi and S. V. Polin, 1986.
H: 7.9 cm; W: 6.3 cm; wt: 13.54 g.

Publications: Mozolevskii and Polin (1987), 8–9; Turku, *Skyyttien* (1990), 16, 56, no. 27; Rimini, *Mille* (1995), 77, no. 44.

The openwork relief plaque depicts a woman standing quietly on a blossom that emerges from two spreading acanthus leaves. Her left leg is relaxed, and her left hand grasps a bird(?), which is also supported by a rosette at her left hip. She wears a belted peplos with overfold and a coiled bracelet on her right wrist. Her head is in right profile, and her hair is brushed forward over her forehead and falls to her shoulders. On either side of her rise ribbed acanthus stalks that branch off into volutes. At the top, flanking her head at shoulder level, each stalk terminates in an acanthus leaf, which takes the form of a stag head. A palmette behind each stag head serves as the antlers.

The plaque was originally part of a female headdress.

Antlers that take the form of palmettes are seen on gold plaques from Solokha[1] and on a bronze bridle plaque from the Semybratni Kurhany.[2]

Opposite: 153

1. Artamonov (1969b), 41, 284, no. 78.

2. Artamonov (1969b), 285, no. 130, pl. 130; Schiltz, *Scythes* (1994), 43, no. 26.

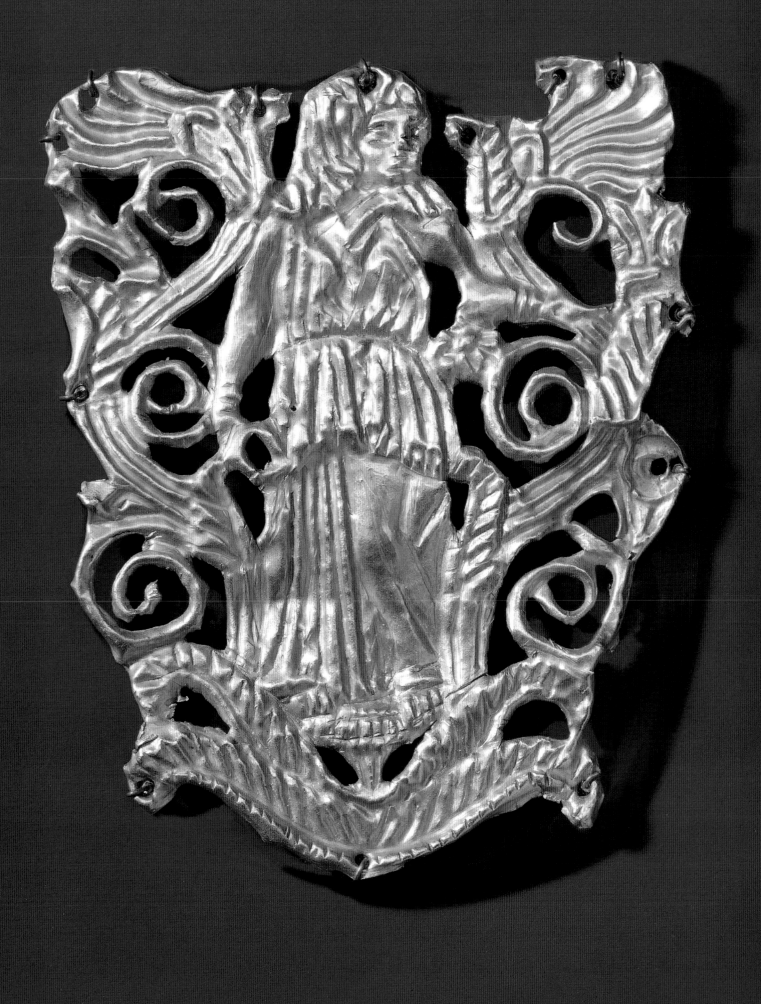

SOBOLEVA MOHYLA

Soboleva Mohyla is located near the town of Ordzhonikidze, Dniropetrovs'ka Oblast', near the village of Hirniats'ke. The excavation was carried out in 1991 and 1992 under the direction of B. M. Mozolevs'kyi and V. P. Bilozor.

The kurhan is located within a constellation of some of the largest and richest of the Scythian kurhany, which include Chortomlyk, Tovsta Mohyla, and Oleksandropols'kyi. Soboleva Mohyla, with a diameter of 50 meters and a height of 6 meters, was constructed during the third quarter of the fourth century. Construction was carried out in three phases, each of which can be linked with a male burial (nos. 1, 2, 5). The other burials in the kurhan are of a woman (no. 3) and adolescent (no. 6), accompanied by three servants (nos. 4, 7, 8) and a bridled horse (nos. 2A).

A circular ditch around the kurhan contained the remains of Greek amphoras, obviously used in the funerary feast, and the bones of ox, dog, and wild boar.

Most of the burials had been looted twice, one not long after the funerary ceremonies, presumably by people who took part in them. One male burial (no. 2), however, survived intact with numerous grave goods. Also surviving intact was the adolescent burial (no. 6). Unnoticed by looters in the female burial (no. 3) were massive silver bridle ornaments and a Greek silver wine vessel.

In the eleventh and twelfth centuries, the Polovetsi erected a stone sculpture of a warrior on top of the kurhan.

154. PLAQUES FROM A GORYTOS

ca. 350–325
Gold
AI, inv. nos. z-1968, z-1969, z-1970–1971, z-1972, z-1973, z-1974, z-1975, z-1976–1984,
z-1985, z-1986, z-1987, z-1988, z-1989–1991, z-1992, z-1993, z-1996
Greek
From Soboleva Mohyla, near village of Hirniats'ke, Nikopol's'kyi Raion, Dnipropetrovs'ka Oblast'.
Excavated by B. M. Mozolevs'kyi and V. P. Bilozor, 1990–1991. Gorytos reconstructed by S. V. Polin.
Openwork plaque with male figure (z-1968): L: 12.7 cm; W: 8.8 cm; wt: 26.62 g. Dragon plaque (z-1969): H: 5 cm; L: 17.3 cm; wt: 18.94 g.
Plaque (z-1970): L: 12.8 cm; W: 7.6 cm; wt: 12.1 g. Plaque (z-1971): L: 11.6 cm; W: 7.6 cm; wt: 12.01 g. Strip (z-1972): L: 10.2 cm; W: 1.3 cm;
wt: 2.33 g. Plaque (z-1973): L: 4.3 cm; W: 7.5 cm; wt: 2.71 g. Plaque (z-1974): L: 5 cm; W: 5 cm; wt: 5.82 g. Plaque (z-1975): L: 5 cm; W: 5
cm; wt: 5.87 g. Plaques (z-1976, Z-1977, z-1978): L: 3.2 cm each; W: 2.5 cm each; wt: 4.55 g (total for 3 pieces). Plaques (z-1979, z-1980,
z-1981): L: 3.75 cm each; W: 2.9 cm each; wt: 6.23 g (total for 3 pieces). Plaques (z-1982, z-1983,z-1984): L: 4.2 cm each; W: 3.2 cm each;
wt: 6.85 g (total for 3 pieces). Plaque (z-1985): L: 9.5 cm; W: 2.1 cm; wt: 3.61 g. Griffin (z-1986): L: 16.5 cm; W: 2.5 cm. Griffin (z-1987):
L: 27.2 cm; W: 2–2.5 cm; wt: 20.32 g (total for units z-1986 and z-1987). Strip (z-1988): L: 43 cm; W: 2.0–2.8 cm; wt: 21.75 g. Strip
(z-1989–1991): L: 81 cm; W: 0.5 cm; wt: 4.4 g. Strip (z-1992): L: 46 cm; W: 0.5 cm; wt: 20.53 g. Strip (z-1993): L: 32.5 cm; W: 0.5 cm;
wt: 10.85 g. Strip (z-1996): L: 21.4 cm; W: 1.2 cm; total wt: 182.63 g.

Publications: Mozolevs'kyi (1992), 72–80; Mozolevs'kyi, Bilozor, and Vasylenko (1993), 71–72; Milan, *Tesori* (1995), 105, 196, no. 60.

The gorytos decoration consists of a number of individual openwork gold plaques that were matrix-hammered.

Opposite: 154

The only figural ornament on the gorytos is an openwork plaque that takes the form of a bearded man standing in three-quarter left profile, his head in left profile. His long hair falls to his shoulders, and he has a large eye beneath a scored eyebrow. Four curling wings extend from each side of his back. He wears a belted costume covered with feathers that cover his body as far as his elbows and knees. His collarbone is indicated by opposing volutes, and at his buttocks a five-petal rosette protrudes like a tail. The man's arms are outstretched, and in each hand he holds the horn of a winged bird-headed serpent-like creature, whose tail ends in a palmette. The heads of the symmetrical serpents are in profile facing outward; their ears are pointed and their bodies are scaled. From the calf of each of the man's legs extends a hooked element, and the feet have

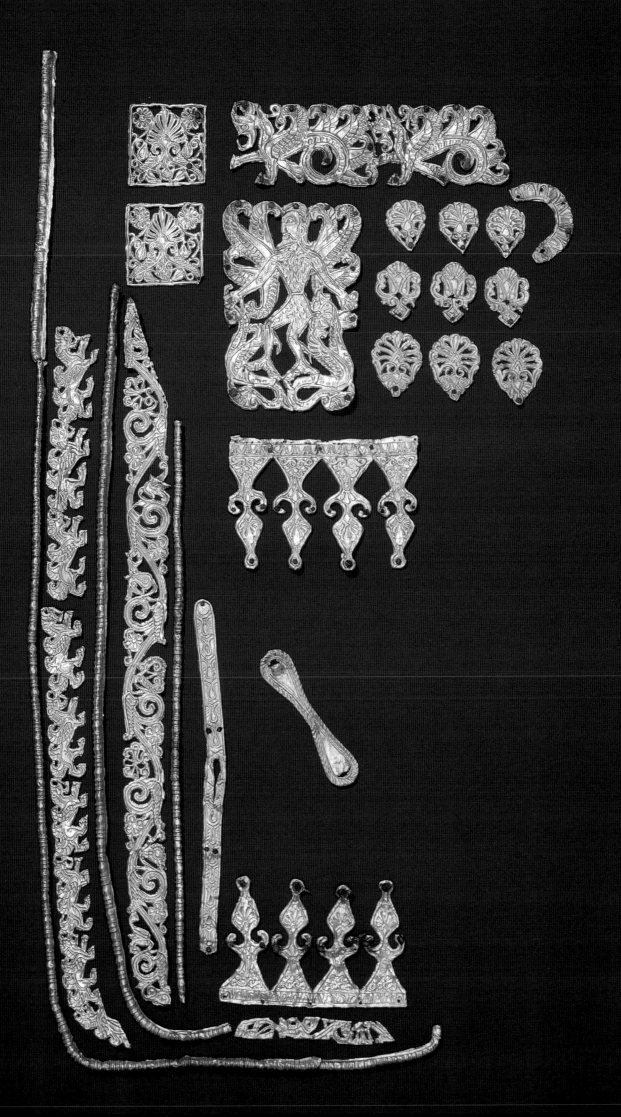

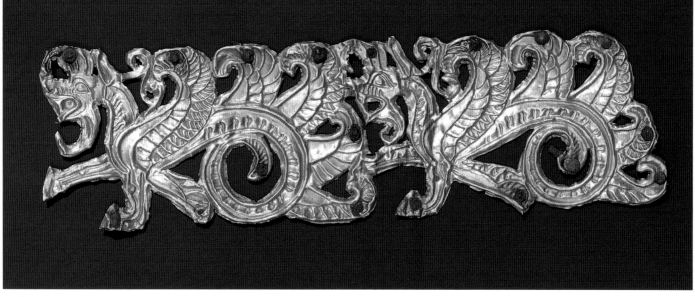

154 detail

an almost fin-like form, with each of the two elements terminating in a talon. The feet rest on the looped tails of the serpents. The edge of the plaque is bent back to enclose a wire. Silver nails, five along the top and three on each side, were used for attachment.

Above this plaque is an openwork relief plaque in the form of two winged hybrid beings. Each has the head of an eagle or a wolf and the lower body of a serpent, whose tail curls into a volute. The beings are in left profile, the right leg advanced and raised. Each head has a long beard curling outward, an open mouth, a horn rising from the nose, a forward-curving crest, and a long pricked ear. Five wings rise from the back and tail; the wing tips curl inward. Behind the ear and the first wing is a small double volute. Another wing-like

Opposite: 154 detail

154 detail

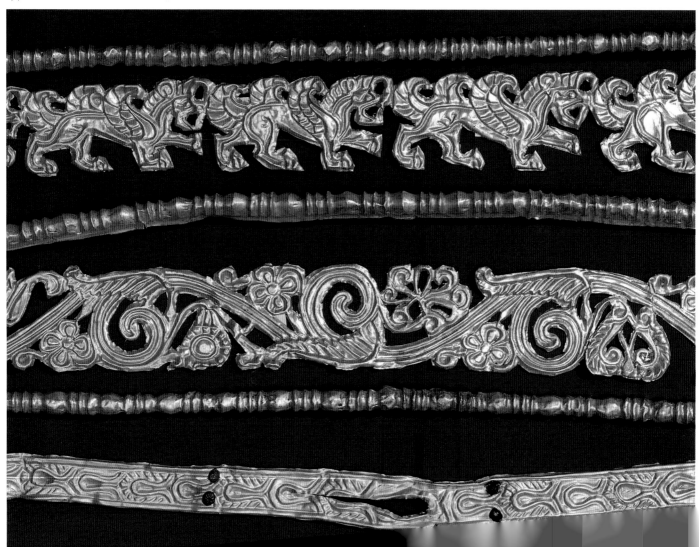

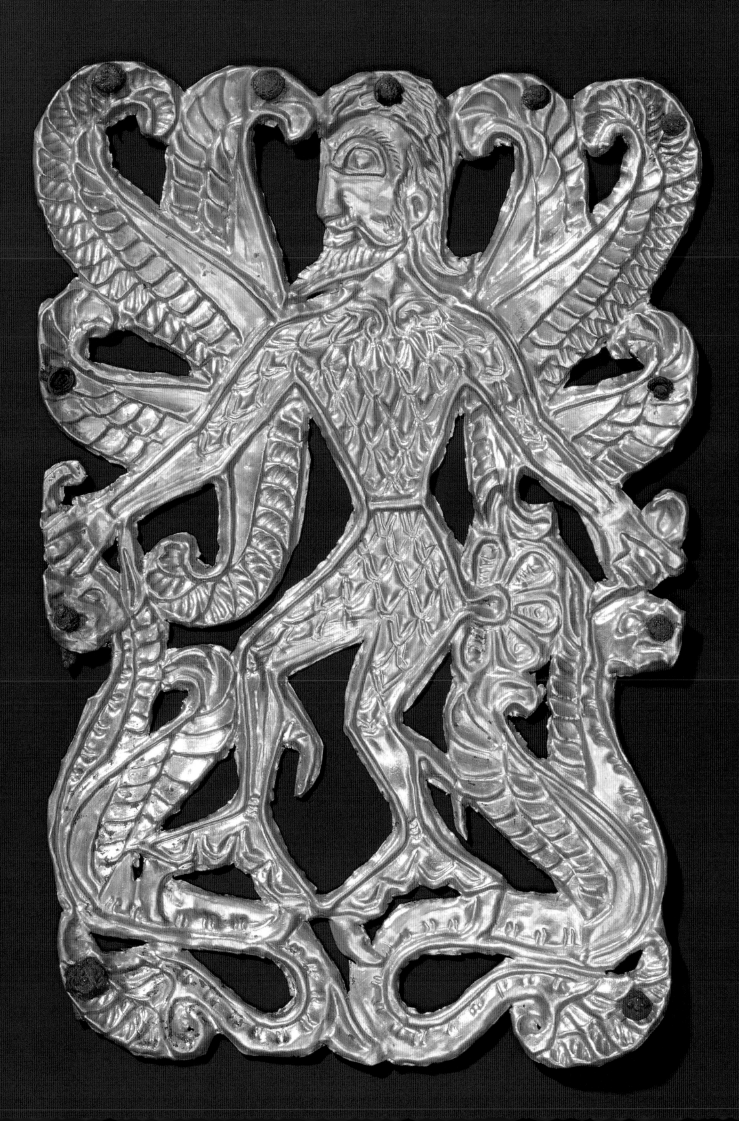

element descends from the juncture of the supporting left leg and first wing. The scales along the body and the wings are differentiated with varied patterns. Some of the wings have hatched grooves indicating feathers. Seventeen silver nails for attachment survive.

Another group of mythical beings is seen on the left side of the gorytos. Here on a band, now in two pieces, is a procession of eight eagle-headed griffins in right profile, with front left leg raised, mouth open, and head surmounted by a crest. Each eagle-griffin has three forward-curving wings, one on the right side nearest the viewer, the other two behind. Each wing is decorated with a double row of feathers. The size of the griffins diminishes along the length of the band, ending in the partial figure of a ninth griffin set at an oblique angle to the others, its hindquarters tapering to a point.

Beneath this band is a second openwork band formed of acanthus scrolls and volutes, also ending in a point. Between the volutes are flowers of different shape: four-petaled, rosette-like, and an openwork cluster of lotus blossoms.

Above this band are two nearly identical square reliefs with openwork designs of acanthus leaves, palmettes, and tendrils that terminate at the corners in rosettes. There were four nails in each plaque, most of which survive.

Nine openwork reliefs are of three closely related types. On the largest, an inverted palmette emerges from a volute above a smaller solid inverted palmette below. On the second type, a lotus blossom enclosing a palmette emerges from a volute above a diamond-shaped base. On the third type, represented by the three smallest plaques, palmettes emerge from a volute above a pointed base. There is a silver nail at the base of each relief, and remains of nails indicate that the open spaces in the design were also used for attachment.

Other pieces on the gorytos include two strips, each with four elements suggesting stylized humans. An ovolo band above an inverted palmette suggests the figure's head. The arms are suggested by symmetrical arcs resembling bird beaks, and the lower body is indicated by an inverted palmette extending to an oval tip. On each element, a silver nail passed through this tip, each hand, and each side of the ovolo where the elements are conjoined.

Further pieces on the gorytos include an elongated hourglass-shaped plaque with a hatched border and smooth interior surfaces. At either end are slots that retain iron residue from the nails that attached it to the support.

The last pieces include an arc of ovolos, and a long gold plaque with rounded ends and a central slot to accommodate a clasp. A plain narrow fillet runs around the perimeter. Inside, the low relief consists of long tongues flanked by rays. Six iron nails that were used to attach the relief still remain: one at each end and two pairs around the center opening.

Completing the ensemble are a smaller openwork band of scrolling vegetation and three long bead-and-reel moldings. The longest of the moldings curves to conform to the shape of the gorytos, and the shorter ones framed other elements in the decoration.

The gorytos is unique and an intriguing fusion of diverse motifs, many of Near Eastern and Greek origin.[1] It is possible that the male figure is wearing cultic garb. The hybrid beings on the band above him recall counterparts on a gold plaque from Kul'-Oba[2] and another from Oleksandropol's'kyi Kurhan.[3] On a relief from the Semybratni Kurhany, the serpent body evolves into two bird heads.[4]

Also interesting are the square plaques with palmette ornament. Although the individual elements are Greek, the design is not, partly because the openwork technique requires that the motifs be contiguous. Also setting a different tone from contemporary Greek floral ornament is the insistent continuity of the acanthus scroll, as well as the angled acanthus stalks winding into volutes. These are echoed in the plaque that decorated the bow found with the gorytos (cat. no. 155), and they find further parallels in a gold relief from the same burial (cat. no. 153).

1. See the essay by Reeder in this volume.
2. New York, *Scythians* (1975), 110, no. 75, pl. 14; Artamonov (1969b), 288, no. 256, pl. 256.
3. Artamonov (1969b), 70, 285, no. 134.
4. Artamonov (1969b), 285, no. 121, pl. 121.

154 detail

155 detail

155. PLAQUE FROM A BOW

ca. 350–325
Gold
AI, inv. no. Z-1995
From Soboleva Mohyla, near village of Hirniats'ke, Nikopol's'kyi Raion, Dnipropetrovs'ka Oblast'.
Excavated by B. M. Mozolevs'kyi and V. P. Bilozor, 1990–1991.
H: 9.9 cm; W: 6.6 cm; wt: 15.41 g.

Publications: Mozolevs'kyi (1992), 72–80; Mozolevs'kyi, Bilozor, and Vasylenko (1993), 71–72; Milan, *Tesori* (1995), 106, 197, no. 63.

The rectangular openwork plaque is framed on the long sides by a guilloche, on the shorter sides by a row of ovolos. Inside is a pattern of palmettes, a lotus bud, and scrolling acanthus leaves. Five holes on the perimeter contain fragments of the silver pins for attachment.

Originally this plaque was wrapped around the tubular hand grip of the bow associated with the gorytos cat. no. 154. The design closely resembles that on the smaller square reliefs on the gorytos and, like them, reflects a non-Greek treatment of traditional Greek motifs.

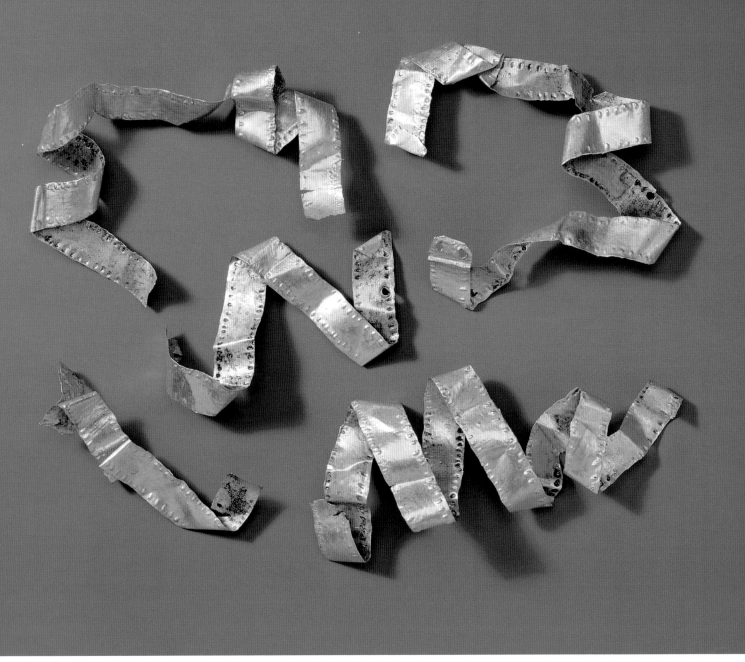

156. FIVE STRIPS FROM A WHIP

ca. 350–325
Gold
AI, inv. no. Z-1997
From Soboleva Mohyla, near village of Hirniats'ke, Nikopol's'kyi Raion, Dnipropetrovs'ka Oblast'.
Excavated by B. M. Mozolevs'kyi and V. P. Bilozor, 1990–1991.
40 x 1 cm; wt: 16.86 g. As currently folded: 5.5 x 7.3 cm; 5.8 x 1.8 cm; 6 x 3.6 cm; 6.5 x 7.3 cm; 9.2 x 4.1 cm.
Each folded piece 0.8–1.2 cm deep.

Publications: Mozolevs'kyi (1992), 72–80; Mozolevs'kyi, Bilozor, and Vasylenko (1993), 71–72; Milan, *Tesori* (1995), 105, 196, no. 60.

Thin gold strips are pierced along each side with a row of ornamental holes. Larger holes at the ends are for attachment.

These thin bands wrapped around the wooden haft of a whip that was similar to cat. no. 14.

157. TORQUE WITH LIONS

ca. 350–325
Gold
AI inv. no. Z-1825
From Soboleva Mohyla, near village of Hirniats'ke, Nikopol's'kyi Raion, Dnipropetrovs'ka Oblast'.
Excavated by B. M. Mozolevs'kyi and V. P. Bilozor, 1990–1991.
D: (at finials) 18 cm; D: (side to side) 19 cm; wt: 520.4 g.

Publications: Mozolevs'kyi (1992), 72–80; Mozolevs'kyi, Bilozor, and Vasylenko (1993), 71–72; Milan, *Tesori* (1995), 101, 195, no. 56.

The torque is cast as a unit. The spiral of heavy wire is decorated along the entire circumference by a bead-and-reel design. The finials take the form of recumbent lions, with engraved detail. The lions are shown in their full length, their over-large heads resting on outstretched paws. Their haunches and shoulders are articulated as swelling forms.

Both the quality and the wit of this piece are worthy of note. The torque extends from the lions' backs in place of tails. The bead-and-reel ornament continues completely around the spirals.

157

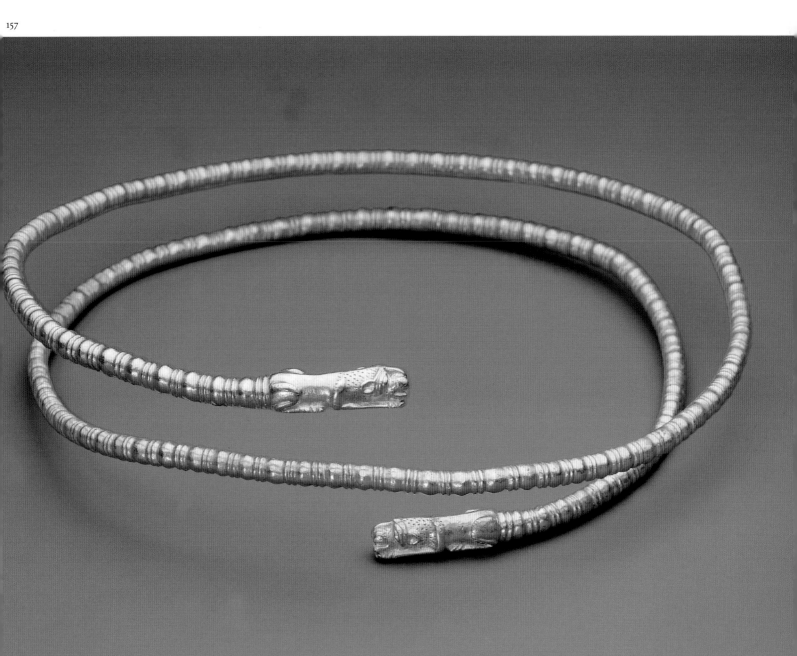

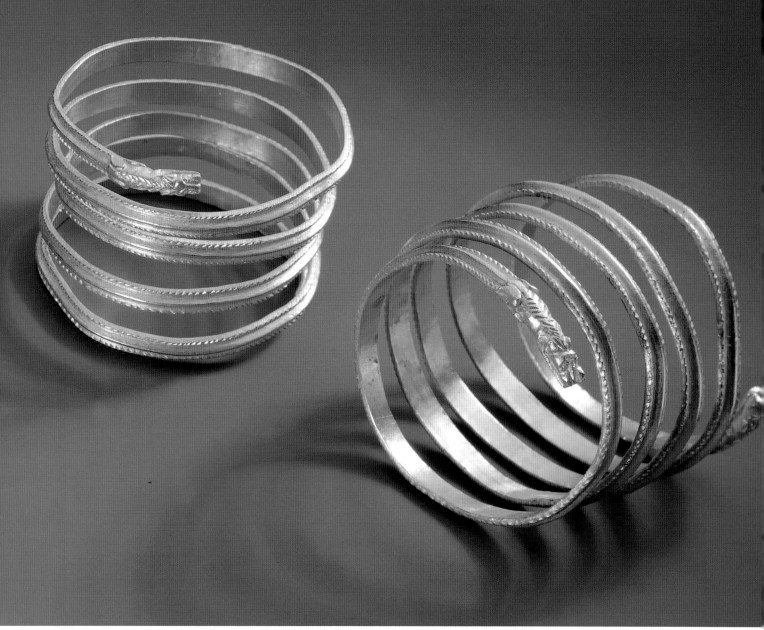

158

158. TWO SPIRAL BRACELETS WITH WOLVES

ca. 350–300
Gold
AI, inv. no. z-1829, Z-1830
From Soboleva Mohyla, near village of Hirniats'ke, Nikopol's'kyi Raion, Dnipropetrovs'ka Oblast'.
Excavated by B. M. Mozolevs'kyi and V. P. Bilozor, 1990–1991.
Bracelet (Z-1829): H: 6.9 cm; D: 6.5 cm; wt: 180.66 g. Bracelet (Z-1830): H: 6.2 cm; D: 5.8 cm; wt: 181.13 g.

Publications: Mozolevs'kyi (1992), 72–80; Mozolevs'kyi, Bilozor, and Vasylenko (1993) 71–72; Milan, *Tesori* (1995), 100, 195, no. 55.

The spiral bracelets are formed of bronze with thin overlays of gold, crimped at the edges to resemble a rope braid flanking the raised central rib. Each finial is in the form of a recumbent wolf seen from above, its head resting on extended forepaws. The hair and nose are indicated.

159. TORQUE FOR A CHILD

ca. 350–325
Gold
AI, inv. no. Z-2121
From Soboleva Mohyla, near village of Hirniats'ke, Nikopol's'kyi Raion, Dnipropetrovs'ka Oblast'.
Excavated by B. M. Mozolevs'kyi and V. P. Bilozor, 1990–1991.
D: (at finials) 8.3 cm; D: (side to side) 7.2 cm; wt: 47.57 g.

Publications: Mozolevs'kyi (1992), 72–80; Mozolevs'kyi, Bilozor, and Vasylenko (1993), 71–72; Milan, *Tesori* (1995), 102, 195, no. 57.

The torque is formed of a single unit. The spiral of plain round wire terminates in animal-head finials. Several grooves in the torque provide a transition to the band. The animal head, probably a wolf, seen from above, has long flat ears and a long nose. This torque was found around the neck of a child four or five years old.

A similar animal head appears both on a bone bow tip of the sixth to fifth century (cat. no. 34) that is associated with the Sauromatians and on a bronze bridle ornament of the sixth to fourth century that was found in eastern Kazakhstan.[1] It appears, therefore, that the motif has deep roots in the art of Central Asia.

1. Mantua, *L'uomo d'oro* (1988), 157, nos. 211–13.

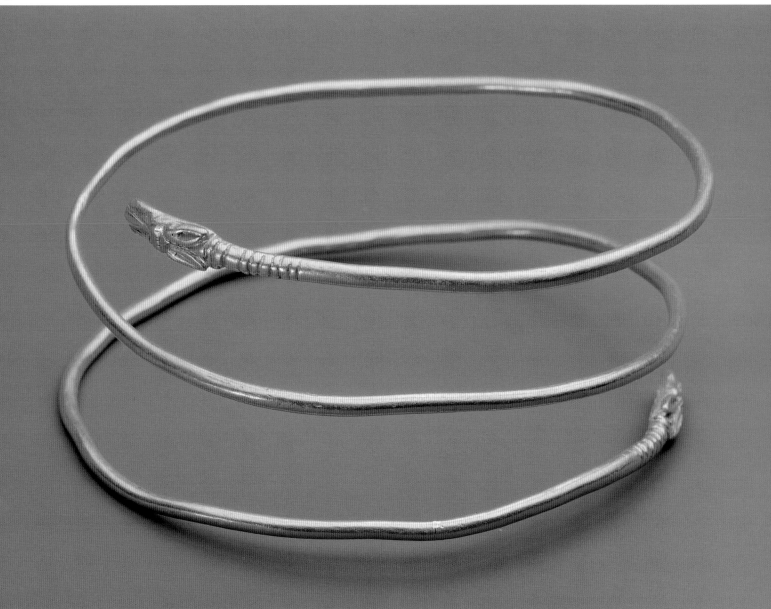

160. TWO RINGS

ca. 350–325
Gold
AI, inv. no.z-1827 (undecorated), z-1826 (decorated)
From Soboleva Mohyla, near village of Hirniats'ke, Nikopol's'kyi Raion, Dnipropetrovs'ka Oblast'.
Excavated by B. M. Mozolevs'kyi and V. P. Bilozor, 1990–1991.
Decorated ring (Z-1826): L: 2.72 cm; W: 2.4 cm; wt: 25.8 g. Undecorated ring (Z-1827): L: 2.35 cm; W: 2.3 cm; wt: 16.8 g.

Publications: Mozolevs'kyi (1992), 72–80; Mozolevs'kyi, Bilozor, and Vasylenko (1993), 71–72; Milan, *Tesori* (1995), 103, 195, no. 58.

The ring with the smooth oval bezel has an adjustable hoop of two tapered, overlapping bands. The second ring is formed of a wide hoop and a domed bezel that is devoted entirely to a relief scene of animal combat. A lion, seen in left profile, arcs its body over its victim, which it holds in place with its extended left paw. The lion's head, eyes, and mane are prominent. The identity of the prey cannot be distinguished.

The Scythian predilection for a mass of intertwined forms that create an allover textured surface is also evident in the gold finial (cat. no. 136).

160

161. PLAQUES WITH ROSETTES AND WINGED BEINGS

ca. 350–325
Gold
AI, inv. no.z-1831–1967
From Soboleva Mohyla, near village of Hirniats'ke, Nikopol's'kyi Raion, Dnipropetrovs'ka Oblast'.
Excavated by B. M. Mozolevs'kyi and V. P. Bilozor, 1990–1991.
D: 2.6–2.8 cm each; total wt: 182.63 g.

Publications: Mozolevs'kyi (1992), 72–80; Mozolevs'kyi, Bilozor, and Vasylenko (1993), 71–72; Milan, *Tesori* (1995), 104, 195–96, no. 59.

The relief appliques are in three designs. Some plaques are in the form of a single nine-petaled rosette centered around a boss. Each of the other two types of appliques depicts a winged being in left profile. It has the curling, scaly tail of a sea monster, with a spiny crest running along its neck, and its feathers and scales are indicated. On some of these the head is that of an eagle; on others the head resembles that of a feline. Each plaque has four punched holes for attachment.

Inspiration for the winged beings undoubtedly lies in the art of the ancient Near East.[1]

1. See the essay by Reeder in this volume.

Following pages: 162, 163

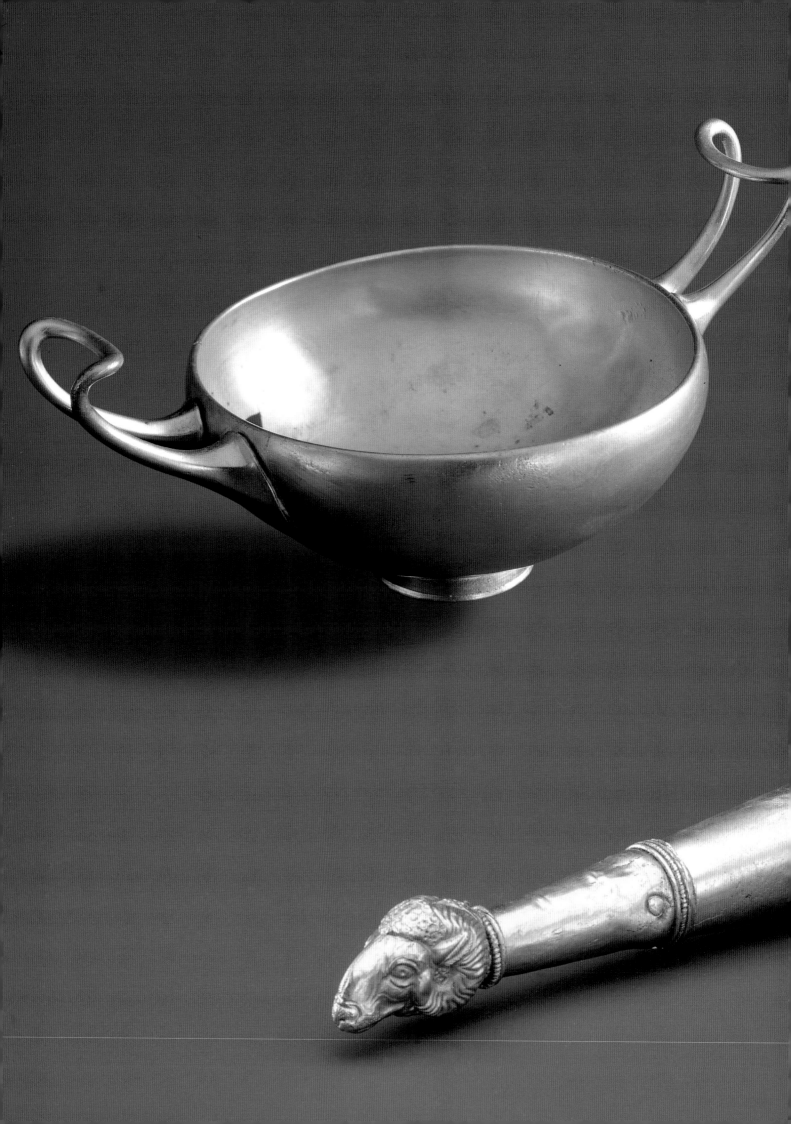

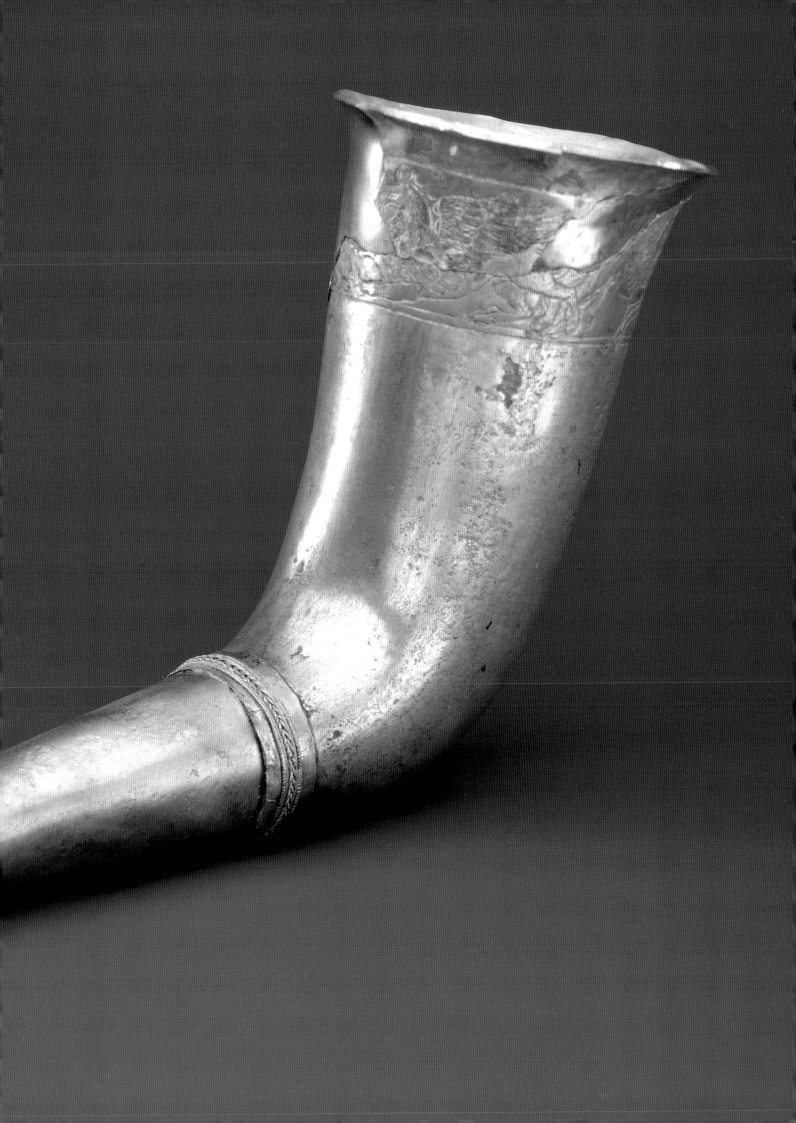

162. KYLIX

ca. 350–325
Silver
AI, inv. no. KP-V-659
From Soboleva Mohyla, near village of Hirniats'ke, Nikopol's'kyi Raion, Dnipropetrovs'ka Oblast'.
Excavated by B. M. Mozolevs'kyi and V. P. Bilozor, 1991–1992.
H: (cup without handles) 4.5 cm; L: (overall) 17.5 cm; D: (cup) 10.6 cm; H: (overall) 7.3 cm; wt: 86.64 g.

Publications: Mozolevs'kyi (1992), 72–80; Mozolevs'kyi, Bilozor, and Vasylenko (1993), 71–72;
Katowice, *Koczownicy* (1996), 181, 228–29, no. 28.2.

The thin-walled silver kylix has a separately cast and soldered ring base. Its solid round, U-shaped handles curl up, and then in toward the bowl, rising above the level of the rim. The handles attach to the body of the vessel with leaf-like extensions. A silver kylix with similar handles was found in Macedonia.[1]

1. Thessalonika, *Treasures* (1978), 107, no. 462, pl. 61.

163. DRINKING HORN

ca. 350–325
Silver, gold
AI, inv. no. KP-V-660
From Soboleva Mohyla, near village of Hirniats'ke, Nikopol's'kyi Raion, Dnipropetrovs'ka Oblast'.
Excavated by B. M. Mozolevs'kyi and V. P. Bilozor, 1991–1992.
Max. dimension 27 cm; D: (mouth) 6.5–8.5 cm; L: (ram's head) 2.2 cm; wt: 285.79 g.

Publications: Mozolevs'kyi (1992), 72–80; Mozolevs'kyi, Bilozor, and Vasylenko (1993), 71–72;
Katowice, *Koczownicy* (1996), 182, 228–29, no. 28.3.

The silver drinking horn has a gold ram-head finial, with beaded border. Gold strips beneath a band of braided wire mask and decorate the joins where the conical mid-section is attached. The rim of the vessel flares out slightly. The neck is engraved with a scene of two griffins back-to-back. One griffin attacks a spotted leopard, which is preceded by another spotted leopard. Traces of gilding were found over the vessel's surface.

A similar drinking horn was found in Kul'-Oba.[1] Also comparable are an example from the Semybratni Kurhany[2] and the drinking horn, cat. no. 116. Similarities in the treatment of the leopard here and on another vessel found in Soboleva Mohyla (cat. no. 164) have led Treister to suggest that the two were made in the same workshop or by the same craftsman.

Similar vessels are still used in the Caucasus, where the drinker's left hand holds the elbow of the horn, while the right hand steadies the tip.

1. Artamonov (1969b), 288, no. 251, pl. 251.

1. Vienna, *Skythen* (1988), 81, no. 42.

164. VESSEL WITH ANIMAL COMBAT

ca. 350–325
Silver, gilding
AI, inv. no. KP-V-661
From Soboleva Mohyla, near village of Hirniats'ke, Nikopol's'kyi Raion, Dnipropetrovs'ka Oblast'.
Excavated by B. M. Mozolevs'kyi and V. P. Bilozor, 1991–1992.
H: 10.5 cm; D: 10.5 cm; D: (mouth) 6.1 cm; wt: 228.11 g.

Publications: Mozolevs'kyi (1992), 72–80; Mozolevs'kyi, Bilozor, and Vasylenko (1993), 71–72;
Katowice, *Koczownicy* (1996), 183–84, 228–29, no. 28.4.

Opposite: 164

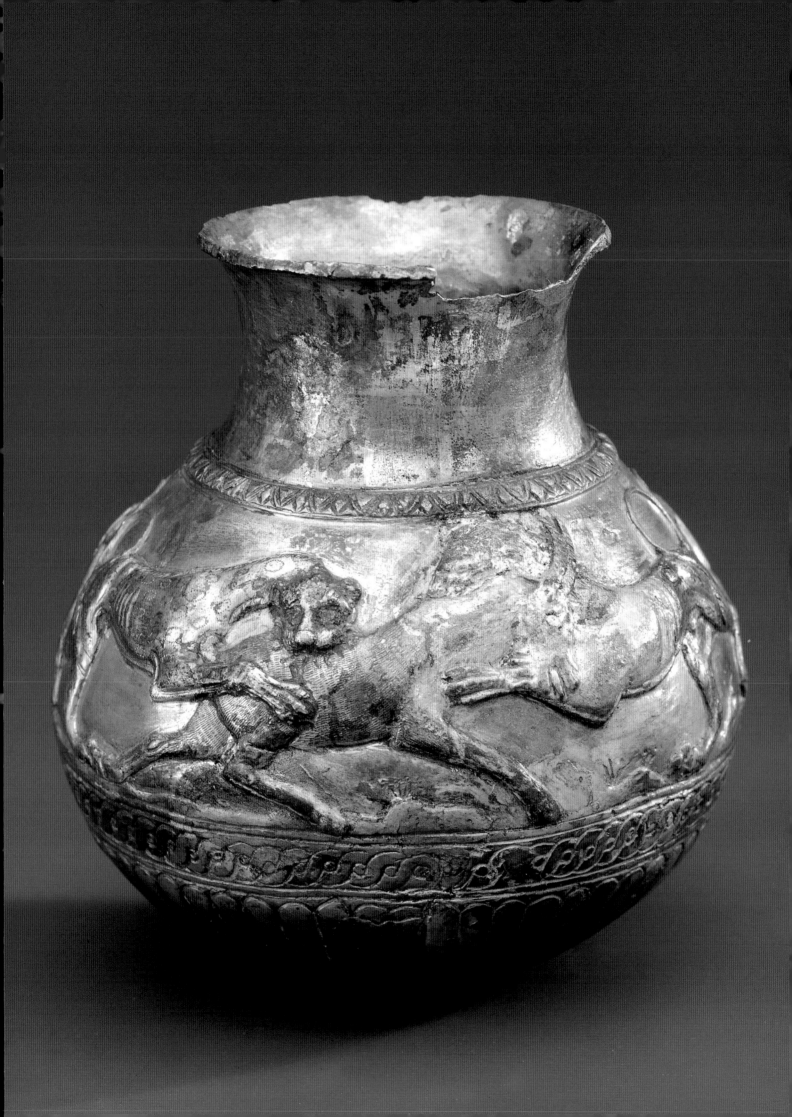

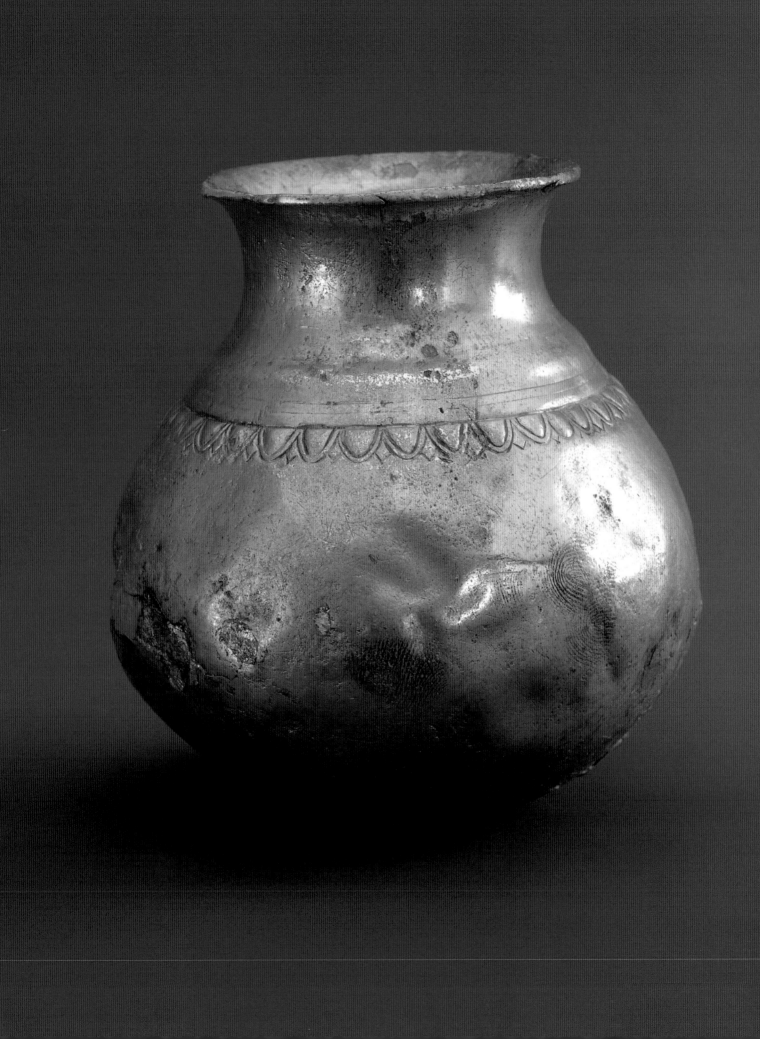

The silver vessel has a round bottom and a short flaring neck. A relief band around the body of the vase depicts two pairs of animals in combat. In the first pair, two lions attack a horse. The tail of the horse flares out in three long wavy locks. The heads of the lions are frontal. In the second combat pair, a lion, again with a frontal mask-like face, and a spotted leopard with articulated ribs, attack a horned ibex. The animals stand on a rocky groundline, from which emerge engraved plants. The stances of the animals are elongated and their long tails arc into high loops to fill the field. Above this scene is a raised band of ovolos. Below is a guilloche with dotted centers between two raised bands. The base of the vessel is decorated with tongues. There is gilding on the guilloche, relief figures, and on the neck of the vessel.

Vessels of similar shape and decorated with friezes of animal combat were found in Kul'-Oba.[1] The flaring horse tail seen here recalls the antlers that extend as palmette leaves on cat. no. 153. The rocky groundline and small plants are similar to those on the helmet from Perederiieva Mohyla (cat. no. 124). Even closer is the treatment of the spotted leopard, which so closely resembles the feline on a drinking horn (cat. no. 163), also found in Soboleva Mohyla, that Treister has suggested a single workshop or artisan was responsible for both pieces.

1. Artamonov (1969b), 287, no. 242, pls. 242, 245, 246; and 287, no. 241, pls. 241, 243, 244.

165. VESSEL

ca. 350–325
Silver, gilding
AI, inv. no. KP-V-661-A
From Soboleva Mohyla, near village of Hirniats'ke, Nikopol's'kyi Raion, Dnipropetrovs'ka Oblast'.
Excavated by B. M. Mozolevs'kyi and V. P. Bilozor, 1991–1992.
H: 9 cm; D: 8.3 cm; D: (mouth) 5.4 cm; wt: 113.91 g.

Publications: Mozolevs'kyi (1992), 72–80; Mozolevs'kyi, Bilozor, and Vasylenko (1993), 71–72;
Katowice, *Koczownicy* (1996), 181, 228, no. 28.1.

The silver vessel has a spherical body and a short neck with an out-turned rim. A clumsy ovolo is engraved at shoulder level, below a convex swelling.

A form without Greek parallels, this vessel may be of a traditional Scythian type. Its size and shape are such that it fits comfortably in the palm of the hand.

166. SET OF HORSE TRAPPINGS

ca. 350–325
Silver
AI, inv. no. KP-V-664/1, 2; 663/1–2; 662/1–2, 665/1
From Soboleva Mohyla, near village of Hirniats'ke, Nikopol's'kyi Raion, Dnipropetrovs'ka Oblast'.
Excavated by B. M. Mozolevs'kyi and V. P. Bilozor, 1990–1991. Reconstruction by S. V. Polin.
Largest pieces (KP-V-662/1,2): H: 6.5 cm; W: 4.2 cm; Roundels (KP-V-663/1,2; KP-V-664/1,2): D: 5–5.5 cm.
Larger piece (KP-V-665/1): H: 11 cm; W: 6.5 cm; wt: 23.2 g, 21.9 g, 27.2 g, 26.3 g, 56.5 g, 61.2 g, 64.1 g.

Publications: Mozolevs'kyi (1992), 72–80; Mozolevs'kyi, Bilozor, and Vasylenko (1993), 71–72;
Milan, *Tesori* (1995), 105, 196, no. 61; Rimini, *Mille* (1995), 78, nos. 46 and 47.

Opposite: 165

The silver ornaments include an engraved noseband plate with a cast protome, two large and two small roundels (phalerae), and two openwork cheekpieces. The protome depicts a mythical creature with large ears and an open mouth full of teeth. The base of its neck provides a slot for attachment to the leather bridle. Each roundel has two silver rivets attaching bronze loops on the reverse through which the bridle straps passed. Both large and small roundels show evidence of deliberate damage. The rectangular cheekpieces have scalloped edges and engraved patterns. Their triangular and crescent-like cutouts represent back-to-back animal heads (felines?). Each head has eye-like bosses. Four pins on each plaque were used for attachment.

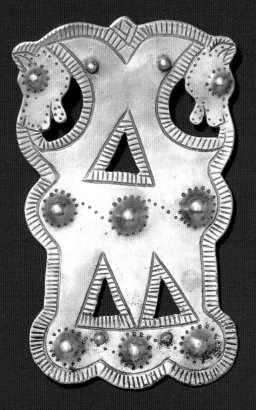
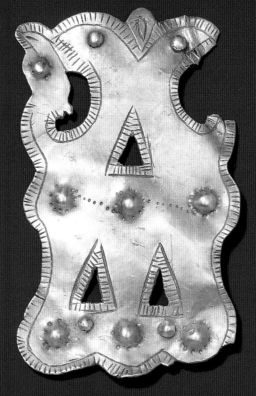

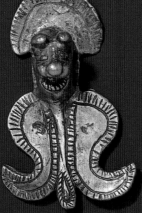

The deliberate damage inflicted on the roundels has been associated with burial rites that "killed" the objects.

The rectangular elements, with their schematic suggestion of reversed animal heads, compare with an elaborate silver plaque from Krasnokuts'kyi Kurhan.[1] The triangular lower extensions of the animals are not dissimilar to the triangular cut-out designs on the gold gorytos (cat. no. 154). The protome finds parallels on other bridle attachments from Soboleva Mohyla (cat. no. 167) and a bridle set from Kurhan Ohuz (cat. no. 32).

1. Artamonov (1969b), 67, 285, no. 128.

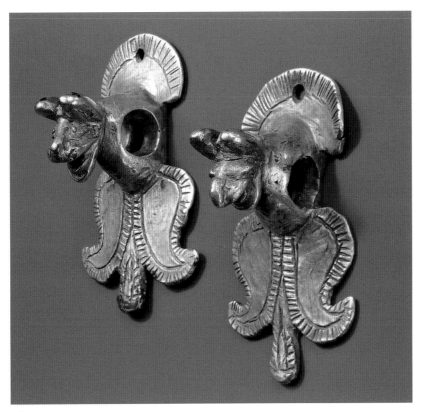

167

167. TWO PLAQUES FROM A BRIDLE

ca. 350–325
Silver
AI, inv. no. KP-V-665/2–3
From Soboleva Mohyla, near village of Hirniats'ke, Nikopol's'kyi Raion, Dnipropetrovs'ka Oblast'.
Excavated by B. M. Mozolevs'kyi and V. P. Bilozor, 1990–1991.
Plaque (KP-V-665/2): H: 6.5 cm; W: 3.9 cm; wt: 64.1 g. Plaque (KP-V-665/3): H: 6.1 cm; W: 3.6 cm; wt: 61.9 g.

Publications: Mozolevs'kyi (1992), 72–80; Mozolevs'kyi, Bilozor, and Vasylenko (1993), 71–72;
Milan, *Tesori* (1995), 105, 196, no. 61; Rimini, *Mille* (1995), 78, no. 46.

Opposite: 166

Each cast-silver bridle plaque has an animal-head protome on an engraved plate, one end of which is in the form of a simplified lotus-like blossom with central bud, the other a fan-shaped extension. The feline heads are fully in the round, with large protruding ears and open mouths full of teeth. The heads are cast as part of a ring, leaving a hole through the center of which the leather bridle straps passed. A hole has been punched through the fan-shaped extension. The size and detail of the two cast heads vary slightly, and one shows evidence of having been deliberately damaged, perhaps as part of burial rites. In the same kurhan was found a set of bridle ornaments that included an element identical to the two seen here; the plaque belonging to the set is cat. no. 166. Still another similar example forms part of a bridle set from Ohuz Kurhan (cat. no. 32).

168. TORQUE

Late 1st–early 2nd c. A.D.
Gold, glass
MHTU, inv. no. AZS-2853
Sarmatian
From Nohaichyns'kyi Kurhan (Kurhan 5), burial 18, near village of Chervone, Nyzhnehirs'kyi Raion, Krym.
Excavated by A. O. Shchepyns'kyi, 1974.
H: 10.2 cm; D: 14 cm; wt: 918 g.

Publications: Shchepyns'kyi (1977), 75–77, no. 10, fig. 4; Turku, *Skyyttien* (1990), 35, 50, no. 109; Schleswig, *Gold* (1991), 325, no. 145; Tokyo, *Scythian Gold* (1992), 108, no. 123; Edinburgh, *Warriors* (1993), 40, no. 65; Simonenko (1993), 71, 88, figs. 1–3; Toulouse, *L'or* (1993), 86, no. 72; Vienna, *Gold* (1993), 212–15, no. 60; Milan, *Tesori* (1995), 137, 200, no. 82; Luxembourg, *TrésORS* (1997), 102, cat. 59; Vicenza, *Oro* (1997), 91, no. 47.

The torque is formed of a heavy round rod shaped into a three-turn spiral with curved relief plaques soldered on the ends. Each plaque is decorated with a row of closely juxtaposed crouching or sitting beasts, which are fully worked on both front and back surfaces. Some of the animals are griffins with upwardly curving wings; others resemble felines. The eyes are inlaid with opaque blue glass, and the bodies bear incised lattice and hatched patterns. Some noses and manes are rendered by ribbing. The profile heads of two animals are worked so that the forms can also be read as a single animal face.

The torque was found in the burial of a woman. Although obviously an expensive and luxurious object, it shows no sign of wear, and thus may have been made specifically for funeral use. This impression is reinforced by the torque's unusually small diameter; it is too narrow to go on easily over the head. Archaeologists date the Nohaichyns'kyi Kurhan to the period when powerful nomads, probably the Sarmatian tribe of the Alany, swept into the area north of the Black Sea from the east. A characteristic feature of Sarmatian art was a preference for the kind of turquoise inlays seen here. Works in the so-called gold-turquoise animal style, including this torque and the similarly fashioned bracelets discovered in the royal mound of Khokhlach near Novocherkas'k,[1] may have been manufactured in a Central Asian workshop.[2]

This piece was found together with cat. nos. 169–171.

1. Vienna, *Skythen* (1988), 237, no. 155, and 238–39, no. 156. For other Sarmatian torques from the lower reaches of the Don, see Gougouev (1994), 76–78.

1. See also Treister and Yatsenko (1997/98), 51–106.

168 detail

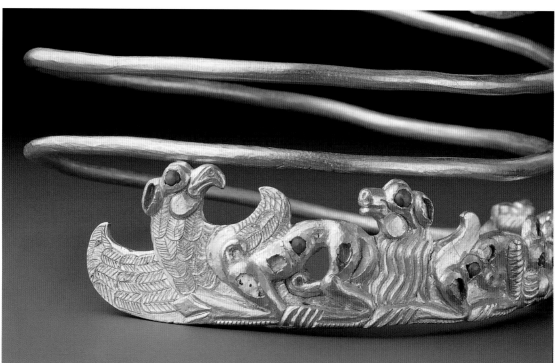

Opposite: 168

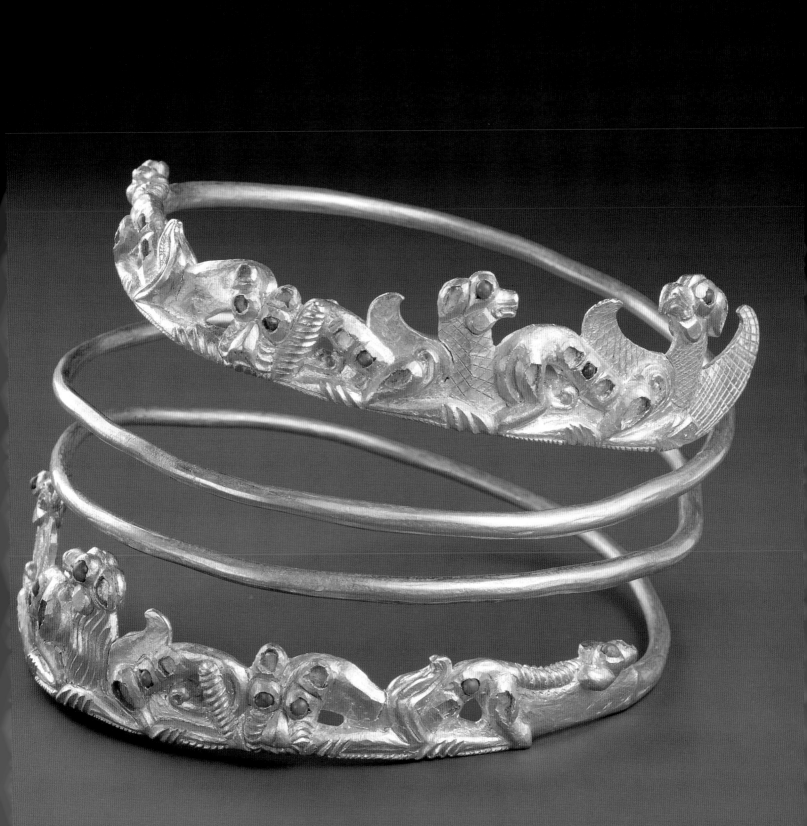

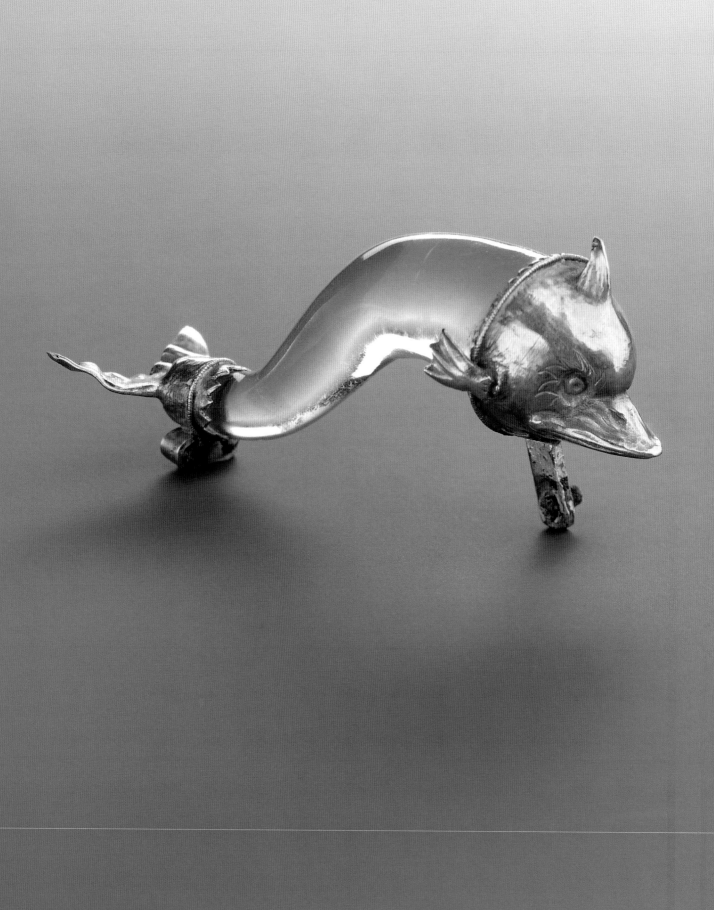

169. DOLPHIN FIBULA

Late 1st–early 2nd c. A.D.
Gold, bronze, rock crystal
MHTU, inv. no. AZS-2878
Sarmatian
From Nohaichyns'kyi Kurhan (Kurhan 5), burial 18, near village of Chervone, Nyzhnehirs'kyi Raion, Krym.
Excavated by A. O. Shchepyns'kyi, 1974.
L: 7.8 cm; wt: 29.7 g.

Publications: Shchepyns'kyi (1977), 75–77, no. 10, fig. 4; Turku, *Skyyttien* (1990), 37, 50, no. 110; Schleswig, *Gold* (1991), 325, no. 146; Tokyo, *Scythian Gold* (1992), 108, no. 124; Edinburgh, *Warriors* (1993), 40, no. 66; Simonenko (1993), 73, 85, figs. 17, 18; Toulouse, *L'or* (1993), 87, no. 73; Vienna, *Gold* (1993), 216–17, no. 61; Milan, *Tesori* (1995), 138, 200, no. 84; Luxembourg, *TrésORS* (1997), 104, no. 60; Vicenza, *Oro* (1997), 92, no. 48.

The bow-shaped fibula takes the form of a dolphin, with gold head and tail sections fitted over a body of polished rock crystal. There are fins on the top and both sides of the head. The deep eyes have an indented pupil and are ringed by engraved lines. The head section is finished by a beaded wire and scalloped edge. A plate under the chin held the spring pin. The tail section, with a horizontal fluke, overlaps the body with a dog-tooth border, followed by a beaded wire. Below the tail are remains of the clasp.

The dolphin was a popular motif in jewelry and other arts. Through numerous accounts of dolphins rescuing swimmers and lost sailors, the animals came to serve as a symbol of selfless goodwill and friendship.

This gold and rock crystal dolphin appears to be unique. Among its closest parallels are the gold and crystal lynxes in a necklace from Olbia, now in the Walters Art Gallery.[1]

This fibula was found together with cat. nos. 168, 170, and 171.

1. Reeder (1988), 236–67, no. 132. The necklace is usually dated to the 1st c. B.C., but see recently, Treister (1997/98), 49–62, for a date in the 1st c. A.D.

170. FIBULA

1st–2nd c. A.D.
Gold, with inlays of garnet and glass
MHTU, inv. no. AZS-2864
Sarmatian
From Nohaichyns'kyi Kurhan (Kurhan 5), burial 18, near village of Chervone, Nyzhnehirs'kyi Raion, Krym.
Excavated by A. O. Shchepyns'kyi, 1974.
D: 5.4 cm; wt: 23.03 g.

Publications: Edinburgh, *Warriors* (1993), 41, no. 67; Simonenko (1993), 72, fig. 12; Toulouse, *L'or* (1993), 88, no. 74; Vienna, *Gold* (1993), 218–19, no. 62; Milan, *Tesori* (1995), 138, 200, no. 83.

Opposite: 169

The round fibula is formed of a thin gold plate with a large central rosette of pointed petals around a green glass inlay in a dog-tooth setting. Beaded wire outlines each petal and forms a filigree pattern on the plate below them. Outside the rosette and separated by plain wire are two concentric bands that contain cones topped by tiny beads. Six settings for stones, five tear-dropped and one in the shape of an ivy leaf, are spaced around the fibula; garnet inlays remain in three of the teardrop settings and in the one ivy-leaf setting. A beaded wire runs around the circumference outside of four evenly spaced pairs of holes. Along one side are ten small coils of wire.

Fibulas were worn on garments both as clasps and decoration. This one is typical of the so-called polychrome style that became widely popular in the Pontic region during the early centuries A.D. after the arrival of Sarmatian tribes. The vogue for jewelry with multi-colored stones had arisen in the eastern Greek world during the Hellenistic period, and the Bosphoran kingdom became a prominent center for its production. The ten rings along the lower edge of the fibula were intended to hold pendants. The fibula was found together with cat. nos. 168, 169, and 171.

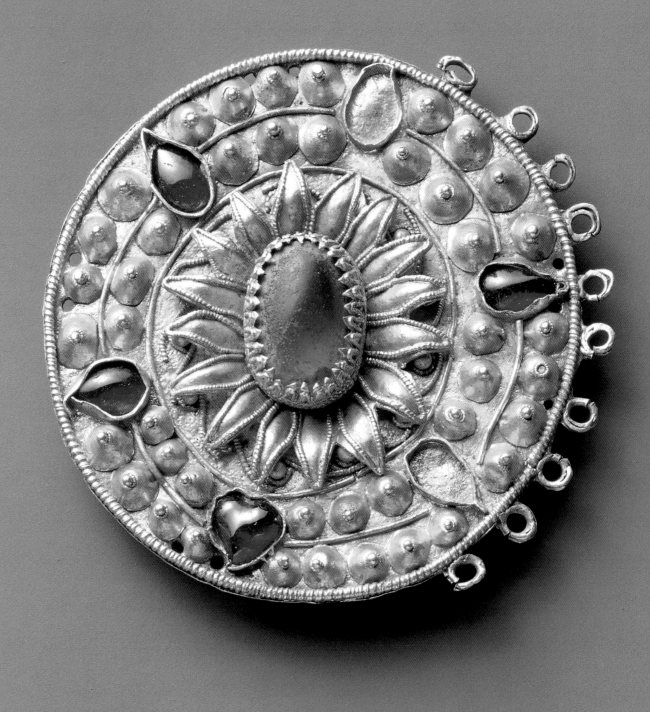

171

171. FINGER RING

1st–2nd c. A.D.
Gold, carnelian
MHTU inv. no. AZS-2866
Sarmatian
From Nohaichyns'kyi Kurhan (Kurhan 5), burial 18, near village of Chervone, Nyzhnehirs'kyi Raion, Krym.
Excavated by A. O. Shchepyns'kyi, 1974.
L: 3.5 cm; W: 3 cm; wt: 10.7 g.

Publications: Shchepyns'kyi (1977), 75–77; Schleswig, *Gold* (1991), 325, no. 147; Tokyo, *Scythian Gold* (1992), 109, no. 126;
Simonenko (1993), 73, 89, pl. 21.

.

The massive gold band increases in thickness toward the bezel, which is set with a carnelian intaglio of the profile head of a woman.

The shape of this ring was common in the third and second century B.C., but this rather clumsy example was probably made several centuries later for a Sarmatian customer.

This ring was found together with cat. nos. 168–170.

171

Opposite: 170

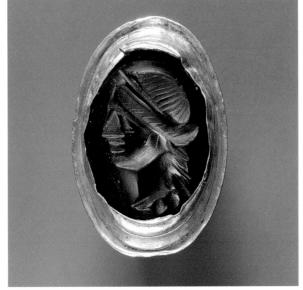

172. PECTORAL

Mid-4th c.
Gold, enamel(?)
MHTU, inv. no. DNF-4
From Tovsta Mohyla, near Ordzhonikidze, Dnipropetrovs'ka Oblast'.
D: 30.6 cm.

Publications: Hanina (1974), figs. 37–46; Sokolov (1974) 45, fig. 25; New York, *Scythians* (1975), 126, no. 171; Piotrovsky, Galanina, and Grach (1987), 95, no. 118; Turku, *Skyyttien* (1990), 32–33, 54, no. 94; Tokyo, *Scythian Gold* (1992), 75, no. 67; Edinburgh, *Warriors* (1993), 37–39, no. 64; Toulouse, *L'or* (1993), 83, no. 71; Vienna, *Gold* (1993), 199–211, no. 59; Schiltz, *Scythes* (1994), 54–55, 58–59, 368–69, 412–13; Jacobson (1995), 100–02, no. II.A.1, fig. 11; Milan, *Tesori* (1995), 181–83, 190, no. 33; Edwards (1996), 64–65; Katowice, *Koczownicy* (1996), 190–91, 230, no. 38; Luxembourg, *TrésORS* (1997), 75, no. 20; Vicenza, *Oro* (1997), 55–57, no. 12.

Four hollow tubes of twisted gold are arranged in concentric arcs to form a crescent enclosing three registers. The tubes are graduated in size, with the largest on the outside, and at each end they are enclosed by a collar attached to a hinge. The collar is decorated with braiding, and with a row of filigree ovolo beneath a wider band of lotus and palmette. Above the hinge, braided wire is banded below with a border of acanthus scroll and above with lotus and palmette. Each terminal has the form of a lion head beneath a row of beading.

In the center of the lowest register three groups are worked in the round; each group comprises two griffins attacking a horse. On each side of these combats are two more: on the viewer's right, a leopard and a lion attack a boar; on the other side a lion and leopard bring down a stag. On each end the narrowing arcs are filled with a hound in pursuit of a hare; and, finally, in each corner, two insects.

The middle register consists of a gold plate, soldered in place. Worked in the round or in high relief are: a band of volute scroll emerging from an acanthus plant in the center; palmettes, rosettes, five birds, and blossoms, of which several still retain their blue enamel inlay.

In the center of the topmost register two kneeling men stitch a fleece between them. They have long hair to the shoulders, bare upper bodies, trousers, and shoes. In the field above them hangs a gorytos, another upon the twisted border beneath. On either side of them is a horse with a foal, one of them nursing. On the other side of the horses are a cow and its calf, one of them nursing. Next follows on each side a kneeling Scythian with a sheep, one of them milking, the other holding an amphora. Beside them are a goat with its young, and, in each corner, a bird.

Although the form of the pectoral may have originated in the Near East, this example is unique in its workmanship and subject matter. Distinctively Greek is the exquisite vegetal ornament of the middle register as well as the fine filigree technique and patterns of the collars and terminals. The pectoral was probably worked by a Greek goldsmith in a workshop in Pantikapaion, who created a variant on the traditional openwork technique by working the figures entirely in the round. The pectoral is certainly a commissioned piece, and thus reflects input from its Scythian owner; however, the emphasis on domesticity, fertility, and the small-scale animal life of the steppes is in stark contrast to the subjects more conventionally encountered on objects from Scythian burials. Also interesting is the emphasis on symmetry, surely a Greek contribution, and the ordering of the subject matter, which is less easy to attribute. The violent and mythic world of the outer register gives way on the inner frieze to the tranquil environment of Scythian daily life. This system of organization can be compared with that of the gold finial, cat no. 136.[1]

1. See the comments in essays by Treister and Reeder in this volume.

Opposite and following pages: 172

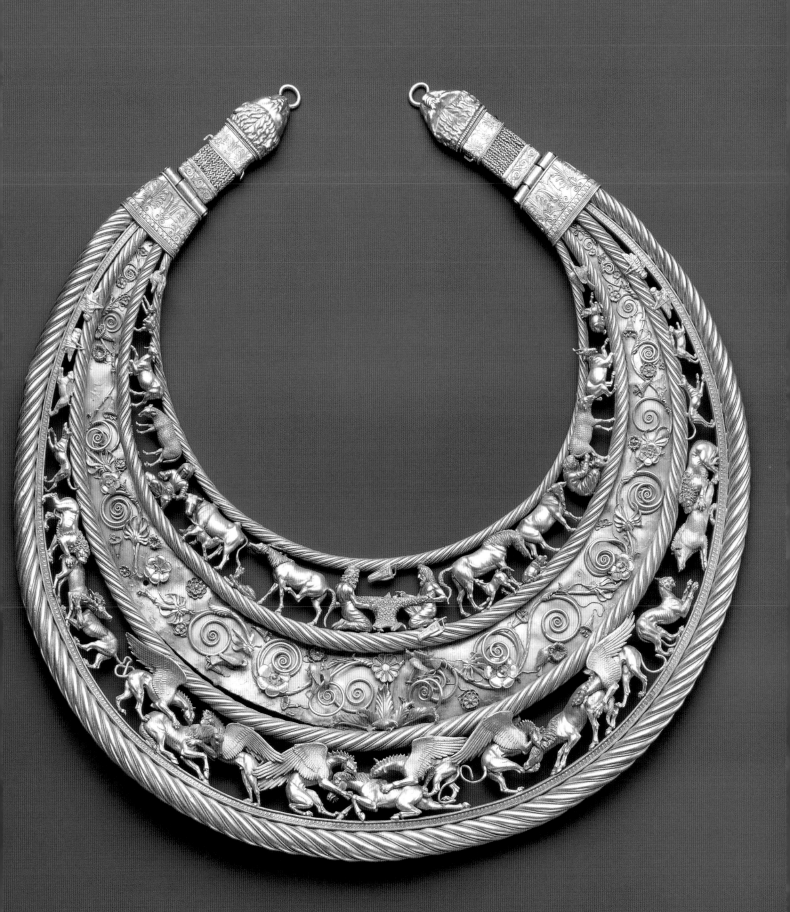

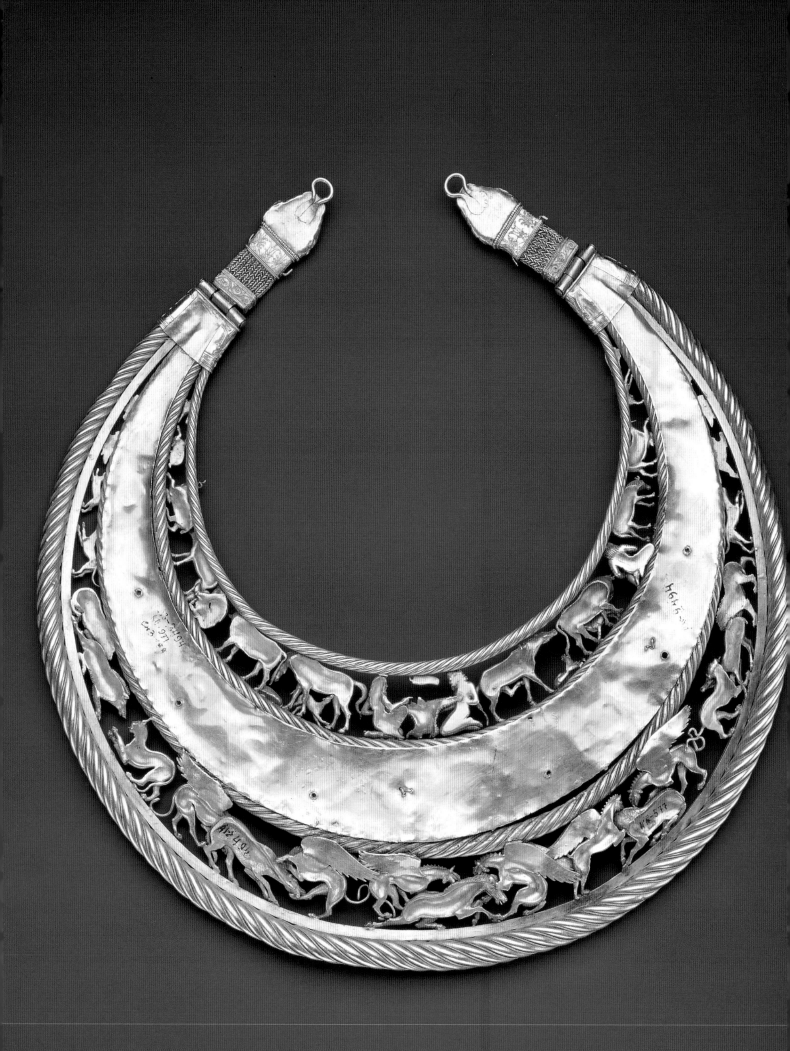

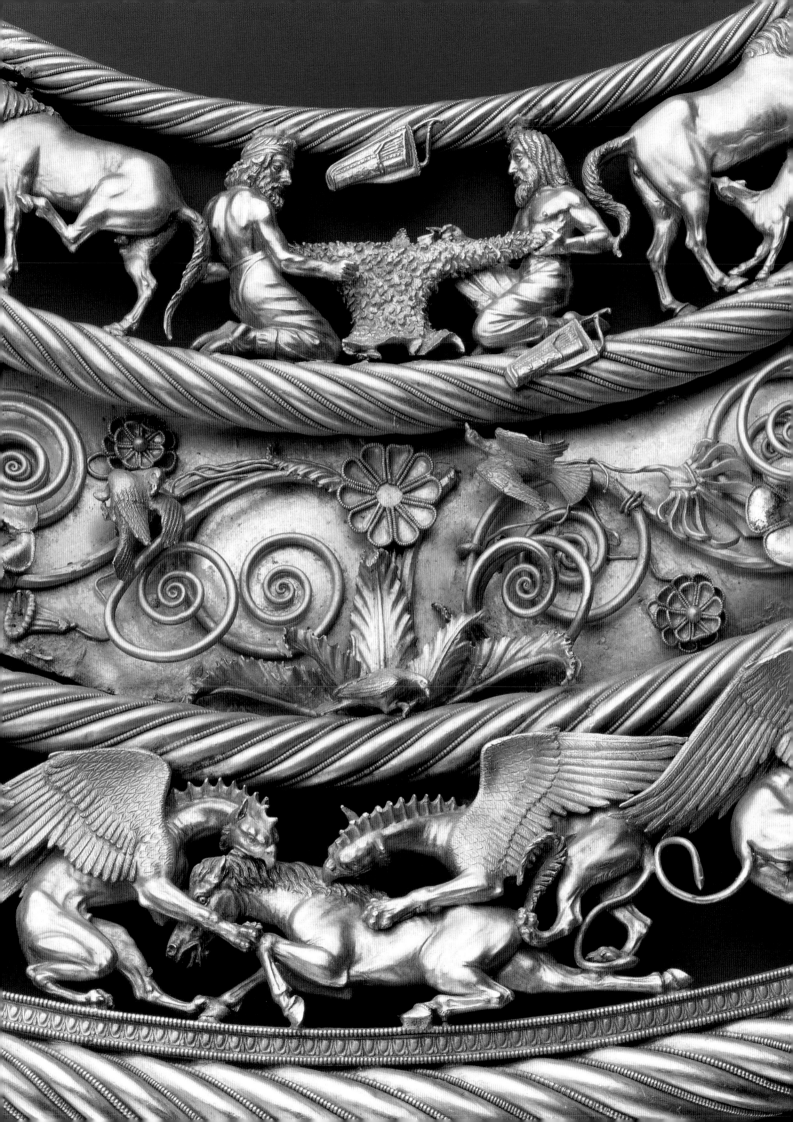

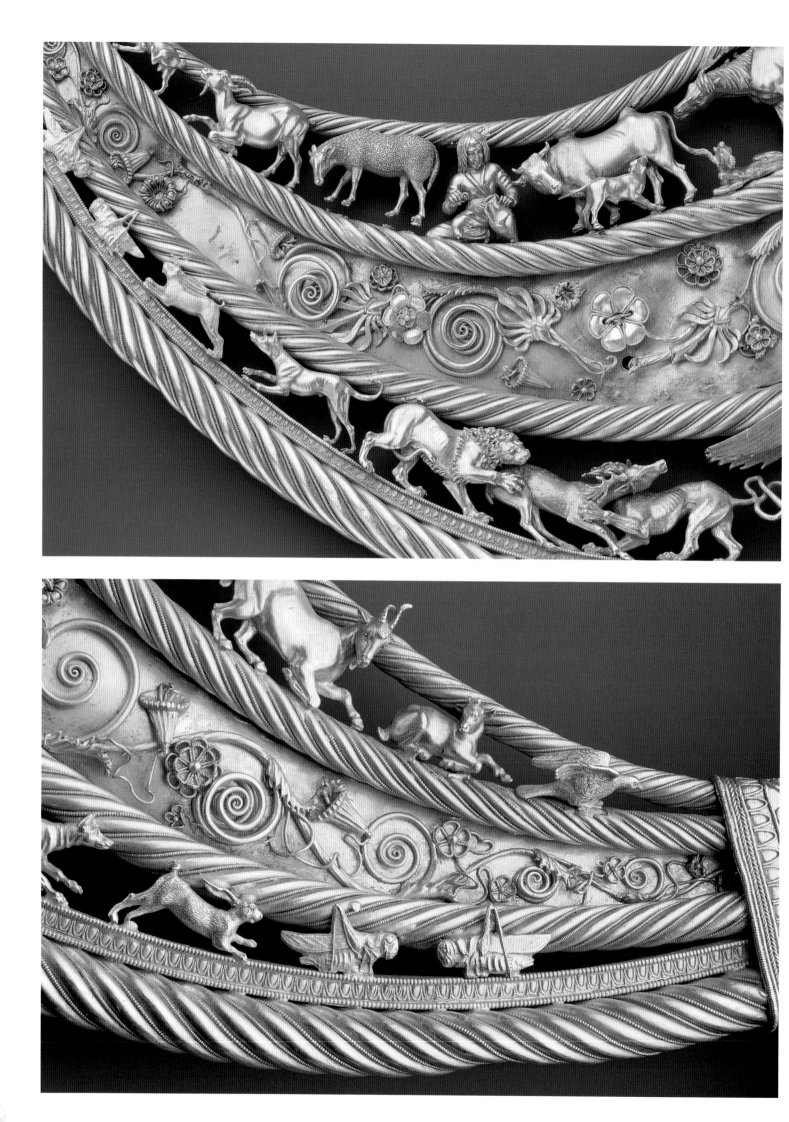

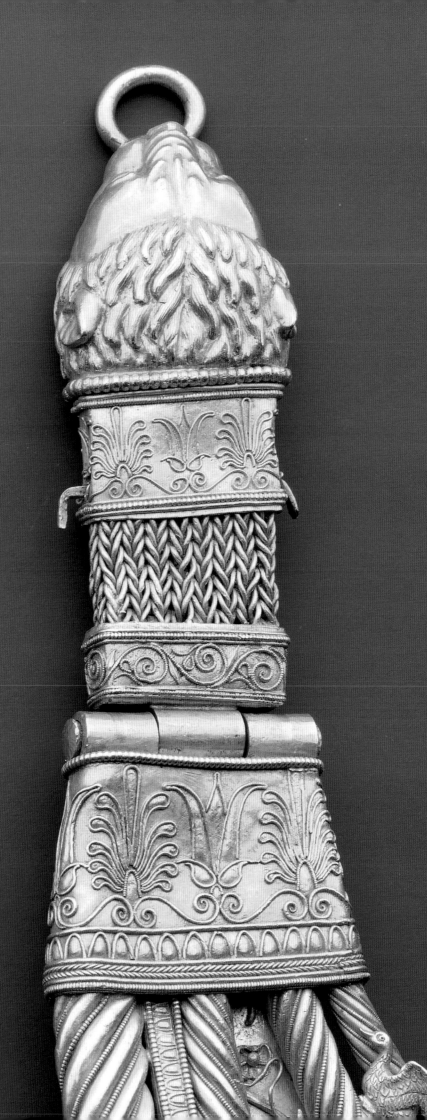

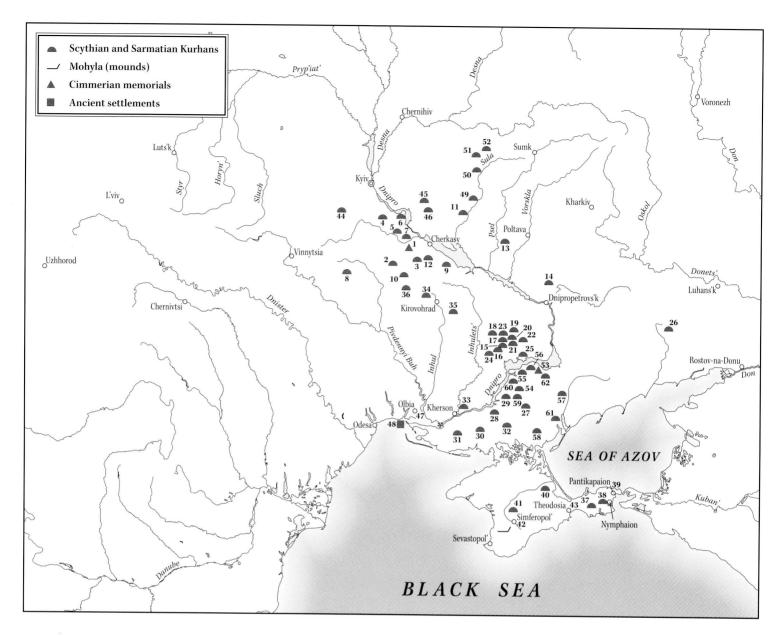

Legend:
- Scythian and Sarmatian Kurhans
- Mohyla (mounds)
- Cimmerian memorials
- Ancient settlements

Map labels: Pryp'iat', Desna, Desna, Voronezh, Chernihiv, Luts'k, Sula, 52, 51, Sumk, Horyn', Styr, Sluch, 50, Kyiv, Dnipro, 45, 49, 11, Vorskla, Kharkiv, L'viv, 44, 46, Oskol, Don, 4, 5, 6, 7, Psel, Poltava, Uzhhorod, Vinnytsia, 1, Cherkasy, 13, Donets', 2, 3, 12, 9, 14, Luhans'k, Chernivtsi, 8, 10, 36, 34, Kirovohrad, 35, Dnipropetrovs'k, 26, Dnister, Inhulets', 18 23 19 20 22, 17, Rostov-na-Donu, Pivdennyi Buh, 15 21 25 56, Inhul, 24 16, 53, Don, 55 62, 60 54, 33, Dnipro, 57, Olbia, Kherson, 29 59 27, 61, Odesa, 48, 47, 28, 32, 58, 31, 30, SEA OF AZOV, Pantikapaion, 39, 40, 37 38, Kuban', 41, Theodosia, 43, Nymphaion, Simferopol', 42, Sevastopol', BLACK SEA, Danube

EXCAVATION SITES OF OBJECTS IN THE EXHIBITION

CHERKAS'KA OBLAST'

1. Kurhan no. 1, burial no. 3, near the village of Vil'shany, Horodyshchens'kyi Raion. Find-spot site for cat. no. 1.
2. Velykyi Ryzhaniv'skyi Kurhan, near the village of Ryzhanivska, Zvenyhorods'kyi Raion. Find-spot for cat. no. 94.
3. Near village of Pastyrs'ke, Smilians'kyi Raion. Find-spot for cat. nos. 56 (Halushchyne Urochyshche) and 91 (Kurhan no. 2).
4. Kurhan no. 4, near the village of Berestniahy, Kanivs'kyi Raion. Find-spot for cat. nos. 12 and 53.
5. Kurhan no. 100, Mohyla Ternivka, near the village of Syniavka, Kanivs'kyi Raion. Find-spot for cat. no. 43.
6. Kurhan no. 35, near the village of Bobrytsia, Kanivs'kyi Raion. Find-spot for cat. nos. 22 and 45.
7. Kurhan no. 2, near the village of Sakhnivka, Korsun'-Shevchenkivs'kyi Raion. Find-spot for cat. no. 40.
8. Kurhan no. 4, near the village of Novosilky, Monastyrshchens'kyi Raion. Find-spot for cat. no. 19.
9. Ancient settlement of Subotiv'ke, near the village of Subotiv, Chyhyrns'kyi Raion. Find-spot for cat. no. 4.
10. Rep'iakhuvata Mohyla, near the village of Matusiv, Shpolians'kyi Raion. Find-spot for cat. nos. 8 and 31.
11. The Supii River, near the village of Pishchane, Hel'm'iazivs'kyi Raion. Find-spot for cat. nos. 82, 83, 84, 85, 86, 87, 88, and 89.
12. The town of Kam'ianka, Smilians'kyi Raion. Find-spot for cat. no. 9.
13. Kurhan no. 2, near the village of Hladkivshchyna, Zolotonos'kyi Raion. Find-spot for cat. no. 10.

DNIPROPETROVS'KA OBLAST'

14. Kurhan no. 6, burial no. 1, near the village of Oleksandrivka, Novomoskovs'kyi Raion. Find-spot for cat. no. 47.
15. Kurhan no. 13, near the village of Ordzhonikidze. Find-spot for cat. nos. 102 and 103.
16. Tovsta Mohyla, near the village of Ordzhonikidze. Find-spot for cat. nos. 14, 37, and 122 (burial no. 1), and 15 (burial no. 2).
17. Babyna Mohyla, near the village of Taraso-Hryhorivka, Apostoliv's'kyi Raion. Find-spot for cat. nos. 137, 138, 139, 140, 141, 142, 143, 144, 145, 146, 147, 148, 149, 150, 151, 152, and 153.
18. Kurhan no. 1, Zavads'ka Mohyla, near the town of Ordzhonikidze. Find-spot for cat. no. 54.
19. Tetianyna Mohyla, near the village of Chkalove, Nikopol's'kyi Raion. Find-spot for cat. nos. 16, 17, and 108.
20. Soboleva Mohyla, near the village of Hirniats'ke, Nikopol's'kyi Raion. Find-spot for cat. nos. 154, 155, 156, 157, 158, 159, 160, 161, 162, 163, 164, 165, 166, and 167.
21. Kurhan no. 4, Ispanova Mohyla, near the village of Nahirne, Nikopol's'kyi Raion. Find-spot for cat. no. 44.
22. Kurhan no. 13, Khomyna Mohyla, burial no. 1, near the village of Nahirne, Nikopol's'kyi Raion. Find-spot for cat. no. 24.
23. Kurhan no. 6, Denysova Mohyla, near the town of Ordzhonikidze. Find-spot for cat. no. 99.
24. Tovsta Zhovtokam'ians'ka Mohyla, burial no. 1, near the village of Taraso-Hryhorivka, Apostoliv's'kyi Raion. Find-spot for cat. no. 113.
25. Lysa Hora. Find-spot for cat. no. 39.

DONETS'KA OBLAST'

26. Kurhan no. 2, Perederiieva Mohyla, near the village of Zrubne, Shakhtars'kyi Raion. Find-spot for cat. no. 124.

KHERSONS'KA OBLAST'

27. Kurhan Ohuz near the settlement of Nyzhni Sirohozy. Find-spot for cat. nos. 101, 111, and 126.
28. Kurhany near the village of Vil'na Ukraina (formerly Chervonyi Perekop), Kakhivs'kyi Raion. Find-spot for cat. nos. 109, 110, 120, and 125.
29. Bratoliubivs'kyi Kurhan, near the village of Ol'hino, Hornostaivs'kyi Raion. Find-spot for cat. nos. 134, 135, and 136.
30. Zolota Balka. Find-spot for cat. no. 133.
31. Kurhan no. 2, near the village of Novofedorivka. Find-spot for cat. no. 11.
32. Kurhan no. 5, burial no. 1, near the village of Arkhanhels'ka Sloboda, Kakhivs'kyi Raion. Find-spot for cat. nos. 46 and 112.
33. Kurhan no. 18, burial no. 2, near the village of L'vove, Beryslavs'kyi Raion. Find-spot for cat. no. 23.

KIROVOHRADS'KA OBLAST'

34. Kurhan no. 9, near the village of Osytniazhka, Novomyrhorods'kyi Raion. Find-spot for cat. no. 117.
35. Taranova Mohyla, near the village of Inhulo-Kam'ianka, Novhorodkivs'kyi Raion. Find-spot for cat. no. 33.
36. Kurhan no. 459, near the village of Turia, Kirovohrads'ka Oblast'. Find-spot for cat. no. 49.

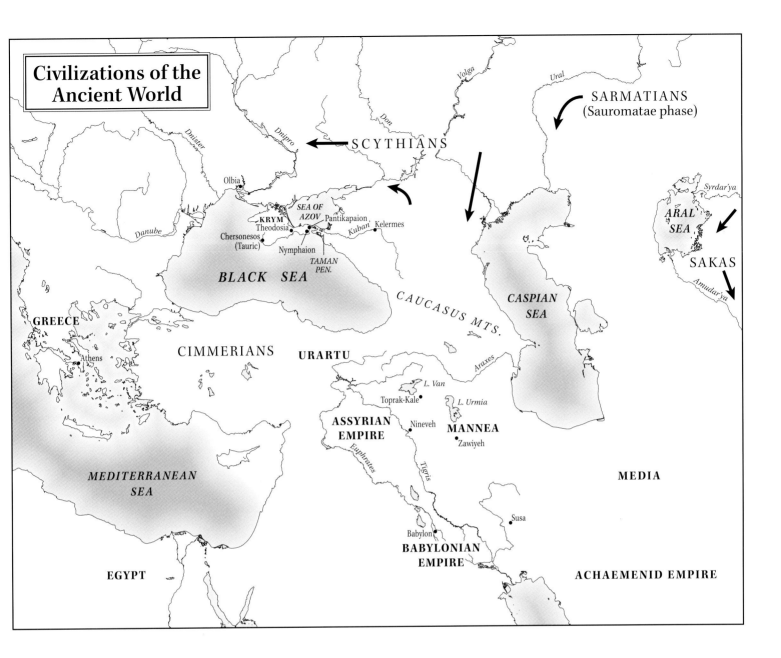

Civilizations of the Ancient World

Selected Ancient Sources Relating to Scythians

Anacreon 356.6–11 (ca. 570)

Herodotus, *Histories* 1.103–106 and book 4 (ca. 450)

Corpus Hippocraticum, *De aere, aquis, locis,* xvii–xxii (post 469–399?)

Demosthenes, *vs. Leptines; vs. Phormion; vs. Lakrytes; vs. Philip of Macedon* (4th c.)

Lysias, *Mantitheus (Or. 16)* (ca. 459–380)

Aristophanes, *Acharnanians* 704 (ca. 457–385)

Isocrates, *Trapezius* xvii (436–338)

Xenophon, *Apologia Socratis* ii.1.10 (ca. 428/7–354)

Aeschines, *vs. Ktesiphon* iii (ca. 397–322)

Aristotle, *Gen. An.* 748a25; 782b30; 783a10; *On the Cosmos* 393b8; *Eth. Nich.* vii.vii.6; *Hist. An.* 605a21; 606a20.b4; 597a5; 576a21; 631a1; *Meta.* 350b7; 362b22; 359b18 (384–322)

Dinarchus, *vs. Demosthenes I* (ca. 360–290)

Polybius iv.38 (ca. 200–after 118)

Ovid, *Tristia* 1.3.6, v.10; *epistula ex Ponto* iii.1.14 (43 B.C.–100 A.D.)

Strabo, *Geography*; vii.3.18–19; vii.4.5–8; xi.493, xiii (64/3 B.C.–21 A.D.)

Diodorus Siculus xx.22; xx.24 (1st c. B.C.)

Pliny, *Nat. Hist* 8.165 (23/24–79 A.D.)

Dio Chrysostomos, *Borysthenitica* (ca. 95 A.D.)

Frontinus II.4.20 (ca. 30–104 A.D.)

Plutarch, *Perikles* xx.1–2 (ca. 50–120 A.D.)

Lucian, *Toxaris or Friendship; The Scythians or the Consul 1* (ca. 120 A.D.)

Clement of Alexandria v:31 (150–211 or 226 A.D.)

Athenaeus, *Deipnosophistae* XI.499f (ca. 200 A.D.)

Hesychius of Alexandria, s.v. ΚΑΝΝΑΒΙΣ (5th c. A.D.)

Justinus, *Epitome* XII.1.4 (3rd c. A.D.)

Macrobius, *Sat.* I. II. 33 (late 4th–early 5th c. A.D.)

ABBREVIATIONS

AA: *Archäologischer Anzeiger.*

AJA: *American Journal of Archaeology.*

AM: *Mitteilungen des Deutschen Archäologischen Instituts, Athenische Abteilung.*

AntK: *Antike Kunst.*

BABesch: *Bulletin antieke beschaving.*

BCH: *Bulletin de correspondence hellénique.*

BJb: *Bonner Jahrbücher des Rheinischen Landesmuseums in Bonn und des Vereins von Altertumsfreunden im Rheinlande.*

BMFEA: *Bulletin of the Museum of Far Eastern Antiquities* (Stockholm)

BWPr: *Winckelmannsprogramm der Archäologischen Gesellschaft zu Berlin.*

CRPétersb: *Compte-rendu de la Commission impériale archéologique, St. Pétersbourg.*

JdI: *Jahrbuch des Deutschen Archäologischen Instituts.*

LIMC: *Lexicon Iconographicum Mythologiae Classicae* (Zurich and Munich 1981–1997).

RA: *Revue archéologique.*

RM: *Mitteilungen des Deutschen Archäologischen Instituts, Römische Abteilung.*

Abaev (1949): Абаев, В.И., *Осетинський язик и фольклор* [Ossetian Language and Folklore] (Москва, Ленинград 1949).

Abaev (1962): Абаев, В.И., "Культ 'Семи боговь' у скифов" [The Scythian Cult of the 'Seven Gods'] *Древний мир* (Москва 1962), 445–50.

Abaev (1965): Абаев, В.И., *Скифо-европейские изолгассы* [Scytho-European Lies] (Москва 1965).

Abgunov (1989): Абгунов, М.В., *Путешествие в загадочную Скифию* [A Journey into Storied Scythia] (Москва 1989).

Adcock (1927): Adcock, F.E., "Breakdown of the Thirty Years' Peace, 445–431 B.C.," in *Cambridge Ancient History,* vol. 5 (Cambridge 1927), 165–92.

Akishev (1978): Акишев, К.А., *Иссик курган* [Issyk Kurhan] (Москва 1978).

Akishev and Kushaev (1963): Акишев, К.А. и Г.А. Кушаэв, *Древная культура саков и усуне д. рики Или* [The Ancient Culture of the Saka and Wu-sun in the Ila River Basin] (Алма-Ата 1963).

Alekseev (1980): Алексеев, А.Ю., "О скифском Аресе" [Regarding the Scythian Ares] *Археологический сборник* 21 (1980), 39–47.

Alekseev (1981): Алексеев, А.Ю., "К вопросу о дате сооружения Чертомлыкского кургана" [On the Question of the Date of the Construction of the Chortomlyk Kurhan] *Археологический сборник* 22 (1981), 75–83.

Alekseev (1983): Алексеев, А.Ю., "О наконечниках стрел из Чертомлыкского кургана" [Regarding Arrowheads from Chortomlyk Kurhan] *Археологический сборник* 24 (1983), 73–77.

Alekseev (1984): Алексеев, А.Ю., "О месте Чертомлыкского кургана в хронологической системе погребениты скифской знати IV–III в. до н.э." [Regarding the Location of the Chortomlyk Kurhan within the Chronology of Scythian Aristocratic Burials of the Fourth and Third Centuries B.C.] *Археологический сборник* 25 (1984), 65–75.

Alekseev (1987a): Алексеев, А.Ю., "Заметки по хронологии скифских степних древностей IV в. до н.э." [Notes on the Chronology of Scythian Steppe Antiquities of the Fourth Century B.C.] *Советская археология* 2 (1987), 28–39. (summary in English)

Alekseev (1987b): Алексеев, А.Ю., "Скифская хронография второй половины IV в. до н.э." [Scythian Chronography of the Second Half of the Fourth Century B.C.] *Археологический сборник Государственного Эрмитажа* 28 (Ленинград 1997), 38–51. (summary in English)

Alekseev (1991): Алексеев, А.Ю., "Хронология и хронография причерноморской Скифии V в. до н.э." [Chronology and Chronography of Black Sea Scythia in the Fifth Century B.C.] *Археологический сборник* 31 (1991), 43–56.

Alekseev (1992): Алексеев, А.Ю., *Скифская хроника* [Scythian Chronicles] (Санкт Петербург 1992).

Alekseev (1993): Алексеев, А.Ю., "Великая Скифия или две Скифии?" [Great Scythia or Two Scythias?] *Скифия и Боспор* (Ленинград, Новочеркаск 1993), 28–38.

Alekseev and Kachalova (1993): Алексеев, А.Ю., Н.К. Качалова и др., *Киммерийцы, этнокультурная принадлежность* [The Ethnocultural Identity of the Cimmerians] (Санкт Петербург 1993).

Alekseev, Murzin, and Rolle (1991): Алексеев, А.Ю., В.И. Мурзин и Р. Ролле, *Чертомлык. Скифский царский курган IV в. до н.э.* [Chortomlyk. A Scythian Royal Kurhan of the Fourth Century B.C.] (Киев 1991).

Alekseeva (1993): Alekseeva, E.M., "Gorgippia. Cité du Bosphore," *Les dossiers d'archéologie* 188 (December 1993), 52–57.

Alexander (1928): Alexander, C., *Jewelry. The Art of the Goldsmith in Classical Times.* The Metropolitan Museum of Art (New York 1928).

Amandry (1953): Amandry, P., *Collection Hélène Stathatos: Les bijoux antiques,* vol. 1 (Strasbourg 1953).

Amandry (1963): Amandry, P., *Collection Hélène Stathatos: Objects antiques et byzantins,* vol. 3 (Strasbourg 1963).

Amandry (1965): Amandry, P., "L'art scythe archaïque," *AA* (1965), 891–913.

Amiet (1977): Amiet, P., *Die Kunst des alten Orient* (Freiburg 1977)

Amiet (1997): Amiet, P., "Le décor architectural des palais achéménides," *Iran. La perse de Cyrus à Alexandre. Les dossiers d'archéologie* 227 (October 1997), 78–83.

Andronicos (1975): Andronicos, M., *Pella Museum* (Athens 1975).

Andronicos (1977): Andronicos, M., "Vergina, the Royal Graves in the Great Tumulus," *Athens Annals of Archaeology* 10 (1977), 1–39.

Andronicos (1978a): Andronicos, M., "Seeking the Tomb of Philip of Macedon," *National Geographic* 154 (1978), 54–77.

Andronicos (1978b): Andronicos, M., *The Royal Graves at Vergina* (Athens 1978).

Andronicos (1984): Andronicos, M., *Vergina: The Royal Tombs and the Ancient City* (Athens 1984).

Andrukh (1988): Андрух, С.И., "Погребение раннескифского воина в Присивашье" [The Burial of an Early Scythian Warrior in Prisivash'e] *Советская археология* 1(1988), 165–66.

Anokhin (1971): Анохін, В.О., "Торгівля і грошовий обіг" [Trade and Monetary Circulation] in *Археологія УРСР,* том 2 (Київ 1971), 423–35.

Anokhin (1986): Анохин, В.А., *Монетное дело Боспора* [Monetary Transactions of the Bosporus] (Киев 1986).

Archibald (1985): Archibald, Z.H., "The Gold Pectoral from Vergina and Its Connections," *Oxford Journal of Archaeology* 4 (1985), 165–85.

Archibald (1998): Archibald, Z.H., *The Odrysian Kingdom of Thrace: Orpheus Unmasked* (Oxford 1998).

Arkas (1969): Аркас, М., *Історія північної чорноморщини* [The History of the Northern Black Sea Region], vol. 1 (Toronto 1969).

Artamonov (1950): Артамонов, М.И., "К вопросу о происхождении скифов" [On the Question of the Origin of the Scythians] *Вестник древней истории* (Москва 1950), 37–47.

Artamonov (1969a): Artamonov, M.I., *Treasures from Scythian Tombs in the Hermitage Museum, Leningrad* (London 1969).

Artamonov (1969b): Artamonov, M.I., *The Splendor of Scythian Art: Treasures from Scythian Tombs* (New York 1969).

Artamonov (1973): Артамонов, М.И., "Кімерійська проблема" [The Cimmerian Problem] *Археологія* 9 (Київ 1973), 3–15.

Artamonow (1970): Artamonow, M.I., *Goldschatz der Skythen in der Eremitage* (Prague 1970).

Artemenko (1984): Артеменко, И.И. и др., *50 лет Институту Археологии АН УССР* [Fifty Years of the Institute of Archaeology of the Academy of Sciences, Ukrainian SSR] (Киев 1984).

Ashik (1848): Ашик, А., *Воспорское царство* [The Bosphoran Kingdom], том 2 (Одесса 1848).

Azarpay (1968): Azarpay, G., *Urartian Art and Artifacts* (Berkeley, Los Angeles 1968).

Bader, Krainov, and Kosarev (1987): Бадер, О.Н., Д.А. Крайнов и М.Ф. Косарев, *Эпоха бронзы лесной полосы СССР* [The Bronze Age in the Forest Region of the USSR] (Москва 1987).

Badian (1975): Badian, E., ed., "Alexander le Grand," in *Entretiens sur l'Antiquité classique* 22 (Vandoeuvres, Genève 1975).

Baltimore, *Jewelry* (1979): *Jewelry: Ancient to Modern.* The Walters Art Gallery, October 13, 1979–January 20, 1980 (Baltimore 1979).

Baran (1994): Баран, В.Д. та ін., *60 років Інституту Археології НАН України* [Sixty Years of the Institute of Archeology of the National Academy of Sciences of Ukraine] (Київ 1994).

Barber (1997): Barber, E.J.W., "On the Origins of the Vily/Rusalki," in *Varia on the Indo-European Past: Papers in Memory of Marija Gimbutas,* eds. M.R. Dexter and E.C. Palome, *Journal of Indo-European Studies* 19 (1997), 6–47.

Barkova (1990): Баркова, Л.Л., "Образ оленя в искусстве древнего Алтая (по материалам больших алтайших курганов)" [The Deer Image in the Art of the Ancient Altai (Based on the Material of the Great Altai Kurhany)] *Археологический сборник* 30 (1990), 55–66.

Barnett (1956): Barnett, R.D., "The Treasure of Ziwiye," *Iraq* 18/2 (1956), 111–16.

Barr-Sharrar (1982): Barr-Sharrar, B., "Macedonian Metal Vessels in Perspective: Some Observations on Context and Tradition," in *Macedonia and Greece in Late Classical and Early Hellenistic Times, Studies in the History of Art* 10, ed. B. Barr-Sharrar (Washington 1982), 123–39.

Basak (1962): Basak, Z., "Dionyzos ayinini tasvir eden altın diadem," [Golden Diadem with the Representation of Dionysiac Rites] *İstanbul arkeoloji müzeleri yıllığı* 10 (1962), 27–29.

Basilov (1989): Basilov, V.N., ed., *Nomads of Eurasia.* Natural History Museum of Los Angeles County, February–April 1989; Denver Museum of Natural History, June–September 1989; and National Museum of Natural History, Washington, D.C., November 1989–February 1990 (Seattle, London 1989).

Beazley (1963): Beazley, J.D., *Attic Red-Figure Vase-Painters,* second edition (Oxford 1963).

Becatti (1955): Becatti, G., *Oreficerie antiche dalle Minoiche alle Barbariche* (Rome 1955).

Berezova (1994): Березова, С.А., "Фігурні сережки із колекції Музею Історичних Коштовностей України" [Figural Earrings from the Collection of The Treasures Museum of Ukraine] in *Музейні читання. Тези доповідей наукової конференції Музею історичних коштовностей України - філіалу НМІУ* (Київ 1994), 6–9.

Berezova and Klochko (1995): Березова, С.А. та Л.С. Клочко, "Так звані сережки "калачики" з колекції Музею Історичних Коштовностей України - філіалу НМІУ" [Earrings called "kalachyky" from the Collection of the Treasures Museum of Ukraine - A Branch of the NHMU] in *Від першовитоків до сьогодення: з історії формування колекції музею* (Київ 1995), 37–52.

Bessonova (1983): Бессонова, С.С., *Религиозные представления скифов* [Religious Representations of the Scythians] (Киев 1983).

Bibikov (1957): Бібіков, С.М. та ін., ред., *Нариси стародавньої історії* [Outline of Ancient History] (Київ 1957).

Bidzilia (1971): Бідзіля, В.І., "Дослідження Гайманової Могили" [Investigations of Haimanova Mohyla] *Археологія* 1 (1971), 44–56.

Bidzilia and Boltrik (1977): Бидзиля, В.И., Ю.В. Болтрик и др., "Курганный могильник в урочище Носаки" [A Kurhan Burial at the Nosaky Gully] *Курганные могильники, рясные могилы и Носаки* (Киев 1977), 91–92.

Bidzilia, Boltrik, Otroshchenko and Iakovenko (1973): Бидзиля, В.И., Ю.В. Болтрик, В.В. Отрощенко и Э.В. Яковенко, "Работы Запорожской экспедиции" [The Work of the Zaporizhzhia Expedition] *Археологические открытия 1972 г.* (1973), 259–62.

Bidzilia and Iakovenko (1974): Бидзиля, В.И. и Э.В. Яковенко, "Киммерийские погребения Высокой Могилы" [Cimmerian Burials at Vysoka Mohyla] *Советская археология* 1 (1974), 150.

Bieber (1961): Bieber, M., *The Sculpture of the Hellenistic Age,* revised edition (New York 1961).

Bieber (1964): Bieber, M., *Alexander the Great in Greek and Roman Art* (Chicago 1964).

Bilimovich (1962): Билимович, З.А., "Зеркало из Артюховского кургана" [The Mirror from Artiukhivs'kyi Kurhan] *Труды Государственного Эрмитажа,* том 7 (Ленинград 1962), 133–42.

Bittner (1987): Bittner, S., *Tracht und Bewaffnung des persischen Heeres zur Zeit des Achaimeniden,* second edition (Munich 1987).

Blavatskii (1954): Блаватский, В.Д., *Очерки военного дела в античных местах Северного Причерноморья* [Outline of Military Practices in the Ancient Cities of the Northern Black Sea Region] (Москва 1954).

Boardman (1962/63): Boardman, J., "Greek Archaeology on the Shores of the Black Sea," *Archaeological Reports* (1962/63), 34–51.

Boardman (1968): Boardman, J., *Archaic Greek Gems* (Evanston 1968).

Boardman (1970): Boardman, J., *Greek Gems and Finger Rings: Early Bronze Age to Late Classical* (London 1970).

Boardman (1972): Boardman, J., *Greek Gems and Finger Rings* (New York 1972).

Boardman (1975): Boardman, J., *Intaglios and Rings: Greek, Etruscan and Eastern from a Private Collection* (London 1975).

Boardman (1980): Boardman, J., *The Greeks Overseas* (London 1980).

Boardman (1994): Boardman, J., *The Diffusion of Classical Art in Antiquity* (London 1994).

Boardman and Kurtz (1971): Boardman, J. and D. Kurtz, *Greek Burial Customs* (Ithaca 1971).

Boardman and Scarisbrick (1977): Boardman, J. and D. Scarisbrick, *The Ralph Harari Collection of Finger Rings* (London 1977).

Bobrinskii (1887): Бобринский, А.А., *Курганы и случайные археологические находки близ местечка Смелы* [Kurhany and Chance Archaeological Finds near the Town of Smely], том 1 (Санкт Петербург 1887).

Bobrinskii (1894): Бобринский, А.А., *Курганы и случайные археологические находки близ местечка Смелы* [Kurhanys and Chance Archaeological Finds near the Town of Smely], том 2 (Санкт Петербург 1894).

Bobrinskii (1901): Бобринский, А.А., *Курганы и случайные археологические находки близ местечка Смелы* [Kurhany and Chance Archaeological Finds near the Town of Smely], том 3 (Санкт Петербург 1901).

Bobrinskii (1905): Бобринский, А.А. "Отчет о раскопках близ села Журовки и Капитановки Чигиринского уезде Киевской губернии в 1904 году" [Report on Excavations near the Villages of Zhurovka and Kapitanovka in the Chyhyryn District of the Kyiv Gubernia in 1904] *Известия Археологической Комиссии* 17 (Санкт Петербург, Москва 1905), 93–97.

Boitani and Bartoli (1983): Boitani, L. and S. Bartoli, *Simon and Schuster's Guide to Mammals* (New York 1983).

Bokovenko (1994): Bokovenko, N.A., "Le kourgane 'royal' d'Arjan et son temps," *Les Scythes. Les dossiers d'archéologie* 194 (June 1994), 30–37.

Bokovenko (1995): Bokovenko, N., "History of Studies and the Main Problems in the Archaeology of Southern Siberia during the Scythian Period," in Davis-Kimball, Bashilov, and Yablonsky, 255–61.

Bokovenko, Tuva (1995): Bokovenko, N., "Tuva during the Scythian Period," in Davis-Kimball, Bashilov, and Yablonsky, 265–81.

Bolla (1993): Bolla, M., "Il vasellame in bronzo in età augustea: osservazioni sulla base di reperti dall'Ager Mediolanensis," *Rassegna di studi del civico museo archeologico e del civico gabinetto numismatico di Milano* 51–52 (1993), 71–97.

Boltrik (1981): Болтрик, Ю.В. "Исследования Кургана Огуз" [Studies of the Ohuz Kurhan] *Археологические открытия 1980* (Москва 1981), 233–34.

Boltrik and Fialko (1991): Boltrik, J.V. and E.E. Fialko, "Der Oguz-Kurhan. Die Grabanlage eines Skythenkönigs der Zeit nach Ateas," *Hamburger Beiträge zur Archäologie* 18 (1991, published in 1996), 107–29.

Boltrik and Fialko (1997): Болтрик, Ю.В. и Е.Е. Фиалко, "Золотые ажурные аппликации у скифов" [Gold Filigree Appliques among the Scythians] in *Ювелирное искусство и материальная культура. Тезисы докладов участников третьего коллоквиума семинара Гос. Эрмитажа* (1997), 75–75.

Boltrik, Otroshchenko and Savovskii (1977): Болтрик, Ю.В., В.В. Отрощенко и И.П. Савовский, "Исследования Рогатинского курганного поля" [Studies of the Kurhan Field in Rohatin] *Археологические открытия 1976 г.* (Москва 1977), 268–70.

Boltryk and Fialko (1991): Болтрик, Ю.В. та О.І. Фіалко, "Огуз - курган скіфського царя кінця IV ст. до н.е." [Ohuz–A Kurhan of a Scythian King at the End of the Fourth Century B.C.] *Золото степу. Археологія України* (Шлезвіг 1991), 178–80.

Borovka (1965): Borovka, G., *Scythian Art* (New York 1928; reprinted London 1965).

von Bothmer (1957): von Bothmer, D., *Amazons in Greek Art* (Oxford 1957).

von Bothmer (1982): von Bothmer, D., *Search for Alexander: Supplement to the Catalogue* (New York 1982).

von Bothmer (1984): von Bothmer, D., "A Greek and Roman Treasury," in *Bulletin of the Metropolitan Museum of Art* 42/1 (New York 1984).

Boucher (1970): Boucher, S., *Bronzes grecs, hellénistiques et étrusques: Collections des musées de Lyon* (Lyon 1970).

Bouzek (1990): Bouzek, J., *Studies of Greek Pottery in the Black Sea Area* (Prague 1990).

Bouzek and Ondrejova (1987): Bouzek, J. and I. Ondrejova, "Some Notes on the Relations of the Thracian, Macedonian, Iranian, and Scythian Arts in the Fourth Century B.C.," *Eirene* 24 (1987), 67–93.

Brakefield (1993): Brakefield, T., *Big Cats. Kingdom of Might* (Stillwater 1993).

Brashinskii (1955): Брашинский, И.Б., "К вопросу о положения Нимфея во второй половине V в. до н.э." [On the Question of the Position of Nymphaion in the Second Half of the Fifth Century B.C.] *Вестник древней истории* (Москва 1955), 148–61.

Brashinskii (1963): Брашинский, И.Б., *Афины и северное Причерноморие в VI–II вв. до н.э.* [Athens and the Northern Black Sea Region in the Sixth–Second Centuries B.C.] (Москва 1963).

Breglia (1941): Breglia, L., *Le oreficerie del Museo Nazionale di Napoli* (Rome 1941).

Briant (1992): Briant, P., *Darius, Les Perses et l'empire* (Paris 1992).

Bruns-Özgan (1995): Bruns-Özgan, C., "Fries eines hellenistischen Altars in Knidos," *JdI* 110 (1995), 239–76.

Brussels, *L'or* (1991): *L'or des Scythes.* Musées royaux d'Art et d'Histoire (Brussels 1991).

Bunker (1989): Bunker, E.C., "Orientations," in *Dangerous Scholarship: On Citing Unexcavated Artifacts from Inner Mongolia and North China* (1989).

Bunker (1991): Bunker, E.C., "The Chinese Artifacts among the Pazyryk Finds," in *Source, Notes on the History of Art* 10/4 (New York 1991), 20–24.

Bunker, Chatwin, and Farkas (1970): Bunker, E.C., C.B. Chatwin, and A.R. Farkas, in *"Animal Style" Art from East to West* (New York 1970).

Burford (1972): Burford, A., *Craftsmen in Greek and Roman Society* (Ithaca 1972).

Bydlowski (1904/1905): Bydlowski, A., "Mogily w Nowosiolce w pow. Lipoweckim, gub. Kijowskiey" [Graves in Nowosiolce in Lipowecki District, Kijowska Gubernia] *Swiatowit* 5 (1904/1905), 59–80.

Byvanck-Quarles van Ufford (1966): Byvanck-Quarles van Ufford, L., "Remarques sur les relations entre l'Ionie grecque, la Thrace et l'Italie," *BABesch* 41 (1966), 34–45.

Campbell and Dennis (1996): Campbell, L. and R. Dennis, *Golden Eagles* (Moray, Scotland 1996).

Carey and Carey (1998): Carey, A. and S. Carey, *Eagles. Creatures of the Wild* (London 1998).

Castoldi (1995): Castoldi, M., "Recipienti di bronzo greci, magnogreci ed etrusco-italici nelle civiche raccolte archeologiche di Milano," *Rassegna di studi del civico museo archeologico e del civico gabinetto numismatico di Milano Suppl.* 15 (Milan 1995).

Cernenko (1983): Cernenko, E.V., *The Scythians* (London 1983).

Chang (1998): Chang, L., "An American Sikh in Ulan Bator Has Plan to Save Falcons," *Wall Street Journal* (July 27, 1998), 1.

Charbonneaux (1958): Charbonneaux, J., *Les bronzes grecs* (Paris 1958).

Charbonneaux, Martin, and Villard (1973): Charbonneaux, J., R. Martin, and F. Villard, *Hellenistic Art,* English edition (London, New York 1973).

Charbonneaux, Martin, and Villard (1988): Charbonneaux, J., R. Martin, and F. Villard, *Das hellenistische Griechenland,* second edition (Munich 1988).

Charrière (1979): Charrière, G., *Scythian Art: Crafts of the Early Eurasian Nomads* (New York 1979).

Cherednychenko and Murzin (1996): Чередниченко, М.М. та В.Ю. Мурзін, "Основні результати дослідження Бердянського кургану" [The Primary Research Results from the Excavations at Berdians'kyi Kurhan] *Археологія* 1 (1996), 69–78.

Chernenko (1968): Черненко, Е.В., *Скифский доспех* [Scythian Armour] (Киев 1968).

Chernenko (1975): Черненко, Е.В., "Оружие из Толстой Могилы" [Weaponry from Tovsta Mohyla] *Скифский мир* (Киев 1975), 152–73.

Chernenko (1981): Черненко, Е.В., *Скифские лучники* [Scythian Archers] (Киев 1981).

Chernikov (1960): Черников, С.С., *Восточный Казахстан в епохи бронзи* [Eastern Kazakhstan in the Bronze Age] (Москва, Ленинград 1960).

Chernikov (1964): Черников, С.С. "Золотий курган Чиликтинской долины" [The Golden Kurhan of Chiliktinska Valley] *Краткие сообщения Института этнографии АН СССР* 98 (Москва 1964), 29–32.

Chernikov (1965): Черников, С.С., *Загадка Золотого Кургана* [The Riddle of the Golden Kurhan] (Москва 1965).

Chlenova (1963): Chlenova, N.L., "Le Cerf Scythe," *Artibus Asiae* 26 (1963), 27–70.

Chlenova (1967): Членова, Н.Л., *Происхождение и ранняя история племен тагарской культуры* [Origins and Early History of the Tribes of the Tagar Culture] (Москва 1967).

Chlenova (1972): Членова, Н.Л., *Хронология памятников карасукской эпохи* [Chronology of Monuments of the Karasuk Period] (Москва 1972).

Chlenova (1976): Членова, Н.Л., *Карасукские кинжали* [Karasuk Daggers] (Moscow 1976).

Chochorowski and Skoryi (1997a): Chochorowski, J. and S. Skoryi, "Prince of the Great Kurhan," *Archaeology* 50/5 (September/October 1997), 32–39.

Chochorowski and Skoryi (1997b): Chochorowski, J. and S. Skoryi, "The "Collateral" (female) Burial at the Great Ryzhanowka Barrow," in *Studies in Ancient Art and Civilization,* vol. 8 (Cracow 1997), 71–92.

Chochorowski and Skoryi (1997c): Chochorowski, J. and S. Skoryi, "Die Zentralbestattung des Gross-Hugelgrabes von Ryzanowka im rechtsseitigen Teil der ukrainischen Waldsteppenzone," in *The Third International Symposium of Funeral Archeology* (Tulcea 1997), 12–13.

Chochorowski and Wielowiejski (1997): Chochorowski, J. interviewed by P. Wielowiejski, "Ostatni wladca Scytów," *Archeologia Zywa* 3/4 (1997), 3–11.

Christofani and Martelli (1983): Christofani, M. and M.C. Martelli, *L'oro degli Etruschi* (Novara 1983).

Coarelli (1966): Coarelli, F., *L'oreficeria nell'arte classica* (Milan 1966).

Coche de la Ferté (1956): Coche de la Ferté, E., *Les bijoux antiques* (Paris 1956).

Collon (1995): Collon, D., *Ancient Near Eastern Art* (London 1995).

Comptes (1860–1893): *Comptes-rendus de la Commission impériale archéologique pour l'année* (St. Petersburg 1860–1893).

Comstock and Vermeule (1971): Comstock, M. and C.C. Vermeule, *Greek, Etruscan and Roman Bronzes in the Museum of Fine Arts, Boston* (Boston 1971).

Culican (1965): Culican, W., *The Medes and Persians* (New York 1965).

Cunliffe (1997): Cunliffe, B., *The Ancient Celts* (Oxford 1997).

Curtis and Reade (1995): Curtis, J.E. and J.E. Reade, eds., *Art and Empire. Treasures from Assyria in the British Museum* (London 1995).

Dashevskaia (1991): Дашевская, О.Д., "Поздние скифы в Крыму" [Late Scythians in Krym] *Археология СССР, Свод археологических источников,* вып. Д1–7 (Москва 1991).

Daumas (1997): Daumas, M., "Des cabires Thébains aux grands dieux de Samothrace: Aspects d'une recherche sur un culte á mystères," *RA* (1997), 201–209.

Davidson (1952): Davidson, G.R., *Corinth. Results of Excavations Conducted by The American School of Classical Studies at Athens, XII: The Minor Objects* (Princeton 1952).

Davidson and Hoffmann (1965): Davidson, P. and H. Hoffmann, *Greek Gold: Jewelry from the Age of Alexander* (Mainz 1965).

Davidson and Oliver (1984): Davidson, P.F. and A. Oliver, *Ancient Greek and Roman Jewelry in the Brooklyn Museum* (New York 1984).

Davis-Kimball (1997): Davis-Kimball, J., "Chieftain or Warrior Priestess?" *Archaeology* 50/5 (September/October 1997), 40–41.

Davis-Kimball, Bashilov, and Yablonsky (1995): Davis-Kimball, J., V.A. Bashilov, and L.T. Yablonsky, eds., *Nomads of the Eurasian Steppes in the Early Iron Age* (Berkeley 1995).

Davudov (1991): Davudov, O.M., "Kimmerier, Skythen und Dagestan. Ein hochalpines Feuerheiligtum im Kontext der reiternomadischen Vorderasiezüge," *Hamburger Beiträge zur Archäologie* 18 (1991, published in 1996), 47–56.

Dawn of Art (1974): *The Dawn of Art: Paleolithic, Neolithic Bronze Age and Iron Age Remains Found in the Territory of the Soviet Union, The Hermitage Collection* (Leningrad 1974).

Densmore Curtis (1925): Densmore Curtis, C., *Sardis, XIII: Jewellery and Goldwork, Part I, 1910–1914* (Rome 1925).

Deppert-Lippitz (1985): Deppert-Lippitz, B., *Griechischer Goldschmuck* (Mainz 1985).

Devlet (1994): Devlet, M.A., "Pierres à cerfs et images rupestres de cerfs au centre de l'Asie," *Les Scythes. Les dossiers d'archéologie* (1994), 26–29.

Di Bello (1997): Di Bello, F., *Elea-Velia. Polis, Zecca e monete di bronzo* (Naples 1997).

Diamantourou Papakonstantinou (1971): Diamantourou Papakonstantinou, D., *Pella*, vol. 1 (Athens 1971).

Dijon, *Scythes* (1994): *Les Scythes guerriers nomads au contact des brillantes civilisations grecque, perse et chinoise* (Dijon 1994).

Drougou and Touratsozoulou (1980): Drougou, S. and D. Touratsozoulou, *Hellenistic Rock-Cut Chamber Tombs at Veroia* (Athens 1980).

Dubovskaia (1997): Дубовская, О.Р., "Плеть как возможный атрибут предскифских погребений" [The Whip as a Possible Attribute of Pre-Scythian Burials] *Древности Подонцовья* (Луганск 1997), 62.

Dvornichenko (1995): Dvornichenko, V.V., "Sauromatian Culture," in Davis-Kimball, Bashilov, and Yablonsky, 105–19.

Dvornichenko and Fedorov-Davydov (1994): Dvornichenko, V.V. and G.A. Fedorov-Davydov, "Trésors des tombes de l'aristocratie Sarmate au nord de la Caspienne," *Les Scythes. Les dossiers d'archéologie* 194 (June 1994), 66–74.

Ebert (1921): Ebert, M., *Südrussland im Altertum* (Bonn, Leipzig 1921).

Ebert (1929): Ebert, M., "Südrussland," *Reallexikon der Vorgeschichte* 13, ed. M. Ebert (Berlin 1929), 32–114.

Edinburgh, *Warriors* (1993): *Golden Warriors of the Ukrainian Steppes*. City of Edinburgh Art Centre, 14 August–17 October 1993 (Edinburgh 1993).

Edwards (1996): Edwards, M., "Searching for the Scythians," *National Geographic* 190/3 (September 1996), 54–79.

Edwards and Thompson (1970): Edwards, G.R. and M. Thompson, "A Hoard of Gold Coins of Philip and Alexander from Corinth," *AJA* 74 (1970), 343–50.

Ellis Jones (1985): Ellis Jones, J., "Laurion: Agrileza 1977–83: Excavations at a Silver-Mine Site," *Archaeological Reports* 31 (1985), 106–23.

Eluère (1993): Eluère, C., *The Celts. Conquerors of Ancient Europe* (New York 1993).

Étienne and Piérart (1975): Étienne, R. and M. Piérart, "Un décret du koinon des Hellènes à Platées en l'honneur de Glaucon, fils d'Étéoclès, d'Athènes," *BCH* 99 (1975), 51–75.

Evdokimov (1994): Эвдокимов, Г.Л., *Скифские каменные изваяния* [Scythian Stone Statues] (Москва 1994).

Farkas (1977): Farkas, A., "Interpreting Scythian Art: East vs. West," *Artibus Asiae* 39 (1977), 124–38.

Farmakowsky (1910): Farmakowsky, B., "Archäologische Funde im Jahre 1909. Rußland," *AA* (1910), 195–244.

Farmakovskii (1911): Фармаковский, Б.В., "Золотые налучья из Чертомлыкского и Иллинетского курганов" [Gold Quivers from the Chortomlyk Kurhan and from the Illinets'kyi Kurhan] *Археологический сборник в честь графа А.А. Бобринского* (Санкт Петербург 1911), 45–118.

Farmakovskii (1914): Фармаковский, Б.В. "Архаический период в России" [The Archaic Period in Russia] *Материалы по Археологии России* 34 (1914), 15–78.

Ferrarese (1974): Ferrarese, P., "Le spedizione di Pericle nel Ponto Euxino," in *Contributi dell'Istituto di Storia Antica* 2 (Milan 1974), 7–19.

Fialko (1993): Фіалко, О.І., "Новий тип дерев'яних чаш у скіфів" [A New Style of Wooden Cups among the Scythians] *Археологія* 1 (1993), 46–53.

Finley (1981): Finley, M.I., *Economy and Society in Ancient Greece* (London 1981).

Formozov and Iatsenko (1977): Формозов, А.А., И.В. Яценко и др., *Произведения искусства в новых находках советских археологов* [Works of Art in Recent Finds by Soviet Archaeologists] (Москва 1977).

Francfort (1995): Francfort, H.P. et al., "Les petroglyphes de Tamgaly," *Bulletin of the Asia Institute* 9 (1995), 167–207.

Francfort and Sher (1995): Francfort, H.P. and J.A. Sher, eds., *Sibérie du sud 2: Tepsej I–III, Ust'-Tuba I–VI (Russie, Khakassie)* (Paris 1995).

Francica (1884/1885): Francica, A., ed., *Oggetti d'Arte Greca nel secolo III avanti l'era volgare* (Rome 1884/1885).

Frankfort (1970): Frankfort, H., *The Art and Architecture of the Ancient Orient* (Frome, London 1970).

Fuhrmeister (1997): Fuhrmeister, K., "Zweiergruppen und Brüdermotiv?" *Zur graeco-skythischen Kunst* (1997), 161–76.

Furtwängler (1883): Furtwängler, A., "Der goldfund von Vettersfelde," in *BWPr* 43 (1883).

Furtwängler (1900): Furtwängler, A., *Die Antiken Gemmen* (Leipzig, Berlin 1900).

Gajdukevic (1971): Gajdukevic, V.F., *Das Bosporanische Reich* (Berlin, Amsterdam 1971).

Galanina (1977): Галанина, Л.К., "Скифские древности Приднепровья" [Scythian Antiquities of the Dnipro River Region] *Археология СССР*, вып. Д1–33 (Москва 1977), 66.

Galanina and Grach (1986): Galanina, L. and N. Grach, *Scythian Art* (Leningrad 1986).

Gamber (1978): Gamber, O., *Waffe und Rüstung Eurasiens. Frühzeit und Antike* (Braunschweig 1978).

Ganina (1964): Ганіна, О.Д., *Античные вазы* [Ancient Vessels] *Археологія* (Київ 1964).

Ganzert (1983): Ganzert, J., "Zur Entwicklung lesbischer Kymationformen," *JdI* 98 (1983), 123–202.

Gauer (1991): Gauer, W., "Die Bronzegefässe von Olympia: mit Ausnahmedes geometrischen Dreifüsse und der Kessel des orientalisierenden Stils," in *Olympische Forschungen* 20 (Berlin, New York 1991).

Gavrysh (1995): Гавриш, П.Я., "Антична монета з скіфського поселення в лісо-степовій Скіфії" [An Antique Coin from a Scythian Settlement in Forest-Steppe Scythia] *Археологія Києва* 2 (1995), 135–37.

Gebauer (1997): Gebauer, J., "Rankengedanken—zum Pektorale aus der Tolstaja Mohyla," *Zur graeco-skythischen Kunst* (1997), 147–60.

Ghirshman (1964): Ghirshman, R., *The Arts of Ancient Iran* (New York 1964).

Gimbutas (1965): Gimbutas, M., *Bronze Age Cultures in Central and Eastern Europe* (The Hague 1965).

Godard (1950): Godard, A., *Le trésor de Ziwiye* (Haarlem 1950).

Godard (1951): Godard, A., "A propos du trésor de Ziwiyè" *Artibus Asiae* 14 (1951), 240–45.

Gorbunova (1997): Gorbunova, X., "Arimaspoi," in *LIMC* 8 (1997), 529–34.

Gorbunova and Saverkina (1975): Gorbunova, X. and I. Saverkina, *Greek and Roman Antiquities in the Hermitage* (Leningrad 1975).

Gougouev (1994): Gougouev, V.K., "Tombe d'une reine Sarmate," *Les Scythes. Les dossiers d'archéologie* 194 (June 1994), 76–83.

Grach (1984): Грач, Н.Л., "Круглодонние серебрианние сосуды из кургана Куль-Оба (к вопросу о мастерских)" [Round-Bottom Silver Vessels from the Kul'-Oba Kurhan (in reference to workshops)] *Труды Государственного Эрмитажа* 24 (1984), 100–109. (summary in English)

Grach (1986): Грач, Н.Л., ред., *Античная торевтика* [Ancient Toreutics] (Ленинград 1986).

Grach (1994): Грач, Н.Л., "Пластинчастие браслети из кургана Куль-Оба" [Lamellar Bracelets from the Kul'-Oba Kurhan] *Вестник древней истории* 1 (Москва 1994), 135–42. (summary in English)

Graef (1901): Graef, B., "Archäologische Beitraege," *Hermes* 36 (1901), 81–106.

von Graeve (1970): von Graeve, V., *Der Alexandersarkophag und seine Werkstatt* (Berlin 1970).

Graham (1982): Graham, A.J., "The Colonial Expansion of Greece," in *Cambridge Ancient History*, vol. 3, part 2, second edition (Cambridge 1982).

Graham (1983): Graham, A.J., *Colony and Mother City in Ancient Greece*, second edition (Chicago 1983).

Grakov (1954): Граков, Б.Н., "Каменское городище на Днепре" [The Settlement of Kamens'ke on the Dnipro] *Материалы и исследования по археологии* 36 (Москва 1954), 236–37.

Grakov (1971): Граков, Б.Н., *Скифы* [The Scythians] (Москва 1971).

Grambo (1997): Grambo, R.L., ed., *Eagles. Masters of the Sky* (Stillwater 1997).

Grandjouan (1989): Grandjouan, C., *Hellenistic Relief Molds from the Athenian Agora* (Princeton 1989).

Greifenhagen (1967): Greifenhagen, A., "Römische Silberbecher," *JdI* 82 (1967), 27–36.

Greifenhagen (1970): Greifenhagen, A., *Schmuckarbeiten in Edelmetall,* vol. 1 (Berlin 1970).

Greifenhagen (1975): Greifenhagen, A., *Schmuckarbeiten in Edelmetall,* vol. 2 (Berlin 1975).

Griaznov (1950): Грязнов, М.П., *Первый Пазырикский Курган* [The First Pazyryk Kurhan] (Ленинград 1950).

Griaznov (1958): Griaznov, M.P., *L'art ancien de l'Altaï* (Moscow 1958).

Griaznov (1961/1963): Грязнов, М.П., "Древнейшие памятники героического епоха народов южной Сибири" [The Most Ancient Monuments of the Heroic Era of the Peoples of Southern Siberia] *Археологический сборник Государственного Эрмитажа* (Ленинград 1961/1963), 7–31.

Griaznov (1980): Грязнов, М.П., *Аржан: царский курган раннескифского времени* [Arzhan: A Royal Kurhan of the Early Scythian Period] (Ленинград 1980).

Grjaznow (1984): Grjaznow, M.P., *Der Grosskurhan von Arzan in Tuva, Südsibirien* (Munich 1984).

Gryaznov (1969): Gryaznov, M.P., *Southern Siberia,* trans. J. Hogarth (Geneva 1969).

Guarducci (1974): Guarducci, M., *Epigrafia Greca* (Rome 1974).

Hadaczek (1903): Hadaczek, K., *Der Ohrschmuck der Griechen und Etrusker* (Vienna 1903).

Hamburg, *Gold* (1993): *Gold der Skythen, Schätze aus der Staatlichen Eremitage St. Petersburg.* Hamburger Museum für Archäologie und Geschichte Harburg-Helms-Museum (Münster 1993).

Hammond (1972): Hammond, N.G.L., *A History of Macedonia,* vol. 1 (Oxford 1972).

Hammond (1978): Hammond, N.G.L., " 'Philip's Tomb' in Historical Context," *Greek, Roman and Byzantine Studies* 19 (1978), 331–350.

Hammond (1979): Hammond, N.G.L., *A History of Macedonia,* vol. 2 (Oxford 1979).

Hammond (1994): Hammond, N.G.L., *Philip of Macedon* (London 1994).

Hammond (forthcoming): Hammond, N.G.L., *A History of Macedonia,* vol. 3 (forthcoming).

Hancar (1952): Hancar, F., "The Eurasian Animal Style and the Altai Complex," *Artibus Asiae* 15 (1952), 171–94.

Hanina (1970): Ганіна, О.Д., *Античні бронзи з Піщаного* [Ancient Bronzes from Pishchane] (Київ 1970).

Hanina (1974): Ганіна, О.Д., ред., *Київський Музей історичних коштовностей* [The Kyiv Museum of Historical Treasures] (Київ 1974).

Hanover, *Makedonen* (1995): Vokotopoulou, I.K., ed., *Makedonen die Griechen des Nordens,* Forum des Landesmuseum Hannover, November 3, 1994–June 6, 1995 (Athens 1995).

Harmatta (1950): Harmatta, J., *Studies in the History of the Scythians* (Budapest 1950).

Haskins (1988): Haskins, J.F., "China and the Altaï," *Bulletin of the Asia Institute* 2 (1988), 1–9.

Hauser (1889): Hauser, F., *Die neu-attischen Reliefs* (Stuttgart 1889).

Havelock (1970): Havelock, C.M., *Hellenistic Art* (Greenwich 1970).

Havryliuk (1984): Гаврилюк, Н.О., "Скіфські імітації форм античного гончарного посуду" [Scythian Imitations of Ancient Pottery Forms] *Археологія* 48 (Київ 1984), 7–11.

Herodotus (1982): Herodotus, *Histories,* trans. A.D. Godley (Cambridge, London 1982).

Higgins (1961): Higgins, R.A., *Greek and Roman Jewellery* (London 1961).

Higgins (1965): Higgins, R.A., *Jewellery from Classical Lands* (London 1965).

Higgins (1980): Higgins, R.A., *Greek and Roman Jewellery,* second edition (London 1980).

Hill (1947): Hill, D.K., "The Technique of Greek Metal Vases and Its Bearing on Vase Forms in Metal and Pottery," *AJA* 51 (1947), 248–56.

Hill (1976): Hill, D.K., *Greek and Roman Metalware.* The Walters Art Gallery (Baltimore 1976).

Hoffmann (1963): Hoffmann, H., "Helios," *Journal of the American Research Center in Egypt* 2 (1963), 117–24.

Hoffmann (1966): Hoffmann, H., *Tarentine Rhyta* (Mainz 1966).

Hoffmann and Davidson (1965): Hoffmann, H. and P.F. Davidson, *Greek Gold: Jewelry from the Age of Alexander* (Mainz 1965).

Hoffmann and von Claer (1968): Hoffmann, H. and V. von Claer, *Antiker Gold und Silberschmuck.* Museum für Kunst und Gewerbe (Hamburg 1968).

Hölscher (1972): Hölscher, F., "Die Bedeutung archaischer Tierkampfbilder," in *Beiträge zur Archäologie* 5 (1972).

Honcharova and Makhno (1957): Гончарова, В.К. та Є.В. Махно, "Могильник Черняхівського типу біля Переяслава-Хмельницького" [A Mound of the Cherniakhivs'kyi Type near Pereiaslav-Khmel'nyts'kyi] *Археологія* 11 (Київ 1957), 127–44.

Hrouda (1983): Hrouda, B., "Der 'Schatzfund' von Ziwiyah und der ursprung des sog. Skythischen tierstils in Vorderasien," *Iranica Antiqua* 18 (1983), 97–108.

Iakovenko (1969): Яковенко, Э.В., "Килики с зооморфными изображениями" [Kylikes with Zoomorphic Representations] *Советская археология* 4 (Москва 1969), 202.

Iakovenko (1985): Яковенко, Э.В., "К вопросу происхождения шедевров торевтики из раннеэллинистических курганов Скифии и Боспора" [On the Question of the Origin of the Toreutic Masterpieces from the Early Hellenistic Kurhany of Scythia and the Bosphorus] in *Причерноморие в эпоху эллинизма. Материали III всесоюзного симпозиума по древней истории Причерноморья. Тсхалтубо, 1982 г.,* ред. О.Д. Лордкипанидзе (Тбилиси 1985), 341–52.

Iatsenko and Raevskii (1980): Яценко, И.В. и Д.С. Раевский, "Некоторые аспекты состояния скифской проблеми" [Some Aspects of the State of the Scythian Problem] *Народы Азии и Африки* 5 (Москва 1980), 102–17.

Ice Mummies (1997): BBC Horizon film, "The Ice Maiden" in the series *Ice Mummies,* aired in Great Britain in January 1997.

Iessen (1953): Эссен, А.А., "К вопросу о памятниках VIII–VII вв. до н.э. на юге европейской части СССР" [On the Question of Monuments of the Eighth–Seventh Centuries B.C. in the Southern European Section of the USSR] *Советская археология* 18 (1953), 49–110.

Illins'ka (1963): Іллінська, В.І., "Про скіфські навершники" [On Scythian Poletops] *Археологія* 15 (Київ 1963), 30–60.

Illins'ka (1966): Іллінська, В.І., "Про походження та етнічні зв'язки племен скіфської культури посульсько-донецького лісостепу" [On the Origins and Ethnic Ties of the Tribes of the Scythian Culture in the Trans-Sul-Donets'k Forest-Steppe] *Археологія* 10 (Київ 1966), 58–92.

Illins'ka, Terenozhkin, V'iazmitina, and Shul'ts (1971): Іллінська, В.І., О.І. Тереножкін, І. Вязмітіна та П.М. Шульц, "Скіфський період" [The Scythian Period] *Археологія Української РСР,* том 2 (Київ 1971), 8–277.

Il'inskaia (1968): Ильинская, В.А., *Скифы Днепровского Лесостепного Левобережья* [Scythians of the Forest-Steppe Region on the Left Bank of the Dnipro] (Киев 1968).

Il'inskaia (1973): Ильинская, В.А., "Скифская узда V в. до н.э" [A Scythian Bridle of the Fourth Century B.C.] *Скифские древности,* ред. А.И. Тереножкин (Киев 1973), 42–63.

Il'inskaia (1975): Ильинская, В.А., *Раннескифские курганы бассейна реки Тясмин* [Early Scythian Kurhany from the Tiasmyn River Basin] (Киев 1975).

Il'inskaia and Mozolevskii (1975): Ильинская, В.А. и Б.Н. Мозолевский ред., *Скифский мир* [The Scythian World] (Киев 1975).

Il'inskaia and Mozolevskii (1977): Ильинская, В.А. и Б.Н. Мозолевский, *Скифы и Сарматы* [Scythians and Sarmatians] (Киев 1977).

Il'inskaia, Mozolevskii, and Terenozhkin (1980): Ильинская, В.А., Б.Н. Мозолевский и А.И. Тереножкин, "Курганы VI в. до н. э. у с. Матусов" [Kurhany of the Sixth Century B.C. in the Village of Matusiv] *Скифия и Кавказ* (Киев 1980), 31–63.

Il'inskaia and Terenozhkin (1973): Ильинская, В.А. и А.И. Тереножкин, ред., *Скифские древности* [Scythian Antiquities] (Киев 1973).

Il'inskaia and Terenozhkin (1983): Ильинская, В.А. и А.И. Тереножкин, *Скифия VII – IV вв. до н.э.* [Scythia from the Seventh through the Fourth Centuries B.C.] (Киев 1983).

Inscriptiones Graecae (1981): *Inscriptiones Graecae,* vol. 1, third edition (Berlin 1981).

Jacobson (1983): Jacobson, E., "Siberian Roots of the Scythians: Stag Image," *Journal of Asian History* 17 (1983), 68–120.

Jacobson (1984): Jacobson, E., "The Stag with Bird-headed Antler Tines: a Study in Image Transformation and Meaning," *BMFEA* 56 (1984), 113–80.

Jacobson (1985): Jacobson, E., "Mountains and Nomads: A Reconsideration of the Origins of Chinese Landscape Representation," *BMFEA* 57 (1985), 133–80.

Jacobson (1987): Jacobson, E., *Burial Rituals, Gender, and Status in South Siberia in the Late Bronze—Early Iron Age* (Bloomington 1987).

Jacobson (1988): Jacobson, E., "Beyond the Frontier. A Reconsideration of Cultural Interchange between China and Early Nomads," in *Early China* 13 (Berkeley 1988).

Jacobson (1990a): Jacobson, E., "The Appearance of Narrative Structures in the Petroglyphic Art of Prehistoric Siberia and Mongolia" in *Первобытное искусство: семантика древних образов,* ред. Р.С. Васильевский (Новосибирск 1990).

Jacobson (1990b): Jacobson, E., "Warriors, Chariots, and Theories of Culture," *Mongolian Studies (The Hangin Memorial Issue)* 13 (1990), 83–116.

Jacobson (1993): Jacobson, E., *The Deer Goddess of Ancient Siberia. A Study in the Ecology of Belief* (Leiden 1993).

Jacobson (1995): Jacobson, E., *The Art of the Scythians. The Interpretation of Cultures at the Edge of the Hellenic World* (Leiden, New York, Cologne 1995).

Jacobson (1997): Jacobson, E., "The 'Bird Woman,' the 'Birthing Woman,' and the 'Woman of the Animals': A Consideration of the Female Image in Petroglyphs of Ancient Central Asia," *Arts Asiatiques* 52 (1997), 37–59.

Jacobson and Kubarev (1994): Jacobson, E. and V.D. Kubarev, "Turu-Alty (Analysis of a Siberian 'Sanctuary')" *Altaica* 4 (1994), 18–29.

Jacobsthal (1927): Jacobsthal, P., *Ornamente griechischen Vasen* (Berlin 1927).

Jacobsthal (1956): Jacobsthal, P., *Greek Pins* (Oxford 1956).

Jacoby (1962): Jacoby, F., *Die Fragmente der griechischen Historiker* (Leiden 1962).

Jeffery (1990): Jeffery, L.H., *The Local Scripts of Archaic Greece. A Study of the Origin of the Greek Alphabet and its Development from the Eighth to the Fifth Centuries* b.c. revised edition, A.W. Johnston, second edition (Oxford 1990).

Jenkins (1994): Jenkins, I., *The Parthenon Frieze* (Austin 1994).

Jentel (1976): Jentel, M.O., *Les gutti et les askoi à reliefs étrusques et apuliens. Essai de classification et de typologie* (Leiden 1976).

Jettmar (1965): Jettmar, K., *L'art des steppes* (Paris 1965).

Jettmar (1967): Jettmar, K., *Art of the Steppes* (London, New York 1967).

Jettmar (1971): Jettmar, K., "Metallurgy in the Early Steppes," *Artibus Asiae* 33 (1971), 5–16.

Johnston (1996): Johnston, P.A., "Cybele and Her Companions on the Northern Littoral of the Black Sea," *Cybele, Attis and Related Cults: Essays in Memory of M.J. Vermaseren*, ed. E.N. Lane (New York 1996), 101–16.

Jones (1996): Jones, D., *Eagles* (Vancouver 1996).

Juliis (1984): Juliis, E.M. de, *Gli ori di Taranto* (Milan 1984).

Jünger (1997) Jünger, F., "Deutungsvorschläge zur sog. 'Sitzenden Göttin'," *Zur graeco-skythischen Kunst* (1997), 49–60.

Kaposhina (1958a): Капошина, С.И., "О скифских элементах в культуре Ольвии" [On Scythian Elements in the Culture of Olbia] *Материалы и исследования по археологии СССР* 50 (Москва 1958), 154–89.

Kaposhina (1958b): Капошіна, С.І., "Пам'ятки скіфського звіриного стилю знайдені в Ольвії" [Objects in the Scythian Animal Style Found in Olbia] *Археологічні пам'ятки УРСР* 7 (Київ 1958), 98–112.

Katowice, *Koczownicy* (1996): Chochorowski, J., ed., *Koczownicy Ukrainy*, Museum Slaskie, (Katowice 1996).

Khanenko and Khanenko (1899): Ханенко, Б.И. и В.Н. Ханенко, *Древности Приднепровья* [Antiquities of the Dnipro River Region], том 1 (Киев 1899).

Khanenko and Khanenko (1900): Ханенко Б.И. и В.Н. Ханенко, *Древности Приднепровья* [Antiquities of the Dnipro River Region], том 2 (Киев 1900).

Khanenko and Khanenko (1901): Ханенко Б.И. и В.Н. Ханенко, *Древности Приднепровья* [Antiquities of the Dnipro River Region], том 3 (Киев 1901).

Khanenko and Khanenko (1907): Ханенко Б.И. и В.Н. Ханенко, *Древности Приднепровья* [Antiquities of the Dnipro River Region], том 6 (Киев 1907).

Khorunzhei (1992): Хорунжей, Ю.М. та ін., *Геродот із Галікарнасу. Скіфія. Найдавніший опис України з V століття перед Христом* [Herodotus of Halicarnassus. Scythia. The Oldest Description of Ukraine from the Fifth Century b.c.] (Київ 1992).

Khudiak (1940): Худяк, М.Н., "Терракоты" [Terracottas] *Ольвия* 4 (Київ 1940), 85–86.

Khvoika (1905): Хвойка, В.В., "Раскопки курганов при с. Оситняжка Чигиринского уезда Киевской губернии" [Excavations of Kurhany near the Village of Osytniazhka in the Chyhyryn District of Kyiv Gubernia] *Археологическая летопись Южной России* (1905), 9.

King, Noble, and Humphreys (1996): King, J., J. Noble, and A. Humphreys, *Central Asia* (Hawthorn, Australia 1996).

Kirilin (1978): Кирилин, Д.С., "Трехбратние курганы в районе Тобечикского озера" [The Tr'okhbratni Kurhany (Three Brothers Kurhany) in the Region of Tobechik Lake] *Античная история и культура Средиземноморья и Причерноморья* (Ленинград 1968), 185. Reprinted in *Античная культура Средиземноморья и Причерноморья* (Москва 1978), 183.

Kiselev (1951): Киселев, С.В., *Древная история Южной Сибири* [Ancient History of Southern Siberia] (Москва 1951).

Klochko (1979): Клочко, Л.С., "Реконструкція скіфських головних жіночих уборів за матеріалами Червоноперекопських курганів" [The Reconstruction of Scythian Women's Headdresses with Material from the Chervonoperekop Kurhany] *Археологія* 31 (1979), 16–28.

Klochko (1982a): Клочко, Л.С., "Новые материалы к реконструкции головного убора скифянок" [New Material for the Reconstruction of Scythian Women's Headdresses] *Древности степной Скифии* (Киев 1982), 124.

Klochko (1982b): Клочко, Л.С., "Скифские налобные украшения IV – III вв.до н.э." [Scythian Frontlet Decorations in the Fourth–Third Centuries b.c.] *Новые памятники древной и средневековой художественной культуры* (Киев 1982), 37–53.

Klochko (1986): Клочко, Л.С., "Реконструкція конусоподібних головних уборів скіф'янок" [Reconstruction of the Cone-like Headdresses of Scythian Women] *Археологія* 56 (1986), 16.

Klochko (1992): Клочко, Л.С., "Плечовий одяг скіф'янок" [Shoulderwear of Scythian Women] *Археологія* 3 (1992), 21.

Klochko, Murzin, and Rolle (1991): Клочко, Л.С., В.Ю. Мурзін та Р. Ролле, "Головний убір з кургану Тетянина Могила" [A Headdress from the Kurhan Tetianyna Mohyla] *Археологія* 3 (1991), 58–62.

Knigge (1980): Knigge, U., "Kerameikos. Tätigkeitsbericht 1978," *AA* (1980), 256–65.

Knipovich (1940): Книпович, Т.Н., "Некрополь в северо-восточной части Ольвийского городища" [The Necropolis in the Northeastern Section of the Settlement at Olbia] *Советская археология* 6 (Москва 1940), 92–106.

Knipovich (1941): Книпович, Т.Н, "Некрополь на территории Ольвии" [The Necropolis in the Territory of Olbia] *Краткие сообщения о докладах и полевых исследованиях Института истории материальной культуры АН СССР* 10 (1941), 112–20.

Kochelenko (1993): Kochelenko, G.A., "Entre Scythes et grecs," *Les villes grecques de la mer noire. Les dossiers d'archéologie* 188 (December 1993), 4–9.

Kochelenko and Kouznetsov (1993): Kochelenko, G.A. and V.D. Kouznetsov, "Le royaume du Bosphore," *Les villes grecques de la mer noire. Les dossiers d'archéologie* 188 (December 1993), 34–39.

Kopeikina (1986): Копейкина, Л.В., "Золотые бляшки из кургана Куль-Оба" [Gold Plaques from the Kul'-Oba Kurhan] *Античная торевтика*, ред. Н.Л. Грач (Ленинград 1986), 28–63.

Korpusova (1987): Корпусова, В.Н., "Восточногреческая расписная керамика" [Eastern Greek Decorated Ceramics] *Культура населения Ольвии и ее округи в архаическое время* (Киев 1987), 50.

Kossack (1987): Kossack, G. von den, "Anfangen des skytho-iranischen Tierstils," *Skythika* (1987), 71–76.

Kouzmine (1994): Kouzmine, N.I., "Les steppes de Siberie du sud," *Les Scythes. Les dossiers d'archéologie* 194 (June 1994), 44–51.

Kouznetsov (1993): Kouznetsov, V.D., "La colonisation grecque du littoral septentrionale de la mer noire," *Les villes grecques de la mer noire. Les dossiers d'archéologie* 188 (December 1993), 10–15.

Kovaleva and Mukhopad (1982): Ковалева, И.Ф. и С.Е. Мухопад, "Скифское погребение конца VI – V вв.до н.э. у с. Александрівка" [Scythian Burials at the End of the Sixth–Fifth Centuries B.C. in the Village of Aleksandrivka] *Древности степной Скифии* (Киев 1982), 97.

Kovpanenko (1967): Ковпаненко, Г.Т., "Розкопки Трахтемирівського городища" [Excavations at the Settlement in Trakhtemyriv] *Археологические исследования Украины в 1965–1966 г.г.* 1 (1967), 103–106.

Kovpanenko (1986a): Ковпаненко, Г.Т., "Работы на Днепровском Правобережье" [Work on the Right Bank of the Dnipro River] *Археологические открытия 1984 г.* (Москва 1986), 248.

Kovpanenko (1986b): Ковпаненко, Г.Т., *Сарматское погребение I в. до н.э. на Южном Буге* [Sarmatian Burials in the First Century B.C. on the Southern Buh River] (Киев 1986).

Kovpanenko, Bessonova and Skoryi (1989): Ковпаненко, Г.Т., С.С. Бессонова, и С.А. Скорый, *Памятники скифской эпохи Днепровского Лесостепного Правобережья* [Remains of the Scythian Era in the Forest-Steppe Region of Right Bank Dnipro] (Киев 1989).

Kozub (1973): Козуб, Ю.І., "Модель лука из Ольвии" [A Model of a Bow from Olbia] *Скифские древности* (Киев 1973), 270–74.

Kozub (1974): Козуб, Ю.І., "Ольвия: керамическое производство и античние керамические строителние материали" [Olbia: Ceramic Production and Ancient Ceramic Building Materials] *Археология СССР* (1974), 1–20.

Kozub (1979): Козуб, Ю.І., "Передмістя Ольвії" [The Outskirts of Olbia] *Археологія* 29 (1979), 3–33.

Kraay (1966): Kraay, C.M., *Greek Coins* (New York 1966).

Kraay (1976): Kraay, C.M., *Archaic and Classical Greek Coins* (London 1976).

Kriseleit (1980): Kriseleit, J., "Antike Guss-und Treibformen," *Funde und Berichte: Staatliche Museen zu Berlin* 20/21 (1980), 189–98.

Kruglikova (1963): Кругликова, И.Т., "Исследование сельских поселений Боспора" [Research on the Village Settlements of the Bosporus] *Вестник древней истории* (1963), 65–79.

Kruglov (1997): Круглов, А.В., "Неоаттические релиефы с менадамы – копии Каллимаха или новотворчество?" [Neo-Attic Reliefs with Maenads: Replicas of Callimachos' Work or New Creations?] *Труды Государственного Эрмитажа* 28 (1997), 117–33. (summary in English)

Kryjitskij (1993): Kryjitskij, S.D., "Olbia l'heureuse," *Les villes grecques de la mer noire. Les dossiers d'archéologie* 188 (December 1993), 16–25.

Kubarev (1987): Кубарев, В.Д., *Курганы Уландрыка* [The Kurhany of Ulandryk] (Новосибирск 1987).

Kubarev (1988): Кубарев, В.Д., *Древние расписи Каракола* [Ancient Painting from Karakol] (Новосибирск 1988).

Kubarev (1991): Кубарев, В.Д., *Курганы Юстыда* [The Kurhany of Iustyd] (Новосибирск 1991).

Kubarev (1992): Кубарев, В. Д. *Курганы Сайлюгема* [The Kurhany of Sailiugem] (Новосибирск 1992).

Kubarev and Jacobson (1996): Kubarev, V.D. and E. Jacobson, *Sibérie du Sud 3: Kalbak-Tash I (République de l'Altai)* (Paris 1996).

Kubyšev (1991): Kubyšev, A.I., "Der Bratoljubovka-Kurhan. Die Grabanlage eines skythischen Nomarchen?" *Hamburger Beiträge zur Archäologie* 18 (1991, published in 1996), 132–40.

Kubyshev (1985): Кубышев, А.И., "Скифский могильник у с. Водославка" [A Scythian Burial Mound in the Village of Vodoslavka] *Археологические открытия 1983* (Москва 1985), 301–302.

Kubyshev, Nikolova, and Polin (1982): Кубышев, А.И., А.В. Николова, и С.В. Полин, "Скифские курганы у с. Львово на Херсонщине" [Scythian Kurhany in the Village of L'vovo in the Kherson Region] *Древности степной Скифии* (Киев 1982), 140–41, 147.

Kubyshev and Koval'ov (1994): Кубишев, А.І. та М.В. Ковальов, "Скіфський Братолюбівський курган V ст. до н.е. на Херсонщині" [The Scythian Bratoliubivs'kyi Kurhan of the Fifth Century B.C. in the Kherson Region] *Археологія* 1 (Київ 1994), 141–44.

Kull (1997): Kull, B., "Orient und Okzident: Aspekte der Datierung und Deutung des Hortes von Rogozen," in *Cronos. Beiträge zur prähistorischen Archäologie zwischen Nord- und Südosteuropa. Festschrift für Bernhard Hänsel,* eds. C. Becker, M.L. Dunkelmann, et al. (Eskelkamp 1997), 689–710.

Kuruniotis (1913): Kuruniotis, K., "Goldschmuck aus Eretria," *AM* 38 (1913), 289–328.

Kyiv, *Археологія* (1971): *Археологія Української РСР* [Archaeology of the Ukrainian SSR], том 1–3 (Київ 1971).

Kyiv, *летопись* (1901): *Археологическая летопись Южной России* [Archaeological Chronicle of Southern Russia], том 3 (Киев 1901), 213–15.

Kyzlasov (1986): Кызласов, Л.Р., *Древнейшая Кавказия* [Ancient Caucasus] (Москва 1986).

Laffineur (1986): Laffineur, R., *Amathonte III, Testimonia 3: L'Orfèvrerie* (Paris 1986).

Lamb (1969): Lamb, W., *Ancient Greek and Roman Bronzes* (Chicago 1969).

Langlotz (1963): Langlotz, E., *Die Kunst der Westgriechen in Sizilien und Unteritalien* (Munich 1963).

Lehmann (1980): Lehmann, P.W., "The So-Called Tomb of Philip II: A Different Interpretation," *AJA* 84/4 (1980), 527–31.

Lemos (1991): Lemos, A.A., *Archaic Pottery of Chios* (Oxford 1991).

Leskov (1968): Лесков, А.М., "Богатое скифское погребение из Восточного Крыма" [A Rich Scythian Burial from Eastern Krym] *Советская археология* 10 (1968), 158–65.

Leskov (1972): Лесков, А.М., *Новые сокровища курганов Украины* [New Treasures from the Kurhany of Ukraine] (Киев 1972). Reprinted in English, Leskov, A., *Treasures from the Ukrainian Barrows: Latest Discoveries* (Leningrad 1972).

Leskov (1974): Leskov, A.M., "Die skythischen Kurhane," *Antike Welt* 5 (1974), 1–100.

Levina (1994): Levina, L.M., "La culture de Djety-Assar," *Les Scythes. Les dossiers d'archéologie* 194 (June 1994), 58–63.

Levy (1990): von Bothmer, D. ed.,*Glories of the Past: Ancient Art from the Shelby White and Leon Levy Collection,* (New York 1990).

Liberov (1965): Либеров, П.Д., "Памятники скифского времени на среднем Дону" [Monuments of the Scythian Period on the Central Don River] in *Археология СССР: Свод археологических источников,* вып. Д1–31 (Москва 1965).

Lieskov (1974): Лєсков, О.М., *Скарби курганів Херсонщини* [Treasures from the Kurhany in the Kherson Region] (Київ 1974).

London, *Frozen Tombs* (1978): *Frozen Tombs: The Culture and Art of the Ancient Tribes of Siberia.* The British Museum (London 1978).

Lordkipanidze (1978): Лордкипанидзе, Г., "Колхида в VI–II вв. до н.э." [Colchis in the Sixth–Second Centuries B.C.] in *Бронзовые удила, случайная находка на Ванском городище* (Тбилиси 1978).

von Lorentz (1937): von Lorentz, F., "ΒΑΡΒΑΡΩΝ ΥΦΑΣΜΑΤΑ," [Barbarian Textiles] *RM* 52 (1937), 165–222.

Lullies (1962): Lullies, R., "Vergoldete Terrakotta-Appliken aus Tarent," *RM* 7 (1962).

Luxembourg, *TrésORS* (1997): *TrésORS d'Ukraine.* Musée national d'histoire et d'art, October 16–December 15, 1997 (Luxembourg 1997).

Maass (1985): Maass, M., *Wege zur Klassik. Führer durch die Antikenabteilung des Badischen Landesmuseums* (Karlsruhe 1985).

Macdonald (1981): Macdonald, B.R., "The Emigration of Potters from Athens in the Late Fifth Century B.C. and Its Effect on the Attic Pottery Industry," *AJA* 85 (1981), 159–68.

Machortych and Cernenko (1991): Machortych, S.V. and E.V. Cernenko, "Zu den kaukasischen "Pektoralen" des 8. bis 7. Jahrhunderts v. Chr. Ein Beitrag zur Kampfausrüstung Kimmerischer Pferde," *Hamburger Beiträge zur Archäologie* 18 (1991, published in 1996) 31–46.

MacPherson (1857): MacPherson, D., *Antiquities of Kertch and Researches in the Cimmerian Bosphorus* (London 1857).

Maier (1994): Maier, F., *Trekking in Russia and Central Asia* (Seattle 1994).

Makaronas (1963): Μακάρονας Χ., "Τάφοι παρὰ τὸ Δερβένι Θεσσαλονίκης," [Tombs near Derveni in Thessalonika] *Ἀρχαιολογικὸν Δελτίον* 18 B2 (1963), 193–96.

Maksimova, Ermolaeva, and Mar'iashev (1985): Максимова, А.Г., А.С. Ермолаева и А.Н. Марьяшев, *Наскальные изображения урочища Тамгалы* [Rock Images from Tamgaly Gully] (Алма-Ата 1985).

Malibu, *Fleischmann* (1994): *A Passion for Antiquities: Ancient Art from the Collection of Barbara and Lawrence Fleischmann*. The J. Paul Getty Museum, October 13, 1994–January 15, 1995; The Cleveland Museum of Art, February 15–April 23, 1995, eds. M. True and K. Hamma (Malibu 1994).

Mallowan (1966): Mallowan, M.E.K., *Nimrud and Its Remains* (New York 1966).

Mannheim, *Gold* (1989): *Gold und Kunst handwerk vorn antiken Kuban: neue archäologische Entdeckungen aus des Sowjetunion*. Städtisches Reiss-Museum Mannheim, January 22–March 27, 1989 (Stuttgart 1989).

Mantsevich (1950): Манцевич, А.П., "Гребень и фиала из кургана Солоха" [A Comb and Phiale from Kurhan Solokha] *Советская археология* 10 (1950), 217–38.

Mantsevich (1962): Манцевич, А.П., "Горит из кургана Солоха" [A Gorytos from the Kurhan Solokha] *Труды Государственного Эрмитажа* 7 (1962), 107–21. (summary in German)

Mantsevich (1969): Манцевич, А.П., "Парадний меч из кургана Солоха" [A Ceremonial Sword from Solokha Kurhan] *Древние фракийцы в Северном Причерноморье. Материали и исследования по археологии СССР*, ред. Т.Д. Златковская и А.И. Мелюкова (Москва 1969), 96–118.

Mantsevich (1980a): Манцевич, А.П., "Находка в царской гробнице у древние Вергини в Северной Македонии" [A Find in a Royal Tomb in Ancient Vergina in Northern Macedonia] *Вестник древней истории* 3 (1980), 153–67.

Mantsevich (1980b): Mantsevich, A.P., "Sur l'origine des objets de toreutique dans les Tumuli de l'époque scythe," *Etudes sur l'orfèvrerie antique*, ed. T. Hackens (Louvain-la-Neuve 1980), 80–105.

Mantsevich (1987): Манцевич, А.П., *Курган Солоха: Публикация одной коллекции* [Kurhan Solokha: A Publication of One Collection] (Ленинград 1987).

Mantua, *L'uomo d'oro* (1998): Popescu, G.A., C.S. Antonini, and K. Baipakov, eds., *L'uomo d'oro. La cultura delle steppe del Kazakhstan dall'eta del bronzo alle grandi migrazioni*. Palazzo del Te, April 25–July 26, 1998 (Milan 1998).

Manzewitch (1932): Manzewitch, A., *Ein Grabfund aus Chersonnes* (Leningrad 1932).

Marazov (1998): Marazov, I., ed., *Ancient Gold: The Wealth of the Thracians. Treasures from the Republic of Bulgaria* (New York 1998).

Marchenko (1974): Марченко, И.Д., "Марионетки и культовые статуэтки Пантикапея" [Marionettes and Cult Statuettes of Pantikapaion] *Археология СССР, Свод археологических источников*, вып. Г1–11 (Москва 1974), 38–46.

Maric (1979a): Maric, Z., "Bronzene Gussformen aus der stadt Daors oberhalb des Dorfes Osanici bei Stolac," *Wissenschaftliche Mitteilungen des Bosnisch-Herzegowinischen Landesmuseums* VI. H. A (Sarajevo 1979), 211–42.

Maric (1979b): Maric, Z., "Depo pronaden u ilirskom gradu Daors (2.st.pr.n.e.)" [The Hoard Found at the Illyrian Town of Daors (Second Century B.C.)] *Glasnik Zemajskog Muzeja Bosne i Hercegovine u Sarajevu. Arheologija* 33 (1979), 23–113.

Marsadolov (1988): Марсадолов, Л.С. "Дендрохронология больших курганов Сайано-Алтая I тисячелетия до н.э." [Dendrochronology of the Large Kurhany of the Saiano-Altai in the First Millennium B.C.] *Археологический сборник* 29 (1988), 65–81.

Marshall (1907): Marshall, F.H., *Catalogue of the Finger Rings, Greek, Etruscan and Roman, in the Departments of Antiquities, British Museum* (London 1907).

Marshall (1911): Marshall, F.H., *Catalogue of the Jewellery, Greek, Etruscan and Roman, in the Departments of Antiquities, British Museum* (London 1911).

Martinov (1979) Мартинов, А.И., *Лесостепная тагарская культура* [Tagar Culture of the Forest-Steppe Zone] (Новосибирск 1979).

Maslennikov (1993): Maslennikov, A.A., "Du nouveau sur les etablissements ruraux du Bosphore," *Les villes grecques de la mer noire. Les dossiers d'archéologie* 188 (December 1993), 68–73.

Maxwell-Hyslop (1971): Maxwell-Hyslop, K.R., *Western Asiatic Jewellery, c. 3000–612 B.C.* (London 1971).

Meiggs and Lewis (1969): Meiggs, R. and D. Lewis, *A Selection of Greek Historical Inscriptions to the End of the Fifth Century B.C.* (Oxford 1969).

Meiggs (1972): Meiggs, R., *The Athenian Empire* (Oxford 1972).

Meletinskii (1963): Мелетинский, Е.М., *Происхождение героического епоса* [Origins of the Heroic Epos] (Москва 1963).

Meliukova (1976): Мелюкова, А.И., "К вопросу о взаимовзязьсх скифського и фракійского искусства" [On the Question of the Mutual Ties of Scythian and Thracian Art] *Скифо-сибирский звериный стиль в искусстве народов Евразии* (Москва 1976), 112–26.

Melyukova (1990): Melyukova, A. I., "The Scythians and the Sarmatians," in *The Cambridge History of Early Inner Asia*, ed. D. Sinor (Cambridge 1990), 97–117.

Melyukova (1995): Melyukova, A.I., "Scythians of Southeastern Europe," in Davis-Kimball, Bashilov, and Yablonsky, 27–62.

Merritt, Wade-Gery, and McGregor (1939–1953): Merritt, B.D., H.T. Wade-Gery, and M.F. McGregor, *The Athenian Tribute Lists*, 4 vols. (Cambridge, Princeton 1939–1953).

Merritt and West (1934): Merritt, B.D. and A.B. West, *The Athenian Assessment of 425 B.C.* (Ann Arbor 1934).

Mertens (1976): Mertens, J., "A Hellenistic Find in New York," *Metropolitan Museum Journal* (1976), 71.

Mertens (1987): Mertens, J.R., et al., *The Metropolitan Museum of Art: Greece and Rome* (New York 1987).

Meyers (1981): Meyers, P., "Three Silver Objects from Thrace: A Technical Examination," *Metropolitan Museum Journal* 16 (1981), 49–54.

Michel (1995): Michel, S., "Der Fisch in der skythischen Kunst," *Europäische Hochschulschriften, Archäologie* 52 (Frankfurt-am-Main 1995).

Michel (1997): Michel, S., " 'Allround-Mischwesen'-Visuelle Formulierung und Tradierung eines skythischen Bildgedankens," *Zur graeco-skythischen Kunst* (1997), 25–36.

Mielczarek (1986): Mielczarek, M., "Gold Pantikapaean Coins Set in Rings Found in the Great Ryzhanovka Barrow (Ukraine)," *Archeologia Warsz* 37 (1986), 99–105.

Milan, *Gli ori* (1985): De Juliis, E. M., ed., *Gli ori di Taranto in età ellenistico*, Brera 2, December 1984–March 1985 (Milan 1985).

Milan, *I Goti* (1994): *I Goti*. Palazzo Reale, 28 January–8 May, 1994 (Milan 1994).

Milan, *Tesori* (1995): *Tesori delle Steppe*. Galleria Ottavo Piano, La Rinascente piazza Duomo, December 1, 1995–January 13, 1996 (Milan 1995).

Miller (1979): Miller, S.G., *Two Groups of Thessalian Gold* (Berkeley 1979).

Minasian (1991): Минасян, Р.С., "Техника изготовления золотых и серебрянних предметов из кургана Чертомлик" [The Technique of Manufacturing Gold and Silver Objects from the Chortomlyk Kurhan] *Чертомлик* (1991), 378–89.

Minns (1913): Minns, E.H., *Scythians and Greeks* (Cambridge 1913).

Minns (1924): Minns, E.H., *The Art of the Nomads* (London 1924).

Minzhulin (1988): Минжулин, А.И., "Защитное вооружение воина лучника V–IV вв. до н.э. из кургана у села Гладковщина (реставрация и научная реконструкция)" [Defensive Fittings of a Warrior-Bowman of the Fifth–Fourth Centuries B.C. from the Kurhan in the Village of Hladkivshchyna] *Советская археология* 4 (1988), 116–26.

Mitten and Doeringer (1967): Mitten, D. and S. Doeringer, *Master Bronzes from the Classical World*. Fogg Art Museum, December 4, 1967–January 22, 1968; The City Art Museum of Saint Louis, March 1–April 13, 1968; Los Angeles County Museum of Art, May 8–June 30, 1968 (Mainz 1967).

Mochkova (1994): Mochkova, M.G., "Le cimetière sarmate de Lebedevka dans le sud de l'oural," *Les Scythes. Les dossiers d'archéologie* 194 (June 1994), 84–87.

Mohen (1975): Mohen, J.P., "Le travail de l'or au pays des Scythes et en Siberie," *Revue du Louvre* 25/5-6 (1975), 305–11.

Molodin (1993): Молодин, В.И., "Эшо раз о датировке турочакских писаниц" [Another Note on the Dating of the Turochak Petroglyph] *Культура древних народов южной сибири* (Барнаул 1993), 4–25.

Monahov (1995/1996): Monahov, S.Ju., "La chronologie de quelques kourganes de la noblesse scythe du IVe siècle av.n.e. du littoral septentrional de la Mer Noire," *Il Mar Nero* 2 (1995/1996), 29–59.

Mongait (1961): Mongait, A.L., *Archeology in the U.S.S.R.* (Baltimore 1961).

Moroujenko (1994): Moroujenko, A.A., "Le kourgane scythe de Perederieva Moguila," *Les Scythes. Les dossiers d'archéologie* 194 (June 1994), 22–25.

Moruzhenko (1992): Моруженко, А.О., "Скіфський курган Передерієва Могила" [The Scythian Kurhan Perederiieva Mohyla] *Археологія* 4 (1992), 61–4.

Moshkova, History (1995): Moshkova, M., "A Brief Review of the History of the Sauromatians and Sarmatian Tribes," in Davis-Kimball, Bashilov, and Yablonsky, 85–90.

Moshkova (1995): Moshkova, M., "Sarmatians. Some Concluding Remarks," in Davis-Kimball, Bashilov, and Yablonsky, 185–88.

Moskva, *Археология* (1984): *Археология СССР-Античные государства Северного Причерноморья* [Archaeology of the USSR – Ancient States of the Northern Black Sea Region] (Москва 1984).

Moskva, Orfèvrerie (1975): *Orfèvrerie ancienne de la collection du Musée des trésors historiques d'Ukraine* (Moscow 1975).

Mozolevskii (1972): Мозолевский, Б.Н., "Скифские погребения у с. Нагорное близ г. Орджоникидзе на Днепропетровщине" [Scythian Burials in the Village of Nahirne near the Town of Ordzhonikidze in the Dnipropetrovs'k Region] *Скифские древности* (Киев 1972), 224.

Mozolevskii (1980): Мозолевский, Б.Н., "Скифские курганы в окрестностях г. Орджоникидзе на Днепропетровщине (раскопки 1972–1975 гг.)" [Scythian Kurhany in the Neighborhoods of the Town of Ordzhonikidze in the Dnipropetrovs'k Region (Excavations from 1972–1975)] *Скифия и Кавказ* (Киев 1980), 108–48.

Mozolevskii (1982): Мозолевский, Б.Н., "Скифский "царский" курган Желтокаменка" [The Scythian "Royal" Kurhan Zhovtokam'ianka] *Древности степной Скифии* (Киев 1982), 211.

Mozolevskii (1990): Мозолевский, Б.М., *Происхождение скифов: основные этапы формирования скифского этноса* [The Origin of the Scythians: Essential Stages of Formation of the Scythian Ethos] (Киев 1990).

Mozolevskii and Polin (1987): Мозолевський, Б.М. и С.В. Полин, "Скифский курган Бабина Могила" [The Scythian Kurhan Babyna Mohyla] in *Задачи советской археологии в свете решений XXVII съезда КПСС, Тезисы докладов всесоюзной конференции* (Москва 1987), 8–9.

Mozolevs'kyi (1979): Мозолевський, Б.М., *Товста Могила* [Tovsta Mohyla] (Київ 1979).

Mozolevs'kyi (1983): Мозолевський, Б.М., *Скіфський степ* [The Scythian Steppe] (Київ 1983).

Mozolevs'kyi (1992): Мозолевський, Б.М., "Під скіфським небом" [Beneath the Scythian Sky] *Київська старовина* 4 (Київ 1992), 72–80.

Mozolevs'kyi, Bilozor, and Vasylenko (1993): Мозолевський, Б.М., В.П. Білозор та В.А. Василенко, "Дослідження Соболевої Могили" [Excavations at Soboleva Mohyla] *Археологічні досліди в Україні 1991 р.* (Луцьк 1993), 71–72.

Munich, Gold (1984): *Gold der Skythen aus der Leningrader Eremitage.* Staatliche Antikensammlungen, September 19 – December 9, 1984 (Munich 1984).

Murzin (1984): Мурзін, В.Ю., "Проблема походження скіфів в сучасній історіографії" [The Problem of Scythian Origins in Contemporary Historiography] *Археологія* 46 (1984), 22–31.

Murzin (1990): Мурзін, В.Ю., *Происхождение скифов: основные этапы формирования скифского этноса* [The Origin of the Scythians: Essential Stages of Formation of the Scythian Ethos] (Киев 1990).

Murzin (1996): Murzin, V., "Nadczarnomorska Scytia," [Scythia on the Black Sea Littoral] *Koczownicy Ukrainy: Katalog Wystawy* (Katowice 1996), 49–64. (Also in Ukrainian)

Murzin, Polin, and Rolle (1993): Мурзін, В.Ю., С.В. Полін та Р. Ролле "Скіфський курган Тетянина Могила" [The Scythian Kurhan Tetianyna Mohyla] *Археологія* 2 (1993), 85–101.

Musche (1992): Musche, B., *Vorderasiatischer Schmuck von den Anfängen bis zur Zeit der Achaemeniden* (Leiden 1992).

Musti (1992): Musti, D. et al., *L'oro dei Greci* (Novara 1992).

Naumann (1983): Naumann, F., "Die Ikonographie der Kybele in der phrygischen und der griechischen Kunst," in *Istanbuler Mitteilungen, Beiheft* 28 (Tübingen 1983).

Naumann-Steckner (1996): Naumann-Steckner, F., "Privater Dank—Silbervotive aus Nordafrika," *Cybele, Attis and Related Cults: Essays in Memory of M. J. Vermaseren* (1996), 167–92.

Newton (1880): Newton, C., "Greek Art in the Kimmerian Bosporos," in *Essays on Art and Archaeology* (London 1880), 373–99.

New York, Scythians (1975): *From the Lands of the Scythians: Ancient Treasures from the Museums of the U.S.S.R. 3000 в.с.–100 в.с* The Metropolitan Museum of Art, April 19–June 29, 1975, and the Los Angeles County Museum of Art (New York 1975). Also issued as *Bulletin of the Metropolitan Museum of Art* 32/5 (1973–1974).

Nikulina (1994): Никулина, Н.М., *Искусство Ионии и ахеменидского Ирана* [The Art of Ionia and Achaemenid Iran] (Москва 1994).

Noble (1996): Noble, J. et. al., *Russia, Ukraine, and Belarus* (Hawthorn, Australia 1996).

Noll (1984): Noll, R., "Zwei römerzeitliche Grabfunde aus Rumänien in der Wiener Antikensammlung. Mit einer Exhurs Goldene Herkuleskeulen," *Jahrbuch Römisch-Germanischen Zentralmuseums Mainz* 31 (1984), 435–54.

Noonan (1973): Noonan, T.S., "The Grain Trade of the Northern Black Sea in Antiquity," *American Journal of Philology* 94/3 or 375 (1973), 231–42.

Novytskii (1990): Новицкий, Е.Ю., *Монументальная скульптура древнейших земледельцев и скотоводов Северо-западного Причерноморья* [Monumental Sculpture of the Oldest Farmers and Herdsmen of the Northwestern Black Sea Littoral] (Одесса 1990).

Odense, Steppens (1994): *Steppens nomader–skaves bunder Ukraines arkacologi i 2000 er (900 f.kr. 1240)* (Odense 1994).

Ogden (1982): Ogden, J., *Jewellery of the Ancient World* (London 1982).

Ogden (1992): Ogden, J., *Interpreting the Past: Ancient Jewellery* (London 1992).

Ogden (forthcoming): Ogden, J., *Gold Jewellery in Ptolemaic, Roman and Byzantine Egypt* (forthcoming).

Ognenova (1961): Ognenova, L., "Les cuirasses de bronze trouvées en Thrace," *BCH* 85 (1961), 501–38.

Okladnikov (1959): Okladnikov, À.P., *Ancient Population of Siberia and Its Cultures* (New York 1959).

Oliver (1966): Oliver, A., "Greek, Roman, and Etruscan Jewelery," *Bulletin of the Metropolitan Museum of Art* 24 (1966), 269–84.

Oliver (1977): Oliver, A., ed., *Silver for the Gods: 800 Years of Greek and Roman Silver.* The Toledo Museum of Art (Toledo 1977).

Ol'khovskii and Evdokimov (1994): Ольховский, В.О. и Г.Л. Эвдокимов, *Скифские каменные изваяния VII–III вв. до н.э.* [Scythian Stone Sculptures of the Seventh–Third Centuries в.с.] (Москва 1994).

Olkhovski (1994): Olkhovski, V.S., "Baite. Un ensemble culturel à l'est de la Caspienne," *Les Scythes. Les dossiers d'archéologie* 194 (June 1994), 54–57.

Onaiko (1966): Онайко, Н.А., "Античный импорт в Приднепровье и Побужье в VII–V вв. до н.э." [Ancient Import in the Dnipro and Buh River Regions in the Seventh–Fifth Centuries в.с.] *Археология СССР: Свод археологических источников*, вып. Д1–27 (Москва 1966), 66–69.

Onaiko (1970): Онайко, Н.А., "Античный импорт в Приднепровье и Побужье в IV–II вв. до н.э." [Ancient Import in the Dnipro and Buh River Regions in the Fourth–Second Centuries в.с.] *Археология СССР: Свод археологических источников*, вып. Д1–27 (Москва 1970), 120–24.

Onaiko (1974): Онайко, Н.А., "Заметки о технике боспорской торевтики" [Notes on the Technique of Bosphoran Toreutics] *Советская археология* 3 (1974), 78–86.

Onaiko (1976): Онайко, Н.А., "Звериный стиль и античний мир в Северном Причерноморье в VII–IV вв. до н.э." [The Animal Style and the Ancient World of the Northern Black Sea Region in the Seventh–Fourth Centuries в.с.] *Скифо-сибирский звериный стиль в искусстве народов Евразии*, ред. А.И. Мелюкова и М.Г. Мошкова (Москва 1976), 66–73.

Onaiko (1982): Онайко, Н.А., "О нових публикациях античной торевтики из скифских курганов Приднепровья" [About the New Publications on Ancient Toreutics from the Scythian Kurhany of the Dnipro River Region] *Советская археология* 4 (1982), 241–55.

Otroshchenko (1984): Отрощенко, В.В., "Парадный меч из кургана у с. Великая Белозерка" [A Ceremonial Dagger from the Kurhan in the Village of Velyka Bilozerka] *Вооружение скифов и сарматов* (Киев 1984), 121–26.

Otroshchenko and Rassamakin (1985): Отрощенко, В.В. та Ю.Я. Рассамакін, "До таємниць Геродотової Скіфії" [About the Mysteries of Herodotus' Scythia] *Наука і культура* 19 (Київ 1985), 240–46.

Paris, *Or* (1975): *Or des Scythes. Trésors des musées soviétiques.* Grand Palais, October 8–December 21, 1975 (Paris 1975).

Parker (1996): Parker, R., *Athenian Religion. A History* (Oxford 1996).

Parrot (1961a): Parrot, A., *The Arts of Assyria*, trans. S. Gilbert and J. Emmons (New York 1961).

Parrot (1961b): Parrot, A., *Nineveh and Babylon* (Paris 1961).

Pchenitchniouk (1994): Pchenitchniouk, A.K., "Le kourgane royal de Filippovka au sud de l'oural," *Les Scythes. Les dossiers d'archéologie* 194 (June 1994), 64–5.

Petrenko (1967): Петренко, В.Г., "Правобережье Среднего Поднепровья в V–III вв. до н.э." [The Central Right Bank Region of the Dnipro River in the Fifth–Third Centuries B.C.] *Археология СССР: Свод археологических источников*, вып. Д1–4 (Москва 1967), 40–48.

Petrenko (1978): Петренко, В.Г., "Украшения Скифии VII–III вв. до н.э." [The Ornamentation of Scythia, Seventh–Third Centuries B.C.] *Археология СССР: Свод археологических источников*, вып. Д4–5 (1978), 45.

Petrenko (1995):Petrenko, V., "Scythian Culture in the North Caucasus," in Davis-Kimball, Bashilov, and Yablonsky, 5–26.

Petrov (1968): Петров, В.П., *Скіфи: мова і етнос* [Scythians: Language and Ethnos] (Київ 1968).

Petsas (1960): Petsas, P., "Pella, Literary Tradition and Archaeological Research," in *Balkan Studies* 1 (1960), 113–28.

Petsas (1965): Petsas, P., "Pella," in *Enciclopedia dell'arte antica*, vol. 6 (Rome 1965), 16–20.

Petsas (1978): Petsas, P., *Pella, Alexander the Great's Capital* (Thessalonika 1978).

Pfrommer (1982): Pfrommer, M., "Grossgriechischer und mittelitalischer Einfluss in der Rankenornamentik frühhellenistischer Zeit," *JdI* 97 (1982), 119–90.

Pfrommer (1983): Pfrommer, M., "Italien-Makedonien-Kleinasien. Interdependenzen spätklassischer und frühhellenistischer Toreutik," *JdI* 98 (1983), 235–85.

Pfrommer (1987): Pfrommer, M., "Studien zu alexandrinischer und grossgriechicher Toreutik frühhelenistischer Zeit," in *Archäologische Forschungen* 16 (1987).

Pfrommer (1990): Pfrommer, M., "Untersuchungen zur Chronologie früh-und hochhellenistischen Goldschmucks," *Istanbuler Forschungen* 37 (1990), 268–69.

Pfrommer (1993): Pfrommer, M., *Metalwork from the Hellenized East: Catalogue of the Collections* (Malibu 1993).

Pfrommer (1994): Pfrommer, M., *Metalwork from the Hellenized East. The J. Paul Getty Museum* (Malibu 1994).

Philipp (1981): Philipp, H., "Bronzeschmuck aus Olympia," in *Olympische Forschungen* 13 (1981).

Phillips (1965): Phillips, E.D., *The Royal Hordes. Nomad Peoples of the Steppes* (New York 1965).

Pianu (1990): Pianu, G., *La necropoli meridionale di Eraclea. 1. Le tombe de secolo IV e III a.C.* (Rome 1990).

Pierides (1971): Pierides, A., *Jewellery in the Cyprus Museum* (Nicosia 1971).

Piotrovsky (1975): Piotrovsky, B., et al., *Or des Scythes* (Paris 1975).

Piotrovsky (1986): Piotrovsky, B., et al., *Skythische Kunst* (Leningrad 1986).

Piotrovsky, Galanina, and Grach (1987): Piotrovsky, B., L. Galanina, and N. Grach, *Scythian Art* (Leningrad 1987).

Pokrovskaia (1955): Покровская, Е.Ф., "Мелитопольский скифский курган" [The Scythian Kurhan in Melitopol'] *Вестник древней истории* (1955), 191.

Polin (1984): Полин, С.В., "Захоронение скифского воина-дружинника у с. Красный Подол на Херсонщине" [The Burial of a Scythian Warrior-Militiaman in the Village of Chervonyi Peredil in the Kherson Region] *Вооружение скифов и сарматов* (1984), 112–13.

Polin (1987): Полін, С.В., "Хронологія ранньоскіфських пам'яток" [The Chronology of Early Scythian Finds] *Археологія* 59 (Київ 1987), 26–27.

Polin (1997): Полин, С.В., "Бронзовые поножи из Соболевой Могилы" [Bronze Knives from Soboleva Mohyla] *Новые страницы древней истории Южной Украины* (Николаев 1997), 12–13.

Polin and Kubyshev (1997): Полин, С.В., и А.И. Кубышев, *Скифские курганы Утлюкского междуречья (в Северо-западном Приазовье)* [Scythian Kurhany of the Utliuk Inter-River Region (in the Northwestern Oziv Littoral)] (Киев 1997).

Pollak (1903): Pollak, L., *Klassisch-Antike Goldschmiedearbeiten im Besitza Sr. Excellenz A. J. von Nelidow* (Leipzig 1903).

Polos'mak (1994): Полосьмак, Н.В., "*Стерегущие золото грифы (акалахинские курганы)*" [The Gold-Guarding Griffins (the kurhany at Ak-Alak)] (Новосибирск 1994).

Polosmak (1994): Polosmak, N.V., "Siberian Mummy Unearthed," *National Geographic Magazine* 186/4 (October 1994), 80–103.

Porada (1963): Porada, E., *Iran Ancien* (Paris 1963).

Potratz (1928): Potratz, J.A.H., *Die Skythen in Südrussland* (Basel 1928).

Prilipko and Boltrik (1991): Прилипко, Я.П. и Ю.В. Болтрик, "Опыт реконструкции скифского костюма на материалах погребения скифянки из Вишневой Могилы" [A Reconstructional Experiment of a Scythian Costume based on the Material Found in the Burial of a Scythian Woman at Vyshneva Mohyla] *Курганы степной Скифии* (1991), 18–33.

Prushevskaia (1917): Прушевская, Э.О., "Родосская ваза и бронзовые вещи из могилы на Таманском полуострове" [A Rhodian Vase and Bronze Items from a Mohyla on the Taman' Peninsula] *Известия Археологической Комиссии* 63 (1917), 31–58.

Pukhov (1962): Пухов, И.В., *Якутский героический епос, "олонхо"* [The Iakut Heroic Epic, 'olonkho'] (Москва 1962).

Rabinovich (1936): Рабинович, Б.С., "О датировке некоторых скифских курганов Среднего Приднепровья" [On the Dating of Some Scythian Kurhany of the Central Dnipro River Region] *Советская археология* 1 (Москва 1936), 79–102. (Summary in French)

Rätzel (1978): Rätzel, W., "Die skythischen Gorytbeschläge," *Bonner Jahrbücher* 178 (1978), 163–80.

Reade (1983): Reade, J., *Assyrian Sculpture* (London 1983).

Reber (1983): Reber, K., "Ein silbernes Kybelerelief aus Eretria," *AntK* 26 (1983), 77–83.

Reeder (1988): Reeder, E.D., *Hellenistic Art in The Walters Art Gallery* (Baltimore 1988).

Reinach (1891): Reinach, S., *Antiquités de la Russie Méridionale* (Paris 1891).

Reinach (1892): Reinach, S., *Antiquités du Bosphore Cimmérien* (Paris 1892).

Reni, *Тезисы* (1989): "История и археология Нижнего Подунавья" [History and Archaeology of the Lower Danube Region] in *Тезисы конференции г. Рени* (Рени 1989).

Riabova (1979): Рябова, В.А., "Женское погребение из кургана Денисова Могила" [A Woman's Burial from the Kurhan Denisova Mohyla] *Памятники древних культур Северного Причерноморья* (Киев 1979), 49.

Riabova (1984): Рябова, В.А., "Дерев'яні чаші з обвивками з курганів скіфського часу" [Decorated Wooden Cups from Kurhany of the Scythian Period] *Археологія* 46 (1984), 31–44.

Riabova (1998): Рябова, В.О., "Повернення до сахнівської діадеми" [Revisiting the Sakhniv Diadem] *Музейні читання. Матеріали наукової конференції Музею історичних коштовностей України - філіалу Національного музею історії України 17–18 грудня 1996 р.* (Київ 1998), 23–26.

Richter (1931): Richter, G.M.A., "A Greek Sword Sheath of a Scythian King," *Bulletin of the Metropolitan Museum of Art* 26/2 (1931), 44–48.

Richter (1932): Richter, G.M.A., "A Greek Sword Sheath from South Russia," *Metropolitan Museum Studies* 4 (1932), 109–30.

Richter (1953): Richter, G.M.A., *The Metropolitan Museum of Art: Handbook of the Greek Collection* (Cambridge 1953).

Richter (1956): Richter, G.M.A., *Catalogue of Engraved Gems: Greek, Etruscan and Roman* (Rome 1956).

Richter (1965): Richter, G.M.A., *The Portraits of the Greeks*, vol. 3 (London 1965).

Richter (1966): Richter, G.M.A., *The Furniture of the Greeks, Etruscans and Romans* (London 1966).

Richter (1968): Richter, G.M.A., *Engraved Gems of the Greeks and the Etruscans* (London 1968).

Rimini, *Mille* (1995): *Dal Mille al Mille Tesori e Popoli dal Mar Nero.* Sala dell'Arengo e Palazzo del Podestà, March 5–June 25, 1995 (Milan 1995).

Robert (1889): Robert, C., "Sitzungsberichte der archäolog. Gesellschaft zu Berlin," *AA* (January 1889), 151–53.

Robert and Robert (1958): Robert, J. and L. Robert, "Bulletin Épigraphique," *Revue des Études Grecques* 21/173 (1958), 226–27.

Robertson (1975): Robertson, M., *The Parthenon Frieze* (New York 1975).

Robertson (1992): Robertson, M., *The Art of Vase-Painting in Classical Athens* (Cambridge 1992).

Robinson (1934): Robinson, D.M., "The Bronze State Seal of Larisse Kremaste," *AJA* 38 (1934), 219–22.

Robinson (1941): Robinson, D.M., *Excavations at Olynthus. Part X: Metal and Minor Miscellaneous Finds, an Original Contribution to Greek Life* (Baltimore 1941).

Roerich (1930): Рерихъ, Ю.Н., "Звериный стиль у кочевниковъ Севернаго Тибета" [The Animal Style among the Nomad Tribes of Northern Tibet] in *Skythika* 3 (Prague 1930). (English translation)

Roes (1952): Roes, A., "Achaemenid Influence upon Egyptian and Nomad Art," *Artibus Asiae* 15 (1952), 17–30.

Rolle (1972): Rolle, R., "Neue Ausgrabungen skythischer und sakischer Grananlagen in der Ukraine und in Kazachstan," *Prähistorische Zeitschrift* 47 (1972), 47–77.

Rolle (1977): Rolle, R., "Urartu und die Reiternomaden," *Saeculum* 28/3 (1977), 291–339.

Rolle (1978): Rolle, R., "Totenkult der Skythen. I. Das Steppengebiet," in *Vorgeschichtliche Forschungen* 18 (1978).

Rolle (1980): Rolle, R., *Die Welt der Skythen* (Luzern, Frankfurt 1980), reprinted as *The World of the Scythians*, trans. F.G. Walls (Berkeley, Los Angeles 1980).

Rolle (1988): Rolle, R., "Erste Ergebnisse der modernen Untersuchungen am skythischen Kurhan Certomlyk," *Antike Welt* 19/4 (1988), 3–14.

Rolle, Murzin, and Šramko (1991): Rolle, R., V.Ju. Murzin, and B.A. Šramko, "Das Burgwallsystem von Bel'sk (Ukraine). Eine frühe stadtartige Anlage im skythischen Landesinneren," *Hamburger Beiträge zur Archäologie* 18(1991, published in 1996), 57–84.

Rolley (1967): Rolley, C., "Greek Minor Arts," in *Monumenta Graeca et Romana*, vol. 5, fasc. 1 (Leiden 1967).

Rolley (1982): Rolley, C., *Les vases de bronze de l'archaïsme récent en Grande-Grèce* (Naples 1982).

Rolley (1984): Rolley, C., *Die griechischen Bronzen* (Munich 1984).

Romiopoulou (1979): Ρομιόπουλου, Κ., ed. Θησαυροῖ τῆς Ἀρχαίας Μακεδονίας [Treasury of Macedonian Antiquities] (Θεσσαλονίκη 1979).

Ross Holloway (1978): Ross Holloway, R., *Art and Coinage in Magna Graecia* (Bellinzona 1978).

Rostovtsev (1913): Ростовцев, М.И., *Античная декоративная живопись на Юге России* [Ancient Decorative Painting in the South of Russia] (Санкт Петербург 1913).

Rostovtsev (1914): Ростовцев, М.И., "Воронежский серебряный сосуд" [A Silver Vessel from Voronezh] *Материалы по археологии России* 34 (Ленинград 1914), 79–93.

Rostovtsev (1925): Ростовцев, М.И., "Скифия и Боспор" [Scythia and the Bosphorus] in *Российская Академия истории материальной культуры* (Ленинград 1925); reprinted in German as Rostowcew, M.I., *Skythien und der Bosporus* (Berlin 1931).

Rostovtzeff (1913): Rostovtzeff, M.I., *Fische als Pferdschmuck, Opuscula archaeologica* (Stockholm 1913).

Rostovtzeff (1922a): Rostovtzeff, M.I., *Iranians and Greeks in South Russia* (Oxford 1922).

Rostovtzeff (1922b): Rostovtzeff, M.I., *The Animal Style in South Russia & China* (Leipzig, London 1922; reprinted Princeton, New York 1929).

Rostovtzeff (1929): Ростовцевъ, М.И., "Срединная Азия, Россия, Китай и звериный стиль," in *Skythika* 1 (Prague 1929). (French translation)

Rubinson (1990): Rubinson, K.S., "The Textiles from Pazyryk," *Expedition* 32/1 (1990), 49–61.

Rudenko (1960): Руденко, С.И., *Культура населения центрального Алтая в скифское время* [Culture of the Population of the Central Altai in the Scythian Period] (Москва, Ленинград 1960).

Rudenko (1962): Руденко, С.И., *Сибирская коллекция Петра I* [The Siberian Collection of Peter I] (Москва, Ленинград 1962).

Rudenko (1970): Rudenko, S.I., *Frozen Tombs of Siberia: The Pazyryk Burials of Iron-Age Horsemen*, trans. M.W. Thompson (London 1970).

Rudolph (1986): Rudolph, W., "A Graeco-Scythian Gold Pectoral from Tolstaja Mohyla near Ordzonikidze," *AJA* 90 (1986), 208–209.

Rudolph (1993): Rudolph, W., "The Great Pectoral from the Tolstaja Mohyla. A Work of the Certomlyk Master and His Studio," *Археологические вести* 2 (1993), 85–90. (summary in English)

Rusiaeva (1979): Русяева, А.С., *Земледельческие культы в Ольвии догетского времени* [Agricultural Cults in Olbia in the Pre-Goth Period] (Киев 1979), 101–14.

Rusiaeva (1997): Русяева, М.В., "Змееногая богиня или Горгона Медуза – Владычица?" [A Serpent Footed Goddess or the Gorgon Medusa-Mistress?] *Херсонес в античном мире. Историко-археологический аспект. Тезисы докладов Международной научной конференции* (Севастополь 1997), 102–105.

Rusiaieva (1994): Русяєва, М.В., "Золоті прикраси у вигляді голови Гери" [Gold Decorations Resembling the Head of Hera] *Археологія* 1 (1994), 104–109.

Rusiaieva (1995a): Русяєва, М.В., "Діонісійські сюжети на пам'ятках торевтики із скіфських курганів" [Dionysiac Subjects in the Toreutic Items from the Scythian Kurhany] *Археологія* 1 (1995), 28–29.

Rusiaieva (1995b): Русяєва, М.В., "Образ Горгони Медузи за пам'ятками торевтики із скіфських курганів" [The Image of the Gorgon Medusa in the Toreutic Items from the Scythian Kurhany] *Музейні читання. Тези доповідей наукової конференції Музею історичних коштовностей України - філіалу Національного музею історії України* (Київ 1995), 16–18.

Rusiaieva (1997): Русяєва, М.В., "Інтерпретація зображень на золотій пластині з Сахнівки" [Interpretations of the Imagery on the Gold Plaque from Sakhnivka] *Археологія* 1 (1997), 46–56.

Ruxer (1938): Ruxer, M.S., *Historja Naszyjnika Greckiego* [The History of a Greek Necklace], vol. 1 (Poznan 1938).

Rybakov (1981): Рыбаков, Б.А., *Язычество древних славян* [Paganism of the Ancient Slavs] (Москва 1981).

Rybakov (1989): Рыбаков, Б.А. и др. *Степи европейской части СССР в скифо-сарматское время* [Steppes of the European Part of the USSR in the Scytho-Sarmatian Period] (Москва 1989).

Ryder (1990): Ryder, M. L., "Wool Remains from Scythian Burials in Siberia," *Oxford Journal of Archaeology* 9/3 (1990), 313–21.

St. Petersburg, *Cimmérien* (1854): *Antiquités du Bosphore Cimmérien*, vols. 1 and 2 (St. Petersburg 1854).

Savostina (1993): Savostina, E.A., "Les kourganes du Bosphore," *Les villes grecques de la mer noire. Les dossiers d'archéologie* 188 (December 1993), 58–67.

Scarfi (1962): Scarfi, B.M., "Gioia del colle (Bari). L'abitato peucetico di Monte Sannace," *Notozie degli scavi antichità* 8/16 (1962), 1–285.

Schefold (1930): Schefold, K., *Kertscher Vasen* (Berlin, Wilmersdorf 1930).

Schefold (1934): Schefold, K., *Untersuchungen zu den Kertscher Vasen* (Berlin, Leipzig 1934).

Schefold (1938): Schefold, K., "Der skythische Tierstil in Südrussland," *Eurasia septentrionalis antiqua* 12 (1938), 1–78.

Schefold (1960): Schefold, K., *Meisterwerke griechischer Kunst* (Basel 1960).

Schiltz (1976): Schiltz, V., "Decouvertes récentes dans le monde des steppes," *RA* 1 (1976), 190–92.

Schiltz (1979a): Schiltz, V., "Deux gorytes identiques en Macédoine et dans le Kouban," *RA* 2 (1979), 305–10.

Schiltz (1979b): Schiltz, V., "Les bronzes de Koban," *Archéologia* 128 (1979), 28–43.

Schiltz (1991): Schiltz, V., *Histoire des Kourgans. La Redecouverte de l'or des Scythes* (Paris 1991).

Schiltz, *Sciti* (1994): Schiltz, V., *Gli Sciti* (Paris 1994).

Schiltz, *Scythes* (1994): Schiltz, V., *Les Scythes et les nomades des steppes* (Paris 1994); reprinted in German as *Die Skythen und andere Steppen Iker* (Munich 1994).

Schleswig, *Gold* (1991): R. Rolle, M. Müller-Wille, and K. Schietzel, eds., *Gold der Steppe: Archäologie der Ukraine* (Schleswig 1991).

Schneider and Zazoff (1994): Schneider, L. and P. Zazoff, "Konstruction und Rekonstruktion: zur Lesung thrakischer und skythischer Bilder," *JdI* 109 (1994), 143–216.

Schöne-Denkinger (1993): Schöne-Denkinger, A., "Terrakotamodel aus dem Bau Y am heiliger Tor (Kerameikos)," *RM* 108 (1993), 151–81.

Schwarzenberg (1969): Schwarzenberg, E., "From the Alessandro morente to the Alexandre Richelieu," *Journal of the Warburg and Courtauld Institutes* 32 (1969), 398–405.

Schwarzenberg (1975): Schwarzenberg, E., "The Portraiture of Alexander," in Badian, 223–78.

Schwarzmaier (1996): Schwarzmaier, A., "Die Gräber in der Grossen Blizniza und ihre Datierung," *JdI* 111 (1996), 105–37.

Schwarzmaier (1997): Schwarzmaier, A., "Griechische Klappspiegel," in *AM, Beiheft* 18 (1997).

Segall (1938): Segall, B., *Museum Benaki, Athens. Katalog der Goldschmiede-Arbeiten* (Athens 1938).

Segall (1966): Segall, B., *Zur griechischen Goldschmiedekunst des 4. Jhs. v. Chr.* (Wiesbaden 1966).

Sekerskaia (1992): Секерская, Е.П., "Анализ остатков лошадей из курганов скифской знати" [Analysis of the Horse Remains from Kurhany of Scythian Nobility] *Древности степного Причерноморья и Крыма*, вып. 5 (Запорожье 1992), 188–90.

Semenov (1997): Семенов, В.А., "Окуневские памятники Тувы и Минусинской котловины" [Okunev Objects from Tuva and Minusinsk Basin] *Окуневский сборник* (1997), 152–60.

Semionov (1994): Semionov, V.A., "Au coeur de l'Asie," *Les Scythes. Les dossiers d'archéologie* 194 (June 1994), 38–43.

Shcheglov and Katz (1991): Shcheglov, A.N. and Katz, V.I., "A Fourth-Century B.C. Royal Kurhan in the Crimea," *Metropolitan Museum Journal* 26 (1991), 97–122.

Shchepinskii (1962): Щепинский, А.А., "Погребение начала железного века у Симферополя" [Burials at the Beginning of the Iron Age in Simferopol'] *Краткие сообщения ИА АН УССР* 12 (Киев 1962), 57–65.

Shelov (1971): Шелов, Д.Б., "Скифо-македонский конфликт в истории античного мира" [The Scytho-Macedonian Conflict in the History of the Ancient World] *Проблемы скифской археологии*, ред. П.Д. Либеров и В.И. Гуляев (Москва 1971), 54–63.

Sher (1980): Шер, И.А., *Петроглифы средней и центральной Азии* [Petroglyphs of Middle and Central Asia] (Москва 1980).

Sher (1994): Sher, J.A., et. al., *Siberie de sud I: Oglakhty I–III (Russie, Khakassie)* (Paris 1994).

Shih Hsio-Yen (1983): Shih Hsio-Yen, "Gold and Silver Vessels Excavated in North China: Problems of Origins," *New Asia Academic Bulletin* 4 (1983), 63–93.

Shilov (1961): Шилов, В.П., "Раскопки Элизаветинского могильника в 1959" [Excavations of the Elysavetyns'kyi Kurhan in 1959] *Советская археология* 1 (1961), 150–68.

Shilov (1989): Шилов, Ю.О., "История и археология Нижнего Подунавья" [The History and Archaeology of the Lower Danube Region] *Тезисы конференции. г. Рени, 1989г.* (1989), 17.

Shleev (1950): Шлеев, В.В., "К вопросу о скифских навершиях" [On the Question of Scythian Poletops] *Краткие сообщения о докладах и полевых исследованиях Института истории материальной культуры АН ССР* 34 (1950), 53–61.

Shoolbraid (1975): Shoolbraid, G.M.H., *The Oral Epic of Siberia and Central Asia* (Bloomington 1975).

Shovkoplias (1972): Шовкопляс, І.Г., *Основи Археології* [The Fundamentals of Archaeology] (Київ 1972).

Shramko, Fomin, and Solntsev (1977): Шрамко, Б.А., Л.Д. Фомин и Л.А. Солнцев, "Начальный этап обработки железа в Восточной Европе" [The Initial Phase of Ironworking in Eastern Europe] *Советская археология* 4 (1977), 63–64.

Shtitel'man (1977): Штітельман, Ф.М., *Античне мистецтво* [Ancient Art] (Київ 1977).

Shul'ts (1957): Шульц, П.Н., "Исследования Неаполя Скифского (1945–1950 гг.)" [Research on Scythian Neapolis (1945–1950)] *История и археология древнего Крыма* (Киев 1957), 76.

Silant'eva (1959): Силантьева, Л.Ф., "Некрополь Нимфея" [The Necropolis of Nymphaion] *Материалы и исследования по археологии СССР* 69 (1959), 3–107.

Simon (1997): Simon, E., "Kybele," in *LIMC* 8 (1997), 744–66.

Simonenko (1987): Симоненко, А.В., "О семантике среднего фриза чертомлицкой амфори" [On the Semantics of the Central Frieze of the Chortomlyk Amphora] in *Скифы Северного Причерноморья* (Київ 1987), 140–44.

Simonenko (1993): Симоненко, А.В., *Сарматы Таврии* [The Sarmatians of Taurus] (Киев 1993).

Siviero (1954): Siviero, R., *Gli ori e le ambre del Museo Nazionale di Napoli* (Naples 1954).

Skoryi (1990): Скорый, С.А., *Курган Переп'ятиха* [Kurhan Perep'iatykha] (Киев 1990).

Skoryj (1991): Skoryj, S., "Der Kurhan Perepjaticha. Ein 'Fürstengrab' der skythischen Landnahmezeit in der ukrainischen Waldsteppe," *Hamburger Beiträge zur Archäologie* 18 (1991, published in 1996), 85–106.

Skudnova (1957): Скуднова, В.М., "Хиосские кубки из раскопок на о. Березани" [Cups from Chios Excavated on the Island of Berezan'] *Советская археология* 4 (1957), 135–48.

Skudnova (1962): Скуднова, В.М., "Скифские зеркала из архаической Ольвии" [Scythian Mirrors from Ancient Olbia] *Труды Государственного Эрмитажа* 3 (Ленинград 1962), 5.

Slavin (1958): Славін, Л.М., "Основні результати та найближчі завдання розкопок Ольвії" [Preliminary Results and Primary Tasks of the Excavations in Olbia] *Археологічні пам'ятки УРСР* 7 (1958), 5–15.

Smirnov (1984): Смирнов, К.Ф., *Сарматы и утверждение их политического господства в Скифии* [Sarmatians and the Affirmation of their Political Domination of Scythia] (Москва 1984)

Smith (1904): Smith, A.H., *Catalogue of Sculpture in the Department of Greek and Roman Antiquities of the British Museum*, vol. 3 (London 1904).

So and Bunker (1995): So, J.F. and E.C. Bunker, *Traders and Raiders on China's Northern Frontier* (Seattle, London 1995).

Sokolov (1974): Sokolov, G., *Antique Art on the Northern Black Sea Coast* (Leningrad 1974).

von Stackelberg (1837): von Stackelberg, Baron Magnus O., *Die Gräber der Hellenen* (Berlin 1837).

Stadter (1989): Stadter, P.A., *A Commentary on Plutarch's Pericles* (Chapel Hill 1989).

Stähler (1997a): Stähler, K., "Zum Relief der Schwertscheide von Certomlyk," in *Zur graeco-skythischen Kunst. Archäologisches Kolloquium Münster. 24–26 November, 1995.* ed. K. Stähler (Münster 1997), 61–84.

Stähler (1997b): Stähler, K., "Zum Gorytrelief aus dem sog. Philippsgrab in Vergina," in *Zur graeco-skythischen Kunst. Archäologisches Kolloquium Münster. 24–26 November, 1995.* ed. K. Stähler (Münster 1997), 85–114.

Stähler and Nieswandt (1991/1992): Stähler, K. and Nieswandt, H.-H., "Der skythische Goryt aus dem Melitopol-Kurhan," *Boreas* 14–15 (1991/1992), 85–108.

Stierlein (1986): Stierlein, H., *Grèce d'Asie* (Fribourg 1986).

Strommenger (1964): Strommenger, E., *The Art of Mesopotamia* (London 1964).

Strong (1966): Strong, D. E., *Greek and Roman Gold and Silver Plate* (London 1966).

Stryzhak (1988): Стрижак, О.С., *Етнонімія Геродотової Скіфії* [Ethnonyms of Herodotus' Scythia] (Київ 1988).

Sulimirski and Taylor (1991): Sulimirski, T. and T. Taylor, "The Scythians," in *Cambridge Ancient History*, vol. 3, part 2, second edition. (Cambridge 1991), 547–90.

Szymanska (1984): Szymanska, Z.H., "Greek or Thracian? Some Problems of Identifying Sources of Metalwork," in *Dritter internationaler Thrakologischer Kongress zu Ehren W. Tomascheks, 2.–6. Juni 1980 Wien*, 2 (Sofia 1984), 106–10.

Taisei Gallery (1992): *Gold and Silver Auction: Ancient to Renaissance.* Taisei Gallery. November 5, 1992, part 2 (New York 1992).

Tait (1986): Tait, H., ed., *Seven Thousand Years of Jewellery* (London 1986).

Takhtai (1964): Тахтай, О.К., "Скіфська статуя з с. Ольховчик Донецької області" [A Scythian Statue from the Village of Ol'khovchyk, Donets'ka Oblast'] *Археологія* 17 (Київ 1964), 205–207.

Talbot Rice (1958): Talbot Rice, T., *The Scythians* (New York 1958).

Tarditi (1996): Tarditi, C., *Vasi di bronzo in area Apula. Produzioni greche ed italiche di età arcaica e classica* (Lecce 1996).

Taylor (1994): Taylor, T., "Thracians, Scythians, and Dacians, 800 B.C.–A.D. 300," in *Oxford Illustrated Prehistory of Europe*, ed. B. Cunliffe (Oxford 1994), 373–410.

Tchlenova (1963): Tchlenova, N.L., *Le cerf scythe* (Ascona 1963).

Terenozhkin (1952): Тереножкин, А.И., "Памятники предскифского периода на Украине" [Remains from the Pre-Scythian Period in Ukraine] *Краткие сообщения о докладах и полевых исследованиях Института истории материальной культури* 17 (1952), 3–14.

Terenozhkin (1955): Тереножкин, А.И., "Скифский курган в Мелитополе" [The Scythian Kurhan in Melitopol'] *Краткие сообщения о докладах и полевых исследованиях Института археологии АН СССР* 5 (1955).

Terenozhkin (1961): Тереножкин, А.И., *Предскифский период на Правобережье* [The Pre-Scythian Period on the Right Bank of the Dnipro River] (Киев 1961).

Terenozhkin (1975): Тереножкин, А.И., "Киммерийскы мечи и кинжали" [Cimmerian Swords and Daggers] *Скифский мир* (Киев 1975), 3–34.

Terenozhkin (1976): Тереножкин, А.И., *Киммерийцы* [Cimmerians] (Киев 1976).

Terenozhkin and Mozolevskii (1988): Тереножкин, А.И. и Б.Н. Мозолевский, *Мелитопольский курган* [The Melitopol's'kyi Kurhan] (Киев 1988).

Тезисы (1989): *Тезисы докладов областной конференции «Проблемы Скифо-сарматской археологии Северного Причерноморья»* [Abstracts of the Provincial Conference "Issues in Scytho-Sarmatian Archaeology of the Northern Black Sea Region"] (Запорожье 1989).

Тезисы (1994): *Тезисы докладов международной конференции «Проблемы Скифо-сарматской археологии Северного Причерноморья»* [Abstracts of the International Conference "Issues in Scytho-Sarmatian Archaeology of the Northern Black Sea Region"] (Запорожье 1994).

Thessalonika, *Treasures* (1978): Ninou, K., ed., *Treasures of Ancient Macedonia.* Archaeological Museum of Thessalonika, August 1978 (Athens 1978).

Thracian (1976): *Thracian Treasures from Bulgaria. The British Museum, January–March, 1976.* (London 1976).

Tian and Guo (1986): Tian, G. and S. Guo, *E-er-duo-si shi qingtong gi* (Beijing 1986).

Titenko (1954): Титенко, Г.Т., "Закавказские удила, найденные на Полтавщине" [A Transcaucasian Bit Found in the Poltava Region] *Краткие сообщения о докладах и полевых исследованиях Института археологии АН УССР* 3 (1954), 77–80.

Tod (1927): Tod, M., "The Economic Background of the Fifth Century B.C." *Cambridge Ancient History*, vol. 5 (Cambridge 1927), 1–32.

Tokyo, *Scythian Gold* (1992): *Scythian Gold: Museum of Historic Treasures of Ukraine* (Tokyo 1992).

Toledo, *Silver* (1977): Oliver, Jr., A., *Silver for the Gods: 800 Years of Greek and Roman Silver.* The Toledo Museum of Art, October 9–November 20, 1977; The William Rockhill Nelson Gallery of Art and Atkins Museum of Fine Arts, December 11, 1977–January 22, 1978; The Kimbell Art Museum, February 18–April 2, 1978 (Toledo 1977).

Tolochko (1994): Толочко, П.П. та ін., *Давня історія України* [The Ancient History of Ukraine] (Київ 1994).

Tolstikov (1993): Tolstikov, V.P., "Panticapée. Capitale du Bosphore," *Les villes grecques de la mer noire. Les dossiers d'archéologie* 188 (December 1993), 40–45.

Tolstoi and Kondakov (1889): Толстой, И.И. и Н.П. Кондаков, *Русские древности в памятниках исскуства* [Russian Antiquities in Objects of Art], том 1 и 2 (Санкт Петербург 1889); reprinted in French, Kondakof, N., J. Tolstoi, and S. Reinach, *Antiquités de la Russie Méridionale* (Paris 1891).

Tonkova (1997): Tonkova, M., "Traditions and Aegean Influences on the Jewellery of Thracia in Early Hellenistic Times," *Archaeologica Bulgarica* 1/2 (1997), 18–31.

Toulouse, *L'or* (1993): Rey-Delqué, M., ed., *L'or des steppes,* Musée des Augustins, October 28, 1993–January 17, 1994 (Toulouse 1993).

Treister (1987): Трейстер, М.Ю., "Бронзолитейное ремесло Боспора IV в. до н.э." [Bronzeworking in the Bosporus in the Fourth Century B.C.] *Краткие сообщения Института археологии АН СССР* 191 (1987), 7–13.

Treister (1988): Treister, M.Yu., "Bronze Statuary in the Antique Towns of the North Pontic Area," *Griechische und römische Statuetten und Großbronzen. Akten der 9. Tagung über antike Bronzen, Wien, 21.–25.April 1986,* eds. K. Gschwantler and A. Bernhard-Wälcher (Vienna 1988), 152–57.

Treister (1994a): Treister, M.Yu., "The Circular Matrix from the Robinson Collection," *Oxford Journal of Archeology* 13 (1994), 85–92.

Treister (1994b): Treister, M.Yu., "The Matrix from Berlin and the Samnite Belt from Reggio Calabria: To the Problem of Evolution of Large-scale Metal Production in the Classical World," *Bulletin of the Metals Museum* 21 (1994), 1–18.

Treister (1996a): Treister, M.Yu., *The Role of Metals in Ancient Greek History* (Leiden 1996).

Treister (1996b): Treister, M.Yu., "Bronze Matrices from the George Ortiz Collection," in *Ancient Jewelry and Archaeology*, ed. A. Calinescu (Bloomington, Indianapolis 1996), 172–84.

Treister (1996c): Treister, M.Yu., "Essays on the Bronze Working and Toreutics of the Pontus," in *New Studies on the Black Sea Littoral (Colloquia Pontica I)*, ed. G.R. Tsetskhladze (Oxford 1996), 73–134.

Treister (1997/1998): Treister, M.Yu., "Further Thoughts about the Butterfly Necklaces from the North Pontic Area," *Journal of the Walters Art Gallery* 55/56 (1997/1998), 49–62.

Treister (forthcoming): Treister, M.Y., *Hammering Techniques in Greek and Roman Jewelry and Toreutics* (forthcoming).

Treister and Yatsenko (1997/8): Treister, M.Yu. and S.A. Yatsenko, "About the Centers of Manufacture of Horse-harness Roundels in the 'Gold-Turquoise Animal Style' " *Silk Road Art and Archaeology* 5 (1997/1998), 51–106.

Turku, *Skyyttien* (1990): *Skyyttien Kulta-aare.* Turku Art Museum, July 1–August 31, 1990 (Turku 1990). (also in English)

Vadetskaia, Leont'ev, and Maksimenkov (1980): Вадетская, Е.Б., Н.Б. Леонтьев и Г.А. Максименков, *Памятники окуневской культури* [Artefacts of the Okunevs'ka Culture] (Ленинград 1980).

Valavanis (1991): Βαλαβάνης, Π., *Παναθεναϊκοῖ Ἀμφορεῖς ἀπὸ τὴν Ἐρετρία* [Panathenaic Amphorae from Eretria] (Ἀθῆναι 1991).

Vasylenko (1993): Василенко, Г.К., *Велика Скіфія* [Great Scythia] (Київ 1993).

Vaulina and Wasowicz (1974): Vaulina, M. and À. Wasowicz, *Bois Grecs et Romains de l'Ermitage* (Wrocław 1974).

Vavritsa (1973): Βαβρίτσα, Α. Κ., "Ἀνασκαφὴ Μεσημβρίας Θράκης," [Excavation of Mesembria in Thrace] *Πρακτικὰ τῆς ἐν Ἀθήναις Ἀρχαιολογικῆς Ἑταιρείας* (1973, published in 1975), 70–82.

Venedikov (1965): Venedikov, I., *Alte Schätze aus Bulgarien* (Sofia 1965).

Venedikov and Gerassimov (1975): Venedikov, I. and T. Gerassimov, *Thracian Art Treasures* (Sofia, London 1975).

Venice, *Tesori* (1987): *Tesori d'Eurasia. 2000 anni di Storia in 70 anni di Archeologia Sovietica*, ed. B. Piotrovskij (Milan 1987).

Vermeule (1980): Vermeule, C.C., "The Search for Alexander," *Archaeology* 33/6 (November–December 1980), 52–55.

Viaz'mitina (1971): Вязьмітіна, М.І., "Сарматський час" [The Sarmatian Period] *Археологія УРСР* (Київ 1971), 185–244.

Vicenza, *Oro* (1997): *Oro delle steppe dell'Ukraina.* Museo Civico Palazzo Chiericati, August 2–September 28, 1997 (Vicenza 1997).

Vickers (1979): Vickers, M., *Scythian Treasures in Oxford* (Oxford 1979).

Vickers (1987): Vickers, M., "Skythische Grabfunde im Ashmolean Museum Oxford," *Antike Welt* 18/4 (1987), 43–50.

Vienna, *Skythen* (1988): *Gold der Skythen aus der Leningrader Eremitage*, Kunstlerhaus, November 30, 1988–February 26, 1989 (Vienna 1988).

Vienna, *Gold* (1993): Seipel, W., ed., *Gold aus Kiew: 170 Meisterwerke aus der Schatzkammer der Ukraine*, Eine Ausstellung des Kunsthistorischen Museums (Vienna 1993).

Vinogradov (1981): Виноградов, Ю.Г., "Синопа и Олвия в V в. до н.э. проблема политического устройства" [Sinope and Olbia in the Fifth Century b.c. the Problem of Political Organization] *Вестник древней истории* (1981), 49–75.

Vlasova (1996): Власова, Э.В., "Золотые ножны меча из Ушаковского кургана" [Gold Sword Scabbard from Ushakovskyi Kurhan] *Эрмитажны чтенья памяты Б. Пиотровского. Тезисы докладов.* (Санкт Петербург 1996), 10–13.

Vokotopoulou (1975): Vokotopoulou, J., "Le trésor de vases de bronze de Votonossi," *BCH* 49 (1975), 729.

Vokotopoulou (1985): Βοκοτόπουλου, I. et al., *Σίνδος Κατάλογος τῆϛ Ἔκθεσιϛ* [Sindos: Catalogue of the Exhibition] (Θεσσαλονίκη 1985).

Vokotopoulou (1988): Βοκοτόπουλου, I. et al., *Ἡ Μακεδόνια ἀπὸ τὰ Μυκηναϊκὰ χρονιὰ ὸϛ τὸν Μέγα Ἀλέξανδρο* [Macedonia from Mycenean Times to Alexander the Great] (Θεσσαλονίκη 1988).

Völker-Janssen (1993): Völker-Janssen, W., "Kunst und Gesellschaft an den Höfen Alexanders d. Gr. uns seiner Nachfolger," in *Quellen und Forschungen zur antiken Welt* 15 (Munich 1993).

Volkov (1981): Волков, В.В., *Оленны камни Монголии* [Deer Stones of Mongolia] (Улан-Батор 1981).

Volkov (1995): Volkov, V.V., "Early Nomads of Mongolia," in Davis-Kimball, Bashilov, and Yablonsky, 315–34.

Vos-Jongkees (1963): Vos-Jongkees, M.F., *Scythian Archers in Archaic Attic Vase-Painting* (Gröningen 1963).

Walter-Karydi (1973): Walter-Karydi, E., "Samische Gefässe des 6. Jhs. v.Chr.," in *Samos* 6/1 (Bonn 1973).

Walters (1899): Walters, H.B., *Catalogue of the Bronzes, Greek, Roman, and Etruscan, in the Department of Greek and Roman Antiquities in the British Museum* (London 1899).

Walters (1926): Walters, H.B., *Catalogue of the Engraved Gems in the British Museum* (London, 1926).

Washington, *Alexander* (1980): *The Search for Alexander*, contributions by N. Yalouris, M. Andronikos, K. Rhomiopoulou, A. Herrmann and C. Vermeule. The National Gallery of Art, Washington, D.C., November 16, 1980–April 5, 1981; Art Institute of Chicago, May 14, 1981–September 7, 1981; Museum of Fine Arts, Boston, October 23, 1981–January 10, 1982; The Fine Arts Museum of San Francisco: M. H. de Young Memorial Museum, February 19, 1982–May 16, 1982 (Boston 1980).

von Wedel (1960): von Wedel, E., *Die geschichtliche Entwicklung des Umformens in Gesenken* (Düsseldorf 1960).

Wheeler (1968): Wheeler, M., *Flames over Persepolis* (London 1968).

Whittell (1993): Whittell, G., *Central Asia. Cadogan Guide* (London 1993).

Williams (1976): Williams, E.R., "Ancient Clay Impressions from Metalwork," *Hesperia* 45 (1976), 41–66.

Williams (1988): Williams, D., "Three Groups of Fourth Century South Italian Jewellery in the British Museum," *RM* 95 (1988), 75–95.

Williams (1996): Williams, D., "Refiguring Attic Red-figure: A Review Article," *RA* (1996), 227–52.

Williams (1998): Williams, D., "Identifying Greek Jewellers" in *The Art of the Greek Goldsmith. Proceedings of the International Conference, London, 4–6 October 1994*, ed. D. Williams (London 1998), 99–104.

Williams and Ogden (1994): Williams, D. and J. Ogden, *Greek Gold Jewelery of the Classical World*. The British Museum, London, June 21–October 23, 1994; The Metropolitan Museum of Art, New York, December 2–March 24, 1995 (New York 1994).

Williams and Ogden (1995): Williams, D. and J. Ogden, *Греческое золото* [Greek Gold] (Санкт Петербург 1995).

Wuilleunier (1939): Wuilleunier, P., *Tarente des origines à la conquête romaine* (Paris 1939).

Yablonsky (1995): Yablonsky, L., "The Material Culture of the Saka and Historical Reconstruction," in Davis-Kimball, Bashikov, and Yablonsky, 201–40.

Yablonsky, History (1995): Yablonsky, L., "Written Sources and the History of Archaeological Studies of the Saka in Central Asia," in Davis-Kimball, Bashikov, and Yablonsky, 193–200.

Zagreb (1989): *Sjaj ukrainski riznica* [The Splendor of Ukrainian Treasures] (Zagreb 1989).

Zavitukhina (1983): Завитухина, М.П., *Древнее искусство на Энисее* [Ancient Art from the Ienisei Region] (Ленинград 1983).

Zazoff, Höcker, and Schneider (1985): Zazoff, P., C. Höcker, and L. Schneider, "Zur thrakischen Kunst im Frühhellenismus. Griechische Bildelemente in zeremoniellem Verwendungszusammenhang," *AA* (1985), 595–643.

Zbruev (1952): Збруев, А.В., "История населения Прикамья в аннаньевскую эпоху" [The History of the Settlement of Prikam'ia during the Annan'evskii Period] in *Материалы и исследования по археологии СССР* 30 (Москва 1952).

Züchner (1938): Züchner, W., "Der Berliner Mänadenkrater," in *BWPr* 98 (Berlin 1938).

Zurich, *Schatzkammern* (1993): Karabelnik, M., ed., *Aus den Schatzkammern Eurasiens: Meisterwerke antiker Kunst*. Kunsthaus Zürich, January 29–May 2, 1993 (Zurich 1993).

INDEX

PHOTOGRAPHY CREDITS

Agora Excavations
51

Tom Brakefield
40–42

Perry Conway
38–39

Lynton Gardiner
4–5,10,14,104–111,114–116,120–121,125 (Cat. no. 22),
130–133,135,138–141,143–145,158–159,169–170,173–180,
182–185,187 (Cat. no.75)–191,194–204,206,208–211,220–222,
224,234–235,247–248,262–263,269–270,272–293,295,
297,299,301–303,305–313,315–316,318–319

Institute of Archaeology, Kyiv
25,30,52,54,56,93,100–101,282

National Geographic
2–3,23,44–45

Charles O'Rear
83

State Hermitage Museum, St. Petersburg
78

Gary Tepfer
36,58,61–67

Bruce White
1,11–13,70,72–74,102–103,112–113,117–118,122–125
(Cat. no. 21),126–128,137,142,146–151,153–156,160–161,
163–164,166,168,171,181,186–187(Cat. no. 74),192,212–213,
215–219,225–227,229–233,236–245,250,252–253,255,
257–261,264–268,320–322,324–325,327–331